Attention and Distraction
in Modern German Literature,
Thought, and Culture

Attention and Distraction in Modern German Literature, Thought, and Culture

CAROLIN DUTTLINGER

Great Clarendon Street, Oxford, OX2 6DP,
United Kingdom

Oxford University Press is a department of the University of Oxford.
It furthers the University's objective of excellence in research, scholarship,
and education by publishing worldwide. Oxford is a registered trade mark of
Oxford University Press in the UK and in certain other countries

© Carolin Duttlinger 2022

The moral rights of the author have been asserted

First Edition published in 2022

All rights reserved. No part of this publication may be reproduced, stored in
a retrieval system, or transmitted, in any form or by any means, without the
prior permission in writing of Oxford University Press, or as expressly permitted
by law, by licence or under terms agreed with the appropriate reprographics
rights organization. Enquiries concerning reproduction outside the scope of the
above should be sent to the Rights Department, Oxford University Press, at the
address above

You must not circulate this work in any other form
and you must impose this same condition on any acquirer

Published in the United States of America by Oxford University Press
198 Madison Avenue, New York, NY 10016, United States of America

British Library Cataloguing in Publication Data
Data available

Library of Congress Control Number: 2021953279

ISBN 978–0–19–285630–2

DOI: 10.1093/oso/9780192856302.001.0001

Printed and bound by
CPI Group (UK) Ltd, Croydon, CR0 4YY

Links to third party websites are provided by Oxford in good faith and
for information only. Oxford disclaims any responsibility for the materials
contained in any third party website referenced in this work.

Preface

This project started out as a study of attention in early twentieth-century German literature and thought. Since these beginnings it has, to use Franz Kafka's formulation, 'turned underneath my hands',[1] as its remit has expanded in temporal, conceptual, and disciplinary terms. The result is a book which is hard to categorize. Its centre of gravity still lies in modernism, but alongside literature and thought, it also explores photography, film, and music. My narrative focuses on German culture while also stressing the transnational nature of this debate. And it soon became apparent that a discussion of attention in modernism required a substantial historical preamble, one which charts the roots of this debate in the eighteenth and nineteenth centuries. The earlier stages of this story, which are mapped out in the first two chapters, are centred on psychology, a field where attention was explored first tentatively and then with increasing experimental rigour. Psychology, as we will see, was in some sense a German invention; and while it soon emerged as one of the master discourses of the time, it did not exist in isolation, but was inflected by other currents, such as philosophy and physiology. In its turn, psychology had a profound impact on modern culture, its conceptions of the self, and its everyday practices.

Finally, another major departure from the original project involved promoting distraction from a supporting role as attention's disruptive adversary to that of an equal counterpart. While attention remained a prominent reference point, modern culture was seen by many through the lens of distraction, *Zerstreuung*, a term evoking not only mental but also sensory and social fragmentation. For many commentators, the rise of distraction spelled the end of contemplative attention; and while not all embraced this shift, many thinkers, writers, and artists engaged with this dynamic constructively, seeking ways to incorporate it into their way of working, and reflecting it in their resulting works.

Accordingly, this study is based on three interconnected premises. First, that attention is intrinsically restless, unpredictable, and uncontrollable, and that, as uncontrollable, it constitutes a standing challenge to or for any modern, self-present, rational selfhood. Second, that this challenge, despite being an anthropological constant, gains a particular urgency in the age of social and technological

[1] '[...] dann aber drehte sich mir alles unter den Händen'. Kafka uses this phrase to describe how his short story 'Das Urteil' (The Judgement) turned out very differently than planned. Letter to Felice Bauer (2 June 1913), in Franz Kafka, *Briefe 1913–März 1914*, ed. Hans-Gerd Koch (Frankfurt a.M.: Fischer, 1999), p. 202.

modernization. In modern economies, labour is extensively and intensively divided, and this approach has knock-on effects for most areas of life. Increasingly, the model of the stable, autonomous, and self-aware subject becomes obsolete and unsustainable, triggering anxious debates and extensive, state-sponsored measures intended to minimize or reverse the perceived decline of attention. Such measures were, however, of limited benefit and often strayed into authoritarian and disciplinary terrain. At the same time, the modern(ist) crisis of attention also has a productive effect, as it prompts artists, writers, and thinkers to conceive of attention in more fluid, dialectical terms, as a faculty which is not closed off but closely linked to distraction in unexpected and often fruitful ways.

For the individuals discussed in this book, to engage with attention always involves a degree of self-reflection. This dynamic also applies to this book. Its rather baggy shape is the result of an evolving thought process that gradually brought new fields and questions into focus, taking me far beyond my initially defined corpus to pursue other routes of enquiry. In particular, it became clear that thought, literature, and other media could not be treated in isolation but had to be understood within a much wider context, against a backdrop of intense activity around attention in experimental psychology, in medicine and psychiatry, and in everyday life, specifically in the domains of work and consumption.

The promotion of distraction to the status of attention's equal counterpart was prompted in part by changes in my own personal and professional situation, where distraction, rather than attention or indeed contemplation, has often seemed the predominant state. This book bears the more or less visible traces of countless disruptions and diversions; but it also enacts the project's broader conclusions: that attention is inherently limited; that depth of focus is incompatible with comprehensive coverage; and that every act of focalization involves ignoring countless other routes of enquiry. Hopefully, the provisional and open-ended form of this study will spark further enquiry. In historical terms, then, the project extends beyond modernism into the years of fascism and exile and finally into the post-war years, with a concluding chapter trying to pinpoint some of the resonances of earlier discourses about attention in literature since the 1960s.

While writing this book, I have greatly benefited from countless conversations with colleagues, friends, and students in Oxford any beyond. I'd like to single out Eric Clarke, Ben Morgan, and Daniel Weidner, who have read parts of this manuscript and have provided invaluable feedback. I am indebted to Christina Striewski for sharing her Magisterarbeit on Benjamin and attention with me and to Benno Wagner, who has kindly made his Habilitationsschrift on Kafka available to me. Detlev von Graeve has offered valuable information about the 1929 'Gesunde Nerven' exhibition in Berlin, while Michael Schwarz at the Theodor W. Adorno Archiv at the Akademie der Künste Berlin has pointed me to material relating to Adorno's radio broadcasts. This project was completed during periods of sabbatical leave funded by the Zvi Meitar/Vice Chancellor of Oxford University

Research Prize, by the Modern Humanities Research Association, and by the Freiburg Institute for Advanced Studies, which provided a collegiate and stimulating research environment. The Oxford Faculty of Medieval and Modern Languages and Wadham College have generously supported me in pursuing these opportunities. I am immensely grateful to my readers for their lucid and constructive feedback, and to the excellent team at Oxford University Press. I have greatly benefited from the research assistance provided by Roland Muntschik and Andreas Schmid. My deepest thanks go to Joe Harris, without whose love, intellectual input, and ongoing support this book would not have come to fruition.

To Joe, Maxi, and Clara, and to my parents, with love

Contents

List of Illustrations	xiii
List of Abbreviations	xv
Introduction	1
1. Virtue, Reflex, Pathology: Attention from the Enlightenment to the Late Nineteenth Century	15
2. Modernity: Fragmentation and Resistance	46
3. Franz Kafka: Diversion, Vigilance, Paranoia	85
4. Psychotechnics: Training the Mind	127
5. Threshold States: Robert Musil	157
6. The Art of Concentration: Weimar Self-Help Literature	204
7. Stillness: Weimar Photography	221
8. Presence of Mind: Walter Benjamin	266
9. Musical Listening between Immersion and Detachment	317
10. Spellbound: Theodor W. Adorno on Music and Style	338
11. Celan, Sebald, Hoppe: Networks of Attention	383
Bibliography	405
Index	429

List of Illustrations

3.1. Franz Kafka, 'Unfallverhütungsmaßregel bei Holzhobelmaschinen' (Measures for Preventing Accidents from Wood-Planing Machines, 1910) 95

4.1. Drop-down tachistoscope for school experiments (*ZP* 11) 133

4.2. Ergograph (*ZP* 24) 134

4.3. Große Versuchsanordnung zur Prüfung der Schreckhaftigkeit, Geistesgegenwart und Entschlußkraft (Large Testing Station for the Assessment of Fright-Reaction, Presence of Mind, and Decisiveness; *ZP* 105) 137

4.4. Gedächtnisprüfer (Memory Testing Device) after Schulte (*ZP* 99) 138

4.5. Devices for measuring the skull and ears (*ZP* 21) 139

4.6. Programming cards for the Hollerith Machine 151

6.1. Philipp Müh's Konzentrator 216

7.1. and 7.2 'Attention'. G.-B. Duchenne (de Boulogne), *Mécanisme de la physionomie humaine* (1862), vol. II, plates 7 and 8 223

7.3. Duchenne's Faradic apparatus. *Mécanisme*, vol. II, p. 5 224

7.4. Umbo (Otto Umbehr), 'Mysterium der Straße' (Mystery of the Street, 1928). New York, Metropolitan Museum of Art. Gelatin silver print. Ford Motor Company Collection, Gift of Ford Motor Company and John C. Waddell, 1987. © 2021. Image copyright The Metropolitan Museum of Art/Art Resource/Scala, Florence; © Phyllis Umbehr/Galerie Kicken Berlin/DACS. 2021 228

7.5. Erna Lendvai-Dircksen, 'Mädchen aus Holstein' (Girl from Holstein), *Das deutsche Volksgesicht*, p. 34 (copyright holder unknown) 238

7.6. Helmar Lerski, 'Maler' (Painter, *KA* 12). © Nachlass Helmar Lerski, Museum Folkwang, Essen 243

7.7 and 7.8. Helmar Lerski, 'Stenotypistin' (Typist; *KA* 10 and 11). © Nachlass Helmar Lerski, Museum Folkwang, Essen 244

7.9. Helmar Lerski, 'Frau eines Chauffeurs' (Chauffeur's Wife; *KA* 17). © Nachlass Helmar Lerski, Museum Folkwang, Essen 245

7.10. Helmar Lerski, 'Bettler aus Sachsen' (Beggar from Saxony, *KA* 41). © Nachlass Helmar Lerski, Museum Folkwang, Essen 246

7.11. Helmar Lerski, 'Reinemachefrau' (Cleaning Woman, *KA* 43). © Nachlass Helmar Lerski, Museum Folkwang, Essen 246

7.12. Helmar Lerski, 'Reporter' (*KA* 50). © Nachlass Helmar Lerski, Museum Folkwang, Essen 250

7.13. David Octavius Hill and Robert Adamson, 'Captain Wilkie (or Captain Sinclair). Has been called "John Ruskin"' (1843–7). PGP EPS 156, National Galleries of Scotland, Edinburgh Photographic Society Collection, gifted 1987 253

7.14. Rudolf Dührkoop, 'Gertrude and Ursula Falke' (1906). History and Art Collection/Alamy Stock Photo 254

7.15. David Octavius Hill and Robert Adamson, 'Mrs Elizabeth (Johnstone) Hall [Newhaven 14]' (1843–7). PGP HA 3786, National Galleries of Scotland 263

8.1. Display on the theme of Baby and Child; Healthy Nerves exhibition, Berlin 1929 283

9.1. Fernand Khnopff, 'En écoutant du Schumann' (Listening to Schumann, 1883) 322

List of Abbreviations

The following abbreviations are used in this book. Unless otherwise indicated, emphases in quotations, including bold print, are in the original. Where a published translation is available, this will be referenced following the German or French original; in all other instances, translations are my own. On occasion, published translations have been tacitly amended.

A Siegfried Kracauer, *Die Angestellten: Aus dem neuesten Deutschland*, in *Soziologie als Wissenschaft, Der Detektiv-Roman, Die Angestellten*, ed. Inka Mülder-Bach with Mirjam Wenzel, Siegried Kracauer, Werke, vol. 1 (Frankfurt a.M.: Suhrkamp, 2006), pp. 211–310

KA Helmar Lerski, *Köpfe des Alltags: Unbekannte Menschen gesehen von Helmar Lerski* (Berlin: Reckendorf, 1931)

KAE Immanuel Kant, *Anthropology from a Pragmatic Point of View*, trans. and ed. Robert B. Louden (Cambridge: Cambridge University Press, 2006)

KAG Immanuel Kant, *Anthropologie in pragmatischer Hinsicht* (Stuttgart: Reclam, 1983)

KK Reinhard Gerling, *Die Kunst der Konzentration: Ein Kursus in Unterrichtsbriefen für Geistesarbeiter, Studierende, Beamte, Kaufleute, für Zerstreute, Nervöse, Gedächtnisschwache* (Prien: Anthropos, no date [1920])

MPS Georg Friedrich Meier, *Philosophische Sittenlehre: Anderer Theil* (Halle: Hemmerde, 1754)

PP William James, *The Principles of Psychology*, vol. 1 (New York, NY: Dover, 1950)

RP Theodor König, *Reklame-Psychologie: Ihr gegenwärtiger Stand—ihre praktische Bedeutung* (Munich: Oldenbourg, 1924)

SM Siegfried Kracauer, *The Salaried Masses: Duty and Distraction in Weimar Germany*, trans. Quintin Hoare, intro. Inka Mülder-Bach (London: Verso, 1998)

ZP E. Zimmermann, *Liste 33 über Psychotechnik* (Leipzig: E. Zimmermann, 1923)

Sigmund Freud

FGW Sigmund Freud, *Gesammelte Werke*, ed. Anna Freud et al., 18 vols, paperback edn (Frankfurt a.M.: Fischer, 1999)

FSE Sigmund Freud, *The Standard Edition of the Complete Psychological Works of Sigmund Freud*, trans. and ed. James Strachey, 24 vols (London: Hogarth Press, 1973)

Franz Kafka

AS Franz Kafka, *Amtliche Schriften*, ed. Klaus Hermsdorf and Benno Wagner, Franz Kafka: Schriften, Tagebücher, Briefe: Kritische Ausgabe (Frankfurt a.M.: Fischer, 2004)

B14 Franz Kafka, *Briefe April 1914–1917*, ed. Hans-Gerd Koch, Franz Kafka: Schriften, Tagebücher, Briefe: Kritische Ausgabe (Frankfurt a.M.: Fischer, 2005)

C Franz Kafka, *The Castle*, trans. Anthea Bell, with an introduction and notes by Ritchie Robertson (Oxford: Oxford University Press, 2009)

DL Franz Kafka, *Drucke zu Lebzeiten*, ed. Wolf Kittler, Hans-Gerd Koch, and Gerhard Neumann, Franz Kafka: Schriften, Tagebücher, Briefe: Kritische Ausgabe (Frankfurt a.M.: Fischer, 1996)

HA Franz Kafka, *A Hunger Artist and Other Stories*, trans. Joyce Crick, with an introduction and notes by Ritchie Robertson (Oxford: Oxford University Press, 2012)

LF Franz Kafka, *Letters to Felice*, trans. James Stern and Elisabeth Duckworth (New York, NY: Schocken, 2016)

MD Franz Kafka, *The Man who Disappeared (America)*, trans. with an introduction and notes by Ritchie Robertson (Oxford: Oxford University Press, 2012)

NS I Franz Kafka, *Nachgelassene Schriften und Fragmente I*, ed. Malcolm Pasley, Franz Kafka: Schriften, Tagebücher, Briefe: Kritische Ausgabe (Frankfurt a.M.: Fischer, 1993)

NS II Franz Kafka, *Nachgelassene Schriften und Fragmente II*, ed. Malcolm Pasley, Franz Kafka: Schriften, Tagebücher, Briefe: Kritische Ausgabe (Frankfurt a.M.: Fischer, 1992)

O Franz Kafka, *The Office Writings*, ed. Stanley Corngold, Jack Greenberg, and Benno Wagner, trans. Eric Patton with Ruth Hein (Princeton, NJ and Oxford: Princeton University Press, 2009)

P Franz Kafka, *Der Proceß*, ed. Malcolm Pasley, Franz Kafka: Schriften, Tagebücher, Briefe: Kritische Ausgabe (Frankfurt a.M.: Fischer, 1990)

PA *Der Proceß: Apparatband*

S Franz Kafka, *Das Schloß*, ed. Malcolm Pasley, Franz Kafka: Schriften, Tagebücher, Briefe: Kritische Ausgabe (Frankfurt a.M.: Fischer, 1982)

T Franz Kafka, *The Trial*, trans. Mike Mitchell, with an introduction and notes by Ritchie Robertson (Oxford: Oxford University Press, 2009)

V Franz Kafka, *Der Verschollene*, ed. Jost Schillemeit, Franz Kafka: Schriften, Tagebücher, Briefe: Kritische Ausgabe (Frankfurt a.M.: Fischer, 1983)

Robert Musil

MGA	Robert Musil, *Gesamtausgabe*, ed. Walter Fanta, 12 vols (Salzburg/Vienna: Jung und Jung, 2016–)
MGW	Robert Musil, *Gesammelte Werke*, ed. Adolf Frisé, 9 vols, 2nd, improved paperback edn (Reinbek bei Hamburg: Rowohlt, 1981)
MwQ	Robert Musil, *The Man Without Qualities*, trans. Sophie Wilkins and Burton Pike, 2 vols (New York, NY: Knopf, 1995)
PA	Robert Musil, 'Psychotechnik und ihre Anwendungsmöglichkeiten im Bundesheere', in Robert Musil, *Beitrag zur Beurteilung der Lehren Machs und Studien zur Technik und Psychotechnik* (Reinbek bei Hamburg: Rowohlt, 1980)
PLA	Robert Musil, *Posthumous Papers of a Living Author*, trans. Peter Wortsman (New York, NY: Archipelago, 2006)

Walter Benjamin

BGS	Walter Benjamin, *Gesammelte Schriften*, ed. Rolf Tiedemann and Hermann Schweppenhäuser, 7 vols, paperback edn (Frankfurt a.M.: Suhrkamp, 1991)
BSW	Walter Benjamin, *Selected Writings*, ed. Michael W. Jennings, 4 vols (Cambridge, MA: Belknap Press, 1996–2003)
WuN	Walter Benjamin, *Werke und Nachlass: Kritische Gesamtausgabe*, ed. Christoph Gödde and Henri Lonitz in collaboration with the Walter Benjamin Archive, 21 vols (Frankfurt a.M.: Suhrkamp, 2008–)

Theodor W. Adorno

AGS	Theodor W. Adorno, *Gesammelte Schriften*, ed. Rolf Tiedemann, 20 vols, paperback edn (Frankfurt a.M.: Suhrkamp, 1997)
CM	Theodor W. Adorno, *Current of Music: Elements of a Radio Theory*, ed. Robert Hullot-Kentor (Frankfurt a.M.: Suhrkamp, 2006)

Introduction

'Every one knows what attention is', declares William James in *The Principles of Psychology* (1890)—only to immediately turn his own attention to 'the confused, dazed, scatter-brained state which in French is called *distraction*, and *Zerstreutheit* in German' (*PP* 403–4). The alleged self-evidence of attention leads James to embark on a lengthy detour into the treacherous terrain of distraction, which he tries to map out in its cognitive and linguistic dimensions. James establishes distraction as the antithesis of attention; while the latter facilitates 'clear and vivid' perception (*PP* 403), the former is characterized by an absence of clarity, focus, and coherence. James here tries to separate the two mental states, but for many of his fellow psychologists things are less clear-cut. In *La Psychologie de l'attention* (The Psychology of Attention, 1888), Théodule-Armand Ribot describes attention as the exception rather than the norm, as a state which cannot endure for any length of time since it contradicts one of the fundamental laws of psychology: the dynamic, constantly changing nature of mental experience.[1] The German physicist and physician Hermann von Helmholtz concurs. Describing a self-experiment in which he tries to focus each eye on a separate image, he finds it impossible to control his focus for more than a few seconds:

> Ein anhaltender Ruhezustand der Aufmerksamkeit ist ja auch unter anderen Verhältnissen kaum für einige Zeit zu unterhalten. Der natürliche ungezwängte Zustand unserer Aufmerksamkeit ist herumzuschweifen zu immer neuen Dingen, und so wie das Interesse eines Objectes erschöpft ist, so wie wir nichts Neues mehr daran wahrzunehmen wissen, so geht sie wider unseren Willen auf etwas anderes über.[2]
>
> [An equilibrium of the attention, persistent for any length of time, is under no circumstances attainable. The natural tendency of attention when left to itself is to wander to ever new things; and so soon as the interest of its object is over, so soon as nothing new is to be noticed there, it passes, in spite of our will, to something else.[3]]

[1] Théodule-Armand Ribot, *The Psychology of Attention*, 5th rev. edn [no translator] (Chicago, IL: Open Court Publishing Company, 1903), p. 2.

[2] Hermann von Helmholtz, *Handbuch der physiologischen Optik* (Leipzig: Voss, 1867), p. 770.

[3] James cites Helmholtz's study in *The Principles of Psychology*, thereby undermining his own earlier statement about the self-evident nature of attention. Helmholtz, he notes, has put 'his sensorial attention to the severest tests, by using his eyes on objects which in common life are expressly

Attention is not sustained but restless and unpredictable, uncontrollable in its hunger for new stimuli. As Helmholtz discovers, it cannot be governed by the will but is rooted in the body, and specifically in the eyes, whose restless movement follows its own dynamic. In Helmholtz's description, the troubling features of attention come to the fore: its spatial and temporal limitations, and its ambivalent location somewhere between body and mind, both of which challenge the notion of the self as rational and autonomous. In describing his experience of split attention, of trying to focus on two images at once, Helmholtz ends up describing an experience which closely resembles what James defines as distraction. His experiment thus spells out what is also evident in James's opening remarks: attention is inseparable from distraction both conceptually and in terms of how it is experienced by the individual.

Helmholtz's report is important beyond his own discipline, for it resonates with the everyday experience of his contemporaries. Indeed, what psychologists in the latter half of the nineteenth century defined as a universal psychological principle was described, by sociologists and psychiatrists, historians and cultural commentators, as a historically and culturally specific phenomenon: the decline of attention as a hallmark of modernity. In an age of acceleration driven by technological progress, they argued, the mind was perpetually stimulated and dispersed—and in turn craved more stimulation. Psychologists sought to instil their findings with a sense of rigour by controlling the conditions of their (self-)experiments and shielding this experimental space from the contingencies of the outside world. But this turned out to be an impossible aspiration. As we will see, the outside world forcefully invaded the psychological laboratory, while the methods and theories developed in this space were in turn disseminated into modern everyday life—into the domains of work and entertainment, of leisure and creativity. This two-way dynamic, as it unfolds in the German-speaking context in the nineteenth and twentieth centuries, is the focus of this study.

Mapping the Field

William James includes the French and German terms for distraction to gesture towards the international nature of psychological research, but also to underline the subtle but important differences between these concepts. No one word, he suggests, can fully encapsulate the state in question, for each has a particular epistemology, particular resonances and blind spots. In a study written in English about German material such as this one, the issues of terminology and translation

overlooked' (*PP* 421). Here, James harks back to an eighteenth-century scholarly and moral ideal: that attention needs to be turned towards marginal, commonly overlooked aspects of the (natural) world.

are thorny but hugely illuminating, for they help to map out the debate about attention and distraction in all its nuances and internal contradictions.

Although I use attention and distraction as the English equivalents of *Aufmerksamkeit* and *Zerstreuung*, these respective terms have different roots and carry different connotations. The English 'attention', like its equivalents in the Romance languages, derives from the Latin *attentio*, which in the Middle Ages is often used synonymously with *intentio*, an epistemology which casts attention as a deliberate act of focusing the mind.[4] As exemplified by the Old Testament hendiadys *audi et attende* (listen and pay heed), religious and moral uses often associate *attentio* with the sense of hearing, with the act of listening to God's calling or commandments. The term *Aufmerksamkeit* was first coined by the Enlightenment philosopher Christian Wolff in 1720, who derives it from the adjective *aufmerksam*, attentive.[5] In his metaphysics *Vernünfftige Gedancken von Gott, der Welt und der Seele des Menschen, auch allen Dingen überhaupt* (Sensible Thoughts about God, the World, the Soul of Man, and all Existing Things), he defines attention as the extension of the faculties of memory and imagination, while warning that 'attention ceases when the senses are strongly occupied by too many things at once'.[6] Here and throughout the period, the phenomenon of distraction is described by commentators, but this debate remains rather fuzzy since this state is not yet defined by one single concept.[7] One of the first writers to use *Zerstreuung* to designate a state of mental fragmentation was the psychiatrist Johann Christian Reil, who in 1802 pinpoints 'Zerstreuung und Vertiefung' (distraction and immersion) as the two pathological aberrations of attention.[8]

Indeed, as in the case of attention, the etymology of the German and the English terms is very different. Distraction is derived from the Latin *trahere*, meaning to pull; dis-traction implies being pulled away from the object of one's focus by some competing stimulus. This sense is perhaps best rendered by the German

[4] On the etymology of the term, see Peter von Moos, 'Attentio est quaedam sollicitudo: Die religiöse, ethische und politische Dimension der Aufmerksamkeit im Mittelalter', in *Aufmerksamkeiten*, ed. Aleida Assmann and Jan Assmann (Munich: Fink, 2001), pp. 91–127 (pp. 92–3).

[5] *Aufmerksamkeit* replaces the older term *Aufmerkung*, which in the early modern period was defined as 'Obacht, Beobachtung, geistige Konzentration' (alertness, observation, mental concentration). *Frühneuhochdeutsches Wörterbuch*, ed. Robert Ralph Anderson et al., vol. 2 (Berlin: De Gruyter, 1994), pp. 559–60.

[6] '[W]enn die Sinnen von vielen Dingen stark eingenommen werden, höret die Aufmerksamkeit auf'. Christian Wolff, *Vernünfftige Gedancken von Gott, der Welt und der Seele des Menschen, auch allen Dingen überhaupt*, in *Gesammelte Werke*, founded by Jean École and Hans Werner Arndt, ed. Robert Theis, Werner Schneiders, and Jean-Paul Paccioni, 3 parts; part I: *Deutsche Schriften*, vol. 2 (Hildesheim: Olms, 1983), p. 151.

[7] Erich Kleinschmidt, 'Die Aufmerksamkeit der Begriffe: Zum figuralen Schwellendiskurs der (Ap)-perzeption', in *Wie gebannt: Ästhetische Verfahren der affektiven Bindung von Aufmerksamkeit*, ed. Martin Baisch, Andreas Degen, and Jana Lüdtke (Freiburg i.Br.: Rombach, 2013), pp. 21–69 (p. 31).

[8] Johann Christian Reil, *Rhapsodien über die Anwendung der psychischen Curmethode auf Geisteszerrüttungen* (Halle: Curtsche Buchhandlung, 1803; repr. Amsterdam: Bonset, 1968), pp. 110–11.

Ablenkung, from the verb *ablenken*, to divert or take off course. James uses the term *Zerstreutheit*, meaning distractedness or absent-mindedness, with the suffix '-heit' indicating the sustained nature of this state. However, by the twentieth century *Zerstreuung* had become the more prominent term, a concept which could refer either to the mindset of the distracted subject or to the external cause of this mental state. For modernist commentators, *Zerstreuung* connotes mental (as well as physical, spatial) dispersal; in the eighteenth and early nineteenth centuries, however, its self-reflexive form, *sich zerstreuen*, carried more positive connotations.[9] The question of how to stop concentration from becoming rigid and pathological was, as we will see in the next chapter, a particular concern of Immanuel Kant's.

To complicate matters even further, attention and distraction are not monolithic notions but umbrella terms encompassing a number of concepts and attendant mental states. Nineteenth-century psychologists often describe attention as a wandering spotlight which casts a range of details into sharp relief;[10] the countermodel is a more stable and sustained state of concentration, variously described as contemplation, collectedness (*Sammlung*), or immersion (*Versenkung*). The religious overtones of these terms are no coincidence. From the eighteenth century onwards, religious devotion is used as the model for secular immersion, and this analogy continues to be used in the twentieth century, by both advocates and critics of contemplation.

The modernist period was marked by unprecedented social and technological change, which many people experienced as confusing and overwhelming; as a consequence, other, more mobile forms of attention, such as *Wachsamkeit* (vigilance) and *Geistesgegenwart* (presence of mind), gained in prominence. The latter term throws up another tricky question: where precisely is attention located? *Geistesgegenwart* casts it as a mental state, and yet the simultaneous emphasis on the 'presence' of the mind also highlights its spatial, embodied character. In modernism, as we will see, a physical, instinctive form of alertness, whereby the body overrides the (rational) mind, becomes important particularly in moments of danger.

As this brief survey has shown, attention and distraction are multi-faceted terms which reflect the equally multi-faceted, fluid nature of human experience. While these and related concepts offer a grid for debates about the mind, they are

[9] The Grimms' German Dictionary includes examples from the early eighteenth century, where *Zerstreuung* designates an '*ablenkende, angenehme beschäftigung, zeitvertreib, vergnügung*' (a 'diverting, pleasant occupation, past-time, entertainment'). Jacob Grimm und Wilhelm Grimm, *Deutsches Wörterbuch* (Leipzig: Hirzel, 1854–1961); digitized version: *Wörterbuchnetz des Trier Center for Digital Humanities*, Version 01/21, https://www.woerterbuchnetz.de/DWB?lemid=Z04869 [accessed 20 January 2022].

On the multi-faceted nature of this term, see for instance Tobias Lachmann, 'Ästhetik und Politik der Zerstreuung: Ausgangspunkte', in Tobias Lachmann (ed.), *Ästhetik und Politik der Zerstreuung* (Paderborn: Brill/Fink, 2021), pp. 1–24.

[10] See for instance Wilhelm Wundt, *Grundzüge der physiologischen Psychologie* (Leipzig: Engelmann, 1874), p. 718.

not static but evolve, reflecting changes in human knowledge and culture. The career of *Zerstreuung* illustrates this close relationship between language and experience. Its growing prominence around 1900 is a product, and symptom, of modernization, and this linguistic shift in turn perpetuates the growing consensus that, in this period, attention was a faculty in crisis.[11]

Time, Space, Culture

In recent years, both attention and distraction have attracted huge interest in the humanities and beyond. Existing studies can be roughly divided into two groups. They are either (literary) historical in character, exploring periods such as the middle ages and early modern period, the eighteenth and nineteenth centuries,[12] or they engage with the current, digital age, which has been labelled an 'attention economy' or else as the 'age of distraction'.[13] The twentieth century is a curious blind spot in both contexts. It is often mentioned in passing, as either a precursor of the current situation or the postscript to earlier traditions.[14] Both approaches

[11] Detlev J. K. Peukert uses the concept of crisis to characterize particularly the interwar period in Germany: *Die Weimarer Republik: Krisenjahre der klassischen Moderne* (Frankfurt a.M: Suhrkamp, 1995).
[12] Studies which focus on the pre-Enlightenment period have highlighted concepts such as immersion, wonder, and fascination. See for instance Peter von Moos, 'Attentio', in *Aufmerksamkeiten*; Hartmut Bleumer (ed.), *Immersion im Mittelalter* (Stuttgart: Metzler, 2012); Mireille Schnyder, 'Überlegungen zu einer Poetik des Staunens im Mittelalter', in *Wie gebannt*, pp. 95–114; Martin Baisch, 'Medien der Faszination im höfischen Roman', in *Wie gebannt*, pp. 213–34; Jutta Eming, 'Faszination und Trauer: Zum Potential ästhetischer Emotionen im mittelalterlichen Roman', in *Wie gebannt*, pp. 235–64; Miriam Lay Brander, 'Mit List und Tücke: Praktiken der Aufmerksamkeit im frühneuzeitlichen Schelmenroman am Beispiel des *Lazarillo de Tormes*', in *Geteilte Gegenwarten: Kulturelle Praktiken von Aufmerksamkeit*, ed. Stephanie Kleiner, Miriam Lay Brander, and Leon Wansleben (Munich: Fink, 2016), pp. 243–63; and Sybille Baumbach, *Literature and Fascination* (Basingstoke: Palgrave Macmillan, 2015). While most literary studies focus on prose narrative, Lucy Alford has explored its role in poetry: *Forms of Poetic Attention* (New York, NY: Columbia University Press: 2020).
[13] The idea of the current 'attention economy', in which attention is a vital and hotly contested resource, has gained in prominence since the turn of the millennium. In German, one of the most influential such studies is Georg Franck, *Ökonomie der Aufmerksamkeit* (Munich: Hanser, 1998); English titles include Thomas H. Davenport and John C. Beck, *The Attention Economy: Understanding the New Currency of Business* (Boston, MA: Harvard Business School Press, 2001); Richard Lanham, *The Economics of Attention: Style and Substance in the Age of Information* (Chicago, IL: University of Chicago Press, 2006); Claudio Celis Bueno, *The Attention Economy: Labour, Time and Power in Cognitive Capitalism* (London: Rowman and Littlefield, 2017); and Karen Nelson-Field, *The Attention Economy: Simple Truths for Marketers* (Basingstoke: Palgrave Macmillan, 2020). They are complemented by an equally vast number of studies which cast the present as an 'age of distraction' and suggest various ways of counteracting this tendency, through government policy, medicine, or personal behavioural adaptations. See for instance Richard DeGranpre, *Ritalin Nation* (New York, NY: Norton, 1999); and Matthew Crawford, *The World Beyond Your Head: How to Flourish in a World of Distraction* (London: Penguin, 2015). The rise of distraction and the corresponding need to return to a slower, less frantic lifestyle is also a core theme of the thriving mindfulness movement.
[14] Two trans-historical studies where a majority of chapters is dedicated to twentieth-century material are Lutz P. Koepnick's *Framing Attention: Windows in German Culture* (Baltimore, MD: Johns Hopkins University Press, 2007), which explores the role of windows in early German cinema, in the Berlin underground system of the 1920s, in Leni Riefenstahl's *Triumph des Willens* (Triumph of the

are fundamentally flawed. The twentieth century is neither a postscript nor a precursor, but a vital chapter, indeed a turning point, in the history of (in-) attention. In this period, psychological knowledge first came to shape social and economic practice, and writers, artists, and thinkers actively partook in this development by adopting, reflecting (on), and critiquing prevailing cognitive practices. The fact that all this activity unfolded against a backdrop of political crisis lends this period its particular urgency and ongoing relevance.

At this point, it is worth briefly commenting on terminology and periodization. I occasionally use the term 'modernism' as a shorthand for the early twentieth century, but this comes with a caveat. 'Modernism' has overtones of social, intellectual, and aesthetic innovation, but to look at the period through the lens of attention and distraction reveals a deep-seated resistance to this idea, which manifests itself as a persistent attachment to what many contemporaries regarded as a more coherent, authentic, and contemplative way of life. Walter Benjamin's nostalgic portrayal of a pre-industrial community in thrall to oral tales, as outlined in his 'Storyteller' essay, is one famous example of a more general discourse, which casts the rural past as an antidote to urban modernity. But debates about attention and distraction do not just highlight political differences; they also cut across ideological divides. As I will argue, neither the critique of modern-day distraction nor the longing for a more contemplative age, or space, are the preserve of the conservative Right but are just as readily evoked in leftist quarters. Accounts of a golden age of sustained, unbroken contemplation are clearly fictional constructs, but they do often refer to particular periods or practices to critique their own culture. This discursive strategy points to a more general feature of modernist narratives about (in-)attention, namely their profoundly historical and comparative approach. Commentators often seek to understand their own culture in comparison and contrast with previous stages of human experience. To trace this longer history, I begin my book with a survey of the eighteenth and nineteenth centuries and keep returning to these periods in later chapters.

In discourses about attention, past and present, tradition and modernity are thus cast as opposed but also as interconnected. The same ambiguity also applies to the mental states under discussion. At first sight, attention and distraction may simply appear as incompatible opposites, but as my opening quotations by James, Ribot, and Helmholtz underline, this division is not sustainable either mentally or conceptually. Just as paying attention always involves a withdrawal of awareness,

Will, 1935), and in the post-war Fluxus movement; and Paul North's study of distraction, which ranges from Aristotle and Jean de La Bruyère to Martin Heidegger: *The Problem of Distraction* (Stanford, CA: Stanford University Press, 2012). Koepnick's and North's engaging books illustrate the benefits of a trans-historical approach, which brings different periods (and media) into dialogue, but also its potential drawbacks, particularly its limited ability to trace how such discourses evolve within a tighter timeframe and as part of a network of individuals, disciplines, and institutions.

so to explore one state also requires us to confront the other. By referencing both attention and distraction in my title, I underline their close relationship since the Enlightenment and particularly in modern culture.[15] Commenting on the early twentieth century, Jonathan Crary speaks of a 'fundamental duality' in contemporaries' attitudes towards the two, citing the example of Benjamin, who holds 'absorbed contemplation, purified of the excess stimuli of modernity' as the polar opposite of distraction.[16] In Chapter 8, I challenge this interpretation, by arguing that Benjamin remains deeply attached to contemplation as the necessary complement of more mobile forms of alertness. A similar point can be made about other writers and artists. Like Benjamin, they are not concerned with one state or the other but with the interaction between the two—with how attention gives way, or rise, to distraction or vice versa. This relationship is sometimes conceived spatially, as a threshold or liminal zone, and sometimes dynamically, in terms of transition, oscillation, or dialectics. Kafka's narratives, for instance, revolve around momentary slippages of attention and their disastrous consequences, while Musil depicts instances of epiphanically heightened awareness and the equally sudden dissipation of such states. Despite their fascination with the instability of mental experience, both writers remain attached to the ideal of sustained, immersed concentration—while highlighting, like their eighteenth-century predecessors, the dangers inherent in this state. Indeed, for Kafka, Musil, and many of their contemporaries, attention and distraction have a deeply personal significance, causing them to examine their own mind and methods, and compelling some of them to use strategies of self-conditioning to enhance their concentration. Finally, as I will outline in more detail below, the writers and thinkers discussed in this book are interested in attention and distraction not solely in relation to their own medium or discipline, but in the ways these issues shape modern everyday life, whether in work or leisure, in politics and education, high and mass culture.

[15] In highlighting their equal importance, I depart from existing studies, which have tended to focus on one or other of these two states. Studies which foreground attention include Franck, *Ökonomie der Aufmerksamkeit*; Jonathan Crary, *Suspensions of Perception: Attention, Spectacle, and Modern Culture* (Cambridge, MA: MIT Press, 1999); Bernhard Waldenfels, *Phänomenologie der Aufmerksamkeit* (Frankfurt a.M.: Suhrkamp, 2004); Barbara Thums, *Aufmerksamkeit: Wahrnehmung und Selbstbegründung von Brockes bis Nietzsche* (Munich: Fink, 2008); and the edited volumes *Liechtensteiner Exkurse III: Aufmerksamkeit*, ed. Norbert Haas, Rainer Nägele, and Hans-Jörg Rheinberger (Eggingen: Edition Isele, 1998); *Aufmerksamkeiten*, ed. Assmann and Assmann; *Wie gebannt*, ed. Baisch et al.; *Aufmerksamkeit: Geschichte—Theorie—Empirie*, ed. Sabine Reh, Kathrin Berdelmann, and Jörg Dinkelaker (Hamburg: Springer, 2015); and *Geteile Gegenwarten*, ed. Kleiner et al. Studies whose principal focus is on distraction include North, *The Problem of Distraction*; Petra Löffler, *Verteilte Aufmerksamkeit: Eine Mediengeschichte der Zerstreuung* (Zurich: Diaphanes, 2014); and Natalie M. Phillips, *Distraction: Problems of Attention in Eighteenth-Century Literature* (Baltimore, MD: Johns Hopkins University Press, 2016). As indicated by the latter two titles, studies which focus on one of these states do also, inevitably, engage with its opposites to some extent.
[16] Crary, *Suspensions of Perception*, p. 50. Crary is here referring to Benjamin's 'The Work of Art in the Age of its Technological Reproducibility'.

Survey of Chapters

The focus of my study is on the German-speaking context, but with recurrent references to the international nature of this debate and to the transnational networks which connect individuals working on these issues in the age of scientific collaboration, of migration and exile.

Chapter 1 traces the history of psychology in the eighteenth and nineteenth centuries—a period in which attention and distraction were at the centre of fast-evolving theories and experimental methods. When Wilhelm Wundt set up the world's first psychological laboratory in Leipzig in 1879, this was a watershed moment for the discipline, but one which emerged from a long-standing tradition of psychological (self-)exploration. In the Enlightenment, attention was seen as a vital moral faculty and cultivated using techniques of self-care and self-observation, but contemporaries were more worried about the excesses of attention—its propensity to turn into fixation—than about its erosion by distraction (which did not yet exist as a self-contained concept). This hierarchy of concern began to change with the development of more targeted experiments and devices designed to measure the precise scope and duration of attention, which quickly revealed its limited and unstable character. In both the early self-experiments of figures such as Helmholtz and Gustav Theodor Fechner and the later, laboratory-based set-ups devised by Wundt and his contemporaries, the exploration of attention inevitably brought the adversaries of this state into focus. Research into attention became research into distraction.

In the German *Kaiserreich*, psychology became a new master discipline aspiring to underpin research across the natural sciences and the humanities, although in institutional terms, psychology long remained a sub-section of philosophy. But psychology's self-declared dominance did not meet with universal approval. At the end of the chapter I turn to Edmund Husserl's new field of phenomenology, conceived as a reaction against 'psychologism', which tried to re-establish attention as an intentional act.

Chapter 2 focuses on the time around 1900 and traces how the findings of psychology resonated with more general social debates. It starts with Ribot, who casts attention not simply as a universal human faculty but, particularly in its voluntary form, as the product of cultural conditions. Psychologists tried, and failed, to keep their laboratories free from distractions; their efforts mirror developments in society at large, where contemporaries felt increasingly assailed by an ever-growing onslaught of stimuli, and where neurasthenia, a conditioning caused by perpetual over-stimulation, became the new *maladie du siècle*. This chapter surveys medical debates about sensory overload, particularly at the modern workplace; it also looks at the tropes of a more general discourse, which casts modernity as a time of hyper-connectivity and social as well as mental

fragmentation, which is conducted across the fields of psychiatry, history, and sociology. It concludes with the writings of Sigmund Freud, a figure not commonly associated with this issue, whose early theories were in fact based on psychological stimulus-response models of the mind, and who continued to engage with the interplay of attention and distraction in everyday life and specifically in the context of trauma across his career.

In his *Psychopathologie des Alltagslebens* (Psychopathology of Everyday Life, 1901), Freud cites examples of writers who use parapraxis—slips of the tongue or the hand—as a plot device. A similar approach is pursued by Kafka, whose writings are explored in Chapter 3. In his risk assessments and general reports for the Workers' Accident Insurance Institute, Kafka describes momentary distraction as inevitable in modern, technological working conditions—as a statistical constant rather than a matter of personal responsibility. A completely different picture emerges in his fiction, where such drops of attention are blamed on the individual and often set into motion a chain of disastrous events. But Kafka's conception of the mind is shaped not only by his insurance work but also by his schooling. In 1825, a Prussian ministerial decree made psychology a compulsory part of the school curriculum in the final two years of the Gymnasium or high school; this law was emulated in Austria, where several generations of pupils studied psychology via the same prescribed textbook, which advocates Johann Friedrich Herbart's theory of the mind as shaped by competing forces. The impact of this psychology syllabus on Kafka's writings has so far not been explored. I trace its resonances in Kafka's *Der Process* (The Trial, 1914–15) and across his prose fiction and personal writings, where sustained attention is held up an ideal, but also shown in its more sinister, disciplinary and (self-)destructive, dimensions.

By the early twentieth century, then, the methods and theories of experimental psychology started to filter through into everyday life. This process is most evident in the emergence of a new discipline: *Psychotechnik* or psychotechnics. Pioneered by the psychologists William Stern and Hugo Münsterberg, the latter William James's successor at Harvard, psychotechnics was a comprehensive programme of aptitude testing and training. Its methods were used in the First World War on both sides of the conflict, but while most countries scaled back their investment in this area after the war, in Weimar Germany psychotechnics was vastly expanded and its methods rolled out across civilian society in an effort to boost productivity with a depleted workforce. Chapter 4 maps out this ambitious but deeply invasive project, which aimed to fundamentally reshape the minds and behaviour of individuals at the workplace and through mass entertainment. Siegfried Kracauer's sociological study *Die Angestellten* (The Salaried Masses, 1930) paints a deeply critical, even bleak, picture of these methods and their exploitative impact on Weimar society.

While the rollout of psychotechnics was relatively short-lived, it profoundly shaped German society in the so-called 'Golden Twenties', a period of unrivalled creativity. Its far-reaching impact on the literature and culture of the Weimar years has so far only been thematized in a couple of studies.[17] In Chapter 5, I turn to the Austrian writer Robert Musil, whose engagement with psychotechnics is rooted in a professional as well as a personal interest in this field. Like Kafka, Musil was taught psychology while he was still at school. He then went on to conduct his doctoral research with the renowned psychologist Carl Stumpf, in whose laboratory he also took part in self-experiments. After the war, Musil briefly worked as scientific adviser to the Austrian Ministry for Military Affairs, advising officials about the potential applications of psychotechnics in the army and beyond. This stint had lasting repercussions for his literary career; Musil repeatedly struggled with his own productivity and turned to psychotechnical methods to make his writing more focused and effective. But he also tried out psychotherapy and autosuggestion in his quest to enhance his concentration. As I argue, these different methods are reflected, and played off against each other, in his texts. His unfinished novel *Der Mann ohne Eigenschaften* (The Man without Qualities, 1930–2) casts psychotechnics in an ambivalent light, oscillating between irony and serious endorsement. Here, as in his short prose writings, however, the attempt to control the mind is disrupted by moments of epiphanically intensified experience. While divine illumination is cited as one possible cause of these incidents, Musil's texts neither confirm nor disprove this explanation.

Musil was an avid reader of the self-help books of Swiss psychologist Charles Baudouin. Chapter 6 puts this interest into a wider context. The Weimar drive to optimize cognitive performance was not confined to the workplace but also had a profound impact on people's private lives, where this effort was continued with different means. This chapter explores the booming market for self-help literature in the interwar period, and specifically for guides promising readers ways to enhance their own concentration in the face of an increasingly complex and competitive world. Focusing on three such books, the chapter explores both their different approaches, which range from meditation to comprehensive programmes of self-discipline, and their similarities—most notably the promise to make the reader fit for the modern attention economy.

Chapter 7 shifts the focus from texts to images and specifically to photography and its role in modernist debates around attention. Adopting a diachronic approach I first trace the role of photography in nineteenth-century psychological experiments, where the medium was used to record the outer signs of attention in face and body. In the 1920s, the resurgence of physiognomy coincided with a

[17] Brigid Doherty, 'Test and Gestus in Benjamin and Brecht', *Modern Language Notes*, 115 (2000), 442–81; and Tobias Wilke, *Medien der Unmittelbarkeit: Dingkonzepte und Wahrnehmungstechniken 1918–1939* (Munich: Fink, 2010).

revival of portrait photography for the purpose of classification, for mapping out the different strata of modern society. As Weimar photographers pursue this project, however, they come up against a number of obstacles, among them the perceived difficulty of finding subjects capable of projecting a sense of presence and authenticity in the age of distraction. This challenge is thrown into sharp relief by historical comparison; in the period, art historians celebrated the work of photography pioneers such as David Octavius Hill and Robert Adamson in Scotland, whose portraits were rediscovered in Weimar Germany and held up as a model and ideal. The quest for stillness, for authentic faces, in the age of distraction united portrait photographers from across the aesthetic and political spectrum. In the second half of my chapter, I compare portraits by Erna Lendvai-Dircksen and Helmar Lerski, whose photobooks hark back to early photography but use very different methods and subjects to do so.

One of the critics who explored photography from a wider historical perspective was Walter Benjamin. Chapter 8 traces Benjamin's sustained and multidisciplinary engagement with attention and distraction and their dialectical interaction. Benjamin first begins to explore these questions during his student years, when he encounters experimental psychology via the journal of his cousin-in-law, the psychologist William Stern; he continues to pursue the dynamics of (in-)attention in his writings on anthropology and literature, on history and modern culture. His most famous text on this issue is 'Das Kunstwerk im Zeitalter seiner technischen Reproduzierbarkeit' (The Work of Art in the Age of its Technological Reproducibility, 1935–6); in a close reading of its five different versions, I trace the presence of psychotechnics in Benjamin's argument, specifically in his analysis of film. While he initially conceives of film as a critical medium which can expose the underhand impact of psychotechnics on everyday life, film is later recast as a quasi-psychotechnical training device which institutes a detached, non-contemplative state of mind. This shift, however, should not be read as indicative of a wholesale U-turn in Benjamin's attitude towards matters of attention. As his writings of the 1930s show in particular, (religious) contemplation remains important as a model of non-instrumentalizing engagement with the world alongside a pre-rational, embodied form of alertness, which Benjamin casts as essential for the project of a 'rescuing' kind of critical enquiry.

Benjamin principally explores attention in relation to the visual media; but contemporary debates on this issue are also concerned with the role of aural perception, in everyday life and particularly in the field of music. Like Chapter 7, Chapter 9 pursues this question from a diachronic perspective. It explores how the model of sustained, contemplative listening first emerged in aesthetic debates around 1800, as part of a drive to underline the autonomy of (instrumental) musical works, and was then put into practice in the listening culture of the period. Treatises such as Eduard Hanslick's *Vom Musikalisch-Schönen* (On the Musically Beautiful, 1854), however, show the fragility of this model even at

the time, a diagnosis which gathers momentum in the twentieth century, when the crisis of traditional musical formats such as the symphony concert is treated as yet another symptom of a larger cultural shift towards distraction. However, as the chapter concludes, responses to this shift were far from uniform, and while some critics and practitioners sought to restore the capacity for sustained, contemplative listening among contemporary audiences, others, such as the musicologist Heinrich Besseler, pursued a different route, looking to earlier periods for examples of embodied and only semi-attentive listening practices.

These debates around musical listening form an important backdrop for the writings of Theodor W. Adorno, for whom music is the key paradigm in his discussion of attention and distraction. Chapter 10 begins with Adorno's essays of the 1920s and 1930s, where he first develops his critique of popular music and the attendant 'fetishistic' and 'regressive' listening practices. But Adorno's often uncompromising critique of modern listening habits undergoes a marked change when, in the early years of his American exile, he is confronted with the experiences of empirical listeners while participating in the Princeton Radio Research Project. While he is critical of US-American musical radio broadcasts, such as the educational flagship programme 'NBC Music Appreciation Hour', he develops his own alternative series of broadcasts, in which he tries to instruct his (young) listeners in what he regards as sustained and constructive modes of listening. The second half of the chapter turns from his musical writings to his aesthetic theory and his more personal, self-reflexive essays of the 1950s and 1960s, where the model of sustained listening is applied to non-musical contexts. Here, I return to Adorno's dialogue with Benjamin; their correspondence in the 1930s reveals sharp divergences concerning the role of contemplation and distraction in modern culture, and yet Benjamin's stance on this matter continues to inflect Adorno's writings far beyond Benjamin's premature death in 1940. In his later writings, Adorno comes much closer to Benjamin's model of a non-contemplative kind of reception, which he transposes from mass culture to modernist music and literature.

The thought of Benjamin and Adorno forms a kind of diptych, which illustrates both the tensions and the dialogical nature of this overarching debate. Writers, artists, and thinkers engage with matters of (in-)attention not in an isolated, individualist manner, but as mediated through the arguments and practices of their contemporaries and predecessors. As a consequence, this debate unfolds not in a linear way, but as a network of resonances and responses. To underline this open-ended process, Chapter 11 turns to three more recent writers—Paul Celan, W. G. Sebald, and Felicitas Hoppe—who continue this discursive tradition in (explicit or implicit) dialogue with earlier periods. For all their differences of style and approach, they are all concerned with the nexus between attention and memory; in exploring it, they evoke images and narratives which we have encountered in other contexts, refiguring them for their own age.

The Limits of Attention

In its scope and structure, my book reflects one of the core insights of psychological research, namely the limited and selective nature of attention. In a field as vast as this, some difficult decisions have had to be made, concerning both the remit of this study and its methodology. Attention and distraction continue to be at the centre of psychological research, which has in turn garnered considerable interest in the humanities. Cognitive approaches have become increasingly popular in literary studies,[18] yielding valuable insights into historical practices and trans-historical patterns of engagement. While I occasionally refer to this research, I do not pursue a cognitive approach. My main aim is not to assess past discourses against current models, but rather to reconstruct these arguments within their historical context and to trace how they evolved over time. Psychology is the starting point of my narrative and remains a reference point throughout, as both theory and practice, as it shapes modern society and culture. In my book, I focus on its resonances in literature, photography, and music; film is not the subject of a dedicated chapter but is discussed across several chapters, as an important, interconnected part of this field. Alongside the arts, thought is the second major strand of this book. Here, I have sought to highlight the resonances between different disciplines, such as sociology, medicine, psychoanalysis, and history, before focusing on the dialogue between a group of thinkers loosely associated with Critical Theory (Kracauer, Benjamin, Adorno, Horkheimer). Others have rightly emphasized the contribution of phenomenology to this debate;[19] here, I confine myself to brief discussions of Husserl's response to experimental psychology, and of Heidegger's impact on musicology.

Among the many other writers who could have fruitfully featured in this book, I want to single out Rainer Maria Rilke and Robert Walser. Rilke's *Aufzeichnungen des Malte Laurids Brigge* (The Notebooks of Malte Laurids Brigge, 1910) offer an early literary response to the cognitive challenges posed by urban modernity. Echoing Georg Simmel's 1903 essay on 'Die Großstädte und das Geistesleben' (The Metropolis and Mental Life), Rilke's protagonist feels violated by the onslaught of stimuli which enter his surroundings, his body, and his mind. Unable to either process or fend them off, Malte responds to this challenge not by retreating from the world, but with heightened openness and self-exposure. The

[18] For an example of this approach, see Natalie M. Phillips's study of readers' attention using fMRI scanning, 'Literary Neuroscience and History of Mind: An Interdisciplinary fMRI Study of Attention and Jane Austen', in *The Oxford Handbook of Cognitive Literary Studies*, ed. Lisa Zunshine (Oxford: Oxford University Press, 2015), pp. 55–81. For a more general overview of current psychological research, see *The Oxford Handbook of Attention*, ed. Sabine Kastner and Anna C. Nobre (Oxford: Oxford University Press, 2014); and *The Handbook of Attention*, ed. Jonathan M. Fawcett, Evan Risko, and Alan Kingstone (Cambridge, MA: MIT Press, 2015).

[19] See for instance Waldenfels, *Phänomenologie der Aufmerksamkeit*, and the chapter on Heidegger in North, *The Problem of Distraction*.

novel's programme of 'sehen lernen' (learning to see), which also underpins the closely observed miniatures of Rilke's *Neue Gedichte* (New Poems, 1908), transplants Enlightenment programmes of attentional self-education into the modern world, anticipating the self-help programmes of the 1920s.[20]

A very different response to the challenge of mental and social fragmentation can be found in the works of the Swiss writer Robert Walser. Where Rilke seeks to capture transitory moments of intensified awareness, Walser's texts anarchically resist the imperative of sustained attention. This resistance is most apparent in his last novel, *Der Räuber* (The Robber, 1925). Recorded in micrographic writing over the course of just six weeks, it is a feat of extreme concentration,[21] but the narrative does not reflect this effort but rather draws the reader into a vortex of fragmentary observations and abandoned storylines. Its first sentence sets the tone: 'Edith loves him. More on that later'.[22] Time and again, the first-person narrator interrupts the narrative through interjections such as 'Hang on a minute please. Let me think. Okay, now it's fine, it's fine'[23] and 'But here comes something new again'.[24] Where Malte seeks to reassert control over his mind and senses, Walser's narrator (who is separate from the protagonist) is unable or unwilling to make this effort: 'How all these impressions are crowding in on me. And on him [the Robber] they're probably crowding in too'.[25] The narrative enacts a state of mind which it also diagnoses in its protagonist. Beneath this scattered narration, however, lurks a sharp alertness. The narrator stresses the Robber's 'Hang zur Genauigkeit' ('tendency to be precise'), while also warning the reader: 'Many think we are forgetful. But we think of everything'.[26]

Like all the writers featured in this book, Walser and Rilke respond to the same enduring challenge: how to orient ourselves in an ever more complex world, where concentration is vital and yet increasingly elusive. While this question affects people across the ages, the interplay between attention and distraction takes on a particularly urgent as well as productive dimension in the early twentieth century. In this period, the issue of (in-)attention highlights profound ideological differences but also bridges divides; most importantly, it produces responses which are astonishing in their richness and creativity.

[20] On attention in the *New Poems*, see Alford, *Forms of Poetic Attention*, pp. 139–41.
[21] Jochen Greve, the editor of the novel, highlights Walser's concentrated working method; he probably wrote the novel in only six weeks, and it is likely that each of 35 paragraphs was written in one day. Jochen Greve, 'Editorische Notiz', in Robert Walser, *Der Räuber* (Frankfurt a.M.: Suhrkamp, 1986), pp. 195–9 (p. 197).
[22] 'Edith liebt ihn. Hiervon nachher mehr'. Walser, *Der Räuber*, p. 7.
[23] 'Warten Sie bitte mal. Lassen Sie mich nachdenken. So, es geht, es geht'. Walser, *Der Räuber*, p. 27.
[24] 'Aber da kommt schon wieder etwas Neues'. Walser, *Der Räuber*, p. 29.
[25] 'Wie alle diese Eindrücke auf mich eindrängen. Auch auf ihn drängten sie wahrscheinlich ein'. Walser, *Der Räuber*, p. 44.
[26] 'Viele halten uns für vergeßlich. Aber wir denken an alles'. Walser, *Der Räuber*, p. 120.

1
Virtue, Reflex, Pathology
Attention from the Enlightenment to the Late Nineteenth Century

Enlightenment Attention

One of the most influential precursors of modern psychology was the polymath Gottfried Wilhelm Leibniz (1646–1716), who coined the terms 'perception' and 'apperception' to map out the difference between preconscious and conscious experience. 'Perception' designates a stimulus that has not yet attracted conscious awareness. As Leibniz stresses, 'at every moment there is in us an infinity of perceptions, unaccompanied by awareness or reflection'; these include 'alterations in the soul itself, of which we are unaware because these impressions are either too minute and too numerous, or else too unvarying, so that they are not sufficiently distinctive on their own'.[1] Perceptions vary in terms of their clarity and intensity, ranging from the obscure and confused to the clear and distinct. The latter require the input of consciousness; only perceptions which enter into the subject's consciousness become clear and vivid,[2] and Leibniz uses 'apperception' to describe this act of self-reflexive experience. Attention thus invests sensory perceptions with a vital level of clarity, lifting them out of their state of semi-obscurity and above the threshold of conscious awareness. That said, this distinction is gradual rather than absolute, for noticeable perceptions arise by degrees from those which are too minute to be observed; apperceptions, in turn, are not clearly defined entities but composites, made up of an infinitesimal number of smaller perceptions, or 'petites perceptions'.

Leibniz was also one of the inventors of infinitesimal calculus; in his model of the mind conscious and preconscious perceptions shade into each other, but the

[1] Gottfried Wilhelm Leibniz, *New Essays on Human Understanding*, ed. P. Remnant and J. Bennett, abridged edn (Cambridge: Cambridge University Press, 1981), p. 53. '[I]l y a à tout moment une infinité de perceptions en nous, mais sans apperception et sans réflexion'; these include 'des changements dans l'âme même, dont nous ne nous appercevons pas, parce que ces impressions sont ou trop petites et en trop grand nombre, ou trop unies, en sorte qu'elles n'ont rien d'assez distinguant à part'. Gottfried Wilhelm Leibniz, 'Nouveaux essais sur l'entendement humain', in *Sämtliche Schriften und Briefe, VI: Philosophische Schriften*, vol. 6: *Nouveaux Essais*, ed. Leibniz-Forschungsstelle der Universität Münster (Berlin: Akademie, 1990), p. 53.
[2] Horst U. K. Gundlach, 'Germany', in *The Oxford Handbook of the History of Psychology: Global Perspectives*, ed. David B. Baker (Oxford: Oxford University Press, 2012), pp. 255–88 (p. 258).

subject is never wholly aware, let alone in control, of her own experience. His is a threshold theory of attention, which involves minute gradations of awareness and a fluid shifting from perception to apperception and back again, rather than any clear-cut, absolute distinctions.

Leibniz's theory of the mind exerted great influence on philosophers and psychologists in the following centuries; as we will see, his categories of perception and apperception remained important reference points for subsequent theories of attention, which continued to explore the shift from preconscious perception to attention as a state of conscious, self-reflexive awareness. In the history of psychology, the focus of this enquiry underwent various changes. In the eighteenth century, thinkers were particularly interested in the role of what they called the 'dark' or obscure regions of the mind and how they could be illuminated, subjected to the reign of reason and morality.

In eighteenth-century Germany, writers and philosophers engaged with these dynamics, as did scholars working in fields ranging from physiology and physics to law and theology. Not all of them were affiliated with a university; psychology was a loosely defined field of intellectual enquiry rather than an academic discipline in its own right.[3] It was a subject of experimental exploration, but also the foundation which enabled such enquiry in the first place, essential for the acquisition of (self-)knowledge and hence for the Enlightenment project as a whole. Attention transformed curiosity—that initial spark needed for intellectual engagement—into more sustained interest, enabling an individual to maintain focus while helping him or her to master fear, superstition, and other distractions.[4] As Michael Hagner puts it, 'the moment reason becomes important, so does attention'.[5]

This faculty was neither instinctive nor universal but had to be carefully cultivated. The importance of fostering attention from an early age was recognized by Enlightenment pedagogues. Though children were naturally curious, they were regarded as lacking the capacity for sustained, rationally controlled concentration. Specific exercises were designed to train their attention;[6] writing in 1782, the reform pedagogue Johann Heinrich Pestalozzi encouraged teachers to make their lessons more tangible and engaging. Focused concentration was one important skill, but Pestalozzi also stressed the need to train a more wide-ranging, distributed kind of attention; to this end, teachers should make their pupils do several tasks at once,

[3] Gundlach, 'Germany', p. 259.
[4] Lorraine Daston, 'Curiosity in Early Modern Science', *Word and Image*, 11 (1995), 391–404 (p. 401).
[5] Michael Hagner, 'Towards a History of Attention in Culture and Science', *Modern Language Notes*, 118 (2003), 670–8 (p. 673).
[6] Yvonne Ehrenspeck-Kolasa, 'Das Thema Aufmerksamkeit in der Pädagogik des 18. Jahrhunderts: Joachim Heinrich Campes Reflexionen zur Beobachtung und Bildung "junger Kinderseelen"', in *Aufmerksamkeit: Geschichte—Theorie—Empirie*, ed. Sabine Reh, Kathrin Berdelmann, and Jörg Dinkelaker (Hamburg: Springer, 2015), pp. 21–34 (p. 27).

such as repeating words while drawing on their slates.[7] Other pedagogues, such as Joachim Heinrich Campe, emphasized the role of the nuclear family, and particularly of the mother, in the formation of the child's mind. In his 1785 treatise 'Über die früheste Bildung junger Kinderseelen' (On the Earliest Education of Young Children's Souls), he enjoins mothers to pay constant attention to the well-being of their children from pregnancy onwards to ensure that they prosper.[8]

The Enlightenment's programme of attentional training started in the nursery and continued into the classroom, but ultimately this was an open-ended, lifelong endeavour. In adults, attention was seen as the bedrock of the rational and moral life.[9] Philosophers, pedagogues, and physicians devised programmes of self-care designed to strengthen voluntary attention and curb its involuntary counterparts. These were laid out in hygiene treatises, the precursors of modern self-help guides, which offered advice on how to subject the appetites of the body and the senses to the control of the rational mind.[10]

One particularly detailed such programme was set out by the philosopher Georg Friedrich Meier (1717–88) in his five-volume *Philosophische Sittenlehre* (Philosophical Treatise on Morality, 1753–61), a comprehensive guide on how to lead a morally responsible life. Attention is at the heart of this project,[11] figuring as both a means and an end in the process of moral self-improvement. The second volume, published in 1754, includes the chapters 'Von der Selbstkenntnis' (On Knowing Oneself), 'Von der Beurtheilung seiner selbst' (On Self-Evaluation), and 'Von der Sorge für uns selbst' (On Caring for Ourselves). Fundamentally, the period believed that attention could be optimized with sustained practice, 'Übung', which would in turn yield both intellectual and moral rewards. A central theme in Meier's argument is moral vigilance, 'moralische Wachsamkeit' (*MPS* 397 and passim), which involves scrutinizing one's thoughts

[7] Johann Heinrich Pestalozzi, *Von der Erziehung*, cited in Ada Wulf, 'Das Problem der Aufmerksamkeit in der modernen Pädagogik', *Schweizerische Pädagogische Zeitschrift*, 27 (1917), 169–217 (p. 210).

[8] Joachim Heinrich Campe, *Über die früheste Bildung junger Kinderseelen*, ed. with an essay by Brigitte H. E. Niestroj (Frankfurt a.M.: Ullstein, 1985), p. 87.

[9] Another leading Enlightenment thinker, the philosopher and jurist Christian Wolff, was pivotal in 'establishing a definable field of knowledge and attaching the word "psychology" to it'. He expanded Leibniz's theory of perception by foregrounding the role of attention, which for him served to isolate perceptions from each other. For Wolff, attention was never simply 'on' or 'off', but 'always somewhere between fully active and completely dormant'. Matthew Bell, *The German Tradition of Psychology in German Literature and Thought, 1700–1840* (Cambridge: Cambridge University Press, 2005), pp. 23–4.

[10] This argument relates to another field: the role of attention in aesthetic experience. Alexander Gottlieb Baumgarten (1714–62), a student of Wolff, founded the new philosophical discipline of aesthetics, which relies on the mental faculties as postulated by Wolff. In his *Aesthetica* (1750/1758) he investigated sensations and feelings, which Wolff had considered lower, pre-rational forms of knowledge. See Gundlach, 'Germany', p. 260.

[11] Meier was a student of Baumgarten; in his writings he distinguishes three aspects, or 'perfections', of attention to which the reader should aspire: breadth, strength, and prolonged use. Each of them can be strengthened with certain exercises, but 'the best aids for improving the attention are the fine arts. [...] For Meier, aesthetic perception is itself a kind of exercise'. Matthew Riley, *Musical Listening in the German Enlightenment: Attention, Wonder, and Astonishment* (Burlington, VT: Ashgate, 2004), p. 16.

and actions for their moral implications. This is no easy goal; indeed, 'it seems as if people flee from themselves and shy away from casting a bold glance straight at their inner life'.[12] Most people, he argues, care more for their body than their soul and are primarily concerned with their material situation. In addition, they are constantly distracted by minor concerns, leaving them little time and attention to focus on what is truly important.

> Denn, wenn unsere Gedanken unter unendliche viele Gegenstände zertheilt sind, oder, wenn sie gar zu stark und emsig auf eine ganz andere Sache als uns selbst gerichtet sind; so sind wir zu der Zeit nicht im Stande, an uns selbst zu denken. Wer nun in einer beständigen Zerstreuung lebt [...], der vergißt seiner selbst, und er erlangt niemals eine recht klare und deutliche Erkenntniß von sich selbst.
> (MPS 389–90)
>
> [For if our thoughts are dispersed among an infinite number of objects, or too strongly and busily turned towards a matter other than ourselves, then we are incapable of thinking of ourselves. He who lives in perpetual distraction [...] will forget himself, and will never attain a clear and vivid understanding of himself.]

How can this state of perpetual distraction be overcome? To do so involves banishing from the mind all those distracting concerns 'which will hinder our understanding of ourselves'.[13] This requires first of all a change in daily routine. The sensible person 'must take some time out to gather his mind in the face of all distraction [...] and henceforth occupy himself with the contemplation of himself so as better to get to know himself'.[14] Distilling the advice of 'some old moral treatises', Meier recommends that readers start each day by reflecting on themselves and the day ahead, then take time over the course of that day to compare their behaviour with the outline, or 'Entwurfe', drawn up in the morning, and finally use the evening to take stock of the preceding day—'what we have done well, where we have been lacking, where we could have done better'.[15]

Meier compares this routine of constant self-monitoring to the behaviour of the prudent wanderer

> welcher auf einem gefährlichen Wege immer vor sich hin sieht, auf die Strecke des Weges die vor ihm liegt, damit er bey Zeiten die Gefahren desselben entdecke und prüfe, ob er rechte sey. Manchmal kehrt er sich um und sieht zurück auf den

[12] '[E]s scheint, als wenn die Menschen sich selbst fliehen, und sich scheuen, recht in ihr Inwendiges hinein einen forschen Blick zu thun' (MPS 389).

[13] '[...] welche uns an der Erkenntniß unserer selbst hindern könnten' (MPS 387).

[14] 'Folglich muß ein vernünftiger Mensch gewisse Zeiten aussetzen, in welchen er sein Gemüth von aller Zerstreuung sammlet [...] und sich alsdann mit der Betrachtung seiner selbst beschäftiget, um sich selbst besser kennen zu lernen' (MPS 390).

[15] '[...] was man guts gethan, wo man gefehlt, wo man es besser hätte machen können' (MPS 392).

Weg, den er schon zurück gelegt. Manchmal bleibt er stehen um zu sehen, wie der Weg unter seinen Füssen beschaffen ist [...], damit er nicht gleite, und damit er keinen Fehltritt thue. (*MPS* 392-3)

[who, walking a perilous path, is always looking ahead, at the road ahead, so he can recognize any dangers in good time and assess whether he is on the right track. Sometimes he turns around and looks back at the road he has already travelled. Sometimes he stops to check the path beneath his feet [...], so that he does not slip and take a wrong step.]

Life is a perilous journey requiring utmost vigilance—a vigilance which is not solely focused at the present but also involves looking both backwards and ahead, into the past as well as the future.[16] This is to avoid the literal as well as metaphorical dangers of diversion, or 'Ablenkung', from the straight, moral, path. Another way of achieving this awareness is to keep a diary; while merely thinking about a goal or issue harbours the risk of becoming distracted from it, writing about it enables the individual 'to keep his thoughts together and think more sharply'.[17] Writing, in other words, can help focus the mind, stabilizing the faculties of memory and reflection—though Meier concedes that those people who lead 'a monotonous and methodical life',[18] where each day follows the same pattern, may not need to keep a written record.

Meier's treatise is addressed at self-aware readers able to control body and soul 'at will [...], when and how we want'.[19] To do so requires moderation—the ability to resist worldly distractions. But this aspiration poses its own risks, notably the danger of neglecting one's social duties 'when one cares all too much for oneself',[20] which is also a sin. Indeed, this need for balance and moderation also applies to the body. As Meier emphasizes, while caring for the soul we must also tend to our bodies.[21] In matters of diet, exercise, and sexuality, the aim is not complete self-abnegation but moderation—the transformation of Christian asceticism 'into the dietetics of moral philosophy'.[22]

[16] Meier returns to the journey motif several times, for instance when he compares people who lack the necessary moral vigilance to 'travellers whose eyes are turned everywhere, just not at that which is in front of their feet, and who therefore constantly stumble and fall' ('Reisende, welche die Augen allerwegen hinrichten, nur nicht auf das, was ihnen vor den Füssen ist, und welche daher alle Augenblicke stolpern und fallen'; *MPS* 398; see also 412).

[17] '[...] so kan man die Gedanken besser zusammen halten, und man denkt auch schärfer nach' (*MPS* 409).

[18] '[...] ein einförmiges und methodisches Leben' (*MPS* 409).

[19] '[...] nach Belieben [...], wenn und wie wir wollen'. Georg Friedrich Meier, *Philosophische Sittenlehre: Anderer Theil* (Halle: Hemmerde, 1754), pp. 666-7.

[20] '[...] wenn man gar zu viel für sich selbst sorgt' (*MPS* 656).

[21] Georg Friedrich Meier, *Philosophische Sittenlehre: Dritter Theil* (Halle: Hemmerde, 1756), pp. 382-3.

[22] Barbara Thums, *Aufmerksamkeit: Wahrnehmung und Selbstbegründung von Brockes bis Nietzsche* (Munich: Fink, 2008), p. 148.

Meier concedes that complete self-awareness can only ever be an aspiration. In one chapter, he speaks of the lacunae of darkness which resist the most sustained introspection, for 'we are a mystery to ourselves, unfathomable to our own mind'.[23] Yet even if complete self-knowledge remains an impossible goal, we must nonetheless strive towards it, in an effort 'gradually to dispel [...] the darkness'.[24] Summing up this aspiration, Meier declares that 'nothing within us must escape our attention'.[25] This maxim, however, is then partially retracted: 'it is neither possible nor necessary nor permitted that we perceive the manifold things that are within us with the same degree of clarity and vividness'.[26] If self-scrutiny is constant and all-encompassing, it risks being side-tracked by irrelevant details and losing sight of its major concerns (*MPS* 397).

In Meier's treatise, the imperative of sustained moral self-scrutiny throws up its own challenges and contradictions. The capacity to direct attention at the self is both the starting point and the goal of this journey of self-improvement. To embark on it, the reader must already have a clearly defined sense of self in order to exclude those thoughts and impressions that distract from this goal. A similar paradox underpins the temporal duration of this process, which is described as open-ended but can, in reality, only ever provide brief moments of introspection in a life lived in the midst of distractions.[27] Finally, as attention is redirected from the outside world to the self, it risks getting absorbed in minor concerns and losing track of its obligation to others. This is a danger replicated in the text, which is full of digressions, particularly in the section on moderation ('Mäßigung'), where the narrative keeps interrupting itself, becoming dispersed and fragmented.[28]

Attention and the Natural World

Both the paramount importance of attention and its inherent contradictions are apparent in eighteenth-century science. Empirical scientists, such as naturalists observing plants and animals, needed to sustain a targeted yet comprehensive focus; diaries and treatises contained extremely detailed descriptions of plants and animals, yet these threatened to dissolve the object of enquiry, and with it the observing subject, into a 'swarm of sensations'.[29] Here, as in the field of morality, the period sought to cultivate a more effective and selective form of attention, one

[23] 'Wir sind uns selbst ein Geheimniß, und wir selbst sind unserm Verstande unerforschlich. Folglich können wir nicht verbunden werden, eine solche Selbsterkenntnis zu erlangen, die gar keine Dunckelheit mehr in sich enthält' (*MPS* 382–3).

[24] '[...] nach und nach die Dunckelheit [...] immer mehr zu vertreiben' (*MPS* 383).

[25] '[N]ichts muß in uns unserer Aufmerksamkeit entwischen' (*MPS* 384).

[26] '[E]s ist weder möglich noch nöthig, noch erlaubt, daß wir alles Mannigfaltige, so in uns befindlich ist, in einem gleichen Grade der Klarheit und Deutlichkeit erkennen' (*MPS* 387).

[27] Thums, *Aufmerksamkeit*, p. 145. [28] Thums, *Aufmerksamkeit*, pp. 26–7.

[29] Lorraine Daston and Peter Galison, *Objectivity* (New York, NY: Zone Books, 2007), p. 238.

which enabled the observer to identify the essential features of a phenomenon while disregarding its marginal and accidental details. In this way, attention 'soldered together the objects and subjects of knowledge, both assembled from the copious but fragmentary materials of sensation'.[30]

Practices of scientific observation have thus been described as 'technologies of the self, often consuming more time than any other single scientific activity'.[31] As in the field of moral self-observation, one way of safeguarding the integrity of this process was by keeping a journal. Naturalists typically recorded personal experiences alongside scientific reflections and observations; the diary was a way of ensuring a sense of mental continuity, of connecting yesterday's thoughts with those of today and tomorrow, as the 'bare act of transcription ensured the continuity of memory, and thus the continuity of the self'.[32] The Genevan naturalist Charles Bonnet, who observed a single aphid from 5.30 a.m. until 11 p.m. every day for over a month, and was disconsolate when it disappeared, exemplifies a form of scientific attention seemingly boundless in its scope and endurance. Indeed, though the eighteenth century regarded attention as a virtue to be cultivated, it was also an appetite, a drive reminiscent of Sigmund Freud's epistophilia or *Wisstrieb*, though the period believed that this impulse 'could be retrained by habit'.[33]

The moral and the empirical facets of attention in the period come together in the poetry of Barthold Heinrich Brockes (1660–1747). His epic nine-volume poetry collection *Irdisches Vergnügen in Gott* (Earthly Pleasure in God, 1721–48) is dedicated to the contemplation of nature; in highly detailed descriptions, it evokes the natural world in its sublime grandeur (the sun, the sea, the sky) and its apparently trivial details (the sunlight on a cherry blossom or a toothache). The poems reflect the scientific spirit of their age; their underlying agenda, however, is religious.[34] By describing nature in all its variety and splendour, Brockes wants to awaken in his readers a sense of awe and gratitude for God's creation.

> Daß man, wenn man was schönes sieht,
> Sich wenigstens so viel bemüht,
> Das was man siehet, recht zu sehn?
> Das heißt, zum Sehn das Denken fügen,
> Das heißt, sich als ein Mensch vergnügen,

[30] Daston and Galison, *Objectivity*, p. 240.
[31] Daston and Galison, *Objectivity*, p. 234.
[32] Daston and Galison, *Objectivity*, p. 236.
[33] Daston and Galison, *Objectivity*, p. 241.
[34] In this way, the didactic poetry of the early Enlightenment reconciles the Baroque tension between pleasure in this world and a focus on the afterlife. Following the influence of Leibniz and Wolff, who argue that the world as it has been created illustrates God's goodness and good intentions, the goal of early eighteenth-century nature poetry was to transform this theological conception into a philosophically inspired observation of reality. By recording natural phenomena as well as bodily sensations, however, the focus of this poetry is both on outside phenomena and on the subject's experience. Hans-Wolf Jäger, 'Lehrdichtung', in *Deutsche Aufklärung bis zur Französischen Revolution 1680–1789*, ed. Rolf Grimminger, Hansers Sozialgeschichte der deutschen Literatur vom 16. Jahrhundert bis zur Gegenwart, 3 (Munich: Hanser, 1980), pp. 500–44 (pp. 508–9).

Und Gott, in unsrer Lust, erhöhn.[35]

[that we, when seeing something beautiful,
at least make enough effort
to behold properly what we see?
This means adding thought to sight,
this means enjoying ourselves as humans
while exalting God in our joy.]

This kind of attention is the basis of both human happiness and religious devotion. Attention is a God-given duty, the way we are meant to respond to the world. In contrast, the poem 'Unselige Unaufmerksamkeit' (Wretched Inattention) focuses on its absence, casting inattention as a sin, a dereliction of one's moral duty:

So liegt die Schuld ja bloß an mir,
Daß ich nicht das, was mich umgiebet,
[...] nicht meines Denkens würdig achte,
Es nicht erwege, nicht geniesse, indem ich alles nicht betrachte.
Die unglückselig' Unterlassung, von dieser Gott geweihten Pflicht,
Ist eine Wurzel unsrer Plagen. [...]
Man sieht nicht, was man siehet; man höret auch ja so wenig, was man höret;
Man schmecket, riecht und fühlet nicht, was man doch schmecket, riecht und fühlet,
[...]
Indeß verfliegen unsre Tage, als wie ein Wind, wie ein Geschrey,
Und unser ganzes Leben fliesset, als wie ein schneller Strom, vorbey.[36]

[Hence the fault is mine alone
That I do not deem that which surrounds me
[...] worthy of my thought,
Do not consider nor enjoy, for I do not regard it.
The wretched neglect of this duty, bestowed by God,
Is a root of our torments. [...]
We do not look at what we see; and listen just as little to what we hear;
We do not taste, smell, and sense that which we taste, smell, and sense;
[...]
Meanwhile our days fly by just like a wind, a cry,
And our whole life passes like a rapid stream.]

[35] Barthold Heinrich Brockes, *Irdisches Vergnügen in Gott*, part 6 (Hamburg: Herold, 1737; repr. Bern: Lang, 1970), p. 405.

[36] Brockes, *Irdisches Vergnügen in Gott*, pp. 478–9.

By looking without seeing and hearing without listening, we deny God's glory and rob ourselves of all pleasure ('alles Gute'). The result of such inattention is a fleeting life which is neither rooted in the here and now nor turned towards the divine. This critique of inattention strikes a surprisingly modern note, anticipating debates about distraction and acceleration around 1900. While the causes for inattention in the twentieth century are more complex, rooted in society rather than (solely) in the self, sustained attention in this period is once again described as a quasi-devotional stance, as a countermodel to a secular and superficial way of life.

Kant: The Art of Distraction

In the eighteenth century, then, detailed attention, particularly when directed at the natural world, is both a skill and a virtue, interlinking science and religious devotion. However, a rather different mode of mental engagement seems to be at work in the literature and thought of period. The pitfalls of the more sustained and immersive concentration required in these domains are explored by Immanuel Kant (1724–1804). In his *Anthropologie in pragmatischer Hinsicht* (Anthropology from a Pragmatic Point of View, 1798), he distinguishes between two forms of attention, which mutually complement each other, while expounding the importance of diversion as a necessary counterweight to both.

Kant's *Anthropology* is based on a lecture course he delivered in every winter semester, from 1772–3 until the end of his lecturing career in 1796.[37] Its aim was to analyse human experience in a conceptually rigorous manner, and in particular to illuminate the 'dark' or 'obscure' parts of the human mind.[38] This project was not a strictly academic one, for Kant's lectures were also aimed at members of the general public; listeners should be able to compare the claims made in these lectures with their own experience. Anthropology was thus a central part of the Enlightenment project of self-exploration and self-improvement.[39]

Kant's elaborations are rooted in everyday experience. Their primary purpose is the understanding of the human faculties, their principal method observation: of people, their behaviour and its underlying motivations. In a letter, Kant describes himself as 'ceaselessly engaged in observation, even in the midst of daily life'; listeners of his lecture course 'are never confronted with dry reflections, but are

[37] The lecture course in turn emerged from that part of his lectures on metaphysics which touched on empirical psychology. See Wolfgang Becker, 'Einleitung', in *Immanuel Kant: Anthropologie in pragmatischer Hinsicht*, ed. and intro. Wolfgang Becker (Stuttgart: Reclam, 1983), pp. 9–26 (p. 9).
[38] That said, the purpose of Kant's *Anthropology* is not moral instruction, nor are its concepts based on rigorous a priori principles, as is the case in his *Critique of Pure Reason*. Becker, 'Einleitung', pp. 10, 14.
[39] Becker, 'Einleitung', p. 11.

entertained, for they are able constantly to compare their own ordinary experience with my remarks'.[40]

Kant's *Anthropology* does not have a self-contained section on attention but touches on this faculty in different contexts. It distinguishes between two forms of attention: *attentio*, which is a mobile form of awareness enabling the subject to orient herself within the world, and *abstractio*, the ability to focus on one particular idea by withdrawing one's attention from the wider field of stimuli.

Echoing Leibniz's apperception, Kant defines *attentio* as a state of being aware of one's own thoughts and perceptions. This act of 'Aufmerken', or 'paying attention',[41] involves a mobile alertness, which enables the individual to orient herself in a complex environment, but this ability also carries certain risks. In one of Kant's examples, a man has the opportunity to make an advantageous marriage but is unable to ignore a wart or tooth gap in his potential bride; as Kant comments, 'it is an especially bad habit of our faculty of attention to fix itself directly, even involuntarily, on what is faulty in others'.[42] Here, *abstractio* comes into play. This is 'the cognitive faculty of stopping a representation of which I am conscious'.[43] This more selective state of awareness enables us to hold a particular idea in our mind while withdrawing attention from the wider field of impressions. Unlike *attentio*, *abstractio* is no natural ability but a 'strength of mind', which can be acquired only with sustained practice.[44]

Of the two faculties, then, *abstractio* is the higher and more accomplished, vital particularly for the work of the scholar. And yet for Kant this mindset harbours its own risks. One of the great weaknesses of the mind is its propensity to become fixated on an idea 'on which one has expended great or continuous attention'.[45] In children, whose attention is particularly malleable, this might manifest itself as repeating the same phrase or rhyme over and over again. But this fixation can also afflict adults, such as the priest unable to get a memorized sermon out of his head.

Having identified this danger, Kant thus turns to the opposite of attention— *distractio* or 'Zerstreuung'. As he argues in the section 'Von den Gemütsschwächen im Erkenntnisvermögen' (On Mental Deficiencies in the Cognitive Faculty), distraction can be involuntary, leading to a state of absent-mindedness or *absentia*,[46] or it can be a deliberate strategy, whereby overly focused attention is diverted 'away from

[40] 'Ich bin unabläßig so bey der Beobachtung selbst im gemeinen Leben daß meine Zuhörer [...] niemals eine trokene sondern durch den Anlaß den sie haben unaufhörlich ihre gewöhnliche Erfahrung mit meinen Bemerkungen zu vergleichen iederzeit eine unterhaltende Beschäftigung habe' [sic?]. Kant, letter to Marcus Herz, late 1773. *Kants gesammelte Schriften*, ed. Königlich-Preußische Akademie der Wissenschaften, vol. 10 (Berlin: Reimer, 1900), p. 138. Cited in Becker, 'Einleitung', p. 24.
[41] KAG 131/KAE 19.
[42] KAE 20; 'es ist aber eine besondere Unart unseres Attentionsvermögens gerade darauf, was fehlerhaft an anderen ist, auch unwillkürlich seine Aufmerksamkeit zu heften' (*KAG* 131).
[43] KAE 19; 'das Absehen von einer Vorstellung, deren ich mir bewußt bin' (*KAG* 131).
[44] KAE 20/KAG 132.
[45] KAE 101; 'auf welche man große oder anhaltende Aufmerksamkeit verwandt hat' (*KAG* 206).
[46] KAE 101; 'Abwesenheit (*absentia*) von sich selbst' (*KAG* 206).

certain ruling ideas by dispersing it among other, dissimilar ones'.[47] Through their practice in *abstractio*, scholars are particularly susceptible to mental disorders caused by excessive concentration:[48]

> Es ist eine von den Gemütsschwächen, durch die reproduktive Einbildungskraft an eine Vorstellung, auf welche man große oder anhaltende Aufmerksamkeit verwandt hat, geheftet zu sein und von ihr nicht abkommen, d.i. den Lauf der Einbildungskraft wiederum frei machen zu können. Wenn dieses Übel habituell und auf einen und denselben Gegenstand gerichtet wird, so kann es in Wahnsinn ausschlagen. (*KAG* 206-7)[49]
>
> [Absent-mindedness is one of the mental deficiencies attached, through the reproductive power of imagination, to a representation on which one has expended great or continuous attention and from which one is not able to get away; that is, one is not able to set the course of the power of imagination free again. If this malady becomes habitual and directed to one and the same object, it can turn into madness. (*KAE* 101)]

Change and stimulation are able to loosen such unhealthy fixations. Kant recommends alternating between the city and the countryside, between work and play, and, in intellectual endeavours, between a variety of subjects ranging from poetry to philosophy and mathematics. The body must not be neglected, for in stimulating the body we also stimulate the mind: 'Thus it is easier to enjoy oneself in *walking* for a considerable length of time, since one muscle (of the leg) *alternates* at rest with the other, than it is to remain standing rigid in one and the same spot, where one muscle must work for a while without relaxing'.[50] Another useful stimulant is tobacco which, by satisfying a physical craving, also reawakens attention and draws it back to its subject, counteracting the risk of monotony and boredom (*KAE* 52-3/*KAG* 160-1).

Excessive concentration or *abstractio* can thus be curbed through a 'mental dietetics'; dispersing one's attention can facilitate its 'Wiedersammeln' or 'recollection' (*KAG* 207/*KAE* 101-2), making this faculty once again freely and flexibly

[47] *KAE* 100; 'Abkehrung der Aufmerksamkeit (*abstractio*) von gewissen herrschenden Vorstellungen durch Verteilung derselben auf andere, ungleichartige' (*KAG* 206).

[48] As Friedrich A. Kittler notes, around 1800 this affliction was associated not only with the scholar but also with the writer. Friedrich A. Kittler, *Aufschreibesysteme 1800/1900* (Munich: Fink, 1985), p. 141. A century later, William James will differentiate between 'sustained attention to a given topic of thought', which involves 'that we should roll it over and over incessantly and consider different aspects and relations in turn' and pathological states, in which 'a fixed and ever monotonously recurring idea possesses the mind' (*PP* 423).

[49] The danger of excessive absorption is also mentioned by Meier, who cites the warning example of scholars so absorbed by their studies that they lose track of the task of self-observation (*MPS* 400).

[50] *KAE* 56. 'So ist es leichter, sich eine geraume Zeit im Gehen zu unterhalten, weil da ein Muskel (der Beine) mit dem anderen in der Ruhe wechselt, als steif auf einer und derselben Stelle stehen zu bleiben, wo einer unabgespannt eine Weile wirken muß' (*KAG* 164).

available to the subject. The object of diversion should be varied and yet coherent enough to stem the endless proliferation of distraction, for otherwise 'the mind finds itself confused and in need of a new distraction in order to be rid of that one'.[51] As Kant concludes, the challenge is 'to distract oneself without being distracted'[52]—an ability which he terms the art, or 'Kunst', of distraction (*KAE* 101/*KAG* 207–8).

Shock and Diversion: The Psychic Cure

Kant was not alone in advocating distraction. Leibniz had already questioned the value of unifocal attention, emphasizing that the mind was able to attend to 'many things all at once',[53] while for the French writer Denis Diderot, distraction allowed ideas 'to reawaken one other', thereby counteracting the 'stupor of attention, which merely rests on, or recycles, the same idea'.[54] For the Swiss physician Samuel Tissot, the effects of excessive concentration ranged from fatigue all the way to madness; in his treatise *De la santé des gens de lettres* (On the Diseases Incident to Literary and Sedentary Persons, 1768), he recommends that scholars engage in hunting, sports, and games to guard their sanity.[55]

These suggestions underline what is apparent throughout the period's literature on attention, namely the gendered dimension of this discourse. Just as science and scholarship were overwhelmingly male pursuits, so the pitfalls of attention were largely cast as dangers to the male mind. One notable exception is the phenomenon of 'Lesewuth', or reading addiction, a widely discussed problem in the period, which was typically said to afflict women. Sufferers became so immersed in a book, typically a novel, that they lost all sense of the world and even of themselves. As the Kant disciple Johann Adam Bergk argued, in its most extreme manifestations, oblivious immersion carried the risk of madness.[56] While the

[51] *KAE* 101; 'das Gemüt sich verwirrt findet und einer neuen Zerstreuung bedarf, um jene loszuwerden' (*KAG* 207).
[52] *KAE* 102; 'sich zu zerstreuen, ohne doch jemals zerstreut zu sein' (*KAG* 208).
[53] Gottfried Wilhelm Leibniz, *New Essays on Human Understanding*, ed. Peter Remnant and Jonathan Bennett (Cambridge: Cambridge University Press, 1996), p. 113.
[54] Denis Diderot, 'Distraction (Morale)', in *Encyclopédie, ou dictionnaire raisonné des sciences, des arts et des métiers, par une société de gens de lettres*, ed. Denis Diderot and Jean le Rond d'Alembert (Paris: le Breton et al., 1751–80), vol. 4, p. 1061. Cited in Natalie M. Phillips, *Distraction: Problems of Attention in Eighteenth-Century Literature* (Baltimore, MD: Johns Hopkins University Press, 2016), p. 5.
[55] Samuel Tissot, *A Treatise on the Diseases Incident to Literary and Sedentary Persons*, trans. by a Physician (Edinburgh: Donaldson, 1772), pp. 24; 77.
[56] Johann Adam Bergk, *Die Kunst, Bücher zu lesen, nebst Bemerkungen über Schriften und Schriftsteller* (Jena: Hempel, 1799), p. 339. See also Kittler, *Aufschreibesysteme*, pp. 183–6. This diagnosis was not shared by previous centuries. The sixteenth-century thinker Michel de Montaigne singles out novels for their healing effect, for immersing ourselves in a story can divert us from our troubles. Michel de Montaigne, 'On Diversion', in *The Complete Essays*, trans. and ed. Michael Andrew Screech (London: Penguin, 2003), pp. 935–46 (p. 937).

dangers of excessive attention are thus coded differently for men and women, both harboured potentially disastrous consequences for the individual and for society.

The Enlightenment focus on pathologies of attention coincided with the emergence of clinical psychiatry. Medical treatises defined mental illness as the result of either a lack or an excess of mental stimulation. In 1765, the Scottish physiologist Robert Whytt first introduced the concept of nerves, which came to play a central role in this discourse, which centred around nervous illnesses and pathological nervousness. His fellow Scotsman, the physician John Brown, argued in his *Elementa Mediciniae* (Elements of Medicine, 1780) that illnesses were caused either by a lack ('asthenia') or an excess of stimulation ('sthenia'); therapies involved making up for either form of extreme to bring the patient back to a state of normality. A new generation of mental institutions were set up, whose purpose was not simply to lock up the insane but to treat and potentially cure them. The treatment methods developed by French psychiatrist Philippe Pinel and his pupil Jean-Étienne Dominique Esquirol were taken up by the German physician and psychiatrist Johann Christian Reil.[57] In his 1803 treatise, *Rhapsodien über die Anwendung der psychischen Curmethode auf Geisteszerrüttungen* (Rhapsodies on the Application of the Method of the Psychical Cure on Mental Disturbance), Reil draws an analogy between a state of deep immersion, in which the individual is oblivious to the outside world, and madness, 'the soul's cataleptic staring at one object, in a state of rapture and feverish raving'.[58] To cure this condition, Reil devises a therapy in which patients are exposed to a programme of targeted stimulation, while at the same time being shielded from harmful impressions.

The prescribed treatments ranged from physical sensations causing either pain or pleasure to sensory stimuli such as sights, sounds, and smells. In the hospital grounds, Reil envisaged building an assault course, where patients were sprayed with water and trapped in a pit; mental hospitals should also contain a theatre equipped with the latest technology, where spectacles inducing 'terror, shock, astonishment, fear' were staged to crowd out the 'obsessions of madness'.[59]

Reil's plans were never realized, but they underline the period's belief in the salutary role of stimulation and targeted distraction. To prepare patients for their return to normal life, hospitals should also host concerts, readings, and theatre performances to enable patients to practise the sustained attention and self-control expected in polite society.[60] At the same time, however, the psychic cure

[57] Petra Löffler, *Verteilte Aufmerksamkeit: Eine Mediengeschichte der Zerstreuung* (Zurich: Diaphanes, 2014), p. 66. See Heinz Schrott and Rainer Tölle, *Geschichte der Psychiatrie: Krankheitslehren, Irrwege, Behandlungsformen* (Munich: Beck, 2006), pp. 59–64.

[58] '[...] dem cataleptischen Hinstarren der Seele auf ein Objekt, in der Entzückung und im fieberhaften Irrereden'. Johann Christian Reil, *Rhapsodien über die Anwendung der psychischen Curmethode auf Geisteszerrüttungen* (Halle: Curtsche Buchhandlung, 1803; repr. Amsterdam: Bonset, 1968), pp. 64–5.

[59] '[...] fixen Ideen des Wahnsinns'. Reil, *Rhapsodien*, p. 210. [60] Reil, *Rhapsodien*, p. 246.

was also meant to prepare patients for the mobile and dispersed attention which was required in an increasingly complex, modernizing world.[61]

This finely balanced equilibrium of attention and distraction, as it was envisaged in the eighteenth century, was soon to be thrown permanently off kilter. In the nineteenth century, human attention became the focus of a rigorous regime of testing and (self-)experimentation. In the psychological laboratory, it was no longer regarded as a mindset which could be cultivated, but as a cognitive faculty with fixed qualities, which were assessed under controlled conditions. Yet the more attention was scrutinized, the more elusive it proved to be. And as attention became the focus of psychological research, this also put the spotlight on distraction, turning it into a puzzle, a problem in its own right.

Self-Observation: The Route to Modern Psychology

This new quantifying approach to attention did not come out of the blue, but emerged out of eighteenth-century regimes of self-care and self-observation. Keeping a diary was a practice advocated by moral hygiene writers such as Meier and used by scientists as a method of self-scrutiny; this method was also central to experiential psychology, or *Erfahrungsseelenkunde*, a movement which thrived in the late eighteenth century. Experiential psychology involved people collecting disparate materials drawn from their own experiences, including dreams and fantasies, as well as from novels, tales, and travelogues; the human mind became the target of extensive self-observation concerned with 'physical and mental boundary states'.[62] The discipline was modelled on medicine, where self-experiment and introspection were regarded as equal in value to anatomical and physiological examination. In fact, experiential psychology was underpinned by 'a common, cross-disciplinary interest in the inner nature of mankind', which drew on anatomical and physiological research as well as on examples recorded in autobiography and fiction.[63] A leading figure in Germany was the writer and essayist Karl Philipp Moritz, founder of the *Magazin für Erfahrungsseelenkunde* (Journal of Experiential Psychology), in which leading figures of the time shared their innermost thoughts. This public display of introspection was designed to serve the common good; the findings 'would be essential for the pastor, the judge, the doctor, and particularly the author exploring the human heart'.[64]

[61] Reil, *Rhapsodien*, p. 437. [62] Hagner, 'History of Attention', p. 671.
[63] Hagner, 'History of Attention', p. 674. See also Hans-Jürgen Schings (ed.), *Der ganze Mensch: Anthropologie und Literatur im 18. Jahrhundert* (Stuttgart: Metzler, 1994); and Wolfgang Riedel, 'Anthropologie und Literatur in der deutschen Spätaufklärung: Skizze einer Forschungslandschaft', *Internationales Archiv für Sozialgeschichte der deutschen Literatur*, 6 (1994), 93–157.
[64] '[...] würde auf diese Art schon ein Werk sein, das dem Seelsorger, dem Richter, dem Arzt, und vorzüglich dem Schriftsteller des menschlichen Herzens unentbehrlich wäre'. Karl Philipp Moritz,

In experiential psychology attention doubled as the tool and the object of enquiry, and was examined in relation to both mental and physiological stimuli. Indeed, self-experiments were central in the early stages of psychological research. In the 1820s, the Leipzig-based physiologist Ernst Heinrich Weber and his anatomist brother Eduard tested their bodies' response to tactile stimuli. They discovered that the smallest perceptible or 'just noticeable' difference (JND) between two stimuli was a constant ratio across a wide range of stimuli, and were able to replicate their findings in relation to auditory and visual sensations.[65] The Webers' law of the sensory threshold (1834) provided the basis for Gustav Theodor Fechner's new science of psychophysics, which had two components. Outer psychophysics explored the relations between physical sensory stimuli and sensation, while inner psychophysics examined the relationship between material processes and the corresponding mental dynamics.[66]

Echoing Leibniz's distinction between perception and apperception, Fechner describes the mind as a fluid entity, in which attention causes sensations to rise above the threshold of conscious awareness:

> Es spricht beispielsweise Jemand mit uns; wir aber sind zerstreut und hören nicht (nicht bewusst), was er gesagt hat. Den Augenblick darauf aber sammeln wir uns, und das, was er gesagt hat, tritt in unser Bewusstsein. Unstreitig mussten also die Bewegungen, an die das Hören knüpfte, schon vorher entstanden sein, und die Sammlung der Aufmerksamkeit hatte nur den Erfolg, sie über die Schwelle zu heben.[67]

> [Say someone is talking to us, but we are absent-minded and do not hear (not consciously) what he is saying. But the next moment we gather our mind, and what he has said enters our consciousness. Undoubtedly, the movements picked up by hearing were generated beforehand, and the gathering of attention merely succeeded in lifting them above the threshold.]

'Vorschlag zu einem Magazin einer Erfahrungs-Seelenkunde', *Deutsches Museum*, 1 (1782), 485–503. Reprinted in Karl Philipp Moritz, *Werke in zwei Bänden*, ed. Heide Hollmer and Albert Meier, vol. 1: *Dichtungen und Schriften zur Erfahrungsseelenkunde* (Frankfurt a.M.: Deutscher Klassiker Verlag, 1999), pp. 793–809 (p. 798). Self-observation was seen as a tool of exercising control over one's body and mind by creating a sense of rational distance. This practice was exemplified by the Kant pupil Marcus Herz, whose *Versuch über den Schwindel* (Attempt on Vertigo, 1786) describes subjecting this state to detached scrutiny in an attempt to overcome it. This strategy was also used by the English naturalist Erasmus Darwin. He recalls that, when suffering from seasickness, 'as often as I bent my attention with energy on the management and the mechanism of the ropes and sails, the sickness ceased; and recurred again as often as I relaxed this attention'. Erasmus Darwin, *Zoonomia, or, the Laws of Organic Life*, vol. 1 (London: Johnson, 1794), p. 231. Cited in Hagner, 'History of Attention', p. 678.

[65] Gundlach, 'Germany', p. 269.

[66] Gundlach, 'Germany', p. 269. Fechner subsequently embarked on another field of enquiry, namely empirical aesthetics, 'which he opposed to philosophical aesthetics, the former starting from below, from experimental research'. Gundlach, 'Germany', p. 270.

[67] Gustav Theodor Fechner, *Elemente der Psychophysik*, vol. 2 (Leipzig: Breitkopf & Härtel, 1860; repr. Amsterdam: Bonset, 1964), p. 433.

This little sketch starts with a state of absent-mindedness, which is overcome by the exertion of the will, causing the scattered mind to become focused ('the next moment we gather our mind'). But Fechner's self-experiments challenged this narrative, according to which attention is an act of volition, a conscious choice. In his 1860 *Elemente der Psychophysik* (Elements of Psychophysics) he applied the optical model of light as waves to human attention, describing how specific impressions could rise up and then sink down again below the threshold of consciousness. One landmark experiment, which he undertook while recovering from an eye condition, focused on binocular competition. If two differently coloured objects are held at a certain distance from each eye, he found, the colours do not mix, but one of the two dominates. Whenever Fechner tried to focus his gaze on one of the two objects, he noticed an involuntary eye movement which caused him to lose focus on the chosen object. In fact, the more strongly he tried to focus his attention, the faster the object disappeared. Attention, then, could not control the senses, and conversely, mental focus could not be wholly or even largely controlled by the will, but was subject to automatic oscillation, which followed specific discernible patterns.[68]

Fechner's findings were later echoed by the memory experiments of psychologist Hermann Ebbinghaus, who made himself learn long sequences of nonsensical syllables to test his mental capacity. When he tried to hold on to a particular thought, he discovered that this was impossible:

Wie schwer ist es, ein und denselben Gedanken längere Zeit festzuhalten! Man will sich ganz in ihn versenken, nichts anderes neben ihm aufkommen lassen. Aber nicht allzulange später, während die äußeren Kennzeichen energischer Konzentration [...] ruhig fortbestehen, ertappt man sich plötzlich darüber, daß man an etwas ganz anderes denkt, und wird sich deutlich bewußt, daß der festzuhaltende Gedanke, statt inzwischen zu beharren, soeben gerade aufs neue auftaucht.[69]

[How hard it is to hold on to one and the same thought for longer periods of time! We want to immerse ourselves in it completely, not allowing anything else to rise up beside it. But just a little later, while the outwards signs of forceful concentration [...] persist, we suddenly catch ourselves thinking about something completely different, and become vividly aware that the original thought, instead of having persisted, has just reappeared.]

[68] Gustav Theodor Fechner, 'Über einige Verhältnisse des binokularen Sehens', in *Abhandlungen der mathematisch-physischen Classe der königlich sächsischen Gesellschaft der Wissenschaften*, vol. 5 (Leipzig: Hirzel, 1861), pp. 337–565. See Hagner, 'History of Attention', p. 680.

[69] Hermann Ebbinghaus, *Grundzüge der Psychologie*, vol. 1 (Leipzig: Veit, 1902), p. 599.

The outward signs of attention bear no reliable link to the inner, cognitive reality. In the eighteenth century, attention was at the heart of an optimistic anthropology, which held human beings to be capable of self-mastery and self-perfection. In the nineteenth century this optimism gave way to a growing sense of uncertainty. The more sophisticated the methods of assessing attention, the more elusive this faculty proved to be.

Quantifying the Subject: Experimental Psychology

Nineteenth-century Germany was the birthplace of experimental psychology, producing a wealth of psychological literature that made the country an international centre of research and German 'the indispensable language of psychology until the World Wars'.[70] The first psychological laboratory was established by Wilhelm Wundt at the University of Leipzig in 1879; his experimental approach to the mind, to faculties such as perception, attention, and memory, was soon emulated by psychologists around the world.

A comprehensive survey of this research is provided in William James's *The Principles of Psychology* (1890). Like many American scientists of his generation, James had spent part of his studies in Germany and later returned to meet leading researchers such as Wundt, Stumpf, and Ernst Mach. Both his sources and his terminology reflect his European training. In his chapter on attention, James cites research by Fechner, Wundt, and Stumpf, by Johann Friedrich Herbart and Hermann Lotze, while simultaneously berating the members of the English empiricist school for neglecting attention 'either as a faculty or as a resultant' (*PP* 402). While thinkers such as Locke, Hume, and Spencer regarded the mind's faculties as the product of experience, James insists that experience is controlled by the mind: '*My experience is what I agree to attend to.* [...] Interest alone gives accent and emphasis, light and shade, background and foreground—intelligible perspective, in a word' (*PP* 402).

In sub-sections entitled 'To how many things can we attend at once?', 'The varieties of attention', 'The effects of attention', 'The intimate nature of the attentive process', 'Is voluntary attention a resultant or a force?', and 'Inattention', James elaborates on this opening gambit. First, attention invariably involves selection, the 'withdrawal from some things in order to deal effectively with others'. The opposite of such focused attention is *Zerstreutheit*, a state which 'we all know [...], even in its extreme degree'. Most people, he notes, fall into distraction several times a day:

[70] Gundlach, 'Germany', p. 266.

The eyes are fixed on vacancy, the sounds of the world melt into confused unity [...]. Every moment we expect the spell to break [...]. But it does continue, pulse after pulse, and we float with it, until [...] something—we know not what—enables us to gather ourselves together, we wink our eyes, we shake our heads, the background-ideas become effective, and the wheels of life go round again. (*PP* 404)

James here uses absent-mindedness to spark his readers' interest, evoking what he claims to be one of the most universal of human experiences. As he bluntly declares, absent-mindedness is 'the usual state of brutes when not actively engaged in some pursuit',[71] but concedes that 'fatigue, monotonous mechanical occupations' can also 'produce it in men' (*PP* 404–5). Modern, industrial society, he suggests, has come full circle, producing mental states that were once associated with 'primitive' communities. That said, the centre of James's chapter remains attention, which is able to curb absent-mindedness and instil a sense of purpose even in animals, 'brutes', and children. The principal aim of (self-)education is 'the awakening of the attention', which may be achieved either by means of an external stimulus or 'in consequence of some unknown inner alteration'; this awakening might result in concentration 'upon one single object with exclusion of aught beside it', but it could also involve 'a condition anywhere between this and the completely dispersed state' (*PP* 405).

This rather open-ended conclusion leads over to the first main section, which asks 'To how many things can we attend at once?' (*PP* 405). Describing the self-experiments of the French philosopher Frédéric Paulhan, who simultaneously wrote out 'the first four verses of [Jean Racine's] *Athalie* whilst reciting eleven of [Alfred de] Musset', James concedes that it is possible to carry out two tasks at once, but only if '*the processes are very habitual* [...]. Where, however, the processes are less automatic [...], there must be a rapid oscillation of the mind from one to the next and no consequent gain of time' (*PP* 409).

In a sub-section on 'The varieties of attention', James comments in more detail on the difference between children, whose attention is characterized by 'extreme mobility', and adults, who 'have generally selected those stimuli which are connected with one or more so-called permanent interests' and have grown 'irresponsive to the rest' (*PP* 417). In principle, attention can be subdivided into four categories: attention directed at external objects or at inner thoughts; and voluntary versus involuntary attention. Voluntary attention means trying to '*discriminate* a sensation merged in a mass of others that are similar'; only in this state can

[71] In this context, he cites Theodor Waitz's *Lehrbuch der Psychologie als Naturwissenschaft* (Textbook of Psychology as a Natural Science, 1848), according to which the first and most difficult task of education, whether of animals or of children, is 'to overcome gradually the inattentive dispersion of the mind which shows itself wherever the organic life preponderates over the intellectual'.

we resist the attractions 'of more potent stimuli and keep our mind occupied with some object that is naturally unimpressive' (*PP* 420). Here, James echoes eighteenth-century commentators, who regarded attention as a sign of willpower and moral resolve. However, while writers such as Meier believed that this state could be achieved with sufficient training, James warns that '*there is no such thing as voluntary attention sustained for more than a few seconds at a time*' and that '*no one can possibly attend continuously to an object that does not change*' (*PP* 420–1). To back up this point, he cites from one of Hermann von Helmholtz's self-experiments, already mentioned in my Introduction, in which he tries to look at two geometrical figures at once. Helmholtz concludes:

> An equilibrium of the attention, persistent for any length of time, is under no circumstances attainable. The natural tendency of attention when left to itself is to wander to ever new things; and so soon as the interest of its object is over, so soon as nothing new is to be noticed there, it passes, in spite of our will, to something else. (*PP* 422)

As James adds, these findings are even more applicable to mental reflection. To maintain the attention directed at 'a given topic of thought', we need to 'roll it over incessantly and consider different aspects and relations in turn'; only in pathological states 'will a fixed and ever monotonously recurring idea possess the mind' (*PP* 423). Echoing earlier commentators such as Kant and Reil, James stresses that attention needs to move freely to be sustainable; this maxim is particularly important for the scholar. Citing eighteenth-century writers such as Helvétius, Buffon, and Chesterfield, he notes that 'geniuses are commonly believed to excel other men in their sustained power of attention', but adds: 'In most of them, it is to be feared, the so-called "power" is of the passive sort. Their ideas coruscate, every subject branches infinitely before their fertile minds, and so for hours they may be rapt' (*PP* 423). What appears like attention sustained by a powerful mind is in fact a passive response to the subject matter at hand, which forms 'a concatenated series' and is hence able to occupy the mind for hours on end (*PP* 423–4). James goes even further when he concludes that genius can actually 'prevent a man from acquiring habits of voluntary attention'; ultimately, attention is not an inborn faculty but can be cultivated with practice: 'the longer one does attend to a topic the more mastery of it one has. And the faculty of voluntarily bringing back a wandering attention, over and over again, is the very root of judgement, character and will' (*PP* 424).

Nineteenth-century psychological research found attention to be unsustainable in the long term and dependent on external stimulation. Helmholtz notes: 'It is natural for the attention to be distracted from one thing to another. [...] When we wish to rivet it on an object, we must constantly seek to find something novel about it, and this is especially true when other powerful impressions of the senses

are tugging at it and trying to distract it'.[72] Following this cue, James concludes his own chapter with a section headed 'Inattention'. One form this phenomenon can take is when we become oblivious to a stimulus (such as a background noise) once it becomes habitual. This process is a universal, trans-historical phenomenon, but James emphasizes its particular significance in the modern age, the age of 'the mill-wheel, the spectacles, the factory, din' (*PP* 456). Though attention is intrinsically unstable, he speaks of the contemporary 'habits of inattention' which can be traced, 'hypothetically at least', to certain environmental factors (*PP* 456).

Here, James returns to an issue he had briefly mentioned at the start of his chapter: to the impact of modern living and working conditions on the mind. Revealingly, though, he does not pursue this argument any further. The emphasis of his chapter is on psychological research, on (self-)experiments carried out in secluded spaces, under carefully controlled conditions, which are meant to reveal the timeless, verifiable workings of the mind. Though 'the mill-wheel, the spectacles, the factory, din' briefly intrude into these reflections, James ultimately disregards them, bracketing off the question of whether the mind is a historically and culturally determined entity. Yet this question reasserted itself with increasing urgency as psychology evolved. Experiments which revealed the instability of attention and related mental faculties triggered heated debates about the aims and methods of the discipline. These debates focused both on the overall epistemological foundations of psychology and on its underlying conception of the individual as both subject and object of psychological experiments.

The Psychological Laboratory and the Problem of Distraction

The experimental exploration of the mind brought with it a fundamental reconceptualization of the human subject. In contrast to the eighteenth century, psychologists were no longer interested in what people could achieve with the right (self-)education, but explored instead 'what they had always been capable of when automatisms were thoroughly tested one by one'.[73] The focus of nineteenth-century psychology, in other words, was on universal, trans-historical psychological faculties and processes, and yet the discipline's institutional structures were also very much a product of their time.

This concerned, firstly, the matter of hardware. An essential device in psychological experiments was the chronoscope, a precision timer with an electromagnetic switch invented by Matthäus Hipp in the 1840s, which was first used by the Swiss astronomer Adolph Hirsch in 1860 in experiments into sensory

[72] Cited in Jonathan Crary, *Suspensions of Perception: Attention, Spectacle, and Modern Culture* (Cambridge, MA: MIT Press, 1999), p. 30.
[73] Kittler, *Aufschreibesysteme*, p. 269.

perception and nerve conduction. Hirsch in turn inspired Wundt's reaction time experiments, which measured the time difference between a metal ball hitting a surface and the listener registering this sound; the discrepancy between the two became known as the 'personal equation' or 'persönliche Gleichung'.[74]

Another tool used to quantify mental processing speed was the tachistoscope, an optical device which displayed a visual stimulus—an image, word, or number— for less than one hundredth of a second, thereby preventing the observer from subjecting a stimulus to repeated or extended scrutiny.[75] Its aim was to produce the conditions for near-instantaneous perception in an immobilized observer.[76] The tachistoscope was used to test the speed and range of human perception, the so-called 'Aufmerksamkeitsbereich' or 'zone of attention', by assessing how many different elements an observer could take in without moving her gaze or while conducting cognitive operations, such as mental arithmetic. Experiments showed that it was possible to attend to several stimuli at once, but only up to a limit; while most subjects were only able to take in five images, and some could stretch to six, seven objects exceeded the capacities of most people in a single act of perception.[77] Some devices, such as the stereoscope, were also used outside the laboratory, for the sake of popular entertainment, underlining the links between experimental psychology and the more general conditioning of the human mind and senses by means of (media) technology.[78]

In their study of the history of objectivity, Lorraine Daston and Peter Galison argue that the model of scientific attention undergoes a radical change between the eighteenth and the nineteenth century. The attention of the eighteenth-century naturalist is virtually insatiable, endlessly fascinated by the empirical world, and yet at the same time selective, able to synthesize the wealth of observed detail. His or her nineteenth-century successor, in contrast, is given over to neither fascination nor selection, but instead aspires to 'waxlike receptivity' and 'self-denying passivity'.[79] In nineteenth-century science, observation and experimentation are reclassified as labour. Helmholtz describes the 'iron work of self-conscious inference' that underpins experimental research, requiring 'great

[74] Henning Schmidgen, 'Zur Genealogie der Reaktionsversuche in der experimentellen Psychologie', in *Instrument—Experiment: Historische Studien*, ed. Christoph Meinel (Berlin: Verlag für Geschichte der Naturwissenschaften und der Technik, 2000), pp. 168–79 (pp. 170–1).

[75] When in 1906 researchers photographed the eyes of subjects exposed to such stimuli, they were able to confirm that the gaze did not move or adjust during the process. Crary, *Suspensions of Perception*, p. 304.

[76] As Crary notes, this experimental set-up embodied a more general paradox of modernization: the fact that technologically produced acceleration could have the inverse effect, leading to the physical immobilization of the human subject. Crary, *Suspensions of Perception*, p. 304.

[77] Crary, *Suspensions of Perception*, p. 304, n. 50. See W. Stanley Jevons, 'The Power of Numerical Discrimination', *Nature*, 9 (1871), 281–2.

[78] See Löffler, *Verteilte Aufmerksamkeit*, pp. 146–58.

[79] Daston and Galison, *Objectivity*, pp. 95; 203.

stubbornness and caution',[80] and for Wundt psychological experiments involve 'tracing the manifestations of attention in a systematic fashion'.[81] Voluntary attention thus became the key paradigm of psychological research, both as the object of psychological experiments and as the mental skill which enabled and underpinned this research.

But this preference was bound up with a paradox. Time and again, experiments underlined the fragility and instability of attention, and yet these experiments were centred on the figure of the impartial observer able to follow them with sustained concentration (albeit with the help of machines). Experimental psychology, in other words, held on to 'the bourgeois virtue of self-discipline' in a field which was comprehensively dismantling the notion of attention as unwavering and unbiased.[82] In a field in which the subject's attentional capacities were subjected to relentless scrutiny, the mental fallacies of the experimenter remained a blind spot—for to address them would undermine the very foundations of the discipline.

The tachistoscope exemplified the new, disciplinary regime towards mind and body as it underpinned the experimental human sciences. Participants were seated in front of a screen covered by a curtain in a state of alertness and expectation, and the lighting and display mechanism were designed to minimize distractions. Paradoxically, however, the experiment produced a fragmented, discontinuous, shock-like perception and thereby replicated comparable experiences in modern life.[83]

Experimental psychologists agreed that attention was no permanent state but subject to constant fluctuation, but individual researchers differed in their interpretation and explanation of this phenomenon. The oscillation of visual, aural, and tactile perception had already been explored by the forerunners of experimental psychology such as Helmholtz, Georg Elias Müller, and Victor Urbantschitsch, and this line of enquiry continued to shape psychological research. Wundt's influential journal *Philosophische Studien* contains several articles on distraction in the different senses. Nicolai Lange, who worked in Wundt's laboratory, used a chronoscope to measure the duration of 'waves of attention' and map them onto different types of sensory stimuli. As he discovered, the fluctuations varied depending on which sense was involved and were smallest

[80] Hermann von Helmholtz, 'Über das Verhältnis der Naturwissenschaften zur Gesamtheit der Wissenschaft', in *Vorträge und Reden*, 5th edn, vol. 1 (Brunswick: Vieweg, 1903), pp. 117–45 (p. 178). Cited in Daston and Galison, *Objectivity*, p. 242.

[81] '[...] die planmäßige Verfolgung der Erscheinungen mit der Aufmerksamkeit'. Wilhelm Wundt, *Logik: Eine Untersuchung der Prinzipien der Erkenntnis und der Methoden wissenschaftlicher Forschung*, vol. 3: *Logik der Geisteswissenschaften*, 4th rev. edn (Stuttgart: Enke, 1921), p. 165. See Jochen Fahrenberg, *Wilhelm Wundts Kulturpsychologie (Völkerpsychologie): Eine Psychologische Entwicklungstheorie des Geistes* (Trier: Leibniz-Zentrum für Psychologische Information und Dokumentation, 2016), p. 3.

[82] Hagner, 'History of Attention', pp. 680–1.

[83] See Crary, *Suspensions of Perception*, pp. 305–7.

in auditory, largest in haptic sensations.[84] Different researchers came up with different explanations for these oscillations. Hugo Münsterberg attributed them to muscular fatigue (for instance, in the eyes), Karl Marbe to the varying intensity of the respective stimuli. For Lange, memories played a key role in shaping attention in the present, for they either enforced or undermined incoming new impressions. According to this model, attention had an inner, experiential and emotional, component; oscillations of consciousness, and specifically of memory images, determine how the mind processes external sensations.[85] Other psychologists, most notably Münsterberg, were sceptical of this qualitative approach and instead sought to trace mental faculties back to physiological processes in the brain and nervous system.[86]

Whether fluctuations of attention were attributed to physiological or psychological factors, research often highlighted the adverse effects of external stimuli. Arved Bertels's *Versuch über die Ablenkung der Aufmerksamkeit* (Attempt on the Diversion of Attention, 1889) tries to map out the causes and mechanisms of distraction, while the US-American psychologist Edward Bradford Titchener, one of Wundt's pupils, assessed to what extent distraction was caused by multi-tasking or by different stimuli such as sounds (the ticking of a metronome), sights (flashing lights, flickering candles), and smells.[87]

In exploring attention, psychologists thus became increasingly focused on distraction, and experiments were designed to test the limits of attention. But distraction also featured in the psychological literature of the time in a different capacity: as an accidental disturbance rather than a deliberate feature of an experiment. Indeed, one major source of unintended and potentially uncontrollable distraction was the psychological experiment itself. The space of the laboratory was designed to shield subjects from the outside world and expose them to stimuli in a controlled manner; indeed, it was the laboratory setting which gave experimental psychology its scientific credentials. Lange describes the precautions taken to ensure the accuracy of his results, emulating the methods of his mentor Wundt:

> Die Registrirungsapparate waren in einem abgesonderten Zimmer aufgestellt, so dass das reagierende Subject von jedem Geräusch und anderen Einflüssen geschützt war. Die Versuche wurden am Abend gemacht, wo der Straßenlärm aufhörte; das Zimmer, in dem der Reagirende sich befand, wurde nur schwach beleuchtet.[88]

[84] Nicolai Lange, 'Beiträge zur Theorie der sinnlichen Aufmerksamkeit und der activen Apperception', *Philosophische Studien*, 4 (1888), 390–422 (p. 405).
[85] Lange, 'Beiträge', pp. 420; 422. [86] See Löffler, *Verteilte Aufmerksamkeit*, p. 173.
[87] Löffler, *Verteilte Aufmerksamkeit*, p. 174. The 1896 and 1897 issues of the *American Journal of Psychology* contain several articles on this topic, including 'Distraction by Odors' and 'Distraction by Musical Sounds: The Effect of Pitch upon Attention'.
[88] Lange, 'Beiträge', p. 402.

[The measuring devices were set up in a separate room, so that the reacting subject was protected from any sound and other influences. The experiments were conducted in the evening when the noise from the streets has ceased; the room in which the subject was situated was only dimly lit.]

In addition, Lange's subjects used a silent electrical switch to operate the chronoscope which measured their response while minimizing the noise coming from the testing apparatus.[89]

Even with these elaborate precautions, however, the experimental hardware remained a potential source of errors and distraction. James McKeen Cattell notes that 'irregularities' in the workings of the apparatuses were frequently misread as a drop in the subjects' attention.[90] Indeed, even the most reliable and discreet devices were liable to distort the results through their very presence, and Ebbinghaus warns that 'the entire experimenting process, the apparatuses, the participating persons etc. have a distracting effect on inexperienced participants, who cannot gather their attention, and hence the ensuing results are distorted by secondary influences'.[91] Some reaction time experiments produced hallucinatory effects, causing subjects to press the requisite button before the signal had even been given.[92] Such phenomena ruptured the causal link between stimulus and response and threatened to eliminate attention from the experimental equation altogether.[93]

A different take on the causes and effects of distraction is offered by Edgar James Swift, who worked in Ebbinghaus's Berlin laboratory. Visual stimuli were more distracting than acoustic ones, he found, but if a subject had to choose between two stimuli of the same kind, this selection process was quicker and more efficient in the case of visual stimuli. Swift attributed this difference not to innate psychological or physiological laws but to the subjects' everyday experience:

> A large part of our knowledge is acquired through the sense of sight. We are constantly called upon to decide quickly between things that we see, seldom between what we hear. We thus gain a faculty in discriminating between objects of sight and in acting in accordance with our decision. [...] In the street many

[89] Löffler, *Verteilte Aufmerksamkeit*, p. 172.
[90] James McKeen Cattell, 'Psychometrische Untersuchungen: Erste Abtheilung', *Philosophische Studien*, 3 (1886), 305–35 (p. 335).
[91] 'Der ganze Vorgang des Experimentierens, die Apparate, die mitwirkenden Personen u.s.w. wirken zerstreuend auf den Ungeübten, er kann sich nicht sammeln, und die von ihm gelieferten Resultate sind daher durch Nebeneinflüsse gefälscht'. Ebbinghaus, *Grundzüge der Psychologie*, p. 579.
[92] See the report by Wladimir Bechterew, 'Ueber die Bedeutung der Aufmerksamkeit für die Lokalisation und Entwicklung halluzinatorischer Bilder', *Centralblatt für Nervenheilkunde und Psychiatrie*, 28 (1905), 329–37 (p. 335).
[93] Löffler, *Verteilte Aufmerksamkeit*, p. 176.

things crowd themselves upon our sight and in the midst of this confusion we are daily called upon to act.[94]

With this explanation, Swift breaks down one of the most rigid barriers of experimental psychology: that between the laboratory and the outside world. Swift's account dissolves this boundary if not practically then at least theoretically. In doing so, he challenges another assumption, namely that in the laboratory mental faculties can be produced, isolated, and assessed in a rigorous manner, undiluted by external influences, yielding conclusions which can in turn be applied to everyday life. Swift reverses this hierarchy. The examined cognitive responses do not originate from this hermetic space, but are imported into it from the messiness and 'confusion' of everyday life, where attention is indeed put to the test and 'daily called upon to act'.

For Swift, psychological faculties are thus the product of habit, shaped by everyday life, and reflecting wider cultural conditions. Many of his contemporaries, however, continued to stress the need to shield subjects from the outside world, and for the confluence of other sensory stimuli to be minimized. And yet, as Wundt conceded, these precautions were ultimately futile: 'Once all other impressions have been excluded, there remain the excitations caused by the movements of one's own body, above all by the motion of breathing and the accompanying sounds and by subjective sensory impressions'.[95] As we will see, this insight is echoed in Franz Kafka's prose fragment 'Der Bau' (The Burrow, 1923–4), where the project of creating a space free from distractions backfires spectacularly. Even as experimental psychology sought to exert complete control over the stimuli involved, distraction remained a rogue element which invaded the most secluded setting, originating from both without and within the subject's own body.

Wilhelm Wundt: Psychology and Culture

Towards the end of this chapter it is worth focusing in more detail on Wilhelm Wundt (1832–1920), founder of the first psychological laboratory and arguably the most influential psychologist of his time, whose many students went on to define the field in both Europe and North America. However, Wundt's psychological writings embody the profound tensions which beset the discipline, and his

[94] Edgar James Swift, 'Disturbances of the Attention during Simple Mental Processes', *American Journal of Psychology*, 5 (1892), 1–19 (p. 13).

[95] 'Sind alle sonstigen Eindrücke ausgeschlossen, so bleiben die Erregungen zurück, die von den Bewegungen des eigenen Körpers, vor allem von den Atembewegungen und den sie begleitenden Geräuschen, und von subjektiven Sinnesreizen herrühren'. Wilhelm Wundt, *Grundzüge der physiologischen Psychologie*, 4th edn, vol. 2 (Leipzig: Engelmann, 1893), p. 297.

work sparked considerable controversy—less in its experimental dimension than in its underlying theoretical and philosophical assumptions.

Wundt built on the psychophysical experiments of Weber and Fechner, which were designed to explore the relationship between stimulus and perception, between the physical world and the workings of the mind. Wundt had himself trained as a physiologist (in Helmholtz's laboratory), but he rejected the notion that mental phenomena could be reduced to processes in the brain or the neurological system. Rather, he followed Fechner's notion that mental operations, while working in a manner comparable to physiological processes, were autonomous, independent of the body. For him, mental operations followed laws of cause and effect and could be gauged through reaction time experiments, 'their workings glimpsed through the milliseconds that separated stimulus from response'.[96]

Wundt's pioneering laboratory reflected the Humboldtian model of the German university, whose two pillars of *Forschung* and *Lehre*, research and teaching, were meant to form one organic entity. In the natural sciences, students participated in and learned from the experiments of their supervisors. Indeed, in Wundt's group, most experimental subjects were members of his research group, and in the early years of the laboratory Wundt 'appeared regularly as a subject or data source in the experiments published by his students', although interestingly he 'does not seem to have taken the role of experimenter'.[97] Unlike in clinical experiments, then, where the subject was commonly the patient of the experimenter,[98] in experimental psychology the boundary between the two roles was fluid; research was a collaborative process and the scientific community was, in these early stages, its own source of data.[99]

These quantitative experiments were, however, underpinned by a set of much older assumptions. Wundt was strongly influenced by Fechner's sensory threshold theory, which in turn harked back all the way to Leibniz's distinction between perception and apperception. In *Grundzüge der physiologischen Psychologie* (Principles of Physiological Psychology), his most famous textbook, Wundt casts the difference between these two states in spatial terms, as the difference between the mind's centre and periphery. Apperception involves an idea entering the 'focal point', or 'Blickpunkt', of the mind;[100] attention is needed to give a sensory impression a sense of clarity and definition,[101] but this attentive state is neither permanent nor all-encompassing, but limited, mobile, and fluctuating.

[96] Roger Chickering, *Karl Lamprecht: A German Academic Life (1856–1915)* (Atlantic Highlands, NJ: Humanities Press, 1993), p. 196.

[97] Kurt Danziger, *Constructing the Subject: Historical Origins of Psychological Research* (Cambridge: Cambridge University Press, 1990), p. 51.

[98] Danziger, *Constructing the Subject*, p. 53. [99] Löffler, *Verteilte Aufmerksamkeit*, p. 162.

[100] Wilhelm Wundt, *Grundzüge der physiologischen Psychologie* (Leipzig: Engelmann, 1874), pp. 717–18.

[101] Wundt, *Grundzüge* (1874), p. 722.

Wundt casts attention as a wandering spotlight which illuminates different regions of the mind:

> Der innere Blickpunkt kann sich nun successiv den verschiedenen Theilen des inneren Blickfeldes zuwenden. Zugleich kann er sich jedoch, sehr verschieden von dem Blickpunkt des äusseren Auges, abwechselnd verengen und erweitern, wobei immer seine Helligkeit abwechselnd zu- und abnimmt. Streng genommen ist er also kein Punkt, sondern ein Feld von etwas veränderlicher Ausdehnung. [...] Je heller und enger aber der Blickpunkt ist, in umso grösserem Dunkel befindet sich das übrige Blickfeld.[102]

> [The inner focal point can successively turn towards the different parts of the field of inner awareness. At the same time, however, it can, in a manner very different from the focus of the external eye, alternately narrow and expand, causing its clarity to increase or decrease. Strictly speaking, the inner focal point is therefore no point but a field of slightly varying expansion. [...] The brighter and narrower the focal point, however, the greater the darkness in which the surrounding area is cast.]

Wundt's spotlight model of attention does not have an empirical basis but precedes his research; its effect is to invest apperception and other mental acts with an active, intentional dimension.[103] Indeed, Wundt describes volition as 'the basic fact, the root of all [mental] processes', and even though he distinguishes between voluntary and involuntary attention, he argues that ultimately both varieties are governed by the will.[104]

Wundt's theories were hotly uncontested. The physicist and physiologist Ernst Mach deemed the pillars of his thought, namely the universal operation of causality and the volitional nature of all mental acts, to be empirically unsupportable, and in the early 1890s, two of Wundt's ablest students, Oswald Külpe and Münsterberg, defected, converted to the view that mental phenomena were rooted in physiological processes.[105] Wundt stubbornly pursued the opposite

[102] Wundt, *Grundzüge* (1874), p. 718.

[103] Sven Lüders, 'The "Fluctuations of Attention": Between Physiology, Experimental Psychology and Psycho-Technical Application', in *Psychology's Territories: Historical and Contemporary Perspectives from Different Disciplines*, ed. Mitchell G. Ash and Thomas Sturm (Mahwah, NJ: Erlbaum, 2007), pp. 31–50 (p. 38). The spotlight model of attention is still used in more recent work on attention. See for instance A. M. Treisman, 'Features and Objects', *Quarterly Journal of Experimental Psychology*, 40 (1988), 201–37.

[104] '[...] das *Wollen* als die Grundthatsache, in der alle die Vorgänge wurzeln'. Wilhelm Wundt, *Grundriss der Psychologie* (Leipzig: Engelmann, 1896), pp. 259; 257.

[105] Indeed, Wundt's predominance in the field waned over the years as both individual researchers and entire groups started to diverge from his methodological path. While he tried to forge strong links with humanities disciplines such as philosophy, linguistics, history, and anthropology, particularly in North America psychology evolved by becoming more closely affiliated with the natural sciences. Danziger, *Constructing the Subject*, pp. 34; 41.

route, and it doing so, he also expanded the remit of psychology to extend beyond the individual to encompass both the natural world and human societies throughout history, across the world.

Building on his theory of the human mind, Wundt came to discern 'the operation of will and purpose' across nature, which he saw as made up of 'volitional units' from the lowest organisms all the way to humanity—an ascending hierarchy which corresponded to ascending levels of consciousness and autonomy. In this context, he outlined a set of developmental laws, such as the 'law of mental growth' and the 'law of dialectical development'.[106]

For Wundt, individual psychology had to be complemented by a much broader cultural and historical approach. In 1889 he embarked on his vast project of *Völkerpsychologie*, to which he dedicated the remaining decades of his life.[107] This project has often been misunderstood. Wundt's *Völkerpsychologie* does not involve the ethnographic, linguistic, or historical analysis of specific communities, but explores how psychological laws inform collective phenomena such as language and art, mythology and law, culture and society. Only by analysing interpersonal dynamics as they unfold in communities, he argued, was it possible to gain a full understanding of the individual.[108] As he stresses in the preface to the first volume of *Völkerpsychologie*, which is dedicated to language, neither the philologist nor the historian is fully equipped to undertake this mission, which requires the experimentally rooted expertise of the psychologist.[109]

As was common for psychologists at the time, Wundt held a chair in philosophy; his ambition was to establish psychology as the basis of the humanities and social sciences.[110] Indeed, his ultimate vision was to synthesize the humanities and the natural sciences into 'one unified theory of knowledge'.[111] The scale of this ambition was not lost on his contemporaries. The rise of psychology and its aspiration to become the new master discipline sparked a fierce backlash, particularly in philosophy.

[106] Chickering, *Karl Lamprecht*, pp. 197–8. The latter law has a Hegelian ring to it, and yet for Wundt's taste Hegel's dialectic was based too much on contradiction; his own developmental laws were more directly influenced by Darwin and Spencer.

[107] The result was his ten-volume magnum opus *Völkerpsychologie: Eine Untersuchung der Entwicklungsgesetze von Sprache, Mythos und Sitte* (Ethnographic Psychology: A Study of the Developmental Laws of Language, Myth and Custom), which appeared over the course of two decades, between 1900 and 1920. The discipline of *Völkerpsychologie* had been instituted by the psychologist Moritz Lazarus in conjunction with the philologist Heymann Steinthal; Wundt built on their work but was critical of what he regarded as their unstructured approach to the field.

[108] Alan Kim, 'Wilhelm Maximilian Wundt', in *The Stanford Encyclopedia of Philosophy* (Fall 2016), ed. Edward N. Zalta, https://plato.stanford.edu/archives/fall2016/entries/wilhelm-wundt [accessed 20 January 2020].

[109] Wilhelm Wundt, *Völkerpsychologie: Eine Untersuchung der Entwicklungsgesetze von Sprache, Mythos und Sitte*, vol. 1: *Die Sprache*, 4th edn (Stuttgart: Kröner, 1921), pp. v–vi.

[110] Wundt, *Grundriss der Psychologie*, pp. 4; 19. [111] Chickering, *Karl Lamprecht*, p. 198.

Attention as Intentionality: Edmund Husserl

At nineteenth-century German universities, psychology was part of philosophy faculties, and psychologists sought to influence their sister discipline. By introducing experimental methods into philosophy,[112] they challenged philosophy's self-proclaimed status as 'the royal road to unlocking the mysteries of the mind'.[113] Even more threatening than these institutional aspirations were the findings of psychological research, which showed mental focus to be inflected by physiological and environmental factors and subject to constant change. As a consequence, human reason, which since antiquity had been upheld as timeless and universal, threatened to 'shatter into the reason of this culture or that time, or even this or that individual'.[114] This shift had profound implications for philosophers and mathematicians, the 'self-declared defenders of reason'. Though experimental research had shown that physiology and perception differed from one person to the next, they continued to insist on the existence of 'a realm of pure thought that was the same for all thinking beings forever'—what Daston and Galison call 'structural objectivity'.[115]

In philosophy, the charge against 'psychologism' was led by Edmund Husserl (1859–1938), founder of the field of phenomenology. Having studied with Wundt, Stumpf, and Franz Brentano, Husserl was familiar with psychological research into attention. His copy of James's *Principles of Psychology* is extensively underlined, particularly in Chapters 9, on the stream of consciousness, and 11, on attention.[116] In the latter, James summarizes experiments which have shown attention to be deeply unstable, and yet he starts this discussion by asserting that 'my experience is what I agree to attend to', adding that attention involves 'the taking possession by the mind, in clear and vivid form, of one out of what seem several simultaneously possible objects or trains of thought' (*PP* 403–4). Even though he challenged the predominance of psychology, Husserl echoed psychologists such as James and Wundt, who regarded attention as a product of the will.

In his *Logische Untersuchungen* (Logical Investigations, 1900), which he dedicates to Stumpf, Husserl seeks to isolate a pure form of consciousness, or 'Bewußtsein', which transcends the contingency of those personal or environmental factors. In particular, he rejects the notion that attention is merely a (transitory) state of heightened awareness, a 'special relief [bevorzugende Hebung] imparted to *experienced* content', which allows certain impressions to

[112] Martin Kusch, *Psychologism: A Case Study in the Sociology of Philosophical Knowledge* (London: Routledge, 1995), p. 127.
[113] Martin Jay, *Cultural Semantics: Keywords of Our Time* (Amherst, MA: University of Massachusetts Press, 1998), p. 166.
[114] Daston and Galison, *Objectivity*, p. 259. [115] Daston and Galison, *Objectivity*, p. 259.
[116] Herbert Spiegelberg, *The Phenomenological Movement: A Historical Introduction*, 2nd edn, vol. 1 (The Hague: Nijhoff, 1965), p. 114.

be 'lifted' out of the wider field of perception.[117] This sculptural image recalls Wundt's spotlight metaphor of attention, according to which attention makes certain impressions appear vivid and three-dimensional, while others recede into the background.[118] For Husserl, however, attention does not merely throw the features of physical and mental experience into sharper relief, along the lines of Leibniz's concept of apperception; rather, he casts attention as *'an emphatic function which belongs among acts defined in the above defined sense of intentional experiences'*,[119] shaping, as Bernhard Waldenfels puts it, not only *what* we see but *how* we see things.[120]

Husserl's response to the rise of psychology and its model of fluid, contextually contingent attention was not simply to reinstate a perceiving subject who could grasp the world objectively, from a position of physical and mental detachment, nor did he completely dismiss the findings of empirical research. For him, attention is synonymous neither with empirical observation nor with traditional introspection, but is in essence an intentional act with a universal structure:

> Wahrnehmung ist hierbei nicht das bloße Dasein des Inhaltes im Zusammenhang des Bewußtseins, sondern vielmehr ein Akt, in dem uns der Inhalt gegenständlich wird. Und so sind es denn überhaupt intentionale Gegenstände irgendwelcher Akte, und nur intentionale Gegenstände, worauf wir jeweils aufmerksam sind und aufmerksam sein können.[121]
>
> [Perception is not the mere being of the content in a conscious setting, but an *act* in which the content is rendered objective. Intentional objects of acts, and only intentional objects, are the things to which we are at any time attentive, and to which we can be so attentive.[122]]

As he puts it elsewhere in his *Logical Investigations*, 'significant talk of attention embraces the whole sphere of thinking and not merely the sphere of intuition'.[123] Husserl's phenomenology reclaims attention as a faculty of insight and (self-)reflection, which is at the disposal of the rational subject. This conception

[117] Edmund Husserl, *Logical Investigations*, ed. Dermot Moran, trans. J. N. Findlay, vol. 2 (London: Routledge, 2001), p. 118. Edmund Husserl, *Logische Untersuchungen*, vol. 2.1: *Untersuchungen zur Phänomenologie und Theorie der Erkenntnis*, ed. Ursula Panzer, Husserliana, 14.1 (The Hague: Nijhoff, 1984), p. 424.

[118] Crary, *Suspensions of Perception*, p. 283.

[119] Husserl, *Logical Investigations*, vol. 2, p. 118; 'eine auszeichnende Funktion [...], die zu den Akten in dem oben präzisierten Sinne von *intentionalen* Erlebnissen gehört'. Husserl, *Logische Untersuchungen*, p. 423.

[120] Bernhard Waldenfels, *Phänomenologie der Aufmerksamkeit* (Frankfurt a.M.: Suhrkamp, 2004), pp. 25–6. Waldenfels describes Husserl's model of attention as 'egological' and 'egocentric'.

[121] Husserl, *Logische Untersuchungen*, p. 424.

[122] Husserl, *Logical Investigations*, vol. 2, pp. 118–19.

[123] Husserl, *Logical Investigations*, vol. 1, p. 274. 'Die sinngemäße Rede von der Aufmerksamkeit umfaßt die gesamte Sphäre des Denkens und nicht bloß die des Anschauens'. Husserl, *Logische Untersuchungen*, p. 167.

harks back to the eighteenth century; it counters a century of psychological experiments which had shown attention to be at the mercy of physiological and environmental factors such as fatigue and sensory overload. And yet his model is also very much a product of its time. By classifying attention as an intentional act, Husserl casts it as a bulwark against the dynamic and impossibly complex nature of modern life, where the subject is increasingly set adrift among a mêlée of stimuli, spectacles, and information.[124] Indeed, a similar impulse underpins the work of experimental psychologists. Wundt regarded intention and the will as central to all psychic process, and psychological experiments sought to stabilize attention by sealing off the laboratory from unwanted distractions, while the experimenter was tacitly assumed to be in charge or his or her own attention and rational faculties. As the following chapter will show, these practical and theoretical defences began to crumble around 1900, when the instability of attention became the subject of a heated debate involving sociologists and historians, engineers, psychiatrists, and psychoanalysts, who all tried to grapple with the challenges of a fragmenting modernity.

[124] See Crary, *Suspensions of Perception*, p. 285.

2
Modernity
Fragmentation and Resistance

Dynamic Attention

As we saw in the previous chapter, experimental psychology assessed attention under controlled conditions, exposing subjects to carefully measured doses of stimuli while seeking to shield them from random distractions. Alongside this quantitative approach, however, another perspective started to emerge: one which explored the mind in relation to its wider social and cultural context. This approach is central to Wundt's *Völkerpsychologie*; in *La Psychologie de l'attention* (The Psychology of Attention, 1888), the French psychologist Théodule-Armand Ribot applies it specifically to attention. The year his treatise was published, Ribot was appointed professor of psychology at the Sorbonne. The scope of his study, however, exceeds the remit of experimental psychology and is in fact rather critical of some of its premises and goals.

Ribot stresses that mind and body are closely interlinked, each mirroring and conditioning the other. Attention, he insists, is not a purely mental state, but 'essentially *motor*' in that it 'always acts upon the muscles, and through the muscles, mainly under the form of inhibition'.[1] In a state of rapt attention, the body's stillness reflects and facilitates the focus of the mind, stalling the fluidity of memories, thoughts, and impressions. Psychological experiments require this state of complete stillness, and yet by enforcing it they show it to be unsustainable, for eventually attention will collapse into 'a constantly increasing cloudiness of the mind, finally a kind of intellectual vacuity, frequently accompanied by vertigo'.[2] As Ribot elaborates, 'if we keep one of our eyes fixed upon any single point, after a while our vision becomes confused; a cloud is formed between the object and ourselves, and finally we see nothing at all'.[3]

The sustained, mono-focal kind of attention demanded of the subject in psychological experiments is thus 'an exceptional, abnormal state', which contradicts what Ribot declares to be the most 'basic condition of psychic life': movement and change.[4] To illustrate this idea, he gives the example of a watchmaker

[1] Théodule-Armand Ribot, *The Psychology of Attention*, 5th rev. edn [no translator] (Chicago, IL: Open Court Publishing Company, 1903), p. 2.
[2] Ribot, *Psychology*, p. 3. [3] Ribot, *Psychology*, p. 11. [4] Ribot, *Psychology*, p. 2.

who is investigating a faulty mechanism. This investigation has a concrete practical purpose; it is focused but not still, involving the movement of eyes and hands.[5] As he concludes from this example: 'totally suppress movements, and you totally suppress attention'.[6]

That said, Ribot does not dismiss all forms of voluntary attention. This faculty is the product of rigorous, sustained education, of the comprehensive 'training of mental-physical impulsion'.[7] It is essential for the formation of the autonomous, self-controlled subject and for society as a whole; indeed, attention is the ultimate hallmark of progress—'both effect and cause of civilization'.[8]

To train the mind is thus to train the body. Citing the British psychiatrist Henry Maudsley, Ribot notes that 'the person who is unable to control his own muscles is incapable of attention'.[9] One of the hallmarks of human civilization is work, specifically 'love of work, industry' as 'the concrete, the most manifest form of attention'.[10] Animals and primitive tribes are incapable of this, as are certain marginal groups within civilized society, such as 'vagabonds, professional thieves, and prostitutes'.[11] Here Ribot references the theories of the Italian criminologists around Cesare Lombroso, for whom such socially marginalized groups embody a modern form of atavism.

Ribot's *Psychology of Attention* is cited in Max Nordau's infamous treatise *Entartung* (Degeneration, 1892–3),[12] which dwells on attention extensively and almost obsessively, describing its voluntary variety as essential for 'morality, domination over the forces of nature', while the lack thereof is the root cause of 'all errors, all superstition'.[13] If attention becomes dispersed, mental processes can no longer be 'supervised and kept in check by attention' and hence become 'confused and aberrant'.[14] In this unchecked mental state, thoughts and impressions 'awaken and expire automatically, and the will does not intervene to enforce them'.[15] This lack of volitional input can lead to erroneous assumptions about reality, with the perceiving subject gaining at best a blurred and distorted image of the world.

Like Ribot, Nordau regards a lack of willpower and attention as the hallmark of the degenerate. The theory of degeneracy was first developed by the psychiatrist Bénédict Morel as a counterpoint to the Darwinist model of evolutionary progress; in this genealogy of mental decline, nervousness in the first generation leads to neurosis in the second, psychosis in the third, and imbecility in the fourth.[16] That

[5] Ribot, *Psychology*, p. 47. [6] Ribot, *Psychology*, p. 19. [7] Ribot, *Psychology*, p. 2.
[8] Ribot, *Psychology*, p. 36. [9] Ribot, *Psychology*, p. 2. [10] Ribot, *Psychology*, p. 37.
[11] Ribot, *Psychology*, p. 38.
[12] Max Nordau, *Entartung*, 3rd edn (Berlin: Duncker, 1896), pp. 97; 103.
[13] '[...] die Gesittung, die Herrschaft über die Naturkräfte'; 'aller Irrtümer, alle[s] Aberglaube[ns]'. Nordau, *Entartung*, p. 102.
[14] '[...] überwacht und gezügelt von der Aufmerksamkeit'; 'plan- und ziellos'.
[15] '[...] erwachen und erlöschen automatisch, und der Wille greift nicht ein, um sie zu verstärken'; Nordau, *Entartung*, p. 104.
[16] Joachim Radkau, *Das Zeitalter der Nervosität: Deutschland zwischen Bismarck und Hitler* (Munich: Propyläen, 2000), p. 180.

said, these groups are by no means the only people said to be afflicted by a pathological lack of voluntary attention, for these states were also observed in hysterics and, indeed, in the exhausted citizen.[17] Here, Nordau touches on a question which came to dominate social debates around 1900. Was a sustained lack of attention inherited (a sign of degeneracy) and hence inevitable, or could this state also be acquired (caused by environmental factors, for instance), afflicting previously healthy individuals? By referencing exhaustion and fatigue, Nordau taps into the period's deep anxieties about the unhealthy and unnatural character of modern life and its disastrous consequences for the health of the individual and the nation.

Modern Life: Fragmentation and Acceleration

Das moderne Leben ist insofern besonders unästhetisch, als es zu beständigen Störungen der geistigen Konzentration führt. Das ewige Hasten, der Pfiff der Lokomotive, das Klingeln der Straßenbahn, die ständige Überschwemmung mit Postsachen, der zudringliche Nachrichtendienst der Zeitungen, die steigende Zahl von persönlichen Berührungen bei ständig erhöhter Leichtigkeit des Personenverkehrs, dies und vieles andere legt vor allem den Wunsch nahe, dem Sklaventum des Augenblicks zu entfliehen: den Wunsch nach Ruhe im geistigen Genuß, ein stilles Sichversenken in ein Dasein, dessen festliche Stunden von keiner Roheit des Daseinskampfes gestört, dessen Summe dem freien Flug der Einbildungskraft gewidmet sein müsse.[18]

[Modern life is particularly non-aesthetic, for it permanently disturbs mental concentration. Perpetual haste, the whistling of the locomotive, the ringing of the tram, the constant deluge of letters, intrusive news reporting in the papers, the growing number of personal encounters, together with the ever-increasing superficiality of such interactions—all this and much more creates a yearning to escape from the slavery of the moment, a yearning for the peace of intellectual pleasures, for quiet immersion in an existence whose festive hours are not disturbed by the brute struggle for survival, and whose sum-total would be dedicated to the free flight of the imagination.]

Thus writes the Leipzig-based historian Karl Lamprecht in his 1902 history of recent Germany. His sketch is typical of a wide-spread lament about the constant

[17] Nordau, *Entartung*, pp. 104–5 and *passim*.
[18] Karl Lamprecht, *Deutsche Geschichte, Ergänzungsband 1: Zur jüngsten deutschen Vergangenheit*, vol. 1: *Tonkunst—Bildende Kunst—Dichtung—Weltanschauung* (Berlin: Gaertner, 1902), pp. 184–5.

rush and pressure of modern life—'das ewige Hasten' (perpetual haste), which is often used in the dual formulation 'das Hasten und Jagen' (rushing and chasing around). Another recurring idea is the social-Darwinist notion of *Daseinskampf*, of life as struggle, as the fight of all against all. Wilhelmine Germany was an entrepreneurial society driven by a mantra of economic and technological progress; work in this society was a moral imperative, a new, secular religion.[19] But this way of life came at a cost. Lamprecht describes the sensory and cognitive overload suffered by contemporaries, caused by modern work and transportation, by communication and the mass media. Indeed, his long and jumbled list of distractions resonantly reflects this chaotic environment.

These different factors all contributed to a way of life which contemporaries felt to be soulless and anonymous, hostile to pleasure, leisure, and reflection—a mode of existence which Lamprecht calls 'un-aesthetic'. To underline his critique he describes a different, more contemplative age in which the body is at rest and the mind free to soar up into the realms of the imagination. This kind of counter-narrative is very common in cultural-critical texts, which contrast modern life either with a bygone age or else with life in a rural community.[20] Lamprecht's text does not situate his idyll in a particular time or place, but simply floats it as a wishful fantasy which emerges from the culture of distraction.

Lamprecht belonged to a Leipzig discussion circle also attended by Wundt, and Wundt's writings deeply influenced his brand of cultural history, just as Wundt in turn used historical evidence to buttress his theory of individual mental development. As Lamprecht writes in his 1896 essay 'Was ist Kulturgeschichte?' (What is Cultural History?), 'everyone agrees that psychology must be the basis of all historical research'.[21]

Indeed, psychology also inflects the sociological perspective on modern society. In his seminal essay 'Die Großstädte und das Geistesleben' (The Metropolis and Mental Life, 1903), published one year after Lamprecht's recent German history, the sociologist Georg Simmel is one of the first to analyse the cognitive effects of the urban environment. The city causes, in his famous formulation, an

[19] See Michael Cowan, *Cult of the Will: Nervousness and German Modern Culture* (University Park, PA: Pennsylvania State University Press, 2008), p. 74.
[20] Michael Löwy has characterized the underlying sentiment of this discourse as 'Romantic anti-capitalism'. *Georg Lukács: From Romanticism to Bolshevism*, trans. Patrick Camiller (London: NLB, 1979), p. 23.
[21] '[E]inig ist man sich allerdings darin, dass die Psychologie die Grundlage aller Geschichtswissenschaft sein müsse'. Karl Lamprecht, 'Was ist Kulturgeschichte? Beitrag zu einer empirischen Historik', *Deutsche Zeitschrift für Geschichtswissenschaft*, Neue Folge, 1 (1896/97), 75–150 (p. 77). Like Wundt, Lamprecht was attacked from within his own discipline. In the so-called *Methodenstreit*, historians from the circle around Leopold von Ranke accused him of a lack of rigour, of giving insufficient attention to political and ideological developments. Both Wundt and Lamprecht shared a comprehensive perspective on the past, on the immanent, psychologically driven laws of cultural development. See Roger Chickering, *Karl Lamprecht: A German Academic Life (1856-1915)* (Atlantic Highlands, NJ: Humanities Press, 1993), p. 199.

'intensification of emotional life due to the swift and continuous shift of external and internal stimuli'.[22] The formation of perceptual habits is impossible in this fast-changing environment, where impressions can no longer be assimilated into long-term memory. Simmel contrasts this frantic, superficial existence with life in a rural community, which is centred on 'feelings and emotional relationships. These latter are rooted in the unconscious levels of the mind and develop most readily in the steady equilibrium of unbroken customs'.[23] Rural life is based on long-standing habits which have evolved over long periods of time and only change very gradually; they are rooted in the deeper, unconscious and emotional layer of the self, 'das Gemüt'. The city-dweller, in contrast, responds to the encountered impressions on a purely rational and hence superficial level, which prevents them being assimilated into a deeper sense of self.[24] This response can lead to 'Blasiertheit', an anaesthetized kind of detachment:

> Wie ein maßloses Genußleben blasiert macht, weil es die Nerven so lange zu ihren stärksten Reaktionen aufregt, bis sie schließlich überhaupt keine Reaktion mehr hergeben—so zwingen ihnen auch harmlosere Eindrücke durch die Raschheit und Gegensätzlichkeit ihres Wechsels so gewaltsame Antworten ab, reißen sie so brutal hin und her, daß sie ihre letzte Kraftreserve hergeben und, in dem gleichen Milieu verbleibend, keine Zeit haben, eine neue zu sammeln. Die so entstehende Unfähigkeit, auf neue Reize mit der ihnen angemessenen Energie zu reagieren, ist eben die Blasiertheit.[25]

> [Just as an immoderately sensuous life makes one blasé because it stimulates the nerves to their utmost reactivity until they finally can no longer produce any reaction at all, so, less harmful stimuli, through the rapidity and the contradictoriness of their shifts, force the nerves to make such violent responses, tear them so brutally that they exhaust their last reserves of strength and, remaining in the same milieu, do not have time for new reserves to form. This incapacity to react to new stimulations with the required amount of energy constitutes in fact that blasé attitude.[26]]

[22] Georg Simmel, 'The Metropolis and Mental Life', in *The Blackwell City Reader*, 2nd edn, ed. Gary Bridge and Sophie Watson (Chichester: Wiley-Blackwell, 2010), pp. 103–10 (p. 103); the '*Steigerung des Nervenlebens*, die aus dem raschen und ununterbrochenen Wechsel äußerer und innerer Eindrücke hervorgeht'. Georg Simmel, 'Die Großstädte und das Geistesleben', in *Gesamtausgabe*, ed. Otthein Rammstedt, vol. VII.1: *Aufsätze und Abhandlungen 1901–1908*, ed. Rüdiger Kramme, Angela Rammstedt, and Otthein Rammstedt (Frankfurt a.M.: Suhrkamp, 1995), pp. 116–31 (pp. 116–17).

[23] Simmel, 'The Metropolis', p. 104; 'das Gemüt und gefühlsmäßige Beziehungen [...]. Denn diese wurzeln in den unbewußteren Schichten der Seele und wachsen am ehesten an dem ruhigen Gleichmaß ununterbrochener Gewöhnungen'. Simmel, 'Die Großstädte', p. 117.

[24] Simmel's essay had a far-reaching impact on an entire generation of thinkers, including Siegfried Kracauer and Walter Benjamin, whose 'sociological turn' of the 1920s was inspired by his writings. See Howard Eiland and Michael W. Jennings, *Walter Benjamin: A Critical Life* (Cambridge, MA: Harvard University Press, 2014), p. 49.

[25] Simmel, 'Die Großstädte', p. 121. [26] Simmel, 'The Metropolis', pp. 105–6.

In the long run, Simmel argues, this defensive kind of indifference can turn pathological. One of its manifestation is 'the fear of coming into too close a contact with objects';[27] its flipside is a craving

> nach An- und Aufregungen, nach extremen Eindrücken, nach der größten Raschheit ihres Wechsels [...]; wodurch freilich eine augenblickliche Ablenkung von ihrer sachlichen Bedeutung, nach kurzem aber das alte Verhältnis, jetzt erschwert durch das gestiegene Maß seiner Elemente, eintritt.[28]
> [for excitement, for extreme impressions, for the greatest speed in its change [...]. The satisfaction of such cravings may bring about a temporary relief, but soon the former condition will be re-established, though made worse by the increased quantity of its elements.[29]]

Simmel's universalist narrative of urban experience largely ignores how this experience was 'stratified by social class, status, gender, and ethnicity, in other words, power relations'.[30] Lamprecht's narrative is similarly generalizing, its implied subject the middle-class, urban male entrepreneur. A closer look at the living and working conditions around 1900, however, uncovers a more complicated picture. Complaints about the growing mental strain of modernization were widespread, almost universal, but by no means uniform; in fact, this debate highlighted and heightened existing social divisions.

In his seminal study about the 'Age of Nervousness', Joachim Radkau explores how rapid social and technological modernization in German society around 1900 sparked great anxiety and manifested itself in a spate of nervous illnesses. Having lagged behind other industrial nations for decades, Wilhelmine Germany was

[27] Georg Simmel, *The Philosophy of Money*, trans. Tom Bottomore and David Frisby (London: Routledge, 2011), p. 515; 'die Furcht, in allzu nahe Berührung mit den Objekten zu kommen'. Georg Simmel, *Philosophie des Geldes* (Frankfurt a.M.: Suhrkamp, 1996), p. 661.
[28] Simmel, *Philosophie des Geldes*, p. 336. In 1896 Simmel describes a similar logic—the constant need for new and stronger stimuli as a remedy against over-stimulation—in his review of the Berlin Trade Exhibition: 'Hier ist die Fülle und Divergenz des Gebotenen, die als schließlichen Einheitspunkt und farbgebendes Charakteristikum nur das Amüsement bestehen läßt. Die nachbarliche Enge, in der die heterogensten Industrieprodukte gerückt sind, erzeugt eine Paralyse des Wahrnehmungsvermögens, eine wahre Hypnose, in der der einzelne Eindruck nur noch die obersten Schichten des Bewußtseins streift und schließlich nur die am häufigsten wiederholte Vorstellung als Sieger über den Leichen unzähliger würdigerer, aber in ihrer Zersplitterung schwacher Eindrücke im Gedächtnis zurückbleibt: die Vorstellung, daß man sich hier amüsieren soll'. Georg Simmel, 'Die Berliner Gewerbe-Ausstellung', in *Soziologische Ästhetik*, ed. Klaus Lichtblau (Bodenheim: Philo, 1998), pp. 71–5 (p. 71) ('In the face of the richness and diversity of what is offered, the only unifying and colourful factor is that of amusement. The way in which the most heterogeneous industrial products are crowded together in close proximity paralyses the senses—a veritable hypnosis where only one message gets through to one's consciousness: the idea that one is here to amuse oneself'. Georg Simmel, 'The Berlin Trade Exhibition', trans. Sam Whimster, *Theory, Culture & Society*, 8 (1991), 119–23 (p. 119)).
[29] Simmel, *Philosophy of Money*, p. 277.
[30] Judy Wajcman, *Pressed for Time: The Acceleration of Life in Digital Capitalism* (Chicago, IL: University of Chicago Press, 2014), p. 52.

keen to make up this disadvantage; the result was a huge push for innovation in the fields of industrial production, transport, media, and communication. As the prominent engineer Alois Riedler, who later became Rector of the Technical University in Berlin Charlottenburg, declared in 1899, the use of high speeds was a feature not only of transport but of 'all areas of technological production in the present'. Another engineer, Wilhelm Berdrow, concurs, predicting that 'increased speed in all technical companies will be the main motto of the twentieth century. As the regular telegraph [...] morphs into the speed telegraph [...] and a locomotive can be created from scratch within just a few days, so the entire field of technology and engineering is straining inexorably towards maximum performance'.[31]

The two domains singled out by Berdrow—transport and communication—underline his argument. In 1875 trains travelled at an average speed of 36 kilometres per hour, but by 1907 a German locomotive achieved a new record of 154.5 kilometres per hour. Increased speed, however, also meant increased technological complexity. The locomotive was the most sophisticated machine of the late nineteenth century, requiring great physical strength as well as alertness on the part of the operator. A similar picture emerges in the field of sea travel. In 1897 the German express liner *Kaiser Wilhelm the Great* broke the record for the fastest crossing of the Atlantic, requiring nearly four hundred people to operate the engine and boiler alone.[32]

These physical speeds were mirrored in the fields of media and communication. In 1901, the German postal service introduced the *Schnellschreibtelegraph*, a new, faster type of telegraph service. German newspapers, particularly the *B.Z. am Mittag* (Berlin Newspaper at Noon), the first street-market tabloid sold in Germany, aspired to be the fastest in the world, particularly in bringing its readers the latest news from the stock exchange. This ambition relied on the Linotype printing machine, invented in the 1880s by the German-American Ottmar Mergenthaler, which could produce an entire line of type at once, using a hot metal typesetting system, and thereby increased the speed of typesetting by a factor of five. As a result, typesetters had to read texts faster and memorize long sentences in order to maximize the Linotype machine's innate possibilities.[33]

The ever-increasing mental strains caused by new technology are particularly apparent in the field of telecommunication. By 1913 Germany had over a million phone lines, nearly five times as many as France, yet this increasingly complex system was still operated by human telephonists, who had to select the right number out of thousands of possible connections. When in 1902 Siemens opened a new telephone exchange in Berlin, the sheer call volume caused delays and misconnections, leading to angry callers and mass nervous breakdown on the part

[31] Cited in Radkau, *Das Zeitalter*, pp. 191-2. [32] Radkau, *Das Zeitalter*, pp. 193-4.
[33] Radkau, *Das Zeitalter*, pp. 226-7.

of the telephonists. With hindsight the shift to a fully automated telephone system seems the obvious solution, but this move was resisted by many contemporaries—for fear of mentally overloading the caller.[34]

The rollout of these new technologies coincided with a steep rise in nervous illnesses, which transcended the boundary between mind and body and manifested themselves in a range of debilitating psychological and physical symptoms. A key term in contemporary debates was nervousness, which denoted a state of constant tension, of excessive alertness and excitability caused by the speed and pressure of modern life. While nervousness could be temporary, many contemporaries felt that it had become the new norm, as they were unable to relax, unable to return to a detached and contemplative mindset. A satirical student song entitled 'Nervöses Zeitalter' (The Nervous Age, 1896) sums up this mood:

> Überall ein Rennen, Jagen nur nach Mammon, schnödem Geld;
> jeder möcht die erste Geige gerne spielen in der Welt.
> Hastges Treiben, hastge Miene, wildes Wogen und Getös!
> Und der Mensch wird zur Maschine und der zweite wird nervös![35]
>
> [Everywhere there's running, chasing after money, filthy lucre;
> everyone wants to play first fiddle in the world.
> Frantic bustle, frantic faces, mad commotion and mad noise!
> And so one man turns into a machine, and another into a nervous wreck!]

Repeating the familiar trope about the rush of modern life, the song suggests that the only remaining choice is between dehumanization and illness. If nervousness was sustained and extreme, it could turn pathological, could turn into neurasthenia, which around 1900 became one of the most talked-about conditions, a new *maladie du siècle*.

Neurasthenia

The medical literature about neurasthenia bears a striking resemblance to sociological and historical texts by authors such as Lamprecht and Simmel; indeed, medical treatises often launched into a wide-ranging cultural critique in their analysis of the condition's causes. At the same time, the neurasthenia debate was also inflected by contemporary psychology, its theories and practices, though it diverged from its assumptions in some significant ways.

[34] See Radkau, *Das Zeitalter*, pp. 193–4; 226–30.
[35] The song's lyrics are by Otto Hausmann, the melody was composed by L. Kreymann. *Allgemeines Deutsches Kommersbuch*, 55th edn (Lahr: Schauenburg, 1896), p. 661. The *Kommersbuch*, an anthology of student songs, was first published in 1858 and is still in print today.

The term 'neurasthenia' was first coined in the 1860s by George M. Beard, whose 1881 study *American Nervousness* made the condition known on both sides of the Atlantic. Neurasthenia was a paradoxical illness, involving restlessness and over-excitability, the inability to fend off the constant onslaught of stimuli, but also ennui, detachment, and fatigue. Beard regarded it as a specifically North American ailment, but European doctors were quick to recognize the condition in their own patients.[36]

What German and American treatises and textbooks have in common is their strategy to attribute the condition to an almost endless list of societal causes. In Beard's *American Nervousness*, for instance, the contributing factors range from technological inventions (train travel, the telegraph, the pocket watch) to general environmental factors such as noise.[37] In Germany, a similarly panoramic narrative unfolds in the lecture 'Ueber die wachsende Nervosität unserer Zeit' (On the Growing Nervousness of our Time), delivered in 1893 by the prominent Heidelberg neurologist Wilhelm Erb. Erb uses neurasthenia to take stock of the manifold problems of his age, while at the same time situating the current crisis in a wider historical context. Human history, he argues, is a succession of crises and upheavals, citing as examples the French Revolution and Napoleonic Wars. Even though they were succeeded by periods of relative stability, they have resulted in 'a reversal of the existing state of affairs so universal and powerful as it has barely ever been seen in world history over the millennia'.[38] Some of these upheavals are military and geopolitical in nature (Erb mentions the Franco-Prussian War), while scientific discoveries and technological innovations have profoundly changed societies and with them the 'nervous system' of entire populations.[39]

Erb concurs with other commentators when he emphasizes the entrepreneurial spirit of the young German state, in which every (male) citizen is encouraged to take part in the race to the top. In addition, Germany is also divided along ideological lines, racked by infighting between Protestants and Catholics, Christians and atheists, capitalists and socialists. In combination, he concludes, these social and technological factors all contribute to the phenomenon of 'our nervous age'.[40] So what features define this new age? While conceding that doctors, as well as patients, disagree about the finer details, Erb gives a long list of symptoms, which include constant restlessness, oversensitivity to stimuli, an

[36] In France, where neurasthenia produced a large number of scientific studies, the condition was initially associated with degeneracy and later became the remit of neurology, while in Great Britain it was principally seen as a somatic rather than a psychological illness. The condition gained the greatest prominence in Germany, a phenomenon which Radkau attributes to the respective speed of industrialization in these countries. *Das Zeitalter*, pp. 182–5.

[37] George M. Beard, *American Nervousness: Its Causes and Consequences* (New York, NY: Putnam's Sons, 1881), pp. 104–13.

[38] '[...] einer so vielumfassenden mächtigen Umwälzung der Verhältnisse, wie sie die Weltgeschichte in früheren Jahrtausenden noch kaum gesehen hat'. Wilhelm Erb, *Ueber die wachsende Nervosität unserer Zeit* (Heidelberg: Hörning, 1893), p. 5.

[39] Erb, *Nervosität*, p. 6. [40] Erb, *Nervosität*, p. 7.

inability to cope with minor obstacles and irritations, insomnia, and exhaustion, even after minor exertion. These symptoms, he stresses, are not in themselves pathological, for they can be observed in otherwise healthy, productive individuals. However, the boundary between a diffuse state of nervousness and nervous illness is fluid. When nervousness turns pathological, it can cause a functional neurosis, which severely impedes a person's ability to function without a discernible physiological cause.[41] Neurotic conditions include hysteria, hypochondria, and obsessive-compulsive disorders (so-called *Beschäftigungsneurosen*) as well as neurasthenia.[42] Neurasthenia is the most prominent of the functional neuroses, its sufferers flooding consultation rooms, mental hospitals, and sanatoriums. Its key symptoms are *Erschöpfbarkeit* (proneness to exhaustion), and the inability to focus on a (mental or physical) task in a sustained manner. A third characteristic is '*a heightened excitability* of the nervous system', whereby sufferers respond strongly even to minor stimuli.[43]

Malfunctioning attention thus lies at the heart of Erb's definition of neurasthenia. Neurasthenics are unable to block out stimuli, prone to over-react to the slightest excitement or distraction, and therefore unable to sustain concentration when faced with a particular task. His lecture recalls the psychological literature of the time, which often casts voluntary attention as the bedrock of productivity and personal autonomy, and which likewise fears that this faculty has come under particular threat, caused by a combination of environmental and hereditary factors, in the current age. Yet while writers such as Ribot and Nordau draw a categorical distinction between those capable of voluntary attention and those 'primitive' or 'degenerate' individuals who are not, Erb's is a more nuanced perspective. For him, the symptoms of neurasthenia are on a continuum with what can be considered normal reactions; all people, for instance, are exhausted after a long walk or a strenuous mental activity, but in neurasthenics this depletion comes about more quickly and lasts longer. Indeed, one way in which neurasthenia can manifest itself is as pathological fatigue, a state in turn linked to sufferers' heightened sensitivity and chronically dispersed attention.[44] Returning to his earlier historical perspective, Erb asks whether there are any precedents for this kind of nervous illness in previous periods, referring to times of decline and crisis, such as the final stage of the Roman Empire, the Crusades, and the Thirty

[41] Erb adds that a general state of nervousness can also make the sufferer more susceptible to physiological conditions such as diphtheria, influenza, syphilis, and tuberculosis, which in turn adversely affect the nervous system. *Nervosität*, pp. 8–9.
[42] In addition, he lists insomnia, epilepsy, and psychosis as possible manifestations. Erb, *Nervosität*, pp. 9–10.
[43] '[...] eine *gesteigerte Erregbarkeit* des Nervensystems'. Erb, *Nervosität*, pp. 10–11.
[44] Erb, *Nervosität*, pp. 11–12. On the prominence of fatigue in turn-of-the-century medical and sociological debates, see Anson Rabinbach, *The Human Motor: Energy, Fatigue, and the Origins of Modernity* (New York, NY: Basic Books, 1999).

Years War.⁴⁵ As he concludes, historical medical records contain no clear evidence that functional neuroses already existed in previous periods, and neurologists have only started to define neurasthenia as a separate illness in the past fifteen years—though literary texts written in the first half of the nineteenth century prefigured this medical consensus.⁴⁶

In line with the scientific orthodoxy of the time, which largely subscribed to Jean-Baptiste de Lamarck's theory of heredity, Erb highlights the congenital factors which underpin the condition, making particular individuals, groups, and cultures more susceptible to this state. Ultimately, however, neurasthenia is for Erb the combined product of nature and nurture, of inner predisposition and environmental factors, though ultimately he places more emphasis on the latter. For him, the principal cause is modern working life and its ethos of fierce competition. In this climate, people feel constantly threatened and overwhelmed, whether they are working in the law or the military, in journalism or the creative arts, in business, banking, or finance. Erb singles out those working in the financial sector, whose lives are fragmented by 'the rapidly increasing traffic, the hunt for wealth and profit [...], the excitements of playing the stock market, exhausting travel, and the like'.⁴⁷

Modern technologies of transport and communication feature prominently in Erb's lecture, where they are blamed for creating a climate of 'haste and excitement [...], the night used for travel, daytime for business transactions, and even "recreational trips" end up putting further strain on the nervous system'.⁴⁸ The resulting hyper-excitability does not only damage the individual but has also sparked a series of 'political, industrial, financial crises' and 'political, religious, social conflicts'.⁴⁹

As already hinted in the above-cited passages, the mental strains which characterize working life also extend to leisure and entertainment. As life becomes more and more frantic, people are unable to relax in their free time:

> Die erschlafften Nerven suchen ihre Erholung in gesteigerten Reizen, in stark gewürzten Genüssen, um dadurch noch mehr zu ermüden; die moderne Literatur [...] bringt pathologische Gestalten, psychopathisch-sexuelle,

⁴⁵ Texts about neurasthenia often cite previous periods as antecedents of the current crisis, a strategy designed to demonstrate the author's historical knowledge while enabling him or her to display a nonchalant attitude towards the current crisis. Even if these historical comparisons were often rather tenuous, they show that the 'modernity hypothesis'—the sense that the current crisis was unique to the modern age—was not uncontested among contemporaries. Radkau, *Das Zeitalter*, p. 175.

⁴⁶ Erb, *Nervosität*, p. 16.

⁴⁷ '[...] die rapid gesteigerten Verkehrverhältnisse, durch die Jagd nach Reichtum und Gewinn [...], durch die Aufregungen des Börsenspiels, durch ermüdende Reisen und dergleichen'. Erb, *Nervosität*, pp. 27–8.

⁴⁸ '[...] Hast und Aufregung [...], die Nacht wird zum Reisen, der Tag für die Geschäfte benützt, selbst die "Erholungsreisen" werden zu Strapazen für das Nervensystem'.

⁴⁹ '[...] politische, industrielle, finanzielle Krisen'; 'politische, religiöse, soziale Kämpfe'. Erb, *Nervosität*, p. 23.

revolutionäre und andere Probleme vor den Geist des Lesers; unser Ohr wird von einer in großen Dosen verabreichten, aufdringlichen und lärmenden Musik erregt und überreizt, die Theater nehmen alle Sinne mit ihren aufregenden Darstellungen gefangen; auch die bildenden Künste wenden sich mit Vorliebe dem Abstoßenden, Häßlichen und Aufregenden zu und scheuen sich nicht, auch das Gräßlichste, was die Wirklichkeit bietet, in abstoßender Realität vor unser Auge zu stellen.[50]

[The worn-out nerves seek respite in increasing stimulation, in strongly seasoned pleasures, only to grow even more tired; modern literature [...] features pathological characters, putting psychopathic-sexual, revolutionary, and other problems before the reader's mind; our ear is excited and overstimulated by a large dose of invasive and noisy music; the theatres captivate all senses with their stirring productions; even the visual arts revel in repulsive, ugly, and startling subject-matters, and don't shy away from putting the most horrifying features of reality before our eyes in repulsive vividness.]

Erb describes a vicious circle of sensory overload, in which an overburdened and exhausted population seeks out even *more* stimulation and excitement in their free time. Both high art and popular entertainment are seen to feed this addiction, their producers just as afflicted by the fatal combination of fatigue and restlessness as their audience; with minor variations, this narrative would remain constant until the Weimar Republic. Around 1900, this debate was spearheaded by medical professionals, particularly by neurologists and psychiatrists, often with transparent social and political aims. The young neurologist Willy Hellpach, for instance, used the nervousness diagnosis to launch a savage critique of both popular and high culture; modernist art and literature is widely labelled as 'impressionistic', as only interested in capturing fleeting subjective impressions at the expense of 'solidity and architectonic form', which had been the hallmark of previous (classical and realist) periods. The artists, like their audience, are caught up in the same crisis, both afflicted by a sense of powerlessness and passivity.[51]

While Erb makes space for historical comparisons, identifying precedents for the current situation in previous periods, he also employs the widely-used trope of a historical counter-narrative, when he contrasts modern life with 'the quieter, more contemplative lives of our ancestors', which were not mobile but stable and settled and therefore left space for 'Neigung und Muße', 'inclination and leisure'.[52]

But these idyllic days are gone for good (if they ever existed in the first place), and despite the wistfulness of his portrayal Erb does not actually want to return to them. In fact, he argues, many of the modern innovations are to be embraced. Communication technology has facilitated an 'unlimited expansion of traffic by

[50] Erb, *Nervosität*, pp. 23–4. [51] Cowan, *Cult of the Will*, p. 31.
[52] '[...] das stillere und beschaulichere Leben unserer Voreltern'. Erb, *Nervosität*, pp. 28–9.

means of a global telegraph and telephone networks',[53] while modern, speedy means of transport such as trains and steam ships enable the bridging of 'time and space [...] we are flying as fast as the wind across entire continents, we are speaking, directly or indirectly, with our antipodes'.[54] For all his emphasis on the strains of modern life, there is an underlying sense of optimism, excitement, and even euphoria which runs through Erb's lecture and lends it an almost futuristic dimension. While some of the described innovations are real, others stray into the realm of science fiction, for in 1893 both air travel and international phone calls were yet to become a reality.[55]

Erb's vision of modernity as an age of global connectivity is instilled with both the colonialist ambition of the Wilhelmine empire and its entrepreneurial spirit. In an age where 'the demands on the individual's capacities in the general struggle for existence' have risen exponentially,[56] human progress, and the success of the (German) nation, can only be maintained 'through great mental exertion', which requires people to summon all their available energy.[57] In contrast to Lamprecht, who uses *Daseinskampf* to bemoan this competitive climate, Erb turns this idea into a rallying cry to his fellow clinicians, calling on them to help turn the tide of modern nervousness. The task of the clinician is not to shelter patients from this environment, he argues, but to make them fit (again) for the challenges and opportunities of this brave new world.

Faced with its demands, however, many patients, as well as their doctors, pursued the opposite route. As Sigmund Freud astutely remarks, nervous illnesses offered the perfect escape strategy, enabling sufferers to withdraw from modern life: 'To-day neurosis takes the place of the monasteries which used to be the refuge of all whom life had disappointed or who felt too weak to face it' (*FSE* XI, 50).[58] So how, if at all, could neurasthenia be treated? This was a controversial issue, and competing methods evolved over time, in turn reflecting broader changes in social attitudes towards the affliction. Since neurasthenia was associated with a pathologically lowered sensory threshold and an inability to fend off stimuli, treatments initially took the form of 'rest cures', whereby sufferers were shielded from all stimulation. The American inventor of the rest cure, Weir Mitchell, however, instituted a change of direction when around 1900 he started to send out his male patients on 'rough-riding cures' designed to stimulate their bodies and minds,

[53] '[...] ins Ungemessene gesteigerten Verkehr, durch die weltumspannenden Drahtnetze des Telegraphen und Telephons'.
[54] '[...] Zeit und Raum [...], wir fliegen mit der Geschwindigkeit des Windes durch ganze Welttheile, wir sprechen direct oder indirect mit unsern Antipoden'. Erb, *Nervosität*, p. 6.
[55] Radkau, *Das Zeitalter*, p. 175.
[56] '[...] die Ansprüche an die Leistungsfähigkeit des Einzelnen im Kampfe um's Dasein'.
[57] '[...] durch große geistige Arbeit'. Erb, *Nervosität*, p. 23.
[58] 'Die Neurose vertritt in unserer Zeit das Kloster, in welches sich alle die Personen zurückzuziehen pflegen, die das Leben enttäuscht hat oder die sich für das Leben zu schwach fühlen' (*FGW* VIII, 54).

while continuing to prescribe the rest cure for his female patients.[59] In the early 1900s, a new, cognitive form of treatment emerged—the so-called 'will therapy', which aimed to strengthen patients' willpower and inner resolve to enable them to withstand the competing demands of everyday life. This process could be undertaken with professional help, but was also on offer in the form of self-help manuals such as Wilhelm Bergmann's *Selbstbefreiung aus nervösen Leiden* (Liberating Oneself from Nervous Illness, 1911).[60] As we will see in Chapter 5, in the Weimar Republic self-help literature branched out into new terrains such as concentration training as part of a more general programme of cognitive (self-) optimization.

Categorizing Neurasthenia: Gender, Race, and Class

The German neurasthenia debate, as we have seen, was a sounding board for deeply rooted anxieties about the effects of modernization. Treatises on the condition list a panoply of social, cultural, and technological factors, which are variously cast as the causes, and sometimes as the effects, of this age of nervousness. The neurasthenia debate also facilitates more general discussions about collective identity in relation to different groups and their relative (in)capacity to sustain attention, to process or fend off an onslaught of stimuli. In Germany, neurasthenia was, following Beard, initially defined as a white, male, middle-class condition afflicting intellectual professionals. With growing medical evidence this position became untenable; this 'democratization' of neurasthenia sparked a renewed debate about it being linked to factors such as gender, class, and race. The resulting theories reveal as much about the perspective and prejudices of the (medical) author as about the experience of the patient.

The most prominent social factor in the neurasthenia discourse was class and the associated factors of familial and educational background, of regional origins, and of manual versus intellectual professions. In casting white-collar professionals as the prime candidates for nervousness, medical writers echoed eighteenth-century treatises about the mental illnesses afflicting writers and scholars. The psychiatrist Richard von Krafft-Ebing singles out 'responsible, exciting, and exhausting' professions, which combine 'great mental exertion' with emotional strain; they include doctors, engineers, entrepreneurs, and stock brokers, but also artists, 'who are already intellectually and emotionally excited because of their

[59] Tom Lutz, *American Nervousness, 1903: An Anecdotal History* (Ithaca, NY: Cornell University Press, 1991), pp. 31–2. See also Radkau, *Das Zeitalter*, pp. 399–400.
[60] On will therapy, see Cowan, *Cult of the Will*, pp. 73–8.

profession, and who are constantly aware of their audience's applause or critique, of the envy and chicanery of their colleagues'.[61]

Increasingly, however, doctors were forced to adapt their theories in response to contrary evidence. As it turned out, for instance, factory workers and people from the countryside were just as susceptible, and Krafft-Ebing observes that nervous conditions are on the rise across society, reflecting the combined impact of environmental and hereditary factors.[62] Indeed, as awareness and clinical experience of the condition increased, the broad-brushstrokes categorisation of neurasthenia as a middle-class, male, urban condition became untenable. Psychiatrists such as Max Laehr, the clinical head of Haus Schönow, a Berlin psychiatric hospital for destitute patients, stressed that factory workers were as likely to suffer from chronic mental over-stimulation as their white-collar peers.[63] And while many commentators saw rural life as healthier, more leisurely and 'natural', than life in the city, nervous conditions were also on the rise among the country population, particularly among those who had moved from agricultural or craft-based professions to industrial labour. Freud emphasizes that people raised in 'simple, healthy, country conditions' are by no means immune to nervous illnesses;[64] on the contrary, they are susceptible particularly if they move from the countryside to the city in an attempt to forge a better life for their children.

As women started to enter the workforce in larger numbers in the late nineteenth century, some of the most pressurized professions attracted many female workers. Apart from the abovementioned example of telephonists, these also included weavers, who were working at increasingly sophisticated mechanical, electrically powered looms.[65] Among the intellectual professions, teachers were seen as particularly vulnerable to nervous illnesses. A senior teacher described the permanent attentional strain faced by colleagues who had to teach in overcrowded classrooms and were forced to divide their attention between their pupils and the ever-expanding syllabus, arguing that the resulting mental pressure far exceeded that faced by regular office workers.[66] As a consequence, female teachers as well as governesses were seen as being at heightened risk of developing neurasthenia or hysteria. The psychiatrist Carl Wernicke declares in 1900 that 'a female teacher who isn't hysterical is the exception'.[67]

While this contemporary, male-dominated discourse about neurasthenia among working women revealed a degree of genuine concern, it was also driven by stubborn prejudices about women's innate (in)capacities, which were backed

[61] '[...] die durch ihren Beruf geistig und gemüthlich ohnehin beständig erregt und des Beifalls oder Tadels des Publicums, des Neids und der Chicanen ihrer Collegen gewärtig sind'. Richard von Krafft-Ebing, *Nervosität und neurasthenische Zustände* (Vienna: Hölder, 1895), p. 57.
[62] Krafft-Ebing, *Nervosität*, pp. 58–9. [63] Radkau, *Das Zeitalter*, p. 219.
[64] *FSE* IX, 182; '[...] aus einfachen und gesunden ländlichen Verhältnissen' (*FGW* VII, 145).
[65] Radkau, *Das Zeitalter*, pp. 230–1. [66] Radkau, *Das Zeitalter*, p. 216.
[67] Cited in Radkau, *Das Zeitalter*, p. 216.

up by spurious medical evidence. Indeed, Krafft-Ebing held the women's emancipation movement directly responsible for the rise in nervous illness among women,[68] while other commentators regarded excessively strenuous study and stressful exams as the root cause of the problem in teachers in particular, arguing that women were mentally and physiologically unfit to withstand such intellectual pressure.[69] This argument is made most infamously in Paul Julius Möbius's essay *Ueber den physiologischen Schwachsinn des Weibes* (On the Physiological Idiocy of Woman, 1900). While girls and women make diligent and attentive students, he concedes, they are incapable of sustained, long-term attention, incapable of synthesizing the acquired knowledge and drawing their own independent conclusions. This inability, he notes, 'is rooted [...] not in what they can do, but in what they want to do',[70] for women are only interested in things that concern them personally and are unable to pursue matters for their own sake. Talking about neurasthenia, which he had discussed in a previous book, Möbius fears that the modern nervousness epidemic risks blurring the 'natural' gender differences, producing 'effeminate men and mannish women'.[71]

Such misogynist arguments often intermingled with racist, particularly anti-Semitic tropes. Jewish men were often cast as weak and effeminate; in the contemporary medical literature, they were also seen as particularly susceptible to hysteria, neurasthenia, and other nervous illnesses.[72] Some commentators, however, adopted a more detached, meta-theoretical perspective. In an 1890 lecture the neurologist G. F. Wachsmuth describes anti-Semitism as a result and symptom of nervousness,[73] an argument echoed by Nordau, who writes that, following the seismic shifts caused by industrialization, war, and unification, 'the German hysteria manifests itself in anti-Semitism, that most dangerous form of persecution mania'.[74]

[68] Richard von Krafft-Ebing, *Über gesunde und kranke Nerven* (Tübingen: Laupp, 1885), p. 56.

[69] That said, other commentators, such as the Braunschweig neurologist Ralf Wichmann, shifted the debate to social factors. A comprehensive survey he carried out among teachers revealed that women teachers worked longer hours and were less well paid than their male colleagues, as their degree only qualified them to teach at primary level and in the lower classes of girls' secondary schools, while the more prestigious and better paid teaching positions at boys' schools and in the higher years of girls' secondary schools were the preserve of men. It was only in 1894, following a political campaign, that women were allowed to sit the examination for senior teaching posts. Karen Nolte, *Gelebte Hysterie: Erfahrung, Eigensinn und psychiatrische Diskurse im Anstaltsalltag um 1900* (Frankfurt a.M.: Campus, 2003), p. 232.

[70] '[...] liegt [...] nicht am Können sondern am Wollen'. Paul Julius Möbius, *Ueber den physiologischen Schwachsinn des Weibes* (Halle/Saale: Marhold, 1900), p. 11.

[71] '[...] weibische Männer und männische Weiber'. Möbius, *Schwachsinn*, p. 18.

[72] As Sander Gilman notes, Freud encountered this argument during his study with Charcot. Medical handbooks of the time commonly associated 'the Jew's potential mental illness with the visible signs of degeneracy'. Sander Gilman, *Freud, Race, and Gender* (Princeton, NJ: Princeton University Press, 1992), p. 95.

[73] See Cowan, *Cult of the Will*, p. 271.

[74] 'Die deutsche Hysterie gibt sich im Antisemitismus kund, dieser gefährlichsten Form des Verfolgungswahnsinns'. Nordau, *Entartung*, p. 372.

An interesting contribution to the nervousness debate, which expands on the links between nervousness, ideology, and mass psychology, is Willy Hellpach's *Nervosität und Kultur* (Nervousness and Culture, 1902). Hellpach had studied psychology with Wundt while simultaneously pursuing a degree in medicine, and he subsequently completed doctoral theses in both subjects. Following Wundt's recommendation, he worked with the renowned psychiatrist Emil Kraepelin in Heidelberg.[75] His publications on neurasthenia reflect his earlier disillusionment with the socialist workers' movement; in them he revives some, by then mostly discarded, stereotypes about factory workers being more likely to suffer from hysteria, a condition stoked by the 'rumorende Monotonie' ('fermenting monotony') of factory work.[76] As he concedes, though, the determining cause of nervous illness is neither environmental nor constitutional but behavioural—nervous illness is the product of people's habits and choices. Commenting on pressurized modern working conditions, particularly among urban white-collar workers, Hellpach notes that complete rest is the only truly effective antidote, the only route to recovery. In a vicious circle, however, exhaustion makes people unable to rest after they finish work, for the entrepreneurial spirit of the age drives them from the desk to the tennis court and back again. Though their bodies may be 'slender, sinewy, and free from haemorrhoids', the nerves of such incurable busybodies will be more damaged than those of a colleague 'who after work stretches out on his chaise-longue'.[77] And yet people of all walks of life, employers as well as employees, actively *flee* the prospect of doing nothing by plunging themselves into ever more stimulating pastimes:

das Kennzeichnende, das alle diese Zerstreuungen umgreift, ist die Flucht aus dem Hause. Nur nicht in den gewöhnten Räumen bleiben, wo die Gefühle so leicht zur täglichen Sorge zurückeilen! Neue Eindrücke, die recht gefangen nehmen, recht ablenken, die gewaltsam eine andere Stimmung uns einimpfen: Konzerte, Theater, Varieté, Vorträge, Jeu, Vereinsgeschäfte.[78]

[characteristic of all these distractions is the flight from our home. Anything but stay in our own four walls, where our feelings tend to return to the worries of the day! Instead we go out in search of new impressions that can captivate us, distract

[75] During the Weimar Republic Hellpach embarked on a political career, first as the President of the state of Baden and then, in 1928–20, as a member of the German Reichstag for the left-liberal German Democratic Party (DDP).
[76] Cited in Radkau, *Das Zeitalter*, p. 219.
[77] '[...] schlank, sehnig und hämorrhoidenlos'; 'der sich nach gethaner Mühe auf die Chaiselogue streckt'. Willy Hellpach, *Nervosität und Kultur* (Berlin: Räde, 1902), p. 88.
[78] Hellpach, *Nervosität*, pp. 89–90. That said, not all cities are equally pathogenic; Hellpach contrasts northern and southern Germany, claiming that the inhabitants of Munich, Stuttgart, Strasbourg, and Heidelberg lead more leisurely lives than their counterparts in Berlin, Hanover, and Hamburg. Hellpach, *Nervosität*, pp. 90–1.

us, forcibly inject us with a different mood: concerts, theatre, variety shows, lectures, gambling, clubs and societies.]

Hellpach's theory of neurasthenia is influenced by Lamprecht's cultural history. A key word coined by Lamprecht is *Reizsamkeit*, excessive excitability or sensitivity towards stimuli. For Hellpach, this manifests itself as an 'infinitely increased sensitivity to the stimuli which constantly intrude upon us', which in turn makes us 'react to the subtlest stirrings in the psyche of fellow human beings'.[79] Echoing Erb, Hellpach notes that heightened sensitivity to stimuli is not a pathological condition in itself, but only *turns* pathological when it is accompanied by 'unmotivated mood changes' and the 'excessive contrasts of emotion'—and when sufferers do not take the necessary rest to aid their recovery.[80]

Based on Lamprecht's notion of *Reizsamkeit*, Hellpach coins his own antonym: *Lenksamkeit*, guidability or suggestibility. This is a natural state in young children, who are not yet capable of thinking for themselves; in adults, it can be observed in hysterics and neurasthenics, but is also becoming increasingly common and widespread in a population addicted to perpetual stimulation and distraction. *Lenksamkeit*, however, paves the way for totalitarianism and fanaticism: 'On every page of its chronicle the age of suggestibility offers us the spectacle of masses which have become fanatical to the point of madness'.[81] In their respective fields, both Lamprecht and Hellpach discern a global 'demise of the liberal optimism' which had characterized previous decades, and which has now given way to a climate of collective anxiety, even fatalism, caused by the sheer speed of social and technological change, and exacerbated by the unpredictability of the economic situation, particularly after the stock market crash of 1873.[82]

In the history of attention, neurasthenia plays an important role, both as a precursor of conditions such as ADHD and as a discursive phenomenon, which crystallized widely shared anxieties about modernity, its effects on the human mind and on society. Radkau calls the medical literature about neurasthenia a 'bourgeois literary genre';[83] the abovementioned texts can certainly be read as the expression of middle-class (male) anxieties about a changing society. Just as neurasthenia sufferers tried to withdraw from society, as Freud puts it, into the sheltered space of illness, these medical commentators sought refuge in the echo

[79] '[...] die unendlich gesteigerte Anteilnahme an den auf uns eindringenden Reizen [...], das Reagieren auf die leisesten Regungen in der Psyche des Mitmenschen'. Hellpach, *Nervosität*, p. 17.
[80] '[...] unbegründeten Stimmungswechseln'; 'überspannte Gefühlskontraste'. Hellpach, *Nervosität*, p. 17.
[81] 'Das Zeitalter der Lenksamkeit bietet uns auf jeder Seite ihrer Chronik das Schauspiel bis zum Wahnwitz fanatisierter Massen'. Hellpach, *Nervosität*, p. 10. The nervousness discourse was politicized from early on. In *Die Frau und der Sozialismus* (Women and Socialism, 1879), the social democrat August Bebel argues that nervousness is the product of social, rather than economic, work-related, acceleration, but Marxist Franz Mehring regards it as the result of capitalist production. See Radkau, *Das Zeitalter*, p. 221.
[82] Cowan, *Cult of the Will*, p. 29. [83] Radkau, *Das Zeitalter*, p. 219.

chamber of a debate which reflected authors' prejudices about gender, race, and class—even as the medical evidence challenged these preconceptions.

Compared to the psychological literature of the time, which largely ignored the wider societal context, texts about neurasthenia were almost obsessively concerned with the link between illness and society. The neurasthenia discourse is a curious hybrid of imagination and reality, but it is also a strikingly transdisciplinary project, which resonates across medicine, psychology, history, and sociology, presenting a medical phenomenon in a narrative form and situating the current crisis within a longer historical context. These sweeping narratives run contrary to a more targeted, scientifically rigorous analysis of specific causes. In most neurasthenia texts, the analysis of the condition morphed into an 'unselective cultural-critical panopticon', whose 'potpourri of potential causes' would have been off-putting to more analytically minded thinkers.[84] One figure who reacted against this scatter-gun approach, and who deemed environmental to be secondary when compared to a patient's personal history, was Sigmund Freud.

Freud: Beyond Attention

In his 1908 essay 'Die "kulturelle" Sexualmoral und die moderne Nervosität' (The 'Cultural' Sexual Morality and Modern Nervousness), Freud cites from three major neurasthenia studies of the previous decade: Erb's 1893 lecture 'On the Growing Nervousness of our Time', Krafft-Ebing's *Nervosität und neurasthenische Zustände* (Nervousness and Neurasthenic States, 1895), and Otto Binswanger's *Die Pathologie und Therapie der Neurasthenia* (The Pathology and Therapy of Neurasthenia, 1896). Though his three extracts differ in length—the quotation from Erb's lecture is the longest, taking up three paragraphs—they summarize the core claims of the debate, namely that the daily 'struggle for existence' or 'Kampf ums Dasein',[85] combined with the 'unbridled pursuit of money and possessions',[86] are responsible for a sharp rise in nervous illness. Freud does not completely dismiss the 'modernity hypothesis' expressed in these texts out of hand; rather than 'erroneous' (*irrtümlich*), he deems it inadequate (*unzulänglich*), for its long list of environmental causes leaves out the most important one: 'the harmful suppression of the sexual life of civilized peoples (or classes) through the "civilized" sexual morality prevalent in them' (*FSE* IX, 185).[87]

Like many of his contemporaries, Freud is interested in the difference between nature and nurture, and specifically in the impact of social codes and conventions

[84] Radkau, *Das Zeitalter*, p. 176. [85] *FGW* VII, 145/*FSE* IX, 183; this is Freud quoting Erb.
[86] *FSE* IX, 184; the 'ungezügelte Hasten und Jagen nach Geld und Besitz' (*FGW* VII, 147).
[87] '[...] die schädliche Unterdrückung des Sexuallebens der Kulturvölker (oder Schichten) durch die bei ihnen herrschende "kulturelle" Sexualmoral' (*FGW* VII, 148).

on human sexual behaviour. The theorist whom he gives pride of place is no psychiatrist but the philosopher and psychologist Christian von Ehrenfels, a pupil of Franz Brentano and one of the founders of Gestalt psychology. In his *Sexualethik* (Sexual Ethics, 1907), Ehrenfels critiques the Western dictum of monogamy for its adverse effects on individual and collective well-being. Marital monogamy, he argues, impedes the natural process of sexual competition and '*virile selection*', whereby the strongest male asserts himself over his rivals (*FGW* VII, 144). Freud's own focus is on the link between sexual morality and neurosis. Civilized society expects its members to suppress and redirect their libidinal energy for the sake of the common good; this mechanism of repression is one of the corner stones of bourgeois society, but also the breeding ground for neurosis. The modern city reveals the unintended side-effects of this repressive culture, for it is a space where sexual perversions can thrive.[88] Freud distinguishes between two forms of nervous illness: common or 'toxic' neurosis, which usually manifests itself as neurasthenia and is caused by damaging experiences in the patient's sexual history, such as masturbation; and psychogenic neurosis (*Psychoneurose*), which manifests itself as hysteria or compulsive disorder (*Zwangsneurose*); the latter has a hereditary component, but is triggered by sexual repression, specifically, by enforced abstinence or *coitus interruptus*. Both neuroses, then, are caused by social conventions, which prescribe abstinence and demand the repression or re-channelling of sexual urges. Neurotic symptoms, in turn, are a form of vicarious satisfaction, the 'negative' or inverse of sexual perversion (*FGW* VII, 154).

Freud's 'repression hypothesis' marks an important moment in the discourse about neurasthenia, for it shifts the focus away from external, environmental factors and towards a patient's personal history and inner psychological dynamics. In a short essay of 1911, Freud introduces two terms which will play a pivotal role in his thought: the pleasure principle and the reality principle, the two opposing impulses which determine psychic life and whose imbalance can cause severe nervous illness.[89] For Freud, social structures and individual psychological dynamics inflect each other, and both the individual mind and human achievements, from art to law and religion, are products of repression and compulsion. As he writes in *Totem und Tabu* (Totem and Taboo, 1913),

> Die Neurosen zeigen einerseits auffällige und tiefreichende Übereinstimmungen mit den großen sozialen Produktionen der Kunst, der Religion und der Philosophie, andererseits erscheinen sie wie Verzerrungen derselben. Man könnte den Ausspruch wagen, eine Hysterie sei ein Zerrbild einer Kunstschöpfung, eine Zwangsneurose ein Zerrbild einer Religion, ein paranoischer Wahn ein Zerrbild eines philosophischen Systems. (*FGW* IX, 91)

[88] Peter-André Alt, *Sigmund Freud: Der Arzt der Moderne* (Munich: Beck, 2016), p. 410.
[89] See *FGW* VIII, 233–4; *FSE* XII, 221–2.

[The neuroses exhibit on the one hand striking and far-reaching points of agreement with those great social institutions, art, religion and philosophy. But on the other hand they seem like distortions of them. It might be maintained that a case of hysteria is a caricature of a work of art, that an obsessional neurosis is a caricature of a religion and that a paranoic delusion is a caricature of a philosophical system. (*FSE* XIII, 73)]

In Freud's theoretical edifice, where culture and psyche are closely intertwined, attention features only in a marginal capacity, in marked contrast to the prominence of the term in contemporary psychology. For Freud, the key tension governing the mind is not that between involuntary and voluntary attention, or between attention and distraction, but rather between consciousness and the unconscious—though his later conceptual pairing of the ego and the id also echoes psychological theories, such as Wundt's, which cast volition as the bulwark against instinct and impulse. For Freud, voluntary attention is a product of consciousness; given that human behaviour is underpinned, at all times, by unconscious motivations which are inaccessible to the rational mind, attention alone cannot enable the individual to exert control over her thoughts and actions.

In fact, in some situations paying deliberate attention can have the adverse effect, causing self-consciousness and impeding otherwise habitual behaviour. This process is recorded in one of Freud's earliest case studies, his 1886 'Beobachtungen einer hochgradigen Hemianästhesie bei einem hysterischen Manne' (Observations about a Severe Case of Hemi-Anaesthesia in a Hysterical Man), written soon after his return from Paris, where he had studied with Jean-Martin Charcot. If neurasthenia manifests itself as excessive sensitivity to stimuli, hysteria presents the opposite problem, namely a state of extremely reduced attention, in which patients are unaware of their immediate surroundings and even of their own bodies.

In his study *L'automatisme psychologique* (The Psychological Automatism, 1889), Charcot's associate Pierre Janet describes hysteria as a condition of split consciousness, or *désagrégation*. Hysterical patients experience states of anaesthesia, in which they are oblivious of their actions or surroundings. For Janet, hysterics are 'systematically distracted', their attention hard to arrest and impossible to direct towards a particular focal point.[90] While split consciousness was seen as a prime characteristic of hysteria, Janet argued that a milder version of it was in fact part of the normal fluctuations of awareness in healthy people: 'The manifestations of distraction in healthy people are equivalent to those in hysterical

[90] Pierre Janet, *Der Geisteszustand der Hysterischen (Die psychischen Stigmata)* (Leipzig: Deuticke, 1894), p. 21. Cited in Petra Löffler, 'Schwindel, Hysterie, Zerstreuung: Zur Archäologie massenmedialer Wirkungen', in *Trancemedien und neue Medien um 1900: Ein anderer Blick auf die Moderne*, ed. Marcus Hahn and Erhard Schüttpelz (Bielefeld: Transcript, 2009), pp. 375–401 (p. 390).

anaesthesia'.[91] Distraction, then, interlinks the different parts of the psychological spectrum, ranging from a healthy, functional mind all the way to almost complete oblivion.

In his 1886 case study, however, Freud pursues a different route. He focuses not on the effects of attentional deficiency but, on the contrary, on attention's impeding effects, its capacity to exacerbate his patient's symptoms. For in fact, the young man's hysterical paralysis varies greatly depending on how much attention he pays to his actions. He struggles when Freud asks him to perform particular movements, in particular when these actions do not have an inherent goal or purpose. The strongest inhibitions occur when he has to perform these movements with his eyes closed, that is, when his attention is fully directed at his own body, without external distractions. In contrast, these inhibitions disappear almost completely when his attention is drawn *away* from his bodily performance and instead focused on a goal beyond himself. Thus, his gait is almost unimpeded when he is out in the street, whereas he struggles to do even a few steps when instructed to walk by his doctor (*FGW* XIX, 62-3).

Freud's argument is echoed in an article published in the same year by the Marburg-based psychiatrist Franz Tuczek. Describing the case of a girl suffering from hysterical symptoms, he stresses the fruitlessness

> forcierter Kurversuche. Uebermässige Anspannung des Willenskraft, jeder Zwang [...] beständiger Concentracion der Aufmerksamkeit auf das Krankheitssymptom [...] wirkt verderblich [...]. Es ist eine allgemeine Eigenthümlichkeit vieler hysterischer Erscheinungen, dass sie bei Ablenkung der Aufmerksamkeit verschwinden.[92]
>
> [of enforced attempted treatments. Excessive straining of willpower, any compulsion [...] perpetually to focus one's attention on the symptom of one's illness [...] are detrimental [...]. It is a universal feature of many hysterical symptoms that they disappear once the attention is diverted from them.]

Tuczek rejects the idea that nervous illness stems from a lack of voluntary attention, and that it can be cured through the application of enforced self-scrutiny. Echoing Freud, he associates self-scrutiny with self-consciousness; in order to recover, patients need to (be allowed to) let go of this impulse, encouraged to let their attention be diverted to matters beyond themselves.

Though Freud's early case study predates his core psychoanalytic theories, it nonetheless anticipates the future direction of his thought on attention. At different points in his writings, Freud displays a sceptical, sometimes an outright

[91] Janet, *Geisteszustand*, p. 30. Cited in Löffler, 'Schwindel', p. 390.
[92] Franz Tuczek, 'Zur Lehre von der Hysterie der Kinder', *Berliner klinische Wochenschrift*, 23 (1886), 511-15; 534-7 (p. 537). Cited in Nolte, *Gelebte Hysterie*, p. 126.

critical, attitude towards voluntary attention, a state widely held to be the bedrock of the mature, autonomous self. This scepticism manifests itself in a number of contexts, ranging from trauma and the method of the talking cure all the way to the everyday phenomena of mental life.

Slippages of Attention

The latter are the focus of Freud's seminal 1905 study *Die Psychopathologie des Alltagslebens* (The Psychopathology of Everyday Life), which he regarded as one of his most successful books.[93] By 1919, it had reached its sixth edition, by 1924 its tenth, and Freud kept adding new material to successive editions.[94] This text exemplifies one of Freud's core missions, namely to draw his readers' attention away from sensational forms of mental illness towards ordinary and seemingly trivial psychical phenomena. In this regard, *Psychopathology* continues the project of *Die Traumdeutung* (The Interpretation of Dreams, 1900). What dreams and Freudian slips have in common is the fact that in both cases the controlling influence of the conscious mind is temporally disabled, allowing the workings of the unconscious to come to the fore.

The importance which Freud accorded parapraxis can be seen in the fact that he returned to this topic in the two opening lectures of his *Vorlesungen zur Einführung in die Psychoanalyse* (Introductory Lectures on Psychoanalysis), delivered in Vienna in the winter semesters 1915–16 and 1916–17 as the conclusion of his lecturing career. As he notes in his preface to the printed edition, the lectures depart from the 'kühle Ruhe', or 'unruffled calm', expected of a scientific treatise; 'on the contrary, the lecturer has to make it his business to prevent his audience's attention from lapsing during a session lasting for almost two hours' (*FSE* XV, 9).[95] This aim of grabbing and sustaining his listeners' attention is apparent throughout the lectures. Freud uses various rhetorical techniques, most notably that of entering into a (virtual) dialogue with his audience by anticipating or voicing their reactions and concerns.

Freud's decision to make parapraxis the subject of his opening lectures fits this overall agenda, although at first sight this entry point into the subject matter may seem more like a handicap. Parapraxes are instances of *Versprechen, Vergessen, Verlieren*, and *Verlegen*—of memory, speech, and actions gone awry. The common prefix '*Ver-*' suggests some kind of mishap or malfunction also indicated by

[93] Letter to Lou Andreas-Salomé. Sigmund Freud and Lou Andreas-Salomé, *Briefwechsel*, ed. Ernst Pfeiffer (Frankfurt a.M.: Fischer, 1966), p. 57.
[94] Alt, *Sigmund Freud*, p. 322.
[95] '[...] vielmehr muß sich der Redner zur Aufgabe machen, die Aufmerksamkeit der Zuhörer während eines fast zweistündigen Vortrags nicht erlahmen zu lassen' (*FGW* XI, 3).

the German term for parapraxis, *Fehlleistung*.[96] Though such experiences, when we temporarily lose control over our words and actions, can be mortifying, in essence they are trivial occurrences which do not seem to merit detailed analysis. In his opening lecture, Freud addresses this objection, summarizing the common view that the vast majority of *Fehlleistungen* are 'without much significance in human life. Only rarely does one of them, such as losing an object, attain some degree of practical importance. For that reason, too, they attract little attention' (*FSE* XV, 26).[97] Here Freud uses a well-established trope employed by literary predecessors such as Barthold Heinrich Brockes, Jakob and Wilhelm Grimm, and Adalbert Stifter, all of whom seek to draw the reader's attention to small, seemingly unimportant phenomena of everyday human and natural life.[98]

In the opening part of his lecture, Freud thus tries to convert those listeners who deem *Fehlleistungen* a trivial subject when compared to the great mysteries of world and mind. Using the analogy of a police detective, who must secure even the 'slight and obscure traces' left by the criminal,[99] Freud confidently declares that the best and most fruitful material for psychoanalytic observation is provided by those 'inconsiderable events which have been put aside by the other sciences as being too unimportant—the dregs, one might say, of the world of phenomena' (*FSE* XV, 27).[100] In psychology, as in the natural sciences, seemingly minor phenomena are often the gateway to major discoveries, for 'everything is related to everything' (*FSE* XV, 27).[101]

In the lectures' introduction, attention features in a mainly rhetorical capacity, but then it becomes a focus of Freud's main argument, where he embarks on his analysis of parapraxis and how this phenomenon comes about. Here, Freud cites a widely held view, namely that such slips are caused by a momentary dip in attention—by 'small failures of functioning, imperfections in mental activity' (*FSE* XV, 28)[102]—which can occur when a person is tired, unwell, nervous, or

[96] *Fehlleistung* is a much more straightforward and accessible term than James Strachey's choice of the Greek 'parapraxis' in the *English Standard Edition*.

[97] '[...] ohne viel Bedeutung im Leben der Menschen. Nur selten erhebt sich eines davon wie das Verlieren von Gegenständen zu einer gewissen praktischen Wichtigkeit. Sie finden darum auch nicht viel Aufmerksamkeit' (*FGW* XI, 19).

[98] On Brockes's poetry collection *Irdisches Vergnügen in Gott* (Worldly Pleasure in God, 1721–48), see Chapter 1, pp. 21–3. His meticulous descriptions of natural phenomena were dismissed as trivial by some of his contemporaries, a charge also levelled against Jakob and Wilhelm Grimm, whose 'Andacht zum Unbedeutenden' ('devotion to the insignificant') was deemed futile by the art historian Sulpiz Boisserée in a letter to Goethe. Letter of 27 October 1815. Sulpiz Boisserée, *Briefwechsel, Tagebücher*, vol. 2: *Briefwechsel mit Goethe*, ed. Mathilde Boisserée (Stuttgart: Cotta, 1862), p. 72. A defence of this practice of paying attention to small things and the ordinary phenomena of everyday life is mounted by the Austrian writer Stifter in the preface to his novella collection *Bunte Steine* (Colourful Stones, 1853).

[99] '[...] schwächeren und undeutlicheren Spuren'.

[100] '[...] jene unscheinbaren Vorkommnisse, die von den anderen Wissenschaften als allzu geringfügig beiseite geworfen werden, sozusagen der Abhub der Erscheinungswelt' (*FGW* XI, 20).

[101] '[A]lles [ist] mit allem verknüpft' (*FGW* XI, 20).

[102] '[...] kleine Entgleisungen der Funktion, Ungenauigkeiten der seelischen Leistung' (*FGW* XI, 21).

distracted. Freud scrutinizes this hypothesis in some detail, first by differentiating between purely physical causes, such as nausea and circulatory problems, and psycho-physiological factors such as 'excitement, fatigue and distraction', 'which may result in insufficient attention being directed to the function in question' (*FSE* XV, 29).[103] Yet ultimately this 'Aufmerksamkeitstheorie der Fehlleistungen', or 'attention theory of parapraxes', is insufficient; crucially, slippages also occur in people whose attention is not depleted by tiredness or distraction. As he stresses, even if we give a task—such as an important speech—our full and undivided attention, this by no means guarantees that we are able to execute it without errors; in fact, the opposite is often the case. Freud tells several entertaining stories about people who make embarrassing slips of the tongue in situations where they are desperate to avoid them,[104] and describes situations 'in which the parapraxes multiply, form chains, and replace one another' (*FSE* XV, 30).[105]

This, however, is only one side of the coin. Conversely, there are many actions 'that one carries out purely automatically, with very little attention, but nevertheless performs with complete security' (*FSE* XV, 29).[106] A good example is the concert pianist, who is so familiar with a piece that she plays it by heart, no longer having to pay conscious attention to the score or the movements of her hands. Indeed, Freud goes one step further when he concludes,

> daß viele Verrichtungen ganz besonders sicher geraten, wenn sie nicht Gegenstand einer besonders hohen Aufmerksamkeit sind, und daß das Mißgeschick der Fehlleistung gerade dann auftreten kann, wenn an der richtigen Leistung besonders viel gelegen ist, eine Ablenkung der nötigen Aufmerksamkeit also sicherlich nicht stattfindet. (*FGW* XI, 23)
>
> [that many procedures are carried out with quite particular certainty if they are not the object of a specially high degree of attention, and that the mishap of a parapraxis is liable to occur precisely if special importance is attached to correct functioning and there has therefore certainly been no distraction of the necessary attention. (*FSE* XV, 30)]

Attention, then, is not only unnecessary for an action to be carried out successfully—it can even be an obstacle. As Freud concludes, to focus solely on psychophysical impediments to attention, such as tiredness, illness, and distraction,

[103] '[...] Erregung, Ermüdung, Ablenkung'; 'die zur Folge haben kann, daß sich der betreffenden Leistung zu wenig Aufmerksamkeit zuwendet' (*FGW* XI, 22).

[104] His examples include a lover several times forgetting a rendezvous, and a stubborn typo which disfigures the title of the crown prince, revealing the typesetter's anti-monarchical sentiment (*FGW* XI, 24).

[105] '[...] in denen die Fehlleistungen sich vervielfältigen, sich miteinander verketten, einander ersetzen' (*FGW* XI, 24).

[106] '[...] die man rein automatisch, mit sehr geringer Aufmerksamkeit vollzieht und dabei doch ganz sicher ausführt' (*FGW* XI, 23).

as the causes of parapraxis is ultimately insufficient. Rather, a situational 'Theorie der Aufmerksamkeitsentziehung' (theory of the withdrawal of attention)—in what conditions do such slippages occur?—has to be complemented by a qualitative and causal approach: 'why it is that the slip occurred in this particular way and no other' (*FSE* XV, 31–2).[107]

As so often in his writings, Freud turns to literature to support his hypothesis that parapraxis is a meaningful psychological phenomenon. Writers use slips of the tongue 'as an instrument for producing an imaginative effect',[108] and they consciously write such instances of parapraxis into their texts: 'For what has happened is not that the author has made an accidental slip of the pen and has then allowed it to be used by one of his characters as a slip of tongue; he intends to bring something to our notice by means of the slip of tongue' (*FSE* XV, 36).[109]

Though Freud concedes that writers may have different explanations in mind when they are depicting such incidents, he nonetheless concludes that such texts can be more instructive than the works of psychiatrists.[110] Literary writers invest parapraxis with psychological meaning and motivation. Freud gives two examples from the theatrical canon: a scene from Schiller's *Wallenstein* and another one from Shakespeare's *Merchant of Venice*. In relation to the latter, he cites a long extract from the psychoanalyst Otto Rank's analysis of the play, in which he concludes that Shakespeare is closely familiar with the mechanism of parapraxis and also presupposes this knowledge among his audience. As Rank points out, in both cases a character's slip of the tongue reveals their (or another character's) secret motivation, in Portia's case her love for Bassanio.[111]

For Freud, such incidents are not solely, or even principally, caused by a drop in voluntary attention, but rather indicate a conflict between the conscious mind and a repressed, unconscious wish. Compared with experimental psychology, psychoanalytic theory may seem rather retrograde for, by trying to explain psychical phenomena, it downgrades both the impact of the environment and the inherent instability of the mind in favour of a much more coherent theoretical model, whereby errors are not random but the product of preceding experience, and where seemingly random behaviour can be traced back to an underlying (albeit unconscious) cause. That said, this approach does justify paying equal attention to all utterances and actions; for although in some instances it may seem as if 'the parapraxis produces nothing that has any sense of its own' (*FSE* XV, 41),[112] Freud contests the distinction between 'meaningful' and 'non-meaningful' instances of

[107] ' [...]warum man sich gerade in dieser Weise verspricht und in keiner anderen' (*FGW* XI, 25).
[108] '[...] als Mittel der dichterischen Darstellung'.
[109] 'Es geht ja doch nicht so vor, daß der Dichter sich zufällig verschreibt und dann sein Verschreiben bei einer Figur als ein Versprechen bestehen läßt. Er will uns durch das Versprechen etwas zum Verständnis bringen' (*FGW* XI, 29).
[110] *FGW* XI, 30; *FSE* XV, 36. [111] *FGW* XI, 31–2; *FSE* XV, 37–8.
[112] '[...] das Versprechen nichts an sich Sinnreiches geliefert hat' (*FGW* XI, 34).

parapraxis, stressing that 'there is by no means so great a distinction between these more obscure cases and the earlier straightforward ones' (*FSE* XV, 42).[113] All such examples point to the same conclusion, namely 'that there are purposes in people which can become operative without their knowing about them'—a claim which 'brings us into opposition to all the views that dominate both ordinary life and psychology' (*FSE* XV, 74).[114]

In Freud's theory, the workings of the unconscious explain psychical phenomena which in traditional psychology would have been understood with reference to (in-)attention. Indeed, this theory of the mind has far-reaching consequences also for therapeutic practice, that is, for the method of the talking cure, which is the bedrock of psychoanalysis.

Attention Suspended

While attention occupies only a marginal place within Freud's theoretical edifice, there is one context in which it takes centre stage, namely in his essays about the method of the talking cure. As he argues, the talking cure requires both patient and analyst to adopt a supple form of attention, in other words, an openness towards the unexpected.

That said, Freud's stance on this issue evolves over time. In his 1906 essay 'Tatbestandsdiagnostik und Psychoanalyse' (Psycho-Analysis and the Establishment of the Facts in Legal Proceedings), he uses forensic imagery when comparing the treatment of a patient to the process of solving a crime: 'In the case of the criminal it is a secret which he knows and hides from you, whereas in the case of the hysteric it is a secret which he himself does not know either, which is hidden even from himself' (*FSE* IX, 108).[115] The task of the analyst is to uncover 'the hidden psychical material', and for this purpose she or he needs to devise 'eine Reihe von Detektivkünsten', 'a number of detective devices'. This involves

> selbst leise Abweichungen von der gebräuchlichen Ausdrucksweise bei unserem Kranken ganz allgemein als Anzeichen für einen verborgenen Sinn anzusehen [...]. Wir lauern ihm geradezu auf Reden, die ins Zweideutige schillern, und bei denen der verborgene Sinn durch den harmlosen Ausdruck

[113] '[...] der Unterschied zwischen diesen dunkleren und früheren klaren Fällen gar nicht so groß ist' (*FGW* XI, 35).

[114] '[...] daß es Tendenzen beim Menschen gibt, welche wirksam werden können, ohne daß er von ihnen weiß. Damit setzen wir uns aber in Widerspruch zu allen das Leben und die Psychologie beherrschenden Anschauungen' (*FGW* XI, 70).

[115] 'Beim Verbrecher handelt es sich um ein Geheimnis, das er weiß und vor Ihnen verbirgt, beim Hysteriker um ein Geheimnis, das auch er nicht weiß, das er vor sich selbst verbirgt' (*FGW* VII, 8).

hindurchschimmert. [...] Es ist schließlich nicht schwer zu verstehen, daß ein sorgfältig gehütetes Geheimnis sich nur durch feine, höchstens durch zweideutige Andeutungen verrät. (*FGW* VII, 9–10)
[We quite generally regard even slight deviations in our patients from the ordinary forms of expression as a sign of some hidden meaning [...]. Indeed, we are on the look-out for remarks which suggest any ambiguity and in which the hidden meaning glimmers through an innocent expression. [...] After all, it is not difficult to understand that the only way in which a carefully guarded secret betrays itself is by subtle, or at most ambiguous, allusions. (*FSE* IX, 108–10)]

Freud here proposes an active form of enquiry, which requires the analyst to stay vigilant (*lauern*, literally, to lie in wait), picking up on minor clues and hidden meanings in a patient's utterances. In commenting on the mindset to be adopted by the analyst, he makes explicit what often remains unspoken in psychiatric and psychological studies, namely the role of the experimenter or clinician, whose attentional prowess is taken as a given.

Six years later Freud returns to the issue of the analyst's mental stance in an essay which uses the critique of existing practices in psychiatry as the springboard for his own model of (psycho)analytical attention. In his essay 'Ratschläge für den Arzt bei der psychoanalytischen Behandlung' (Recommendations to Physicians Practising Psycho-Analysis, 1912), he critiques the psychiatric treatment protocol, which seeks to give a comprehensive account of a patient's symptoms and interactions with the medical staff, for its 'Scheinexaktheit' ('*ostensible* exactness'), noting that the wealth of detail usually does not result in any clear analysis or conclusions.[116]

Freud's own alternative method, however, seems to raise similar problems. Its starting point is a practical problem: how can the analyst remain alert and effective if s/he has to see up to eight patients a day, many of whom s/he will see for daily sessions over the course of months? The sheer amount of collected data is overwhelming, as the analyst tries to remember 'the innumerable names, dates, detailed memories and pathological products which each patient communicates in the course of months and years of treatment' (*FSE* IX, 111)[117]—and then has to avoid confusing one case with another. The required mental effort appears superhuman, impossible.

Freud's suggested answer to this cognitive challenge is very simple and requires no particular training or devices. Rather than taking any notes, the analyst should adopt an open state of mind, which involves 'not directing one's notice to

[116] *FGW* VIII, 379; *FSE* XII, 114.
[117] '[...] die unzähligen Namen, Daten, Einzelheiten der Erinnerung, Einfälle und Krankheitsproduktionen [...], die ein Patient im Laufe von Monaten und Jahren vorbringt' (*FGW* VIII, 376).

anything in particular and in maintaining the same "evenly suspended attention"' throughout the session (*FSE* IX, 111).[118] This method counteracts the risks of the psychiatric treatment protocol, with its excessive focus on (irrelevant) detail. Freud reassures his readers that their memory is much more capacious than they may think. His own practice is to write down his impressions of a session at the end of the day, for in hindsight relevant details and connections will become apparent without mental effort. This analytical (or narrative) synthesis, however, must be able to draw on a wealth of material, and for this the analyst's attention must be completely open and unprejudiced. The adjective *gleichschwebend*, 'evenly floating' or 'suspended', suggests lightness and an ability to detach oneself from the encountered narratives of suffering.

Freud's particular form of attention is thus in part motivated by concerns of self-care, for it saves the analyst 'a strain on our attention which could not in any case be kept up for several hours daily' (*FSE* IX, 112).[119] In this regard, his essay also echoes psychological research, which had shown time and again that voluntary attention could not be sustained over extended periods. But beyond this aspect of self-care, the recommended, only semi-deliberate state of attention also yields great analytical benefits. It forestalls the dangers of excessive analytical vigilance, which therefore 'never finding anything but what [the analyst] already knows' and which therefore skews ('fälschen') and distorts 'what one may perceive' (*FSE* IX, 112).[120] Freud here gives an early account of cognitive bias, specifically of expectation and confirmation bias, while critiquing the established methods of scientific observation, which can easily turn into a self-perpetuating, cyclical process.

Freud's talking cure thus runs counter to established practice in medicine and experimental psychology, where an expert observer maintains a close watch over their subject, cross-matching his or her behaviour with a catalogue of faculties or symptoms. But while Freud is critical of recording practices in psychiatry, he commends the 'emotional coldness' of the surgeon, who sets aside all sympathy and instead directs his or her mental energy towards the present operation.[121] Evenly suspended attention, in other words, does not involve empathy, but rather combines openness and (emotional) detachment.

Finally, the analyst's evenly suspended attention is not just an end in itself but is designed as a dialogical counterpart to the mindset of the patient. By suspending any prior expectations, the analyst mirrors and models what is expected of the

[118] '[...] sich nichts besonders merken zu wollen und allem, was man zu hören bekommt, die nämliche "gleichschwebende Aufmerksamkeit" [...] entgegenzubringen' (*FGW* VIII, 377).

[119] '[...] eine Anstrengung der Aufmerksamkeit, die man doch nicht durch viele Stunden täglich festhalten könnte' (*FGW* VIII, 377).

[120] '[...] niemals etwas anderes zu finden, als was man bereits weiß'; 'die mögliche Wahrnehmung' (*FGW* VIII, 377).

[121] *FGW* VIII, 381; *FSE* IX, 115.

patient, namely to 'communicate everything that occurs to him without criticism or selection'—what Freud calls the process of free association (*FSE* IX, 112).¹²² If the patient suspends any self-censoring activity, the analyst must in turn match this stance, rather than engage with what she hears only selectively. Here, Freud advocates an approach which already underpins his *Psychopathology*: a fundamental openness towards all aspects of human experience, including minor, seemingly trivial details, for these can yield the most surprising new insights, not least because they have been ignored by generations of researchers. Evenly suspended attention requires the analyst to delve into her or his own unconscious as a tool of analysis, and so Freud demands that prospective analysts first undergo a psychoanalytic treatment course themselves in order to become aware of any complexes that might skew their response, for every unanalysed complex amounts to a 'blind spot' on the analyst's radar of awareness (*FGW* VIII, 382).

Summing up his method, Freud takes recourse to a technological metaphor. The analyst

> soll dem gebenden Unbewußten des Kranken sein eigenes Unbewußtes als empfangendes Organ zuwenden, sich auf den Analysierenden einstellen wie der Receiver des Telephons zum Teller eingestellt ist. Wie der Receiver die von Schallwellen angeregten elektrischen Schwankungen der Leitung wieder in Schallwellen verwandelt, so ist das Unbewußte des Arztes befähigt, aus den ihm mitgeteilten Abkömmlingen des Unbewußten dieses Unbewußte, welches die Einfälle des Kranken determiniert hat, wiederherzustellen. (*FGW* VIII, 381–2)
>
> [must turn his own unconscious like a receptive organ towards the transmitting unconscious of the patient. He must adjust himself to the patient as a telephone receiver is adjusted to the transmitting microphone. Just as the receiver converts back into sound waves the electric oscillations in the telephone line which were set up by sound waves, so the doctor's unconscious is able, from the derivatives of the unconscious which are communicated to him, to reconstruct that unconscious, which has determined the patient's free associations. (*FSE* IX, 115–16)]

The envisaged communication from one unconscious to another has overtones of telepathy, a pseudo-scientific phenomenon in which Freud was very interested as an example of proto-psychoanalytic interaction.¹²³ In his model, the corresponding stances of free association and evenly suspended attention allow one unconscious to communicate with another, bracketing out the censoring activities of the conscious, rational self. And yet shortly afterwards, Freud apparently retreats from this position when he counsels fellow analysts to make themselves opaque,

¹²² '[...] ohne Kritik und Auswahl alles zu erzählen, was ihm einfällt' (*FGW* VIII, 377).
¹²³ For details, see Chapter 8, pp. 266–316.

'undurchsichtig', towards their patients, turning themselves into a mirror which reflects back what it is shown.[124] Conversely, patients must not be made mentally to exert themselves, to solve tasks, collect memories, or reflect on a particular time of their lives. Above all, they must learn 'that mental activities such as thinking something over or concentrating the attention solve none of the riddles of a neurosis' (*FSE* IX, 119).[125] As the essay concludes, the successful therapeutic strategy is to follow the rule of free association, which tries to disable critique of the unconscious and its products.

Here as in other texts, Freud uses technology as a metaphor for the mind, in this case by highlighting technology's superior capacity for unlimited and unfiltered transmission. Since the late nineteenth century, the ideal scientific observer resembled a machine and its unwavering, unemotional vigilance. Indeed, the same hierarchy also applied to the world of work more generally; in the industrial age, 'patient, indefatigable, ever-alert machines would relieve human workers whose attention wandered, whose pace slackened, whose hand trembled'.[126]

In some regards, then, Freud's dictum of evenly suspended attention corresponds to the period's ideal of the scientific observer displaying wax-like receptivity, and yet his essay also includes a jibe against the psychiatric treatment protocol, which indiscriminately records all symptoms and utterances. By listening without writing, the analyst is later able to pick out and record the most salient details, in a process which in fact recalls the eighteenth-century ideal of the scientist as a genius of observation who is able to synthesize the wealth of empirical data into a coherent theory or narrative.

Modernist treatises about nervousness often implicitly or explicitly reflect their authors' own struggles with this condition.[127] A similar, personal experience also inflects Freud's essay, in which the psychoanalyst is shown to be part of the (large) group of professions that are groaning under the burden of cognitive overload. In his practice, Freud saw up to eight patients every day, many of whom had daily sessions over the course of several months. To protect his mental capacity during sessions, he liked to look at the ethnographic objects he collected and displayed in his treatment room; the spatial set-up of the talking cure, with patients lying on a sofa, facing away from the seated analyst, was not only designed to make the patient less self-conscious, but also served to protect the analyst, who in this way did not have to maintain eye contact.[128]

[124] *FGW* VIII, 384; *FSE* IX, 118.
[125] '[...] daß durch geistige Tätigkeit von der Art des Nachdenkens, daß durch Willens- und Aufmerksamkeitsanstrengung keines der Rätsel der Neurose gelöst wird' (*FGW* VIII, 386).
[126] Lorraine Daston and Peter Galison, *Objectivity* (New York, NY: Zone Books, 2007), p. 123.
[127] Radkau, *Das Zeitalter*, p. 14.
[128] In their treatment of hysterical patients, Freud and Breuer initially used a different treatment method, what they called the 'cathartic technique'. With the use of hypnosis and suggestion, patients were meant to relive the traumatic (sexual) experience which had caused their condition. But gradually,

Indeed, the challenge of how to sustain his own concentration both within and outside the treatment room was a recurring concern for Freud, particularly in the 1880s and 1890s. He habitually smoked up to twenty-five cigars a day while reading and writing, though he tried to quit in the mid-1890s after a string of serious health problems, including arrhythmia, on the advice of his friend, the Berlin physician Wilhelm Fließ. As a result, his productivity plummeted, and so he took up smoking again. In addition, Freud also had started to experiment with cocaine in 1884, at a time when its addictive properties were ill understood,[129] and he continued to take the drug on and off for over ten years. In an article published a few months after he first started taking cocaine, Freud praises its 'wonderful stimulating effect [...]. Long-lasting, intensive mental or physical work can be performed without fatigue; the need for food and sleep [...] appears completely eliminated'.[130]

Freud's model of evenly suspended attention is arguably an echo of this experience, an attempt to at least approximate this state of effortless receptivity and productivity. The word *Ratschläge* in the title of his essay recalls Enlightenment self-care and hygiene literature, while also anticipating the rise of *Ratgeberliteratur*, self-help guides, in the Weimar Republic, which offer readers practical strategies for sharpening and expanding their concentration.

Shielding the Mind

At the end of this chapter it is illuminating to return to the beginnings of Freud's psychoanalytic project, specifically to a text in which he first tries to formulate his theory of the mind as based on the interaction between perception, attention, and memory. This is his *Entwurf einer Psychologie* (Project for a Scientific Psychology, 1895), which Freud wrote chiefly for himself, as an exercise in self-reflection, and subsequently sent to his friend Fließ. The text appeared only after Freud's death, in 1950.

Freud's *Project* is inflected by different aspects of his training and practical experience. His notion of the 'psychic apparatus' reflects, as Mei Wegener points out, the prominence of apparatuses in the experimental sciences and in Freud's

this technique was replaced by the talking cure in which the patient continued to lie on a sofa, but stayed awake. Its aim was to stimulate associations which could offer a pathway to the repressed traumatic experiences. See Alt, *Freud*, pp. 196–9.

[129] Alt, *Freud*, pp. 182–3. In letters to his fiancée Martha Bernays, Freud reported his increased energy and concentration and recommended that Martha try the drug against headaches and indigestion; she followed his advice and took cocaine for two years, fortunately without developing an addiction. Alt, *Freud*, p. 130.

[130] Sigmund Freud, 'Über Coca', trans. Steven A. Edminster, *Journal of Substance Abuse Treatment*, 1 (1984), 206–17 (p. 211); 'wunderbare stimulierende Wirkung [...]. Langanhaltende, intensive geistige oder Muskelarbeit wird ohne Ermüdung verrichtet, Nahrungs- und Schlafbedürfnisse [...] sind wie weggewischt'. Freud, *Über Coca*, expanded reprint (Vienna: Perles, 1885), p. 13.

own research—his work with the microscope as a young medical student in Ernst Brücke's physiological laboratory, the camera which he saw in use in Charcot's hypnosis sessions, and the dynamometer he acquired during his time in Paris.[131] Though he does not explicitly cite any current psychological research, Freud's argument is underpinned by the theories of Brentano and of Wundt's Leipzig school of psychology.[132] His model of the mind echoes Leibniz's concept of apperception, which in turn shaped Gustav Theodor Fechner's theories, in which attention is held to be necessary to lift a stimulus beyond the threshold of awareness.

At the same time, however, Freud's *Project* is also influenced by his background in physiological research. In a letter to Fließ, he declares that in his *Project* he wanted to outline a theory of psychology 'for the neurologist'.[133] According to his text, the brain is made up of two neuronal systems; the outward layer is the perceptual system Φ, which consists of permeable neurons, so-called *Mantelneuronen* or 'pallium neurones', that allow stimuli (Qη) to enter into the mind. There they are passed on to system ψ, which is made up of impermeable neurons, 'the vehicles of memory and so probably of psychical processes in general';[134] only the latter are able to retain a record of the encountered stimuli. As Freud puts it, 'they are permanently altered by the passage of an excitation' (*FSE* I, 300).[135]

The reception of stimuli and their permanent preservation, then, are tasks carried out by two topologically separate systems. But how do they pass from one system to the other? To explain this process, Freud uses the notion of *Besetzung*, 'cathexis'. In perception, stimuli entering system Φ are met, and invested, with attention by the psychical system ψ. In this energeticist model of the mind, the psychical system sends 'a constant, even though displaceable, cathexis (*attention*) [...] into the pallium neurones, which receive perception

[131] Mai Wegener, *Neuronen und Neurosen: Der psychische Apparat bei Freud und Lacan. Ein historisch-theoretischer Versuch zu Freuds Entwurf von 1895* (Munich: Fink, 2004), p. 20.
[132] Alt, *Freud*, p. 195.
[133] Letter of 27 April 1895; *FGW* XIX, 376. On Freud's *Project* and his psychoanalytic theories more generally in the light of the neurosciences, see Martha Koukkou, Marianne Leutziger-Bohleber, and Wolfgang Mertens (eds), *Erinnerung von Wirklichkeiten: Psychoanalyse und Neurowissenschaften im Dialog* (Stuttgart: Verlag der Internationalen Psychoanalyse, 1998); Wegener, *Neuronen*, p. 105; and Sigrid Weigel and Gerhard Schabert (eds), *A Neuro-Psychoanalytical Dialogue for Bridging Freud and the Neurosciences* (Cham: Springer, 2016). As Nadine Werner has pointed out, Freud's topological distinction between two different systems in the brain, which are respectively responsible for the reception of stimuli and for their recording as permanent memory traces, corresponds to more recent neurophysiological findings, according to which the hippocampus is responsible for the consolidation of short- into long-term memory, but does not store memories itself: *Archäologie des Erinnerns: Sigmund Freud in Walter Benjamins 'Berliner Kindheit'* (Göttingen: Wallstein, 2015), pp. 27–8.
[134] '[...] die Träger des Gedächtnisses, wahrscheinlich also der psychischen Vorgänge überhaupt sind' (*FGW* XIX, 392).
[135] '[S]ie werden durch den Erregungsablauf dauernd verändert' (*FGW* XIX, 392).

from Φ' (*FSE* I, 337).¹³⁶ Cathexis is here equated with attention, that response which activates the receptive capacities of the intermediate neuronal layer. Only with the help of attention, the additional investment coming from within the mind, can impressions be converted into memories.

Freud's theory bears a striking resemblance to the concept of apperception as originally defined by Leibniz, which was still widely used in nineteenth- and early twentieth-century psychology. As Fechner declared in 1860, only a 'Sammlung der Aufmerksamkeit' or 'gathering of attention' can lift impressions 'over the threshold' of conscious awareness,¹³⁷ while for Wundt the clarity with which a stimulus is received does not depend on its intensity but solely on 'the subjective activity [. . .] through which consciousness turns towards a particular sensory stimulus'.¹³⁸

Freud then turns to the states of sleep and hypnosis, in which the subject has little or no awareness of the outside world. In such states, the sensory system does not cease to operate; rather, it is the inner system ψ that withdraws its attentional investment:

> Zieht ψ diese Mantelbesetzungen ein, so erfolgen die Wahrnehmungen auf unbesetzte Neuronen, sind gering, vielleicht nicht imstande, von Wahrnehmungen aus ein Qualitätszeichen zu geben. [. . .]. Auf dieser Einziehung der Aufmerksamkeitsbesetzung wird die scheinbare Unerregbarkeit der Sinnesorgane beruhen. Durch einen automatischen Mechanismus also, das Gegenstück vom Aufmerksamkeitsmechanismus, schließt ψ die Φ-Eindrücke aus, solange es selbst unbesetzt ist. (*FGW* XIX, 432-3)
>
> [If ψ withdraws these pallium cathexes, the perceptions take place upon uncathected neurones and are slight, and perhaps not capable of giving an indication of quality [. . .]. The apparent unexcitability of the sense organs [in hypnosis] must rest on this withdrawal of the cathexis of attention. Thus, by an automatic mechanism, the counterpart of the mechanism of attention, ψ excludes the Φ impressions so long as it itself is uncathected. (*FSE* I, 337)]

Noteworthy here is the word *scheinbar* (apparently), which implies that while sensory impressions Qη still enter the system during states of severely reduced attentional investment, they are not processed by the neuronal system which would allow them to be committed to (conscious) memory. This argument is significant, for it anticipates Freud's later theory of trauma, as developed in *Jenseits*

¹³⁶ '[. . .] den Mantelneuronen, welche Wahrnehmungen von Φ her empfangen, eine beständige, wenngleich verschiebbare Besetzung entgegen [. . .] (*Aufmerksamkeit*)' (*FGW* XIX, 432).
¹³⁷ Gustav Theodor Fechner, *Elemente der Psychophysik*, vol. 2 (Leipzig: Breitkopf & Härtel, 1860; repr. Amsterdam: Bonset, 1964), p. 433.
¹³⁸ The 'subjectiven Thätigkeit [. . .], durch welche sich das Bewusstsein einem bestimmten Sinnesreiz zuwendet'. Wilhelm Wundt, *Grundzüge der physiologischen Psychologie* (Leipzig: Engelmann, 1874), p. 720.

des Lustprinzips (Beyond the Pleasure Principle, 1920). In this text, he returns to the notion that under certain conditions sensory impressions can bypass conscious awareness—but this time not in the context of sleep and hypnosis but of wartime experience and trauma.

In *Beyond the Pleasure Principle* Freud cites Fechner's treatise *Einige Ideen zur Schöpfungs- und Entwicklungsgeschichte der Organismen* (Some Reflections on the Creation and Developmental History of the Organisms, 1873), which focuses on the role of the sensory stimulus and its impact on human experience. As he argues, the relative pleasure or displeasure we derive from a sensation is determined not solely by the nature of that stimulus but also, and more fundamentally, by its intensity:

> Es läßt sich hierauf die [...] Hypothese begründen, dass jede, die Schwelle des Bewusstseins übersteigende psychophysische Bewegung nach Massgabe mit Lust behaftet sei, als sie sich der vollen Stabilität über eine gewisse Grenze hinaus nähert, mit Unlust nach Massgabe, als sie über eine gewisse Grenze davon abweicht, indes zwischen beiden, als qualitative Schwelle der Lust und Unlust zu bezeichnenden, Grenzen eine gewisse Breite ästhetischer Indifferenz besteht.[139]

> [From this we can derive the hypothesis that every psychophysical movement that exceeds the threshold of consciousness is accordingly invested with pleasure as it approximates full stability to a particular extent, and with displeasure as this movement diverges from stability to a certain degree; though there is a degree of aesthetic indifference between the two qualitative thresholds of pleasure and displeasure.]

Once a stimulus exceeds a certain level of intensity, it will cease to be pleasurable—although this threshold is not absolute but individually variable, depending on personal disposition. Freud comments that Fechner's theory 'coincides in all essentials with the one that has been forced upon us by psycho-analytic work';[140] the workings of the 'psychic apparatus', and specifically of the pleasure principle, have one overriding aim, namely to keep the 'quantity of excitation low' (*FSE* XVIII, 8–9).[141]

At first sight, then, the mental laws described in *Beyond the Pleasure Principle* seem to be exactly the inverse of the ones outlined in the *Project*. In Freud's 1920 text, the psyche does not reach out towards the encountered stimuli by investing (or cathecting) them with attention, but is, on the contrary, intent on minimizing

[139] Gustav Theodor Fechner, *Einige Ideen zur Schöpfungs- und Entwicklungsgeschichte der Organismen* (Leipzig: Breitkopf und Härtel, 1873), p. 94. See *FGW* XIII, 4–5.

[140] '[...] im wesentlichen mit dem zusammenfällt, die uns von der psychoanalytischen Arbeit aufgedrängt wird' (*FGW* XIII, 4–5).

[141] '[...] die Erregungsquantität niedrig zu halten' (*FGW* XIII, 4–5).

any external stimulation in order to maintain an inner equilibrium. This theoretical U-turn is motivated by a particular condition with which Freud was confronted in his psychoanalytic practice: traumatic neurosis, which was common particularly in former soldiers.

In the medical literature of the time, traumatic neurosis was commonly associated with physical shock caused by railway and other traumatic accidents. The physical impact of the collision, particularly on the spine, was believed to cause neurological symptoms.[142] Freud, however, also encountered traumatic neurosis in soldiers returning from the First World War, who had not been exposed to any physical kind of trauma. Characteristic of war experience, he notes, is not physical but sudden mental shock, 'the element of surprise, [...] fright' (*FSE* XVIII, 12).[143] In his essay, Freud distinguishes between *Angst* (fear) and *Schreck* (sudden shock and fright). Fear serves to prepare the psyche for any sudden fright and thereby enhances its protective capacities; in combat, however, shocks tend to come out of the blue, disabling this protective mechanism.[144] Their combined suddenness and intensity exceeds the processing, and hence the protective, capacities of the mind, whose aim is to maintain an inner equilibrium, to prevent stimuli from crossing that threshold where even pleasurable sensations turn painful and potentially traumatic.

To explain this psychological phenomenon, Freud returns to a topological model of the mind. The outward-facing part of the psyche, what he calls the system '*W-Bw*' [Wahrnehmung-Bewußtsein] or '*Pcpt.-Cs.*' [Perception-Consciousness], is responsible for the reception of stimuli. It is situated 'on the borderline between outside and inside; [...] turned towards the external world and must envelop the other psychical systems' (*FSE* XVIII, 24).[145] As he concedes, this model of the psyche is not entirely new but echoes neurological models, according to which consciousness is located in the 'cerebral cortex—the outermost, enveloping layer of the central organ' (*FSE* XVIII, 24),[146] a topological framework very similar to his own *Project*, where stimuli from the outside world enter the mind via the layer of 'pallium neurones'.

Here, as in the *Project*, Freud stresses that this outward-facing layer or system is only a point of transition, which cannot retain the permanent traces of the encountered stimuli. To do so would quickly take up all its available capacity

[142] The first detailed study of the condition was John Eric Erichsen's *On Railway and Other Injuries of the Nervous System* (1867); the German neurologist Hermann Oppenheimer attributed these symptoms to physical injuries to the spinal cord or brain, while other neurologists, such as Charcot, argued that some instances were caused by hysteria.

[143] '[...] das Moment der Überraschung, [...] der Schreck' (*FGW* XIII, 9–10).

[144] As Freud concedes, above a certain level of intensity, trauma will always have a destructive effect, regardless of whether or not the psyche's defences are up (*FGW* XIII, 32).

[145] '[...] an der Grenze von außen und innen [...], der Außenwelt zugekehrt [...] und die anderen psychischen Systeme umhüllen[d]' (*FGW* XIII, 23).

[146] The 'Hirnrinde, [...] die äußerste, umhüllende Schicht des Zentralorgans' (*FGW* XIII, 23).

and prevent the system from processing new incoming impressions. As a consequence, the experience of a stimulus and it being committed to memory are two separate processes which cannot take place within the same system:

> Wir würden so sagen können, im System *Bw.* werde der Erregungsvorgang bewußt, hinterlasse aber keine Dauerspur; alle die Spuren desselben, auf welche sich die Erinnerung stützt, kämen bei der Fortpflanzung der Erregung auf die nächsten inneren Systeme in diesen zustande. (*FGW* XIII, 24)
>
> [Thus we should be able to say that the excitatory process becomes conscious in the system *Cs.* but leaves no permanent trace behind there; but that the excitation is transmitted to the systems lying next within and that it is in *them* that its traces are left. (*FSE* XVIII, 25)]

In *Beyond the Pleasure Principle*, Freud thus returns to his physiological roots when he encourages his readers to picture the human organism as an 'undifferentiated vesicle of an excitable substance', whose 'receptive cortical layer' is turned towards the outside world and its stimuli. As this surface layer is exposed to stimuli, it gradually loses much of its sensitivity, turning 'to some degree inorganic' (*FSE* XVIII, 26–7).[147] This means that any energies entering the organism from the outside world 'are able to pass into the next underlying layers, which have remained living, with only a fragment of their original intensity' (*FSE* XVIII, 27).[148] As he boldly concludes:

> Für den lebenden Organismus ist der Reizschutz eine beinahe wichtigere Aufgabe als die Reizaufnahme; er ist mit einem eigenen Energievorrat ausgestattet und muß vor allem bestrebt sein, die besonderen Formen der Energieumsetzung, die in ihm spielen, vor dem gleichmachenden, also zerstörenden Einfluß der übergroßen, draußen arbeitenden Energien zu bewahren. (*FGW* XIII, 27)
>
> [Protection against stimuli is an almost more important function for the living organism than reception of stimuli. The protection shield is supplied with its own store of energy and must above all endeavour to preserve the special modes of transformation of energy operating in it against the effects threatened by the enormous energies at work in the external world—effects which tend towards a levelling out of them and hence towards destruction. (*FSE* XVIII, 27)]

[147] An 'undifferenziertes Bläschen reizbarer Substanz', its 'reizaufnehmende Rindenschichte' turning 'gewissermaßen anorganisch' (*FGW* XIII, 25–6).

[148] '[...] sich nur mit einem Bruchteil ihrer Intensität auf die nächsten lebend gebliebenen Schichten fortsetzen können' (*FGW* XIII, 27).

In *Beyond the Pleasure Principle*, Freud echoes contemporary psychiatrists' concerns about excessive stimulation and sensory overload. His theory of *Reizschutz* is a partial answer to this problem, though ultimately, this model owes its very existence to the fact of its own inadequacy, its collapse in the face of trauma and shock. 'By its death, the outer layer has saved the deeper ones from a similar fate—unless, that is to say, stimuli reach it which are so strong that they break through the protective shield' (*FSE* XVIII, 27).[149]

The mind in *Beyond the Pleasure Principle* is not open and receptive, but turned in on itself, sheltered behind an outer layer which has hardened into almost complete insensitivity. This outside-facing system is only able to process 'very small quantities of external stimulation', in the manner of an insect's antennae, 'which are all the time making tentative advances towards the external world and then drawing back from it' (*FSE* XVIII, 28).[150]

Freud's psycho-physiological model echoes what Simmel in 1903 described in sociological, behaviourist terms: the experience of the modern city-dweller, whose attention is blunted by constant exposure to a flood of sensations, leaving her detached, blasé, indifferent. As the steep rise of neurasthenia and neurosis showed, however, even such protective mechanisms proved inadequate in the face of relentless and competing cognitive demands. The experiences of modernity, and particularly of modern warfare, showed the limits of *Reizschutz*, but as traumatic phenomena, they also generated this theory in the first place.[151]

Outlook

Faced with the cognitive, social, and political challenges of modern life, the period's underlying conception of the mind, indeed of the subject, undergoes a major shift. A subject who is fundamentally open towards the world, though sometimes distracted and dispersed by its many spectacles, is replaced by a more reticent, inward-looking, and protective self, who only momentarily extends its antennae—but whose precautions ultimately prove inadequate. In his study of the

[149] 'Die Außenschicht hat aber durch ihr Absterben alle tieferen vor dem gleichen Schicksal bewahrt, wenigstens so lange, bis nicht Reize von solcher Stärke herankommen, daß sie den Reizschutz durchbrechen' (*FGW* XIII, 27).

[150] '[...] sehr geringe Quantitäten des äußeren Reizes'; 'die sich an die Außenwelt herantasten und dann immer wieder von ihr zurückziehen' (*FGW* XIII, 27).

[151] Freud's theory of the soldier's trauma is part of a longer discursive tradition. Pierre Janet, for instance, uses the example of a soldier in combat who is so immersed that he does not immediately feel his injuries to illustrate his theory of *désagrégation*, the splitting or narrowing of attention, which is common in hysterics but can also be observed in otherwise healthy people in extreme situations. See Löffler, 'Schwindel', p. 391. A few years later, Krafft-Ebing argues that the 'erschöpfende, aufreibende Einfluss des Kriegslebens', specifically of the Franco-Prussian War, could cause such lasting damage to soldiers' mental and physical health that their resulting nervous illness could even be passed on to their children. Krafft-Ebing, *Nervosität*, p. 18.

Weimar Republic, Helmut Lethen uses the phrase 'cool conduct' to describe a similar strategy of inner detachment;[152] its roots extend back to attentional debates around 1900.

In the first decades of the twentieth century, the challenge of how to sustain attention when faced with competing cognitive demands morphs into a different project: how to shield the mind against sensory overload caused by intense and sometimes traumatic experiences? This aim underpins Freud's model of evenly suspended attention as the stance to be adopted by the therapist as a measure of self-protection and self-care; in *Beyond the Pleasure Principle*, he goes one step further when he declares a level of zero stimulation, as can only ultimately be achieved in death, as the mind's ultimate goal—a goal pursued by the death drive, which co-opts the pleasure principle for this purpose.[153]

The debates outlined in this chapter resonate far into the twentieth century, where anxieties about social, political, and technological modernity show no sign of abating, and where the First World War marks a great caesura, causing more change and crisis. If anything, the question of attention becomes even more urgent in this context, but the principal site of its exploration shifts from psychology and psychiatry and into the terrain of literature, thought, and culture. Modernist writers pick up on many of the questions discussed in this chapter both through what they write and in terms of their strategies of production and cognitive self-conditioning.

Freud's models of free association and suspended attention, for instance, inflect avant-garde strategies such as automatic writing, and many modernist writers experiment with autosuggestion, therapy, and other strategies of mental self-conditioning to achieve that elusive state of complete immersion. Another vital impulse of Freud's work is his focus on everyday life. His work on dreams and parapraxis lays the foundation for authors exploring the psychology of their characters, which they chart as an ongoing struggle between the conscious mind and its deeper, unconscious foundations. In his *Psychopathology*, Freud draws attention to the prominent role of parapraxis in works by Shakespeare and Schiller. This literary technique is not confined to previous centuries; it also features in texts by Freud's contemporaries—particularly in the works of Franz Kafka (1883–1924), where slippages of attention are both a central plot device and a feature of narrative focalization.

[152] Helmut Lethen, *Cool Conduct: The Culture of Distance in Weimar Germany*, trans. Don Reneau (Berkeley, CA: University of California Press, 2002).
[153] See *FGW* XIII, 69. Freud's favourite daughter Sophie died suddenly in January 1920, after Freud had completed his text. Following her death, he revised the ending to lend more emphasis to the death drive and its reign over the pleasure principle. For a comparison of the different versions of the essay, see Ilse Gubrich-Simitis, *Zurück zu Freuds Texten: Stumme Dokumente sprechen machen* (Frankfurt a. M.: Fischer, 1993), p. 242.

3
Franz Kafka
Diversion, Vigilance, Paranoia

Many tropes of modernist discourses about attention are echoed in Kafka's writings. The instability of attention and its interplay with distraction are recurrent concerns in both his literary and his personal texts; indeed, these issues beset him from his school years all the way to his end of his life. Attention is a challenge facing both the writer and his protagonists; it underpins Kafka's texts on the levels of plot, focalization, and narrative voice.

Kafka's troubled fascination with attention has several sources. While still at school, he was introduced to contemporary psychological theories; later on, the risks posed by inattention at the workplace and in everyday life were issues with which he grappled in his role at the Workers' Accident Insurance Institute. But attention also had an intensely personal significance for Kafka the author. Complete immersion in his work remained an impossible creative aspiration, the hallmark of a life wholly dedicated to writing, which he was unable to pursue. As a result, attention for Kafka became the source of great, multi-faceted anxiety, and his characters likewise struggle to achieve that elusive state of sustained concentration. His prose fiction is full of distracted protagonists, whose resolve to stay focused crumbles in the face of competing cognitive demands. What is more, attention is often depicted not as a mindset that is adopted freely and voluntarily, but as something imposed on the individual by disciplinary individuals and institutions. As his later texts show, however, when a protagonist is able to sustain a state of unbroken alertness, attention often turns destructive, giving rise to suspicion and paranoia. Overall, then, Kafka's texts display a profound ambivalence towards attention as a personal goal and a social imperative, and yet this faculty nonetheless retains an emancipatory, even utopian, dimension particularly in his last writings.

Attention on Trial

Kafka's particular brand of realism, his idiosyncratic style and use of narrative focalization, have been the subject of detailed analysis, with critics emphasizing how his 'meticulous attention to accuracy of detail' is paradoxically used in

narratives that subvert and parody 'the representational conventions of realism'.[1] Ritchie Robertson links Kafka's realism to the classic detective story in the tradition of Arthur Conan Doyle, in which the close observation of objects, spaces, and people yields insights into events and motivations, arguing that this hermeneutic framework is evoked in Kafka's texts only to be continually undermined.[2] Crucially, this ambivalent attachment to the codes of realism operates on the levels of both Kafka's narratives and their characters. Kafka's protagonists often believe that, with the right level of attention, the world can be decoded and hence controlled, and this belief in turn infuses the narrative, whose abundance of physical details reflects the protagonists scanning their surroundings for salient information, their gaze zooming in on particular segments with forensic acuity.

This mode of attention is prominently on display in Kafka's second novel, *Der Process* (The Trial, 1914–15), where Josef K. resolves early on to make sense of his arrest 'by means of attention and reflection' (*T* 8).[3] The guard seems to concur with this goal, but also issues a warning: 'We advise you not to waste your energy on pointless thoughts but to compose yourself, great demands are going to be made on you' (*T* 8).[4] Overly focussed attention risks becoming dispersed, lost among the endless details of the world—a danger whose potentially pathological consequences were emphasized by contemporary psychiatrists.

As it unfolds, Kafka's novel both illustrates K.'s resolve and bears out the warning of the guard. K.'s gaze is attracted by people and objects—by facial features and expressions, by clothing, bodily gestures, and objects, such as the candle handled by the inspector and Fräulein Bürstner's white blouse hanging by the window. All of these are rendered in great vividness; the narrative tracks K.'s gaze, with which he scans his surroundings and then zooms in on particular aspects.[5] And yet his impressive skills of observation are shown by narrative events (and, occasionally, by the voice of the omniscient narrator) to be futile and misguided. Not only does K. draw the wrong conclusions from what he observes, but his attention is prone to be side-tracked and misdirected, either by focusing on irrelevant details at the expense of the bigger picture or, conversely,

[1] Stephen Dowden, *Sympathy for the Abyss: A Study in the Novel of German Modernism. Kafka, Broch, Musil, and Thomas Mann* (Tübingen: Niemeyer, 1986), pp. 102–3.

[2] Ritchie Robertson, 'Reading the Clues: Franz Kafka, *Der Proceß*', in *The German Novel in the Twentieth Century*, ed. David Midgley (Edinburgh: Edinburgh University Press, 1993), pp. 59–79.

[3] '[...] durch Aufmerksamkeit und Überlegung' (*P* 8).

[4] '[Z]erstreuen Sie sich nicht durch nutzlose Gedanken, sondern sammeln Sie sich, es werden große Anforderungen an Sie gestellt werden' (*P* 8).

[5] Emily Troscianko has explored Kafka's particular, cognitive, brand of realism, emphasizing how in *The Trial* K. sees the world 'in the way that we do the real'; rather than giving the reader a panoramic picture of K.'s surroundings, in the manner of nineteenth-century realists such as Theodor Fontane, the narrative only provides details as they are relevant for K., and so 'the fictional world expands as the events unfold'. Emily T. Troscianko, *Kafka's Cognitive Realism* (New York, NY: Routledge, 2014), pp. 125–6. See also Emily T. Troscianko, 'Reading Kafka', in *Franz Kafka in Context*, ed. Carolin Duttlinger (Cambridge: Cambridge University Press, 2017), pp. 283–92.

by missing a crucial aspect because he is otherwise preoccupied. One of the most striking such incidents occurs in the first chapter when, during his interrogation by the inspector, K. fails to notice his three junior colleagues from the bank, who are standing in a corner of the same room.

K.'s inattentional blindness is comical given his earlier resolve to pay close attention.[6] He is so absorbed by his interrogation that he does not recognize the three clerks, an oversight which also reflects his cognitive bias, specifically his hierarchical, authoritarian mindset. When he comes to his senses, K. is shocked but immediately realizes the cause of his oversight: 'He must have been entirely taken up with the supervisor and the guards not to recognize the three' (T 15).[7] And yet, before the end of this episode, he is once again distracted—this time when the man from the window opposite appears in the street, which causes him to miss the departure of the guards and the inspector:

> Viel Geistesgegenwart bewies das nicht und K. nahm sich vor, sich in dieser Hinsicht genauer zu beobachten. [. . .] Aber gleich wendete er sich wieder zurück ohne auch nur den Versuch gemacht zu haben jemanden zu suchen, und lehnte sich bequem in die Wagenecke. (P 29)
>
> [It did not show great presence of mind, and K. resolved to keep a better eye on himself in that respect. But he [. . .] immediately turned back again, however, without even having attempted to look for anyone, and leant back comfortably in the corner of the seat. (T 16)]

The adversative 'but' is voiced by the omniscient narrator, who repeatedly alerts the reader to the gulf between K.'s inner resolve and his behaviour.[8] As the novel wears on, this gulf between his intention and attention becomes ever more apparent, in chapters which all follow the same pattern. In each instance, K. is confronted with a new situation, which he approaches in a confident, aggressive manner, only eventually to be confronted with a new detail which overthrows all his previous assumptions. Thus, he takes the audience at his first hearing to be

[6] The phenomenon of inattentional blindness is memorably demonstrated by Daniel Simons and Christopher Chabris in their famous 'gorillas in our midst' experiment, where participants were tasked with counting the number of passes in a filmed basketball game; absorbed in this task, about half of them failed to notice a woman dressed in a gorilla costume who was passing through the scene. Simon J. Daniels and Christopher F. Chabris, 'Gorillas in our Midst: Sustained Inattentional Blindness for Dynamic Events', *Perception*, 28 (1999), 1059–74.

[7] 'Wie hatte er doch hingenommen sein müssen, von dem Aufseher und den Wächtern, um diese drei nicht zu erkennen' (P 27). Though K.'s self-diagnosis is broadly valid, he arguably fails to reflect on the principal cause of his oversight. Apart from the white blouse and the inspector's hand gestures, his gaze is repeatedly drawn to Fräulein Bürstner's photographs. Though the three clerks stand right beside them (P 20/T 8), K.'s focus throughout the scene is on the pictures rather than the people. For more details on this episode and the role of photography in the novel more generally, see Carolin Duttlinger, *Kafka and Photography* (Oxford: Oxford University Press, 2007), pp. 173–205.

[8] See for instance P 20; 32; 53; 250; 253.

divided spatially into two camps, but fails to spot the badges, which are hidden, and yet visible, underneath the spectators' thin beards (P 71/T 38); important information in Kafka's novel is neither concealed nor on full display, but tucked away at the margins of the protagonist's field of awareness. K.'s attention is focused on what he deems important, guided by his own preconceptions and prior experiences, which turn out to be useless in the context of the trial. His predicament echoes Freud's warning, in his 1912 'Recommendations to Physicians Practising Psychoanalysis', about the fallacies of an overly narrow, targeted attention that only sees what it wants to see. In exploring the fallout from this cognitive stance *The Trial* resonates with the psychological and psychoanalytic discourses of the time; in particular, Kafka's conception of attention is shaped by the theories of empirical psychology, with which he became acquainted while still at school.

The growing dominance of psychology in the German-speaking countries was cemented by a Prussian edict of 1824, which stipulated that all teachers working at the Gymnasium (secondary or high school) had to sit a psychology exam as part of their university degree. Though the proportion of psychology, compared to other, 'weightier' subjects, was minuscule, this edict nonetheless formed 'the seed for a slow, but substantial transformation of psychology' and its eventual installation at the heart of German-speaking academia and society.[9] Only one year later, a ministerial decree made psychology a compulsory subject in the final two years of the Prussian Gymnasium, as part of a curriculum of philosophical propaedeutics. This programme was subsequently emulated by most other German states as well as in Austria. Though existing studies have either ignored this compulsory training or mentioned it only in passing,[10] several generations of writers, thinkers, and researchers thus encountered psychology at a formative stage in their lives. In late nineteenth-century Austria, the syllabus included topics such as 'sensations from the outer senses, imaginative faculty, memory and other mental faculties, association of ideas, and the difference among ideas, thoughts, and concepts'.[11] These, then, were the kinds of questions with which Kafka grappled during his final two years at school. For him, as for all pupils in Austria, psychology lessons were based on the government-prescribed textbook, Gustav Adolf Lindner's *Lehrbuch der empirischen Psychologie* (Handbook of Empirical Psychology).[12]

[9] Horst U. K. Gundlach, 'Germany', in *The Oxford Handbook of the History of Psychology: Global Perspectives*, ed. David B. Baker (Oxford: Oxford University Press, 2012), pp. 255–88 (p. 264).

[10] A notable exception is Wilhelm Hemecker's study *Vor Freud: Philosophiegeschichtliche Voraussetzungen der Psychoanalyse* (Munich: Philosophia, 1991), which focuses on the impact of this syllabus on Freud's theories.

[11] Gundlach, 'Germany', p. 264.

[12] Gustav Adolf Lindner and F. Lukas, *Lehrbuch der empirischen Psychologie: Für den Gebrauch an höheren Lehranstalten*, 4th edn (Vienna: Carl Gerolds Sohn, 1912). This fourth edition is identical to the third, 1900 edition used by Kafka's class teacher Moritz Gschwindt. See Peter-André Alt, *Franz Kafka: Der ewige Sohn* (Munich: Beck, 2005), p. 79. On the use of Lindner's textbook in the Austrian school system and its influence on Freud in particular, see Hemecker, *Vor Freud*. Kafka's exposure to

Lindner (1828–87) held the first Chair in Psychology, Pedagogy, and Ethics at the Charles University in Prague. His textbook starts off with a physiological account of the brain and the different senses, but then moves on to theories of the mind which are based on the writings of Johann Friedrich Herbart (1776–1841).

Herbart was a philosopher at Königsberg and one of the advisers who led the Prussian government to introduce psychology as part of a course of philosophical propaedeutics. His theory of the mind was 'of a complexity never seen before in the history of psychology'.[13] This theory had two components. One was a relatively conventional breakdown of the different mental faculties, but the other was a new and radical dynamic theory of the mind, in which impressions and ideas are conceived as forces of differing strength which vie with each other for predominance.[14] Thus, new ideas and impressions are subsumed by older, more established ones; even though new impressions can initially seem to have the upper hand, in the long run only those impressions which can be harmonized with the existing mass of ideas, or *Vorstellungsmasse*, stand a chance of being assimilated.

Herbart's model of the mind is essentially conservative, emphasizing stability over novelty and change. As Lindner summarizes, 'apperception gives our mental life a certain *continuity* and *stability* by subordinating new impressions to older ones, and by putting everything in its rightful place and into the right relation to the whole'.[15] This process ensures a sense of cognitive continuity: 'Through apperception, individual impressions, which would normally pass us by in a fleeting manner, are held firmly in place'.[16]

Kafka's *Trial* echoes Lindner's argument both in its imagery and in the explicit theory of the mind which is outlined by the protagonist early on in the novel. In addition, the narrative gives enactive insights into the workings of attention, for its

empirical psychology did not end when he left school. As a law student in Prague, he took courses in philosophy taught by Anton Marty, a pupil of Brentano's, and was also part of the so-called 'Brentano Circle' that met in the Café Louvre between 1903 until 1905. In the following decade he regularly attended the philosophical salon run by Berta Fanta, where Brentano's theories were discussed alongside those of Freud. See Judith Ryan, *The Vanishing Subject: Early Psychology and Literary Modernism* (Chicago, IL: University of Chicago Press, 1991), p. 100.

[13] Gundlach, 'Germany', p. 263.

[14] See Gundlach, 'Germany', p. 263; and Rosemarie Sand, 'J. F. Herbart (1776–1841)', in *The Freud Encyclopedia: Theory, Therapy, and Culture*, ed. Edward Erwin (New York, NY: Routledge, 2002), pp. 376–8.

[15] 'Die Apperzeption bringt in unser Seelenleben eine gewissen *Stetigkeit* und *Festigkeit*, indem sie die neuen Eindrücke den älteren unterordnet, alles an seinen richtigen Platz und in die richtige Beziehung zum Ganzen stellt'. Lindner, *Lehrbuch*, p. 71.

[16] 'Durch die Apperzeption wird das einzelne festgehalten, während es sonst flüchtig an uns vorbeiginge'. Lindner, *Lehrbuch*, p. 71. This theory of apperception anticipates the twenty-first-century cognitive framework of 'predictive processing', which conceives of cognition not as passive and stimulus-driven but as a top-down process, whereby prior knowledge about the world is used to predict current and future sensory input: 'Mismatches between predictions and actual sensory input are not used passively to form percepts, but only to inform *updates* of representations which have already been created'. Wanja Wiese and Thomas Metzinger, 'Vanilla PP for Philosophers: A Primer on Predictive Processing', in *Philosophy and Predictive Processing*, ed. Thomas Metzinger and Wanja Wiese (Frankfurt a.M.: MIND Group, 2017), pp. 1–18 (p. 3).

shifting and often limited focalization reflects the gaps and slippages in Josef K.'s focus. On a more general level, then, the novel is concerned with one fundamental question: what happens if a person's habitual experience of the world is suddenly and completely derailed, and how can this radical change be understood in psychological terms?

In the novel, this disrupting event is of course K.'s arrest. In the opening chapter, he tries to understand what has just happened to him by recalling a theory he had once been told by an unnamed acquaintance. Given its complexity and stylistic intricacy it is worth quoting this passage in full:

> Jemand sagte mir, ich kann mich nicht mehr erinnern, wer es gewesen ist, dass es doch sonderbar sei, dass man, wenn man früh aufwacht, wenigstens im allgemeinen alles unverückt an der gleichen Stelle findet, wie es am Abend gewesen ist. Man ist doch im Schlaf und im Traum wenigstens scheinbar in einem vom Wachen wesentlich verschiedenen Zustand gewesen und es gehört wie jener Mann ganz richtig sagte eine unendliche Geistesgegenwart oder besser Schlagfertigkeit dazu, um mit dem Augenöffnen alles, was da ist, gewissermassen an der gleichen Stelle zu fassen, an der man es am Abend losgelassen hat. Darum sei auch der Augenblick des Erwachens der riskanteste Augenblick im Tag, sei er einmal überstanden, ohne dass man irgendwohin von seinem Platze fortgezogen wurde, so könne man den ganzen Tag über getrost sein. Zu welchen Folgerungen der Mann—ich habe mich übrigens schon erinnert wer es gewesen ist, aber der Name ist jagleichgültig [*sic*]— (*PA* 168-9)

> [Someone, I can't remember who it was, once said to me, isn't it strange how when we wake up in the morning generally speaking everything is still in the same place as the night before. It seems that while sleeping and dreaming we were in a state that's fundamentally different from waking life and it takes, as that man quite rightly said, an infinite presence of mind or, better, alertness [Schlagfertigkeit] to grasp things, as it were, in the place we'd let go of them the night before. That's why the moment of awakening is the riskiest moment in the day; once we've passed it without having been dragged away from our place to somewhere else we can be calm for the rest of the day. What conclusions that man—by the way, I've already remembered who it was, though the name of course doesn't matter—]

This paragraph clearly draws on Herbart's (and Lindner's) model of apperception as the guarantor of mental stability; more specifically, it echoes the spatial imagery used by Lindner when he argues that only apperception has the capacity of putting 'everything *in its rightful place* and into the right relation to the whole [...]' (my emphasis), thereby preventing impressions from fleetingly passing us by. In Kafka's novel, this same contrast between cognitive stability and disorienting

mobility is explored by K.'s nameless acquaintance—someone who obviously paid more attention at school than K. himself. As he argues, in the moment of awakening we must summon 'an infinite *presence* of mind' to 'grasp' things where they had been left the night before. If normality is not reinstated through this herculean effort of alertness, we risks being 'dragged away *from our place*' into unknown territory (my emphases).

In Lindner's textbook attention is discussed as the (causal) effect of a prior process of apperception: 'Mental attention is stimulated once an idea is capable of summoning an apperceptional mass of ideas into consciousness'.[17] In *The Trial*, this hierarchy is reversed: presence of mind is here seen as the precondition for cognitive stability, particularly in mental transition states such as awakening, when a habitual (apperceptional) view of the world first has to be re-established after a period of oblivion and is liable to be derailed by sudden, unexpected events.

In fact, Lindner also accounts for this possibility. Sometimes

> ältere Apperzeptionsmassen [werden] durch neu eintretende Vorstellungen erschüttert, zerfetzt, ja sogar vollständig umgewandelt [...], so daß sich der Gang der Apperzeption umkehrt. Eine solche Umwälzung geht, wenn sie *plötzlich* hereinbricht, nicht ohne die heftigsten Gemütsaufregungen vor sich, wie wenn wir etwa erfahren, daß eine Person, die wir bisher hochgeachtet haben, eine Tat begangen hat, die wir unbedingt missbilligen müssen.[18]
>
> [older clusters of apperceptions are shaken, destroyed, and even completely transformed by new ideas [...], and so the course of apperception is reversed. If it happens suddenly, such a radical change will trigger violent emotions, as when we learn that a much-esteemed person has committed a deed of which we must most strongly disapprove.]

This passage reads like a commentary on *The Trial*, where the arrest and subsequent trial do indeed shake up, destroy, and transform K.'s life and his understanding of the world. But while Lindner attributes this change to the sheer force of new impressions, that is, to phenomena in the *outside* world, Kafka locates the primary cause of this rupture *within* the protagonist, whose momentary inattention leaves him unable to incorporate new experiences into his habitual perception of the world.

For a reading of *The Trial* the above passage and its psychological intertext have vast implications. They reveal that in essence K.'s trial is not caused by external forces and events (his prior behaviour; the workings of an opaque institution) but come from within, springing from a set of psychological dynamics. If

[17] 'Die geistige Aufmerksamkeit wird erregt, sobald irgend eine Vorstellung imstande ist, eine apperzipierende Vorstellungsmasse ins Bewußtsein zu rufen'. Lindner, *Lehrbuch*, p. 71.

[18] Lindner, *Lehrbuch*, p. 70.

apperception guarantees the stability of cognitive experience then even a momentary drop in alertness can disrupt this semblance of normality and cast the observer afloat, forever at the mercy of new impressions and unfolding events.

Importantly, *The Trial* does not merely describe these psychological dynamics but enacts them within the narrative. Thus K.'s musings on the 'dangerous moment' of awakening are themselves presented as a meandering cognitive process. His reflections are disrupted by qualifying sub-clauses, his thought process repeatedly stalled by the uncertainty surrounding the identity of his acquaintance. By the end of the passage K. claims to have remembered the person's name but does not actually reveal it, declaring it to be irrelevant.

This sequence of forgetting, remembering, and foreclosing mirrors the fate of the passage within the body of the text. Having presented a psychological theory to account for K.'s arrest and trial, Kafka then deletes the passage from the manuscript—probably because it spells out its rationale all too clearly. Yet the argument is too compelling to be omitted altogether, and so the link between inattention and arrest recurs, in a revised form, in K.'s conversation with his landlady Frau Grubach. As he declares,

> ich wurde überrumpelt, das war es. Wäre ich gleich nach dem Erwachen, ohne mich durch das Ausbleiben der Anna beirren zu lassen, gleich aufgestanden und ohne Rücksicht auf irgendjemand, der mir in den Weg getreten wäre, zu Ihnen gegangen [...], kurz hätte ich vernünftig gehandelt, es wäre nichts weiter geschehn, es wäre alles, was werden wollte, erstickt worden. Man ist aber so wenig vorbereitet. In der Bank z.B. bin ich vorbereitet, dort könnte mir etwas derartiges unmöglich geschehn, ich habe dort einen eigenen Diener, das allgemeine Telephon und das Bureautelephon stehn vor mir auf dem Tisch, immerfort kommen Leute, Parteien und Beamte; außerdem aber und vor allem bin ich dort immerfort im Zusammenhang der Arbeit, daher geistesgegenwärtig, es würde mir geradezu ein Vergnügen machen dort einer solchen Sache gegenübergestellt zu werden. (P 34)
>
> [I was taken by surprise, that was all. If I'd got up as soon as I woke and come straight to you, without allowing myself to be flustered by Anna's non-appearance and not bothering about anyone who might have stood in my way, [...] if, in short, I had behaved sensibly, nothing would have happened, everything that was about to happen would have been nipped in the bud. But one is so ill prepared. In the bank, for example, I am prepared, it's impossible for something like that to happen to me there, I have a man of my own there, the outside telephone and the office telephone are on the desk in front of me, people are always coming in, clients and clerks; moreover, and above all, I'm constantly involved in my work, therefore always on the alert, it would be a real pleasure to be faced with such a situation there. (T 19)]

Unlike in the earlier, deleted passage, here the emphasis is not only on an inner state or faculty but also on the physical environment, on the force of habits and behaviour. If only he had *acted* sensibly, K. claims, if he had carried on with his morning routine, he could have regained control over events. Once again, reality is here seen not as a set of external events, but as a state that has to be physically and cognitively re-enacted every day. However, the ability to do so crucially depends on the context. As K. argues, the familiar setting of the bank and the routine of work facilitate a habitual state of alertness, while colleagues and communication technology act as a bulwark against the unexpected.

To be sure, K.'s claim that in the right state of mind he could have prevented his arrest, and hence his trial, is a megalomaniac fantasy, an instance of self-delusion. However, this sense of being able to control reality cognitively, to impose a sense of stability by means of attention, is important as a direct echo of Herbart's (and Lindner's) conservative theory of the mind. In Kafka's writings, this psychological model of attention as the guarantor of cognitive stability coexists, and arguably clashes, with the impact of another context in which (in-)attention played a crucial role: the field of accident insurance, which was the setting of Kafka's day-to-day professional role.

Absent-Mindedness

One controversial issue within the world of accident insurance around 1900 was the role of human error. Industrialized production and other forms of modern (transport) technology had led to a sharp increase in serious, often lethal, workplace accidents. The accelerated yet monotonous nature of modern labour produced boredom and inattention, a fatal combination in settings where even minimal errors could lead to major injury.[19] But who should pay for the consequences of such incidents? Did responsibility lie with the individual worker or with the employer?

A report presented at the 1899 International Conference for Workers' Accident Insurance in Paris reveals that the year-on-year number of workplace accidents had remained surprisingly consistent and concludes 'that these accidents, even if they are owed to mere chance, seem to be governed by mysterious laws'.[20] These mysterious laws are the laws of statistics, which injected a sense of predictability into the perilous process of modernization. By stressing the high statistical probability of workplace accidents, insurance law and practice echoed the

[19] See Benno Wagner, *Der Unversicherbare: Kafkas Protokolle* (Habilitationsschrift, University of Siegen, 1998), p. 4 and *passim*.
[20] 'Daraus folgt, daß die Unfälle, selbst wenn sie sich dem bloßen Zufall zu verdanken scheinen, von mysteriösen Gesetzen bestimmt werden'. Cited in François Ewald, *Der Vorsorgestaat*, trans. Wolfram Bayer and Hermann Kocyba (Frankfurt a.M.: Suhrkamp, 1993), p. 214.

conclusions of experimental psychology, whose investigations had shown attention to be universally and intrinsically unstable.

As a consequence, workplace accidents were re-coded around 1900 first as a professional and then a more general social risk, meaning that workers were covered by insurance as long as they were seen to be acting within the (statistical) norm. This maxim did not, however, extend to all forms of human behaviour. One question which troubled legal experts concerned the difference between 'ordinary' inattention and severe negligence (*Fahrlässigkeit*). To clarify this distinction, the Austrian lawyer Gustav Hanausek introduced an additional category: that of reckless behaviour, such as the climbing of a church spire, whereby individuals deliberately seek out danger.[21] The behaviour of a firefighter, in contrast, who is injured when saving someone from a burning building, does not fall under the category of uninsurable recklessness, for he acted for the common good.[22]

These debates about human behaviour and its underlying psychological motivations were central to Kafka's work for the Workers' Insurance Institute for the Kingdom of Bohemia. One of his main tasks was to assign employers to one of several risk categories, or *Gefahrenklassen*, according to the level of accident risk faced by employees. Echoing the Paris report, Kafka focuses not on workers' personal responsibility but on the risks posed by the working environment. In his 1910 article 'Unfallverhütungsmaßregel bei Holzhobelmaschinen' (Measures for Preventing Accidents from Wood-Planing Machines) (Figure 3.1), he warns that industrial planing machines are so badly designed that, even if an 'extremely cautious worker might well take care that, as he works guiding the piece of wood over the planing blade, no part of his fingers protrudes beyond the wood',[23] the primary danger 'makes a mockery of all caution', for the extremely dangerous occurrence 'of raising and pitching back of the wood can never be either predicted or prevented' (*O* 110).[24] Kafka here posits the 'extremely cautious worker' as the rare, non-representative exception, and warns that even exceptional alertness is powerless in the face of the accident risk posed by the inadequate hardware.

In Kafka's article, human error is deliberately underplayed—in part no doubt a rhetorical strategy designed to emphasize the need for safer working conditions. A very different picture, however, emerges in his fiction. Here, slippages and errors are put centre stage, as the driving force of narratives where even minor

[21] Gustav Hanausek, *Unfallversicherung und Beweislast nach österreichischem Rechte: Zugleich ein Beitrag zur allgemeinen Rechtslehre* (Vienna: Manz, 1916), p. 61, n. 101. Cited in Wagner, *Der Unversicherbare*, p. 6.

[22] Thus the verdict of the Oberlandesgericht in Stuttgart, which is cited in Hanausek, *Unfallversicherung*, p. 57, n. 93.

[23] An 'äußerst vorsichtiger Arbeiter konnte wohl darauf achten, daß bei der Arbeit [...] kein Fingerglied über das Arbeitsstück hinaus vorstand', but the 'Hauptgefahr spottet jeder Vorsicht' (*AS* 196).

[24] The 'Emporheben und Zurückschleudern des Holzes war weder vorherzusehen noch zu verhindern' (*AS* 196).

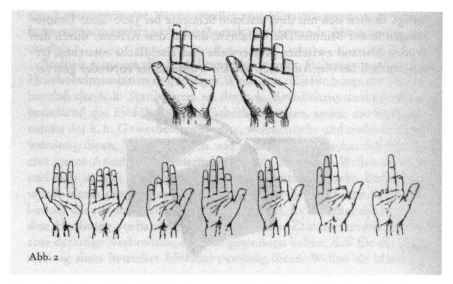

Figure 3.1 Franz Kafka, 'Unfallverhütungsmaßregel bei Holzhobelmaschinen' (Measures for Preventing Accidents from Wood-Planing Machines, 1910)

oversights can have major, catastrophic consequences.[25] Turning points in his plots are rarely caused by external events alone; they are the result of characters' behaviour, more specifically of the constitutive instability of human attention.

One of the most mysterious figures in Kafka's literary universe is the mythological Hunter Gracchus, traveller between life and death. Across several fragments the hunter tells his story, which is punctuated by two crucial, disastrous, moments of inattention. The first causes the hunter's death:

> Hier liege ich seit damals, als ich, noch lebender Jäger Gracchus, zuhause im Schwarzwald eine Gemse verfolgte und abstürzte. Alles ging der Ordnung nach. Ich verfolgte, stürzte ab, verblutete in einer Schlucht, war tot und diese Barke sollte mich ins Jenseits tragen. (*NSF I*, 312)
>
> [I have been lying here since the time when I was still alive, Huntsman Gracchus, at home in the Black Forest, when I chased after a mountain-goat, and fell. Everything went in the right order. I chased, I fell, I bled to death in a ravine, and this barque was meant to bear me to the beyond. (*HA* 116)]

[25] Wagner, *Der Unversicherbare*, p. 9.

The story is set in the fifth century AD,[26] but the hunter's account is underpinned by a distinctly modern sentiment. The story's tuning point, when his pursuit turns into a fall, is not dwelt upon as tragic, but presented as a commonplace, predictable sequence of events. What is described here is a workplace accident—the kind of incident which Kafka encountered on a daily basis at the Insurance Institute. As the hunter narrates his lethal fall, his detached tone suggests that he has internalized the modern notion of such accidents as statistically predictable. While he does not spell out the reasons behind his fall, his conversation with the mayor suggests that human error was the most likely cause:

> 'Ein schlimmes Schicksal', sagte der Bürgermeister mit abwehrend erhobener Hand. 'Und Sie tragen gar keine Schuld daran?' 'Keine', sagte der Jäger, 'ich war Jäger, ist das etwa eine Schuld? Aufgestellt war ich als Jäger im Schwarzwald, wo es damals Wölfe gab. Ich lauerte auf, schoß, traf, zog das Fell ab, ist das eine Schuld? Meine Arbeit wurde gesegnet. Der große Jäger vom Schwarzwald hieß ich. Ist das eine Schuld?' 'Ich bin nicht berufen, das zu entscheiden', sagte der Bürgermeister, 'doch scheint auch mir keine Schuld darin zu liegen. Aber wer trägt dann die Schuld?' (*NSF I*, 310)
>
> ['A terrible fate', said the Mayor, his hand raised as if to ward it off. 'And that is in no way your fault?' 'None', said the huntsman, 'I was a huntsman, is that my fault? I was appointed to be a huntsman in the Black Forest, where in those days there were still wolves. I would lie in wait, shoot, hit the animal, skin it—is that my fault? My work was blessed. The great huntsman of the Black Forest they called me. Is that my fault?' 'I am not called to decide on this', said the Mayor, 'but it does not seem to me either that there is any fault in that. But who does bear the blame then?' (*HA* 115)]

In an argument which evokes the modern notion of professional risk, the hunter rejects any personal responsibility, repeatedly stressing that he was just doing his job; indeed, the verb 'aufgestellt' (appointed) implies that he was doing so at someone else's behest. The question of personal guilt is raised and dismissed— only to be raised again. A little later, the hunter points the finger at the animal he was pursuing before his fall: 'If the mountain-goat hadn't tempted me—well, now you know—I would have had a fine long life of hunting, but the mountain-goat tempted me, I fell, and smashed myself to death on the rocks' (*HA* 120).[27] Here, the narration changes from an impersonal chain of events to an encounter

[26] The hunter claims that he has been travelling the oceans of the world for fifteen hundred years (*NSF I*, 396/*HA* 117).

[27] 'Hätte mich nicht die Gemse verlockt—so, nun weißt Du es—hätte ich ein langes schönes Jägerleben gehabt, aber die Gemse lockte mich, ich stürzte ab und schlug mich auf den Steinen tot' (*NSF I*, 383).

involving two parties with their own intentions and desires. The mountain-goat is no longer simply the prey but is said to lure the hunter, who is unable to resist. This alternative, more personally involved explanation for the accident prepares the ground for the second turning point of the story: an incident which takes place after the hunter's death.

The hunter is reconciled with death, indeed enthusiastic about his impending journey to the afterlife:

> Ich hatte gern gelebt und war gern gestorben, glücklich warf ich, ehe ich den Bord betrat, das Lumpenpack der Büchse, der Tasche, des Jagdrocks von mir hinunter, das ich immer stolz getragen hatte und in das Totenhemd schlüpfte ich wie ein Mädchen ins Hochzeitskleid. (*NSF I*, 312–13)
>
> [I had lived gladly, and I died gladly, I was happy to throw off from me, before I stepped on board, the useless burden of my gun and bag, and the hunting-jacket I had always worn with pride, and I slipped into my shroud like a girl into her wedding-dress. (*HA* 116–17)]

But on the journey another error is committed, this time by the helmsman who is to steer his boat into the underworld:

> '[...] Mein Todeskahn verfehlte die Fahrt, eine falsche Drehung des Steuers, ein Augenblick der Unaufmerksamkeit des Führers, eine Ablenkung durch meine wunderschöne Heimat, ich weiß nicht, was es war, nur das weiß ich, daß ich auf der Erde blieb und daß mein Kahn seither die irdischen Gewässer befährt. [...]'
> (*NSF I*, 309)
>
> ['[...] My ship bearing the dead took the wrong course, a false turn of the wheel, a moment of inattention on the part of the helmsman, a diversion through my wonderfully beautiful homeland, I don't know what it was, I only know that I remained on earth, and that since then my ship has sailed on earthly waters. [...]' (*HA* 115)]

Both hunter and helmsman are lured off their chosen route: one by the tempting mountain-goat, the other by the equally entrancing sight of the Black Forest, the hunter's beautiful homeland. The psychological dynamic which is glossed over in the first account is here spelled out in more detail. The sight of the beautiful landscape causes a 'moment of inattention', which in turn leads to a diversion or 'Ablenkung' in both a spatial and a mental sense. In this archaic tale, as in the modern workplace, momentary slips of attention can have major consequences.

Seen through the lens of the contemporary accident insurance discourse, however, these two accidents are very different. While the hunter's fall can be mapped onto the statistical pattern of human error followed by accidental death,

the helmsman's distraction falls outside the bounds of predictability, for it occurs in the liminal, entirely unpredictable space between life and death.[28] Death, as the one definitive outcome of any life, is here playfully undermined by Kafka. Revealingly, it is at this point that the story reinstates the notion of personal responsibility. When the mayor asks who is to blame for his terrible fate, the hunter unequivocally replies: 'The helmsman' (*HA* 115/*NSF II*, 310). The religious model of salvation, of life after death, as the ultimate 'insurance' against death, becomes null and void at the point when the person charged with conveying the hunter to his final destination turns out to be unreliable and error-prone in a domain 'where human errors can no longer be corrected'.[29] Once he has been taken off course, the hunter is doomed to sail the oceans forever.

Not all of Kafka's texts project the consequences of a single moment of absent-mindedness thus far into the future. But the basic pattern—the inverse relation between a minor error and its major consequences—is one which Kafka employs in several narratives. One disturbing example is the fragment 'Der Schlag ans Hoftor' (The Knock at the Courtyard Gate):

> Es war im Sommer, ein heißer Tag. Ich kam auf dem Nachhauseweg mit meiner Schwester an einem Hoftor vorüber. Ich weiß nicht, schlug sie aus Mutwillen ans Tor, oder in Zerstreutheit oder drohte nur mit der Faust und schlug gar nicht. Hundert Schritte weiter an der nach links sich wendenden Landstraße begann ein Dorf. (*NSF I*, 361–2)
>
> [It was in the summer, a hot day. On the way home with my sister I passed by a courtyard gate. I don't know whether she knocked on it out of mischief, or absent-mindedness, or whether she just shook her fist at it and didn't knock at all. A hundred paces further on, where the highway turned left, the village began.
> (*HA* 183–4)]

As in 'The Hunter Gracchus', the decisive event takes place en route, in this case on the siblings' way home. In this transitional state, which resembles *The Trial*'s moment of awakening, the characters are once again vulnerable to diverting forces. The topography of manor house and village prefigures Kafka's last novel *Das Schloss* (The Castle, 1922), for in both texts, the villagers are under the spell of a feudal authority. In fact, 'The Knock at the Courtyard Gate' combines features of both *The Castle* and *The Trial*. The villagers seem to have witnessed the sister's action, for they emerge from their houses

[28] Wagner calls the story an 'explorative protocol about the stakes, conditions, and dangers of the transition into a trans-normalist state'. *Der Unversicherbare*, p. 24.

[29] Wagner, *Der Unversicherbare*, p. 21.

freundschaftlich, aber warnend, selbst erschrocken, gebückt vor Schrecken. [...]
Die Hofbesitzer werden uns klagen, gleich werde die Untersuchung beginnen.
Ich war sehr ruhig und beruhigte auch meine Schwester. Sie hatte den Schlag
wahrscheinlich gar nicht getan und hätte sie ihn getan, so wird deswegen
nirgends auf der Welt ein Proceß geführt. Ich suchte das auch den Leuten um
uns begreiflich zu machen, sie hörten mich an, enthielten sich aber eines Urteils.
Später sagten sie, nicht nur meine Schwester, auch ich als Bruder werde angeklagt
werden. Ich nickte lächelnd. (*NSF I*, 362)

[in a friendly way, but in warning, themselves terrified, and crouching low in
their terror. [...] The owners are going to bring a complaint against us, and the
investigation will begin right away. I was very calm, and calmed my sister down
as well. She probably hadn't struck the blow at all, and if she had, there was
nowhere on earth where a trial would be held on that account. And I tried to
make the people around us understand this too; they listened to me, but withheld
their judgement. Later they said that not only my sister, but I too, as her brother,
would be charged. I nodded, giving a smile. (*HA* 184)]

Though the narrator tries to reassure his sister and himself, the villagers turn out to be right; armed riders are dispatched from the manor almost immediately, accompanied by a judge and his assistant. The narrator sends his sister away, asking her to get changed. He himself is taken to a 'Bauernstube' which is part prison, part interrogation (or torture) room. This is where the story breaks off, leaving a lingering sense that this trial, once set in motion, will unfold with merciless efficiency. As the judge remarks ominously, 'I feel sorry for this man' (*HA* 184).[30]

The storyline is puzzling in several respects; the draconian response to the sister's harmless action is only one part of this. Just as opaque are the causes behind this incident. Describing his sister's action, the narrator gives no fewer than three different explanations: 'I don't know whether she knocked on it out of mischief, or absent-mindedness, or whether she just shook her fist at it and didn't knock at all' (*HA* 183–4).[31] *Mutwillen* (mischief) and *Zerstreutheit* (absent-mindedness) map out the fraught terrain of insurability in Kafka's time. A classic example of human error, absent-mindedness falls squarely within the insurable domain, while mischief lies beyond it in the realm of deliberate, possibly malicious, transgression. This interpretation seems to be pursued by the prosecuting authorities in Kafka's tale. The third option mooted by the narrator—namely, that his sister raised her fist without actually knocking—is not really a separate scenario, although it does raise questions about the fundamental rationale of this 'trial'. Is the punishable offence the action itself, or is it the (criminal) mindset

[30] 'Dieser Mann tut mir leid' (*NSF I*, 363).
[31] 'Ich weiß nicht, schlug sie aus Mutwillen ans Tor, oder in Zerstreutheit oder drohte nur mit der Faust und schlug gar nicht' (*NSF I*, 363).

behind it, a view propagated by the Austrian penal code of the time, which criminalized not just the criminal act itself but also the intention to commit a crime?[32] According to this interpretation, an absent-minded, rather than a deliberate, knock might be even more transgressive, betraying a deeply rooted and almost casual defiance of the authorities.

Ultimately, though, all of these reflections are mere conjecture, for as the narrator admits, he did not actually witness what happened. Brother and sister, it seems, are linked by a shared absent-mindedness; his *Zerstreutheit* mirrors and exacerbates hers, and so he is neither able to prevent her action nor to provide a reliable testimony.

At a time when insurance law eliminated the principle of personal responsibility in all but the most extreme cases of recklessness, Kafka's fiction reinstates this principle in unsettling narratives where the smallest of errors have the gravest of consequences. At the same time, responsibility in this universe is rarely clear-cut, not least because the motivation behind such errors ultimately remains opaque. In narratives which recall Freud's *Psychopathology of Everyday Life*, Kafka shows attention to be deeply unstable, incapable of preventing errors and other transgressions which are driven by ultimately unknowable motivations.

Disciplining Attention

In the texts discussed so far, such errors are committed by adults,[33] who, according to the psychological and legal models of the time, should have acquired some degree of self-control. A rather different take on the problem of attention is presented in Kafka's first novel, *Der Verschollene* (The Man who Disappeared, 1912/1914), which features an adolescent protagonist whose attention is still in flux and whose mind and body are subject to constant conditioning interference.

Kafka's America is a hyperbolic version of modernity. For European commentators such as Karl Lamprecht, Georg Simmel, Wilhelm Erb, and Willy Hellpach, modern life is too fast and too complex, made up of a mêlée of stimuli, a barrage of information. The settings of Kafka's first novel take this speed and intensity to a new level, requiring superhuman vigilance and processing powers and lightning-fast reaction time. These cognitive strains are experienced by the European outsider and illustrated through a succession of iconic spaces of American life.

New York City as seen from Karl Rossmann's balcony in his uncle's skyscraper is an overwhelming multi-sensory spectacle. The never-ending traffic is accompanied by a mixture of sounds and smells, and all of this is illuminated by

[32] See Theodore Ziolkowsky, 'Law', in *Franz Kafka in Context*, ed. Duttlinger, pp. 183–90.
[33] The age of the siblings in 'The Knock on the Courtyard Gate' is not specified, though the judge's reference to the narrator as a man suggests that they are adults.

einem mächtigen Licht, das immer wieder von der Menge der Gegenstände zerstreut, fortgetragen und wieder eifrig herbeigebracht wurde und das dem betörten Auge so körperlich erschien, als werde über der Straße eine alles bedeckende Glasscheibe jeden Augenblick immer wieder mit aller Kraft zerschlagen. (V 56)

[a mighty light, that was forever being scattered, carried off and eagerly returned by the multitude of objects, and that seemed so palpable to the confused eye that it was like a sheet of glass spread out over the street that was being continually and violently smashed. (MD 29)]

The shattered pane of glass is a vivid image for mental fragmentation, as the senses are flooded with a barrage of stimuli. In this frantic world, unwavering vigilance is more important than ever, an economic imperative. This fact becomes apparent during Karl's visit to his uncle's haulage company, one of several chronotopes of modernity in the novel:

Mitten durch den Saal war ein beständiger Verkehr von hin und her gejagten Leuten. Keiner grüßte, das Grüßen war abgeschafft, jeder schloß sich den Schritten des ihm Vorhergehenden an und sah auf den Boden, auf dem er möglichst rasch vorwärtskommen wollte. (V 67)

[Through the middle of the room people were constantly coming and going at a frantic pace. Nobody said good day, that had been abolished, each person followed in the footsteps of the one preceding him and looked at the floor, on which he wanted to advance as fast as possible. (MD 35)]

Verkehr, which can be translated as traffic, or else as social or sexual intercourse, is a key word in Kafka's texts, and particularly in his first novel, where it refers to the endless and increasingly abstract circulation of goods, bodies, and information.[34] In the uncle's company, the huge volume of transactions requires an equally complex network of communication to maintain 'continuous connections by telephone and telegraph with its clients' (*MD* 35).[35] This vision of hyper-connectivity recalls Erb's 1893 lecture, where a virtually 'unlimited expansion of traffic' is facilitated by 'global telegraph and telephone networks'.[36] Unlike many of the neurasthenia treatises written around 1900, however, Kafka's novel does not focus on the pathogenic effects of this system but depicts people who rise to the

[34] See Mark M. Anderson, *Kafka's Clothes: Ornament and Aestheticism in the Habsburg 'Fin-de-Siècle'* (Oxford: Clarendon Press, 1992), pp. 22–3 and *passim*.
[35] '[...] unaufhörliche telephonische und telegraphische Verbindungen mit den Klienten' (*V* 66).
[36] Wilhelm Erb, *Ueber die wachsende Nervosität unserer Zeit* (Heidelberg: Hörning, 1893), p. 6. See Chapter 2, pp. 54–8.

challenges of their age with superhuman speed and efficiency. In one hall, Karl observes a telephonist

> gleichgültig gegen jedes Geräusch der Türe, den Kopf eingespannt in ein Stahlband, das ihm die Hörmuscheln an die Ohren drückte. Der rechte Arm lag auf einem Tischchen, als wäre er besonders schwer, und nur die Finger, welche den Bleistift hielten, zuckten unmenschlich gleichmäßig und rasch. (*V* 66)
> [ignoring the sound of the door, his head encased in a steel band that pressed the earpieces against his ears. His right arm was lying on a small table as though it were particularly heavy, and only his fingers, holding the pencil, twitched with inhuman regularity and rapidity. (*MD* 35)]

As discussed in the previous chapter, telephone operators were working in an exceptionally challenging environment, whose sensory overload regularly led to (mass) breakdown and nervous illness. Kafka's American telephonist bucks this trend. A man in a predominantly female profession, he seems indifferent to the noise around him, or at least able to ignore it as he focuses on the instructions he receives through the telephone. With his mind thus shielded, his body has become an extension of the apparatus, his hand twitching with mechanical regularity. From time to time he seems to have objections to what he is told, but instead of answering back, he is compelled 'to lower his eyes and write' (*MD* 35).[37]

The economic conditions which spark this passive alertness are lucidly described by the Frankfurt School critic Max Horkheimer, who notes that the ideal modern subject

> ist stets wachsam und bereit, immer und überall von derselben Wachsamkeit und Bereitschaft, immer und überall auf unmittelbar Praktisches gerichtet, auf Sprache nur hörend wie auf Information, Orientierung, Anordnung, ohne Traum und ohne Geschichte. [...] Das Individuum hat nicht mehr die Geschichte zu überblicken, es muß bloß bereit dazu sein, sich einzufügen, jedem Wink zu genügen, jeden Hebel zu bedienen, immer Verschiedenes und immer dasselbe zu tun. [...] Der Kampf ums Dasein besteht in der Entschlossenheit des einzelnen, in der Welt von Apparaten, Maschinen, Handgriffen nicht jeden Moment physisch vernichtet zu werden.[38]
> [is always watchful and ready, always aiming at some immediate practical goal; he takes the spoken word only as a medium of information, orientation, and command, and lacks both dreams and history. [...] The individual no longer has any future to care for, he has only to be ready to adapt himself, to follow orders,

[37] '[...] die Augen zu senken und zu schreiben' (*V* 67).
[38] Max Horkheimer, 'Vernunft und Selbsterhaltung', in *Gesammelte Schriften*, vol. 5, ed. Alfred Schmidt and Gunzelin Schmid Noerr (Frankfurt a.M.: Fischer, 1987), pp. 320–50 (p. 337).

to pull levers, to perform ever different things which are ever the same. [...] The fight for survival consists in the individual's determination not to be physically destroyed at any moment in the world of apparatuses, machines, abrupt hand gestures.[39]]

Though Kafka's novel describes these same conditions, its depiction of American modernity is, for the most part, not explicitly critical but rather portrays this dynamism with an almost giddy sense of excitement. Its young protagonist, in large parts the focalizer of the narrative, throws himself into the tasks imposed upon him, eager to excel at them. After he has been expelled by his uncle, Karl is hired as liftboy in the Hotel Occidental. His mentor, the head cook, stresses the paramount importance of paying attention (*V* 171/*MD* 88), and Karl quickly masters the mental and physical dexterity required to operate his elevator. Great 'presence of mind' is needed when deciding which lift to prioritize (*V* 208/*MD* 106), and the 'nervous rich guests' only add to this pressure (*V* 212/*MD* 109).

Karl, however, seems more than equal to these challenges until he is fired following the incident with his drunken companion Robinson. Before he leaves the hotel, he has the chance to observe the hotel system from the outside. Here, as at various points, the narrative revels in a kinetic account of American life. The two porters on duty at the reception desk are faced with 'at least ten enquiring faces' at once who ask questions in a multitude of languages (*V* 155/*MD* 130). This Babylonian mix sparks an equally confusing stream of replies, in which 'one piece of information followed so closely on another and faded into it' (*MD* 130) that Karl is unable to make any sense of what is said.[40]

One aspect highlighted in this sequence is the hierarchical nature of the modern attention economy. Supervised by the head porter, the assistant porters 'had only to think and speak', whereas the messenger-boys had to 'think and run simultaneously' (*MD* 131).[41] The physical and mental load is greatest for those at the bottom of the pile, their plight further exacerbated by constant surveillance—a pattern which is spelled out by Siegfried Kracauer in his 1930 sociological study *The Salaried Masses*.[42]

By using a young European protagonist to witness and partake in these scenes of American life, Kafka resorts to the traditional narrative device of the travelogue, whereby a foreign culture is seen through the eyes of an outsider. That said, the distinction between the New and the Old Worlds is far from clear-cut in Kafka's novel, particularly when it comes to mechanisms of attention. Karl is seventeen, a boy on the cusp of manhood, but even though he has already fathered a son, he

[39] Max Horkheimer, 'The End of Reason', in *The Essential Frankfurt School Reader*, ed. Andrew Arato and Eike Gebhardt (New York, NY: Continuum, 1982), pp. 26–48 (pp. 37–8).
[40] '[...] eine Auskunft so knapp an die andere anschloß und in sie übergieng' (*V* 256).
[41] '[...] gleichzeitig nachdenken und laufen mußten' (*V* 257). [42] See Chapter 5, pp. 145–56.

appears naïve and is often treated like a child by others. He is more likeable than the protagonists of *The Trial* and *The Castle*, but critics have also found him frustrating, noting that he acts 'like a three-year-old. We never have a sense that Karl can think about two things at once, or that his attention has a foreground and a background'.[43] His dreamy mindset is portrayed as childlike, but more specifically as European. Soon after his arrival, his uncle warns Karl that he

> sollte wohl alles prüfen und anschauen, aber sich nicht gefangen nehmen lassen. [...] Er selbst habe Neuankömmlinge gekannt, die z.B. statt nach diesen guten Grundsätzen sich zu verhalten, tagelang auf ihrem Balkon gestanden und wie verlorene Schafe auf die Straße heruntergesehen hätten. Das müsse unbedingt verwirren! Diese einsame Untätigkeit, die sich in einen arbeitsreichen Newyorker Tag verschaut, könne einem Vergnügungsreisenden gestattet und vielleicht, wenn auch nicht vorbehaltlos angeraten werden, für einen der hier bleiben wird sei sie ein Verderben. (*V* 55–6)
>
> [should observe and examine everything, but not let himself be taken captive. [...] He had himself known newcomers who, instead of following these sound principles, had spent whole days standing on their balconies gazing down into the street like lost sheep. That was bound to confuse them! For a tourist such solitary inactivity, gaping idly at a busy working day in New York, might be permissible and even, though not without reservations, advisable, but for someone who meant to stay here it was pernicious. (*MD* 30)]

The uncle's warning that Karl must not 'let himself be taken captive' prefigures *The Trial*, whose protagonist, absent-minded in the moment of awakening, is quite literally captured, dragged away from his usual place in the world.[44] In both novels, alertness is cast as an anchoring device, a vital skill in an unpredictable and potentially hostile world. To fend off its dangers, Karl must stay alert and detached; failure to do so spells not just inertia but loss of autonomy. Indeed, the uncle's description of newcomers as lost sheep aptly anticipates Karl's own experience, forever at the beck and call of good or (mostly) bad shepherds.

His uncle devises an educational programme designed to keep Karl busy, leaving no time for idle reverie. His English lessons are complemented by riding lessons at dawn, and Karl soon realizes that his constant tiredness stems not only from a lack of sleep but from 'the constant attention required during the day'

[43] Ryan, *The Vanishing Subject*, p. 107. Ryan reads the novel as a parody of Brentano's single-minded model of consciousness (p. 106).

[44] The 'einsame Untätigkeit' of the European newcomer recalls Kafka's solitary window-gazers in his first prose collection *Betrachtung* (Meditation, 1912), who are capable of neither clear thoughts nor decisive action. See Carolin Duttlinger, 'Kafkas Poetik der Aufmerksamkeit von *Betrachtung* bis "*Der Bau*"', in *Kafka und die kleine Prosa der Moderne/Kafka and Short Modernist Prose*, ed. Manfred Engel and Ritchie Robertson (Würzburg: Königshausen & Neumann, 2010), pp. 79–97.

(*MD* 33).⁴⁵ Ultimately, these lessons are less about specific skills than about instilling a more general state of alertness as demanded by the modern attention economy across all tiers of (American) society.

For all his apparent compliance, however, Karl's behaviour is not uniform. Time and again, he lapses into a different state of mind, one which oscillates between inadvertent reverie and conscious resistance. Thus, he continues to marvel at the design of the mechanical desk which his uncle has placed in his room, despite the uncle's warning not to do so. Indeed, this American desk, with its changeable drawers and compartments, reminds Karl of a very different, a European spectacle—a mechanical nativity scene also operated by turning a handle, which he watched as a child at the Christmas market. This sight is situated somewhere between a devotional image and a mechanized spectacle. Particularly revealing is its impact on the observers. Karl is spellbound, but it seems to him

> als ob die Mutter die hinter ihm stand nicht genau genug alle Ereignisse verfolge, er hatte sie zu sich hingezogen, bis er sie an seinem Rücken fühlte, und hatte ihr solange mit lauten Ausrufen verborgenere Erscheinungen gezeigt [...], bis die Mutter ihm den Mund zuhielt und wahrscheinlich in ihre frühere Unachtsamkeit verfiel. (*V* 58)
>
> [as if his mother, standing behind him, was not following all the events closely enough; he had pulled her towards him till he could feel her at his back, and spent so long drawing her attention with loud cries to inconspicuous details [...], that finally she put her hand over his mouth and probably relapsed into her previous state of inattention. (*MD* 31)]

Karl's mother cannot be shaken out of her habitual inattention, her detachment insulating her against spontaneous pleasure and immersion. Karl's childhood memory shows adults and children to be divided along cognitive lines, a divide which applies in both Europe and America. The novel, however, also contains a second childhood memory, which presents a very different image of family life as a space of *shared* immersion. Later on in the narrative, when he is Brunelda's captive, Karl remembers how he used to do his homework,

> während der Vater die Zeitung las oder Bucheintragungen und Korrespondenzen für einen Verein erledigte und die Mutter mit einer Näharbeit beschäftigt war und hoch den Faden aus dem Stoffe zog. [...] Wie still war es dort gewesen! Wie selten waren fremde Leute in jenes Zimmer gekommen! Schon als kleines Kind hatte Karl immer gerne zugesehen, wenn die Mutter gegen Abend die Wohnungstür mit dem Schlüssel absperrte. (*V* 342–3)

⁴⁵ '[E]r litt hier, wohl infolge der steten Aufmerksamkeit, die er während des Tages aufwenden mußte, geradezu an Schlafsucht' (*V* 63).

[while his father read the paper or made ledger entries and answered letters for a club and his mother occupied herself with sewing, pulling the thread high up out of the fabric. [...] How silent it had been there! How rarely did strangers enter that room! Even as a small child Karl had always enjoyed watching his mother, as evening approached, lock the door of their flat with her key. (*MD* 174)]

While other childhood memories highlight the rift between Karl and his parents, this memory recalls a caring, sheltered home life based on a sense of common purpose, of three people individually yet jointly immersed in their respective tasks. As an ideal of community bound together by labour and concentration, it is reminiscent of Walter Benjamin's 'Storyteller' essay,[46] though the scene is more ambiguous than it may at first appear. The mother's act of locking the door implies that this shared state of concentration is not wholly self-sufficient but requires external barriers to protect it against disruption. Indeed, the continuation of this childhood memory undermines the notion of study as a protective space. Not only has Karl forgotten most of what he learnt at home, but

wenn es darauf angekommen wäre, hier sein Studium fortzusetzen, es wäre ihm sehr schwer geworden. Er erinnerte sich daran, daß er zu Hause einmal einen Monat lang krank gewesen war—welche Mühe hatte es ihn damals gekostet, sich nachher wieder in dem unterbrochenen Lernen zurechtzufinden. Und nun hatte er außer dem Lehrbuch der englischen Handelskorrespondenz schon so lange kein Buch gelesen. (*V* 343)

[if there had been any question of continuing his studies here, he'd have found it very hard. He remembered how he had once been ill at home for a month—what effort it had cost him to find his way back into his interrupted course of learning. And now, apart from the textbook of English business correspondence, it was so long since he'd read a book. (*MD* 175)]

The irreversible break with studying as a state of deep immersion happens not when Karl is exiled, but while he is still at home; it is a rupture caused by his own body, pointing to the physiological limits of concentration.

Indeed, any vestigial idealism associated with the act of studying is destroyed when one night Karl gets to talk to the student sitting on the balcony next door. Though he appears completely immersed, Karl soon begins to wonder 'whether he was again reading his book or only looking into it absent-mindedly' (*MD* 178).[47] Is immersion an inner state or merely a pose, a performance? The student complains to Karl that 'the way you stare across is terribly distracting' (*MD* 175),[48] adding

[46] See Chapter 8, pp. 000–0.
[47] '[...] ob er in seinem Buche schon wieder las oder nur zerstreut hineinstarrte' (*V* 349).
[48] 'Ihr Herüberstarren stört mich schrecklich' (*V* 343).

that 'unfortunately, I'm so nervous that it takes me a long time to find my place again. Since you started your walks on the balcony, I haven't been able to get on with studying' (*MD* 176).[49]

Study is no bulwark against distraction, but is subject to the same fragmenting forces which also govern modern life as a whole. In the age of nervousness and sensory overload, it is reduced to a transient state, to a mere mechanical routine with little substance. The student reveals that he studies at night while holding down a daytime job in a department store; if he had to choose, he would opt for his daytime work over his studies any day. In Kafka's America, learning is part of a pervasive disciplinary regime, in which people are 'made productive and orderly, whether as student, worker, or consumer'.[50]

From the ocean liner to the skyscraper, from the factory to the grand hotel, from the demonstration to the recruitment fair, the novel takes its readers and protagonist through a succession of modern spaces. The locations are varied, but the power dynamics remain the same. Kafka's America is a vast psychological laboratory where the protagonist is put through his paces, his mental and physical capacities tested to the limit and often found wanting.

Yet this disciplinary narrative is punctuated by moments of respite—moments where the mind is released from the stranglehold of constant alertness. The novel contains several scenes that hint at such alternative states of mind, where Karl is immersed in an activity or able to lose himself in a spectacle. Many of them are flashbacks, but there is one scene set in the present, which stands out from the rest of the novel and offers a potential antidote to the imperative of perpetual alertness but also to the supposedly dangerous state of passive absorption warned against by Karl's uncle. Having been fired from his liftboy post, Karl is chased by a police officer. As he races through a maze of backyards, he comes across a sight that will become etched into his memory: 'in one office the window was open and a clerk sitting at his desk had turned away and was looking pensively out just as Karl and Delamarche went past' (*MD* 146).[51] Karl later recalls this scene when he is held captive by Brunelda and tries to think of an aspiration for the future:

> Er wollte ja gern, wenn es sein mußte, Geschäftsdiener werden, aber schließlich war es ja gar nicht ausgeschlossen, daß er auch für reine Büroarbeit aufgenommen werden konnte und einstmals als Bürobeamter an seinem Schreibtisch

[49] '[I]ch bin leider so nervös, daß ich lange Zeit brauche, um mich wieder hineinzufinden. Seit Sie da Ihre Spaziergänge auf dem Balkon angefangen haben, komme ich mit dem Studieren nicht vorwärts' (*V* 346).

[50] Jonathan Crary, *Suspensions of Perception: Attention, Spectacle, and Modern Culture* (Cambridge, MA: MIT Press, 1999), p. 23. Thus, when he opposes Karl visiting Herr Pollunder, the uncle notes that 'ich kann sein Studium nicht so in Unordnung kommen lassen' ('I can't allow his studies to become disorganized in such a way'; *V* 72/*MD* 38).

[51] '[I]n einem Bureau war das Fenster geöffnet und ein Angestellter, der an einem Schreibpult saß, hatte sich von ihm abgewendet und sah nachdenklich hinaus, wo gerade Karl und Delamarche vorübergiengen' (*V* 288).

sitzen und ohne Sorgen ein Weilchen lang aus dem offenen Fenster schauen
würde wie jener Beamte, den er heute früh beim Durchmarsch durch die Höfe
gesehen hatte. (*V* 353)

[He would be glad, if necessary, to become a shop assistant, but after all it wasn't
impossible that he might be employed for pure office work and would one day be
an office worker sitting at his desk and gazing for a while, free from worries,
through the open window, like the official he had seen this morning while
marching through the courtyards. (*MD* 180)]

The sight of the clerk gazing out of the window is etched in Karl's memory; the importance of this vignette for Kafka's writings overall cannot be overstated. Unlike roles which require unceasing vigilance—those of hunter and helmsman, liftboy, porter, and telephonist—office work is depicted as allowing for brief moments of reverie and reflection, momentarily releasing the mind from any specific focus. Having been put through his paces in the American system, Karl's goal is neither freedom nor a complete escape from the rat race of capitalism, but merely to carve out a space of relative autonomy within the existing disciplinary structures of attention.

Writing Scenes: Noise, Silence, Immersion

It is of course rather ironic that Kafka chooses an office clerk as the focus of Karl Rossmann's aspirations given how bitterly he resented the monotony of his own role at the Workers' Accident Insurance Institute. Kafka regarded his post as a distraction from his literary vocation, though his daytime work was by no means the only source of distraction which interfered with his writing.

In his letters and diaries, Kafka repeatedly records his anxieties concerning his own productivity and attention span. His nocturnal writing routine was designed to shelter him from all distractions,[52] particularly the ones emanating from his family. The early prose piece 'Großer Lärm' (Great Noise, 1911), which started its life as a diary entry, depicts the manifold distractions of domestic life:

Ich sitze in meinem Zimmer im Hauptquartier des Lärms der ganzen Wohnung. Alle Türen höre ich schlagen, durch ihren Lärm bleiben mir nur die Schritte der zwischen ihnen Laufenden erspart, noch das Zuklappen der Herdtüre in der Küche höre ich. Der Vater durchbricht die Türen meines Zimmers und zieht im nachschleppenden Schlafrock durch, aus dem Ofen im Nebenzimmer wird die

[52] Kafka's office post finished at 2 p.m.; following an afternoon nap, he typically started to write after his parents and sisters had gone to bed.

Asche gekratzt, Valli fragt, durch das Vorzimmer Wort für Wort rufend, ob des Vaters Hut schon geputzt ist. (*DL* 441)

[I am sitting in my room, in the headquarter of the noise of the entire flat. I hear all the doors bashing, because of their noise I am only spared the sound of the steps of those who are running between them, I still hear the door of the oven being shut in the kitchen. The father bursts through the doors of my room and crosses it, his nightgown trailing behind, ash is being scraped out of the stove in the room next door, Valli asks, calling the words across from the hallway, whether father's hat has already been brushed.]

Neurasthenia writers and anti-noise campaigners usually cite work, urban life, and mass entertainment as the main sources of distraction. In Kafka's text, the narrator is driven to despair by the more low-key sounds of home life. The imagery of doors being open and shut, even broken down (*durchbrochen*), reflects the violent collapse of the mind's protective barriers. Here, the invasiveness of the different sounds is inversely proportionate to their volume; after the parents have left, the narrator's ordeal is far from over, for now begins 'the gentler, more dispersed and more hopeless noise, led by the voices of the canaries'.[53] In response, the narrator wonders whether he should crawl 'snake-like into the adjoining room [...], begging my sister and her governess to be quiet'.[54]

'Great Noise' is precariously balanced between humour and despair. Life in the 'headquarter of noise' erodes concentration and indeed the narrator's humanity; and yet, this distracting soundscape provides the impetus and subject for writing. In this regard, 'Great Noise' reflects a challenge which is repeatedly addressed, but never resolved, in Kafka's personal and fictional writings: how to strike a balance between the seclusion needed for sustained writing and continued contact with the outside world, which provides stimulation and inspiration as well as much-needed diversion from the effort of creative production?

One text which illustrates that this balance can be struck successfully is 'Das Urteil' (The Judgement). Kafka wrote it over the course of one night, on 22–23 September 1912. His account of this experience, which he records immediately after finishing the story itself and which acts as a kind of autobiographical postscript, offers some revealing insights into the writing process:

Wie es vor dem Fenster blau wurde. Ein Wagen fuhr. Zwei Männer über die Brücke giengen. Um 2 Uhr schaute ich zum letztenmal auf die Uhr. Wie das Dienstmädchen zum ersten Mal durchs Vorzimmer gieng, schrieb ich den letzten

[53] '[...] der zartere, zerstreutere, hoffnungslosere Lärm, von den Stimmen der Kanarienvögel angeführt' (*DL* 441).
[54] '[...] ob ich nicht [...] schlangengleich ins Nebenzimmer kriechen und so auf dem Boden meine Schwester und ihr Fräulein um Ruhe bitten sollte' (*DL* 441-2).

Satz nieder. [...] Viele während des Schreibens mitgeführte Gefühle: z. B. die Freude daß ich etwas Schönes für Maxens Arcadia haben werde, Gedanken an Freud natürlich, an einer Stelle an Arnold Beer, an einer andern an Wassermann, an einer (zerschmettern) [sic] an Werfels Riesin, natürlich auch an meine 'Die städtische Welt'.[55]

[How it turned blue outside the window. A wagon rolled by. Two men walked across the bridge. At two I looked at the clock for the last time. As the maid walked through the ante-room for the first time I wrote the last sentence. [...] Many emotions carried along in the writing, joy, for example, that I shall have something beautiful for Max's Arkadia, thoughts about Freud, of course; in one passage, of Arnold Beer; in another, of Wassermann; in one (shattered one), of Werfel's giantess; of course, also of my 'The Urban World'.[56]]

Crucially, writing is here experienced not as a state of oblivious immersion but of continued awareness of the world beyond the text. Sights and sounds from outside the window, as well as thoughts about the afterlife of the text and its potential sources, accompany its production and are recorded after it is completed, as an integral part of the writing experience. Creativity does not happen sealed off from outside distractions but is located on the interface between the mind and the world. As various critics have noted, for Kafka the writing process was more important, and more satisfying, than the finished product.[57] In his diary account Kafka uses images of water and swimming, which literalize the experience of deep concentration, or 'flow',[58] where focusing on a task requires no conscious effort but becomes pleasurable and self-perpetuating.

In Kafka's biography, the status of 'The Judgement' as his breakthrough text is certainly deserved, but for its author this ecstatic experience was not only a model and ideal, but something of a stumbling block. Kafka struggled to repeat this immersive experience, not least because longer texts could not be written in a single sitting but required ongoing, sustained effort over many days and weeks. Kafka never felt comfortable with this slower, drawn-out approach. He did not make plans and often abandoned texts after one sentence or paragraph. If the opening did not have the momentum to propel the narrative then no amount of editing was going to change that.

[55] Franz Kafka, *Tagebücher*, ed. Hans-Gerd Koch, Michael Müller, and Malcolm Pasley, Franz Kafka: Schriften, Tagebücher, Briefe: Kritische Ausgabe (Frankfurt a.M.: Fischer, 1990), p. 461.

[56] Franz Kafka, *Diaries, 1910–1923*, ed. Max Brod, trans. Joseph Kresh and Martin Greenberg with the cooperation of Hannah Arendt (New York, NY: Schocken, 1988), p. 213.

[57] See for instance Gerhard Neumann, 'Der verschleppte Prozeß: Literarisches Schreiben zwischen Schreibstrom und Werkidol', *Poetica*, 14 (1982), 92–111.

[58] Mihaly Csikszentmihalyi, who coined this term, describes it as 'the ability to focus attention at will, to be oblivious to distractions, to concentrate for as long as it takes to achieve a goal, and not longer'. *Flow: The Psychology of Happiness. The Classic Work on How to Achieve Happiness* (London: Rider, 2002), p. 31.

The night in September 1912 became a benchmark against which every subsequent writing session in Kafka's life was measured—and usually found wanting. This sense of failure was sometimes attributed to inner causes—tiredness, a lack of concentration, a scattered, dispersed state of mind—but sometimes to external factors. 'Great Noise' describes the obstacles to immersion posed by family life; another potential source of disturbance are sexual relationships.

In a letter written two months after the creation of 'The Judgement', at a time when his relationship with Felice Bauer in Berlin had become established and intimate in tone, Kafka implores Bauer not to stay up late to write to him. At first, this request is dressed up as concern for her health, but then Kafka changes tack: 'Well, no more late writing, leave writing at night to me, give me this faint chance to be proud of my nightwork, it is the only pride I feel vis-à-vis you' (*LF* 59).[59] To support his claim that nocturnal work all across the world 'belongs' to men, he cites a poem by the eighteenth-century Chinese poet Yan-Tsen-Tsai, in which a writer who stays up late eventually has his lamp taken away by his 'beautiful friend', who asks exasperated: 'Do you know how late it is?' (*LF* 60).[60] Though Kafka recounts this episode in a humorous tone, his letter reflects deep-rooted anxieties about what he perceived to be the incompatibility of the creative and the domestic life. Nocturnal writing is here designated as a male space, as part of a gendered division of labour; the letter expresses this idea playfully, via the erotically charged dialogue between two lovers, but it raises an existential question: how to preserve this protected space in marriage, which was fast becoming a real prospect?

Kafka's concerns are expressed rather more bluntly in a letter written two months later. His ideal mode of existence, he states, would be to live 'in the innermost room of a spacious locked cellar with my writing things and a lamp. Food would be brought and always put down far away from my room, outside the cellar's outermost door' (*LF* 156).[61] This 'innermost' cellar room is the antidote to the bedroom in 'Great Noise', which is exposed to physical and acoustic intrusions. Kafka's little vignette is a thinly veiled rejection of married life, in which his wife would be entitled to curtail his writing sessions. In the cellar, no such interference is possible, for in this self-imposed prison the lamp is the writer's sole companion. For Kafka, this solitary life sparks no anxiety but only elation:

[59] 24 November 1912. 'Also nicht mehr abends schreiben, mir das Schreiben in der Nacht überlassen, mir diese kleine Möglichkeit des Stolzes auf die Nachtarbeit überlassen, es ist der einzige, den ich Dir gegenüber habe'. Franz Kafka, *Briefe 1900–1912*, ed. Hans-Gerd Koch, Franz Kafka: Schriften, Tagebücher, Briefe: Kritische Ausgabe (Frankfurt a.M.: Fischer, 1999), p. 258.

[60] 'Weißt Du, wie spät es ist?'. Kafka, *Briefe 1900–1912*, p. 259.

[61] 14–15 January 1913; '[...] mit Schreibzeug und einer Lampe im innersten Raume eines ausgedehnten, abgesperrten Kellers [...]. Das Essen brächte man mir, stellte es immer weit von meinem Raum entfernt hinter der äußersten Tür des Kellers nieder'. Franz Kafka, *Briefe 1913–März 1914*, ed. Hans-Gerd Koch, Franz Kafka: Schriften, Tagebücher, Briefe: Kritische Ausgabe (Frankfurt a.M.: Fischer, 2001), p. 40.

'How I would write! From what depths I would drag it up! Without effort! For utmost concentration knows no effort' (*LF* 156).[62]

As in Kafka's diary account about 'The Judgement', writing is cast as deep, effortless immersion, except that in this narrative no window connects the author to the outside world. This shift—from the desk by the window to the windowless cellar—reflects Kafka's growing concerns about the vulnerability of his physical as well as mental writing space, his fragile concentration. But is this state of seclusion really viable, let alone productive? In 'Great Noise', as in other diary passages, letters, and prose texts, observation of the outside world sparks creativity and self-reflection; far from simply being obstacles and disturbances, the 'distractions' of real life facilitate a form of writing which is focused and yet open to the outside world, to the inevitable messiness of human experience.

Over the course of his life, however, Kafka's tolerance towards this messiness declined markedly, as his noise sensitivity turned into an affliction. In 1915, he writes to Felice Bauer:

> Ich will nur Ruhe, aber eine Ruhe, für welche den Leuten der Begriff fehlt. Sehr verständlich, kein Mensch braucht im gewöhnlichen Haushalt die Ruhe, die ich brauche; zum Lesen, zum Lernen, zum Schlafen, zu nichts braucht man die Ruhe, die ich zum Schreiben brauche. (11 February 1915; *B14* 119)
>
> [All I want is peace, but the kind of peace that is beyond people's understanding. Obviously—since no one in any ordinary household needs the kind of peace necessary to me; neither reading, nor studying, nor sleeping, in fact nothing needs the kind of peace I need for writing. (*LF* 445)]

During the war, Kafka had moved out of his parents' flat into private lodgings, but there, living conditions were even worse than at home:

> Seit gestern bin ich in meinem neuen Zimmer und habe gestern abend Verzweiflungsanfälle gehabt, daß ich glaubte, die Notwendigkeit aus dem Zimmer und aus der Welt hinauszukommen sei für mich die gleiche. Und dabei geschah nichts besonderes, alle sind rücksichtsvoll, meine Wirtin verflüchtigt sich zum Schatten mir zuliebe, der junge Mensch, der neben mir wohnt, kommt abends müde aus dem Geschäft, macht paar Schritte und liegt schon im Bett. Und trotzdem, die Wohnung ist eben klein [...], ein wenig flüstern wird man immer, die Türglocke wird läuten, gestern hat der Mieter zweimal gehustet, heute schon öfter, sein Husten tut mir mehr weh als ihm.
>
> (*B14* 119–20)

[62] 'Was ich dann schreiben würde! Aus welchen Tiefen ich es hervorreißen würde! Ohne Anstrengung! Denn äußerste Koncentration kennt keine Anstrengung'. Kafka, *Briefe 1913–März 1914*, p. 40.

[I have been in my new room since yesterday, and last night I was in such a state of despair that I imagined the urgency with which I longed to get out of this room, and out of the world, were equal. And yet nothing unusual had happened; they are all very considerate, my landlady fades quietly into the shadows for my sake; the young man who sleeps next door comes home tired from the office, takes a few steps, and is in bed. And yet the apartment is undoubtedly small [...], there is always bound to be a certain amount of whispering, the doorbell is bound to ring; the lodger coughed twice yesterday, by today it was more often, his cough hurts me more than it does him. (*LF* 445)]

As in 'Great Noise', the smallest sounds are the most corrosive, breaking down the barrier between self and other as the neighbour's cough seems to become Kafka's own. His painstaking description is full of self-irony, even self-disdain, acknowledging both the disproportionateness of his response and the huge sacrifices made by those around him, such as his brothers-in-law, who were fighting in the war.[63] Indeed, the wartime situation is incorporated into Kafka's complaint:

Lache nicht, F., finde mein Leiden nicht verächtlich, gewiß, so viele leiden jetzt, und was ihr Leiden verursacht, ist mehr als ein Flüstern im Nebenzimmer, aber gerade im besten Falle kämpfen sie für ihre Existenz oder richtiger für die Beziehungen, die ihre Existenz zur Gemeinschaft hat, nicht anders ich, nicht anders ein jeder. (*B14* 120)

[Don't laugh, F., don't look upon my suffering as despicable; no doubt many people are suffering nowadays, and the cause of their suffering is something more than whispers in the next room; at best, however, they are fighting for their existence, or rather for the bonds connecting their existence to that of the community, and so do I, and so does everyone. (*LF* 445)]

Kafka's comparison of his own suffering to the experience of the fighting soldiers can be read as an instance of almost laughable narcissism. He is well aware of this—and yet he tells Bauer not to laugh. What is at stake, for both the writer and the soldiers fighting for survival, is a continued connection to others, to the community, to life itself. For him, this involves shielding himself, cutting himself off from all evidence that these others exist. It is a curious paradox, whose implications he will only trace several years later.

Kafka's definition of silence goes beyond common, everyday definitions of the term, even beyond what can be expressed in language itself. The purchase of a pair

[63] 'Die Wirtin hat sich früh wegen des Flüsterns entschuldigt, es sei nur ausnahmsweise gewesen, weil der Mieter (meinetwegen) das Zimmer gewechselt hat'. 11 February 1915; *B14* 120 ('this morning my landlady apologized for the whispering, it was most unusual and had occurred only because the lodger (for my sake) was moving to another room'; *LF* 445).

of earplugs is one of many ways in which he tries to alleviate his sufferings.[64] As so often, however, his attitude towards noise is not without contradictions. A long letter to Bauer about his new lodgings begins: 'I shall grumble, F., grumble until I feel better' (*LF* 444).[65] Kafka's letters and diaries are full of noise protocols, in which the surrounding, distracting sounds are painstakingly recorded. Such records can offer some relief, an emotional outlet, for the writer's strained nerves, and they are also drivers of productivity. 'Great Noise', which started its life as a diary entry, is one example; another is 'Blumfeld ein älterer Junggeselle' (Blumfeld, an Elderly Bachelor), which was inspired by some strange sounds Kafka heard in the (allegedly uninhabited) room above.[66] In Kafka's writings, distraction is an omnipresent threat, and aural stimuli are more invasive than visual ones. Particularly if they are divorced from sight, sounds can be puzzling, spark vigilance and ultimately paranoia, in stories where even utmost alertness no longer provides certainty about the world.

'The Burrow', 'The Neighbour', *The Castle*: Attention at the Limits

Perhaps the most extreme example of this self-perpetuating process is 'Der Bau' (The Burrow), an unfinished story on which Kafka worked during his last winter, in 1923–4, living in Berlin. According to Dora Diamant, the bulk of the text was written in one night,[67] thus harking back to the immersive experience of writing 'The Judgement'. Indeed, the story reflects the coherence of the writing process, for it is as captivating as it is relentless. 'The Burrow' is an exploration of the psychodynamics of paranoia. Readers find themselves trapped in a claustrophobic narrative where dissenting views do not exist. The only respite is humour; in the course of the story, the animal's labyrinthine thoughts and compulsive behaviour become increasingly grotesque.

The narrator is an unspecified animal who lives in a vast underground burrow. He, or she, spends all his time repairing and extending it, for the burrow is a safe haven, offering protection against a hostile outside world. Soon, however, it becomes a site of danger and endless distraction. Early on, the animal declares that

[64] 'Für den Tageslärm habe ich mir aus Berlin [...] eine Hilfe kommen lassen, Oropax' ('For the daytime noise I have ordered some aids from Berlin [...]: ear plugs'. 4 April 1915; *B14* 126). Interestingly, Kafka only specifies the problem of daytime noise.

[65] 'Ich werde klagen F., klagen bis mir leichter ist' (*B14* 118).

[66] See his letter of 21 March 1915; *B14* 123–4.

[67] Dora Diamant, 'Mein Leben mit Franz Kafka', in *'Als Kafka mir entgegenkam...': Erinnerungen an Franz Kafka*, ed. Hans-Gerd Koch (Frankfurt a.M.: Fischer, 2000), pp. 174–85 (p. 179).

> es sind nicht nur die äußern Feinde die mich bedrohen, es gibt auch solche im Innern der Erde, ich habe sie noch nie gesehn, aber die Sagen erzählen von ihnen und ich glaube fest an sie. Es sind Wesen der innern Erde, nicht einmal die Sage kann sie beschreiben, selbst wer ihr Opfer geworden ist hat sie kaum gesehn, sie kommen, man hört das Kratzen ihrer Krallen knapp unter sich in der Erde, die ihr Element ist, und schon ist man verloren. (*NS II*, 578)
>
> [it is not only external enemies from outside who threaten me, there are also some deep in the earth; so far I have never seen them, but legends tell of them, and I firmly believe in them. They are beings within the depths of the earth; not even legend can describe them, even those who become their victims have scarcely seen them; they come; you can hear their claws scratching just below you in the earth, which is their element, and already you are lost. (*HA* 154)]

Given that the animal feeds him- or herself by killing small animals that live underground, these imagined enemies are obviously projections, doubles of the narrator, just as the imagined moment of terror is undoubtedly experienced by the animal's victims. But in the absence of real adversaries, the burrow absorbs all of his or her efforts; it is so large and intricately structured that it is impossible to maintain.

This vigilance, already prone to excesses, is taken to new extremes when one day the narrator is woken by a strange hissing sound. Having ruled out other causes, s/he concludes that it must stem from another animal—the dreaded enemy who has finally invaded the burrow. But all efforts to find this enemy come to nothing, and so the situation remains unchanged. As the burrow turns into a danger zone, only the (exposed) entrance area can grant momentary respite:

> Ich dringe bis hinauf vor und horche. Tiefe Stille; wie schön es hier ist, niemand kümmert sich dort um meinen Bau, jeder hat seine Geschäfte, die keine Beziehung zu mir haben [...]. Hier an der Moosdecke ist vielleicht jetzt die einzige Stelle in meinem Bau, wo ich stundenlang vergebens horchen kann. Eine völlige Umkehrung der Verhältnisse im Bau, der bisherige Ort der Gefahr ist ein Ort des Friedens geworden, der Burgplatz aber ist hineingerissen worden in den Lärm der Welt und ihrer Gefahren. (*NS II*, 621)
>
> [I climb up towards it and listen. Deep silence; how beautiful it is here; no one troubles themselves about my burrow down below; everyone goes about his business, which has no connection with me, how have I arranged things to achieve this? Here, by the covering of moss, is perhaps the only place in my burrow now where I can listen for hours without hearing a thing. The complete reverse of the situation in the burrow; what had once been the place of danger has become a place of peace. The citadel, on the other hand, has been carried away into the clamour of the world and its perils. (*HA* 176)]

Noise and danger are here treated as synonyms; unlike in Kafka's other texts, noise is no longer a nuisance; it is (the sign of) an existential threat. The animal's rational self realizes that the outside world is no safe haven either, but given this new, internal threat he or she has become desensitized to these outside dangers:

> Noch schlimmer, auch hier ist in Wirklichkeit kein Frieden, hier hat sich nichts verändert, ob still ob lärmend, die Gefahr lauert wie früher über dem Moos, aber ich bin unempfindlich gegen sie geworden, allzu sehr in Anspruch genommen bin ich von dem Zischen in meinen Wänden. (*NS II*, 621)
>
> [Even worse, there is in reality no peace up here either; nothing has changed here, whether quiet or loud, danger still lurks above the moss, as before—but I have become unresponsive to it: the hissing in my walls claims far too much of me.
> (*HA* 176)]

In Kafka's earlier letters and diaries, the world was mapped out into clearly delineated zones: sites of endless distractions, which are contrasted with (real or imaginary) safe spaces of peace and quiet. In 'The Burrow' this distinction is put under intense pressure until it finally collapses altogether. Boundaries only exist to be undermined, and once the innermost protective space has been invaded, it turns into a trap, a prison from which the narrator cannot escape, as well as 'an amplifier that sharpens the creature's hearing'.[68] Crucially, this reversal does not take place *after* the purported invasion but is part of the story from the very start. Though the burrow is conceived as a defence structure, it ultimately has a more basic purpose: 'But the best thing about my burrow is its silence' (*HA* 154).[69] The burrow is the expanded successor of the remote cellar onto which Kafka had once pinned his hopes for complete immersion and effortless production. The spatial set-up, then, is similar, but its effects are very different. Here, the 'utmost concentration', which Kafka had once longed for, has no real object or purpose and hence turns into a state of perpetual empty vigilance broken only by spells of exhausted oblivion.

'The Burrow' deconstructs the ideal of the ascetic writerly life, which had been central to Kafka's self-narrative and conception of authorship. Once this scenario is played out through a fictional reality, it is revealed to be (self-)destructive. It is tempting to ascribe this insight to the greater maturity of the 'late' Kafka, as a realization acquired with growing life experience. But in fact, this realization is already present in his 1913 letter to Bauer: 'The trouble is that I might not be able to keep it up for long, and at the first failure—which perhaps even in these

[68] Paul North, *The Problem of Distraction* (Stanford, CA: Stanford University Press, 2012), p. 103. As North continues, the shape and emblem of the burrow is an ear, 'whose canals, the more they turn around themselves into the depths of the head, expose themselves to what is without'.

[69] 'Das schönste an meinem Bau ist aber seine Stille' (*NS II*, 579).

circumstances could not be avoided—would be bound to end in a grandiose fit of madness' (*LF* 156).[70] These lucid remarks anticipate the core idea of 'The Burrow'—except that in Kafka's biased first-person narrative the crucial word 'madness' is never uttered.

'The Burrow' marks one extreme moment in Kafka's exploration of the dynamics of distraction and immersion, sound and silence. An inverse scenario is played out in the earlier fragment 'Der Nachbar' (The Neighbour, 1917). Its first-person narrator is also faced with an invisible enemy, but here the sense of threat is embodied not by the noise made by this adversary but by his complete silence. 'The Neighbour', like other Kafka texts of the 1910s, is set in a world of male rivalry and competition. The narrator is a young businessman, whose affairs are going smoothly until a new neighbour moves into the apartment next door. This young man, Harras, is a double of the narrator. He too is young and runs a 'bureau' of unspecified purpose; upon his enquiries, the narrator is merely told that he has 'a business similar to my own'.[71] These similarities are as vague as they are disconcerting, and Harras appears as a mysterious, ghost-like figure.[72] While the narrator's 'working apparatus' consists of two 'Fräulein' with typewriters and a telephone, Harras conducts his affairs alone and in complete silence, making the narrator hyper-aware of his own voice during phone calls. Here, then, the narrator is not the recipient of noise but its producer, who pictures his silent adversary sitting by the wall, listening in on his conversations before slinking off into town to sabotage his plans (*NS I*, 372). As in many contemporary texts, the telephone stands for hyper-connectivity, but also for the threats of exposure and surveillance in this increasingly disembodied modern world.[73]

In its premise, 'The Neighbour' prefigures 'The Burrow': both texts explore how, in a climate of danger and competition, practised vigilance tips over into paranoia, stoked by real or imagined enemies who act as the doubles of the

[70] 14–15 January 1913; 'Nur daß ich es *vielleicht* nicht lange treiben würde und beim ersten vielleicht selbst in solchem Zustand nicht zu vermeidendem Mißlingen in einen großartigen Wahnsinn ausbrechen müßte'. Kafka, *Briefe 1913–März 1914*, p. 41.

[71] '[...] ein Geschäft ähnlich dem meinigen' (*NS I*, 370).

[72] '[E]r huscht förmlich an mir vorbei. Genau gesehen habe ich ihn noch gar nicht' ('he practically scurries past me. I have not yet got to see him properly'; *NS I*, 371).

[73] This fear is not limited to the telephone but also extends to written communication. As Kafka writes to Milena Jesenská: 'Briefe schreiben [...] heißt, sich vor den Gespenstern entblößen, worauf sie gierig warten. Geschriebene Küsse kommen nicht an ihren Ort, sondern werden von den Gespenstern auf dem Wege ausgetrunken'. Late March 1922; Franz Kafka, *Briefe an Milena*, ed. Jürgen Born and Michael Müller, ext. and rev. edn (Frankfurt a.M.: Fischer, 1999), p. 302 ('Writing letters [...] means exposing oneself to the ghosts, who are greedily waiting precisely for that. Written kisses never arrive at their destination; the ghosts drink them up along the way'. Franz Kafka, *Letters to Milena*, trans. Philip Boehm (New York, NY: Schocken, 1990), p. 223). On the profoundly ambivalent status of the telephone in Kafka's writings, see Wolf Kittler, 'Schreibmaschinen, Sprechmaschinen: Effekte technischer Medien im Werk Franz Kafkas', in *Franz Kafka: Schriftverkehr*, ed. Wolf Kittler and Gerhard Neumann (Freiburg i.Br.: Rombach, 1990), pp. 75–163; and Gerhard Neumann, 'Nachrichten vom "Pontus": Das Problem der Kunst im Werk Franz Kafkas', in *Schriftverkehr*, ed. Kittler and Neumann, pp. 164–98.

narrators. If anything, Harras's silence is even more disconcerting than the hissing sounds that trouble the animal; as both texts show, echoing the findings of experimental psychologists, distractions originate not only from the outside world but also, and more insidiously, from inside our own body and mind.

In both 'The Neighbour' and 'The Burrow', vigilance is stoked by a lack of stimuli and stimulation and hence turns self-destructive, giving rise to suspicion and paranoia. In this regard, Kafka's later texts reflect the contemporary notion of *Daseinskampf*, of life as a struggle of all against all, a dynamic also memorably illustrated in 'Eine kleine Frau' (A Little Woman), written in the same winter as 'The Burrow', in which the narrator and the eponymous 'little woman' are locked in a stalemate situation of mutual hostile scrutiny.

Another take on the destructive effects of vigilance, finally, is offered by Kafka's third and last novel, *The Castle*. Like the animal in 'The Burrow', its protagonist K. is slowly worn down by a lack of sleep and by his inner restlessness and paranoia. After a succession of futile manoeuvres, he finally comes face to face with one of the Castle secretaries, Bürgel, who offers to grant him any wish. K., however, is too tired to pay attention. Before he is able to utter his request, he falls asleep on Bürgel's bed, and when he wakes up, the moment has passed, and he is expelled from the secretary's room.

Here, Kafka plays with another central aspect of attention—its relationship not to space (as visualized in self-contained or porous spaces) but to time. Bürgel calls his nocturnal encounter with K. an 'extraordinarily rare and uniquely great [...] opportunity' (C 235);[74] indeed, the scene exemplifies a temporal structure which in Greek is known as *kairos*. Kairos designates the opportune moment, which cannot be predicted or brought about, but which has the power to change the course of one's life. In Greek mythology, it is depicted as a winged young god with a full fringe and a bald back of the head.[75] The moment needs to be seized head on, this image implies, for once it has passed it can no longer be grasped. The kairos thus inverts the structure of many of Kafka's texts, where brief moments of carelessness or inattention can spark disastrous consequences. Indeed, the unique opportunity which presents itself to K. stems from precisely such a moment, for he walks into Bürgel's room by accident rather than design. While we do not know

[74] An 'außerordentlich selten[e]' and 'groß[e] [...] Gelegenheit' (S 424). The term *Gelegenheit*, opportunity, features repeatedly in the novel. Olga, for instance, stresses the importance of seizing the 'günstige Gelegenheiten' ('good opportunities') offered to the villagers by the castle authorities: 'ein Zuruf, man eilt herbei, und was man vor einem Augenblick noch nicht war, man ist es geworden, ist Angestellter. Allerdings wann findet sich eine solche Gelegenheit? Manchmal gleich, kaum ist man hingekommen, kaum hat man sich umgesehn, ist die Gelegenheit schon da, es hat nicht einmal jeder die Geistesgegenwart sie so als Neuling gleich zu fassen' (S 351; 'someone calls, you come hurrying up, and now you are employed, which you weren't a moment before. But when does such an opportunity arise? Sometimes quickly, you have hardly arrived, you have hardly looked around you when the opportunity comes, not everyone has the presence of mind to take it at once'; C 195–6).

[75] Brigitte Schaffner, 'Kairos', in *Der neue Pauly: Enzyklopädie der Antike*, ed. Hubert Cancik and Helmuth Schneider, series Altertum, vol. 6 (Stuttgart: Metzler, 1999), pp. 138–9 (p. 138).

whether Kafka was familiar with this Greek concept, the naked secretary whom K. defeats in the dream he has on Bürgel's bed is said to resemble 'the statue of a Greek god'; and when he wakes up again, the sight of Bürgel's naked chest makes him think: 'Here's your Greek god! Get him out of bed!' (C 231).[76]

Not only does K. miss this unique opportunity which arises out of a moment's inattention, he seems positively eager to let it pass. In his mind, Bürgel is no god-like benefactor, but merely an obstacle that separates him from the long-awaited sleep:

> K. schlief, es war zwar kein eigentlicher Schlaf, er hörte Bürgels Worte vielleicht besser als während des frühern totmüden Wachens [...], aber das lästige Bewußtsein war geschwunden, er fühlte sich frei, nicht Bürgel hielt ihn mehr, nur er tastete noch manchmal nach Bürgel hin, er war noch nicht in der Tiefe des Schlafs, aber eingetaucht in ihn war er, niemand sollte ihm das mehr rauben.
> (S 415)
>
> [K. was sleeping. It was not real sleep; he could hear what Bürgel was saying perhaps better than during his early period of wakeful exhaustion [...], but his troublesome consciousness was gone; he felt free, Bürgel no longer had a hold on him, he just sometimes made his way towards Bürgel, he was not yet deeply immersed in slumber but he had taken the plunge, and no one was going to rob him of that now. (C 231)]

K. experiences his descent into sleep as a great victory, one which is celebrated in his dream (S 415; C 231). A toned-down version of this response is described in 'The Burrow'. Having waited for potential intruders by the burrow entrance for ages, unable to leave his cover, the animal narrator is eventually so worn down by exhaustion that s/he shuffles to the entrance,

> denkunfähig von Müdigkeit [...], hebe langsam das Moos, steige langsam hinab, lasse aus Zerstreutheit den Eingang überflüssig lange unbedeckt, erinnere mich dann an das Versäumte, steige wieder hinauf um es nachzuholen [...], und nun endlich ziehe ich die Moosdecke zu. Nur in diesem Zustand, ausschließlich in diesem Zustand kann ich diese Sache ausführen. (NS II 602)
>
> [unable to think for weariness [...]; slowly I lift the moss, slowly I climb down. Distracted, I leave the entrance uncovered unnecessarily long, then remind myself of my omission, climb up again to put it right [...]; and I finally draw the moss covering close. It is only in this condition, solely in this condition, that I am able to carry it out. (HA 166)]

[76] 'Hier hast du ja deinen griechischen Gott! Reiß ihn doch aus den Federn!' (S 415–16).

Only complete exhaustion of the body can temporarily still the ever-active mind, and so both the animal and K. experience sleep as a liberation. But this respite does not last. When K. reawakens he has not only missed a unique opportunity but feels 'grenzenlos schlafbedürftig' ('in dire need of more sleep'; S 426/C 237) and more tired than before. The respite of true stillness and complete oblivion is not granted to Kafka's protagonists, whose attention is constantly rekindled by the modern *Daseinskampf* and its mixture of over- and under-stimulation, of endless distractions barely concealing the underlying emptiness.

Nightwatch: The Ethics of Attention

This, at least, is the double-bind portrayed in many of Kafka's later prose texts. In a small cluster of texts, however, vigilance and alertness take on a more positive, almost redemptive quality. From 1917 onwards, Kafka engaged with the Old Testament, adapting biblical stories in idiosyncratic ways. Two of these texts merit particular attention, both of them dating from the second half of 1920, when Kafka experienced a burst of productivity. The first of them is written in the second-person narrative voice ('you') which is characteristic of his work in this period:

> Läufst Du immerfort vorwärts, plätscherst weiter in der lauen Luft, die Hände seitwärts wie Flossen, siehst flüchtig im Halbschlaf der Eile alles an woran Du vorüberkommst, wirst Du einmal auch den Wagen an Dir vorüberrollen lassen. Bleibst Du aber fest, läßt mit der Kraft des Blicks die Wurzeln wachsen tief und breit, nichts kann Dich beseitigen und es sind doch keine Wurzeln, sondern nur die Kraft Deines zielenden Blicks, dann wirst Du auch die unveränderliche dunkle Ferne sehn, aus der nichts kommen kann, als eben nur einmal der Wagen, er rollt heran, wird immer größer, wird in dem Augenblick, in dem er bei Dir eintrifft, welterfüllend und Du versinkst in ihm wie ein Kind in den Polstern eines Reisewagens, der durch Sturm und Nacht fährt. (*NS II*, 359)

> [If you keep running forward, splashing through the tepid air, your hands by your side like fins, fleetingly glancing at everything you are passing in the semi-sleep of hurry, then at one point you will also let the carriage pass you by. If however you stay firm, allowing the power of your gaze to grow roots, deep and wide, then nothing can eradicate you, and yet they are no roots but the power of your gaze taking aim; then you will see the unchanging dark distance out of which nothing can emerge but that very carriage, it is approaching, getting bigger and bigger, filling the whole world in the moment when it stops next to you, and you sink into it like a child into the cushions of a travelling carriage driving through storm and night.]

In modern society, constant forward movement is synonymous with progress and autonomy, but here it is cast as a sign of almost vegetative inertia: in the 'semi-sleep of hurry' nothing can be taken in, and everything becomes a blur. In contrast, a true state of watchfulness roots the subject to his or her place; this watchfulness is not focused on the here and now, but on the horizon as a space which offers the prospect of salvation. Though the text does not have one specific biblical intertext, it recalls numerous instances where God's people are called—either individually or collectively—to stay vigilant, ready for the coming of the messiah, who will come when he is least expected. The arrival of the messiah is the quintessential kairos—that unique, impossible event which cannot be predicted. In Kafka's text, we are told that nothing can ever come out of this 'unchanging dark distance'—except for that carriage, whose arrival is a real, albeit unique, event.

'If you keep running forward...' contrasts with two other instances of (in-)attention in Kafka's work. The first is featured in the 'Hunter Gracchus' fragment, where the journey of redemption has already begun but is then diverted, perverted, into a story of eternal damnation by a brief moment of distraction. The second such instance occurs in *The Castle*, in the chapter 'Das Warten auf Klamm' (Waiting for Klamm). Having waited for the secretary in vain outside the Castle Inn, K. decides to climb into Klamm's sleigh, where he sinks into the soft cushions and gets drunk on some schnapps he finds in a flask—a classic case of vigilance faltering just when it is most needed, in a scene which anticipates K.'s encounter with Bürgel.

In the 1920 fragment, in contrast, vigilance is both possible and amply rewarded. The carriage's soft cushions shelter the traveller, who is returned to the carefree state of a child as he or she finds shelter from the stormy night. The vehicle's vastness, which seems to fill the entire world, lends this moment of salvation a more universal character—although the text also casts watchfulness as a personal duty that sets the individual apart from the inattentive masses.

In another 'you'-narrative written in August 1920, the virtue of vigilance serves an entire community:

> Versunken in die Nacht. So wie man manchmal den Kopf senkt, um nachzudenken, so ganz versunken sein in die Nacht. Ringsum schlafen die Menschen. Eine kleine Schauspielerei, eine unschuldige Selbsttäuschung daß sie in Häusern schlafen, in festen Betten unter festem Dach ausgestreckt oder geduckt auf Matratzen, in Tüchern, unter Decken, in Wirklichkeit haben sie sich zusammengefunden wie damals einmal und wie später einmal in wüster Gegend, ein Lager im Freien, eine unübersehbare Zahl Menschen, ein Heer, ein Volk, unter kaltem Himmel auf kalter Erde, hingeworfen wo man früher stand, die Stirn auf den Arm gedrückt, das Gesicht gegen den Boden hin, ruhig atmend. Und Du wachst, bist einer der Wächter, findest den nächsten durch Schwenken des brennenden

Holzes aus dem Reisighaufen neben Dir. Warum wachst Du? Einer muß wachen, heißt es. Einer muß dasein, (*NS II*, 260–1)

[Immersed in the night. As one sometimes lowers one's head to think, being fully immersed in the night. All around people are sleeping. It's a little pretence, an innocent kind of self-deception, to assume that they're asleep in their houses, in stable beds under a stable roof, stretched out or curled up on mattresses, wrapped in sheets, under blankets. In reality they are gathered together, as in the past and as in the future, in a desolate area, an outdoor camp: a vast number of people, an army, a people [ein Volk], gathered under a cold sky, on the cold earth, lying where they used to stand, the forehead buried in the arm, the face on the ground, breathing quietly. And you are watching, are one of the guards, will find the next one by waving the burning stick taken from the burning pile of wood next to you. Why are you keeping watch? Someone has to keep watch, they say. Someone has to be there,]

The opening sentences recalls earlier letters and diary entries, in which Kafka describes nocturnal writing experiences, but here this state is given a new import and a new context: as a role, a vocation, within the community. In fact, the opening word *versunken* (immersed) is misleading, for the core mindset of this fragment is not immersion but vigilance. Sleep, we are told, is a highly exposed state outside the bounds of bourgeois existence; the image of a 'people', or 'army', of sleepers resting in the wilderness evokes Israel's journey through the desert, though the vast number of sleepers lends the scene a universality which exceeds the biblical intertext. At stake might be the fate of humanity as a whole. That these people are able to sleep in peace is due to the guard, the lone individual. His duty is to keep watch, a role cast somewhere between tradition and prophecy: 'Someone has to keep watch, *they say*. Someone has to be there' (my emphasis).[77]

In August 1920, Kafka writes to Milena Jesenká: 'For a few days now I've been performing my "military service"—or more correctly "manoeuvres," which is sometimes the best thing for me, as I discovered years ago'.[78] These military terms are metaphors for the writing process, lending it a strategic and potentially dangerous character. A few days later, he produces 'Immersed in the night...'. The military imagery used in the letter recurs in the text's unspecified sense of threat, which requires the narrator to stay awake and alert. Unlike in 'The Burrow', the aim is not only to fend off external enemies. Wakefulness is a necessity, but also a calling and vocation, an intensified form of existence outside

[77] On Kafka's watchmen and guardians as figures of responsibility, see Ritchie Robertson, *Kafka: Judaism, Literature, and Politics* (Oxford: Oxford University Press, 1987), pp. 135–6.

[78] 26 August 1920; Kafka, *Letters to Milena*, p. 169. 'Ich habe seit paar Tagen mein "Kriegsdienst"- oder richtiger "Manöver"leben aufgenommen, wie ich es vor Jahren als für mich zeitweilig bestes entdeckt habe'. Kafka, *Briefe an Milena*, p. 229.

the confines of the ordinary, bourgeois life. Kafka's narrator keeps watch alone at night, and yet he is not alone. He is 'one of the guards', who are in turn recruited from the 'army' of sleepers. Vigilance is a living tradition that is passed on from one person to the next by the waving of a burning stick—an image evocative of illumination and inspiration.

The text thus presents a vision of the outsider who watches on behalf of others, of the community of which he remains a part. What the guard is waiting for is not spelled out. He might be on the lookout for enemies approaching in this hostile environment, although the fragment 'If you keep running forward...', written a few months later, points to another purpose: watching and waiting for salvation, for the coming of the messiah.

Immersion

In 'Immersed in the night...', immersion is refigured as an outward-looking alertness, a state which combines contemplation and watchfulness, individualism and service to the community. Since this vigilance has a purpose beyond itself, it is unlikely to fall prey to the sudden bouts of distraction which prove so disastrous for Kafka's other protagonists.[79] As such, this fragment gestures towards a kind of resolution to Kafka's long and torturous struggle with attention, its inherent fragility and proneness to be exploited, but also its tendency to grow paranoid and self-destructive. There is, however, a postscript to the story of this engagement.

Immersion makes one further appearance in a puzzling fragment written in the spring or summer of 1922, while Kafka was working on *The Castle*:

> Atemlos kam ich an. Eine Stange war ein wenig schief in den Boden gerammt und trug eine Tafel mit der Aufschrift 'Versenkung'. Ich dürfte am Ziel sein, sagte ich mir und blickte mich um. Nur paar Schritte weit war eine unscheinbare dicht mit Grün überwachsene Gartenlaube, aus der ich leichtes Tellerklappern hörte.
>
> (*NS II*, 376–7)
>
> [Breathless, I arrived. A pole had been rammed into the ground slightly askew, bearing a sign with the word 'Immersion'. I seem to have reached my destination, I said to myself and looked around. Only a few steps ahead there was an inconspicuous arbour, thickly overgrown with greenery, from which I heard the quiet clattering of plates.]

[79] Indeed, the tone of the piece, which is addressed to an unspecified 'you', lends it an openness which is very different from Kafka's claustrophobic narratives told from the biased perspective of one character.

In German, *Versenkung* is usually used in the figurative sense, meaning a state of immersion or contemplation, but it can also be used literally, to describe the process of lowering something (or someone) into water or into a hole in the ground. Kafka's story exploits this double meaning to comical as well as eerie effect. In the opening scene, the narrator's breathlessness as well as details such as the wonky pole lend the scene a concrete physicality which is at odds with the single cryptic word painted on the sign. In the arbour he (or she) finds a young family—husband, wife, and three young children—who are having lunch.

> Ich ging hin, steckte den Kopf durch die niedrige Öffnung, sah kaum etwas in dem dunklen Innern, grüßte aber doch und fragte: 'Wissen Sie nicht wer die Versenkung besorgt?' 'Ich selbst, Ihnen zu dienen', sagte eine freundliche Stimme, 'ich komme sofort.'
>
> [I walked across, stuck my head through the low opening, barely able to see anything in the dark interior, nonetheless said my greeting, and enquired: 'Do you happen to know who will carry out the immersion?' 'I myself, at your service', replied a friendly voice, 'I'll be there instantly.']

Revealingly, the narrator avoids making himself either the grammatical subject or the object of this process, but phrases his request in impersonal terms ('wer die Versenkung besorgt'). Mental immersion is not something that can be 'carried out' (*besorgen*) by one person on another's behalf; the phrasing of the narrator's question thus implies that the 'service' he is after is a more literal, physical *Versenkung*—in other words, a burial, with pole and sign marking the site of the prospective grave.

This curious fragment is the endpoint, the morbid yet logical conclusion of a quest—or flight—which spans the entirety of Kafka's work, leading from the exposed bedroom in 'Great Noise' via the innermost cellar described in the letter to Felice Bauer to the burrow of his late short story. It is a flight whose movement is not only vertical but horizontal, leading away from society and ordinary life in a downward motion.[80] As this fragment suggests, the only place where absolute silence and unbroken seclusion can be found is the tomb, which puts an end to all distractions, all desire.[81] Kafka's fragment echoes Freud's theory of the death drive, set out just two years earlier in *Beyond the Pleasure Principle*, whose purpose is likewise a return to a state of zero stimulation.

[80] Time and again in Kafka's writings, this desire is associated with downward movement and burial imagery. On 11 February 1915, for instance, Kafka writes to Felice Bauer: 'Wieder saß ich in der stillen Wohnung und suchte mich von neuem einzugraben' ('Once again I was sitting in the silent apartment seeking to bury myself'; *B14* 119; *LF* 445).

[81] W. G. Sebald reads K.'s quest in *The Castle*, which was written at the same time as this fragment, as a search for eternal rest. W. G. Sebald, 'The Undiscover'd Country: The Death Motif in Kafka's *Castle*', *Journal of European Studies*, 2 (1972), 22–34 (p. 34).

That said, another character resists the fulfilment of the narrator's wish:

> Der Mann der in der Tiefe der Laube saß wollte gleich aufstehn und sich hinausdrängen, die Frau aber bat ihn herzlich, zuerst das Essen zu beenden, er jedoch zeigte auf mich, sie wiederum sagte, ich werde so freundlich sein und ein wenig warten und ihnen die Ehre erweisen, an ihrem armen Mittagessen teilzunehmen, ich schließlich, äußerst ärgerlich über mich selbst, der ich hier die Sonntagsfreude so häßlich störte, mußte sagen: 'Leider leider, liebe Frau, kann ich der Einladung nicht entsprechen, denn ich muß mich augenblicklich, ja wirklich augenblicklich versenken lassen.'

> [The man sitting in the depths of the arbour was about to get up and come outside, but his wife warmly begged him first to finish his meal; he however pointed at me, yet she retorted that surely I would be so kind as to wait a little and grant them the honour of partaking in their simple lunch; I, finally, extremely annoyed at myself for disrupting their Sunday joy in such an ugly manner, had to reply: 'Very unfortunately, my dear lady, I am unable to follow your invitation, for I must instantly, yes, instantly, let myself be immersed.']

In this breathless, almost Kleistian exchange largely made up of indirect speech, the husband is eager to oblige his guest, yet his wife rebuts his request, first politely and then with increasing brusqueness. After stressing the inconvenient timing 'on a Sunday of all days and, worse, over lunch',[82] she turns to a more general line of attack: 'Oh the whims of the people. This eternal enslavement'.[83] This nameless woman undermines the poignancy of the narrator's wish by dismissing it as a frivolous whim, a wish which is enslaving rather than liberating.[84] Notably she leaves it open who is the victim of this 'eternal enslavement'—the person seeking immersion or those around him, who will be left behind.

Reading Kafka's fictional and his personal writings, it may seem that the quest for solitude is a point where the desires of Kafka's characters and of their author converge. In 'Breathless, I arrived...', however, the search for *Versenkung* is stripped of its noble, ascetic overtones, and instead dismissed as a selfish whim, which reveals the narrator's indifference towards those unable to escape the distractions of everyday life—of work, family, childcare. As female characters' voices gain in prominence in Kafka's late fiction—particularly in 'A Little Woman', *The Castle*, and 'Josefine, die Sängerin oder Das Volk der Mäuse' (Josefine, the Singer or The Mouse People, 1924)—this unnamed woman's

[82] '[...] gerade am Sonntag und noch beim Mittagessen'.
[83] 'Ach die Launen der Leute. Die ewige Sklaverei'.
[84] Kafka's prose texts and diaries repeatedly depict the process of dying, or being killed, in extremely graphic terms, though this experience, which is usually recounted by a first-person narrator, is often cast as a liberation. See for instance the texts 'Ein Traum' (A Dream, c.1914–16), 'Die Brücke' (The Bridge, 1917) and 'Der Geier' (The Vulture, 1920).

response provides an indirect answer to a question that remains revealingly unaddressed in Kafka's letter to Felice Bauer: who cooks and delivers the food that is left outside the cellar door to sustain the reclusive writer?

By contrasting the model of ascetic immersion with the practicalities of everyday life, Kafka's text queries this contemplative ideal, which, as we have seen, is shared by many of his contemporaries. At the same time, it shows that the realms of life and writing are inextricably linked. The narrator replies to the woman almost apologetically: 'wüßte ich wie man es [Versenkung] macht, hätte ich es schon längst allein getan' ('if only I knew how to do it [to immerse/bury myself], I would have long since done it myself'). Immersion is by definition solitary, but its realization depends on others. In situating family life right next to the site of *Versenkung*, the text emphasizes the close, ongoing connection between the two.

By the standards of today's world, Kafka's ascetic ideal of complete, unbroken immersion—which is shared by some of his characters—may seem masochistic and austere. As a response to sensory overload and distraction, however, this wish is also eminently relatable. The more interesting question is what Kafka *does* with this desire. Just as the endless obstacles which prevent the author from ever achieving his goal feed into his writings, so his characters' pursuit of this ideal sparks a succession of narrative quests which are in turn humorous, haunting, and poignant. In charting, and lamenting, modern distraction, his texts remain connected to everyday life in all its messiness and mundanity. And crucially, they explore the downsides—the slow-burning destruction—wreaked by rigid, unwavering attention. Sometimes, as in 'The Burrow', this imperative is imposed by inner compulsion, but more commonly, it is shown to be the result of disciplinary structures. In this regard, Kafka's works critique a development that was gathering pace during his lifetime but only came to full fruition after his death. In the Weimar Republic, a set of theories, practices, and technologies known as psychotechnics aspired to radically reshape society, making its population physically and mentally fit for the demands of modern life through means both insidious and coercive.

4

Psychotechnics

Training the Mind

A New Science

During Kafka's tenure at the Workers' Accident Insurance Institute, accident prevention primarily focused on improving the safety of the industrial hardware and of working conditions more generally. The responsibility of the individual worker was underplayed, perhaps deliberately, in risk assessments and the associated insurance policies.[1] In other contexts, however, a more human-centred, individualized approach was beginning to emerge. As we have seen in Chapter 2, the huge mental strain imposed on modern, technology-facing professions such as train drivers and telephone operators, which was widely discussed in the medical profession, also became a concern in experimental psychology. A leading figure in this field was Hugo Münsterberg (1863–1916), who devised aptitude tests for such pressurized and high-risk professions, aiming to weed out applicants with a nervous or distractible disposition as well as those who were easily fatigued by monotony and repetition.[2] In the case of tram driver applicants, assessments tested subjects' attention—whether it was stable or easily distracted by chance occurrences. A key requirement was the ability 'to survey the street in its totality, so that the many possible movements of pedestrians, vehicles, and cars are all grasped at once',[3] a 'uniquely complex attentional performance [...], which enables the viewer continually to assess the speed of individual moving objects [...] within the fast-changing street panorama'.[4]

[1] One exception is drunkenness, which Kafka singles out as an accident risk factor, but even here his emphasis is on more general working conditions—for instance, the provision of alcohol at the workplace as enshrined in workers' contracts—which cause individuals to behave in unsafe ways (AS 387–9).

[2] See Joachim Radkau, *Das Zeitalter der Nervosität: Deutschland zwischen Bismarck und Hitler* (Munich: Propyläen, 2000), pp. 222–4; and Jeremy Todd Blatter, 'The Psychotechnics of Everyday Life: Hugo Münsterberg and the Politics of Applied Psychology, 1887–1917' (doctoral dissertation, Harvard University, Cambridge, MA, 2014), https://core.ac.uk/download/pdf/28948930.pdf [accessed 20 January 2022].

[3] '[...] die Schwankung der Aufmerksamkeit, die Ablenkung der Aufmerksamkeit durch Zufallsvorgänge auf der Straße, vor allem aber die fortwährend benötigte Fähigkeit, das Gesamtstraßenbild so zu überschauen, daß alle die vielen möglichen Bewegungen der Fußgänger und der Wagen und der Autos gleichzeitig erfaßt werden'.

[4] The 'eigentümlich komplizierte Aufmerksamkeitsleistung [...], mit Hilfe derer in dem schnellwechselnden Straßenbild in beharrlicher Weise die zahlreichen Einzelobjekte [...] auf ihre Schnelligkeit beurteilt werden müssen'. Hugo Münsterberg, *Psychologie und Wirtschaftsleben: Ein Beitrag zur angewandten Experimental-Psychologie* (Leipzig: Barth, 1912), pp. 45–6.

This new testing regime is outlined in Münsterberg's 1912 study *Psychologie und Wirtschaftsleben* (Psychology and Economic Life), followed, two years later, by his ground-breaking *Grundzüge der Psychotechnik* (Principles of Psychotechnics), which casts psychotechnics as the means by which the methods and findings of experimental psychology could be put to concrete economic and social use.

Münsterberg's central role in the field underlines both the transnational nature of psychological research at the time and Germany's dominant place in this international field. He completed his doctorate with Wilhelm Wundt in 1885; after a few years of postdoctoral research at the universities of Heidelberg and Freiburg, he accepted William James's invitation to a visiting post at Harvard University in 1892, where he succeeded James as Chair of Psychology five years later. Though Münsterberg remained in the United States for the rest of his life and published most of his books and articles in English, he maintained close academic and personal ties to Germany. In 1910 he spent a year as a visiting professor in Berlin, where he taught a seminar on the topic of 'applied psychology', a field that would later become known as psychotechnics. As he recalls, this was the first time that this new method was systematically outlined at a German university; with his seminar, Münsterberg wanted to address challenges that were characteristic for the age and its 'current goals'.[5]

With his close links to German-speaking academia, Münsterberg was not alone. Several leading US-American psychologists had studied in German laboratories, including James McKeen Cattell and Edward Titchener, who were both students of Wundt, and James, who had also spent parts of his studies in Germany and whose *Principles of Psychology* makes constant reference to German research. Münsterberg adds a particular dimension to this transnational dialogue, for he actively sought to disseminate the results of his American research in his native country. His *Principles of Psychotechnics* had a huge resonance in Germany, and after the war, Weimar Germany implemented psychotechnical methods on a scale that was unrivalled among industrialized nations.

The term 'psychotechnics', however, was coined not by Münsterberg but by the German psychologist William (Wilhelm Louis) Stern (1871–1938), co-founder, in 1904, of the Deutsche Gesellschaft für Psychologie (German Society for Psychology) and of the *Zeitschrift für angewandte Psychologie* (Journal for Applied Psychology), a leading journal in the field. Stern was also instrumental in the foundation of the University of Hamburg in 1919, where he became the joint head of the Institutes of Psychology and Philosophy.[6]

[5] Münsterberg, *Psychologie und Wirtschaftsleben*, p. v.

[6] Stern was Jewish and was removed by the Nazis from his chair in 1933; in the same year he and his family emigrated first to the Netherlands and then to the United States, where he held a chair at Duke University. I am indebted to Andreas Schmid for sharing his research into the relationship between Stern and Münsterberg.

In a 1903 article Stern defines the two branches of the new field as 'psychognostics' and 'psychotechnics'. The former involves assessing an individual's disposition, skills, and values; the latter then helps to implement these findings in a practical manner, particularly at the workplace, where 'worthwhile purposes' were matched with 'suitable modes of action'.[7] In the Weimar Republic, these two strands became known as 'subjective' and 'objective' psychotechnics.

Münsterberg and Stern had many shared aims and interests, chiefly the mission of using the findings of psychological research in a practical, work-related context. But this shared ambition also highlighted fundamental differences in emphasis and approach. Münsterberg's *Principles of Psychotechnics* makes only five passing references to Stern's work and does not credit Stern for coining the original term. Stern, in turn, commented favourably on Münsterberg's earlier work, but became increasingly critical of the way he developed psychotechnics in theoretical and practical terms, arguing that he elided the crucial difference between psychognostics, the 'knowledge of people', and psychotechnics, which focuses on their practical treatment.[8] Even in his obituary of Münsterberg, Stern repeats this critique, claiming that Münsterberg was split between the mindset of an experimental psychologist, for whom the individual was merely a set of faculties, and the more holistic outlook of a philosopher.[9]

Münsterberg's *Principles of Psychotechnics* was published on the eve of the First World War, and the war, that most perilous of modern workplaces, also provided the first large-scale opportunity to put his methods into practice. Psychotechnical assessment methods were used by the French, the British, and the Germans to recruit soldiers for particular roles, including drivers, artillerists, pilots, and wireless operators.[10] Once the war was over, these initiatives were largely discontinued—but not in Germany. Faced with the dire consequences of the lost war and the ensuing reparations, the country turned to psychotechnics as the key plank in its strategy of economic recovery. The German army, severely reduced in size after the Treaty of Versailles, set up a psychology department to optimize its

[7] William Stern, 'Angewandte Psychologie', *Beiträge zur Psychologie der Aussage: Mit besonderer Berücksichtigung der Rechtspflege, Pädagogik, Psychiatrie und Geschichtsforschung*, 1 (1903), 4–45 (p. 28).

[8] As Stern concludes, following Münsterberg's appropriation it was doubtful whether the concept could ever be restored to its intended, original meaning. William Stern, *Die Differentielle Psychologie in ihren methodischen Grundlagen*, 3rd edn (Leipzig: Barth, 1921 [1911]), p. 508.

[9] Despite these reservations, Stern praises Münsterberg as a great and incisive researcher and a mediator between the research cultures of the United States and Germany, noting that during the First World War he vocally asserted his loyalty to his native Germany, at great personal and professional cost to himself. William Stern, 'Hugo Münsterberg: Ein Gedenkwort', *Zeitschrift für pädagogische Psychologie und Jugendkunde*, 18 (1917), 54–7 (pp. 54–5).

[10] Horst U. K. Gundlach, 'Germany', in *The Oxford Handbook of the History of Psychology: Global Perspectives*, ed. David B. Baker (Oxford: Oxford University Press, 2012), pp. 255–88 (p. 274). On the use of psychotechnics in the First World War, see also Dominik Schrage, *Psychotechnik und Radiophonie: Subjektkonstruktionen in artifiziellen Wirklichkeiten 1918-1932* (Munich: Fink, 2001), pp. 91–107.

limited resources;[11] more importantly, psychotechnical testing and training were now rolled out across civilian society. The same psychologists who had previously overseen its military application were now in charge of a much broader, government-funded initiative, which encompassed industry and universities, transport and education.[12]

At first sight, the aims and methods of Weimar psychotechnics were remarkably similar to Münsterberg's first experiments. Accident prevention by means of aptitude testing and on-the-job training remained a priority, particularly in high-risk professions, and publications continued to single out attention as the foremost cognitive skill. A 1928 article on the recruitment of train drivers repeats Münsterberg's 1912 study almost verbatim, stressing that the role required 'a single act of exhausting, unbroken attention, focussed on the perception of regular and irregular, occasionally even completely unexpected stimuli'; applicants, in other words, needed to be able to divide their attention, to 'focus on several objects simultaneously', for failure to do so could lead to 'serious problems and catastrophes'.[13]

This article appeared in *Industrielle Psychotechnik* (Industrial Psychotechnics), the leading journal of a thriving new discipline. In the early 1920s psychotechnical testing stations were set up across Germany, run either by the Arbeitsamt (Employment Office) or by companies themselves. A few years later practically all major corporations had set up their own testing centres, which were used for recruitment as well as in-house training to improve productivity. But the advocates of psychotechnics were aiming even higher; they successfully lobbied for the creation of a university curriculum and standardized examinations in 'wissenschaftliche Psychotechnik' (scientific psychotechnics), to lend the discipline, also known as 'Arbeitswissenschaft' (the science of work) academic rigour and

[11] The German army 'established strict selection procedures to get only the best from the masses of unemployed who, in the economic chaos after the defeat, saw their sole future in the armed services. Personnel selection was the speciality applied psychology had provided during the war and could provide now. Since the Versailles Treaty prohibited cooperation between the army and the universities, the army even established its own psychological research institute'; at the beginning of the Second World War, 'nearly 200 psychologists worked in the army, navy, and air force'. Gundlach, 'Germany', p. 275. See also Ulrich Geuter, *The Professionalization of Psychology in Nazi Germany*, trans. Richard J. Holmes (Cambridge: Cambridge University Press, 1992). On the continuities of psychotechnical practice between the Weimar Republic and the Third Reich, see also R. Bauer and Gerald Ullrich, 'Psychotechnik: Wissenschaft und/oder Ideologie. Dargestellt an der Zeitschrift für *Industrielle Psychotechnik*', *Psychologie und Gesellschaftskritik*, 9 (1985), 106–27.

[12] Gundlach, 'Germany', p. 275. Once *Arbeitswissenschaft* and psychotechnics had managed to dissociate themselves from Taylorism as a field predominantly geared towards increased efficiency, they were broadly endorsed by trade unions and political parties across the spectrum, and indeed across Europe, from fascist Italy to the Soviet Union, which hosted the first International Psychotechnical Congress in 1931. On the role of psychotechnics in the Soviet Union, see Irina Sirotkina and Roger Smith, 'Russian Federation', in *The Oxford Handbook of the History of Psychology*, ed. Baker, pp. 412–41 (pp. 421–4).

[13] A. Kolodnaja, 'Beiträge zur Berufsanalyse des Lokomotivführerberufs', *Industrielle Psychotechnik*, 5 (1928), 278. Cited in Frederic J. Schwartz, *Blind Spots: Critical Theory and the History of Art in Twentieth-Century Germany* (New Haven, CT: Yale University Press, 2005), p. 82.

credibility. In this regard, psychotechnics helped transform psychology from a sub-discipline of medicine or a 'stepchild' of philosophy to 'the status of a natural science in its own right'.[14] In 1921, the first chair in psychotechnics, held by Dr Walther Moede, was established at the Technische Hochschule in Berlin Charlottenburg, and similar posts were soon set up at universities across the country.[15] From 1928, advertising psychology and psychotechnics even appeared on the Bauhaus curriculum. The artist and Bauhaus lecturer László Moholy-Nagy had close ties to the Stuttgart psychotechnician Fritz Giese, and each of them, 'perhaps at the urging of his counterpart, dabbled in the other's field'.[16] When Moholy took over the famous *Vorkurs*, the Preliminary Course compulsory for all Bauhaus students, from Johannes Itten in 1922, he instituted a systematic programme of perceptual training, which included tactile as well as visual perception. Moholy references 'psychotechnical aptitude testing' as a model for this training programme; its focus was meant to be on 'der totale mensch' ('the whole person'), setting itself apart from a more compartmentalized approach to human beings as prevalent in Taylorism and modern (industrial) labour.[17] After Moholy left the Bauhaus, psychotechnics not only remained on the curriculum but actually increased in prominence; from 1929 onwards it was taught by another prominent psychotechnician, the Dresden-based Hans Riedel.

In Weimar Germany, psychotechnics was thus as ubiquitous as it was symbolically charged. In a country depleted by war and hyperinflation, shaken by a series of political crises, and undergoing radical social change, psychotechnics was seen as modern and forward-looking, but also offered a sense of stability. For all its novelty, it was rooted in the much older and well-established field of experimental psychology. In its self-presentation, psychotechnics was thus able to combine its projected dynamism and innovation with a sense of scientific rigour—as well as with social values such as fairness and equality.

The faith put into psychotechnics may seem rather curious for a society which had just emerged from the trauma of technological warfare; after all, its aim was to assess and train individuals with the help of methods often developed during the war and trialled in a military context. And yet these initiatives were widely endorsed by employer organizations, trade unions, and all major political parties

[14] Schwartz, *Blind Spots*, p. 93.

[15] Moede, who during the war had been director of the German military-psychological laboratories, subsequently founded the Institute for Industrial Psychotechnics at the Technische Universität Berlin together with Georg Schlesinger. See Horst U. K. Gundlach, 'Moede, Walther', *Neue Deutsche Biographie*, 17 (1994), 611.

[16] Schwartz, *Blind Spots*, p. 68. As Schwartz elaborates, 'the psychologists of the laboratories and the typographers of the avant-garde met on the common ground of visual attention as an object of knowledge. Both groups investigated the nature of colours, explored the laws of contrast and measured the differing amounts of attention granted to various parts of the visual field'.

[17] László Moholy-Nagy, *Von Material zu Architektur*, Bauhausbücher, 14 (Munich: Langen, 1929), p. 18. For more details on Moholy's approach, see Tobias Wilke, *Medien der Unmittelbarkeit: Dingkonzepte und Wahrnehmungstechniken 1918–1939* (Munich: Fink, 2010), pp. 195–200.

as part of the collective effort to rebuild the German economy. To gain this universal support, psychotechnics first had to distance itself from Taylorism, its American cousin, which was seen as a profit-driven system indifferent to workers' welfare.[18] The support which psychotechnics enjoyed in the 1920s relied chiefly on its more personal approach: on its promise to cater for the needs of the individual worker by improving working conditions, productivity, and pay.

The movement's motto was 'Der rechte Mann am rechten Platz' ('the right man in the right place'). Often cited in English, it evoked an American, dynamic modernity while also harking back to a more traditional model of society in which each person had his or her rightful (God-given) place—at work, in the family, and in the community. The fact that this model was fast becoming obsolete in an age of social and geographical mobility did little to dampen the initial enthusiasm for this mission. A 1919 article in the *Berliner Illustrirte Zeitung* (Berlin Illustrated Newspaper) argued that if used in the proper (socialist) spirit, psychotechnics could benefit both the individual and the economy: 'Everyone will be assigned that task for which they are best suited, so that even older and damaged workers can still earn their crust, when in the past anyone over the age of forty would have been rejected as worn out'.[19] But such improvements also required a willingness for change, particularly to end traditional, paternalistic recruitment practices based on personal, mostly family, ties: 'Tradition, convenience, and thoughtlessness no longer determine one's career, but mental and physical skill'.[20]

In an age of growing anonymity and complexity, Weimar psychotechnics offered a reassuringly rigorous as well as a people-centred approach that promised to benefit both individual and society. Its testing regimes shifted the focus away from applicants' personal background towards quantifiable skills and abilities. In essence, psychotechnics was underpinned by a social utopia, by the dream of a fairer and more productive society—although the reality did not always match these lofty aspirations.

Testing the Body—Testing the Mind

So how did psychotechnics operate in practice? A glimpse into this vast and complex machinery is offered by the catalogue *Psychotechnik*, published in 1923 by E. Zimmermann, Leipzig- and Berlin-based manufacturers of 'wissenschaftliche

[18] See Schrage, *Psychotechnik und Radiophonie*, pp. 114–15.
[19] 'Jedem wird die Tätigkeit zugewiesen, für die er am besten geeignet ist, so daß auch ältere und beschädigte Arbeiter noch ihr Brot finden, während früher der über 40 Jahre alte Arbeitnehmer im allgemeinen als verbraucht galt'. Albert Neuburger, 'Das Taylor-System: Das vielumstrittene Verfahren zur Erhöhung und Prüfung der Arbeitsleistung', *Berliner Illustrirte Zeitung*, 28:21 (25 May 1919), 182–4 (p. 182).
[20] 'Nicht Ueberlieferung, Bequemlichkeit und Gedankenlosigkeit bestimmen mehr den Beruf, sondern geistige und körperliche Befähigung'. Neuburger, 'Das Taylor-System', p. 183.

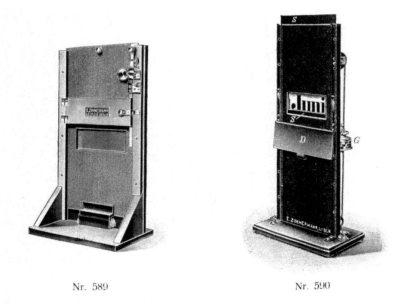

Nr. 589 Nr. 590

Figure 4.1 Drop-down tachistoscope for school experiments (*ZP* 11)

Apparate', scientific apparatuses. This 116-page illustrated publication lists all the tools that institutions engaged in psychotechnical testing and training might require, ranging from low-tech devices such as stopwatches, weighing scales, height charts, and colour cards to complex and expensive apparatuses, or 'testing stations', designed to test several skills at once, on a mass scale.

In assessing different faculties, psychotechnics drew on a number of tried-and-tested devices which had been in use in psychological laboratories since the nineteenth century, including the chronoscope and tachistoscope, the latter used in experiments testing reaction time, attention, and recall. Zimmermann's catalogue lists seven such devices, including one simple design for use in schools (Figure 4.1).

To guide the customer through this vast assortment, the catalogue is divided into different categories.[21] Some of these are by type of device, while others focus on the context(s) of use: aptitude testing for specific professions and for other areas such as sport and education.[22] Some devices are aimed at one very specific

[21] In fact, this catalogue is only a first entry point into an even vaster terrain of psychotechnical hardware. The first inside page lists additional brochures dedicated to more specialist sub-categories such as 'Tachistoscopes and Memory Apparatuses', 'Acoustic and Phonetic Instruments', and 'Devices for Measuring Blood Pressure' (*ZP* 2).

[22] The final two sections are dedicated to sport, the first focusing on the physical, the second on the psychological requirements of sports such as football, boxing, gymnastics, and track and field.

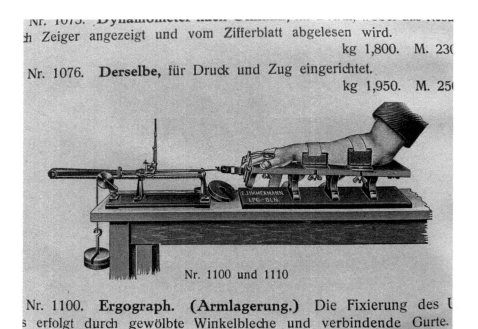

Figure 4.2 Ergograph (ZP 24)

task—testing the finger strength of typists or aspiring hairdressers' ability to handle a curling iron (ZP 88; 90)—while others assess more general faculties that are required across settings. Contrary to what is suggested by the brochure's title, the devices actually fall into two categories: those primarily assessing physical skills and others which test the mind, though sometimes one domain is assessed via the other.

Physical tests target aspects such as strength and dexterity, balance, steadiness of hand, and the ability to hit a target. Various dynamometers test the ability to pull or push against resistance, with small-scale models available for use with children.[23] Of all the body parts, the hand is a particular focus of psychotechnical testing; Zimmermann's catalogue contains several 'ergographs', elaborate contraptions which measure the strength of individual fingers, while the hand, and sometimes the whole arm, is strapped into a rigid frame (Figure 4.2). As the blurb assures, 'all metal parts are padded and adjustable; if correctly applied they enable complete fixation [of the body]'.[24]

[23] Indeed, many of the most popular devices were also available in a version suited for children. In addition, the catalogue contains a list of textbooks and tests for use in schools, including a questionnaire 'zur Beobachtung und Beurteilung von Schulneulingen am Ende des ersten Schuljahres' ('for the observation and assessment of pupils at the end of their first year at school'; ZP 83).

[24] 'Alle anliegenden Metallteile sind gepolstert und verstellbar; sie sichern bei richtiger Einstellung eine komplette Fixierung' (ZP 24).

One group which mediates between physical and cognitive testing are devices which test sensory awareness (ZP 86), such as the ability to gauge angles, shapes, and distances, and to distinguish between colours, sounds, tastes, and smells. An 'aesthesiometer' even assesses haptic sensitivity either via the skin or via hair follicles (ZP 21–2).

As these devices reveal, attention is a matter of the body as well as the mind. Basic tests assess the receptivity of individual senses, while more complex scenarios test mental faculties, ranging from instinctive and reactive ones—reaction time, alertness, and vigilance, particularly in dangerous situations—to more complex mental operations such as memory, concentration, the ability to multi-task, to learn a new skill, and to resist boredom and distraction, particularly during monotonous tasks. While the body has certain physiological limits, the list of desirable mental qualities is almost endless. The inclusion of persistence, courage, and empathy among the evaluated qualities lends psychotechnical assessment a moral dimension; sub-headings such as 'Wille und Arbeit' (Will and Work) and 'Gefühlsleben' (Emotional Life) implicate the entire person, their values, motivations, and desires, in the process.

Aufmerksamkeit is a term which recurs throughout the catalogue in different contexts. These include assessments which test the speed and acuity of visual perception but also cognitive skills such as memory and alertness. Attention takes centre stage in the section 'Aufmerksamkeit und Vorstellungsleben' (Attention and Imagination; ZP 96–9), where a total of fifteen devices serve to break down this faculty into its constituent parts. One such object, called an 'Obachtprüfer' (alertness tester), assesses three skills at once, namely 'sustained concentration, attention, reactivity', while a 'Sammlungs-(Konzentrations-)Prüfer' tests applicants' sense of vision and touch as well as their concentration, or 'collectedness', during mental tasks. A device which measures how fast someone can take in visual stimuli can be used for professional aptitude testing but also in commercial contexts such as advertising (ZP 96).

The most complex apparatuses advertised in Zimmermann's catalogue are the so-called 'Große Versuchsanordnungen' (Large Testing Stations), which test several interlocking skills and faculties and can be used 'for the sake of research as well as in industry, transport, and sport'.[25] One version focuses on 'concentration, distractibility, proneness to take fright, and readiness for action', another on 'presence of mind and decisiveness'.[26] In both cases, a candidate's concentration while performing a certain task is undermined by visual and acoustic distractions such as flashlights and sirens, which form the sensory backdrop for the actual assessment:

[25] '[. . .] zu Forschungszwecken, sowie in Industrie, Fahrwesen, Sport' (ZP 104).
[26] 'Konzentration, Ablenkbarkeit, Schreckhaftigkeit und Tatbereitschaft'; 'Geistesgegenwart und Entschlußkraft' (ZP 105).

Nach vorbereitender Überschüttung mit mannigfachen Schreckreizen wird der Prüfling in eine für ihn neue gefahrdrohende Situation hineingeführt, aus der er sich durch klare Geistesgegenwart und Entschlußkraft befreien muß. Schnelligkeit und Zweckmäßigkeit der Reaktionen werden bestimmt. (*ZP* 104–5)

[After the preparatory exposure to a multitude of shock-inducing stimuli the candidate is led into a new dangerous situation from which he has to liberate himself by means of lucid presence of mind and decisiveness. These serve to assess the speed and appropriateness of his reactions.]

The primary purpose of these testing stations is to test applicants for professions such as train and tram driver, crane operator, and for the police force (*ZP* 105). Their ultimate ambition, however, is more universal: to replicate, and hence master, the bewildering complexity of modern life, conceived as a mental and physical danger zone, under controlled conditions.

As the brochure reveals, the psychotechnical agenda was not simply descriptive but normative and prescriptive. As well as identifying the skills that were already 'out there' in the general population, psychotechnics taught behavioural patterns that were deemed better, safer, and more efficient. Here, Germany took its cue from US-American scientific management; in Frank and Lillian Gilbreth's time and motion studies, for instance, work processes were filmed, broken down into their constituent parts, and then reconfigured in more effective ways.[27] As these experiments showed time and again, the 'natural', instinctive way of performing a task is rarely the most efficient. And this relates to a second, even more fundamental point. In both experimental psychology and psychotechnics, the assessment is conducted by machines whose sensitivity lies far beyond the scope of the human mind and senses, for the recorded differentials are minute, discernible only with the help of technology.[28] As a consequence, psychotechnical assessors are reduced to machine-operators reliant on their hardware, just as the test subjects are no longer the 'owners' of their mental and physical faculties and hence become fundamentally divorced from any intuitive forms of self-knowledge.

Zimmermann's catalogue provides a striking snapshot of Weimar Germany—a society which embraced technology in its drive towards modernization, populated by people who were subjecting themselves, more or less willingly, to a testing and training regime which started at school and included most professions and many

[27] See Brian Price, 'Frank and Lillian Gilbreth and the Motion Study Controversy, 1907–1930', in *A Mental Revolution: Scientific Management since Taylor*, ed. Daniel Nelson (Columbus, OH: Ohio State University Press, 1992), pp. 58–73; Richard Lindstrom, '"They All Believe They are Undiscovered Mary Pickfords": Workers, Photography, and Scientific Management', *Technology and Culture*, 41 (2000), 725–51; and Elspeth Brown, *The Corporate Eye: Photography and the Rationalization of American Commercial Culture, 1884–1929* (Baltimore, MD: Johns Hopkins University Press, 2005).

[28] Important parameters are breath and pulse; the catalogue lists several 'sphygmographs' for use on either the arm or the neck.

Figure 4.3 Große Versuchsanordnung zur Prüfung der Schreckhaftigkeit, Geistesgegenwart und Entschlußkraft (Large Testing Station for the Assessment of Fright-Reaction, Presence of Mind, and Decisiveness; *ZP* 105)

other areas of life. The catalogue's descriptions outline the purposes of each device in sober, functional prose, reflecting the field's equally sober, purpose-driven self-presentation. These texts are accompanied by drawings of the devices in question, though the catalogue also contains twenty photographs, three of which show psychotechnics in action. In the photo of a 'Große Versuchsanordnung', a male subject is seated with his back to the camera; he is being observed by two standing assessors, both dressed in uniform (Figure 4.3).

Women in the 1920s made up a growing proportion of the German workforce, yet only one photograph depicts a female subject (Figure 4.4). This image of a seated young woman, writing pad at the ready, who is overseen by a standing male assessor, evokes a familiarly gendered scene: that of a secretary taking dictation from her male boss.[29]

In a catalogue aimed at government agencies, employers, and supervisors, both photographs depict psychotechnical assessment as a hierarchical, disciplinary

[29] The brochure contains several devices explicitly designed for female clerical staff, such as an 'Anschlagprüfer für Schreibmaschinistinnen', a device which assesses the typing skills of (female) typists (*ZP* 90).

Figure 4.4 Gedächtnisprüfer (Memory Testing Device) after Schulte (*ZP* 99)

process which enforces existing patriarchal power structures. This agenda is spelled out in the description of a 'Taylor Stopwatch' designed to track workers' output: 'Since the watch operates noiselessly and can comfortably be carried in one's coat pocket, it yields very precise results, for the worker in question can be assessed without his knowledge'.[30] For all its egalitarian rhetoric and professed commitment to fairness and workers' welfare, the psychotechnical project was based on the premise that knowledge is power. As the catalogue spells out, data collection is a means of control, or bio-power, particularly when what is being assessed lies beyond the subject's realm of awareness.

[30] 'Da die Uhr ohne Lärm funktioniert und bequem in der Rocktasche getragen werden kann, ist ihre Kontrolle sehr genau, da der betr[effende] Arbeiter ohne sein Wissen kontrolliert werden kann' (*ZP* 29).

PSYCHOTECHNICS: TRAINING THE MIND 139

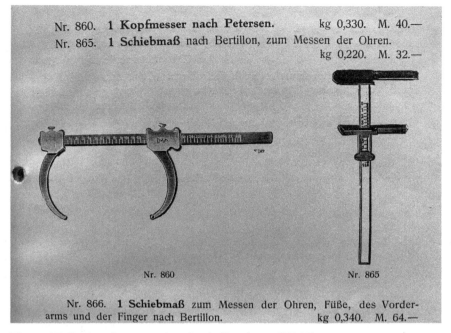

Figure 4.5 Devices for measuring the skull and ears (*ZP* 21)

Optimizing the German workforce was one principal aim, but the reach of psychotechnics also extended to those who did not belong to this core group. The catalogue makes repeated references to illness and abnormality, promising that they too can be detected with psychotechnical methods. One 'Aufmerksamkeits- und Reaktionsprüfer' (attention and reaction testing device) designed for professional aptitude testing can also be used for the 'diagnosis and therapy of concentration disorders';[31] in addition, the list includes picture cards 'to test recall in imbeciles',[32] and a device to assess involuntary reactions as they occur during psychological and psychiatric treatment (*ZP* 100).

Psychotechnical testing thus shades into the field of psychiatry on the one hand, and into eugenicist screening programmes on the other, in each case helping to identify those who did not fit the healthy, productive norm. To this end, the catalogue also contains tools for the measuring of body parts such as feet, hands, fingers, heads, noses, and ears, several of them attributed to the French police inspector and inventor of anthropometry, Alphonse Bertillon (Figure 4.5).[33]

[31] '[...] Diagnose und Therapie von Konzentrationsstörungen' (*ZP* 98).
[32] '[...] zur Untersuchung der Merkfähigkeit bei Schwachsinnigen' (*ZP* 20).
[33] See *ZP* 20–1. Bertillon claimed that criminals shared certain physical characteristics; identifying them would make it easier to recognize people who were likely to offend or reoffend.

The meteoric rise of psychotechnics in Weimar Germany was part of an ambitious and, in some regard, idealistic drive towards social progress, and yet it was also the symptom of a crisis. Psychotechnics was concerned with 'vision that was tired, attention that could no longer focus, minds that no longer registered like machines but wandered, switched off, turned in on themselves, then retreated';[34] as attention was put under unprecedented scrutiny, its limitations were exposed like never before. Zimmermann's 'Large Testing Stations' replicated a world of perpetual shock and distraction; they assessed not sustained concentration but vigilance and 'Schreckreaktion', the ability to withstand fright. By simulating the sensory overload of modern life, psychotechnics became part of the problem, contributing to the adverse mental conditions for which it was trying to prepare. This is nowhere more apparent than in advertising, a field where psychological research into attention directly fed through into creative and economic practice.

Advertising Psychology: The Modern Attention Economy

Weimar Germany was home to some of the most innovative and skilful graphic designers in the world and boasted 'the strongest native advertising tradition in Europe', rooted in a unique synthesis of commerce and aesthetics.[35] Compared to the United States, however, which was widely seen as pioneering in advertising and consumer research, the principles which drove German advertising were rather conservative; when it came to evaluating an advert, artistic goals often trumped commercial criteria.[36] Even so, the rise of psychotechnics and an accompanying focus on consumer psychology had a powerful effect on advertising practice in interwar Germany, resulting in more finely calibrated strategies based on psychological research.

In the United States, the early twentieth century saw a shift towards a more discursive, 'editorializing' type of advertising, which described the merits of a product in some detail and was aimed at a pragmatic and 'use-oriented' customer base.[37] Such advertisements required more sustained concentration on the part of the consumer than traditional poster-style adverts featuring bold images and catchy slogans. Another area of innovation which pulled in the opposite direction, however, was the shop window display. From the 1880s onwards, shop front displays became larger and increasingly elaborate. This development, which started in the United States, was soon emulated in European cities such as

[34] Schwartz, *Blind Spots*, p. 70.
[35] Corey Ross, 'Visions of Prosperity: The Americanization of Advertising in Interwar Germany', in *Selling Modernity: Advertising in Twentieth-Century Germany*, ed. Pamela E. Swett, S. Jonathan Wiesen, and Jonathan R. Zatlin (Durham, NC: Duke University Press, 2007), pp. 52–77 (pp. 53–4).
[36] Ross, 'Visions', p. 58. [37] Ross, 'Visions', p. 55.

Berlin, where major department stores had up to forty window displays each and where window display design became an art in its own right, as supported by a 1907 *Werkbund* conference on 'The Decoration of Shop Fronts'.[38]

These developments were driven by extensive research into consumer psychology. One Weimar study which showcases this research and its practical applications is Theodor König's 1924 *Reklame-Psychologie: Ihr gegenwärtiger Stand—ihre praktische Bedeutung* (Advertising Psychology: Its Current State—its Practical Significance). As the author notes in his introduction, advertising is second only to aptitude testing when it comes to the importance of psychotechnics for economic strategy (*RP* v). While the latter enhances productivity, the former ensures that the resulting goods and services are sold in the most profitable way.

König's book tries to bridge the gap between theory and practice, reporting the findings of the latest psychological research together with suggestions for how they could be implemented in advertising strategies and design. To this end, the study opens with some general reflections on the faculty of attention. Attention is initially described as an anthropological constant, subject to universal laws and patterns, which explain the 'uniformity of psychical processes under identical or similar conditions'.[39] One of the challenges facing the advertising industry is consumers' natural indifference, which manifests itself in an instinctive tendency to ignore or even resist the impact of advertising.

König then breaks down this claim, exploring the factors that determine consumer choices in people of different gender, class, and education. Female consumers, for instance, are more attentive to details such as brand names and model specifications because of their responsibility to provide for the family (*RP* 19). When it comes to advertising, this means that 'women can cope with more extensive and detailed advertisements which they will read attentively',[40] while men, particularly those making personal purchases, need more frequent but less detailed adverts to jog their memory. Then again, female attention, while more capacious, is also prone to be side-tracked by irrelevant information and clichés (*RP* 21).

A similar differentiation can be made when it comes to consumers' level of education. The taste of more highly educated customers is generally more discerning, and so adverts should avoid 'garish colours' and 'frequent superlatives',

[38] See Janet Ward, *Weimar Surfaces: Urban Visual Culture in 1920s Germany* (Berkeley, CA: University of California Press, 2001), p. 200 and *passim*.

[39] The 'Gleichförmigkeit des psychischen Geschehens unter gleichen und ähnlichen Bedingungen' (*RP* 14). One example which underlines the uniformity of psychological response is the direction of the gaze, for viewers tend to look down when standing in front of a shop window; another is the fact that repetition reduces reaction time, making it an essential advertising tool. These examples are complemented by what König calls the 'secondary uniformity' of psychological response: our unconscious drive to mimic others in appearance and behaviour. Fashion is one field where this mimetic impulse is particularly obvious (*RP* 17–18).

[40] '[...] der Frau bedeutend ausführlichere, ins einzelne gehende Anzeigen zugemutet werden dürfen, die sie mit Aufmerksamkeit liest' (*RP* 20).

while the 'uneducated' will respond to 'more primitive images' and simple language. But these parameters are in turn overlaid with factors of regional origin. Designers also need to distinguish between city-dwellers and people living in rural areas. The former have a more sophisticated taste, but their mind and senses are blunted ('abgestumpft') by constant over-stimulation. Country-dwellers, in contrast, live in a state of 'uniform contemplation' and are therefore likely to mistrust radically new sights and experiences (*RP* 22).[41]

König here echoes medical and sociological texts about attention and distraction in modern culture, which similarly differentiate along geographical and social lines. In his text, sophisticated but over-stimulated city-dwellers are once again assumed to have little in common with their rural counterparts, who are used to a slower, more traditional lifestyle. Advertising is not seen as a social leveller, but as a domain where differences of class, gender, and education are reinforced through differently targeted designs. As in psychotechnical testing, then, the evidence-based methodology conceals a prescriptive, or at least a socially conservative, agenda.

König returns to the practical implications of all this research in a 40-page chapter entitled 'Die Aufmerksamkeitswirkung der Reklame' (The Effect of Advertising on Attention). Its first half is dedicated to the external factors that influence the reception of adverts, whether in print media or in poster form. Factors include size (a bigger advert will stand out amongst smaller ones), font, shape, contrast (a white font on a black background can be more striking than the reverse; *RP* 40-1), and colour.[42]

Such findings are easy to implement. Much more complex and harder to control is the wider context in which adverts are viewed, which relates to the challenge of creating the most favourable viewing conditions. Adverts need to stand out from their surroundings, shaking consumers out of their habitual indifference (*RP* 47), but achieving this aim is a balancing act. König cites an American study which found that the 'attentional value' of an advert, its ability to attract attention, does not necessarily correspond to its 'Apperzeptionswert' (value of apperception), that is, the degree to which it enters into conscious perception and hence memory (*RP* 62).[43] Indeed, adverts with a high attentional value risk leaving viewers with 'more or less incomprehensible fragments of information',[44]

[41] Finally, distinctions also apply on a transnational level. One attempt to use US-American adverts in Switzerland turned out to be a complete failure; in this context, König cites a study by Christoph von Hartungen about advertising in Italy, which finds that 'jede Nation ihre besonderen Geistesanlagen und psychischen Qualitäten besitzt' ('every nation has its own mental disposition and psychological qualities'). When it comes to advertising, the natives of a particular country are more attuned to the prevailing mood and taste and hence able to design adverts suitable for the local population (*RP* 24).

[42] König lists colour combinations in order of effectiveness, from a black font on a yellow backdrop (most effective) to red on green, which is hardest to read.

[43] Echoing contemporary psychology, König repeatedly uses the term 'apperception' to distinguish conscious, self-aware perception from the mere registration of sensory stimuli (see for instance *RP* 46).

[44] '[...] mehr oder weniger unverständlichen[n] Fragmente[n] von Informationen'.

while simpler, less flashy designs can have a longer lasting effect. Here König singles out the benefit of images, which make an object more tangible and memorable than verbal description (*RP* 62–3).

To explore these challenges in more detail, the book then provides a comprehensive survey of psychological theories of attention, which centres on the distinction between voluntary and involuntary, active and passive, attention. Advertising strategies often target the involuntary variety, trying to *make* consumers pay attention rather than relying on their own active decision to do so. In addition, attention can be categorized using three criteria: intensity, spatial distribution, and duration. The three are closely linked; for instance, the greater the intensity of focus, the smaller its spatial expansion. A particular challenge is how to sustain attention over time, given its transience and natural fluctuation. König warns that 'only in exceptionally favourable conditions can we rely on a certain constancy of attention'.[45] Such favourable conditions may apply, for instance, in waiting rooms and tram carriages, where individuals will be 'more inclined to pay constant attention than at other times'.[46]

The role of attention in advertising is thus emblematic of a more fundamental paradox besetting modernity. In an age when attention is recognized as a vital personal and economic resource, the many competing efforts to attract, manipulate, and enhance it ultimately have the opposite effect of dispersing it. The professed aim of advertising psychology is to fight consumers' indifference and fluctuating attention, but given that individual advertisers are competing for the limited resources of consumers' attention (and spending power), advertising ends up exacerbating the perpetually distracted mindset it must battle against.

König understands this vicious circle and suggests a number of possible solutions. One would involve moving from attention-grabbing advertisements towards the more discursive, editorializing adverts popular in the United States, which require more sustained attention. Another option would be to tap into consumers' pre-existing interests, to tailor adverts more closely to a particular group. The more relevant the words and images used in an advert for its actual, practical purpose, studies suggest, the better the attentional response—so no more 'empty phrases' (*RP* 74–5).

König hopes that these findings will pave the way for a different, more subtle form of advertising, causing the field to turn away from the 'schreiende Reklame' ('screaming adverts') of the past, which sought to overpower viewers but often caused aversion, even repulsion, particularly in more sensitive persons (*RP* 75). New media and technology might offer ways out of this impasse; they include

[45] '[N]ur in ausnahmsweise günstigen Fällen darf auf eine gewisse Konstanz der Aufmerksamkeit gerechnet werden'.
[46] '[...] weil der Mensch als Wartender [...] zur Aufwendung konstanter Aufmerksamkeit mehr geneigt ist als zu anderen Zeiten' (*RP* 68).

'Lichtreklame', illuminated displays, as well as the use of film for advertising purposes (*RP* 76).

In drawing on new technologies and designs, Weimar advertising was a dynamic and creative field whose aims—to stir people out of their habitual indifference, baiting their attention with ingenious means—were informed by the latest psychological research. In this regard, advertising had a close affinity with avant-garde movements such as Dadaism and the photomontages of John Heartfield, which used similar effects of incongruity and shock to attract viewers' attention.[47] That said, the techniques of advertising psychology were more covert and secretive, verging on subliminal manipulation. Its aim was to forge a long-standing interest in, and identification with, the product.[48] For this purpose, designers needed to delve into the wishes and desires of their audience. This required a more personalized approach than the above-mentioned broad-brushstroke classification of consumers along lines of gender and class. In designing an advert, 'the psychological state of the target audience needs to be borne in mind [...]; closely studying the people to be won over, their wishes and expectations, their way of thinking etc., is its essential precondition'.[49] This aspiration echoes what Stern called 'psychognostics'—the effort to gain an intimate understanding of the individual who is the target of psychotechnical measures.

In this regard, advertising psychology feeds into the larger psychotechnical project of the Weimar Republic, which aims to maximize cognitive performance as part of a national drive towards greater productivity. Indeed, in this context König introduces a new idea: the consumer's attention as a form of labour. Modern life is hard work, particularly when different stimuli 'simultaneously invade the eye, ear, nose, and our tactile perception'.[50] König speaks of the sustained 'physical and mental work' which is needed to process the barrage of messages targeting the consumer, requiring vast amounts of 'physical and psychical strength'.[51] Alongside labour, force, and effort, the text thus

[47] On the links—both personal and aesthetic—between Heartfield and Weimar advertising, see Sabine T. Kriebel, *Revolutionary Beauty: The Radical Photomontages of John Heartfield* (Berkeley, CA: University of California Press, 2014), pp. 76–8 and *passim*.

[48] As König writes, citing the research of psychologist E. K. Strong, 'die Erregung der unwillkürlichen Aufmerksamkeit setzt eine passive Einstellung voraus [...], während die Erweckung des Wunsches eine aktive Einstellung des Lesers nötig macht' (*RP* 78; 'exciting involuntary attention presupposes a passive stance [...], while awakening a wish requires that the reader adopt an active stance').

[49] 'Bei der Gestaltung des Reklamestoffes ist also der psychische Zustand des zu beeinflussenden Käuferkreises genau zu beachten [...]; dazu ist ein genaues Studium der zu gewinnenden Personen, ihrer Wünsche und Ansprüche, ihrer Denkweise usw. notwendige Voraussetzung' (*RP* 99).

[50] 'Besonders gefährlich [...] werden zu lange andauernde Reize, wenn sie gleichzeitig ungegliedert und abwechslungslos auf Auge, Ohr, Nase und Tastsinn eindringen' (*RP* 104).

[51] The 'körperliche und Bewußtseinsarbeit' and 'körperliche und psychische Kraft' (*RP* 104).

introduces another term: *Ermüdung* (fatigue), a key topos in contemporary debates.⁵²

But if advertising adds to the overall sensory overload and produces fatigue, how can this strain be reduced? Once again, König calls for designers to use more subtle techniques, complemented by the subdivision of 'extensive material into several parts and presentations'.⁵³ These recommendations could be taken from a psychotechnical handbook; indeed, König repeatedly refers to psychotechnical studies, for instance when citing research which has shown that repeated practice reduces the required mental effort. Applied to advertising, this could entail tapping into recipients' mindsets, drawing on 'pre-existing mental pathways', in order to 'weave' the communicated message into their existing thought processes until they become part of individuals' identity (*RP* 105).

Though parts of König's argument are sympathetic to the needs of the consumer, ultimately his book describes how to make advertising more subliminally effective by targeting the millions of people worn down by the daily *Daseinskampf*, who are unable to reflect on, let alone resist, the messages they are bombarded with. Consumption *is* labour, its importance for the economy on a par with the work of tram drivers and telephonists, office and factory workers. Indeed, one form of attentional labour segues into the other as people leaving work at the end of the day are made to continue their mental efforts in their free time. This insidious link, the mutually stabilizing effects of work and leisure, is highlighted by one of Weimar Germany's most perceptive cultural critics: the writer and journalist Siegfried Kracauer (1889–1966).

Against Psychotechnics: Siegfried Kracauer

While support for psychotechnics was high throughout the 1920s, Kracauer's was one, relatively isolated, voice of dissent. His pioneering sociological study *Die Angestellten* (The Salaried Masses, 1930) casts Germany's work and leisure culture in a bleak light. Subtitled *Aus dem neuesten Deutschland* (From the Latest Germany), it forms part of a gradual backlash against psychotechnics, although the controversy surrounding its publication also reflects the ongoing support for psychotechnical methods, which continued to be widely used in the Third Reich.

Kracauer was a pioneer of cultural studies, being one of the first thinkers who subjected film and other forms of popular culture to serious analysis. In a series of essays published in the *Frankfurter Zeitung*, the leading left-liberal German

⁵² See Ansom Rabinbach, *The Human Motor: Energy, Fatigue and the Origins of Modernity* (Berkeley, CA: University of California Press, 1992).
⁵³ The 'Zerlegung eines umfangreichen Stoffes in mehrere Teile und Darbietungen' (*RP* 105).

newspaper,⁵⁴ he returns to a topic familiar from the neurasthenia debates around 1900: consumerism, mass entertainment, and their impact on the mind. The title of his 1927 essay 'Kult der Zerstreuung' (Cult of Distraction) brings together two contrasting spheres: religious worship, usually associated with a contemplative mindset, and *Zerstreuung*, a byword for secular superficiality. This, however, is a false opposition. Weimar movie and variety theatres try to generate a 'lofty' and '*sacred*' atmosphere, which is 'just one step short of burning votive candles'.⁵⁵ Its purpose is to invest the performed spectacles with a sense of 'aesthetic totality'.⁵⁶ At the same time, Kracauer highlights the calculated state of *Zerstreuung* engendered by films, revues, and the (illustrated) print media. They rivet the audience's attention 'to the peripheral [...]. The stimulations of the senses succeed one another with such rapidity that there is no room left between them for even the slightest contemplation'.⁵⁷ *Zerstreuung*, in other words, is no accidental side effect of mass entertainment but its core aim and purpose. Why? For without it, people would sink 'into the abyss' ('ins Bodenlose') of their own isolated and superficial existence. But then, in a dialectical twist, Kracauer endorses distraction, arguing that it harbours a subversive potential. For in fact, the spectacles of mass entertainment are themselves superficial and fragmented, and thereby hold up a mirror to an equally fragmented and inauthentic society. Both these spectacles and the society they reflect are characterized by a deeply-rooted sense of '*disorder*', '*Unordnung*'.⁵⁸ Rather than merely diverting viewers from the reality of their situation, cinematic images enable them to 'encounter themselves', as their shallow and isolated lives are mirrored, 'revealed in the fragmented sequence of splendid sense impressions. Were this reality to remain hidden from the viewers, they could neither attack nor change it; its disclosure in distraction is therefore of *moral* significance'.⁵⁹ By mirroring the viewers' situation, the images on screen

⁵⁴ Kracauer became the newspaper's *Feuilleton*, or arts, editor in 1930, a role he had to give up after the Nazis came to power in 1933, when he fled first to France and later, in 1941, to the United States.

⁵⁵ Siegfried Kracauer, 'Cult of Distraction: On Berlin's Picture Palaces', in *The Mass Ornament: Weimar Essays*, trans., ed., and intro. by Thomas Y. Levin (Cambridge, MA: Harvard University Press, 1995), pp. 323–8 (p. 327); 'noch einen Schritt weiter und die Weihkerzen brennen'. Siegfried Kracauer, 'Kult der Zerstreuung: Über die Berliner Lichtspielhäuser', in *Das Ornament der Masse: Essays* (Frankfurt a.M.: Suhrkamp, 1977), pp. 311–17 (p. 315). As Kracauer warns, echoing Moholy-Nagy's programmatic treatise *Malerei, Fotografie, Film* (Painting, Photography, Film, 1925), film should not seek to emulate the theatre and other traditional artforms but needs to capitalize on its own unique technological potential.

⁵⁶ Kracauer, 'Cult', p. 327; Kracauer, 'Kult', p. 316.

⁵⁷ Kracauer, 'Cult', p. 326; 'das Publikum an die Peripherie zu fesseln, damit es nicht ins Bodenlose versinke. Die Erregungen der Sinne folgen sich in ihnen so dicht, daß nicht das schmalste Nachdenken sich zwischen sie einzwängen kann'. Kracauer, 'Kult', p. 314.

⁵⁸ Kracauer, 'Cult', p. 327; Kracauer, 'Kult', p. 315.

⁵⁹ Kracauer, 'Cult', p. 326. 'Hier, im reinen Außen trifft es [das Publikum] sich selber an, die zerstückelte Folge der splendiden Sinneseindrücke bringt seine eigene Wirklichkeit an den Tag. Wäre sie ihm verborgen, es könnte sie nicht angreifen und wandeln; ihr Offenbarwerden in der Zerstreuung hat eine *moralische* Bedeutung'. Kracauer, 'Kult', p. 315.

awaken a sense of tension (*Spannung*) in the audience 'that must precede the inevitable and radical change'.⁶⁰

Over the course of his argument, the meaning of *Zerstreuung* shifts from a state of mindless absorption to a sense of cognitive, spatial, and social fragmentation. This state is not an end in itself but an 'improvisation', the 'reflection of the uncontrolled anarchy of our world'.⁶¹ *Zerstreuung* is endorsed by Kracauer for its anarchical, nihilistic impulses. Any attempt to deliberately restore a sense of unity to modern culture in order to paper over these cracks must therefore be resisted.⁶² As he sums up, 'the shows aiming at distraction are composed of the same mixture of externalities as the world of the urban masses'; conversely, Kracauer casts modern urban life as intrinsically unstable: 'In the streets of Berlin, one is often struck by the momentary insight that someday all this will suddenly burst apart'.⁶³

Kracauer's essay prefigures Benjamin's 'Work of Art' essay of the mid-1930s, which, as we will see in Chapter 8, likewise rejects the traditional artwork and endorses the distracted reception of mass culture.⁶⁴ That said, Benjamin's conception of distraction is more ambivalent, underpinned by contrasting influences: by a Brechtian model of the critically detached spectator on the one hand, by the psychotechnical mission of readying people for the challenges of modernity on the other. For Kracauer, the task of the critic is (on the face of it) a simpler one. It involves highlighting, indeed embracing, 'a kind of distraction that exposes disintegration instead of masking it'. He adds: 'It could be done in Berlin, home of the masses—who so easily allow themselves to be stupefied only because they are so close to the truth'.⁶⁵ This statement reflects the cautious hope that absorption will eventually give rise to realization and resistance. Two years later, Kracauer's faith in the subversive potential of film and the acuity of the urban masses gives way to a much bleaker assessment of modern Germany, where work and

⁶⁰ Kracauer, 'Cult', p. 327; 'die dem notwendigen Umschlag vorangehen muß'. Kracauer, 'Kult', p. 315.

⁶¹ Kracauer, 'Cult', p. 327; '[das] Abbild des unbeherrschten Durcheinanders unserer Welt'. Kracauer, 'Kult', p. 316.

⁶² For this reason, Kracauer critiques those who call for the restoration of the traditional arts and their lofty values of 'personality, inwardness, tragedy, and so on' as a bulwark against modern-day distraction. In the present, these ideals, which are based on the individual as an autonomous and self-aware being, have lost their meaning. A return to high culture is thus merely a sticking plaster, which ignores the deeper causes of distraction. Kracauer, 'Cult', p. 326; Kracauer, 'Kult', p. 314.

⁶³ Kracauer, 'Cult', p. 327. 'In den Straßen von Berlin überfällt einen nicht selten für Augenblicke die Erkenntnis, das alles platze eines Tages entzwei'. Kracauer, 'Kult', p. 315.

⁶⁴ Indeed, in emphasizing the precariousness of the social order, whose smooth surfaces might 'burst open' any second Kracauer anticipates Benjamin's materialist conception of history, specifically his notion of the 'now of recognizability', or 'Jetzt der Erkennbarkeit' (*AP* 464; 473; *BGS* V.1, 578; 591–2), whereby insights into the past do not appear gradually, as the result of contemplative immersion in historical sources, but are suddenly and unpredictably revealed, the product of a unique historical configuration of the past and the present moment.

⁶⁵ Kracauer, 'Cult', p. 328; 'eine Zerstreuung [...], die den Zerfall entblößt, nicht ihn verhüllt. Sie können es in Berlin, wo die Massen leben, die nur darum so leicht sich betäuben lassen, weil sie der Wahrheit so nahe sind'. Kracauer, 'Kult', p. 317.

leisure, two spheres tied together by psychotechnics, coalesce to stabilize the oppressive status quo. This U-turn has several reasons. The world economic crisis, which had a devastating effect on the German economy, is one factor. More specifically, his reassessment is informed by the empirical research he conducted for *The Salaried Masses*.

One aspect carried over from 'Cult of Distraction' is Kracauer's preference for fragmentation over a (false) sense of coherence. He is keen to distinguish his book from journalistic reportage, a genre which merely offers 'the reproduction of observed reality' (*SM* 32; *A* 222). As he counters, reality is a mere construction; capturing it requires numerous detailed snapshots to be combined into a 'mosaic', in which the discrete parts remain visible, in an effort to reveal the underlying structures of power.

On the level of content, the book elaborates on a claim made in 'Cult of Distraction', namely on the deeply fragmented character of modern life. To do so, it zooms in on a tranche of Weimar society: the *Angestellten*, or white-collar workers. This category includes shop assistants and typists, clerical workers and middle management; *Angestellte* are different from *Arbeiter*, manual and industrial workers, and from self-employed tradespeople or *Handwerker*. Though they are the fastest-growing group within the Weimar economy, they are largely ignored in public debate and scholarship. 'But you can already find all that in novels' is the book's opening sentence,[66] citing the response of one female office worker to Kracauer's project. Weimar novels are indeed often set among this demographic, but this does not mean that their experience is well understood.[67] On the contrary, Kracauer casts their lives as 'more unknown than that of the primitive tribes' depicted in the cinema (*SM* 29; *A* 218), before embarking on an ethnographic study of their everyday lives.[68]

Psychotechnics features prominently in his book, for it shapes the lives of the *Angestellten* from the application process and training via everyday working conditions all the way to leisure and entertainment. Zimmermann's catalogue contains numerous devices designed to assess clerical workers. In his chapter

[66] *SM* 28. 'Das steht doch schon alles in den Romanen' (*A* 217).
[67] Weimar novels often revolve around the experiences of *Angestellte* and specifically young working women. Prominent examples include Erich Kästner's *Fabian*, Marieluise Fleißer's *Mehlreisende Frieda Geier* (Travelling Flour Saleswomen Frieda Geier), Gabriele Tergit's *Käsebier erobert den Kurfürstendamm* (Käsebier Conquers the Kurfürstendamm; all 1931), and Irmgard Keun's *Das kunstseidene Mädchen* (The Rayon Silk Girl, 1932). On this literary genre, see Christa Jordan, *Zwischen Zerstreuung und Berauschung: Die Angestellten in der Erzählprosa am Ende der Weimarer Republik* (Frankfurt a.M.: Lang, 1988).
[68] To this end, Kracauer does extensive research. His sources include magazines, books, and trade union publications as well as interviews with various groups: employees, employers, politicians, and representatives of the 'Allgemeiner freier Angestelltenbund', an amalgamation of various left-wing trade unions representing technical and administrative staff. In addition, Kracauer attended trials at the *Arbeitsgericht*, the Berlin Employment Tribunal, and was granted access to court files by the court's presiding judge, Otto Kahn-Freund.

'Auslese' (Selection), Kracauer looks at how this process works from the viewpoints of applicants, employees, employers, and those who have devised the selection process. The latter group is represented by none other than William Stern, one of the inventors of psychotechnics, whom Kracauer encounters at a trade union conference. For Stern, an *Angestellter* is 'something infinitely more complicated than a worker. While a simple functional test is normally sufficient for the latter, the greater demands imposed by commercial occupations mean that the former can be fathomed only by a "total view"'.[69] This total view, or *Totalschau*, which promises to take account of the whole person, is a notion to which Kracauer returns to several times. Stern explains that clerical work requires a range of skills, from manual dexterity, concentration, and recall, to multi-tasking and the ability to resist boredom. In fact, the assessment of specific skills amounts to a covert character assessment:

> Man macht Experimente mit ihm: Buchungsproben, Telephonproben usw. Man beobachtet ihn: wie legt der Kandidat die Rechnungen hin, die er zu ordnen hat? Man studiert ihn physiognomisch und graphologisch. Kurzum, der kleinste Angestellte ist für den Berufspsychologen ein Mikrokosmos. (*A* 226)
>
> [They experiment with him: accounting tests, telephone tests, etc. They observe him: how does the candidate lay out the invoices he has to classify? They study him physiognomically and graphologically. In short, for occupational psychologists every least employee is a microcosm. (*SM* 36)]

Kracauer casts the graphologist's task as one of colonial (or sexual) invasion. He or she 'penetrates' the employees' souls 'like a government spy in hostile territory', and both thereby procure 'by secret paths [...] from the enemy camp material of value to their principals'.[70] The image of spies invading a hostile territory may seem over-dramatic, but its sentiment is echoed in Zimmermann's catalogue—which lists devices designed to map out subjects' 'emotional life' and character traits[71]—and König's *Advertising Psychology*, both of which promise that psychotechnics can grant covert insights into the minds of workers and consumers.

Kracauer's study contests one of the core claims of psychotechnics, namely its interest in the 'whole person'. Citing the movement's slogan, 'The right person in the right place!', he contrasts this aspiration with the sobering reality. Most tests assess aptitude only on a narrow scale—'Telephone girl or shorthand typist—that

[69] *SM* 36; 'ein unendlich viel komplizierteres Ding als ein Arbeiter. Genügt bei diesem in der Regel die einfache Funktionsprüfung, so ist jener der höheren Anforderungen wegen, die kaufmännische Berufe stellen, nur in einer "Totalschau" zu ergründen' (*A* 226).

[70] *SM* 37; 'dringt in die Angestelltenseele ein wie ein Regierungsspion in feindliche Länder. Beide sollen auf Geheimpfaden Material aus dem gegnerischen Lager beschaffen, das für ihre Auftraggeber von Wert ist' (*A* 228).

[71] See *ZP* 99–107.

is the question'[72]—and the focus is not on the employee but on the needs of the company: 'Jobs are precisely not vocations tailored to so-called personalities, but jobs in the enterprise, created according to the needs of the production and distribution process'.[73]

Once selection and training are complete, this mixture of drill and covert surveillance continues at the workplace. Here, Kracauer zooms in on one particular example of modern working conditions. Large companies often use a Powers Accounting Machine, an electromechanical tabulating apparatus and forerunner of the computer. This device, alongside its commercial rival, the Hollerith Machine, was used to monitor the different stages of the working process, each of which was represented by a numerical code, recorded on a perforated filing card that could be read by the machine.

Once in operation, the machine basically runs by itself. Setting it up, however, requires programming the perforated cards. Like many routine clerical tasks, this was largely done by women, who were chosen for their dexterity—and because they were paid less.[74] One company director is keen to stress that his 'girls' spend 'only' six of their eight working hours at the machine to avoid exhaustion and take regular shorter breaks 'for hygienic reasons' (A 232; SM 41)—remarks which drive home the mental strain of this occupation, which was comparable to professions such as typesetter and telephonist (Figure 4.6).

For Kracauer, the Hollerith and Powers Machines exemplify modern, technologized working conditions and their impact on the mind:

Dank der in dem Instrumentarium investierten Geistesarbeit bleibt seinen Handlangern der Besitz von Kenntnissen erspart [...]. Auch die Mysterien des Betriebs sind ihnen verschlossen, da sie nur mit Ziffern verkehren. Verlangt wird von ihnen eines: Aufmerksamkeit. Sie kann nicht frei schalten, sondern untersteht der Kontrolle des Apparats, den sie kontrolliert, und muß, im Verein mit dem Geräusch in den Maschinensälen, die Nerven um so mehr beanspruchen, je weniger der Gegenstand lockt, dem sie zu gelten hat. (A 233)

[Thanks to the intellectual labour invested in the equipment, its handmaidens are spared the possession of knowledge [...]. The mysteries of the firm too are a closed book to them, since they deal only with figures. Just one thing is required of them: attention. This cannot wander free but is under the control of the apparatus it controls and—what with the noise in the machine-rooms—the less enticing the object at which it is to be directed, the more it must demand of the nerves. (SM 42)]

[72] SM 35; 'Telephonistin oder Stenotypistin, das ist die Frage' (A 225).
[73] SM 35; 'Stellen sind nicht Berufe, die auf sogenannte Persönlichkeiten zugeschnitten wären, sondern Stellen im Betrieb, die je nach den Notwendigkeiten des Produktions- oder Verteilungsprozesses geschaffen werden' (A 225).
[74] Though women make up over one third of *Angestellte*, they earn 10–15 per cent less than their male counterparts (A 220; SM 31).

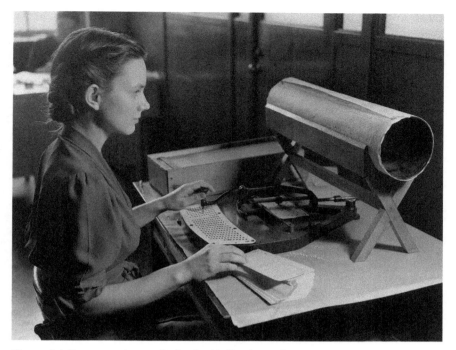

Figure 4.6 Programming cards for the Hollerith Machine

The apparatuses themselves are feats of great ingenuity; their operation, in contrast, requires no active intellectual input, reducing the human operators to *Handlanger* or 'handmaidens'. Attention, traditionally regarded as the hallmark of the rational, autonomous individual, is here reduced to a passive impulse myopically tied to details but oblivious of the bigger picture. Here, as in Kafka's *The Man who Disappeared*, the apparatus dominates the mind rather than vice versa. Indeed, Kracauer references Kafka's works, specifically their depiction of the 'labyrinthine large corporation',[75] as emblematic of Weimar working culture, a system which has grown unfathomably abstract and minimizes human (inter-)action and understanding.

The mental strain posed by this kind of work is huge, and Kracauer cites employees who complain that factors such as fatigue are ignored in the setting of performance targets. Some, however, relish the machine's high processing speed, which forces their operatives 'to bring even their brains to an appropriate "frequency". [...] work thus acquires a tempo and therewith, in my view, that which endows even a monotonous job with charm'.[76] The fact that this remark is

[75] *SM* 48; the 'verworrene menschliche Großbetrieb' (*A* 240).
[76] *SM* 42; 'auch das Gehirn auf eine entsprechende "Tourenzahl" zu bringen. [...] dadurch kommt Tempo in die Arbeit und damit meiner Meinung nach das, was auch einer einförmigen Arbeit Reiz gibt' (*A* 234).

cited in the official company newspaper, informally known as the 'Slime-Trumpet', somewhat diminishes its credibility. That said, even serious experts are happy to endorse these modern working conditions. Kracauer cites the sociologist and economist Ludwig Heyde, editor of the socially progressive weekly *Soziale Praxis* (Social Practice), who has devised an entire theory of monotony, which endorses the benefits, even 'joys', of this experience. The male worker, he notes, is able to use his spare mental capacity to think about 'his class ideal' or about family matters, while the 'young girl' dreams 'of teenage novels, film dramas, or betrothals'.[77]

As Heyde suggests, popular culture is not the subversive force Kracauer had held it to be in his 1927 essay, but offers a momentary escape from everyday life. This argument is then expanded in the chapters on mass entertainment, which make for particularly bleak reading. Kracauer's investigation uncovers what he casts as the systematic interconnection of work and leisure. Mass entertainment perpetuates the same mindset, the same passive attention, which is also required at the workplace, but passes this off as fun and distraction. Having been conditioned at work, many employees are positively averse to any form of concentration, which they regard as a burden and an unnecessary strain. *Zerstreuung*, as a result, becomes 'a deadly serious matter', a state which is actively to be pursued by the employees and encouraged from above (*KSM* 89; *KA* 289). For 'at the same moment at which firms are rationalized, these establishments rationalize the pleasure of the salary-earning armies'.[78] Mass entertainment is not tailored to the individual but aimed at the masses, for 'people's lives are bled far too dry for them to have the least idea what to do with themselves'.[79]

In his book, Kracauer reclassifies the 'temples' of mass entertainment as an 'Asyl für Obdachlose', shelter for the homeless (*SM* 88; *A* 288). This is not a literal but a spiritual homelessness. Mass entertainment fills a gap which used to be filled by community and a higher (religious) sense of purpose. Modern-day employees not only lack this higher purpose but are positively afraid

> aufzublicken und sich bis zum Ende durchzufragen; nichts kennzeichnet so sehr dieses Leben, das nur in eingeschränktem Sinne Leben heißen darf, als die Art und Weise, in der ihm das Höhere erscheint. Es ist ihm nicht Gehalt, sondern Glanz. Er ergibt sich ihm nicht durch Sammlung, sondern durch Zerstreuung.
>
> (*A* 288)

[77] *SM* 45; 'von Backfischromanen, Kinodramen und vom Brautstand' (*A* 237). Using the author's own words, Kracauer exposes Heyde's spineless endorsement of increasingly inhuman working conditions. With this attack, he challenges left-wing loyalties; as we will see at the end of this section, the trade unions did not take kindly to his analysis.

[78] *SM* 91; 'in demselben Augenblick, in dem die Betriebe rationalisiert werden, rationalisieren jene Lokale das Vergnügen der Angestelltenheere' (*A* 292).

[79] *SM* 91; 'weil das Leben der Leute viel zu ausgepowert ist, als daß sie noch etwas mit sich anzufangen vermöchten' (*A* 292).

[of looking up and asking their way to the destination. Nothing is more characteristic of this life, which only in a restricted sense can be called a life, than its view of higher things. Not as substance but as glamour. Yielded not through concentration, but in distraction. (*SM* 88)]

What ultimately drives the period's fixation on glamour, entertainment, and distraction is an age-old human experience: the fear of death. While young working people succeed in repressing this prospect, it imposes itself with even greater force on those who are left behind in the Weimar economy. Kracauer cites some harrowing responses to a survey among unemployed white-collar workers, among them a 39-year-old with three children, who has earned no money for three years and who outlines his future options as 'work, madhouse, or turn on the gas', and a married father of two for whom the future is 'hopeless and without prospects. Early death would be best'.[80] Contrary to earlier assurances, by the late 1920s psychotechnics no longer provided opportunities for all, regardless of their age or background. In the age of mass unemployment, it became a blunt and brutal selection tool which excluded all but the most skilled and flexible. The resulting two-tier system, where a very young workforce pushes out the older generation, has knock-on effects for young and old:

So innig sind Tod und Leben ineinander verschränkt, daß man dieses ohne jenes nicht haben kann. Wird also das Alter entthront, so hat zwar die Jugend gewonnen, aber das Leben verspielt. Nichts kennzeichnet mehr die Tatsache, daß man seiner nicht mächtig wird, als das Nachlaufspiel mit der Jugend, die Leben zu nennen ein verhängnisvolles Mißverständnis ist. Es duldet keine Zweifel, daß der rationalisierte Wirtschaftsbetrieb dieses Mißverständnis begünstigt, wenn nicht erzeugt. Je weniger er sich seines Sinnes sicher ist, desto strenger untersagt er der Masse der erwerbstätigen Menschen die Frage nach seinem Sinn. Wenn aber die Menschen den Blick nicht auf ein bedeutendes Ende richten dürfen, entgleitet ihnen auch das äußerste Ende, der Tod. (*A* 254)

[Death and life are so intimately interwoven with one another that you cannot have the latter without the former. If old age is dethroned, therefore, youth may have won, but life has lost the game. Nothing more clearly indicates that it is not mastered than the dangling after youth—which it is a disastrous misconception to call life. The rationalized economy undoubtedly encourages, if not engenders, this misconception. The less sure it is of its meaning, the more strictly it forbids the mass of working people to ask about its meaning. But if people are not permitted to look towards a meaningful end, then the ultimate end—death—likewise eludes them. (*SM* 58–9)]

[80] *SM* 57; 'trostlos und aussichtslos. Der baldige Tod dürfte das Beste sein' (*A* 252).

Is there any way out of this vicious circle of distraction and denial? For some on the left, the answer lies in collective activities and the sense of belonging they can foster. Team sport is a prime example; but Kracauer worries that for many people sport provides yet another 'welcome opportunity for distraction—which they exploit to the full'.[81] Indeed, its (however tentative) prospect of fame and recognition makes sport a kind of sedative, comparable to the fairy-tale plots of the cinema, which suppresses critical dissent. In a society where distraction is systematically fostered as the mindset most conducive to work *and* leisure, sport becomes 'a symptom of repression on a grand scale; it does promote the reshaping of social relations, but all in all is a major means of depoliticization'.[82]

In a final challenge to leftist orthodoxy, Kracauer stresses that the big questions of the age cannot be resolved by the collective but have to be confronted by the individual. To underline this point, he returns to that most existential of challenges: the prospect of death:

Der Mensch, der allein dem Tod gegenübersteht, geht in das Kollektiv nicht ein, das sich zum Endzweck übersteigern möchte. Ihn bildet nicht die Gemeinschaft als solche, sondern Erkenntnis, durch die auch Gemeinschaft entstehen kann. [...] Es kommt nicht darauf an, daß die Institutionen geändert werden, es kommt darauf an, daß Menschen die Institutionen ändern. (*A* 310)

[The human individual, who confronts death alone, is not submerged in the collectivity striving to elevate itself into a final purpose. He/she is formed not by community as such but by knowledge, from which community too may arise. [...] What matters is not that institutions are changed, what matters is that individuals change institutions. (*SM* 106)]

In his opening chapter, Kracauer compares the existence, or *Dasein*, of the *Angestellten* to Edgar Allan Poe's 'purloined letter'. Though it is in full public view, and central to the Weimar economy, even the employees themselves have little awareness of their own situation. 'Nobody notices the letter because it is out on display'.[83] Kracauer's approach is a variant of the eighteenth- and nineteenth-century model of 'Andacht zum Unbedeutenden', the contemplation of the (seemingly) insignificant. In analysing these people's daily lives, he wants to uncover the power dynamics, the assumptions, and the covert practices that govern the Weimar economy. Echoing the experience of Poe's Auguste Dupin, who has to confront the unscrupulous Minister D–, Kracauer realizes that this is no easy task:

[81] *SM* 94; a 'willkommene und [...] voll ausgenutzte Möglichkeit der Zerstreuung' (*A* 295).

[82] *SM* 95; 'eine Verdrängungserscheinung großen Stils; sie fördert nicht die Umgestaltung der sozialen Verhältnisse, sondern ist insgesamt ein Hauptmittel der Entpolitisierung' (*A* 296).

[83] *SM* 29. 'Niemand bemerkt den Brief, weil er obenauf liegt' (*A* 218).

'Powerful forces are admittedly in play, anxious to prevent anyone noticing anything here'.[84]

These forces already made themselves felt in the run-up to the book's publication. The study was first serialized in the *Frankfurter Zeitung* in 1929, just six weeks after the Wall Street crash of 29 October, but this had required the intervention of Benno Reifenberg, head of the Feuilleton section, who praised *The Salaried Masses* as a 'sensation' and a 'discovery' to overcome the obvious resistance of the paper's general editor, Heinrich Simon (*A* 383). The book version, published by the Societäts-Druckerei in Frankfurt, ran into even more serious difficulties,[85] following the intervention of powerful industry leaders such as Carl Duisberg, chair of the 'Reichsverband der deutschen Industrie' (National Association of German Industry), and director of I. G. Farben. But Kracauer also managed to alienate the leading trade unions with his study.[86] The union representing middle management accused Kracauer of siding with its left-wing rival, the 'Gewerkschaftsbund der Angestellten'. This union, in turn, branded Kracauer a bourgeois 'Bohème-Reporter', accusing him of ignoring the views of its members, who were in fact happy to endorse modern working conditions in their commitment to the socialist common good.[87] Kracauer's book, they argued, ignored the higher aspects of human nature; any sense of idealism was dissolved in the 'corrosive lye' of his ironic commentary. That said, his irony and laconic understatement were praised by fellow critics Ernst Bloch and Walter Benjamin as integral to the humanism of Kracauer's seminal study (*A* 386–7).

Across Weimar Germany, men, women, and children were put through their paces by psychotechnical apparatuses, made to perform repetitive tasks with maximum speed and efficiency. The technological side of this project—the astonishing range of devices invented for every imaginable task or context—was complemented by an equally comprehensive mission to map out the mind, assessing people's skills and preferences, values and aspirations. In modern history, psychotechnics thus marked one of the most ambitious and invidious drives to recondition the human subject in both body and mind. Its particular mix of social utopia and rigid discipline garnered it broad social support in postwar German society, and with it almost unfettered licence to select, train, and exclude.

[84] *SM* 29. 'Freilich sind gewaltige Kräfte im Spiel, die es hintertreiben möchten, daß einer hier etwas bemerkt' (*A* 218).
[85] See Kracauer's letter to Friedrich Traugott Gubler of 23 January 1930 (*A* 384, n. 33).
[86] In 1929 I. G. Farben acquired 49 per cent of the shares of the Societäts-Druckerei (*A* 384).
[87] As Henri Band concludes, the social heterogeneity and political and ideological polarization of white-collar workers in the Weimar Republic prevented a unified reception. *Mittelschichten und Massenkultur: Siegfried Kracauers publizistische Auseinandersetzung mit der populären Kultur und der Kultur der Mittelschichten in der Weimarer Republik* (Berlin: Lukas, 1999), p. 203; on the reception of *The Salaried Masses* more generally, see pp. 202–18.

Kracauer's *Salaried Masses* seeks to highlight the scale of this project and its corrosive but ill-understood consequences for individuals and society. His clear-sighted and often acerbic analysis was met with a fierce backlash which, just like the endorsement of psychotechnics, transcended categories such as social class and political affiliation. The following chapters continue the investigation of psychotechnics by exploring its resonances within modernist literature and thought, focusing first on its central but ambivalent role in the works of the Austrian writer Robert Musil.

5
Threshold States
Robert Musil

The Uses of Psychotechnics

The devices used in experimental psychology and psychotechnics made mental processes measurable, but in doing so they also determined what was being assessed in the first place. Technological materiality shaped the knowledge and conception of the human subject. In the process, the shaded and perpetually fluctuating realm of awareness was often reduced to sets of blunt oppositions—voluntary versus involuntary attention; alertness versus distraction. But this approach ran contrary to developments in modernist art and literature, which turned from a depiction of outer reality to an exploration of the mind, emphasizing its fluid nature by unearthing fantasies, fears, and desires. Likewise, creative production resisted psychotechnical principles of speed and efficiency, relying instead on more elusive processes such as invention and experimentation. The Surrealists' *écriture automatique* (automatic writing) sought to unshackle the mind from rational control, an approach which harked back to the Romantic model of the writer as inspired genius.[1] This idea widely resonated in modernism; Kafka's account of the ecstatic creation of 'The Judgement' is one example. That said, not all modernist writers subscribed to this spontaneous model of literary production. One author who was strongly drawn to the supposed rigour of psychotechnics and experimental psychology was Robert Musil (1880–1942).

A writer of fiction as well as essays, Musil was one of the period's most versatile and perceptive commentators on modern life. His magnum opus, the unfinished novel *Der Mann ohne Eigenschaften* (The Man without Qualities), offers a portrait of the Habsburg monarchy prior to the First World War not through a conventionally realist narrative but as a self-consciously artificial construct, a textual entity made up of a multitude of discourses—models of interpretation through which both the narrative and its many characters try (and fail) to make sense of an increasingly complex world. Psychotechnics is one such discourse, one model among many, and yet it is not afforded the same level of satirical critique as some of the novel's other modern obsessions. Its different depiction is no coincidence.

[1] On the history of this concept, see Jochen Schmidt, *Die Geschichte des Genie-Gedankens in der deutschen Literatur, Philosophie und Politik 1750–1945*, 3rd, improved edn (Heidelberg: Winter, 2004).

Not only was Musil closely familiar with psychology and psychotechnics through his scientific training, but he transposed this expertise into what could be called techniques of cognitive self-fashioning, which are reflected in his diaries, letters, and, more indirectly, his essays and prose works. This chapter considers the interplay between these discourses as different responses to one overriding problem: that of the mobile and unstable mind. Psychotechnics is not the only prism through which Musil explores this issue, for it is complemented by other, contrasting paradigms such as mysticism and autosuggestion.

In the autumn of 1903, Musil matriculated at the Friedrich Wilhelm University in Berlin to study philosophy, physics, and mathematics. His doctoral supervisor was Carl Stumpf, Chair of Philosophy and founding director of the University's Psychological Institute. Stumpf was a central figure in experimental psychology, where he was known particularly for his work on the psychology of tones.[2] One of Stumpf's main rivals was his Leipzig-based colleague Wilhelm Wundt. While Wundt sought to measure sensory perception using objectively quantifiable data, Stumpf relied on self-experiment and self-observation. The graduate students who partook in his experiments were carefully pre-selected and trained so they could extract reliable data from self-observation.[3] Attention was foremost among the mental faculties tested in Stumpf's laboratory, in experiments involving apparatuses such as the tachistoscope, which would later play a leading role in psychotechnics.

Musil took part in these experiments while writing his dissertation on Ernst Mach and even devised his own version of the tachistoscope tailored to the group's specific needs. The official records of his self-experiments have not survived, but his 1906 diary offers a glimpse of this experience:

Die auszeichnende Funktion der Aufmerksamkeit erhebt noch nicht das betreffende Moment zum Begriff. Denn gerade im Erkennen,—vor dem Erkannthaben—achten wir mit aller Aufmerksamkeit auf das Moment und wissen doch nicht, was es ist, z.B. wenn wir die Farbe eines entfernten Gegenstandes erkennen wollen.[4]

[The distinguishing function of attention does not yet raise the observed feature to the conceptual level. For particularly in the process of perception—prior to having apprehended a feature—we strain our attention to focus on that feature

[2] Having studied with Franz Brentano and Hermann Lotze, Stumpf numbered the founders of Gestalt psychology, Max Wertheimer, Kurt Koffka, and Wolfgang Köhler, among his pupils, as well as Edmund Husserl. See Helga Sprung with Lothar Sprung, *Carl Stumpf: Eine Biografie. Von der Philosophie zur experimentellen Psychologie* (Munich: Profil, 2006).

[3] These experiments were headed by Stumpf's assistant Friedrich Schumann; Musil attended his lecture course on the 'Einheitlichkeit der Bewußtseinsinhalte' (Unity of the Contents of Consciousness) in the winter semester 1904-5. On Musil's studies in Berlin, see Christoph Hoffmann, *'Der Dichter am Apparat': Medientechnik, Experimentalpsychologie und Texte Robert Musils, 1899-1942* (Munich: Fink, 1997), pp. 64-7.

[4] Robert Musil, *Tagebücher*, ed. Adolf Frisé (Reinbek bei Hamburg: Rowohlt, 1976), pp. 125-6.

yet do not know what it is, as for instance when we want to determine the colour of an object in the distance.]

Musil casts attention as a pre-rational and pre-linguistic operation; attending to a sensation by isolating it from the wider perceptual field precedes identifying it by means of concepts. This and other diary entries are too associative and subjective to conform to the prescribed recording format used under experimental conditions, but they do reflect Musil's own experience of this process and those aspects—such as the unfathomable nature of sensory perception—that resonated with him far beyond this time.[5]

After his doctorate in Berlin, Musil turned down an offer for a postdoctoral position in psychology at the University of Graz to pursue his literary career. His training in Stumpf's laboratory did, however, come in useful when in 1920 he was appointed 'Fachbeirat für Methoden der Geistes- und Arbeitsausbildung' (Scientific Adviser for Methods of Mental and Professional Training) at the Austrian Ministry for Military Affairs.[6] One of his tasks was to evaluate the merits of psychotechnics and how it could be used in the Austrian army. Austria was lagging behind Germany, which had invested heavily in psychotechnics during the war, and was now trying to make up lost ground. In March 1922 Musil presented his findings in a lecture delivered to an audience of officers and civil servants.[7] Entitled 'Psychotechnik und ihre Anwendungsmöglichkeit im Bundesheere' (Psychotechnics and its Applicability in the Austrian Army), it was published in the journal *Militärwissenschaftliche und Technische Mitteilungen* (Communications on Military Research and Technology) later that year.

Though Musil was familiar with the methods and theories of experimental psychology, he was by no means an expert in psychotechnics but first had to acquaint himself with this fast-moving field. Large parts of his argument are taken, sometimes verbatim, from the three texts listed in his bibliography—Hugo Münsterberg's *Grundzüge der Psychotechnik* (Principles of Psychotechnics) as well as studies by Curt Piorkowski and Karl August Tramm.[8] That said, there

[5] In the same year, Musil published his first novel, the coming-of-age narrative *Die Verwirrungen des Zöglings Törless* (The Confusions of Young Törless, 1906), which explores extremes of human emotion and experience and the paradoxes inherent in supposedly rational disciplines such as mathematics.

[6] During and after the war, psychotechnical methods were used in the assessment and rehabilitation of injured soldiers, particularly those with head injuries and neurological deficits, who were then retrained to work in alternative professions if necessary. See Dominik Schrage, *Psychotechnik und Radiophonie: Subjektkonstruktionen in artifiziellen Wirklichkeiten 1918–1932* (Munich: Fink, 2001), pp. 94–107.

[7] See Robert Musil, *Briefe 1901–1942: Kommentar, Register*, ed. Adolf Frisé (Reinbek bei Hamburg: Rowohlt, 1981), p. 147.

[8] Hugo Münsterberg, *Grundzüge der Psychotechnik* (Leipzig: Barth, 1914); Curt Piorkowski, *Die psychologische Methodologie der wirtschaftlichen Berufseignung*, 2nd ext. edn (Leipzig: Barth, 1919); Karl August Tramm, *Psychotechnik und Taylor-System* (Berlin: Springer, 1921). On Musil's sources, see also Christoph Hoffmann, 'Technische Aufsätze', in *Robert-Musil-Handbuch*, ed. Birgit Nübel and Norbert Christian Wolf (Berlin: de Gruyter, 2016), pp. 429–34 (p. 432).

are moments when Musil strays from this grid into domains which reflect not his official brief but his literary interests.

The lecture starts with an overview of the uses of psychotechnics in the recent war, citing statistics that nearly two million US soldiers were subjected to intelligence testing. In Germany, psychotechnical laboratories assessed applicants for roles such as pilot, driver, and radio operator, and psychotechnical methods were even used for the training of dogs and for the treatment and convalescence of injured soldiers (*PA* 182). In summarizing these military uses, Musil draws analogies to civilian society, noting for instance that the presence of mind 'required by a squad or platoon leader when firing at an unexpected target is not so very different from that required by a tram driver'.[9] The two spheres are linked by a mobile form of alertness, a faculty to which he returns later in his paper.

Though the lecture's focus is on military applications, Musil gives a broad overview of psychotechnics as a whole and its almost unlimited benefits. 'There is barely any field', he declares, 'where the current state of scientific inquiry would not allow psychological knowledge to be put to practical use', facilitating the 'most economical use of all available capacity'.[10] In his lecture, he calls psychologists *Leistungsingenieure* (performance engineers), whose task is 'the correct selection of human resources'.[11] Coming from a writer whose work satirizes the crazes and fashions of modern life, including its obsession with speed and efficiency, such formulations are striking indeed. True, Musil also touches on the benefits of psychotechnics for the individual worker, which include better pay, shorter working hours, and safer working conditions. But ultimately, his attitude towards the experience of the individual soldier, student, or worker is cool to the point of indifference, his image of the human subject mechanistic and utilitarian. One prominent theme is discipline and the ways in which psychotechnics can serve to uphold it. The Austrian army had struggled to maintain discipline among its soldiers towards the end of the war in particular;[12] echoing a section in Münsterberg's book, which addresses matters of education and obedience, Musil remarks that applied psychology can offer 'many valuable clues' ('manchen wertvollen Fingerzeig') in situations where 'traditional forms of discipline' must be restored.[13]

Unlike Kracauer, Musil is no critic of the psychotechnical machinery, and he barely weighs up its costs and benefits. Rather, his attitude is one of wholehearted

[9] 'Die "Geistesgegenwart", die ein Schwarm- oder Zugskommandant braucht, um ein überraschendes Ziel zu beschießen, ist nicht so sehr verschieden von der eines Straßenbahnführers' (*PA* 199).
[10] '[E]s gibt kaum ein Gebiet [...], wo der gegenwärtige Stand der Wissenschaft nicht schon erlauben würde, psychologische Kenntnisse in den Dienst der Zwecke zu stellen', facilitating the 'ökonomischeste [...] Bewirtschaftung aller Kräfte' (*PA* 181).
[11] '[...] die richtige Auslese des Menschenmaterials' (*PA* 182; 193).
[12] See Manfried Rauchensteiner, 'Österreich-Ungarn', in *Enzyklopädie Erster Weltkrieg*, ed. Gerhard Hirschfeld et al., updated and ext. edn (Paderborn: Schöningh, 2009), pp. 64–86 (p. 84).
[13] *PA* 200; see Christoph Hoffmann, 'Militärische Ausbildung, Arbeits- und Ordnungswissenschaft', in *Musil-Handbuch*, pp. 499–503 (p. 500). On Musil's reception of Münsterberg, see also Elena Calamari, 'Hugo Münsterberg nell'opera di Musil', *Annali: Studi Tedeschi*, 23 (1980), 287–314.

endorsement, as when he calls it a *'new and incomplete, but serious scientific and practical phenomenon of the utmost importance'*,[14] which has the potential to revolutionize all areas of modern life.

Musil then outlines specific applications in telephony, transport, and education, where psychotechnical methods can be used to inflect examination and teaching methods. Written exams should assess not only subject-specific knowledge but underlying mental faculties such as multi-tasking, concentration, and the ability to resist fatigue, while in the classroom attention must be recognized as a vital skill, the basis of successful learning. Deliberately diverting pupils' attention away from a problem can actually encourage them to come up with a solution, while the ability to block out distracting stimuli in the classroom is a skill that can be fruitfully transferred to other contexts (*PA* 189).

The word *Aufmerksamkeit* features twenty times in the lecture, a prominence which Musil notes and justifies, declaring it to be a concept that will be familiar to many of his listeners. Its prominence in his report also reflects the studies he is drawing on, where attention is used as an umbrella term for a multitude of mental states, and as a form of engagement which changes over time. At one point, Musil cites a taxonomy of attention broken down by line of work, which is featured in Piorkowski's *Psychologische Methodologie der wirtschaftlichen Berufseignung* (Psychological Methodology of Economic Aptitude Testing):[15]

a) Die Aufmerksamkeit gleichmäßig dauernd auf einen Gegenstand zu richten, z. B. beim Trennen von Stein und Kohle am Band ohne Ende.

b) Die Aufmerksamkeit gleichmäßig dauernd zu verteilen, z. B. beim gleichzeitigen Arbeiten an mehreren Webstühlen.

c) Durch die Periodizität der Arbeit bedingt, die Aufmerksamkeit rhythmisch schanhend [*sic*] anzupassend [*sic*] [...].

d) Aperiodisch schwankend, die Aufmerksamkeit in gewissen Augenblick [*sic*] zu konzentrieren, z. B. Anstich beim Stahlguß.

e) Endlich solche, welche eine fluktuierende, labile Aufmerksamkeit verlangen. (*PA* 193)

a) Focusing the attention permanently and evenly on an object, for instance when separating coal from stones on a conveyor belt.

b) Evenly distributing the attention over a long period of time, for instance when operating several looms simultaneously.

c) Adjusting the attention to the different work stages in a rhythmically oscillating manner [...].

[14] '[Eine] *neue und unvollendete, aber wissenschaftlich wie praktisch vollkommen ernst zu nehmende Erscheinung größter Wichtigkeit*' (*PA* 182).
[15] Piorkowski, *Die psychologische Methodologie*, pp. 17–19.

d) Focusing the attention in a particular moment in an irregularly oscillating pattern, for instance in steel production, when tapping.
e) Finally, such tasks which require a fluctuating, unstable kind of attention.]

The text's many typos reflect the fluctuating and unstable nature of attention mentioned at the end of this list; it also highlights the paradoxical nature of a discipline that sought to control inherently fluid states of mind. On a personal level, these errors testify to what is a prominent theme in Musil's life and personal writings: his own, increasingly desperate struggles to sustain concentration, particularly in the sphere of literary production.

Indeed, the lecturer gives a brief glimpse into his own literary vocation when he departs from the examples used in the cited studies and provides some examples of additional applications. Psychotechnics could fruitfully be brought to bear on the field of writing, he notes, for instance to the formulation of *Vorschriften*, written and spoken instructions, so that they are more easily remembered:

Man ist im Kriege dieser Frage z. B. bei den Merkblättern nahegetreten und schließlich vermag sie jeder Schriftsteller in irgend einer Weise zu lösen; es liegen aber doch auch weniger subjektive Erfahrungen auf diesem Gebiet vor, die man bei psychotechnischen Untersuchungen des Reklamewesens gemacht hat, ferner könnte vieles aus dem Gebiet des Lernens, der Aufmerksamkeit usw., herangezogen werden, kurz es handelt sich um eine ganz aussichtsreiche Aufgabe. (*PA* 196)

[During the war this question was addressed, for instance in the context of instruction sheets, and besides, every literary writer is able to resolve it in some way; but there is also less subjective evidence, for instance the data provided by psychotechnical studies of advertising, and finally one could draw on much in the field of learning, attention, etc.—in short, this is a very promising project.]

In this slightly rambling passage, Musil moves from war to advertising and then education. The literary writer is slipped into this list in an almost underhand fashion, as someone who rises to the challenge of effective description 'in some way', suggesting an intuitive kind of psychotechnical knowledge. Elsewhere in the lecture, he declares that 'the more cerebral a performance, the more it resists the grasp of psychotechnics',[16] and yet language, particularly description, is a field where psychotechnical methods can be most usefully deployed: 'Without targeted instruction, description can offer excellent but also misleading information. In this vital domain psychology can be very useful by fostering the right, practical kind of attitude'.[17]

[16] '[J]e geistiger eine Leistung, desto mehr entzieht sie sich der Psychotechnik' (*PA* 198).

[17] 'Ohne spezifizierte Anleitung liefert sie [Beschreibung] sowohl ausgezeichnete wie ersichtlich irrige Angaben. Auf diesen sehr wichtigen Gebieten könnte die Psychologie durch Schaffung der richtigen und praktikablen Einstellungen sehr nützliches leisten' (*PA* 199).

Musil here repeats one of the key messages of psychotechnics: the 'natural', intuitive way of performing a given task is rarely the best, most efficient way (*PA* 192). His references to the task of the author suggest that even creative writing could benefit from experimentally tested strategies. Musil's comments echo the opening statement of Münsterberg's *Principles of Psychotechnics*: 'Psychotechnics is the science of the practical application of psychology for the sake of cultural tasks'.[18] This sentence could act as the motto of Musil's literary project. Having familiarized himself with the uses of psychotechnics in the military, in labour and education, he went on to apply its principles to his own creative production.

Psychotechnics and the Novel: *The Man without Qualities*

Musil's stint at the Ministry did not distract him from his writing; on the contrary, it proved very productive in literary terms. During this time, he completed two plays as well as his prose collection *Drei Frauen* (Three Women, 1924).[19] In essays and book reviews he critically engaged with pre-war society and its role in the outbreak of the recent war, and he laid the ground for *The Man without Qualities*, whose composition would occupy—and eventually defeat—him for the rest of his life.[20] This explosion of creativity was no coincidence; for Musil, psychotechnics and literary writing inflected each other, as part of a cross-fertilizing dynamic.[21]

When in 1920 Musil first conceived the plan of writing a novel with over one hundred characters he notes in his diary: 'Need to explore from a psychology angle how to prevent these figures from blurring with each other in the reader's memory'.[22] His initial concern is with the psychodynamics of reception and how this could be steered by the writer—a theme also addressed in his lecture. Building on this resolve, he draws up forty-five rules for how to write a novel, which address reception as well as production. Musil singles out features such as suspense and anticipation as vital for sustaining the reader's interest and attention; another way to achieve this effect is through incomplete, allusive description, which forces the

[18] 'Die Psychotechnik ist die Wissenschaft von der praktischen Anwendung der Psychologie im Dienste der Kulturaufgaben'. Münsterberg, *Grundzüge*, p. v.

[19] The plays are *Die Schwärmer* (The Enthusiasts, 1921) and *Vinzenz und die Freundin bedeutender Männer* (Vinzenz and the Girlfriend of Important Men, 1924).

[20] Musil worked on his novel from 1918 until his death. Its first two books appeared in 1930 and 1932; a third volume was published posthumously by his widow Martha Musil in 1943. Musil's bequest contains 11,000 manuscript pages of material, which are assembled in the *Klagenfurter Gesamtausgabe*, published by the Robert-Musil Institut Kärnten.

[21] As Hoffmann comments, not only did Musil produce official and literary texts alongside each other, but it appears that in their execution, these two sets of texts were not always kept strictly separate but crowded into each other's terrain. Hoffmann, 'Militärische Ausbildung', p. 502.

[22] Robert Musil, *Diaries 1899–1941*, selected, trans., and annotated by Philip Payne, ed. Mark Mirsky (New York, NY: Basic Books, 1999), p. 209. 'Psychologisch informieren, wie man es macht, daß die Figuren nicht im Gedächtnis des Lesers verschwimmen'. Musil, *Tagebücher*, p. 356.

reader to fill in the gaps: 'Keep it exciting! Make the readers guess what is coming. Make them think along for a while and then let them go it alone. Anticipate an impeding situation, making them wonder: what will our dear X do next?'[23]

Maxims such as this suggest a relatively traditional, immersive approach to storytelling, but this feature is counterbalanced by the novel's digressive, essayistic, and experimental features. Its short, episodic chapters fit the model of the 'small, coherent theme', but also make for a rather fragmented reading experience. Two decades later, in the summer of 1941, when work on the novel had once again ground to a halt, Musil returns to this idea: 'As an aside: The decisive reason for writing in chapters is a psychotechnical one: a small, coherent topic can be tackled more easily, and such a frame is more easily filled with material and its supplements'.[24]

The list ends with the resolve to 'Taylorize' writing ('das Schreiben zu "taylorisieren"'), a maxim which extends the remit of psychotechnics to literary production. The core issue is not whether Musil actually put this strategy into practice,[25] nor whether it yielded the desired effects, but how he conceived of writing in the first place—namely as a targeted operation designed to produce certain intellectual and emotional responses, which could also be controlled on the level of production. In this regard, Musil's approach to *The Man without Qualities* chimes with one of the key challenges of modernity as epitomized by the First World War: the challenge of organization, which involved people as well as objects, information as well as stimuli. Psychotechnics was conceived in response to this challenge. It played a key role in the optimization of the available mental resources and their allocation where they were most needed. This process started during the war and was subsequently rolled out in civilian society. Its subject was the statistically average individual without any distinguishing personal features, defined in purely functional terms. This individual is the 'man without qualities', embodied in Musil's novel by Ulrich, its eponymous protagonist.

Like his author, Ulrich is well versed in experimental psychology and drawn to the new science of psychotechnics as a means of enhancing individual performance and controlling group behaviour. Given that the novel is set before the First World War, this endorsement appears rather prescient. That said, both the protagonist and the novel's narrator retain a degree of ironic scepticism towards

[23] 'Spannen! Den Leser das Kommende raten lassen. Ein Stück mitdenken und dann allein gehen lassen. Man deutet eine kommende Situation an und es muss der Gedanke entstehen: was wird denn unser guter X. da machen?' Robert Musil, *Der literarische Nachlaß*, CD-ROM, ed. Friedrich Aspetsberger, Karl Eibl, and Adolf Frisé (Reinbek bei Hamburg: Rowohlt, 1992), vol. II.1, p. 143. For a more detailed analysis of Musil's literary strategies in the novel and his ways of organizing his text, see Albert Kümmel, *Das MoE-Programm: Eine Studie über geistige Organisation* (Munich: Fink, 2001), particularly pp. 323–44.

[24] 'Nebenbei: Das Entscheidende, weshalb Kapitel zu bilden sind, ist etwas Psychotechnisches: ein kleines geschlossenes Thema ist leichter anzupacken, u[nd] ein solcher Rahmen füllt sich leichter mit dem Stoff und seinen Ergänzungen'. Musil, *Tagebücher*, p. 965.

[25] Hoffmann, 'Militärische Ausbildung', p. 501.

psychotechnics and its implications for culture and society. In fact, Ulrich's story shows that the psychotechnical approach has both limits and unintended consequences.

The first time we encounter him, Ulrich is engaged in a little scientific experiment. Standing by his window, a watch in his hand, he

> zählte mit der Uhr seit zehn Minuten die Autos, die Wagen, die Trambahnen und die von der Entfernung ausgewaschenen Gesichter der Fußgänger, die das Netz des Blicks mit quirlender Eile füllten; er schätzte die Geschwindigkeit, die Winkel, die lebendigen Kräfte vorüberbewegter Massen, die das Auge blitzschnell nach sich ziehen, festhalten, loslassen, die während einer Zeit, für die es kein Maß gibt, die Aufmerksamkeit zwingen, sich gegen sie zu stemmen, abzureißen, zum nächsten zu springen und sich diesem nachzuwerfen. (*MGA* 1, 14)
>
> [had been ticking off on his stopwatch the passing cars, trucks, trolleys, and pedestrians, whose faces were washed out by the distance, timing everything whirling past that he could catch in the net of his eye. He was gauging their speeds, their angles, all the living forces of mass hurtling past that drew the eye to follow them like lightning, holding on, letting go, forcing the attention for a split second to resist, to snap, to leap in pursuit of the next item. (*MwQ* 1, 5–6)]

The passage echoes familiar modernist portrayals of the city as an amalgam of disparate stimuli 'whirling past' the observer. Rather than allowing himself to be engulfed by them, Ulrich tries to quantify these stimuli, their speeds and effect on mind and senses. The impersonal narration leaves it unclear whether 'the eye' and 'the attention' are Ulrich's or those of some hypothetical observer. Implicitly, though, his role in this experiment is a dual one; like Musil in Stumpf's laboratory, Ulrich is supervisor and experimental subject in one. With his measurements, he tries to impose some degree of order onto chaos; but then, he abruptly abandons his efforts:

> Er steckte, nachdem er eine Weile im Kopf gerechnet hatte, lachend die Uhr in die Tasche und stellte fest, daß er Unsinn getrieben habe.—Könnte man die Sprünge der Aufmerksamkeit messen, die Leistungen der Augenmuskeln, die Pendelbewegungen der Seele und alle die Anstrengungen, die ein Mensch vollbringen muß, um sich im Fluß einer Straße aufrecht zu halten, es käme vermutlich—so hatte er gedacht und spielend das Unmögliche zu berechnen versucht—eine Größe heraus, mit der verglichen die Kraft, die Atlas brauchte, um die Welt zu stemmen, gering ist, und man könnte ermessen, welche ungeheure Leistung heute schon ein Mensch vollbringt, der gar nichts tut. (*MGA* 1, 14–15)
>
> [then, after doing the arithmetic in his head for a while, he slipped the watch back into his pocket with a laugh and decided to stop all this nonsense. If all those

leaps of attention, flexing of eye muscles, fluctuations of the soul, if all the effort it takes for a person just to hold himself upright within the flow of traffic on a busy street could be measured, he thought—as he toyed with calculating the incalculable—the grand total would surely dwarf the energy needed by Atlas to hold up the world, and one could then estimate the enormous undertaking it is nowadays merely to be a person who does nothing at all. (*MwQ* 1, 7)]

The remit of Ulrich's experiment is vast even by contemporary standards. It seeks to quantify the experience of the city, its many conflicting stimuli, which Zimmermann's Large Testing Station tries to simulate. The novel takes these experiments from the laboratory (back) into real life, but in doing so reveals the limits, indeed the absurdity, of this project. The subject's experience is broken down, in textbook fashion, into its component parts, made up of physiological, psychological, and even spiritual elements (the 'fluctuations of the soul'). However, even if these forces could be isolated (and the narrative here employs the subjunctive), the sum total would be enormous, bearing no relation to actual human experience. This disjuncture is underlined by the reference to Atlas carrying the weight of world; in its quantifying approach, psychotechnics is fundamentally divorced from human experience as it is sedimented in literature, art, and culture. After a long build-up the passage ends in a deadpan manner, a typical example of Musil's ironic portrayal of the foibles and fashions of modern life.

That said, Ulrich's aborted experiment reflects a more serious point. In the later, self-reflexive chapter 'Heimweg' (The Way Home), the narrator speaks of 'life's notorious turning into abstraction',[26] which resists its depiction in traditional narrative, epic, form. Quantifying all the components of modern life and their effect on the mind does not reverse this process but exacerbates it, for it effectively eliminates the experiencing subject from the equation. Ulrich recognizes this effect: 'no matter what you do', he notes with a shrug, 'within this mare's nest of forces at work, it doesn't make the slightest difference'.[27]

The novel echoes this assessment through its mode of narration. Its opening chapter, one of the most distinctive in literary modernism, presents the modern city—Vienna in 1913—not from a subjective, embodied viewpoint nor from a detached, omniscient perspective, but as an abstract force field of speeds, rhythms, and intensities.

Wie alle großen Städte bestand sie [die Stadt] aus Unregelmäßigkeit, Wechsel, Vorgleiten, Nichtschritthalten, Zusammenstößen von Dingen und Angelegenheiten, bodenlosen Punkten der Stille dazwischen [...], aus einem großen rhythmischen

[26] *MwQ* 1, 708; 'das berüchtigte Abstraktwerden des Lebens' (*MGA* 2, 546).
[27] *MwQ* 1, 5. 'Man kann tun, was man will, [...] es kommt in diesem Gefilz von Kräften nicht im geringsten darauf an!' (*MGA* 1, 16).

Schlag und der ewigen Verstimmung und Verschiebung aller Rhythmen gegeneinander. (*MAG* 1, 10)

[Like all big cities, it was made up of irregularity, change, forward spurts, failures to keep step, collisions of objects and interests, punctuated by unfathomable silences; [...] of one great rhythmic beat as well as the chronic discord and mutual displacement of all its contending rhythms. (*MwQ* 1, 4)]

The opening paragraph describes the atmospheric pressure above Europe, the 'barometric low' over the Atlantic, which is moving towards a 'high-pressure area' over Russia—a meteorological event reflecting the build-up of political tension across the continent. The second paragraph then zooms in on the city, where cars are depicted as 'more powerful lines of speed' running through the 'casual haste' of the pedestrians, causing their movement to 'clot up, then trickle on faster', before resuming their previous speed.[28] The many noises are visualized in abstract yet strangely tactile terms as a 'wiry texture of sound with barbs protruding here and there [...], with clear notes splintering off and dissipating'.[29] Critics have related this mode of representation to Musil's encounter with Gestalt psychology during his studies in Berlin.[30] But this depiction also harks back to his 1906 diary note, recorded during his doctorate, where he observes that sensory data precedes conceptual synthesis.

This defamiliarizing viewpoint is then juxtaposed with the human perspective, which is not attuned to all of these nuances but shaped, blunted, by habit. The narrator concedes that 'the two people who were walking up one of its wide, bustling avenues naturally were not thinking along these lines'.[31] Indeed, the ensuing traffic accident throws the inadequacy of human attention into sharp relief:

Schon einen Augenblick vorher war etwas aus der Reihe gesprungen, eine quer schlagende Bewegung; etwas hatte sich gedreht, war seitwärts gerutscht, ein schwerer, jäh gebremster Lastwagen war es, wie sich jetzt zeigte, wo er, mit einem Rad auf der Bordschwelle gestrandet dastand. (*MGA* 1, 11)

[Just a moment earlier something there had broken ranks; falling sideways with a crash, something had spun around and come to a skidding halt—a heavy truck,

[28] 'Autos schossen aus schmalen, tiefen Straßen in die Seichtigkeit heller Plätze. Fußgängerdunkelheit bildete wolkige Schnüre. Wo kräftigere Striche der Geschwindigkeit quer durch ihre lockere Eile fuhren, verdickten sie sich, rieselten nachher rascher und hatten nach wenigen Schwingungen wieder ihren gleichmäßigen Puls' (*MGA* 1, 9/*MwQ* 1, 3).
[29] 'Hunderte Töne waren zu einem drahtigen Geräusch ineinander verwunden, aus dem einzelne Spitzen vorstanden, längs dessen schneidige Kanten liefen und sich wieder einebneten, von dem klare Töne absplitterten und verflogen' (*MGA* 1, 9–10/*MwQ* 1, 3).
[30] Karl Corino, *Robert Musil: Eine Biographie* (Reinbek bei Hamburg: Rowohlt, 2003), pp. 227–31.
[31] *MwQ* 1, 4. 'Die beiden Menschen, die darin eine breite, belebte Straße hinaufgingen, hatten natürlich gar nicht diesen Eindruck' (*MGA* 1, 10).

as it turned out, which had braked so sharply that it was now stranded with one wheel on the curb. (*MwQ* 1, 576)]

The accident is only grasped with a few seconds' delay, just as the vehicles involved in this collision are only identified after the event. Delay is a key theme in modernist literature, where it underlines the mismatch between technological acceleration and the much slower pace of the human body and senses. Indeed, a momentary drop of attention is also cited as the cause of the accident. While the moment of impact eludes the absent-minded observers (and with them the reader), the narrator spells out that one of the parties was harmed because of 'his own carelessness'.[32] In this regard, the opening scene, which has no further relevance for the plot, serves to underline a more general point. The novel shows the inhabitants of Kakanien (Musil's satirical version of Austria-Hungary) to be perpetually distracted; assailed by stimuli, they are 'willing to work themselves up over them, even to intervene, but they never got around to it because a few minutes afterward the stimulus had already been displaced in their minds by more recent ones'.[33] Ulrich's friend Walter declares that modern life is characterized by an 'overestimation of facts',[34] which can no longer be fused into a coherent whole.

In many ways, the novel's diagnosis of the 'modern condition' echoes those critical voices cited in Chapter 2. Its characters, however, are ahead of their time when they discuss psychotechnics as a remedy and solution. Psychotechnics is explicitly mentioned five times over the course of the novel, and it profoundly inflects the thoughts and experiences of its characters and its portrayal of, and reflections on, modernity.

Between Discipline and Mysticism

In his 1922 lecture, Musil underlines the link between soldiers' physical and psychological conditioning. Military drills are an 'eminently effective means of suggestion', which should be employed where 'traditional forms of discipline' need to be restored or replaced by other methods (*PT* 199–200). The novel echoes this approach. Ulrich endorses psychotechnics when it comes to the general population, advocating a 'systematics of communal life' ('Systematik des Zusammenlebens') and a 'psychotechnics of collectives' to counteract the growing

[32] *MwQ* 1, 5; 'war durch seine eigene Unachtsamkeit zu Schaden gekommen' (*MGA* 1, 12).
[33] *MwQ* 1, 576; 'bereit, sich über sie zu erregen, ja sogar einzugreifen, aber es kam nicht dazu, denn einige Augenblicke später war der Reiz schon durch neuere aus dem Bewußtsein verdrängt' (*MGA* 2, 346).
[34] *MwQ* 1, 666; 'Überbewertung der Einzelheiten' (*MGA* 2, 481).

fragmentation of society.³⁵ Another character, Count Leinsdorf, expresses a similar idea: 'as we advance in psychotechnics', he hopes, the present moral relativism will be replaced by more 'accurate' categories of good and evil.³⁶ To implement this programme, Ulrich wants to set up a 'General' or 'World Secretariat for Precision and Soul',³⁷ which is meant to support humanity's systematic intellectual *and* spiritual development—an establishment modelled, as Hoffmann notes, on a state institute for psychotechnics.³⁸

In other contexts, however, psychotechnics is portrayed in a more critical light, most famously in the chapter featuring a 'race horse of genius' or 'genialisches Rennpferd'. A little earlier, the narrator had declared that 'human goodness depends on the psychotechnical skills with which one evaluates human qualities'.³⁹ This far-reaching claim is then illustrated by means of a concrete example:

> Sollte man einen großen Geist und einen Boxlandesweltmeister psychotechnisch analysieren, so würden in der Tat ihre Schlauheit, ihr Mut, ihre Genauigkeit und Kombinatorik sowie die Geschwindigkeit der Reaktionen auf dem Gebiet, das ihnen wichtig ist, wahrscheinlich die gleichen sein, ja sie würden sich in den Tugenden und Fähigkeiten, die ihren besondere Erfolg ausmachen, voraussichtlich auch von einem berühmten Hürdenpferd nicht unterscheiden, denn man darf nicht unterschätzen, wieviele bedeutende Eigenschaften ins Spiel gesetzt werden, wenn man über eine Hecke springt. Nun haben aber noch dazu ein Pferd und ein Boxmeister vor einem großen Geist voraus, daß sich ihre Leistung und Bedeutung einwandfrei messen läßt und der Beste unter ihnen auch wirklich als der Beste anerkannt wird, und auf diese Weise sind der Sport und die Sachlichkeit verdientermaßen an die Reihe gekommen, die veralteten Begriffe von Genie und menschlicher Größe zu verdrängen. (*MGA* 1, 68)

> [A psychotechnical analysis of a great thinker and a champion boxer would reveal their cunning, courage, precision and technique, and the speed of their reactions in their respective fields to be the same. It is probably a safe assumption that the qualities and skills by which they succeed do not differ from those of a famous steeplechaser—for one should not underestimate how many major qualities are brought into play in clearing a hedge. But on top of this, a horse and a boxer have an advantage over a great mind in that their performance and rank can be objectively measured, so that the best of them is really acknowledged

³⁵ Robert Musil, *Der Mann ohne Eigenschaften*, ed. Adolf Frisé, rev. edn, 2 vols (Reinbek bei Hamburg: Rowohlt, 1978), vol. 2, p. 1867.
³⁶ *MwQ* 1, 560; 'mit fortschreitender Entwicklung der Psychotechnik' (*MGA* 2, 322).
³⁷ *MwQ* 1, 634; 803; a 'General-' or 'Erdensekretariat der Genauigkeit und Seele' (*MGA* 2, 436; *MGA* 3, 262–3).
³⁸ Hoffmann, *Der Dichter*, p. 260.
³⁹ *MwQ* 1, 31; 'die Güte der Menschen von dem psychotechnischen Geschick [abhängt], mit dem man ihre Eigenschaften auswertet' (*MGA* 1, 55).

as the best. This is why sports and strictly objective criteria have deservedly come to the forefront, displacing such obsolete concepts as genius and human greatness. (*MwQ* 1, 42)]

Ulrich's career so far has taken him from the military via engineering to mathematics, but just as he comes close to reaching his goal of becoming a 'man of stature', he has to discover that, according to the terms of his age, 'the horse had beaten him to it'.[40] This discovery can be added to the three 'narcissistic injuries' described by Freud, according to whom the Copernican, the Darwinist, and the psychoanalytic paradigm shifts have progressively marginalized the human subject from its position at the centre of the universe, of the natural world, and of its own self (*FGW* XII, 6–7). Experimental psychology and psychotechnics, in turn, challenge the uniqueness of human intellectual and creative achievement by judging them according to a set of criteria—'cunning, courage, precision and technique, and the speed of [...] reactions'—which cannot capture their essence. If applied across different fields, these criteria erode any qualitative difference between, say, boxing and thinking, between humans and animals. Since the thinker's 'performance' cannot be quantified in psychotechnical terms it is irrelevant, non-existent according to the criteria of this new discipline. Just as important are the secondary, linguistic consequences of this approach. After the thinker has come a distant third in this new ranking, the word 'genius' is not simply discarded, but rather transferred to the racehorse and the sports person. Psychology and physiology have turned existing social and cultural hierarchies upside down, and yet people remain attached to the old ways of describing the world and apply them to new contexts to which they are ill-suited.[41]

The racehorse genius deals a serious blow to Ulrich's aims and self-importance, but it does not make him abandon his attachment to psychotechnics altogether. On the contrary, his views and behaviour remain influenced by one of the mantras of psychotechnics, namely the importance of regular practice, of seeking to condition the mind through the body. Outlining this idea, Ulrich admiringly speaks of 'stimuli and strings of reflexes, entrenched habits and skills, reiteration, fixation, imprints, series, monotony'.[42] To achieve these skills, he does regular exercise, chiefly boxing; 'one hour a day was sufficient [...] to keep a trained body

[40] *MwQ* 1, 41–2/*MGA* 1, 67.
[41] Musil describes a similar process in the domain of speed. Technological advances have led to a vast process of acceleration, but the new speeds exceed the human sensorium, and metaphors to describe them are stubbornly wedded to a pre-technological era: 'schneller als der Gedanke oder der Blitz und langsamer als eine Schnecke ist in der Sprache nichts geworden' ('in language there is nothing faster than thoughts or lightning and nothing slower than a snail'; *MGW* 7, 684).
[42] *MwQ* 1, 420; 'Reize und Reflexbahnen, Einbahnung von Gewohnheiten und Geschicklichkeiten, Wiederholung, Fixierung, Einschleifung, Serie, Monotonie' (*MGA* 2, 98–9).

in the condition of a panther alert for any adventure'.⁴³ Echoing the common modernist trope of the city as a jungle,⁴⁴ the animal simile suggests a state of pre-rational alertness, a readiness for the unexpected. In moments of danger, the highly trained body should be able to respond 'automatically in its finely tuned way to every stimulus, so surely that its owner is left with an uncanny sensation of having to watch helplessly as his character runs off with some parts of his anatomy, as it were'.⁴⁵ Though repeated practice yields vast cognitive benefits, it also creates a certain disjuncture between mind and body, causing a loss of control which runs contrary to Ulrich's own intentions. For him, boxing is a tool of self-mastery, an aid in his 'urge to attack life and master it'⁴⁶ and a shorthand for a more general 'law of all waking thought and action',⁴⁷ which Ulrich wants to achieve in all areas of life.

These lofty aims, however, are resolutely undermined over the course of the novel, in episodes which show the faltering of trained alertness, but also, more importantly, its affinity with fundamentally different, non-rational states of mind. When in an early chapter Ulrich is attacked one night on his way home, he is unable to respond in kind, incapable of putting his training into practice. Confronted with his attackers, he hesitates; instead of acting, he thinks and hence emerges severely battered.⁴⁸ In another chapter, a walk through a different, unknown city creates a more ambivalent mindset. Initially, Ulrich is alert, but this vigilance has an unexpected side effect when he experiences

> eine leichte Bewußtseinsspaltung. Man fühlt sich umarmt, umschlossen und bis ins Herz von einer willenlos angenehmen Unselbständigkeit durchdrungen; aber anderseits bleibt man wach und der Geschmackskritik fähig und sogar bereit, mit diesen Dingen und Menschen, die voll ungelüfteter Anmaßung sind, Streit anzubinden. (*MGA* 3, 96)
>
> [like a slight split in one's consciousness. One feels enfolded, embraced, pierced to the heart by a sense of involuntary dependence; but at the same time one is still

⁴³ *MwQ* 1, 42. 'Eine Stunde täglich [...] genügt, um einen geübten Leib in dem Zustand eines Panthers zu erhalten, der jedes Abenteuers gewärtig ist' (*MGA* 1, 70). Musil was a keen tennis player, swimmer, and boxer as well as a spectator of sporting competitions. See Corino, *Musil*, pp. 809–22. His enthusiasm, mixed again with a sense of ironic distance, is reflected in several essays on the history of sport and its role in modern culture. See Anne Fleig, *Körperkultur und Moderne: Robert Musils Ästhetik des Sports* (Würzburg: de Gruyter, 2008).

⁴⁴ See for instance Bertolt Brecht's early play *Im Dickicht der Städte* (In the Jungle of the Cities, 1921–4). Helmut Lethen speaks of the 'cold persona' and the 'radar type' as behavioural strategies which emerge in response to this situation. Helmut Lethen, *Cool Conduct: The Culture of Distance in Weimar Germany*, trans. Don Reneau (Berkeley, CA: University of California Press, 2002).

⁴⁵ *MwQ* 1, 25; 'auf jeden Reiz ohne zu fragen, mit seinen automatisch eingeschliffenen Bewegungen so sicher zu antworten, daß dem Besitzer nur noch das unheimliche Gefühl des Nachsehens bleibt, während ihm sein Charakter mit irgendeinem Körperteil gleichsam durchgeht' (*MGA* 1, 43).

⁴⁶ *MwQ* 1, 646; 'Drang zum Angriff auf das Leben und zur Herrschaft darüber' (*MGA* 2, 450).

⁴⁷ *MwQ* 1, 647; 'Gesetz des wachen Denkens und Handelns' (*MGA* 2, 453).

⁴⁸ *MwQ* 1, 22/*MGA* 1, 37.

alert and capable of making critical judgements, and even ready to start a fight with these people and their stuffy presumptuousness. (*MwQ* 1, 786)]

Being on the lookout and yet feeling at one with one's surroundings—though these are very different, almost opposite states, they can be experienced at the same time. Ulrich reflects that 'one can be hard, selfish, eager, sharply profiled against the world, as it were, and can suddenly feel oneself [...] quite the opposite: deeply absorbed, a selfless, happy creature at one with an ineffably tender and somehow also selfless condition of everything around him'.[49] Elsewhere, the narrator draws a direct connection between boxing and mystical experience. The trained alertness which causes the body to take over from the rational mind is akin to

> verlorengegangenen Erlebnissen, die den Mystikern aller Religionen bekannt gewesen seien [...]; und das Boxen oder ähnliche Sportarten, die das in ein vernünftiges System bringen, seien also eine Art von Theologie, wenn man auch nicht verlangen könne, daß das schon allgemein eingesehen werde. (*MGA* 1, 41–2)
>
> [lost experiences, which were familiar to mystics of all religions [...]; and boxing and similar sports, which transfer these into a sensible system, are hence a kind of theology, even if one could not expect that this was already widely recognised. (*MwQ* 1, 23–4)]

In one of his essays, 'Als Papa Tennis lernte' (When Daddy Learnt to Play Tennis, 1931), Musil elaborates on this idea. Sport is a form of mental training, which can teach a flexible kind of attention. In this way, it can prepare for the world of (manual) labour—Musil cites (mechanical) looms as well as 'Kartoffelgraben', digging for potatoes (*MGW* 7, 690):

> Man lernt, die Aufmerksamkeit zu sammeln und zu verteilen wie ein Mann, der mehrere Spinnstühle beaufsichtigt. Man wird angelernt, die Vorgänge im eigenen Körper zu beobachten, die Reaktionszeiten, die Innervationen, das Wachstum und die Störungen in der Koordination der Bewegungen, man erlernt die Beobachtung und Auswertung von Nebenvorgängen [...]. Man erwirbt Bekanntschaft mit den Fehlleistungen, welche der wahrnehmbaren Müdigkeit voranschleichen. (*MGW* 7, 689)

[49] *MwQ* 2, 747; 'man kann hart sein, selbstsüchtig, bestrebt, gleichsam hinaus geprägt, und kann sich plötzlich [...] auch umgekehrt fühlen, eingesenkt als ein selbstlos glückliches Wesen in einem unbeschreiblich empfindlichen und irgendwie auch selbstlosen Zustand aller umgebenden Dinge' (*MGA* 3, 36).

[One learns to gather together or distribute one's attention like a person who is supervising several looms at once. One is taught to observe the processes within one's body, reactions times, innervations, the increase and disruptions in the coordination of one's movements; one learns to watch and assess minor processes [...]. One gets acquainted with [Freudian] slips, which sneak ahead of noticeable fatigue.]

This characterization echoes the list of different professions and the types of attention they require which is provided in Musil's 'Psychotechnics' lecture, but adds to this the psychoanalytic concepts of innervation and parapraxis. In this regard, the effect of physical exercise is similar to the aims of the talking cure; as Musil boldly claims, 'the essence of the self radiates from the darkness of the body during sporting experiences'.[50]

Vigilance and immersion, antagonistic detachment and a quasi-mystical merging with one's surroundings—*The Man without Qualities* maps out these different states of consciousness in a manner reminiscent of Musil's lecture. But these categories are there to be blurred. The novel shows that a trained state of alertness cannot be upheld at will; indeed, it is precisely when it collapses, where strategies of attentional training fail, that new realms of experience become accessible.

In scholarship, Musil's famous but elusive notion of the 'other state' (*anderer Zustand*) is commonly associated with the modernist revival of medieval mysticism, particularly the writings of Meister Eckhart,[51] but this complex owes at least as much to Musil's engagement with psychotechnics. The attempt to condition body and mind, making them 'fit' for the modern world, can spark precisely the opposite effect, for attention is not monolithic but part of a field of mobile and contrasting impulses. As the narrator explains, trying to define the 'other state',

Der Zustand hatte aber sonst nichts mit Traum gemeinsam. Er war klar und übervoll von klaren Gedanken. [...] Es war eine völlig veränderte Gestalt des Lebens; nicht in den Brennpunkt der gewöhnlichen Aufmerksamkeit gestellt, von der Schärfe befreit und so gesehen, eher ein wenig zerstreut und verschwommen war alles, was zu ihr gehörte; aber offenbar wurde es von anderen Zentren aus wieder mit zarter Sicherheit und Klarheit erfüllt. (*MGA* 1, 196-7)

[Other than this, however, his state of mind had nothing in common with dreaming. It was clear, and brimful of clear thoughts [...]. Life's very shape was completely altered. Not placed in the focus of ordinary attention but freed from sharpness. Seen this way, everything seemed a little scattered and blurred,

[50] 'Das Wesen des Ich leuchtet in den Erlebnissen des Sports aus dem Dunkel des Körpers empor' (*MGW* 7, 690).
[51] See Martina Wagner-Engelhaaf, 'Mystik', in *Musil-Handbuch*, pp. 705–10; and Wagner-Engelhaaf, 'Anderer Zustand', in *Musil-Handbuch*, pp. 710–12.

and being infused all the while with a delicate clarity and certainty from other centers. (*MwQ* 1, 131)]

The Man without Qualities explores different mental states, ranging from vigilance to immersion, from aggression to *unio mystica*, and shows them to be intrinsically connected. Alertness, in particular, is shown to be fragile; when it collapses, where strategies of attentional training fail, new realms of experience become accessible. To delve more deeply into these dynamics, Musil turned to psychotherapy and autosuggestion—fields which complement and yet contrast with the psychotechnical project of cognitive (self-)optimization.

Writer's Block and Therapy

In September 1928 Musil responded to a questionnaire by the journal *Die literarische Welt* (The Literary World). Entitled 'Physiologie des dichterischen Schaffens' (Physiology of Literary Production), it echoes Münsterberg's quantitative approach to the mind—the notion that mental processes have a physiological dimension and can hence be conditioned by means of training and practice.

Musil's answers reveal a tension between control and spontaneity. In reply to a question about the moment of first inspiration, he describes both the 'apparently sudden arrival' ('das scheinbar unvermittelte Kommen') of ideas and the drawn-out process of their realization: 'any plan for an executed work is usually produced by merging several existing plans. This process takes a long time, and quite often the so-called initial idea disappears completely in the process'.[52] Musil likes to write in a quiet room at home and tries to follow a fixed schedule (from 9 a.m. to 12.30 and again from 4 p.m. to 7 p.m.), though he often exceeds these slots. As he notes, 'I think it's better to compress work more strongly and then interrupt it with busy breaks; would like to change my habits in this regard'[53]—a 'less is more' approach to concentration which is also extolled, as we will see in Chapter 6, in the self-help literature of the time. But this resolve is at odds with Musil's obsessive streak. He describes completely reworking large sections, even entire texts, up to twenty times and adds: 'I keep several notebooks in my study but write in them only intermittently. I constantly think about my plan. Need to distract myself. Exercise, walking'.[54] As Enlightenment writers knew, for sanity's sake periods of

[52] 'Der Plan zu ausgeführten Werken ist gewöhnlich erst durch Verschmelzung mehrerer schon vorhanden gewesener Pläne entstanden. Dieser Prozeß dauert lange an, und oft verschwindet der sogenannte erste Einfall dabei völlig' (*MGW* 7, 945).

[53] '[...] halte es aber für richtiger, die Arbeit mehr zusammenzudrängen und durch stark ausgefüllte Pausen zu unterbrechen; wünsche, mich in diesem Sinn umzustellen' (*MGW* 7, 946).

[54] 'Ich habe in meinem Arbeitszimmer Notizhefte, bin aber unregelmäßig im Eintragen. Ich beschäftige mich dauernd mit meinem Plan. Muß mich ablenken. Sport, Spaziergänge' (*MGW* 7, 945).

concentration and diversion need to complement each other. Musil, however, applied his controlling approach even to leisure and recreation, keeping a precise record of his daily cigarette consumption in a slender blue notebook (his doctor had allowed him to smoke eight cigarettes a day), and recording the rhythm of smoking and writing in his diary in a painstaking fashion.[55]

Indeed, his diaries are full of passages in which Musil tries to take stock, and hence control, of what remains an unpredictable undertaking.

> Worauf es mir ankommt, ist die leidenschaftliche Energie des Gedanken. Wo ich nicht irgendeinen besonderen Gedanken heraus arbeiten kann, wird mir die Arbeit sofort zu langweilig [...]. Warum geht nun dieses Denken, das doch schließlich gar keine Wissenschaftlichkeit, sondern nur eine gewisse individuelle Wahrheit anstrebt, nicht rascher?[56]
>
> [What matters to me is the passionate energy of the idea. In cases where I am not able to work out a specific idea, the work immediately begins to bore me [...]. Now why is it that this thinking, which after all is not aiming at any kind of scientific validity but only a certain individual truth, cannot move at a quicker pace?[57]]

One key problem is what Musil calls the 'dissipative element' of writing: 'The idea immediately disperses in all directions, the ideas go on growing outward on all sides, the result is a disorganized, amorphous complex'.[58] Time and again in his writings, the point of comparison is the 'exact' and controllable nature of scientific research. In 1910, the experience of his doctorate fresh in his mind, he compares literary to scientific writing, where 'the idea is tied up, delineated, articulated'[59] by the goal of the project or experiment, 'the way it is limited to what can be proven, the separation into probable and certain, etc.'.[60] In contrast, literary production is sprawling and unpredictable:

> Ich kann das Gedankenmaterial für eine Arbeit zunächst nur bis zu einem ziemlich nahen Punkt ausdenken, dann zerstreut es sich mir unter der Hand. Dann kommt eine Periode, wo ich das Vorhandene bis ins Kleinste ausfeile [...]. Dann erst kann ich, durch das Vollendete gefesselt u[nd] beengt, weiter 'denken'.[61]

[55] See for instance *Tagebücher*, pp. 801–2. As he writes shortly before his death, 'Ich behandle das Leben als etwas Unangenehmes, über das man durch Rauchen hinwegkommen kann! (Ich lebe, um zu rauchen)'; *Tagebücher*, p. 917 ('I treat life as something unpleasant that one can get through by smoking! (I live in order to smoke)'; Musil, *Diaries*, p. 441).
[56] 13 August 1910; Musil, *Tagebücher*, p. 214. [57] Musil, *Diaries*, p. 117.
[58] Musil, *Diaries*, p. 117. 'Der Gedanke geht nach allen Richtungen sofort immer weiter, die Einfälle wachsen an allen Seiten auseinander heraus, das Resultat ist ein ungegliederter, amorpher Komplex'. *Tagebücher*, p. 214.
[59] Musil, *Diaries*, p. 117; 'verschnürt, begrenzt, artikuliert'. *Tagebücher*, p. 214.
[60] Musil, *Diaries*, p. 117. 'Beschränkung auf das Beweisbare, die Trennung in Wahrscheinliches u[nd] Gewisses usw'. *Tagebücher*, p. 214.
[61] Musil, *Tagebücher*, pp. 214–15.

[I am only able at first to develop the thought-material for a piece of work to a point that is relatively close by, then it dissolves in my hands. Then the moment arrives when the work in hand is receiving the final polish, the style has reached maturity, etc. It is only now that, both gripped and constrained by what is now in a finished state, I am able to 'think' on further.[62]]

Musil thus seeks to import the methods of scientific research into his literary production. By proceeding in small steps, focusing on minute details, he tries to 'anchor' his focus, seeking to shield his thought processes from infinite digression. These techniques, however, are only partly effective. In April 1930 he resolves

beim Schreiben schwieriger Partien zuerst das Leichte in Schlagworte, die Knoten- u[nd] Übergangsstellen aber ausführlich u[nd] richtig machen, um nicht schon ermüdet zu ihnen zu kommen.
Ferner: Nie etwas zu Ende entwerfen, sondern immer einen Schritt über das Ende hinaus, in das Nächste hinein. Tue ich das nicht, so stopft sich zw[ischen] Anfang u[nd] Ende zuviel u[nd] tendiert in die Breite.[63]
[when writing difficult passages, first do the easy part in key words, but pay detailed and correct attention to the knotty intersections and transitions in order not to be tired before I arrive at them.
Furthermore: never sketch something out just to the end but always go one step beyond the end, and into the next passage. If I don't do this, too much gets stuffed in between the start and the finish and tends to spread out.[64]]

Breaking down a task into smaller components is a strategy Musil also advocates in his 'Psychotechnics' lecture. But elsewhere in his diaries, he speaks of the novel's narrative arc as 'two fixed supports and, between them, a transition that refuses to take shape'.[65]

Musil's struggles are deeply personal, but they are also symptomatic of his time, when tarrying and hesitation were symptoms of an accelerated, fragmented, and increasingly disparate modernity, whose imperative of constant forward motion sparked fears, phobias, and eventually paralysis.[66] Musil was all too familiar with this effect:

Es scheint eine Verwandtschaft zu bestehen zwischen dem Bergschwindel u[nd] der Arbeitshemmung. In beiden Fällen stellt sich die Vorstellung ein: du kommst über dieses Stück nie hinweg. Diese Vorstellung wirkt ihrerseits lähmend. [...]

[62] Musil, *Diaries*, p. 118. [63] Musil, *Tagebücher*, p. 716. [64] Musil, *Diaries*, p. 371.
[65] 3 January 1929; Musil, *Diaries*, p. 341. 'Zwei fixierte Pfeiler u[nd] dazwischen ein Übergang, der nicht zustande kommen will'. *Tagebücher*, p. 681.
[66] Joseph Vogl, *On Tarrying*, trans. Helmut Müller-Sievers (Calcutta: Seagull Books, 2011).

Die Unsicherheit, die sich einstellt, ist keine andere als die nervöse, die ich beim Tennis, Fechten, Maschinenschreiben kenne, wenn mir jemand zusieht oder ich es besonders gut machen will.[67]

[There seems to be a similarity between mountain vertigo and a work block. In both cases the idea appears that you will never get beyond this stretch. This idea, for its part, has a numbing effect. [...] the uncertainty that arises is none other than the nervous uncertainty that I feel when I play tennis, or fence, or type while someone is watching me or I resolve to do something particularly well.[68]]

The Man without Qualities represents Musil's most concerted effort to 'Taylorize' the writing process and with it the reader's experience, but its sprawling manuscript, complete with multiple, conflicting plans and parallel and alternative versions, illustrates the spectacular failure of this undertaking. Contrary to what he envisaged in his lecture and diaries, the writing process resisted efficiency measures of the kind that were applicable to more routine tasks.

Musil struggled with periods of writer's block throughout his literary career. In 1926, during a particularly debilitating spell, he embarked on a course of psychotherapy with Dr Hugo Lukács, a pupil of Alfred Adler's.[69] Unlike Freud, Adler focused not primarily on a patient's past but on the future, promising to 'dislodge neurosis by awakening willpower'.[70] Lukács pursued a similar approach. Though no records of their therapy sessions have survived, Musil's long review of Lukács's 1928 study *Psychologie des Lehrlings* (Psychology of the Apprentice), probably written as a favour to his therapist, contains some clues about his own experience.[71] Key to the therapeutic process, he stresses, is 'continuous practice'; only by getting patients to implement alternative, less harmful behavioural patterns is psychotherapy able to correct 'the whole vast arsenal of suffering and missteps' that stem from 'a few small errors in one's way of life' (*MGW* 9, 1683). Notable here is the causal link between minor errors and major ailments, as well as the emphasis on practice. Musil ends his account on a note of personal gratitude.

[67] 28 April 1930; *Tagebücher*, pp. 714–15. In his diary, Musil sketches out the corresponding story about a girl who is overcome by a sudden inability to move while walking in the street. The narrating observer recognizes her paralysis as one from which he also suffers in his dreams. Offering her his arm, her paralysis suddenly dissipates. Musil, *Tagebücher*, p. 640.

[68] Musil, *Diaries*, 370.

[69] His wife Martha Musil recounts a visit by fellow writer Alfred Döblin, who playfully signed his name on a manuscript Musil was working on at the time; Musil was unable to progress with the text for several months. The incident probably took place in 1926; in the autumn of 1927, following pressure from the film theorist Béla Balázs, Musil started his sessions with Lukács. See Corino, *Musil*, p. 967.

[70] William M. Johnston, *The Austrian Mind: An Intellectual and Social History, 1848–1938* (Berkeley, CA: University of California Press, 1972), p. 257. On Musil's reception of Adler's theories more generally, see Corino, *Musil*, pp. 970–3.

[71] Robert Musil, 'Psychologie des Lehrlings: Das Buch von Hugo Lukacs', *Der Wiener Tag*, 30 May 1928, reprinted in *MGW* 9, 1681–3.

Psychotherapy is 'in essence nothing but a kind of medically directed school of life, but I believe to be able to say that with its help it is possible, in surprising ways, to literally get in the way of fate'.[72] Psychotechnics and psychotherapy stand for very different approaches to the mind. Musil's engagement with both shows his curiosity and willingness to try out a range of approaches to enhance his productivity. Indeed, his arsenal also contained a third tool: autosuggestion, which he encountered via the self-help books of the Swiss psychologist Charles Baudouin.

Collectedness

Baudouin (1893–1963) held the Chair of Psychology at the University of Geneva; in his teaching and publications, he sought to bridge the gulf between Freudian and Jungian theories. He produced a total of seventeen books, many of them at the popular end of the spectrum. Baudouin was particularly interested in the New Nancy School and its method of autosuggestion, developed by the French psychologist Emile Coué, which he helped to popularize. The German translations of his books were published by the Dresden-based Sibyllen-Verlag, where Musil's own play *Die Schwärmer* (The Enthusiasts) had appeared in 1921.[73]

In a diary entry of 1930, Musil recounts getting stuck near the end of a chapter of *The Man without Qualities*, but the blockage, which he attributes to a state of overly focused attention, could be lifted once he stopped writing and resumed his preparations for an upcoming trip:

> Die Ordnung wurde sofort zu einer Fortsetzung u[nd] die Arbeitsstimmung stellte sich wieder ein. [...] Eins nach dem andern. Es ist bei allen Dingen so. Ich muß wahrscheinlich gar keine sachlich richtige Disposition machen, sondern bloß eine Disposition über mich selbst treffen. Die Aufgabe in Teilaufgaben zerlegen.[74]

[72] '[...] eigentlich nichts anderes als eine Art ärztlich geleiteter Lebensschule, aber ich glaube sagen zu können, daß es mit ihrer Hilfe in erstaunlicher Weise gelingt, dem Schicksal buchstäblich an den Leib zu rücken' (*MGW* 9, 1683).

[73] Both Musil and his wife Martha repeatedly mention Baudouin in their letters between 1923 and 1941. See Musil, *Briefe*, 297; 300–1; 315–16; 1288. In one letter, Musil jokes that Martha was planning to put one of Baudouin's books under her pillow to alleviate his pessimistic outlook (6 October 1923; *Briefe*, 316), while Martha in turn wonders whether she should try Baudouin's method given that nothing else seemed to help, but adds: 'Früher ist mir das oft gelungen, aber zur Erfüllung des Wunsches trat oft etwas Unerwünschtes hinzu' ('In the past I often succeeded, but the fulfilment of a particular wish was often accompanied by something undesirable'). Martha Musil, *Briefwechsel mit Armin Kesser und Philippe Jaccottet*, ed. Marie-Louise Roth, vol. 1 (Bern: Lang, 1997), p. 66.

[74] 28 April 1930; Musil, *Tagebücher*, pp. 715–16. On the relationship between Musil's strategy of deliberate distraction and his essays on sport, where excessive attention is also said to be hampering, see Julian Bauer, 'Aufmerksamkeit, Zerstreuung, Erschöpfung: Skizzen zur Körpergeschichte bei Mach, Meinong, Musil und Malinowski', in *Geteilte Gegenwarten: Kulturelle Praktiken von Aufmerksamkeit*, ed. Stephanie Kleiner, Miliam Lay Brander, and Leon Wansleben (Munich: Fink, 2016), pp. 59–90 (pp. 69–71).

[This ordering straightaway became a continuation, and a working mood returned. [...] One thing at a time. This is the case in all things. It is likely that I shall not have to set things out in an objective and correct fashion at all, but only set myself up correctly! Divide the task up into subtasks.[75]]

Musil sums up this strategy with the Latin maxim 'divide et impera'—divide and conquer. This phrase also appears in Baudouin's 1923 book *La Force en nous* (The Power within Us), published a year later in German as *Die Macht in uns*:

> Divide et impera. Unter diesem Leitspruche muß man auch an seine Selbsterziehung schreiten. Man hat so viele Feinde in der nächsten Umgebung und in der ferneren Außenwelt; noch zahlreichere, gefährlichere lauern in unserer Innenwelt. Dafür sind diese inneren Feinde im unmittelbaren Griffbereich unseres Willens und können so am wirksamsten bekämpft werden.[76]
>
> [Divide et impera. That must be your device if you wish to be your own educator. You have many enemies: some of them are outside you, and they surround you; others, even more numerous and more formidable, are within. But these inward enemies are, as a compensation, those on which your will can be brought to bear most directly and effectively.[77]]

Baudouin's emphasis on self-control and self-conditioning chimes with Musil's own aims and interests. In a chapter dedicated to the faculty of attention, he references the work of William James and Théodule-Armand Ribot. Following Ribot's *Psychology of Attention*, he casts the essence of attention as perpetual, ever-expanding movement:

> der Gegenstand der Aufmerksamkeit wirkt auf sie nur als Zentrum, zu dem sie immer wieder zurückkehrt; immer wieder und in immer weiteren Kreisen verläßt sie diesen Mittelpunkt; jeder Teil des Gegenstandes, dann die Betrachtungen, die wir darüber anstellen, nehmen abwechselnd unser Interesse gefangen.[78]
>
> [the object of attention is merely a centre, the point to which attention returns again and again, to wander from it as often on ever-widening circles. All parts of the object, and then the reflections inspired by these various parts, hold our interest by turns.[79]]

[75] Musil, *Diaries*, pp. 370–1.
[76] Charles Baudouin, *Die Macht in uns: Entwicklung einer Lebenskunst im Sinne der neuen Psychologie*, trans. Paul Amann (Dresden: Sibyllen-Verlag, 1924), p. 152. In this context, Baudouin cites Louis Benoist-Hanappier, *En marge de Nietzsche: Tactique de la volonté* (Paris: Figurière, 1912) [no page ref.]. In this chapter, I am citing from the German version read by Musil.
[77] Charles Baudouin, *The Power within Us*, trans. Eden Cedar Paul (London: Allen & Unwin, 1923), p. 115.
[78] Baudouin, *Die Macht*, p. 109. [79] Baudouin, *The Power*, p. 84.

Baudouin explicitly rejects Romantic models of genius and creative inspiration; for him, practice and routine are the bedrocks of intellectual endeavour. While attention alone cannot *produce* genius, it is essential to wrench inspiration 'from the realm of possibility' and lead it 'into the realm of action'.[80] This requires

> Gewöhnung an eine mehr gesammelte, intensivere und still gefaßte Aufmerksamkeit, durch die unser Licht in einem Brennpunkt vereinigt wird. [...] Die Intelligenz darf nicht länger an sich zweifeln; sie muß sich ein für allemal klar machen, daß die Kraft in ihr beschlossen ist.[81]
>
> [the sustained habit of a more convergent attention, intenser and more tranquil, the lens which will assemble the rays of light into a focus of active heat. [...] The intelligence must no longer lack faith in itself, but has merely to recognise once and for all that the source of power is within itself.[82]]

Time and again, Baudouin emphasizes the benefits of such practice: 'Through this mastery of attention we are in very truth enabled to master our actions, to win the power of carrying our decisions into effect'.[83] This applies not only to individual actions, but to 'the course of our whole life [...]. We shall march the more surely towards our goal in proportion as we have more perfectly concentrated our mind thereon'.[84]

Strictly speaking, however, the state of concentration referenced at the end of this passage does not belong in the same category as attention. In Baudouin's theory of mind, concentration stands for a very different mode of experience, one which is not voluntary and controlled but involves complete surrender to the captivating power of an object or idea:

> bei der Aufmerksamkeit im landläufigen Sinne geht die Bemühung, den Gegenstand festzuhalten, durchaus von unserm Denken aus; bei der Konzentration hingegen erreicht man einen Zustand, bei dem der Gegenstand das Denken fast ohne dessen Hinzutun, ja, ob es will oder nicht, einfach gefesselt hält.[85]

[80] Baudouin, *The Power*, p. 89; 'aus dem Dämmerlicht der bloßen Möglichkeit [...] ins Reich der Tat'. Baudouin, *Die Macht*, p. 115.

[81] Baudouin, *Die Macht*, p. 117. [82] Baudouin, *The Power*, 90.

[83] Baudouin, *The Power*, 78. 'Durch solche Beherrschung unserer Aufmerksamkeit gelangen wir tatsächlich zur Herrschaft über unser Tun, gewinnen die Kraft zur restlosen Durchführung der Dinge, die wir uns vorgenommen haben'. Baudouin, *Die Macht*, p. 102.

[84] Baudouin, *The Power*, p. 79; 'die ganze Linie unseres Lebens [...]. Je besser wir unseren Geist auf ein Ziel konzentriert haben, desto sicherer werden die Schritte, die uns ihm näherbringen'. Baudouin, *Die Macht*, p. 103. To drive home his message, Baudouin cites some historical figures, who turned this cognitive maxim into a way of life. Napoleon Bonaparte visualized his own mind as a cupboard in which each task occupied one self-contained drawer and was reportedly able effortlessly to sustain an unwavering state of concentration. Baudouin, *Die Macht*, p. 105; Baudouin, *The Power*, pp. 79–80. Another role model is the American philosopher Ralph Waldo Emerson, who declares concentration to be a moral 'commandment' in the face of worldly pleasures and other needless distractions. Baudouin, *The Power*, p. 82; Baudouin, *Die Macht*, pp. 107–8.

[85] Baudouin, *Die Macht*, pp. 100–1.

[in ordinary attention, it is the thought which constrains itself to hold the object in focus, whereas in concentration the object simply ties the mind to itself without the mind's active involvement, indeed, regardless of whether the mind wants to or not.[86]]

Such concentration can be achieved with the help of autosuggestion, a method which Baudouin explains in his 1919 book *Suggestion et Autosuggestion* (Suggestion and Autosuggestion).[87] Here, he focuses on a state of *Sammlung* or collectedness, in which the subconscious becomes fully transparent, is 'laid bare' and 'uncovered'.[88] This state can come about spontaneously, for instance when waking up in an unknown environment; the aim of autosuggestion is to be able to produce it at will. Achieving it can have major benefits, freeing the individual from the need for stimulants such as tobacco, alcohol, or opium, and from dependency on the entertainment provided by 'the newspapers' toxins'.[89]

Indeed, the first stage of entering collectedness is to let go of all external concerns: 'As soon as the attention is relaxed, it becomes possible for all our inner life to flow together, to collect itself within us'.[90] Autosuggestion exercises are best performed first thing in the morning or last thing at night. The aim is to 'summon the subconscious, without going to sleep, but so as to become accustomed to these mixed states, wherein the ordinary consciousness is not completely annulled, but wherein it ceases to form a rigid cortex and becomes a transparent veil'.[91]

Though for Baudouin autosuggestion is no purpose-driven undertaking, his method chimes with the larger modernist project of cognitive optimization.[92] With regular practice, the reader will be able to enter into a state of autohypnosis

[86] Baudouin, *The Power*, p. 77.
[87] The book was translated into German in 1923. In *The Force within Us*, Baudouin also points to Christian devotional practices, such as litanies and the rosary, and to Yogic meditation as ways of achieving this state of concentration, 'which is so completely effortless that in the end it borders on unconsciousness'—remarks which obviously resonate with Musil's 'other state'. Baudouin, *Die Macht*, p. 101; Baudouin, *The Power*, p. 77.
[88] Charles Baudouin, *Suggestion und Autosuggestion*, trans. Paul Amann (Dresden: Sibyllen-Verlag, 1923), p. 144. Charles Baudouin, *Suggestion and Autosuggestion: A Psychological and Pedagogical Study*, trans. Eden and Cedar Paul (New York, NY: Dodd, Mead and Company, 1922), p. 154. Baudouin here uses the Jungian notion of the subconscious, or *Unterbewusste*, rather than the Freudian unconscious, or *Unbewusste*.
[89] Baudouin, *Suggestion and Autosuggestion*, p. 160; 'die Giftstoffe der Zeitungen'. Baudouin, *Suggestion und Autosuggestion*, p. 143.
[90] Baudouin, *Suggestion and Autosuggestion*, 163; 'indem sich die Aufmerksamkeit entspannt, läßt sie unser ganzes Innenleben herzuströmen, sich in uns ansammeln'. Baudouin, *Suggestion und Autosuggestion*, 145.
[91] Baudouin, *Suggestion and Autosuggestion*, pp. 160–1; 'das Unterbewußte heraufzurufen, ohne doch einzuschlafen, so daß wir uns an jene Zwischenzustände gewöhnen, worin das Oberflächenbewußtsein nicht geschwunden ist, aber keine starre Rinde mehr, sondern einen durchsichtigen Schleier darstellt'. Baudouin, *Suggestion und Autosuggestion*, p. 143.
[92] In particular, Baudouin endorses the memory exercises of the US-American self-help guru Herbert Parkyns. *Suggestion und Autosuggestion*, p. 153.

almost anywhere, whether on the tram, in the doctor's waiting room, or in the city: 'Even without closing the eyes we shall be able to isolate ourselves in the street, in a crowd, during a country walk, and on many other occasions'.[93]

This image is reminiscent of the 'split consciousness' which Ulrich experiences on his walk through the city, where vigilance coexists with boundless, empathetic awareness. Musil was an avid reader of *Suggestion and Autosuggestion*, requesting not one but two copies from his publisher.[94] Echoes of Baudouin's theories can be found across his writings—in the expanded state of consciousness, which *The Man without Qualities* calls the *andere Zustand*, and in other, related experiences of perceptual alteration and intensification, which feature prominently in his 1936 collection *Nachlaß zu Lebzeiten* (Posthumous Papers of a Living Author).

Threshold States

Traces of Baudouin's theories are readily apparent in several of Musil's stories, which depict intensified mental states as a rupture from everyday experience. Many of these episodes take place on the threshold between sleep and wakefulness. In the story 'Hellhörigkeit' (Clearhearing), the focus is on aural sensations. Its first-person narrator is suffering from a fever; lying in bed at night, he is listening to his wife getting ready in the bathroom next door. The sounds produced by these ordinary preparations seem wholly incomprehensible to him, producing a milder version of the alienation from his spouse that is also experienced, as we will see, by the narrator of 'The Blackbird'.

In 'Der Erweckte' (The Awakened One), in turn, the principal focus is on sight rather than sound. Its first-person narrator has woken up early, at the break of dawn: 'God woke me up. I shot up out of sleep. I had absolutely no other reason to wake up. I was torn out like a page from a book'.[95] Here, as in the Bible, awakening is cast as the response to a divine calling; the image of the page torn from a book expresses the rupture from the everyday, which continues as the narrator gazes out of the window:

> Die Häuser stehn kreuz und quer; seltsame Umrisse, abstürzende Wände; gar nicht nach Straßen geordnet. Die Stange am Dach mit den sechsunddreißig Porzellanköpfen und den zwölf Verspannungsdrähten, die ich verständnislos

[93] Baudouin, *Suggestion and Autosuggestion*, p. 189. 'Wir können uns sogar mit offenen Augen isolieren, mitten im Gedränge einer Straße und bei vielen anderen Gelegenheiten'. *Suggestion und Autosuggestion*, p. 169.

[94] In a letter to Annina Marcovaldi, Martha Musil complains that Dr Leo Francke, the head of the Sybillen-Verlag, had sent them Baudouin's book 'nur einmal,—Robert hatte um 2 Exemplare gebeten' ('only once—Robert had requested two copies). 17 May 1923; Musil, *Briefe*, pp. 300–1.

[95] *PLA* 17. 'Gott hat mich geweckt. Ich bin aus dem Schlaf geschossen. Ich hatte gar keinen anderen Grund aufzuwachen. Ich bin losgerissen worden wie ein Blatt aus einem Buch' (*MGW* 7, 483).

zähle, steht vor dem Morgenhimmel als ein völlig unerklärliches, geheimnisvolles oberstes Gebilde. Ich bin jetzt ganz wach, aber wohin ich mich auch wende, gleitet der Blick um Fünfecke, Siebenecke und steile Prismen. (*MGW* 7, 483–4)

[The houses stand helter-skelter; curious contours, steep sloping walls; not at all arranged by the streets. The rod on the roof with the thirty-six porcelain heads and the twelve stretched wires, which I count without comprehension, stands as a completely inexplicable secret structure up against the early morning sky. I'm wide awake now, but wherever I look, my eyes glide over pentagons, heptagons and steep prisms. (*PLA* 18)]

A near contemporary of Kafka's, Musil would have studied the same psychology textbook by Gustav Adolf Lindner, which argues that focused attention is vital in maintaining the continuity of experience by subsuming new sensations to pre-existing, familiar ones. Both Kafka and Musil invert this idea in their narratives of awakening, where this familiarizing mechanism is disabled. In 'The Awakened One', this entails a disintegration of the familiar environment into a set of abstract geometric shapes reminiscent of cubist paintings (and of the opening of *The Man without Qualities*). The above quotation resembles a passage by Baudouin, in which he describes staring at his fingertip for an extended time:

Zunächst habe ich die Gesichtswahrnehmung meiner Fingerspitze; schon diese zerfällt in eine Unzahl von Farben- und Formwahrnehmungen; dazu kommt eine verschwommene, mondhofartige Wahrnehmung der Oberflächen, die den fixierten Punkt umgeben; schließlich der Gedanke an den Versuch, den ich anstelle, und, wenigstens im Hintergrunde des Bewußtseins, die Erinnerung des Verbots, an anderes zu denken.[96]

[First, I look at my fingertip; it disintegrates into a multitude of colour and shape perceptions; in addition, there is a blurred, moon-crater-like perception of the surfaces which surround this fixated point; finally, there is the thought of the experiment I am executing and, at least at the back of my mind, the memory of the interdiction to think of anything else.]

Echoing Ribot's *Psychology of Attention*, Baudouin shows closely focused attention to be unsustainable over time; the longer it lasts, the more the object of perception disintegrates, while the mind begins to wander off into different directions. In Musil's story, the strange geometric shapes cause the narrator to question his own identity: 'Wer bin dann ich?' ('So who am I?'). From vision, the text then moves on to hearing: 'I don't want to look. My ear stands like a gateway on the street. Never will I be so at one with a woman as with this unknown figure

[96] Baudouin, *Suggestion und Autosuggestion*, p. 110.

whose steps disappear ever deeper in my ear'.[97] The verb *vereinigen*, to merge or unite, echoes Musil's earlier short story collection *Vereinigungen* (Unions, 1911), where intensified perception leads to an almost complete breakdown of conventional narrative structures.

In 'The Awakened One', however, this quasi-erotic union ends with an anticlimax:

> Dann zwei Frauen. Die eine filzig schleichend, die andere stapfend mit der Rücksichtslosigkeit des Alters. Ich sehe hinab. Schwarz. Seltsame Formen haben die Kleider alter Frauen. Die da streben zur Kirche. Längst ist ja die Seele um diese Stunde schon in Zucht genommen, und ich will nun nichts mehr mit ihr zu tun haben. (*MGW* 7, 484)
>
> [Then two women. The one sordidly slinking along, the other stamping with the disregard of age. I look down. Black. The clothes of old women have a form all of their own. These two are bound for church. At this hour, the soul has long since been taken into custody, and so I won't have anything more to do with it. (*PLA* 18)]

While the moment of awakening was attributed to God's calling, the narrator's epiphany is dispelled by the two women shuffling to the church, an emblem, as in so many modernist texts, of ossified religious traditions.

The shift from epiphanic exhilaration to disillusionment also features in the collection's final and longest piece, the novella 'Die Amsel' (The Blackbird), which Musil wrote in 1927, shortly after embarking on psychotherapy with Hugo Lukács.[98] The text's exploration of mental threshold states reflects Musil's attempts to break away from engrained habits to foster creativity and echoes Baudouin's texts down to specific images and ideas.

The novella's premise is rather contradictory. It recounts three epiphanies in immersive detail, but the surrounding narrative has a detached feel to it, reminiscent of a narrative experiment. This sense is underlined by the protagonists' names: Aeins and Azwei (Aone and Atwo). Two former school friends, they are reunited after many years; during this meeting Azwei recounts three (apparently unrelated) episodes from his adult life. The first is a night time episode set in Berlin. Azwei has stayed up long after his wife has gone to bed: 'I realized that I was waiting for something, but I didn't know what for'.[99] At 3 a.m. he lies down

[97] *PLA* 18. 'Nicht schauen will ich. Mein Ohr steht auf der Straße wie ein Eingang. Niemals werde ich mit einer Frau so vereint sein wie mit dieser unbekannten, deren Schritte jetzt immer tiefer in meinem Ohr verschwinden' (*MGW* 7, 484).

[98] The text was completed in the autumn of 1927 and published in January 1928.

[99] *PLA* 151. 'Mir wurde bewußt, daß ich auf etwas wartete, aber ich ahnte nicht, worauf' (*MGW* 7, 551).

on his bed, but just as he is about to fall asleep he is reawaken by approaching sounds. At first they appear to sit

> auf dem First des Nachbarhauses und sprangen dort in die Luft wie Delphine. Ich hätte auch sagen können, wie Leuchtkugeln beim Feuerwerk; denn der Eindruck von Leuchtkugeln blieb; im Herabfallen zerplatzten sie sanft an den Fensterscheiben und sanken wie große Silbersterne in die Tiefe. Ich empfand jetzt einen zauberhaften Zustand; ich lag in meinem Bett wie eine Figur auf ihrer Grabplatte und wachte, aber ich wachte anders als bei Tage. (*MGW* 7, 551–2)
> [on the roof of the building next door and leaped into the air like dolphins. I could just as well have said, like balls of fire at a fireworks display, for the impression of fireworks lingered; in falling, they exploded softly against the windowpanes and sank to the earth like great silver stars. Then I experienced a magical state; I lay in my bed like a statue on a sarcophagus cover, and I was awake, but not like during the day. (*PLA* 151)]

The expansion of awareness which Baudouin's readers are meant to achieve by means of autosuggestive exercises comes out of the blue for Musil's narrator; as in Baudouin, this expansion takes place on the threshold between wakefulness and sleep. The verb *erweckt*, which is used instead of the more conventional *geweckt*, echoes the earlier short story 'The Awakened One', again carrying overtones of spiritual awakening. Heightened awareness is here not limited to one of the senses but conveyed through a synaesthetic narration, in which sounds are described as 'balls of fire' and 'silver stars'. Their fragility contrasts with the narrator's body, which is compared to a tomb monument. Baudouin speaks of the 'mental immobility', which people experience when they enter a state of collectedness.[100] In this state, Azwei feels 'as though something had turned me inside out'.[101] At the heart of this experience, then, is a radical opening up of body and mind;[102] the narrator feels himself merging with the fabric of the room, 'a consistency unknown to the daylight senses, a blackness I could see through, a blackness I could feel through, and of which I too was made'.[103] This expanded, multi-sensory awareness is geared towards one sensation: the song of a bird, apparently a

[100] Baudouin, *Suggestion und Autosuggestion*, p. 156. Baudouin, *Suggestion and Autosuggestion*, p. 168.
[101] *PLA* 151; 'als ob mich etwas umgestülpt hätte' (*MGW* 7, 552).
[102] Optical inversion, the shift from a convex to a concave state, is a key focus of Gestalt theory, particularly in the work of Erich von Hornbostel, and provides a model for Musil's 'other state', which is likewise described as a turning inside out. See Florence Vatan, 'Gestalttheorie', in *Musil-Handbuch*, pp. 531–7 (pp. 534–5). See also Silvia Bonacchi, *Die Gestalt der Dichtung: Der Einfluß der Gestalttheorie auf das Werk Robert Musil* (Bern: Lang, 1998).
[103] *PLA* 152; 'einem Stoff, den es unter den Stoffen des Tages nicht gibt, einem schwarz durchsichtigen und schwarz zu durchfühlenden Stoff, aus dem auch ich bestand' (*MGW* 7, 552).

nightingale, which Azwei believes has come to visit him from afar, and which he feels compelled to follow, leaving his old life behind.

But just as he is about to get up, he experiences a second awakening, so to speak, when he realizes that what he took to be a nightingale is in fact a humble blackbird imitating the call of the other bird. This realization affects him deeply, as it abruptly propels him back into normality. The moment of awakening, the return from the depths of immersion to the surface of everyday life, is a moment of no return. The narrator is deeply disappointed, and yet the nocturnal episode nonetheless has a life-changing effect on him 'as a signal from afar—so it seemed to me at the time'.[104] That same night, he leaves his wife for good—and goes to war.

The word 'signal' provides the cue for the second episode, which explores heightened perception in the face of mortal danger. Azwei's battalion is stationed in the mountains, the Alps, where his unit comes under fire from the air.[105] Initially, only he seems able to hear the approaching *Fliegerpfeil*, or flechette, a pointed steel projectile dropped from an enemy aircraft designed to impale its human target. The sound of the descending weapon is barely audible, at the outer limits of the human sensorium: 'a shrill, singing, solitary, high-pitched tone, like the ringing rim of a glass [...]. And this tone was directed at me'.[106]

As in 'The Blackbird', sound takes on an epiphanic character, causing a radical opening of the body and the senses: 'I can only say that I was certain that in the next second I would feel God's proximity close up to my body—which, after all, is saying quite a bit for someone who hasn't believed in God since the age of eight'.[107] Here, epiphany does not remain solitary, but becomes a collective experience. When his comrades become aware of the threat, they seem to share Azwei's experience: 'fellows, for whom nothing would have been more unlikely than to think such thoughts, stood there, without knowing it, like a group of disciples waiting for a message from on high'.[108]

[104] PLA 154. 'Es hatte mich von irgendwo ein Signal getroffen—das war mein Eindruck davon' (*MGW* 7, 553).

[105] The episode reflects Musil's own experience of the Fourth Battle of the Isonzo (in modern-day Slovenia), in which he fought as a first lieutenant in November and December 1915. See Oliver Pfohlmann, 'Robert Musil', in *1914–1918 online: International Encyclopedia of the First World War*, https://encyclopedia.1914-1918-online.net/article/musil_robert [accessed 20 January 2022].

[106] PLA 159; 'ein dünner, singender, einfacher hoher Laut, wie wenn der Rand eines Glases zum Tönen gebracht wird [...]. Und dieser Laut war auf mich gerichtet' (*MGW* 7, 556). As Peter Berz argues, Musil's depiction of the approaching flechette is underpinned by research carried out by von Hornbostel and Wertheimer, who during the war focused on the problem of directional hearing, or 'Richtungshören', and who in 1915 devised experiments to localize acoustic perception. Peter Berz, 'Der Fliegerpfeil: Ein Kriegsexperiment Musils an den Grenzen des Hörraums', in *Armaturen der Sinne: Literarische und technische Medien 1870 bis 1920*, ed. Jochen Hörisch and Michael Wetzel (Munich: Fink 1990), pp. 265–88 (p. 279).

[107] PLA 159; 'ich war sicher, in der nächsten Minute Gottes Nähe in der Nähe meines Körpers zu fühlen. Das ist immerhin nicht wenig bei einem Menschen, der seit seinem achten Jahr nicht an Gott geglaubt hat' (*MGW* 7, 556).

[108] PLA 159. 'Burschen, denen nichts ferner lag als solche Gedanken, standen, ohne es zu wissen, wie eine Gruppe von Jüngern da, die eine Botschaft erwarten' (*MGW* 7, 557).

In the end, the flechette enters the ground right next to Azwei's feet, and he escapes unharmed.

In diesem Augenblick überströmte mich ein heißes Dankgefühl, und ich glaube, daß ich am ganzen Körper errötete. Wenn einer da gesagt hätte, Gott sei in meinen Leib gefahren, ich hätte nicht gelacht. Ich hätte es aber auch nicht geglaubt. Nicht einmal, daß ich einen Splitter von ihm davontrug, hätte ich geglaubt. Und trotzdem, jedesmal, wenn ich mich daran erinnere, möchte ich etwas von dieser Art noch einmal deutlicher erleben! (*MGW* 7, 557)

[At that instant a hot rush of gratitude swept through me, and I believe that my whole body turned red. And if at that very moment someone had said that God had entered my body, I wouldn't have laughed. But I wouldn't have believed it either—not even that a splinter of His being was in me. And yet whenever I think back to that incident, I feel an overwhelming desire to experience something like it again even more vividly! (*PLA* 160)]

Like the previous scene, the episode ends on an ambivalent note, with the divine nature of this experience neither confirmed not discredited. This ambivalence continues into the third and final episode, which returns to the theme of bird song. Azwei's parents have died in quick succession; when he returns to the family home alone, he discovers some old fingerprints he had left in an old book—traces of his former self at once alien and familiar: 'Well, as I told you, though it may for some people not be an earthshattering event to remember themselves, it was for me as if my life had been turned upside down'.[109] This image of inversion recalls the Berlin episode, where the narrator had felt 'as though something had turned me inside out'. It in turn anticipates another instance of nocturnal revelation. The narrator is sleeping in his old bedroom when in the middle of the night, he is again roused by bird song:

Und da kam dann die Amsel wieder. Einmal nach Mitternacht weckte mich ein wunderbarer, herrlicher Gesang. Ich wachte nicht gleich auf, sondern hörte erst lange im Schlaf zu. Es war der Gesang einer Nachtigall; aber sie saß nicht in den Büschen des Gartens, sondern auf dem Dach eines Nebenhauses. Ich begann mit offenen Augen zu schlafen. Hier gibt es keine Nachtigallen—dachte ich dabei—es ist eine Amsel. (*MGW* 7, 561)

[And then the blackbird came again. Once after midnight I was awakened by a wonderful, beautiful singing. I didn't wake up right away but listened first for a long time in my sleep. It was the song of the nightingale; she wasn't perched in the garden bushes, but sat instead on the rooftop of a neighbour's house. Then

[109] *PLA* 166; 'für andere Menschen mag es nichts Besonderes sein, wenn sie sich an sich selbst erinnern, aber für mich war es, als ob das Unterste zu oberst gekehrt würde' (*MGW* 7, 561).

I slept on a while with my eyes open. And I thought to myself: There are no nightingales here, it's a blackbird. (*PLA* 167)]

This time, Azwei immediately recognizes the bird to be a blackbird, and yet he nonetheless identifies its song as that of a nightingale. The spheres of the ordinary and the extraordinary are no longer separated by disillusionment but coexist, with everyday life containing and facilitating a sense of epiphany. Once again, this experience provides access to the spiritual, the supernatural or divine: 'I am your blackbird—it [the bird] said—Don't you remember me? [...] I am your mother— she said'.[110] While the previous epiphanies turned out to be short-lived, the blackbird becomes a lasting, albeit a domesticated, presence in the narrator's life:

Ich ging auf den Dachboden und suchte einen großen Holzkäfig, an den ich mich erinnerte, weil die Amsel schon einmal bei mir gewesen war; in meiner Kindheit, genau so, wie ich es eben sagte. Sie war im Fenster gesessen und dann ins Zimmer geflogen, und ich hatte einen Käfig gebraucht, aber sie wurde bald zahm, und ich habe sie nicht gefangengehalten, sie lebte frei in meinem Zimmer und flog aus und ein. Und eines Tags war sie nicht mehr wiedergekommen, und jetzt war sie also wieder da. (*MGW* 7, 562)

[I went up to the attic and looked for a large wooden bird cage that I seemed to remember, for the blackbird had visited me once before—in my childhood, like I just told you. She sat on my windowsill and then flew into my room, and I needed a cage. But she soon grew tame, and I didn't keep her locked up anymore, she lived free in my room and flew in and out. And one day she didn't come back again, and now she had returned. (*PLA* 167)]

As the narrative suggests, perhaps the different, lasting import of this final scene is linked to Azwei being able to revive and draw on experiences of his childhood, a time when experience is not yet bound by habit, but open towards the magical and unexpected.

Ultimately, though, the novella ends on an ambiguous note. Azwei concedes that the three episodes may be connected, but he refuses to invest them with a deeper meaning. Rejecting Aeins's suggestion 'that all this is supposed to have a common thread', he exclaims: 'For God's sake, [...] this is just the way it happened; and if I knew the point of it all, then I wouldn't need to have told it in the first place. But it's a bit like hearing a whisper and a rustling outside, without being able to distinguish between the two!'[111]

[110] *PLA* 167–8. 'Ich bin deine Amsel,—sagte er [der Vogel]—kennst du mich nicht? [...] Ich bin deine Mutter—sagte sie' (*MGW* 7, 561).
[111] *PLA* 169. 'Du lieber Himmel [...] es hat sich eben alles so ereignet; und wenn ich den Sinn wüßte, so brauchte ich dir wohl nicht erst zu erzählen. Aber es ist, wie wenn du flüstern hörst oder bloß rauschen, ohne das unterscheiden zu können!' (*MGW* 7, 562).

The human senses, which channel these different, particularly aural, epiphanies, cannot distinguish between music and sound, sense and white noise, with ultimate certainty, and this also applies to the interpretation of these three incidents. For all its metaphysical overtones, the text ends on a sceptical and ironic note—just as the blackbird never speaks again.

Captivation

A very different mindset informs the opening text of the *Posthumous Papers of a Living Author* collection, the striking 'Fliegenpapier' (Flypaper), which was first published in 1913. Here, Musil demonstrates his skill of close observation, channelling the perspective of the experimental scientist:

> Das Fliegenpapier Tangle-foot ist ungefähr sechsunddreißig Zentimeter lang und einundzwanzig Zentimeter breit; es ist mit einem gelben, vergifteten Leim bestrichen und kommt aus Kanada. Wenn sich eine Fliege darauf niederläßt— nicht besonders gierig, mehr aus Konvention, weil schon so viele andere da sind—klebt sie zuerst nur mit den äußersten, umgebogenen Gliedern aller ihrer Beinchen fest. (*MGW* 7, 476)
>
> [Tangle-foot flypaper is approximately fourteen inches long and eight inches wide; it is coated with a yellow poison paste and comes from Canada. When a fly lands on it—not so eagerly, more out of convention, because so many others are already there—it gets stuck at first by only the outermost joints of all its legs. (*PLA* 3)]

The narrative takes an ordinary, overlooked feature of daily life—the dying of flies caught on flypaper—and subjects it to close scrutiny, using this hyper-realism for some disconcerting thought experiments and far-flung associations. The text opens in a conventionally realist mode, but then description gives way to a more surreal, immersive narration:

> Eine ganz leise, befremdliche Empfindung, wie wenn wir im Dunkel gingen und mit nackten Sohlen auf etwas träten, das noch nichts ist als ein weicher, warmer, unübersichtlicher Widerstand und schon etwas, in das allmählich das grauenhaft Menschliche hineinflutet, das Erkanntwerden als eine Hand, die da irgendwie liegt und uns mit fünf immer deutlicher werdenden Fingern festhält! (*MGW* 7, 476)
>
> [A very quiet, disconcerting sensation, as though while walking in the dark we were to step on something with our naked soles, nothing more than a soft, warm, unavoidable obstruction, and yet something into which little by little the dreadful human essence flows, recognized as a hand that just happens to be lying there, and with five ever more decipherable fingers, holds us tight. (*PLA* 3)]

The flies' experience is likened to the field of human experience by means of the comparative 'as though' (*wie*), and yet what follows is by no means an ordinary occurrence. The 'we' perspective draws the reader into a bizarre nocturnal scene, in which a diffuse set of sensations eventually converges in the horrible sensation of a grasping hand. This realization is marked by a shift from the subjunctive to the indicative—from a mere thought experiment to an actual experience. The verb *festhalten* (to hold fast) links the flies' entrapment to this eerie nocturnal scene, and it also encapsulates the reader's experience, captivated by this strange narrative. Throughout the text, Musil skilfully interweaves closeness and distance, familiarity and detachment. A key device is anthropomorphism:

> Dann stehen sie [die Fliegen] alle forciert aufrecht, wie Tabiker, die sich nichts anmerken lassen wollen, oder wie klapprige alte Militärs (und ein wenig o-beinig, wie wenn man auf einem scharfen Grat steht). Sie geben sich Haltung und sammeln Kraft und Überlegung. Nach wenigen Sekunden sind sie entschlossen und beginnen, was sie vermögen, zu schwirren und sich abzuheben. Sie führen diese wütende Handlung so lange durch, bis die Erschöpfung sie zum Einhalten zwingt. Es folgt eine Atempause und ein neuer Versuch. Aber die Intervalle werden immer länger. (*MGW* 7, 476)
>
> [Here they [the flies] stand all stiffly erect, like tabetics pretending to be normal, or like decrepit old soldiers (and a little bowlegged, the way you stand on a sharp edge). They hold themselves upright, gathering strength and pondering their position. After a few seconds they've come to a tactical decision and they begin to do what they can, to buzz and try to lift themselves. They continue this frantic effort until exhaustion makes them stop. Then they take a breather and try again. But the intervals grow ever longer. (*PLA* 3-4)]

Here, the flies' dying is framed in human categories of ageing and illness. Tabetics, people suffering from *tabes dorsalis*, the degeneration of the spinal cord in the tertiary stage of syphilis, are in turn compared to old military men; the description of them 'hold[ing] themselves upright, gathering strength and pondering their position' could refer to either group; it also provides the bridge which leads the narrative back to the flies' struggle. Musil's text is full of such chains of association. Their effect is less to make the flies more familiar than to highlight the shared grotesqueness of human *and* animal life.

Such jarring associations recur throughout the text, as when flies' heads are described as 'brown and hairy, as though made of a coconut, as manlike as an African idol'.[112] Even as it is exposed to quasi-microscopic scrutiny, the fly cannot ultimately be understood in its animal nature, but has to be brought into the realm

[112] *PLA* 4; 'braun und haarig, wie aus einer Kokosnuß gemacht; wie menschenähnliche Negeridole' (*MGW* 7, 476).

of human experience, here by means of ethnographic, colonial, imagery. But then the distance created by these far-flung comparisons suddenly gives way to identification:

> Und dann kommt der immer gleich seltsame Augenblick, wo das Bedürfnis einer gegenwärtigen Sekunde über alle mächtigen Dauergefühle des Daseins siegt. Es ist der Augenblick, wo ein Kletterer wegen des Schmerzes in den Fingern freiwillig den Griff der Hand öffnet, wo ein Verirrter im Schnee sich hinlegt wie ein Kind, wo ein Verfolgter mit brennenden Flanken stehen bleibt. (*MGW* 7, 476)
>
> [And then comes the extraordinary moment when the imminent need of a second's relief wins out over the almighty instincts of self-preservation. It is the moment when the mountain climber because of pain in his fingers wilfully loosens his grip, when the man lost in the snow lays himself down like a child, when the hunted man stops dead with aching lungs. (*PLA* 4)]

The flies are not even mentioned in this passage, which describes a sudden collapse of resistance and composure—the victory of the body over the will, which is sketched out in three archetypal scenes of no return. Only as an afterthought does the narrator return to the flies: 'They no longer hold themselves up with all their might, but sink a little and at that moment appear totally human'.[113]

Only once, about a third of the way through, does a personal narrator come to the fore to share his thoughts. Having described how the intervals between the flies' escape attempts grow longer and longer, he remarks: 'They stand there and I feel how helpless they are'.[114] This comment marks a rare moment of empathy facilitated by stillness. The account of the creatures' death, in turn, is more ambivalent, mixing empathy and detachment:

> Noch am nächsten Tag wacht manchmal eine auf, tastet eine Weile mit einem Bein oder schwirrt mit dem Flügel. Manchmal geht solch eine Bewegung über das ganze Feld, dann sinken sie alle noch ein wenig tiefer in ihren Tod. Und nur an der Seite des Leibs, in der Gegend des Beinansatzes, haben sie irgend ein ganz kleines, flimmerndes Organ, das lebt noch lange. Es geht auf und zu, man kann es ohne Vergrößerungsglas nicht bezeichnen, es sieht wie ein winziges Menschenauge aus, das sich unaufhörlich öffnet und schließt. (*MGW* 7, 477)
>
> [Sometimes even the next day, one of them wakes up, gropes a while with one leg or flutters a wing. Sometimes such a movement sweeps over the lot, then all of

[113] *PLA* 4. 'Sie halten sich nicht mehr mit aller Kraft ab von unten, sie sinken ein wenig ein und sind in diesem Augenblick ganz menschlich' (*MGW* 7, 476–7).
[114] *PLA* 4. 'Sie stehen da, und ich fühle, wie ratlos sie sind' (*MGW* 7, 476).

them sink a little deeper into death. And only on the side, near their leg sockets, is there some tiny flickering organ that still lives a long time. It opens and closes, you can't describe it without a magnifying glass, it looks like a minuscule human eye that ceaselessly opens and shuts. (*PLA* 5)]

In their dying moments, the flies are no longer seen through an anthropomorphic lens as the focus returns to their tiny bodies. The 'flickering organ', which resembles an eye opening and closing, evokes the exchanged gaze as that archetypal moment of inter-subjectivity, but this, like so many of the text's descriptions, is but a human projection. In truth, the gaze is one-sided, belonging to the human observer equipped with his magnifying glass, who continues to scrutinize the flies until any trace of life is extinct.

In his very first diary entry, Musil adopts for himself the authorial persona of '*monsieur le vivisecteur*' (Mr Vivisector).[115] 'Flypaper' channels this persona, building on Musil's scientific training, though the narrative mode remains ambiguous, oscillating between observation and empathy, between scrutiny and far-flung associations, which detract from the flies' experience even as they seek to make it more relatable: 'Here they lie. Like crashed planes with one wing reaching out into the air. Or like dead horses. Or with endless gesticulations of despair. Or like sleepers'.[116] It is impossible to read this passage without thinking of the impending carnage of the war;[117] looking back on his text in the 1930s, Musil calls it a 'Vorausblick', a look ahead based not on prophetic faculties but on attention:

jedermann werden solche Weissagungen gelingen, der an kleinen Zügen, wo es sich unachtsam darbietet, das menschliche Leben beobachtet und sich den 'wartenden' Gefühlen überläßt, die bis zu einer Stunde, die sie aufrührt, scheinbar 'nichts zu sagen haben' und sich harmlos in dem ausdrücken, was wir tun und womit wir uns umgeben. (*MGW* 7, 474)

[such prophecies are likely to occur to every man who observes human life in the tiny traits by which it carelessly reveals itself, to every man who pays attention to the 'loitering' sensibilities, which, apparently, up until a certain hour that stirs them up, 'have nothing to say' and harmlessly express themselves in our actions and our choice of surroundings. (*PLA* ix)]

This passage is taken from the collection's preface, which sums up its programme of painstaking attention as a vehicle of altered, defamiliarizing experience. Musil's

[115] Musil, *Tagebücher*, p. 1.
[116] *PLA* 5. 'So liegen sie da. Wie gestürzte Aeroplane, die mit einem Flügel in die Luft ragen. Oder wie krepierte Pferde. Oder mit unendlichen Gebärden der Verzweiflung. Oder wie Schläfer' (*MGW* 7, 477).
[117] A first version of the text is recorded in Musil's diary in November 1913. *Tagebücher*, p. 285.

narrative texts zoom in on the 'tiny traits' of human (and animal) life; they are complemented by more essayistic pieces which negotiate the role of attention in modern life.

Inattentive Readers and Invisible Monuments

After the second part of *The Man without Qualities* was published in 1932, Musil struggled to make further headway with his novel.[118] To overcome his writer's block, he started to compile a volume of 'little tales and observations',[119] which had appeared in newspapers and magazines between 1914 and 1932. *Posthumous Papers of a Living Author* was published in December 1935. In a letter, its author describes it somewhat dismissively as his 'little stopgap book'.[120] This phrase conceals the considerable effort Musil invested in the collection. He changed the titles of eleven of the thirty pieces and revised all of them, some of them extensively; in addition, he gave a lot of thought to the order of the texts, which are arranged in four groups.[121] Not only was the volume intended to conceal a drop in his creative stamina and keep his name in the public domain, but this editing and collating work also had a practical, therapeutic purpose which reflects Baudouin's maxim of 'divide et impera', as it enabled the author to immerse himself in a series of clearly defined tasks.

In the preface, Musil projects his own struggles with his concentration onto the world around him. Conceding that the volume might be seen to lack coherence, he blames this heterogeneity on the prevailing cultural climate. The assembled pieces were originally written for newspapers, 'with their inattentive, motley, inordinately large readerships. No doubt they would have turned out otherwise had I written them, as I did my books, with just myself and my friends in mind'.[122] Musil here treads a fine line between criticism and flattery. By churning out well-worn clichés about the short-lived sensationalism of the print media and its perpetually distracted readership, he prudently leaves it open whether the readers of his collection belong to this category or can count themselves among those select few still capable of the sustained concentration which was required to master *The Man without Qualities*. In another trope familiar from

[118] Helmut Arntzen describes the almost ritualistic alternation between setting and missing a deadline, a pattern which came to dominate Musil's work on the novel in the 1930s and 1940s. *Musil-Kommentar zu dem Roman 'Der Mann ohne Eigenschaften'* (Munich: Winkler, 1982), p. 47.
[119] *PLA* viii; 'kleine Geschichten und Betrachtungen' (*MGW* 7, 473).
[120] '[...] kleine[s] Lückenbüßer-Buch'. Musil, *Briefe*, p. 674.
[121] See Helmut Arntzen, *Musil-Kommentar sämtlicher zu Lebzeiten erschiener Schriften außer dem Roman 'Der Mann ohne Eigenschaften'* (Munich: Winkler, 1980), pp. 140–1; and Thomas Hake, 'Nachlass zu Lebzeiten (1936)', in *Musil-Handbuch*, pp. 320–40 (pp. 321–2).
[122] *PLA* x; 'für Zeitungen [...], mit ihrem unaufmerksamen, ungleichen, dämmerig-großen Leserkreis, und hätten ohne Frage anders ausgesehen, wenn ich sie, so wie meine Bücher, für mich allein und für meine Freunde geschrieben hätte' (*MGW* 7, 474).

modernity-critical texts, the writer is portrayed as someone who leads a life of deep contemplation, 'completely cut off from life', but who, being compelled to cater for the taste of the time, is forced to attend to mere 'Nebensachen' (incidentals), rather than to the world's many pressing concerns.[123]

These complaints sound sincere enough; read in the light of the assembled pieces, however, they appear misleading, even disingenuous. The assembled texts may be short, but they are neither trivial nor easily consumable. At the time when the collection was published, Musil was living in Germany, 'still free from the debilitating pressures of exile' and hence able to 'assert an aesthetic in which the literary dimension functioned [...] both autonomously and as a social fact'; in his lucid exploration of the collection, Andreas Huyssen calls the assembled pieces 'a vibrant afterimage of interwar modernism at a time when modernism was officially ostracized in Germany and the Soviet Union'.[124] Even short pieces trace complex psychological dynamics using experimental narrative techniques, and the 'incidentals' they focus on have a deeper import. Some texts are highly subjective, others more detached, while several have a satirical, socially critical edge to them. One of them is the witty 'Denkmale' (Monuments), which describes the effects of inattention on our relationship to our physical surroundings:

> das auffallendste an Denkmälern ist nämlich, daß man sie nicht bemerkt. Es gibt nichts auf der Welt, was so unsichtbar wäre wie Denkmäler. Sie werden doch zweifellos aufgestellt, um gesehen zu werden, ja geradezu, um die Aufmerksamkeit zu erregen; aber gleichzeitig sind sie durch irgend etwas gegen Aufmerksamkeit imprägniert, und diese rinnt Wassertropfen-auf-Ölbezug-artig an ihnen ab, ohne auch nur einen Augenblick stehenzubleiben. (*MGW* 7, 506)
>
> [The most conspicuous thing about monuments is that one does not notice them. There is nothing in this world as invisible as a monument. They are no doubt erected to be seen—indeed to attract attention. But at the same time they are impregnated with something that repels attention, causing the glance to roll right off, like water droplets off an oilcloth, without even pausing for a moment. (*PLA* 64)]

Monuments exist below the radar of consciousness, but Musil wants to draw the reader's attention to them through a mixture of social satire and psychological reflection. Our attention is more likely to be drawn to the transient and trivial details of daily life (such as a coin in the gutter) than to a memorial plaque on the wall. Indeed, even larger-than-life statues tend to fade into the background. Though their purpose is to spark recollection and awareness, they not only fail

[123] *PLA* viii; 'in einer tiefen Abgeschiedenheit vom Leben' (*MGW* 7, 473).

[124] Andreas Huyssen, *Miniature Metropolis: Literature in the Age of Photography and Film* (Cambridge, MA: Harvard University Press, 2015), pp. 244–5.

in this undertaking, but seem to actively dispel attention: 'One cannot say that we don't notice them; one would have to say that they "de-notice" us, they elude our perceptive faculties'.[125] There are some exceptions, but by and large, monuments thus illustrate a timeless psychological law:

> Alles Beständige büßt seine Eindruckskraft ein. Alles, was die Wände unseres Lebens bildet, sozusagen die Kulisse unseres Bewußtseins, verliert die Fähigkeit, in diesem Bewußtsein eine Rolle zu spielen. Ein lästiges dauerndes Geräusch hören wir nach einigen Stunden nicht mehr. [. . .] Und in welch erhöhtem Maße müssen sich diese psychologischen Nachteile, denen das Beständige ausgesetzt ist, bei Erscheinungen aus Erz und Marmor geltend machen! (*MGW* 7, 507)
>
> [Anything that endures over time sacrifices its ability to make an impression. Anything that constitutes the walls of our life, the backdrop of our consciousness, so to speak, forfeits its capacity to play a role in that consciousness. A constant, bothersome sound becomes inaudible after several hours. [. . .] And to what heightened degree must these psychological detriments of durability manifest themselves in bronze and marble! (*PLA* 66)]

Habit and routine and how they blunt awareness are prominent themes in modernist psychological and cultural debate; to counteract this effect, critics such as the Russian Formalist Viktor Shklovsky argue that literature must defamiliarize readers from the world as they know it. Musil's texts pursue a similar aim; his 'Monuments' essay describes the effects of habit while at the same time trying to rekindle our awareness by highlighting monuments' eerie quality. In an age of acceleration, he notes, their stillness is almost a provocation, as the depicted people resemble

> die schweren Melancholiker in den Nervenheilanstalten. [. . .] Noch gruseliger ist es, wenn die Bildhauer einen General oder Prinzen darstellen. Die Fahne flattert in der Hand, und es geht kein Wind. Das Schwert ist gezückt und niemand fürchtet sich davor. (*MGW* 7, 508)
>
> [the acute melancholics in the mental hospitals. [. . .] It is even more frightening when the sculptors depict a general or a prince. His flag is waving in his hand, and there's no wind. His sword is drawn and no one draws back in fear. (*PLA* 67–8)]

Musil is here gesturing towards Freud's theory of the uncanny; the most disconcerting experiences are those subtler changes which cast our familiar world in an

[125] *PLA* 65. 'Man kann nicht sagen, wir bemerken sie nicht; man müßte sagen, sie entmerken uns, sie entziehen sich unseren Sinnen' (*MGW* 7, 507).

eerie light. Musil uses this technique in his texts; in everyday life, however, subtlety often risks being drowned out by more obtrusive stimuli:

> Wollte man die Warnungstafel für Kraftwagen so unauffällig einfarbig gestalten wie Denkmale, so wäre das ein Verbrechen. Auch die Lokomotiven pfeifen doch schrille und keine versonnenen Klänge, und selbst den Briefkasten gibt man eine anlockende Farbe. Mit einem Wort, auch die Denkmäler sollten sich heute, wie wir es alle tun müssen, etwas mehr anstrengen! Ruhig am Wege stehn und sich Blicke schenken lassen, könnte jeder; wir dürfen heute von einem Monument mehr verlangen. (*MGW* 7, 508)
>
> [It would be a crime to want to make the danger signs for cars as inconspicuously monochrome as monuments. Locomotives, after all, blow shrill, not sleepy tones, and even mailboxes are accorded alluring colors. In short, monuments ought also to try a little harder, as we must all do nowadays! It is easy for them to stand around quietly, accepting occasional glances; we have a right to ask more out of monuments today. (*PLA* 66–7)]

In the over-saturated environment of the modern city, our attention is governed by signals, signs, and slogans, which forcefully imprint themselves onto the mind. Advertising is a prime example of this technique, which the essay ironically compares to the humble monument: 'The very minimum that we ought to ask of monuments, to make them attract attention, would be tried and true logos, like "Goethe's Faust is the best!" or "The dramatic ideas of poet X are the cheapest!"'.[126]

Both monuments and habitual perception are timeless, or at least pre-modern, phenomena, but Musil uses them to critique his own age. His essay continues the theme of the volume's preface; both in turn echo the period's widespread critique of an accelerated and over-stimulated modernity and its concomitant yearning for a more contemplative age, although the essay does so with an ironic edge. This critique of modern life is, however, only one facet of Musil's writings; in other texts, he embraces the media technological innovations of the age and the associated opportunities for perceptual change.

Technological Vision

At the close of this chapter it is worth returning to Hugo Münsterberg, pioneer of psychotechnics as well as film theory. His 1916 study *The Photoplay* is one of the

[126] *PLA* 67. 'Das mindeste, was man verlangen müßte, um die Aufmerksamkeit zu erregen, wären bewährte Aufschriften wie "Goethes Faust ist der beste!" oder "Die dramatischen Ideen des bekannten Dichters X. sind die billigsten!"' (*MGW* 7, 508).

earliest attempts to theorize the new medium; as its title suggests, film is cast as the successor and amalgam of both theatre and photography. The live theatre performance, in particular, is a recurring point of comparison, which serves to highlight the new technical and cognitive possibilities of the cinematic medium.

In essence, Münsterberg's theory of film is a theory of psychology, as indicated by its subtitle, *A Psychological Study*. The book discusses various mental faculties and maps them onto film, analysing how film affects inner states while at the same time exteriorizing psychological processes. Attention features prominently in this two-pronged argument. The fourth chapter, entitled 'Attention', sums up psychological theories on this matter: 'Of all internal functions which create the meaning of the world around us, the most central is attention', the author declares, adding that 'our attention must be drawn now here, now there, if we want to bind together that which is scattered in the space before us. Everything must be shaded by attention and inattention'.[127] For over a century, he continues, psychological theory has placed attention at the centre of mental operations. It alone can ensure cognitive continuity and coherence in a world of disparate stimuli, by lifting particular sensations onto the level of consciousness, where they can resonate with 'the remnants of earlier experiences'.[128] Münsterberg also recites the two main varieties of this faculty: voluntary and involuntary attention. The former enables us to 'seek something and accept the offering of the surroundings only in so far as it brings us what we are seeking'; in instances of involuntary attention, in contrast—when we are startled by a loud noise or drawn to a shining object—'the guiding influence [...] comes from without'.[129] In practice, however, the two are often intertwined: 'Our life is a great compromise between that which our voluntary attention aims at and that which the aims of the surrounding world force on our involuntary attention'.[130]

This is where film comes into the equation. For Münsterberg, cinematic images firmly belong to the latter category of stimuli which force a reaction, thereby overriding pre-existing interests, perceptual patterns, and rational considerations. In the theatre, attempts to channel the audience's attention are limited by the spatial distance which separates them from the stage and which makes it nearly impossible to focus their attention on subtler details, such as small objects. (Silent) film is a different case. Since there is no spoken dialogue, attention is primarily visual, focused by the camera 'on the play of the face and the hands'.[131] The close-up is able to bring even the smallest objects—a locket or a scrap of paper—forcefully to the viewer's attention.[132] This technique is the medium's principal tool of attention management; it

[127] Hugo Münsterberg, *The Photoplay: A Psychological Study* (New York, NY: Appleton, 1916), pp. 73–4.
[128] Münsterberg, *Photoplay*, p. 72. [129] Münsterberg, *Photoplay*, pp. 74–5.
[130] Münsterberg, *Photoplay*, p. 75. [131] Münsterberg, *Photoplay*, p. 80.
[132] Münsterberg, *Photoplay*, pp. 88–9.

externalizes an inner process—the aforementioned 'shading' of the world into areas of attention and inattention—by means of technology. In film, 'the events without have become obedient to the demands of our consciousness. [...] *The close-up has objectified in our world of perception our mental act of attention*'.[133]

Münsterberg concedes that it is of course perfectly possible for viewers to ignore the attentional cues provided by the film and assert their own, voluntary attention instead, for instance by focusing on a particular actor. However, 'by such behaviour we break the spell in which the artistic drama ought to hold us. [...] If we really enter into the spirit of the [photo] play, our attention is constantly drawn in accordance with the intentions of the producers'.[134]

Here Münsterberg brings his perspective as an experimental psychologist to bear on his film theory. His ideal viewer is not a free agent able to respond to the artwork guided by her own interests and preconceptions; rather, his model of aesthetic pleasure is strictly deterministic, founded on the same stimulus-response model as psychotechnics. The 'correct' response to the cinematic spectacle is to allow one's attention to be wholly determined by machine-based modes of focalization.[135]

The Photoplay thus spells out the agenda of psychotechnics, namely to condition human behaviour, and applies this to the field of aesthetic experience. Although Musil is extremely unlikely to have read *The Photoplay*, which only appeared in German translation eighty years after its first publication,[136] he extrapolates similar ideas from Münsterberg's psychotechnical writings and applies them to his own literary production. Both are interested in ways of channelling recipients' attention, and both focus on involuntary rather than voluntary attention in their writings on aesthetic and everyday experience.

While Musil was not familiar with Münsterberg's treatise, he reviewed another early text of film theory, namely Béla Balázs's *Der sichtbare Mensch* (The Visible Man, 1924). Balázs regards film as the vanguard of a new age of visual literacy, which will succeed the text-centred culture of the 'Gutenberg galaxy'.[137] As he stresses, echoing other Weimar critics,[138] the purpose of film is not to depict the world as we know it but to offer a new, defamiliarizing perspective on everyday life. For Balázs,

[133] Münsterberg, *Photoplay*, pp. 87-8. [134] Münsterberg, *Photoplay*, p. 76.

[135] On the reception of Münsterberg's film theory, see Jörg Schweinitz, 'Psychotechnik, idealistische Ästhetik und der Film als mental strukturierter Wahrnehmungsraum: Die Filmtheorie von Hugo Münsterberg', in Hugo Münsterberg, *Das Lichtspiel: Eine psychologische Studie [1916] und andere Schriften zum Kino*, ed. and trans. Jörg Schweinitz (Vienna: Synema, 1996), pp. 9-26; and *Hugo Münsterberg*, ed. Christine N. Brinckmann and Evelyn Echle, Montage, AV (Marburg: Schüren, 2018).

[136] Münsterberg, *Das Lichtspiel*.

[137] Hence the term coined by Marshall McLuhan in his 1962 book of the same title.

[138] See for instance László Moholy-Nagy programmatic treatise, *Malerei, Photographie, Film*, Bauhausbücher, 8 (Munich: Langen, 1925).

Die Gewohnheit des Alltagsanblicks hat unsere Umgebung unsichtbar gemacht. Wir sehen nur die Existenz der Dinge, nicht ihre Gestalt. Wir sehen nicht, wir orientieren uns bloß. Die ungewohnte Einstellung aber reißt das Gesicht der Dinge aus dem Nebel der Abgestumpftheit heraus und macht sie wahrnehmbar.[139]

[the habitual nature of everyday appearance has rendered our nearest surroundings invisible. We only see that things exist, not their actual appearance. We do not see, we merely find our bearings. The unfamiliar shot, however, wrenches the face of things out of the fog of blunted awareness and makes them experienceable again.]

Like Münsterberg, Balázs casts the close-up as the cinematic equivalent of heightened attention, a technique able to counter the audience's habitual 'insensitivity and sloppiness'.[140] Unlike Münsterberg, he does not see the main purpose of this technique as foregrounding details which are vital to the plot, but argues for the need to broaden the audience's attentional focus beyond them: 'modern directors do not usually highlight the central feature, on which the attention is focused anyway and which therefore does not need to be singled out'.[141]

Musil echoes some of these points in his long review of *Visible Man*, 'Ansätze zu neuer Ästhetik' (Towards a New Aesthetic, 1925). As the title indicates, Balázs's film theory serves him as the springboard for some far-reaching reflections on modern art and experience, in the course of which he first coins his famous notion of the 'other state', which is here used to describe the particular experience engendered by film and other modernist art forms.

As Musil notes, both our mind and our senses are '"intellectual". It is common knowledge that we see what we know';[142] sensory perception is not immediate but shaped, structured, by prior experience and concrete, practical concerns. Without prior selection, the experiential world is nothing but chaos. The radical antithesis to such purpose-driven perceptual strategies is the 'other state'. This state is hard to define in its own right; attempts to describe it almost always involve negative formulations: 'purpose*less* movement' in modern dance, '*non*-representational

[139] *Der sichtbare Mensch oder die Kultur des Films*, in Béla Bálazs, *Schriften zum Film*, vol. 1, ed. Helmut H. Diedrichs, Wolfgang Gersch, and Magda Nagy (Munich: Hanser, 1982), pp. 43–143 (p. 50).

[140] 'Unempfindlichkeit und Schlamperei'. Bálazs, *Der sichtbare Mensch*, p. 83.

[141] 'Moderne Regisseure bringen meist nicht das Hauptmoment, nicht das, auf welches sich die Aufmerksamkeit ohnehin konzentriert und das darum nicht besonders unterstrichen werden muß'. Bálazs, *Der sichtbare Mensch*, p. 86.

[142] Robert Musil, 'Toward a New Aesthetic: Observations on a Dramaturgy of Film', in *Robert Musil: Precision and Soul*, ed. and trans. Burton Pike and David S. Luft (Chicago, IL: University of Chicago Press, 1995), pp. 193–207 (p. 201); 'daß nicht nur unser Verstand, sondern auch schon unsere Sinne "intellektuell" sind. Bekanntlich sehen wir, was wir wissen' (*MGW* 8, 1146). On the role of the essay for Musil's theory of attention and his literary portrayal of inanimate objects in particular, see Dorothee Kimmich, 'Kleine Dinge in Großwahrnehmung: Bemerkungen zu Aufmerksamkeit und Dingwahrnehmung bei Robert Musil und Robert Walser', *Jahrbuch der deutschen Schillergesellschaft*, 44 (2000), 177–94.

seeing' in abstract art. Rather than being tied to everyday life, modernist artistic experimentation tries to open up a space of 'pure sensing and feeling', of 'heightened perceptiveness and responsiveness'.[143] And yet, however welcome such disruptions to habit are, there is a limit to this kind of aesthetic experimentation. In order to remain comprehensible and relevant in the real world, Musil argues, these moments of rupture and intensity must somehow be contained within familiar frameworks of experience, just as mystical experiences, which serve as their model, require 'the rational scaffolding of a religious dogmatism'.[144]

The stories and essays assembled in *Posthumous Papers* echo these reflections. As we have seen, any intensification of experience, whereby characters are wrenched out of their habitual mode of perception, is only ever temporary, framed by the familiar and the mundane, while even striking monuments fade into the backdrop of everyday life. But there is one text in the collection which pursues a different path, merging the technologically enhanced vision of reality advocated by Balázs with Baudouin's writings to create a psychotechnological literary experiment. This is the essay 'Triëdere!', first published in 1926. The English title, 'Binoculars', is slightly misleading, for a *Triëder* is in fact a telescope, which in turn provides the basis for the verb *triëdern*, to look through a telescope. The imperative in the German title serves as an instruction to the reader, encouraging her to try out the experiment described in the text.

Like Balázs, Musil here casts film as the vehicle of altered perception, but remarks that this technology has a much older predecessor:

Zeitlupenaufnahmen tauchen unter die bewegte Oberfläche, und es ist ihr Zauber, daß sich der Zuschauer zwischen den Dingen des Lebens gleichsam mit offenen Augen unter Wasser umherschwimmen sieht. Das hat der Film volkstümlich gemacht; aber es ist schon lange vor ihm auf eine Weise zu erleben gewesen, die sich noch heutigentags durch ihre Bequemlichkeit empfiehlt: indem man nämlich durch ein Fernrohr etwas betrachtet, das man sonst nicht durch ein Fernrohr ansieht. In der Folge ist ein solcher Versuch beschrieben. (*MGW* 7, 518–19)

[Slow motion pictures dive beneath the agitated surface, and it is their magic that permits the spectator to see himself with open eyes, as it were, swimming among the objects of life. Movies may have popularized this phenomenon; but it has long been available to us by a means still to be recommended nowadays because of its convenience: by looking, that is, through a telescope at objects that one would not normally watch through a telescope. (*PLA* 81)]

[143] Musil, 'Toward a New Aesthetic', p. 202; 'reines Empfinden und Fühlen'; 'erhöhtes Bemerken' (*MGW* 8, 1147).
[144] Musil, 'Toward a New Aesthetic', p. 202; 'das rationale Gerüst einer religiösen Dogmatik' (*MGW* 8, 1147).

Visual technologies bring about heightened perception and altered experience.[145] The telescope is situated between tradition and modern technology; an old invention, it foreshadows cinematic techniques such as close-up and slow motion. At the same time, the narrator's suggestion, or instruction, to aim this device at familiar people and objects lends this experiment a self-reflexive dimension. Like the telescope, the 'old' medium of literature has the capacity to reframe the everyday, exposing its hidden, disconcerting sides.

The viewing position used in this experiment is identical to that adopted by Ulrich during his first appearance in *The Man without Qualities*. Both feature an observer at the window, scrutinizing the street below—with a pair of binoculars in the novel, with a 'Triëder' in the essay. But while Ulrich uses his binoculars to survey the entirety of the urban landscape, trying to extrapolate some quantitative calculations, the telescope is directed at a succession of specific sights to uncover previously invisible details. At times this scrutiny takes on a predatory or voyeuristic character. The two men in the building opposite are 'trapped in the little circle' of the observer's instrument,[146] and when it is directed at some passing women, it seems to gain X-ray powers, uncovering the shapes beneath their clothes—'those ancient simple hills that constitute the eternal landscape of love'.[147]

From buildings and pedestrians the telescope then shifts to a moving object, namely a tram. The magnification enhances the speed of this vehicle, lending it a quasi-cinematic dynamism. Indeed, this sight recalls the famous anecdotes about early cinema audiences fleeing from the spectacle of an approaching train. Describing how the tram first seems foreshortened, almost crushed, then released to its familiar proportions, the narrative associates this defamiliarizing effect with this public ('öffentlich') object rather than the observer's personal ('persönlich') gaze, setting these optical effects apart from a subjective impression or illusion.

The telescopic gaze thus anticipates certain cinematic effects, but in the eyes of the experimenter its underlying motivation is diametrically opposed to the medium of film: 'the cinema serves our love of life, and makes every effort to

[145] Interestingly, Baudouin also refers to film when he describes the state of collectedness and its abrupt termination: 'Was eben noch an Bildern in uns wimmelte, verschwindet plötzlich, wie wenn ein Kinematograph ausgelöscht wird' ('The moving swarm of mental images suddenly vanished, as when the lighted pictures vanish from the cinematographic screen'). The sensations encountered during this intensified state cannot be carried over into ordinary life: 'Wir sind wie Taucher, die wieder an die Oberfläche kommen; wir begeben uns [...] von einer Bewußtseinseben auf eine andere, wir zerreißen gewaltsam das Netz der Ideenassoziationen, in dem wir uns verfangen haben' ('we are like divers who have come back to the surface. [...] we pass from one plane of consciousness to another. We break the net of associated ideas in which we were enmeshed'). Baudouin, *Suggestion und Autosuggestion*, pp. 148–9; *Suggestion and Autosuggestion*, pp. 165–6.

[146] PLA 82; 'in dem kleinen Kreis seines Instruments gefangen' (*MGW* 7, 519).

[147] PLA 83; the 'ureinfachen Hügeln, aus denen die ewige Landschaft der Liebe besteht' (*MGW* 7, 520).

beautify its deficiencies' with the help of technology.¹⁴⁸ The telescope has the opposite effect: it mercilessly exposes the ridiculous, ugly, and inhuman aspects of people's behaviour, an effect which Musil replicates in his satirical texts. The key principle used for this effect is isolation:

> Man sieht Dinge immer mitsamt ihrer Umgebung an und hält sie gewohnheitsmäßig für das, was sie darin bedeuten. Treten sie aber einmal heraus, so sind sie unverständlich und schrecklich, wie es der erste Tag nach der Weltschöpfung gewesen sein mag, ehe sich die Erscheinungen aneinander und an uns gewöhnt hatten. So wird auch in der glashellen Einsamkeit alles deutlicher und größer, aber vor allem wird es ursprünglicher und dämonischer. (*MGW* 7, 520–1)
>
> [We always see things amidst their surroundings and generally perceive them according to what function they serve in that context. But remove them from that context and they suddenly become incomprehensible and terrible, the way things must have been on the first day after creation, before the new phenomena had yet grown accustomed to each other and to us. So too, in the luminous solitude of our telescopic circle, everything becomes clearer and larger, but above all, things become more arcane and demonic. (*PLA* 84)]

This passage sums up the double bind underpinning technological as well as scientific progress. As things and people become 'clearer and larger' and hence accessible to scrutiny and rational exploration, this process also renders them demonic and uncanny, revealing the stubborn residues of the irrational and inexplicable in the modern world. For Musil, psychotechnics, with its mission to map out and enhance human attention, conceals a similar bind, one which he exploits in his novel and short prose texts. His attitude towards this and other fields of modern knowledge remains ambivalent, torn between fascination and resistance. As he writes in 1927,¹⁴⁹ the increasing irrelevance of literature in the modern world has one main reason: the delay with which literary writers have adapted to the 'scientific world view'; however, literature 'cannot be spared', cannot avoid, this challenge.¹⁵⁰

Musil's own texts testify to the productive alliance between literature and science, between creative writing and methods of psychological conditioning; in

¹⁴⁸ *PLA* 85; 'das Kino dient der Liebe zum Dasein und bemüht sich, dessen Schwächen zu beschönigen' (*MGW* 7, 522).
¹⁴⁹ In the piece 'Zu Kerrs 60. Geburtstag' (On Alfred Kerr's 60th Birthday); Alfred Kerr was an influential theatre critic and essayist.
¹⁵⁰ '[D]ie Anpassung an das naturwissenschaftliche Weltbild kann der Literatur nicht erspart bleiben und ein gut Teil ihrer heutigen Gegenstandslosigkeit geht darauf zurück, daß sie sich dabei verspätet hat' (*MGW* 8, 1183).

this regard, they show literature to be an integral, but also a critical and resistant, part of the modernist project of enhancing attention. In an early diary note dating from his years in Stumpf's laboratory, he defends 'the novel's capacious style' ('[die] Breite des Stils im Roman') as 'an antidote against science. Faced with these people who want to fix everything in its place, one may feel the urge to depict life in a looser way'.[151] To illustrate this point, he gives the example of the Italian writer Gabriele d'Annunzio, who provides lengthy lists of the names of all the people and churches in one neighbourhood, even though they are completely irrelevant to the plot. Musil comments:

> Nur um zu manifestieren, daß das Leben gelebt werden soll und daß ein bim-bim-bim der Elektrischen trotz der anzustrebenden Genauigkeit der Begriffe auch etwas Selbstherrliches ist, und daß der Reichtum der Sinne auch ein Reichtum ist. Man kann aus diesem Bedürfnis heraus die hundert Attribute eines jeden Gegenstandes aufzählen.[152]
>
> [Just to show that life ought to be lived, and that the ring-ring-ring of the tram is something wonderful even in the face of conceptual precision, which we are all meant to strive towards, and that the wealth of the senses is a wealth in its own right. Out of this urge one may list the hundred attributes of every single object.]

Here Musil advocates an engagement with the world in all its inconspicuous details, its ugliness and absurdity—an engagement which goes far beyond, and indeed against, the mantra of 'precision' governing most sectors of modern life. Although he struggled with his own concentration for much of his literary career, and was fascinated by psychology and psychotechnics, by strategies of mental conditioning and cognitive (self-)optimization, Musil also mounts an emphatic defence of literature as a medium of experimentation, of openness towards the uncontrollable and unexpected.

[151] '[...] Mittel gegen die Wissenschaft. Man kann diesen Menschen gegenüber, die Alles verfestigen, das Bedürfnis haben das Leben aufgelockert darzustellen'. 1904 or 1905; Musil, *Tagebücher*, p. 119.
[152] Musil, *Tagebücher*, p. 119.

6
The Art of Concentration
Weimar Self-Help Literature

In using a combination of psychotechnics, psychotherapy, and autosuggestion to enhance his concentration, Musil was far from alone. The project of maximizing attention was not confined to the sphere of work, nor did responsibility for this mission rest solely with companies and public institutions. In fact, psychotechnics was only one (admittedly large) part of a complex set of behavioural strategies which reshaped individuals' lives in the public as well as the private domain. Crucially, these strategies were not simply 'imposed' by some external agency; rather, the cognitive and behavioural models propagated by psychotechnics and related disciplines were quickly internalized by individuals as part of a supreme effort of cognitive self-optimization.

Wilhelmine Germany, as already mentioned, was characterized by an aggressive entrepreneurial culture whose figurehead was the 'self-made man'—the outgoing, confident (male) individual who took charge of his own destiny, ruthlessly seizing the opportunities which presented themselves. This ideal lived on into the interwar years, where a harsher economic climate further exacerbated these pressures. At the same time, however, the process of social liberalization, which had been accelerated by the war, also harboured many opportunities; as binding moral and social codes fell away, the Weimar Republic was a time of (personal and collective) experimentation and self-reinvention.[1]

The challenges and opportunities of this situation are reflected in one intriguing phenomenon of early twentieth-century culture: the veritable explosion of self-help guides which flooded the book market. These books were written in response to an increasingly anonymous society, in which traditional communal ties and the corresponding codes of conduct were progressively eroded. Weimar self-help guides encouraged their readers to seize the opportunities of social mobility while helping them to negotiate the attendant uncertainty through a mixture of empathy, encouragement, and (at times rather stern) instruction.

[1] See Stephanie Kleiner and Robert Suter, 'Konzepte von Glück und Erfolg in der Ratgeberliteratur (1900–1940): Eine Einleitung', in *Guter Rat: Glück und Erfolg in der Ratgeberliteratur 1900–1940*, ed. Stephanie Kleiner and Robert Suter (Berlin: Neofelis, 2015), pp. 9–40 (p. 25).

Many of the bestselling titles were written by American authors and translated into German,[2] but German-speaking authors also fuelled the near-insatiable appetite for *Ratgeberliteratur*. Weimar self-help guides targeted a wide range of areas, from child-rearing and marriage to healthy lifestyle and minor as well as serious physical and mental illnesses, including phobias and obsessive-compulsive disorders. One of the most popular themes addressed in these guides was concentration. Weimar society was gripped by a veritable panic about the perceived erosion of concentration in a climate of over-stimulation and perpetual distraction. As a result, books which promised their readers enhanced, indeed unprecedented, powers of concentration were booming—though their advice was far from uniform. The authors often belonged to one of the many competing alternative health and lifestyle movements of the period, and their programmes reflect the philosophy of these movements. A comparison of three popular titles reveals stark differences of tone and approach—but also some illuminating similarities.

Dressage of the Mind

One popular sub-genre of Weimar self-help literature was the training manual—books which set out a carefully designed programme of physical and mental exercises to be pursued over the course of several weeks. In some cases, the individual lessons were published as self-contained booklets or *Lehrbriefe* sold in a box set, evoking the model of the *Fernlehrgang*, or long-distance learning course, with its systematic curriculum. Such formats also served a more general aim: to establish a bond between author and reader. Self-help guides needed to transplant the immediacy of the face-to-face encounter into the reading experience, where advice and response are spatially and temporally decoupled, leaving readers free to skip chapters, ignore parts of the advice, or stop reading altogether. These were risks that self-help authors had to mitigate, for instance through the use of particular rhetorical strategies designed to keep readers on board. While some adopted an empathetic and encouraging tone, others resorted to a more authoritative (authoritarian) type of instruction. In addition, authors often extolled their academic credentials and personal experience to bolster their credibility.

[2] The motivational guru Orison Swett Marden was the author of several books and founder of *Success* magazine; other American bestsellers were Napoleon Hill's *The Law of Success* (1928) and Dale Carnegie's *How to Win Friends and Influence People* (1936). The books by the journalist and American *Vogue* editor Marjorie Hillis catered specifically for the single working woman: *Live Alone and Like it: A Guide for the Extra Woman* (1936) and *Orchids on Your Budget: Live Smartly on What You Have* (1937). These titles encapsulated a particular vision of success; in Germany, they were seen to represent a more general brand of 'Americanism' which pervaded German culture, fuelling a fascination with the New World as a land of unlimited opportunities.

One of the most rigorously detailed such programmes is Reinhard Gerling's *Die Kunst der Konzentration* (The Art of Concentration, 1920).[3] Gerling (1863–1930) was an actor and public speaker and a prolific contributor to the self-help market. In an earlier book, *Die Gymnastik des Willens* (Will Gymnastics, 1905), he had tapped into the pre-war craze for 'will therapy', a form of self-conditioning which promised to strengthen the individual's mental defences against a chaotic modernity.[4] After the war, Gerling tried his hand at relationship and family counselling, producing guides such as *Das goldene Buch der Ehe* (The Golden Book of Marriage, 1919), *Bub oder Mädel nach Wunsch* (Boy or Girl as Desired, 1926), and *Diskrete Antworten auf vertrauliche Fragen* (Discreet Answers to Confidential Questions, 1928). With *The Art of Concentration*, he builds on his earlier interest in will therapy; his book casts concentration not only as an 'art' but as a science, and promises to give readers complete control over this faculty.

What is immediately striking is the book's rhetorical force. Gerling addresses the reader directly, and while he occasionally offers empathy and encouragement, the prevailing tone is rather stern. To undertake his course, the reader must abandon any hope of a 'quick fix', for this desire is itself symptomatic of an underlying problem: 'The fast-living merchant wants an *immediate* result, the impatient neurasthenic to be cured *at once*. The young man is awaiting a sudden miracle'.[5] However, rather than expecting such a miracle cure, as often promised by widely available 'pills and powders', the reader must be patient. The goal is not sudden transformation but a gradual, continuous process of development (*KK* 5). To this end, Gerling's method has two pillars. The first is sustained practice; the second the notion that mind and body are inextricably linked, with each shaping the other. Gerling's programme promises to tackle them both; concentration is a matter of reasserting control over mind *and* matter.

The starting point to all this is introspection. Before embarking on the course, readers must take stock of their present situation, owning up to any character flaws and past mistakes. Rather than blaming illness or external circumstances, for instance, they must take responsibility for their past failings as the first, essential step towards a more liberated and fulfilled future.[6] Gerling praises the Catholic practice of confession as an important tool of moral self-education (*KK* 53), an

[3] Reinhard Gerling, *Die Kunst der Konzentration: Ein Kursus in Unterrichtsbriefen für Geistesarbeiter, Studierende, Beamte, Kaufleute, für Zerstreute, Nervöse, Gedächtnisschwache* (Prien: Anthropos, n.d. [1920]). The 1936 edition carries the revised subtitle *Ein Lehrgang für alle, die an Zerstreuung, Gedächtnisschwäche, Unlustgefühlen und anderen Hemmungen geistiger Leistungsfähigkeit leiden.*

[4] See Michael Cowan, *Cult of the Will: Nervousness and German Modernity* (University Park, PA: Pennsylvania State University Press, 2008), pp. 69–110.

[5] 'Der schnellebige Kaufmann will *sofort* das Resultat, der ungeduldige Nervöse *auf der Stelle* Heilung. Der Jüngling wartet auf das Wunderbare, das plötzlich eintreten soll' (*KK* 7).

[6] As part of this process, Gerling recommends that readers undergo a graphological analysis (a trustworthy institute is advertised at the back of the book) to deepen their self-understanding (*KK* 18).

argument which chimes with a more generally revived interest in religion and spiritualism in the early twentieth century. But once this stage is completed, the reader must look to the future: 'Take stock of your previous life. [...] But then: time to move on!'[7]

In preparation for the next steps, the reader is then treated to Gerling's theory of the mind. His model, which is loosely, but not explicitly, based on Freudian psychoanalysis, consists of an 'outer' and an 'inner' self. While the former (akin to the Freudian Ego) subjects stimuli and impressions to a process of rational assessment, the latter (a kind of simplified Id) comes to the fore during sleep, hypnosis, intoxication, and states of creative inspiration (*KK* 24–6). Thus artists and writers often lack the requisite degree of concentration to function in daily life; their concentration is considerable but one-sided, for their 'thoughts are turned only towards one subject [...]. For all other matters they lack attention'.[8] In such people, absent-mindedness at least serves a higher purpose; a more obviously negative case is that of the neurasthenic, whose concentration is completely and destructively absorbed by his or her illness.[9]

The good news is that *Zerstreuung* is nothing but a bad habit that can be cured through a set of exercises training the brain to absorb the 'right' kinds of stimuli—though their exact nature remains unspecified (*KK* 30). Sensory overload is a recurrent theme in the book; another, related one is *Ermüdung* (fatigue). Fatigue affect people from all walks of life, from the child, victim of 'the rousing stimuli of modern education', via young people pursuing the pleasures of mass entertainment, to parents worn out by care for the family (*KK* 36). Fundamentally, though, it is a product of modernity itself—specifically of the 'overcoming of time and space' by means of modern technology and the associated effects of acceleration and fragmentation (*KK* 36). As Gerling argues, the main causes of fatigue are not biological (such as ageing[10]) but cultural, what nowadays would be called 'lifestyle factors': over-eating, alcohol, sexual excesses, and mental titillation by 'filthy novels' (*Schmutzlitteratur*), and plays about 'loose women' (*KK* 41–3).[11] All of these must be avoided to restore energy and concentration. Gerling does

[7] 'Ziehen Sie also die Bilanz Ihres bisherigen Lebens. [...] Dann aber: Strich darunter!' (*KK* 18).

[8] '[Ihre] Gedankenrichtung kehrt sich nur *einem* Gegenstande zu [...]. Für andere Dinge fehlt [ihnen] die Aufmerksamkeit' (*KK* 28).

[9] The cognitive basis of concentration is memory, a faculty which, as Gerling argues, is in turn dependent on the ability to forget. Inadequate memory and concentration are described as the result of cognitive overload; as a result, the goal must be 'nur gute, d.h. zweckmäßige Gedanken aufzunehmen, nur wertvolles [sic] zu konservieren' ('to take in only good, that is, worthwhile thoughts and only preserve what is valuable'; *KK* 23). With this argument about the intrinsic link between memory and forgetting, attention and inattention, Gerling is rehearsing well-established psychological theories of the time.

[10] The book gives a list of artists and intellectuals who produced their main work in their sixties and seventies (*KK* 40).

[11] Gerling's warning echoes Wilhelmine treatises on neurasthenia and sensory overload such as Wilhelm Erb's lecture, which likewise singles out urban entertainment as both the effect and the perpetuating cause of nervous excitement. See Chapter 2, pp. 54–8.

eventually concede that some causes of fatigue are beyond the individual's control: inadequate housing, long working hours, and work that is strenuous and repetitive. And yet his book is no manifesto for social change. On the contrary, as the author stresses time and again, responsibility for tackling these adverse conditions lies not with employers or politicians but with the individual. The programme is designed to equip its readers with the tools to succeed in a hostile environment—to succeed, as the text repeatedly stresses, where most others will fail.

To this end, Gerling then sets out a rigorous ten-week course of self-improvement. As new components are added, exercises from previous weeks must be kept up alongside them. The first part, building on the preparatory exercise of introspection, is headed 'Sammlung und Innenschau' (Contemplation and Introspection; *KK* 47). Regardless of personal circumstances, the reader is told to spend some time (ideally several hours) alone every day, whether this involves going for a walk, playing music, reciting poetry, or prayer. The second week adds to this systematic relaxation exercises which are to be repeated once or twice a day, more frequently in case of severe nervousness.[12]

Next, the body must be conditioned, for 'there is no mental concentration without simultaneous physical concentration'.[13] Elaborate breathing exercises are complemented by a programme of 'hemi-gymnastics' devised by the author. By strengthening the left-hand side of the body, one can stimulate the corresponding right side of the brain, thus alleviating pressure on the left hemisphere, which in right-handers is typically overused.

In the following week, the focus of the course expands to include more general lifestyle questions, providing the reader with instructions in the 'dietetics of nutrition, work and sleep' (*KK* 93). This section also includes recommendations on how to structure the working day to make it more varied and engaging, for example by alternating between mathematical and verbal tasks, and by taking regular breaks (*KK* 98–9).[14] Here, as on sleep and nutrition, Gerling's ideas are largely sound and plausible, with the occasional quirky exception.[15]

[12] He promises: 'Sie werden sehr bald eine Zunahme Ihrer Arbeitsfrische verspüren' ('soon you will notice an increase in your ability to work'; *KK* 61).

[13] 'Es gibt keine geistige Konzentration ohne gleichzeitige körperliche Konzentration' (*KK* 66).

[14] This section is loosely based on Richard von Krafft-Ebing's *Über gesunde und kranke Nerven* (On Healthy and Ill Nerves, 1885).

[15] Insomniacs are told to keep a rubber syringe or 'Gummiballspritze' filled with warm water next to the bed, so they can self-administer an enema in case of sleeplessness (*KK* 103). Elsewhere, echoing contemporary theories about gender, such as Otto Weininger's *Geschlecht und Charakter* (Sex and Character, 1903), Gerling argues that every person has a mixture of female and male 'cell material' in their body, which is distributed unevenly in the different halves of the body. An imbalance of cell distribution can lead to more general problems which can be corrected with specific exercises (*KK* 78–81). But the text also includes creditable scientific sources, for instance on the cognitive benefits of ambidexterity, which are borne out by current research. More generally, the parallels between Gerling's ten-week course and current self-help programmes, most notably in the booming field of mindfulness, are striking indeed.

Only once readers have embraced this rigorous programme of relaxation, breathing and other exercises, and after they have reformed their diet, sleep, and work routines are they allowed to proceed to the core seventh chapter, entitled 'Konzentration'. As Gerling declares at the outset: **'Without attention, concentration is impossible'**.[16] But how to bring about this state? In tune with psychological theories, which cast attention as a limited resource, he notes that it is strongest 'when it is only turned towards one process, object, or thought. [...] If we want to direct it at one object we must withdraw it from all the others, must limit the range of our mental content'.[17] This rule is particularly important for children, whose attention is naturally mobile and dispersed and who need to be taught how to focus. The key, once again, is practice, a precept which is by no means limited to children. In people of all age groups, concentration must be subjected to a kind of 'dressage' (*KK* 112). To this end, the reader is given a series of exercises designed to train attention in the different senses. The first step involves sitting in front of a picture and closely observing it, first as a whole, then in detail.[18] Next comes a training in aural concentration which involves listening to a piece of classical music, either in a live performance or on the gramophone. Mirroring contemporary initiatives, which tried to re-educate audiences in the art of attentive listening,[19] Gerling stresses the need for active engagement: 'Focus on every movement, on every note, and always reflect on the meaning of what is being performed'.[20] The same active awareness should then also be applied to smell and touch, through exercises conducted with closed eyes. All of these practices are aimed at sharpening what Gerling calls the 'external', that is, the conscious and rational self. In a final step, this systematic dressage of attention is then extended to the 'inner' self—that part which comes to the fore during sleep and other semi-conscious states. To this end, readers should train themselves to wake up at a particular time by firmly and loudly instructing themselves before going to sleep: **'Now it is half past one. At two o'clock, so in half an hour, I will wake up again'**.[21] Success, Gerling stresses, *will* come with perseverance, for soon the reader will be able to make herself wake up at any time, day or night.

The final plank of Gerling's programme is memory training. The author rejects the popular view that memory loss is inevitable with older age; rather, he attributes

[16] **'Ohne Aufmerksamkeit ist Konzentration nicht möglich'** (*KK* 109).
[17] '[...] wenn sie nur *einem* Vorgang, Gegenstand oder Gedankenbilde zugekehrt ist. [...] Wollen wir die Aufmerksamkeit einem Gegenstande zuwenden, so müssen wir sie von den übrigen abwenden, müssen unsern Vorstellungsinhalt einengen' (*KK* 111).
[18] **'Lenken Sie dabei den Blick nicht ab,** sehen Sie nicht auf andere Gegenstände' ('**Do not avert your gaze,** do not look at other objects'; *KK* 113).
[19] See Chapter 9, pp. 327–30.
[20] 'Achten Sie auf jeden Satz, jeden Ton und dabei denken Sie nur an die Bedeutung dessen, was gespielt wird' (*KK* 114).
[21] 'Jetzt ist's ½2 Uhr. Um 2 Uhr, also in einer halben Stunde, werde ich erwachen' (*KK* 115).

it to lack of practice. This is a risk which affects even academics and other intellectual professions, for their mental efforts tend to be limited to specific areas (*KK* 129).²² To remedy this imbalance, Gerling again stresses the need for regular rigorous practice, in this case the memorizing of colours, shapes, faces, names, places, and numbers. But the best method is to learn texts by heart: poems, prose passages, quotations, and proverbs. In customary fashion, the book offers three six-day courses, whereby each day a new passage has to be memorized, while the seventh day is used to revise the whole week's material. This pattern is then repeated in subsequent weeks with passages of increasing complexity.

The time needed for these memory exercises is, as the author reassures the reader, 'a mere half hour', 'ein halbes Stündchen' (*KK* 144). This reassuring diminutive cannot quite conceal a realization which by now will have dawned on even the most compliant of readers, namely the vast, all-encompassing scope of Gerling's programme. Once all its components are in place (existing exercises need to be continued as new ones are added to the routine), the daily total amounts to several hours; once work and the sternly stipulated eight hours of sleep are added, this easily takes up all available time. Leisure, then, become an extension of work, as every spare minute, every waking (and dreaming) thought, every bodily function has to be dedicated to the supreme effort of self-improvement, in a programme whose rigour and comprehensiveness by far exceed those of historical predecessors such as religious spiritual exercises or Enlightenment hygiene treatises.

In fact, one of the book's most telling features is its attitude towards time. Time is cast as extremely precious and yet as an almost limitless resource given the right level of commitment. There is always scope to do more. Gerling reminds his readers at the end: 'In the meantime you should use every spare minute—*and surely you will have some time to spare*—to reflect on the meaning of certain words'.²³

Even once the course is completed, there is no end in sight. The tenth and final letter contains a page to be cut out and pinned up next to the reader's bed. Headed 'Die zehn Gebote der Willensbildung' (The Ten Commandments of Will Formation; *KK* 164), it sums up the rules regarding sleep, exercise, food, work, and leisure. Commandment six is rather chilling: 'I avoid the company of all those who fail to understand my way of life'.²⁴ Contrary to its title, Gerling's book is not merely an 'art', nor indeed a science, of concentration. By the end, his programme

²² Before they are allowed to move to the final, combined chapters eight and nine, Gerling sternly warns readers against skipping the previous steps, which lay the necessary foundations for them to (re-)gain control over body and mind. To let the previous exercises fully sink in, readers should wait for at least two to three, though preferably for four to six weeks before embarking on the final stage, which is 'Die Überwindung der "Gedächtnisschwäche"' (Overcoming 'Weak Memory'; *KK* 121).
²³ 'Indessen sollten Sie jede freie Minute—*und es bleiben Ihnen sicher welche*—zum Nachdenken über die Bedeutung gewisser Wörter verwenden' (*KK* 169; my emphasis).
²⁴ 'Ich meide jede Gesellschaft, der das Verständnis für mein Leben fehlt'.

takes on unmistakably ideological, cult-like overtones in its attempt to silence any dissenting voices within the reader's mind and beyond.

In fact, the foundations for this commandment are laid right at the start. As the reader is told in the preface,

> Sie dürfen nicht absichtlich widerstreben, oder in Passivität verharren. [...] Zur Psyche des Menschen führen gewundene Wege. Da ist ein erfahrener Führer vonnöten. Erst wenn Sie am Ziele sind, haben Sie ein Urteil darüber, ob das Ziel den Weg lohnt, früher nicht. Vertrauen darf ein Führer verlangen. Haben Sie's nicht, so verzichten Sie auf den Kursus. (KK 8)
>
> [You must not consciously resist, nor remain passive. [...] Meandering paths lead to the human psyche. On them, an experienced guide is necessary. Only once you have reached your destination, not before, are you able to judge whether this goal has merited the journey. A guide is entitled to demand trust. If you lack it you should abandon this course.]

Here, Gerling's prose recalls Georg Friedrich Meier's *Philosophical Treatise on Morality*, which compares the challenge of maintaining a focus on one's deeper goals and priorities in the midst of everyday life to the experience of a wanderer walking a treacherous path.[25] For Meier, the prudent wanderer, equipped with attention, foresight, and reflection, can chart this path alone. By the 1920s, in contrast, these mental and moral qualities can no longer be presumed, and so control over the journey needs to be handed to an external guide or *Führer*. Gerling's ideal of concentration, in other words, is not only focused on personal achievement but also essentially authoritarian in structure. True, sustained concentration requires the willingness to hand over control over one's entire life to the guidance of a supreme leader—an age-old idea which does, however, take on a particular poignancy in the run-up to fascism.

That said, the book's overall message is mixed, even contradictory. The call for unquestioning obedience is fused with an aggressive brand of social Darwinism: '**Whip yourself forward every day**. Daily reflect on what you want to achieve. Your place is at the top. Where millions stop, that is where your path begins'.[26] This Nietzschean rhetoric pits the individual against the masses in a world where only the most determined can succeed. One of the book's core terms is the familiar trope of *Daseinskampf*, the 'struggle for existence', which remains a prominent theme in the 1920s, in the face of growing social and economic pressures.[27] A lost

[25] MPS 392–3; see Chapter 1, pp. 18–19.
[26] '**Peitschen Sie sich täglich an.** Denken Sie täglich an das, was Sie erreichen wollen. Ihr Platz ist an der Spitze. Wo die Millionen halt machen, da fängt Ihr Weg an' (KK 163).
[27] On the rise of this idea in Wilhelmine society, particularly in the decade preceding the First World War, see Cowan, *Cult of the Will*, pp. 72–5.

world war followed by attempted revolution and civil war; a new republic attacked from the left and the right; and a succession of economic crises which stripped the middle classes of their economic and social standing—all of these factors fed into a sense of anxiety which was echoed and reinforced by the self-help industry. In such uncertain times, concentration becomes a tool of survival—not only at the workplace but in everyday life, particularly in the cities, where traditional social ties are replaced by a sense of anonymity.

What, then, is the book's target readership? The subtitle lists 'Geistesarbeiter, Studierende, Beamte, Kaufleute, [...] Zerstreute, Nervöse, Gedächtnisschwache' (Mental Labourers, Students, Civil Servants, Merchants, [...] Distracted and Nervous People, and those with a Weak Memory). According to the neurasthenia discourse of the 1900s, academic and clerical professions were particularly susceptible to nervousness and distraction. Despite these continuities with pre-war debates, however, Gerling's manual is firmly of its own time. Written in an age of hyperinflation and mass unemployment, it is aimed at formerly middle-class readers, who were now forced to fight for their bare survival. The text is full of cultural allusions and anecdotes about prominent historical figures such as the German archaeologist Heinrich Schliemann and James Abram Garfield, the twentieth American president (*KK* 159–61). Indeed, inspirational biographies of 'great men' (great women were notably absent from this genre) played a key part in *Ratgeberliteratur* from the late nineteenth century onwards. Franz Otto's bestselling *Männer eigener Kraft* (Men of Great Strength, 1875), for instance, assembles the life stories of men driven by 'the spirit of self-help'.[28] In the 1910s and 1920s, the emphasis shifted from biographical anecdotes to practical instructions, but the inspirational force of the 'great success' still had a place in self-help guides, where it could inspire a programme of small successes—of incremental but steady steps towards a more modest and achievable personal goal.[29]

In Gerling's book, such life stories are combined with learned references to poetry, history, and philosophy; together they serve a dual purpose. Not only do they underline the author's own intellectual credentials, but they tap into one of the most powerful founding myths of German collective identity—the ideal of *Bildung*, education, which had acted as the bedrock of bourgeois self-confidence since the eighteenth century. That Gerling should evoke this value in a text offering to equip the reader for the challenges of the *modern* world speaks volumes about the Weimar Republic: a society given over to ruthless modernization, which at the same time remained nostalgically fixated on the past.

[28] Franz Otto, *Männer eigener Kraft: Lebensbilder verdienstvoller, durch Thatkraft und Selbsthülfe emporgekommener Männer* (Leipzig: Spamer, 1875), p. viii. Another popular such title was Hugo Schramm-Macdonald's *Der Weg zum Erfolg durch eigene Kraft* (The Path to Success through One's Own Strength, 1889).

[29] Kleiner and Suter, 'Konzepte von Glück und Erfolg', pp. 17–20.

Meditation: Techniques and Technologies

With its firm tone and step-by-step programme of self-improvement, *The Art of Concentration* offers practical guidance in times of uncertainty. Other self-help manuals pursued a different, more contemplative approach in trying to tackle the problem of distraction. Spiritism, occultism, and esotericism were thriving in the early twentieth century alongside alternative health and lifestyle movements. Particularly prominent during the Weimar Republic was the so-called *Neugeist* (New Spirit) movement.[30] Its core strategy was meditation, practised either in groups or individually. Numerous titles instructed the reader in this practice, often drawing on religious, and specifically mystical, traditions.[31] A leading figure was Karl Otto Schmidt (1904–1977), a prolific author and editor of the movement's main periodical, *Die weiße Fahne* (The White Flag).[32] One of his most influential books, *Wie konzentriere ich mich?* (How Do I Concentrate?), was published around 1927. Its subtitle promises *Eine praktische Anleitung zur Ausbildung der Denkkraft und zur Ausübung des Kraftdenkens* (A Practical Guide for Developing Mental Power and Exercising Powerful Thinking).

Schmidt's book contains breathing and concentration exercises as well as meditations involving autosuggestion, whereby the reader is given sentences to repeat or images to hold in her or his mind. In addition, he also outlines some physical exercises. The programme as a whole, then, is not dissimilar to Gerling's, but the tone is very different; Schmidt addresses the reader with the familiar *du*, and his tone is not hectoring but gentle and compassionate. Like Gerling, he mentions the example of the child, but here children's attention is not described as deficient, in need of dressage and discipline, but as a model to be emulated. The child is 'still inwardly at one, unfragmented, unburdened [. . .]. He/she lives in the eternal present'.[33] The adult self, in contrast, is internally divided, and it is this division which the book aims to overcome. The key challenge for Schmidt is how to restore unity—both within the individual and on a collective level. The path to this goal is via a new, more focused and decisive mode of thinking,

[30] See Karl Baier, 'Der Magnetismus der Versenkung: Mesmeristisches Denken in Meditationsbewegungen des 19. und 20. Jahrhunderts', in *Aufklärung und Esoterik: Wege in die Moderne*, ed. Monika Neugebauer-Wölk with Holger Zaunstöck (Berlin: de Gruyter, 2013), pp. 407–40 (pp. 430–1). The Neugeist movement derived from the American New Thought movement, founded by Phineas Parkhurst Quimby, who was famous for his spiritual healing practice; one of his early disciples, Mary Baker Eddy, later founded the Christian Science movement.

[31] They include Wolf Chr. von Schuh's *Die stille Stunde: Ein Andachtsbüchlein für Neudenker*, K. O. (Karl Otto) Schmidt's *Herzdenken: Die Praxis der Meditation als Weg zur seelischen Wiedergeburt und zum Geist-Erleben*; and Schmidt's *Unio Mystica (Gott-Einheit): Der Pfad der Kontemplation*, all published by the Prana-Haus imprint of Johannes Baum Verlag in Pfullingen.

[32] Schmidt was arrested in 1941 and interned in the Gestapo prison of Welzheim.

[33] '[. . .] noch innerlich eins, unzerrissen, unbelastet [. . .]. Es lebt im ewigen Jetzt'. K. O. Schmidt, *Wie konzentriere ich mich? Eine praktische Anleitung zur Ausbildung der Denkkraft und zur Ausübung des Kraftdenkens* (Pfullingen: Baum, n.d. [*c*.1927]), p. 3. Schmidt's book is still in print today. The 1991 edition, published by the Drei Eichen Verlag, bears the simplified subtitle *Konzentration leicht gemacht*.

what the Neugeist movement calls *Kraftdenken*—forceful or powerful thinking. Concentration is key to achieving this state, for 'true concentration is nothing but unified inner creation and experience, *mental construction*'.[34]

Schmidt's text combines Buddhist meditation with references to Christian teaching and devotional practice. He repeatedly quotes from the Bible, particularly to underline the merit of constant prayer, citing Christ's instruction to 'watch and pray so that you will not fall into temptation' (Matt. 26:41) and St Paul's command to 'pray ceaselessly' (1 Thess. 5:17). As he elaborates, 'praying is nothing but concentration with a particular *heartfelt fervour*', for 'in these minutes you are infinitely close to God within you'.[35] Early twentieth-century guides on concentration and willpower routinely reference a whole range of religious practices, from the contemplative rules of the monastic orders to Jesuit spiritual exercises,[36] and combine these with an interest in non-Western religions and alternative forms of spirituality.[37]

Schmidt defines concentration as 'concentration on one centre, amalgamation, union',[38] and hence as a force which helps to resist distraction and dispersal. It involves directing all one's mental energy towards one thought or action[39]—in other words, immersion in the present through body *and* mind. Importantly, though, meditation is not conceived as passive and inward-looking. In a striking echo of Gerling's mantra that work and self-discipline are the route to success, Schmidt declares that 'the focused person is also a person of action'; the reward for following his course is thus more than a state of inner equilibrium: 'to lose time because of concentration is in truth to gain time by working faster and better'.[40] Though their tone and approach are rather different, the goals—and sellingpoint—of Gerling's and Schmidt's books are in fact fairly similar. Even in the

[34] '[R]echte Konzentration ist nichts anderes als einheitliches inneres Gestalten und Erleben, *geistiges Bauen*'. Schmidt, *Wie konzentriere ich mich?*, p. 10.

[35] 'Beten ist nichts als Konzentration mit besonders *herzsinniger Inbrunst*', for 'unendlich nahe bist du in diesen Minuten dem Gott in dir'. Schmidt, *Wie konzentriere ich mich?*, pp. 19–20.

[36] Georg Lomer's 1913 'pathographical' study of Ignatius of Loyola, *Vom Erotiker zum Heiligen* was a bestseller; echoing the precepts of will therapy, it argues that Ignatius achieved spiritual salvation by working with, rather than against, the body and its sensations. See Cowan, *Cult of the Will*, p. 106.

[37] See Philipp E. Reichling, *Rezeption als Meditation: Vergleichende Untersuchungen zur Betrachtung in Mystik und klassischer Moderne* (Oberhausen: Athena, 2004). The Neugeist movement in particular saw itself as drawing on religious tradition and practices in ways that transcended specific denominations.

[38] '[...] Sammlung auf einen Mittelpunkt, Zusammenfassung, Vereinigung'. Schmidt, *Wie konzentriere ich mich?*, p. 12.

[39] This involves 'das Sammeln und zielstrebige Richten aller Gedanken-, Gefühls- und Willenskräfte auf ein Zentrum [...], nämlich auf das, was man gerade tut' (p. 12).

[40] '[D]er konzentrierte Mensch ist zugleich *Tatmensch*'; 'Zeitverlust durch Konzentration ist in Wahrheit Zeitgewinn durch schnelleres und besseres Arbeiten'. Schmidt, *Wie konzentriere ich mich?*, pp. 14; 21. There are other parallels with Gerling's book, for instance when Schmidt stresses that readers embarking on his programme should perform the stipulated exercises at a fixed time every day, preferably in the morning (p. 20).

depths of meditation, society's call for increased efficiency and productivity cannot be silenced.

A third self-help author, finally, whose book straddles Schmidt's inward-looking meditative approach and Gerling's more structured programme is Philipp Müh. Billed as a *Heilpädagoge*, or remedial teacher, Müh was also associated with the Neugeist movement, echoing many of Schmidt's ideas. Indeed, he references Schmidt's *How Do I Concentrate?* in his slender, fifty-page booklet *Coué in der Westentasche! Durch Konzentration (Kraftdenken) und dynamische Autosuggestion zum Lebens-Erfolg* (Coué for the Waistcoat Pocket! Concentration (Powerful Thinking) and Dynamic Autosuggestion as the Route to Success). Published around 1927, the book draws on Émile Coué's method of autosuggestion, of which Musil was also a follower—but with a surprising twist.

Müh opens with the familiar litany of modern ailments, expanding them into the portrait of an ailing society: 'Our time is ill.—And we too and all those around us have grown joyless, inwardly and outwardly torn and tired. We see suffering, misery, illness, destitution, conflict, and disharmony wherever we look'.[41] This discontent springs from a lack of concentration, he claims, and so 'how do I concentrate?' is the desperate question asked by all those unfortunate people 'who are unable to either relax or properly to concentrate'.[42]

As he concludes, social and political reforms will not resolve this crisis. Rather, readers need to look elsewhere, namely within themselves, for solutions: 'Only **one thing** can help us, something which comes from within: **unity, concentration!**'[43] Like Schmidt, Müh invests concentration with the power to bring about unity in fragmented times—unity within the individual, which will then radiate outwards to the collective. The many ailments affecting the individual—tiredness, forgetfulness, and insomnia; anger, nervousness, and anxiety; blushing, headaches, and stammering—can all be tackled using techniques of autosuggestion, and Müh's book provides mental images and phrases to remedy these conditions.

Ultimately, though, even autosuggestion might not be powerful enough to address the many challenges facing the modern subject. For this reason, its techniques needs to be supplemented with some ground-breaking hardware. Müh's book is essentially an advertisement for a brand-new invention: the 'Konzentrator' (Figure 6.1).

[41] 'Unsere Zeit ist krank.—Und auch wir und alle Menschen um uns sind freudlos, innerlich und äußerlich zerrissen, müde geworden. Leid, Elend, Krankheit, Not, Streit und Disharmonie, wohin wir sehen'. Philipp Müh, *Coué in der Westentasche! Durch Konzentration (Kraftdenken) und dynamische Autosuggestion zum Lebens-Erfolg* (Pfullingen: Baum, n.d. [c.1927]), p. 3.

[42] '[...] die sich weder zu entspannen noch richtig zu sammeln vermögen'. Müh, *Coué*, p. 7.

[43] 'Uns kann nur noch **Eines** helfen, das aus dem Innern kommt: **Einheit, Konzentration!**' Müh, *Coué*, p. 3.

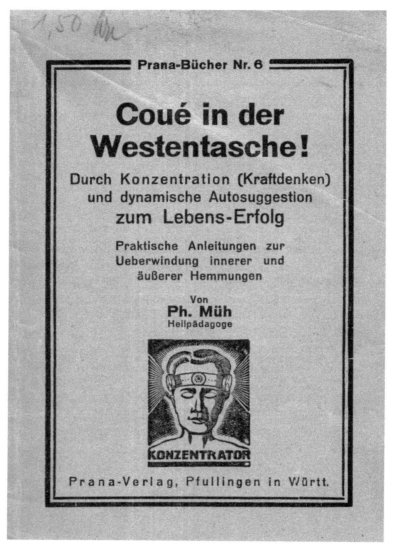

Figure 6.1 Philipp Müh's Konzentrator

Devised by none other than the author himself, the Konzentrator consists of a leather belt to be strapped around the forehead, fitted on both sides with 'receptor plates' that channel spiritual energies to produce a 'passively harmonious equilibrium' ('passiv-harmonischen Gleichgewichtszustand'). A capsule attached to the forehead is filled with a 'concentration substance' consisting of four homeopathic ingredients and a 'psycho-physiological conductor fluid', which has been developed over twenty years of painstaking research, its effectiveness certified by legal

and scientific experts.[44] If used three times a day for up to fifteen minutes, the Konzentrator will yield amazing results. Though its inventor warns that it can never be a substitute for mental exertion, it will enhance cognitive performance in tasks such as memorizing and revision and also act as a shield to block out distracting stimuli. As one user testifies (one third of the book is made up of an appendix of glowing reviews), the device can even facilitate clairvoyance and long-distance suggestive healing.[45]

Müh thus caters for those readers yearning for the kind of quick fix so sternly dismissed by Gerling; his invention is part of a long tradition of bogus devices and miracle cures pitched to a gullible public. At the same time, however, it is very much of its time. Billed as both 'indispensable' and 'up to date',[46] the Konzentrator straddles the boundaries between science and esotericism, between body and mind. More specifically, the apparatus is described as a 'psychotechnical stimulant and device to aid mental concentration'.[47] Müh thus associates his own invention, designed for personal use, with the psychotechnical testing and training regimes in use across Weimar society. As his book implies, in these competitive and uncertain times the pressure coming from 'above' needs to be anticipated and redoubled by individuals within their private lives.

Escaping the World

Each of the three manuals occupies a different position on the broad spectrum of Weimar self-help literature. While Schmidt aligns himself with the contemporary strand of *Besinnungsliteratur* (contemplative literature), advocating meditation and introspection in an intimate, confessional narrative, Müh supplements meditative techniques with some innovative hardware to fend off those corrosive distractions. Gerling's book, which is more than three times the length of its competitors', stands out for its forceful rhetoric and detailed instructions backed up by a combination of (pseudo-)scientific evidence, literary quotations, and historical examples. Its comprehensive programme of self-improvement covers all aspects of the reader's life.

For all their differences, though, the three texts have much in common. All three authors begin by describing the dual challenge of sensory overload and fierce competition in modern society, but they do not use this diagnosis as a springboard for social or political critique. In this regard, these Weimar guides point to a blind spot at the heart of self-help literature, whether in the Weimar Republic or today.

[44] Müh, *Coué*, p. 25. [45] Müh, *Coué*, pp. 33–5.
[46] '[...] ein *unentbehrliches und zeitgemäßes Hilfsmittel*'. Müh, *Coué*, p. 32.
[47] A 'psychotechnisches Anregungsmittel und Hilfsmittel zur Gedankenkonzentration'. Müh, *Coué*, p. 27.

In these texts, any obstacles to success and personal fulfilment are not attributed to factors such as class, race, gender, or age, to 'a lack of material wealth or inherited cultural capital', nor to 'any structural characteristics of [...] capitalist society itself'—but to the individual,[48] who as a consequence is responsible for trying to find a solution, a way forward. This approach is encapsulated in Schmidt's description of meditation: 'As the outside world recedes, goes down, disappears, dies, also let the bustle of your *thoughts* gradually subside. Imagine [...] that *you*, your solitary, thinking *self*, are a *snail, completely retreating into its little shell*'.[49] Gerling makes a similar point when he declares that 'only solitude enables *contemplation* and *introspection*'.[50]

Escaping from society, shielding oneself from this frantic world, its people and ceaseless distractions—these aims are at the heart of Weimar guides to improved concentration, whatever their style, strategy, or underlying philosophy. The presented images of physical and mental retreat, of thoughts fading to nothing, of achieving complete stillness, have unmistakably escapist, even nihilistic, overtones. In his study of the Weimar years, Helmut Lethen points to the revealing coincidence that several leading thinkers, including Benjamin, the political scientist Carl Schmitt, and the social anthropologist Helmuth Plessner, were fascinated by the seventeenth century,[51] a period when the devastation wrought by wars of religion caused the Spanish Jesuit Baltasar Gracián to set out a behavioural code that emphasized caution, conformity, cunning, and emotional self-control. As Gracián writes in *The Art of Worldly Wisdom* (1647): '*Know how to withdraw.* If it is a great lesson in life to know how to deny, it is still greater to know how to deny oneself as regards both affairs and persons'.[52] The surge in guides to meditation and concentration in the Weimar Republic is symptomatic of a similar pattern: of a society which, for all its political upheavals, was characterized by an underlying culture of *dis*engagement and retreat—a stance as manifest in the noisy distractions of mass entertainment as in the armour-plated silence of the contemplative mind.

Another feature common to all three texts is their almost religious advocacy of work as the bedrock of happiness and fulfilment. In the absence of a wider social vision or critique, the imperative of self-improvement is not aimed at the common good, but pits reader against reader in the race for personal success. Schmidt's and Müh's guides are less openly antagonistic in their rhetoric, but ultimately their

[48] Cowan, *Cult of the Will*, p. 1.
[49] 'In dem Maße, wie die Außenwelt für dich abklingt, versinkt, entschwindet, stirbt, laß auch den Trubel deiner *Gedanken* allmählich abklingen. Stelle dir vor [...], *du*, also dein jetzt allein vorhandenes denkendes *Ich*, seiest *eine Schnecke, die sich ganz in ihr Häuschen zurückzieht*'. Schmidt, *Wie konzentriere ich mich?*, p. 25.
[50] 'In der Einsamkeit allein ist *Sammlung* möglich und *Innenschau*' (*KK* 51).
[51] Helmut Lethen, *Cool Conduct: The Culture of Distance in Weimar Germany*, trans. Don Reneau (Berkeley, CA: University of California Press, 2002), p. 90.
[52] Cited in Lethen, *Cool Conduct*, p. 35.

meditative approach feeds into the same individualistic agenda. At the same time, these guides do not seek to foster real autonomy in their readers but demand—very explicitly, in Gerling's case—obedience to the authority of the author as a cross between motivational example, personal trainer, and spiritual guide.

Weimar self-help manuals thus form part of a much longer disciplinary tradition, as traced by theorists such as Michel Foucault, whereby precepts of human behaviour are inscribed onto body and mind. With historical hindsight, their more authoritarian passages certainly strike an uncomfortable and proleptic note; and yet the disciplinary programmes of self-control here promoted also have a compassionate dimension, responding to 'genuine therapeutic needs'.[53] To read these guides simply as cashing in on people's insecurities is to ignore their authors' attempt to forge a real bond with their readers. Even if these are not political manifestos, there is an underlying sense of solidarity which drives these narratives of self-reinvention.

Weimar self-help guides thus need to be read both with and against the grain. They are the products of their time, reflecting a climate of great economic and social uncertainty, but it would be reductive to simply dismiss them as yet another manifestation of the 'troubled' Weimar years as a precursor to fascism. One feature which complicates such a teleological reading is the role of religion, which, though very much of its time, also lends these texts a trans-historical dimension. All three authors advocate prayer as an effective means of entering a state of contemplation and moral introspection. As another self-help author, Wilhelm Bergmann, writes in 1911, by submitting to God, 'we gain a much-needed independence vis-à-vis the external world, as well as freedom from the influence of our own passion'.[54] This argument points in a direction quite different from the imperatives of competition and obedience to authority. For all its granular advice, self-help literature of the 1910s and 1920s sought to give individuals a greater sense of autonomy and control in times of ever-increasing complexity. Concentration was key to this project of self-assertion, and so for all their differences the discussed self-help guides are united by a belief that people *can* change and reinvent themselves, even though this emancipatory project often comes at the price of either subjection to authority or retreat from the political sphere.

As we turn to the present, it is clear that the recent boom of mindfulness and meditation echoes the 1920s in both technique and aspiration. Indeed, both the diagnosed problem and the proposed remedies have remained strikingly constant. The case for mindfulness is succinctly made by bestselling authors Mark Williams and Danny Penman, who castigate 'our frantic and relentless way of life'.[55]

[53] Cowan, *Cult of the Will*, p. 79.
[54] Wilhelm Bergmann, *Selbstbefreiung aus nervösen Leiden* (Freiburg i.Br.: Herder, 1922), p. 236. Cited in Cowan, *Cult of the Will*, p. 81.
[55] Mark Williams and Danny Penman, *Mindfulness: A Practical Guide to Finding Peace in a Frantic World* (London: Piatkus, 2011), p. 2.

Mindfulness offers the prospect of a happier, calmer, and more productive existence; as they put it, 'helping you to cope more skilfully with the worst that life throws at you'.[56] The aim in both periods, then, is to equip individuals with coping strategies for life's ever-increasing cognitive demands, rather than addressing the underlying root causes, such as social inequality.[57] By offering strategies of self-care and self-conditioning, both periods set out *individual* responses to *collective* problems. Schmidt's image of the snail retreating into its shell is a concise expression of this sentiment, as is Kafka's vision of splendid subterranean isolation.

After this foray into *Ratgeberliteratur*, it is time to return to the aesthetic sphere. The following chapter shifts the focus from texts to images, focussing on photography and its role within the history of (in-)attention. A nineteenth-century invention, photography plays a prominent role in the disciplinary history of attention, marked by attempts to condition the mind and the senses, but it is also a medium of artistic expression and experimentation, and in this capacity resists disciplinary appropriation. The next chapter explores how in the nineteenth century photography was used to both document and instil attention, before turning to the Weimar Republic, where photography was often accused of furthering a culture of distraction. My aim is to trace evolving photographic practices around attention from the perspectives of the viewer, the photographer, and the sitter, and to show how photographers with very different artistic and political agendas nonetheless coalesced around the same aesthetic and cognitive challenges.

[56] Williams and Penman, *Mindfulness*, p. 2.

[57] Critics of mindfulness and meditation have highlighted this point. Miguel Farias and Catherine Wikholm, for instance, argue that these programmes do not address the underlying causes of our growing distraction but merely tackle its effects, thereby providing a 'good fit with our ideologies, in particular individualism: we are each responsible for our own life, our own happiness'. Miguel Farias and Catherine Wikholm, *The Buddha Pill: Can Meditation Change You?*, rev. edn (London: Watkins, 2019), p. xi. Going even further, Ronald Purser calls meditation and mindfulness tools of 'self-discipline, disguised as self-help'; rather than questioning the status quo, in which our attention 'is monetized and manipulated' by large corporations, they 'locate the crisis in our mind' and then 'sell us solutions that make us contented mindful capitalists'. Ronald Purser, *McMindfulness: How Mindfulness Became the New Capitalist Spirituality* (London: Repeater, 2019), pp. 8; 10.

7
Stillness
Weimar Photography

Capturing Attention

As Chapter 1 has shown, the experimental exploration of attention relied on a plethora of apparatuses, ranging from measuring devices such as the chronoscope to the tachistoscope, which was used to display letters and images. Photography occupied an intermediary position in this field. Its principal purpose was not to produce mental processes but to record them. Scientists were particularly interested in the outward, facial and bodily, manifestations of inner states, which they tried to assess in people of different ages, genders, and social groups, in different cultural contexts, and even across species. The latter comparison is the subject of Charles Darwin's *The Expression of the Emotions in Man and Animals* (1872); Darwin in turn references the work of the French neurologist Duchenne de Boulogne (1806–75), contained in his illustrated two-volume *Mécanisme de la physionomie humaine* (The Mechanism of Human Facial Expression, 1862).

Duchenne sought to establish a fixed taxonomy of facial expressions, associating specific muscles with different emotional states. In his preface he cites the eighteenth-century naturalist Georges Buffon, who describes the face agitated by emotion as a 'tableau vivant'.[1] In his experiments Duchenne tried to recreate these *tableaux vivants* by stimulating the muscles of the face and head using electrodes. According to his theory, particular inner states corresponded to particular expressions, and so conversely, these inner states could be produced externally, by electrical means.

Duchenne lists thirteen 'primary emotions', whose expression is in each case controlled by one or two facial muscles. Attention is one of them; indeed, it is the first emotion which is explored in the book.[2] The expression of attention, Duchenne argues, is produced by the frontalis muscle; it is documented by five consecutively printed photographic plates showing three sitters: an old man, a little girl, and a 41-year-old woman. Each plate is printed *recte*, faced, with the

[1] G.-B. Duchenne (de Boulogne), *Mécanisme de la physionomie humaine, ou analyse électro-physiologique de l'expression des passions applicable à la pratique des arts plastiques*, 2 vols (Paris: Renouard, 1862), vol. 1, p. v.

[2] Duchenne, *Mécanisme*, vol. 2, pp. 2–18.

exception of the first image, by a blank page. The first three plates show the same sitter, the old man, who is Duchenne's principal subject (Figures 7.1 and 7.2).

Commenting on this mini-series, Duchenne notes that, although all images show the same state, 'they nonetheless strike the viewer in a different manner',[3] for the subject evidently experiences a greater degree of emotion in the last image of the sequence than in the preceding ones. Though this sequence is contained in the scientific rather than the aesthetic part of Duchenne's book, the arrangement and commentary infuse these images with a narrative as well as a dramatic character.

Duchenne believed that the face (and, to a lesser extent, the body) was a map on which the skilled observer could read different inner states. Having forged a 'physiognomic language' of emotions in the act of creation, he argued, God then rendered this language 'universal and immutable' and gave every human being the ability to express her or his emotions through the same muscles.[4] Duchenne explores this natural, God-given language, but by using technology to produce these facial expressions he in fact severs the link between body and mind, signifier and signified. Indeed, his images are doubly contrived, produced by and for the photographic medium. The conditioning effect of electrical stimulation is overlaid with the effects of the photographic recording process, with its various drawn-out stages and technological constraints. In this regard, Duchenne's images embody a more general problem discussed in Chapter 1: the fact that attention, when tested under controlled conditions, is never fully 'natural' but a construct, the product of those very conditions.

Duchenne's project thus builds on the methods of experimental psychology while anticipating the psychotechnical conditioning of body and mind. Indeed, an illustration of his Faradic apparatus, which he used for electrical stimulation, bears a striking resemblance to the psychotechnical devices that were used in the Weimar Republic (Figure 7.3).

Other scientists followed Duchenne's lead. Darwin's *The Expression of the Emotions in Man and Animals*, which uses photography to illustrate the universality of emotions and their physiological expression in humans and animals, is in turn cited by Théodule-Armand Ribot, who emphasizes that 'attention does not exist *in abstracto*, as a purely inward event: it is a concrete state, a psycho-physiological complex'.[5] Indeed, the physical manifestations of attention continued to occupy researchers well into the twentieth century. The psychiatrist Robert Sommer devised a 'motor-graphic method' to record facial movements, such as

[3] '[...] elles impressionnent cependent le spectateur d'une manière différente'. Duchenne, *Mécanisme*, vol. 2, p. 18.

[4] Duchenne, *Mécanisme*, vol. 1, p. 31.

[5] Théodule-Armand Ribot, *The Psychology of Attention*, 5th rev. edn [no translator] (Chicago, IL: Open Court Publishing Company, 1903), pp. 23; 25. Ribot also references the research of Charlet Féré, assistant of Jean-Martin Charcot at the Salpetrière, whose psychomotor theory stipulated that body and mind mutually influence each other (pp. 18–19).

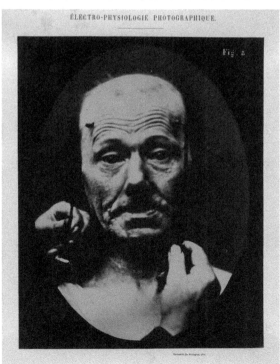

Figures 7.1 and 7.2 'Attention'. G.-B. Duchenne (de Boulogne), *Mécanisme de la physionomie humaine* (1862), vol. II, plates 7 and 8

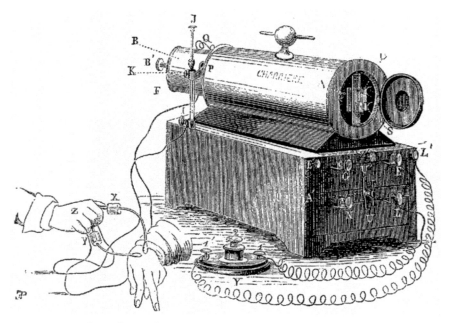

Figure 7.3 Duchenne's Faradic apparatus. *Mécanisme*, vol. II, p. 5

the wrinkling of the forehead, on paper strips covered in soot. In mentally ill patients, his device recorded a 'curious jumble of the lines on the forehead', whose irregular pattern reflected an equally disordered mind.[6] Trying to capture facial expressions in a more natural and spontaneous context, the Italian psychiatrist Sante de Sanctis used both film and (snapshot) photography as the basis of his 1904 study *La mimica del pensiero* (The Reflection of Thought in Facial Expression),[7] and in 1925 the psychologist Hans Henning drew up a comprehensive list of the physical signs of attention, which includes not only facial expressions but also invisible symptoms such as blood pressure and breathing patterns.[8]

[6] '[Ein] ganz seltsames Durcheinander der Linienführungen an den Stirnfalten'. Robert Sommer, 'Zur Messung der motorischen Begleiterscheinungen psychischer Zustände', *Beiträge zur psychiatrischen Klinik*, 1 (1902), 143–64 (p. 150).

[7] De Sanctis differentiates between optical and acoustic attention, arguing that they manifest themselves differently in the body, and also between static attention, which is focused on one particular object and manifests itself as stillness, and split attention, which results in the fast movement of the eyes and the head. Sante de Sanctis, *Die Mimik des Denkens*, trans. Joh[annes] Bresler (Halle: Marhold, 1906), p. 99. Cited in Petra Löffler, *Verteilte Aufmerksamkeit: Eine Mediengeschichte der Zerstreuung* (Zurich: Diaphanes, 2014), p. 186.

[8] Hans Henning, 'Die Untersuchung der Aufmerksamkeit', in *Handbuch der biologischen Arbeitsmethoden*, Abteilung VI: *Methoden der experimentellen Psychologie*, part b, vol. 5 (Berlin: Urban & Schwarzenberg, 1925), pp. 593–802 (p. 716). See Löffler, *Verteilte Aufmerksamkeit*, p. 187.

That Henning was still engaged in such a project in the 1920s may at first glance seem surprising, and yet his taxonomy of attention closely aligns with the psychotechnical project of cognitive testing and training. In the Weimar Republic photography was utilized not only to record the outward signs of attention but also to condition the viewer, as the reach of psychotechnics extended to visual culture.

Weimar Photography: Pedagogy and Experimentation

In 1926, at the height of the psychotechnical boom, the illustrated magazine *Uhu* (Eagle Owl) published an article which asks its readers: 'Können Sie schnell denken? Sind Sie ein guter Beobachter?' ('Can you think quickly? Are you a good observer?'). As the article proudly declares, *Uhu* is the first magazine to test the 'astuteness and quick-wittedness' of its readers; just as physical exercise keeps the body 'resilient and supple [...] these intelligence tests serve to exercise the mind. They are no pointless "pastime", but [...] welcome training for sharp vision and quick thinking'.[9]

This emphasis on the link between physical and mental exercise echoes contemporary self-help guides, as does the assurance that such exercises are no waste of time. Their aim is to increase *Schlagfertigkeit*, alertness and speed of response. The accompanying illustration shows the photograph of a young woman and its inverted copy; readers are asked to identify the original image 'at *one* glance'.

Such light-hearted pastimes have a serious core, illustrating how far psychotechnics has penetrated from work into leisure, so that even light entertainment becomes a site of cognitive training. 'Consumers of the illustrated press were being conditioned to think on their feet and constantly search for new information', and magazines aspired to train their readers 'to sustain a coherent space of perception that at once overcomes and depends on a world of fragmentation, shock, and simultaneity'.[10]

A hybrid mix of text and images, the illustrated magazine, or *Illustrierte*, both drives and embodies a radical shift in habits of reading and seeing. It does not require sustained concentration but encourages a more casual, semi-distracted mindset, in which content is scanned rather than read attentively. Texts and images are often placed side by side, requiring the eye to move between the two.

[9] '[...] widerstandsfähig und elastisch [...], so dienen diese Intelligenzprüfungen der Gymnastik des Geistes. Sie sind kein müßiger "Zeitvertreib", sondern [...] ein willkommenes Training für scharfes Sehen und rasches Denken'. [Anonymous], 'Können Sie schnell denken? Sind Sie ein guter Beobachter? Neue Intelligenzproben', *Uhu*, 2:11 (1926), 108. See the discussion of this article in Pepper Stetler, *Stop Reading! Look! Modern Vision and the Weimar Photographic Book* (Ann Arbor, MI: University of Michigan Press, 2015), pp. 10–11.

[10] Stetler, *Stop Reading*, p. 10.

Alongside illustrated fashion features and stories about celebrities, one of the most popular genres was the photo-essay—a narrative in which images told the story, with text—captions—reduced to a secondary role.[11]

Alongside the illustrated magazine, however, the Weimar Republic also witnessed the rise of another text–image hybrid: the photobook. Recent advances in printing technology meant that photographs could now be reproduced in high quality, in large print runs, and at relatively affordable prices.[12] To be sure, at first sight this alliance between (art) photography and the medium of the book may seem hopelessly anachronistic in a time when the printed page was outpaced by faster, more exciting and spectacular forms of entertainment. And yet in the interwar years the photobook became a key site for the dissemination of art photography, giving prominence to emerging photographers and making photography accessible beyond the exhibition space and to new audiences.[13] Beyond this, however, many photobooks of the period had an explicitly pedagogical agenda: to train their readers in new ways of looking. Prefaces, written either by the photographers themselves or by another commentator, included reflections on how these pictures were taken, what they were trying to do, and how they were meant to be viewed.

This aspiration—the transformation of visual habits and skills by means of technology—marks out the photobook as a characteristically modern medium, which partakes in wider discussions about the transformation of the human cognitive apparatus. Irrespective of whether this aspiration was actually achievable, Weimar photographers '*thought* that it was, and this belief motivated their interest in the photographic book'.[14]

This pedagogical agenda was realized in a number of ways, reflecting a wide range of photographic styles and techniques. Broadly speaking, Weimar photobooks fall into two categories which in turn pursue different pedagogical agendas—what Bernd Stiegler calls the syntagmatic and paradigmatic varieties of the genre.[15] In syntagmatic photobooks, the photographs take pride of place, accompanied by discreet captions, whereas the paradigmatic variety uses more experimental, jumbled layouts whereby images are juxtaposed with each other and with textual commentary, creating collage effects or picture poems. Syntagmatic photobooks try to decelerate the viewing experience, imposing a sense of order

[11] On the Weimar photo-essay, see Daniel H. Magilow's comprehensive study, *The Photography of Crisis: The Photo Essays of Weimar Germany* (University Park, PA: Pennsylvania State University Press, 2012).

[12] For an overview of the history of printing technology up to the Weimar years, see Dorothea Peters, 'Fotografie, Buch und grafisches Gewerbe: Zur Entwicklung der Druckverfahren von Fotobüchern', in *Autopsie: Deutschsprachige Fotobücher 1918 bis 1945*, ed. Manfred Heiting and Roland Jaeger, vol. 1 (Göttingen: Steidl, 2012), pp. 12–23.

[13] On the Weimar photobook in a European context, see Martin Parr and Gerry Badger, *The Photobook: A History*, vol. 1 (London: Phaidon, 2004); and Heiting and Jaeger (eds), *Autopsie*.

[14] Stetler, *Stop Reading*, p. 14.

[15] Bernd Stiegler, *Der montierte Mensch* (Munich: Fink, 2016), p. 308.

and stillness, whereas paradigmatic ones seek to emulate the experience of modern life, the jumble of words and images as it would have been encountered on a walk through a city.[16]

These two types of layout in turn reflected different attitudes towards photographic technique and tradition. The Weimar Republic was the age of the snapshot, of smaller and lighter cameras and faster, more light-sensitive lenses, which allowed photographers to capture modern life in all its dynamic transience. In a sense, snapshot photography tried to emulate, and perhaps compete with, film, and yet by arresting fleeting sights and showing the world from unfamiliar angles it also stalled routine cognitive processes and offered defamiliarizing and potentially disorienting views of the world, as in Weimar photographer Umbo's bird's-eye view, 'Geheimnis der Straße' (Mystery of the Street, 1928) (Figure 7.4).[17]

Snapshot photography opened the medium to amateurs, but the technique was also embraced by professional photographers wanting to defy the rules of 'good' composition. This defiance is palpable in Werner Gräff's *Es kommt der neue Photograph!* (Here Comes the New Photographer!, 1929), where conventionally composed images are juxtaposed with more unorthodox ones; his photobook accompanied the landmark 'Film und Foto' exhibition in Stuttgart organized by the Deutsche Werkbund, an association of artists, designers, architects, and craftspeople.[18]

This rejection of aesthetic conventions, however, is only one part of the story of Weimar photography. During the same period, traditional (art) photography was given a new lease of life, whether in the form of the still life, of landscape, or of portrait photography. Such images were typically assembled in more conventionally laid out photobooks, where each image is given a page or even double page to itself, encouraging a slower, more deliberate engagement with every single picture. Ultimately, the Weimar photobook is a hybrid genre, suspended 'between stillness and motion, new and old, past and present'.[19] Indeed, the photobook was the very site where the role of photography—as a link to the past or as the expression of the modern age—was being debated.

[16] As Stiegler notes, the image sequences in syntagmatic photobooks, which make up the vast majority of Weimar photobooks, try to educate their viewers in a new form of 'visual literacy'. Paradigmatic photobooks, in contrast, do not aim to stabilize perceptual habits but to unsettle them, making them more fluid. Stiegler, *Der montierte Mensch*, pp. 309–10; 315.

[17] A different kind of snapshot photography was practised by Dr Erich Salomon, who hid his light-sensitive Ernox camera in a bowler hat and managed to take pictures of closed political meetings and high society events. His photobook *Berühmte Zeitgenossen in unbewachten Augenblicken* (Famous Contemporaries in Unguarded Moments, 1931), an early example of the candid camera movement, was a bestseller.

[18] By rejecting the conventions of old, however, Gräff's book ends up prescribing new orthodoxies, casting itself as an alternative kind of training manual. See Magilow, *Photography of Crisis*, pp. 16–33 and Stetler, *Stop Reading*, p. 47.

[19] Stetler, *Stop Reading*, p. 14.

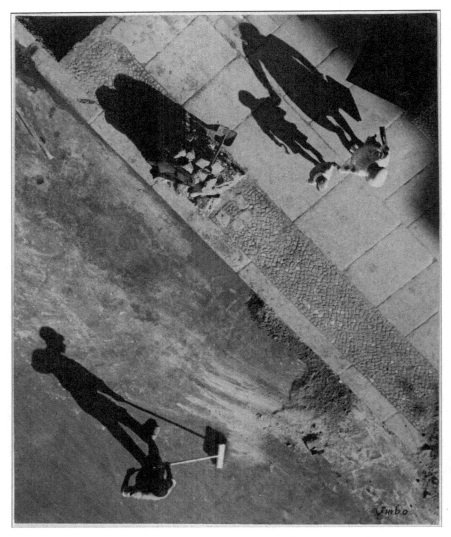

Figure 7.4 Umbo (Otto Umbehr), 'Mysterium der Straße' (Mystery of the Street, 1928)

The Weimar Republic saw the publication of several illustrated surveys of the medium, including Josef Maria Eder's *Geschichte der Photographie* (History of Photography),[20] Helmuth Theodor Bossert and Heinrich Guttmann's 1930 *Aus der Frühzeit der Photographie, 1840–70* (The Early Days of Photography, 1840–70), and Walter Benjamin's 'Kleine Geschichte der Photographie' (Little History of

[20] The fourth, revised edition of Eder's authoritative work appeared in 1932.

Photography, 1931). Weimar histories of the medium often tell a three-part story, which leads from the early heyday of the medium via its artistic decline in the second half of the nineteenth century, the age of commercialization, to the Weimar Republic, which was widely seen as the dawn of a new golden era. This new dawn was often linked back to the beginnings, as Weimar photographers were cast as the heirs of the pioneers of photography, as artists who tried to return to the roots of their medium.

This gesture of turning backwards manifested itself on several levels. Apart from issues of subject matter and style, it also related to the practical side of photography. At a time when technological innovations made *new* kinds of images possible, many Weimar photographers consciously employed more traditional, outdated recording methods in an attempt to capture a slower and supposedly more authentic mode of experience.

Returning to the Roots: Hill and Adamson

For people who were concerned about a modern *Bilderflut*, a deluge of images, the early days of the medium stood for a very different photographic culture: one which did not pander to commercial interests but produced images of artistic integrity and lasting value. In this regard, the Weimar nostalgia for early photography repeats many of the tropes which can be found in turn-of-the-century critiques of modern life. While casting the present (and its photographic representations) as frantic and superficial, they turned to early photography as the site of a slower, contemplative way of life.

The photographic portrait stood at the centre of this debate, which underlines the dual capacity of the medium to record as well as construct reality. Yet the often remarked-upon stillness of these early subjects, who seem immersed in deep contemplation, was arguably no intrinsic, 'natural' state but the result of the photographic process, which imposed its own constraints. Two artists who featured prominently in these Weimar debates are the Scottish photographer David Octavius Hill (1802–70) and his partner, the chemist Robert Adamson (1821–48). Their work was rediscovered in the 1920s; it had a profound impact on German photographers working across the aesthetic and political spectrum.

Hill and Adamson were among the first to apply the new technique of the calotype to portrait photography, a genre which posed much greater technical challenges than still lives or landscape photography. Their subjects included the founding members of the Scottish Free Church as well as other local Edinburgh citizens. Many of their images, which date from the 1840s, were recorded in the Greyfriars Churchyard in Edinburgh. Though their work was revolutionary at the time, it subsequently fell into obscurity and was only rediscovered in the following century.

German viewers were first introduced to Hill and Adamson's work through a landmark photography exhibition held at the Kunsthalle Hamburg in 1899, which featured six of their calotypes.[21] However, it was only three decades later that their images became known to a wider public. The photobook *David Octavius Hill: Der Meister der Photographie* (The Master of Photography, 1931), edited by the art historian Heinrich Schwarz, made their work available to a wider audience for the first time.[22]

Schwarz's book was widely received and cemented Hill's reputation as one of the founding fathers of portrait photography.[23] Hill and Adamson's portraits were feted by Weimar photographers, art historians, and critics alike, who praised the pictures' vividness and authenticity, and the models' sense of repose, which they contrasted favourably with the images produced in their own, frantic, age. But the Weimar reception was also concerned with technical issues, particularly the question of exposure time. In his preface, Schwarz describes how Hill and Adamson used the most light-sensitive lenses available at the time to reduce exposure time from half an hour to a few minutes, but stresses at the same time that a certain anachronism was key to their artistic vision:

> Hills Kamera wahrt in diskreter Zurückhaltung die Distanz. Sie zerrt die Menschen und Dinge nicht schonungslos in ein grausames Licht, das alles Geheimnis zerstört. Denn Hill bleibt auch dann seinen primitiven technischen Mitteln treu, als eine fortgeschrittene Technik schon über optische Instrumente verfügt, die das Dunkel ganz überwinden und die Erscheinungen spiegelhaft aufzeichnen. Sein Verfahren erfordert das pralle Sonnenlicht und die Aufnahme im Freien.[24]

> [Hill's camera keeps a discreet distance. It does not brutally drag people and things into a harsh light that destroys all mystery. For Hill stays loyal to his primitive technical means, even as technological advances were providing optical

[21] See Enno Kaufhold, '"Wir trauten anfangs unseren Augen nicht": David Octavius Hill. Legitimation der photographischen Unschärfe', in *David Octavius Hill & Robert Adamson: Von den Anfängen der künstlerischen Photographie im 19. Jahrhundert*, ed. Bodo von Dewitz and Karin Schuller-Procopovici (Cologne: Museum Ludwig/Agfa Photo-Historama, 2000), pp. 33–44 (p. 33).

[22] Three years earlier, in 1928, Andrew Eliot had published a slim volume, *Calotypes by D. O. Hill and R. Adamson: Illustrating an Early Stage in the Development of Photography*, but this was intended for private circulation only. Schwarz's book, which was translated into English the following year, was the first volume to offer a comprehensive overview of their work. See Martin Gasser, 'A Master Piece: Heinrich Schwarz's Book on David Octavius Hill', *Image*, 36 (1993), 33–53; and Bodo von Dewitz, 'Zur Geschichte des Buches "David Octavius Hill—Der Meister der Photographie" von Heinrich Schwarz (1931)', in *David Octavius Hill & Robert Adamson*, ed. Dewitz and Schuller-Procopovici, pp. 45–52.

[23] Robert Adamson, who is nowadays recognized as Hill's equal partner, was at the time usually classed as his assistant. Schwarz's introduction is typical in this regard; it focuses on Hill's life and work and only mentions Adamson thirteen pages into his preface, although he does acknowledge Adamson's vital role and describes the two men's 'gegenseitiger Austausch der Fähigkeiten und Kenntnisse' ('mutual exchange of knowledge and skills') in the course of their collaboration. Heinrich Schwarz, *David Octavius Hill: Der Meister der Photographie* (Frankfurt a.M.: Insel, 1931), p. 34.

[24] Schwarz, *David Octavius Hill*, p. 40.

instruments which could conquer darkness and record phenomena as if in a mirror. His procedure requires direct sunlight and recording outdoors.]

Even 'interior photographs', which show the model seated in an armchair reading a book, were recorded outside, with furniture used to simulate a domestic space where the model could sit 'in quiet thoughtfulness'.[25] Schwarz repeatedly emphasizes the sitters' sense of immersion; crucially, though, he does not regard this state as natural or integral to their character. Rather, he argues, this stillness has to be fostered with great care. First of all, the photographer has to gain the trust of his subjects to rid them of 'all fearful shyness and constraint'; only this will then enable him 'to capture the breathing life in his pictures'.[26] Indeed, the deep contemplation which pervades the portraits is mirrored by the photographer. Schwarz speaks of the close attention with which Hill scrutinized his subjects: 'He studies the physiognomy, the habits and movements of his models [. . .] with such an intensity that nothing essential in their mental and physical constitution evaded him'.[27]

As he concludes, Hill's genius lies in transforming the photographic process from a purely technical into an intellectual, even a spiritual, experience. Inwardness, contemplation, and study, *Studium*, are key words in Schwarz's discussion.[28] Hill and Adamson's portraits testify to a state of contemplation shared by model and artists, and these images in turn demand to be viewed in a similar state.

Schwarz's volume was instrumental in shaping the twentieth-century reception of Hill and Adamson's work. Walter Benjamin discusses the Hill photobook in his 'Little History of Photography'. Citing the German painter and graphic artist Emil Orlik,[29] he highlights the models' contemplative stillness and its effect on the portraits' simplicity and intensity:

Die Synthese des Ausdrucks, die durch das lange Stillhalten des Modells erzeugt wird [. . .], ist der Hauptgrund, weshalb diese Lichtbilder neben ihrer

[25] '[. . .] in dem sein Modell in stiller Versonnenheit sitzt'. Schwarz, *David Octavius Hill*, p. 40.

[26] '[. . .] alle ängstliche Scheu und Gezwungenheit'; 'das atmende Leben in seinen Bildern zu fassen'. Schwarz, *David Octavius Hill*, p. 42. Schwarz also echoes the narrative about the subsequent decline of photography; calling some of Julia Margaret Cameron's portraits worthy successors of the early pioneers, he notes that the majority of her work reveals 'den unaufhaltsamen Verfall der Photographie' ('the unstoppable decline of photography'; p. 45). As he elaborates, Hill and Adamson's work was practically forgotten until 1898 when seventy of their images were displayed at an exhibition of the Royal Photographic Society at Crystal Palace; this was followed by the 1899 Hamburg exhibition. In Weimar Germany, the Hamburg and Dresden Kupferkabinette were the only public collections which held a small number of their prints (p. 48).

[27] 'Er studiert die Physiognomie, die Gewohnheiten und die Bewegungen seiner Modelle [. . .] mit einer Eindringlichkeit, der nichts Wesentliches in der geistigen und körperlichen Beschaffenheit des Individuums zu entgehen scheint'. Schwarz, *David Octavius Hill*, p. 41.

[28] Hill 'überträgt den Begriff der Studie von der Malerei auf die Photographie' ('transposes the concept of the study from painting to photography'). Schwarz, *David Octavius Hill*, p. 41.

[29] Benjamin is here citing from Orlik's volume of *Kleine Aufsätze* (Berlin: Propyläen, 1924).

Schlichtheit [...] eine eindringliche und länger andauernde Wirkung auf den Beschauer ausüben als neuere Photographien. (*BGS* II.1, 371)

[The synthetic character of the expression which was dictated by the length of time the subject had to remain still [...] is the main reason these photographs, apart from their simplicity, [...] produce a more vivid and lasting impression on the beholder than more recent photographs. (*BSW* II.2, 514)]

For Benjamin, as for Schwarz, this stillness does not simply testify to a different, less frantic age, but is the result of *technological* factors, specifically the long exposure time in early photography, whereby an extended time period was condensed into a single image. Noting how the sitters appear to feel at home in the Greyfriars cemetery as if in their own living room, he adds:

Nie aber hätte dies Lokal zu seiner großen Wirkung kommen können, wäre seine Wahl nicht technisch begründet gewesen. Geringere Lichtempfindlichkeit der frühen Platten machte eine lange Belichtung im Freien erforderlich. Diese wiederum ließ es wünschenswert scheinen, den Aufzunehmenden in möglichster Abgeschiedenheit an einem Orte unterzubringen, wo ruhiger Sammlung nichts im Wege stand. (*BGS* II.1, 371)

[But this setting could never have been so effective if it had not been chosen on technical grounds. The low light-sensitivity of the early plates made prolonged exposure outdoors a necessity. This in turn made it desirable to take the subject to some out-of-the-way spot where there was no obstacle to quiet concentration.
(*BSW* II.2, 514)]

Cemeteries are generally conducive to reflection, but as Benjamin argues, Greyfriars Churchyard was also chosen for simpler practical reasons, namely for its secluded location. Even though in 1840s Edinburgh the conditions for sustained concentration were arguably more favourable than in the Weimar Republic, Hill's sitters still needed help in the effort of posing. Being photographed in a quiet spot was a relatively straightforward way of bringing about the required stillness; a few decades later, with the commercialization of the studio portrait, photographers would turn to more physical means to achieve the same effect. Public figures were photographed holding objects relating to their field of achievement, while ordinary citizens would pose holding a book to occupy their hands and minds. Towards the end of the nineteenth century, the aids to stillness became ever more constrictive: 'Heads were held firm by iron clamps supported on stands. With the emergent photographic industry came [...] manufacturers of props, clamps and supports'.[30]

[30] Peter Hamilton and Roger Hargreaves, *The Beautiful and the Damned: The Creation of Identity in Nineteenth Century Photography* (Aldershot: Lund Humphries, 2001), p. 33.

In 'Little History of Photography' Benjamin picks up on the artificial aesthetic of late nineteenth-century photography when he describes the studio as a cross between a 'throne room' and a 'torture chamber'.[31] Weimar photographers were keen to distance themselves from this legacy, as they tried to infuse their portraits with a greater sense of authenticity. Hill and Adamson were important role models in this undertaking. This chapter will trace the resonances of their method in the work of two Weimar photographers: Erna Lendvai-Dircksen and Helmar Lerski. Situated at opposite ends of the aesthetic and political spectrum, they are nonetheless linked by some shared goals and ideas.

Erna Lendvai-Dircksen: The Rural Countenance

Erna Lendvai-Dircksen (1883–1962) was one of the most prominent German photographers between 1918 and 1945. She trained at the Arts Academy in Kassel and the Lette-Verein (Lette Association) in Berlin, where she set up her own studio in 1916, which she maintained until 1943. She photographed some famous women, such as the author Ricarda Huch, the artist Käthe Kollwitz, and the dancer Mary Wigman, and her images were also featured in illustrated magazines. Alongside this commercial work, however, she pursued a very different project. From 1916 onwards, Lendvai-Dircksen travelled to different parts of rural Germany; the resulting portraits are assembled in her debut photobook, *Das deutsche Volksgesicht* (The Face of the German People, 1932), published one year after Schwarz's *David Octavius Hill* volume. It contains portraits of peasants, many of them children or elderly people, arranged according to the different German regions. Lendvai-Dircksen's captioned photographs sentimentalize rural life, casting it as wholesome and authentic. That said, her close-up portraits have a more modern edge than for instance August Sander's full-length and rather formal portraits, assembled in his photobook *Antlitz der Zeit* (Face of our Time, 1929), which depicts members of the different strata of Weimar society.[32]

For all their differences, both photobooks pander to the Weimar craze for physiognomy—the eighteenth-century pseudo-science, which claimed that people's character, social class, and political views could be deduced from their

[31] *BSW* II.2, 515; *BGS* II.1, 375.
[32] See Wolfgang Brückle, 'Kein Porträt mehr? Physiognomik in der deutschen Bildnisphotographie um 1930', in *Gesichter der Weimarer Republik: Eine physiognomische Kulturgeschichte*, ed. Claudia Schmölders and Sander Gilman (Cologne: DuMont, 2000), pp. 131–55 (p. 141). Claudia Schmölders concurs, arguing that Lendvai-Dircksen's images, which alternate between close-up, half-body, and full-body portraits, are livelier and more personal than Sander's, but also than the *völkisch* photobooks published during National Socialism. Accompanied by text—about the sitter and his or her relationship to the photographer—every image tells a story. Claudia Schmölders, 'Das Gesicht von "Blut und Boden": Erna Lendvai-Dircksens Kunstgeographie', in *Körper im Nationalsozialismus: Bilder und Praxen*, ed. Paula Diehl (Munich: Fink, 2006), pp. 51–78 (p. 56).

facial appearance. Physiognomy experienced a revival during and after the First World War, when it became the basis of an entire *Weltanschauung* and one of the master discourses of the Weimar Republic. In an increasingly anonymous and mobile society, physiognomy catered for people's desire for orientation; it promised to make faces legible, enabling the observer to distinguish between 'us' and 'them', friend and foe. Though largely a right-wing project, the physiognomic discourse cut across the political spectrum;[33] the interest in the face as the bearer of personal and collective identity was reflected in countless portrait photobooks whose titles use the face metonymically, as the embodiment of a particular group or class, or else of the entire nation.[34]

Echoing this fixation on the readable face, Benjamin describes Sander's *Face of our Time* as a physiognomic *Übungsatlas*, or training manual, adding that in the present climate the 'ability to read facial types' had become a vital necessity: 'Whether one is of the Left or the Right, one will have to get used to being looked at in terms of one's provenance. And one will have to look at others the same way' (*BSW* II.2, 520).[35] His words echo the aforementioned picture puzzle in *Uhu*, which likewise casts photography as a training device to teach 'astuteness and quick-wittedness'.

Lendvai-Dircksen's vision of a rural, timeless Germany was popular with the political right and would later chime with the Nazi slogan of 'Blut und Boden' (blood and soil)—the sense of a primal, almost mystical, connection between the physical landscape and the people living within it. In the Third Reich, she published several sequels dedicated to specific German and (according to Nazi doctrine) 'Germanic' regions, such as Denmark, Flanders, and Norway. Her enthusiastic endorsement of the new regime earned her the 'Master' (*Meister*) title in 1933.[36] Like Willy Hellpach, author of the 1902 treatise *Nervousness and*

[33] Though the physiognomic discourse was mostly driven by conservative, nationalist voices such as Oswald Spengler, Rudolf Kassner, Helmut Plessner, and Ernst Jünger, it also included Jewish critics such as Theodor Lessing, Béla Balász, Max Picard, and Josef Roth. See Schmölders, 'Das Gesicht', pp. 52–3.

[34] Apart from Lendvai-Dircksen's and Sander's above-mentioned photobooks, they also include Helmar Lerski's *Köpfe des Alltags* (Everyday Heads, 1931) and Erich Retzlaff's *Das Antlitz des Alters* (The Countenance of Old Age, 1930). Hans Killian's *Facies Dolorosa* (Faces of Suffering, 1934) presents black-and-white portraits of terminally ill patients, some of them depicted at different stages of their illness. During the Third Reich, the nationalist sentiment reigned supreme, with titles including *Das deutsche Antlitz* (The German Countenance, 1933), *Das heilige deutsche Antlitz* (The Holy German Countenance, 1934), *Das deutsche Antlitz in der Kunst* (The German Countenance in Visual Art, 1939), and *Das Gesicht des Führers* (The Face of the Führer, 1939). See Schmölders, 'Das Gesicht', p. 53.

[35] 'Man mag von rechts kommen oder von links—man wird sich daran gewöhnen müssen, darauf angesehen zu werden, woher man kommt. Man wird es, seinerseits, den andern anzusehen haben' (*BGS* II.1, 381).

[36] While Lendvai-Dircksen's portrait photobooks do not have quite the same explicitly racist and eugenicist slant as those of other Nazi photographers, her portraits of children were included in 'race charts' used in schools during National Socialism. Though after the war she was occasionally known as 'Brown Erna', her continued popularity, in both West Germany and the GDR, was curiously indifferent to her role under National Socialism. *The Face of the German People* was republished by the West German Umschau Verlag in 1961. See Schmölders, 'Das Gesicht', p. 54.

Culture, who later adopted Nazi racist and eugenicist ideology and published several books on the subject,[37] Lendvai-Dircksen was one of many supporters of the Nazi regime who reflected its views in their own discipline.

These affinities already became apparent in the Weimar Republic, when Lendvai-Dircksen emerged as an outspoken critic of the photography of Neue Sachlichkeit (New Objectivity), and its international influences. Her comments reflect her aesthetic and political conservatism, but they are also underpinned by a psychological argument. Reiterating the tropes of the neurasthenia discourse, she complains in her 1931 essay 'Psychologie des Sehens' (Psychology of Vision) that in the current, fast-moving age people's mental equilibrium is put out of kilter by 'one-sided attention and excessive strain'.[38] As she elaborates:

> Der moderne Mensch kommt mittels Zeitung, Telefon, Radio, Flugzeug zu allem, nur nicht zu sich selbst. Der Wahn des Vielen und Immernochmehr verlangt dauernde Steigerung und Überbietung, Eindruck jagt Eindruck, der nie zum Erlebnis werden kann, weil die Ruhe dazu fehlt. Abgestumpftheit, Blasiertheit und Ekel sind natürliche Folgen, und nur Reizmittel und Sensation haben eine Aussicht auf Wirkung.[39]
>
> [By means of newspaper, telephone, radio, aeroplane the modern individual attends to everything except herself. The madness of more and more stimulation demands perpetual exaggeration, constantly upping the stakes; one impression chases the next, but they never become proper experiences for the necessary repose is lacking. The natural results are numbness, aloofness, and disgust, and only [artificial] stimulants and sensations have any chance of making an impact.]

This passage echoes the familiar critiques of modernity as a time of sensory overload and mental fragmentation by turn-of-the-century critics such as Simmel and Lamprecht. In the Weimar Republic, the tropes of this discourse are still alive; so what are its implications for the field of photography? Lendvai-Dircksen does not endorse photography movements such New Vision and New Objectivity, which try to attract the viewer's attention through defamiliarizing and disorienting images, presenting 'a world of a strange mixtures of styles, of

[37] His books include the photographically illustrated *Deutsche Physiognomik: Grundlegung einer Naturgeschichte der Nationalgesichter* (Germany Physiognomy: Foundations of a Natural History of National Countenances, 1942). After the First World War, Hellpach had in fact joined the left-liberal German Democratic Party (DDP), for which he served as Education Minister and as President for the state of Baden.

[38] '[...] durch einseitige Aufmerksamkeit und Überlastung'. Erna Lendvai-Dircksen, 'Psychologie des Sehens', in *Theorie der Photographie*, vol. 2: *1912–1945*, ed. Wolfgang Kemp (Munich: Schirmer/Mosel, 1979), pp. 158–62 (p. 159). The article was originally published in the journal *Das deutsche Lichtbild*.

[39] Lendvai-Dircksen, 'Psychologie des Sehens', p. 159.

excessive enlargement, an artificial primitivism',[40] for they only exacerbate the wider problem of perpetual overstimulation. As she warns, this new, artificial aesthetic has even invaded the photographic portrait, which no longer seeks to depict a sitter's individuality but eliminates it, reducing it to 'a socially standardized gesture' and turning faces into masks. The resulting images, she concludes, bear little resemblance to the experiential reality of actual people.[41]

Lendvai-Dircksen's political views are diametrically opposed to Benjamin's and yet her critique chimes with Benjamin's 'Little History of Photography', published in the same year, which is similarly scathing about some of the photographers of New Objectivity, accusing them of prioritizing gimmicky effects over substance.[42] Indeed, just like Benjamin, Lendvai-Dircksen is a great admirer of the work of Hill and Adamson, which she casts as a salutary antidote to the contemporary obsession with an 'empty' kind of experimentation. In a 1935 essay, she writes:

> Der alte, nie übertroffene Octavio *Hill* durfte es sich noch leisten, seine Menschen eine halbe Stunde lang in praller Sonne dem lichtschwachen Objektiv auszusetzen—und welches Leben, welche dokumentarische Gewalt sieht uns aus seinen Bildern an![43]
>
> [The old, never surpassed Octavio *Hill* could still afford to place his people in the direct sunlight for half an hour to expose them to his not very light-sensitive lens—and what life, what documentary force is looking back at us from these images!]

Like Benjamin, Lendvai-Dircksen highlights the authenticity of Hill's portraits, drawing particular attention to their long exposure time. But whereas for Benjamin their sense of stillness is the result of the photographic process, Lendvai-Dircksen casts this repose as an intrinsic quality, as symptomatic of a bygone contemplative age, whose foundations have been eroded in modernity: 'The modern person is no longer able to endure this method. To him, who is distracted, lost to a thousand agendas, lacking nerves and self-control, the camera lens seems like the evil eye'.[44]

[40] '[. . .] eine Welt fremder Stilmischungen, übergrößerter Ausschnitte, künstlicher Primitivität'. Lendvai-Dircksen, 'Psychologie des Sehens', p. 161.

[41] Lendvai-Dircksen, 'Psychologie des Sehens', p. 161.

[42] *BGS* II.1, 383/*BSW* II.2, 526. Benjamin's particular target, here and in his essay 'Der Autor als Produzent' (The Author as Producer, 1934), is August Renger-Patzsch, a prolific photographer and photo-theorist, whose Weimar photobook *Die Welt ist schön* (The World is Beautiful, 1928) was one of the most popular photo-essays of the period.

[43] Erna Lendvai-Dircksen, [untitled], in *Meister der Kamera erzählen: Wie sie wurden und wie sie arbeiten*, ed. Wilhelm Schöppe (Halle: Wilhelm Knapp, n.d. [1935]), pp. 35–41 (p. 37). Unusually for the time, Lendvai-Dircksen largely wrote the prefaces and commentaries for her own photobooks.

[44] 'Der moderne Mensch ist dieser Methode nicht mehr gewachsen. Das Objektiv wirkt auf ihn, der zerfahren, an tausend Interessen verloren, ohne Nerven und Selbstbeherrschung ist, wie der böse Blick'. Lendvai-Dircksen, in *Meister der Kamera*, p. 37.

As she adds in the preface to her 1932 photobook *The Face of the German People*, the only constant in the life of the city dweller is change,

> der Wechsel äußerer und innerer Eindrücke [...]. Nichts kann wahrhaft aufgenommen werden, es bleiben nur flüchtige Oberflächenberührungen, die nicht zum Wesensbestandteil kristallisieren können. [...] Es ist, als ob in Steigerung und Übersteigerung der Stadtmensch zu allem käme, nur nicht zu sich selbst. Er weiß alles, was außerhalb dieses Selbst geschieht; und so ist er immer außer sich, nie in sich.[45]

> [the alternation of external and internal impressions [...]. Nothing can truly be taken in; all that remains are fleeting, superficial encounters, which can no longer crystallize into anything essential. [...] It's as if, in being stimulated beyond measure, the city-dweller has time for everything except for himself. He knows of everything that is happening beyond himself; and hence he is always outside himself, never within himself.]

In drawing an essential distinction between the modern, urban subject and the people portrayed by Hill, Lendvai-Dircksen diverges from Schwarz, who argues that Adamson and Hill had to help their sitters overcome their 'fearful shyness and constraint'.[46] To be sure, the reasons for their self-consciousness were different—a lack of familiarity with the camera, rather than a self-conscious over-familiarity—but in each instance the photographer is facing comparable challenges in trying to produce a 'natural' likeness.

So what is the modern portrait photographer to do in this situation? Is there still a way of producing authentic portraits in inauthentic times? Lendvai-Dircksen offers two possible answers to this question. The first requires the photographer to be highly alert, almost preying on her nervous sitter, in order to capture that rare glimpse of authenticity:

> Da braucht der Fotograf vollkommene Instrumente, um mit List und Überrumpelung den kleinen Moment natürlichen Ausdrucks zu erjagen. Viel kommt dabei auf seine Festigkeit und gespannte Aufmerksamkeit an, auf seine Persönlichkeit, die einem Modell Vertrauen und damit wieder Gleichgewicht geben.[47]

> [The photographer needs perfect instruments to capture, with cunning and sudden attack, that tiny moment of natural expression. Here, much depends on his steadfastness and taut attention, on his personality, which can give a model trust and hence a sense of equilibrium.]

[45] Erna Lendvai-Dircksen, *Das deutsche Volksgesicht* (Berlin: Kulturelle Verlagsgesellschaft, 1932), pp. 4–5.
[46] Schwarz, *David Octavius Hill*, p. 42. [47] Lendvai-Dircksen, in *Meister der Kamera*, p. 37.

To produce such authentic images, then, the photographer needs the very best technology, but ultimately the success of this mission will depend on her strength of personality. Lendvai-Dircksen casts the photographer as a kind of mental and spiritual guide; through attention and steadfastness, s/he can instil a similar state of mind in the sitter. Her second solution is more radical; it involves leaving the city and its nervous inhabitants and heading for the countryside. There, Lendvai-Dircksen found people apparently unaffected by modern life, many of whom had never even encountered a camera.[48] Recording them required a quasi-ethnographic immersion in their way of life in order to gain their trust[49]—a skill which Schwarz also attributes to Hill (Figure 7.5).

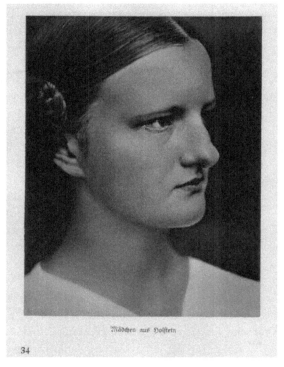

Figure 7.5 Erna Lendvai-Dircksen, 'Mädchen aus Holstein' (Girl from Holstein), *Das deutsche Volksgesicht*, p. 34

[48] 'Im Gesicht des unbewußten, typischen Menschen waltet die Natur und erst mit dem Erscheinen des Geistigen wird das menschliche Antlitz grundanders. Er fängt an, seine Sicherheit zu verlieren'. ('Nature determines the face of the unselfconscious, typical [or archetypal] person; but once the mind begins to dominate, the human countenance changes complete. It begins to lose its certainty'.) Lendvai-Dircksen, *Das deutsche Volksgesicht*, p. 3.

[49] Lendvai-Dircksen, in *Meister der Kamera*, p. 38.

In her rural portraits, Lendvai-Dircksen seeks to present a timeless image of Germany and its people, one which chimed with the Nazis' vision of an Aryan nation rooted in tradition and free from the corrupting effects of modernity. That said, in her search for authentic faces, she was far from alone, and her photographs and essays are part of a much bigger debate about photographic authenticity in Weimar Germany and beyond. Her concerns about the modern, superficial, and decentred subject were shared by critics such as Béla Balázs, Siegfried Kracauer, and Max Picard,[50] while the mission to find faces able to project a sense of authenticity was by no means limited to politically conservative photographers. This was a quest described by none other than the Soviet film director Sergei Eisenstein, who in an interview printed in the socialist newspaper *Die rote Fahne* (The Red Flag) declared that Soviet filmmakers must recruit lay actors—'wahre Menschen' (authentic people).[51] Benjamin echoes this point when he describes the actors of Soviet films as people 'who had no use for their photographs. And immediately the human face appeared on film with new and immeasurable significance'.[52]

Another commentary on the problem of photographic authenticity is offered by the psychologist Ludwig Ferdinand Clauss, who in 1931 published an article on 'Das menschliche Antlitz' (The Human Countenance) in *Das deutsche Lichtbild* (The German Photograph), an influential annual review dedicated to contemporary photography. His contribution underlines how the debate about portrait photography—in its aesthetic and technical dimensions—was infused with psychological questions, in particular with the perceived cognitive challenges of modern life. Like Lendvai-Dircksen, Clauss addresses the problem of the sitter's self-consciousness. As he argues, people's increasing detachment from nature makes it difficult for the photographer to capture a natural expression; the city-dweller is too familiar with the camera and hence tends to pose and try to play a role.

> Es hängt vom verstehenden Takte des Lichtbildners ab, ob es ihm gelingt, das Spiel des Ausdrucks im Antlitz seines Objektes zu lenken: weg von der Kamera und hin zum unbewussten Ausdruck. Wie dies zu machen sei? Es gibt kaum eine

[50] See Béla Balázs, 'Nicht der Maler, der Gemalte ist schuldig', in *Wechselwirkungen: Ungarische Avantgarde in der Weimarer Republik*, ed. Hubertus Gassner (Marburg: Jonas, 1986), pp. 535–6; Siegfried Kracauer, 'Die Photographie', in *Schriften*, vol. 5.2: *Aufsätze 1927–1931*, ed. Inka Mülder-Bach (Frankfurt a.M.: Suhrkamp, 1990), pp. 83–98 (p. 94); Max Picard, *Das Menschengesicht* (Munich: Delphin, 1929), pp. 83–4.
[51] Sergej Eisenstein, 'Zum Prinzip des Helden im Panzerkreuzer Potemkin', in *Schriften*, vol. 2: *Panzerkreuzer Potemkin*. ed. Hans-Joachim Schlegel (Munich: Hanser, 1973), pp. 126–7 (p. 127). Cited in Wolfgang Brückle, 'Schauspiel Authentizität: Die Vermittlung "wahrer" Leidenschaften durch Fotografie und Film der späten Stummfilmzeit', in *Fotografische Leidenschaften*, ed. Katharina Sykora, Ludger Derenthal, and Esther Ruelfs (Marburg: Jonas, 2006), pp. 144–65 (p. 148).
[52] *BSW* II.2, 520; 'die für ihr Photo keine Verwendung haben. Und augenblicklich trat das menschliche Gesicht mit neuer, unermeßlicher Bedeutung auf die Platte' (*BGS* II.1, 380).

allgemeine Regel. Die Wege sind so verschieden wie die Menschen selbst, die wir im Lichtbild erfassen wollen.⁵³

[The photographer's empathetic sensitivity determines whether the sitter's changing facial expressions can be directed: away from the camera and towards unconscious expression. How can this be done? There is virtually no general rule. The routes are as manifold as the people whom we are trying to capture by means of the photographic image.]

Echoing Freudian psychoanalysis, Clauss calls on the photographer to unearth a sitter's 'unconscious' expression as a hidden layer of authenticity. Doing so does not necessarily require the photographer to find her subjects in the countryside, but could also be achieved through a change of photographic technique. This might be a shift from the single portrait to the portrait group or series:

In den seltensten Fällen freilich kann ein einziger Augenblick, auch wenn er 'fruchtbar' ist, genügen, um durch ihn das ganze Wesen eines Menschen zu begreifen [...]. Eine Wendung zur Seite, ein Wechsel der Beleuchtung, ein Umschlagen des Ausdrucks etwa vom Ernste zum Lachen, und schon schwindet der Stil, unter dem wir das Antlitz begriffen und ein neuer Stil bricht gleichsam aus ihm hervor.⁵⁴

[Only in the rarest of cases does one single moment, even if it is highly 'fruitful', suffice to capture the whole essence of a person. [...] One turn to the side, one change of lighting, one shift of expression—for instance from seriousness to laughter—and the countenance's 'style', through which we had understood it, has vanished, and a new style is breaking through.]

Clauss's emphasis on the intrinsic diversity of every human countenance could have been written as a commentary on the work of one of the most idiosyncratic of Weimar photographers: Helmar Lerski (1871–1955), who pushed the concept of the photographic series, of the face as the site of a multitude of expressions, to a new extreme.

[53] Ludwig Ferdinand Clauss, 'Das menschliche Antlitz', in *Das deutsche Lichtbild* (Berlin: Schultz, 1931), [no page numbers]. Cited in Stetler, *Stop Reading*, p. 221.

[54] Clauss, 'Das menschliche Antlitz'. Cited in Stetler, *Stop Reading*, p. 221. In the early 1920s Clauss was Edmund Husserl's assistant; he published several treatises on racial theory and was a sought-after speaker during National Socialism. His approach, which stressed the intrinsic value of different races, put him at odds with Nazi party doctrine, although he did propagate the notion of the Jewish 'race' as inferior and degenerate. See Peter Weingart, *Doppel-Leben: Ludwig Ferdinand Clauss. Zwischen Rassenforschung und Widerstand* (Frankfurt a.M.: Campus, 1995).

Everyday Heads: Sequence and Diversity

Lerski was of the son of Lithuanian Jewish parents, who had made their home in Switzerland. Aged seventeen, he emigrated to the United States, where he became an actor with German theatre troupes. Through his wife, a photographer, he came to photography, and quickly made a name for himself with his unconventional portraits, which broke many established rules of the trade. In 1915, the Lerskis moved back to Europe and settled in Berlin, where he became a cameraman and worked on over twenty silent film productions with renowned directors such as Paul Leni, Berthold Viertel, and Fritz Lang. In the late 1920s, as silent film was replaced by the talkies, Lerski returned to photography. One lucrative line of work, capitalizing on his film experience, was to photograph actors and other Weimar celebrities, and his images were frequently featured in magazines such as *Uhu* and *VU*. Like Lendvai-Dircksen, however, he also pursued his own artistic project alongside this commercial work; like her and other Weimar photographers, Lerski was interested in people unused to the art of posing, but he found such 'authentic' faces not among the rural population but in the city.

Lerski recruited his sitters from the streets of Berlin and from the *Arbeitsnachweis*, the unemployment office. In 1929, a small selection of these portraits appeared in the periodical *Die Form*, and fifteen images were displayed at the Film und Foto exhibition of the same year. A year later, this was followed by a solo exhibition in a small gallery space at the Staatliche Kunstbibliothek (National Art Library) in Berlin. Its director, Curt Glaser, had transformed the Kunstbibliothek into a research library actively engaged with contemporary photography.[55] Glaser curated the exhibition of Lerski's photographic portraits and wrote the preface for the accompanying photobook, through which these images were meant to reach a wider audience. Published in 1931, it was entitled *Köpfe des Alltags* (Everyday Heads), subtitled *Unbekannte Menschen gesehen von Helmar Lerski* (Unknown People Seen by Helmar Lerski).[56] This title seems to align his artistic agenda with New Objectivity, a movement which sought to make visible the unknown aspects of everyday life, but Lerski was in fact a scathing critic of Neue Sachlichkeit, calling its photographic portraits superficial, 'a deformation and annihilation of the individual's real, living features'.[57] Unlike Sander, he does not show his sitters in their

[55] Stetler, *Stop Reading*, p. 137.
[56] Costing 18 marks, the volume was relatively expensive; it appeared with Hermann Reckendorf, a publisher known for major art periodicals such as *Das Kunstblatt* (The Art Journal) and the Werkbund's *Die Form*. A handful of these images had already been on display at the 1930 portrait exhibition *Gezeichnet oder geknipst?* (Drawn or Photographed?), including a portrait of Hermann Reckendorf. See Roland Jaeger, 'Bleibende Dokumente des Neuen Sehens: Der Verlag Hermann Reckendorf, Berlin', in *Autopsie*, ed. Heiting and Jaeger, vol. 1, pp. 248–67 (pp. 255; 261). See also Stetler, *Stop Reading*, p. 138.
[57] '[…] eine Verschandelung und Unterschlagung der wirklich lebendigen Merkmale eines Individuums'. Helmar Lerski's bequest, Museum Folkwang, Essen. Cited in Florian Ebner, *Metamorphosen des Gesichts: Die 'Verwandlungen durch Licht' von Helmar Lerski* (Göttingen: Steidl, 2002), p. 86.

everyday surroundings. He does not portray them as the members of a particular group, does not seek to make faces readable in terms of class, race, or political affiliation. Rather, he emphasizes the endless transformability of the human face, the countless identities and expressions inherent in every countenance. In doing so, he draws on his expertise as a cameraman. The style of his portraits is expressive, even Expressionist, reminiscent of the stills of silent film classics. Indeed, this cinematic quality inheres not only in every single image, but is rooted in Lerski's use of the photo-sequence, the (narrative) series.

Everyday Heads features thirty sitters across a total of eighty portraits. Nearly all subjects thus appear more than once; the portraits of each sitter are printed in succession, as a self-contained series. So who are these people? Lerski does not give the viewer a panorama of German society, but focuses on one particular segment: on the urban proletariat. His subjects include porters and factory workers, market-stall holders and cleaners, vagrants and beggars. They are the kind of people commonly ignored by more affluent passers-by, but Lerski's images bring them almost forcefully to the viewer's attention.

One interesting aspect of his photobook is its attitude towards gender. In Sander's large photographic archive, *Menschen des 20. Jahrhunderts* (People of the Twentieth Century), the male subjects are labelled as bakers, bankers, or doctors; the female ones as mothers, wives, or daughters. In Sander's stratified vision of Weimar society, the working woman is a troubling indicator of change, but Lerski takes a very different approach. Sixteen of his thirty sitters are women, and nearly all of them are characterized by their profession.[58] Women first took up traditionally male roles during the First World War and refused to settle back into the domestic sphere after the war. By the 1920s, nearly a quarter of the Berlin workforce was made up of women,[59] with the largest increase among white-collar workers such as typists, secretaries, and sales staff who are the focus of Kracauer's *The Salaried Masses*. With the exception of one typist, however, Lerski does not focus on this group, but on working-class women such as cleaners, washerwomen, and chambermaids; his line-up also includes a seamstress and a furrier or 'Pelzarbeiterin'. Many of these portraits are extremely androgynous. Indeed, throughout the book, gender difference is underplayed to the point of elimination. This is partially an effect of the photos' expressive lighting and extreme close-up perspective, which excludes features such as clothing and imposes a certain stylistic uniformity across the volume. In addition, several models, both male and female, wear hats or caps concealing their hair, which enforces this sense of androgyny.

Lerski's portraits are grouped not along extra-photographic, sociological criteria, such as regional origin, gender, or profession, but according to purely visual, aesthetic

[58] The one exception is the 'Frau eines Chauffeurs', while the book's penultimate image, showing a young girl, is simply listed as 'Hildchen' (*KA* xi).
[59] Alexandra Richie, *Faust's Metropolis: A History of Berlin* (London: HarperCollins, 1999), p. 349.

principles, creating carefully calibrated and often disorienting effects of contrast and similarity within and between photo-groups. Glasses, for instance, are worn by four sitters—three men and one woman—whose portraits are all assembled in the first half of the book. A typist is shown wearing glasses in the second of her two photos (*KA* 10 and 11); this image is followed by five portraits of a painter (*KA* 12–16), who wears glasses in the first image, though in successive pictures these are pushed up onto his forehead. In the painter's portraits, the glasses add a self-reflexive dimension. In one picture, they mirror the sunlight falling through a window, a feature which, as we will see, is central to Lerski's photographic method (Figure 7.6).

The motif of the glasses thus creates a bridge between the two portrait sequences, while at the same time introducing a sense of diversity into the respective groups. The two portraits of the typist, one showing her with glasses and the other without, but wearing a woollen hat, are so different they are barely recognizable as showing the same person (Figures 7.7 and 7.8).[60]

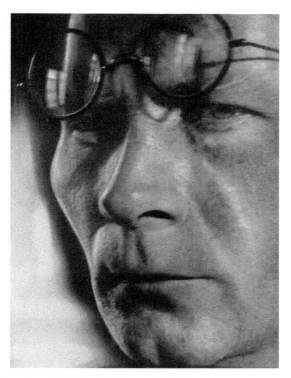

Figure 7.6 Helmar Lerski, 'Maler' (Painter; *KA* 12)

[60] Glasses are also worn by the 'revolutionäre Arbeiter' (Revolutionary Worker, *KA* 21–2) and the 'Wäschefahrer' (Laundry Driver, *KA* 28). The latter, an elderly man, is shown in profile, melancholically gazing downwards, a pose familiar from portraits of intellectuals, such as Gisèle Freund's famous photographs of Walter Benjamin.

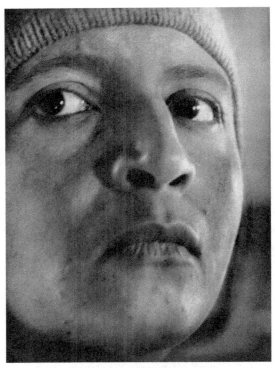

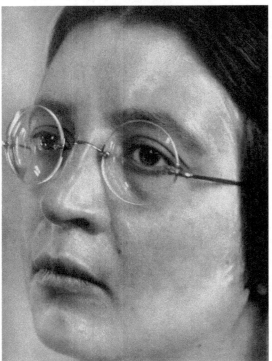

Figures 7.7 and 7.8 Helmar Lerski, 'Stenotypistin' (Typist; *KA* 10 and 11)

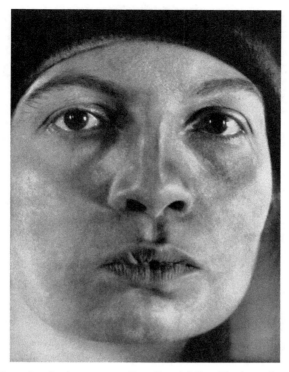

Figure 7.9 Helmar Lerski, 'Frau eines Chauffeurs' (Chauffeur's Wife; *KA* 17)

While some photo-groups are thus extremely heterogeneous, across groups Lerski creates images which are strikingly, disorientingly similar. Thus, the first of the typist's portraits (*KA* 10) looks almost identical to the image of the 'Chauffeur's Wife' (*KA* 17) (Figure 7.9).

In some contiguous groups, these similarities of lighting, angle, and expression make it hard to tell where one sequence ends and the next one begins. This effect can be observed towards the end of the book, where the boundaries between the images a 'Waschfrau' (Washer Woman, *KA* 68–9), a 'Junge Arbeiterin' (Young Female Worker, *KA* 70–1), and a 'Hausangestellte' (Domestic Servant, *KA* 72) are potentially blurred. Another example of this effect can be found in the middle of the book. With ten pictures, the series of the 'Bettler aus Sachsen' (Beggar from Saxony) is the largest in the book (*KA* 33–42); his portraits resemble those of a 'Reinemachefrau' (Cleaning Woman, *KA* 43–9) in terms of their expression of melancholy resignation (Figures 7.10 and 7.11).

These effects would be much less disorienting if the photographs were captioned. But unlike the majority of Weimar photobooks, *Everyday Heads* maintains a strict separation between images and text. The identity of the models—their profession

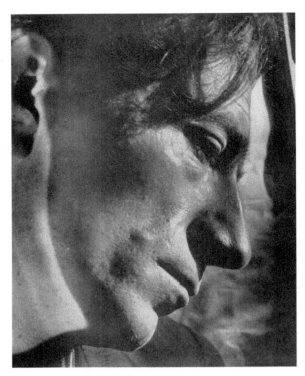

Figure 7.10 Helmar Lerski, 'Bettler aus Sachsen' (Beggar from Saxony, *KA* 41)

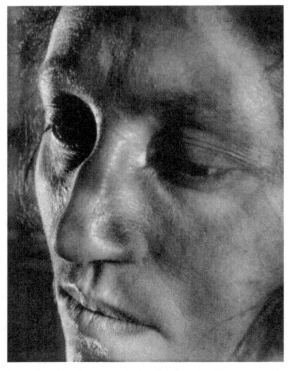

Figure 7.11 Helmar Lerski, 'Reinemachefrau' (Cleaning Woman, *KA* 43)

and sometimes their regional origin—is revealed in a list of captions doubling as a contents page ('Inhalt'), which precedes the photographic plates (*KA* xi).

This list offers a mini-panorama of proletarian Berlin, reminiscent perhaps of a list of job-seekers (or vacancies) displayed at the employment office. It also sums up the underlying principles of Lerski's photobook and its vision of Weimar society. First of all, there is a carefully constructed gender symmetry, which is mirrored by his photos' androgynous style. The list includes a 'Revolutionärer Arbeiter' (Revolutionary Worker) and a 'Junge Arbeiterin' (Young Female Worker), a 'Junger Händler vom Markt' (Young Market Trader) and a 'Junge Obsthändlerin' (Young Female Fruit Seller), a 'Wäschefahrer' (Laundry Driver) and two 'Waschfrauen' (Washer Women). Other structuring principles are age and regional origin.[61] The latter, however, is specified only in the case of the three most destitute sitters, all of them men: the aforementioned 'Beggar from Saxony' as well as a 'Landstreicher aus Schlesien' (Tramp from Silesia), and a 'Junger Bettler aus Bayern' (Young Beggar from Bavaria). In the case of the jobless and homeless, their roots are the only distinctive feature of their identity; by emphasizing their origins in a photobook recorded in Berlin, these captions also gesture towards a prominent concern of the period: the uprooting effects of modernization, whereby individuals leave their (rural) birthplace and end up stranded in the city. This process is made most explicit in the caption 'Bauernsohn, jetzt Gelegenheitsarbeiter' (Farmer's Son, now Occasional Worker). In his preface, art historian Curt Glaser tells a similar story of social decline:

> Da ist einer von vielen, die einstmals im Wohlstand lebten, durch Krieg und Inflation verarmten und zu niederem Berufe sich bequemen mußten. Der Fotograf sieht diesen Niedergang einer Existenz und gestaltet ihn in einer Abfolge von Bildern, indem er das Licht einmal sanft und ruhig, ein andermal hart und flackerig führt. (*KA* vii)
>
> [There is one who, like so many, used to lead a prosperous life but has been impoverished by war and inflation, forced to take on menial work. The photographer sees this decline of someone's existence and renders it in a sequence of images, by directing the light to be gentle and calm in some images, harsh and flickering in others.]

Lerski's photo sequences show people displaced and fallen upon hard times. This was a classic storyline in the Weimar Republic, told for instance in F. W. Murnau's film *Der letzte Mann* (The Last Man, 1924) and Hans Fallada's novel *Kleiner*

[61] Although there are various older sitters, the captions only single out a sitter's youth, as in the case of the 'Junger Händler vom Markt', the 'Junge Obsthändlerin', the 'Junge Arbeiterin', and the 'Junge Verkäuferin'. The depiction of mostly young sitters contrasts with the pronounced and explicit focus on old faces in Lendvai-Dircksen's *Deutsches Volksgesicht* as well as in Erich Retzlaff's 1930 *The Countenance of Old Age*.

Mann, was nun? (Little Man—What Now?, 1932).⁶² Glaser's preface and the accompanying captions hint at a socially critical message, but the images themselves pull in a different direction. With their expressive style, they challenge the readability of the face and the associated notion that a person has a fixed place in society, showcasing instead their almost unlimited transformability.

Contemplation: Historical Models

Reading any photobook is to be torn between movement and stillness. On the one hand, the viewer wants to move from page to page, seeing the images as an unfolding sequence; on the other, there is the desire to pause and immerse oneself in a particular photo, isolating it from its wider context. Lerski's book plays with and enhances this tension. The arrangement of the portraits into mini-series lends the viewing experience a dynamic, quasi-filmic character, and yet the separation of images and text makes this experience disorienting, for it compels the viewer to go back and forth between photos and captions in order to put names (or professions) to these arresting faces. What is more, the arrangement of the photos on the page also counteracts this sense of flow, for both the size of the images—Lerski uses two different formats, 18 × 24 cm and 24 × 30 cm—and their placement on the page differs from one page to the next. Their positioning may seem random at first sight, but it is in fact carefully calibrated to create certain effects. As Stetler notes, 'the heads are often positioned to balance and complement the image's location on the page', so that a sitter looking down towards the left is placed towards the top-right-hand corner of that page.⁶³ Overall, though, the images' varying size and location makes for a discontinuous viewing experience, whereby turning from one page to the next creates a subtle jerk. *Everyday Heads* keeps its readers on their toes, compelling them to continually adjust their focus rather than letting the portrait series unfold as smooth sequences, in the manner of the proto-cinematic flick-book or *Daumenkino*.

That said, the portraits' sequential arrangement and the resulting synergies between images is at odds with the emphasis given to each individual picture. Every plate, as already mentioned, takes up a double page, printed *recto* and faced by a blank page on the left. By isolating the individual images in this way, Lerski gives them space for maximum effect. In these portraits, the play with light and darkness, surface and depth, lends the depicted faces an almost epiphanic character, whereby a starkly lit centre seems to emerge from a dark and blurry backdrop.

Compared to Sander's detached documentary style, Lerski's portraits are striking, intimate, and unsettling in their closeness and level of textural detail. His

⁶² For details of Lerski's use of this and other narrative tropes, see Carolin Duttlinger, 'From Photography to Film and Back Again: Helmar Lerski's Dramaturgy of the Human Face', *Monatshefte*, 109 (2017), 229–42.

⁶³ Stetler, *Stop Reading*, p. 147.

models are ordinary people, but their portraits are far from ordinary. The subtitle, *Unknown People Seen by Helmar Lerski*, pits the models' anonymity against the photographer's creative vision. This contrast is echoed in the book's preface. Contrary to other photography critics, who describe the autonomy of the camera, its ability to produce pictures almost without the knowledge of its operator, Glaser stresses Lerski's supreme control over his tools:

> Die technischen Mittel, derer sich Lerski bedient, gründen sich auf die Ausnützung der äußersten Möglichkeiten des Apparates. Das Bild [...] wird mit der höchsten erreichbaren Schärfe und Genauigkeit auf der Platte fixiert. So wird in diesen Bildern nichts verschwiegen und nichts hinzugefügt, nichts verschönert und nichts vertuscht. Die Linse rückt so nahe, daß die Poren der Haut wie unter einem Vergrößerungsglas erscheinen, und daß selbst die größte Platte oft nicht den ganzen Kopf erfaßt. Es muß ein Stück von dem Kinn oder dem Schädel geopfert werden, aber wenn Augen und Mund und Nase als Träger des Ausdrucks um so stärker erscheinen, ist der Verzicht gerechtfertigt, der zugleich Konzentration bedeutet. (*KA* ix)
>
> [Lerski's technique exploits the technological possibilities of the apparatus to the full. The image [...] is fixed onto the plate with the greatest possible sharpness and precision. In this way, nothing is excluded and nothing is added in these pictures, nothing is beautified and nothing redacted. The lens gets so close that the pores of the skin appear as if under a magnifying glass, and even the largest plate cannot capture the entire head. Hence a piece of the chin or the skull has to be sacrificed, but if the eyes and mouth and nose gain even greater prominence as the bearers of expression then this justifies reduction, which at the same time means concentration.]

This intensity of focus, however, comes at the expense of context and recognizability. Lerski's sitters are 'unknown people', part of the urban masses, yet even if a reader happened to know one of the models, he or she might be hard pressed to recognize them in these pictures. Where Sander and Lendvai-Dircksen aim for the single, characteristic portrait in an attempt to extrapolate trans-individual features, Lerski's photographs challenge the notion of identity as coherent and stable and with it the use of photography to categorize, and potentially police, identity. That said, this approach throws up its own aesthetic as well as ethical questions. With their expressive lighting, their extreme close-ups and dramatic camera angles (from below or above, but rarely at eye level), the images have a 'signature style' and with it a certain uniformity. By showing the many facets of every face, Lerski's portraits dissolve identity as a recognizable, clearly delineated entity, offering instead a panorama of expressions and emotions.[64]

[64] This is an experiment which Lerski took to an extreme when he was living in Palestine, where in 1936 he spent three months photographing the same sitter, the young Swiss-born engineer Leo

Ultimately, though, the hypnotic effect of these pictures is not solely the result of the photographer's creative vision, for this effect is very much tied to the sitters' presence in the pictures—their posture and expression. Lerski's models display a wide range of emotions. Some look angry, others serene, many of them melancholy or resigned. Common to all portraits is a sense of inwardness, a state of deep contemplation; the majority of models gaze downwards or into the distance, and several subjects are shown with their eyes closed. The two portraits of the reporter (*KA* 50–1) and the subsequent image of a washerwoman (*KA* 52) form an eerie little sequence, for they are reminiscent of images of death masks, which were a popular subject of Weimar photobooks[65] (Figure 7.12).

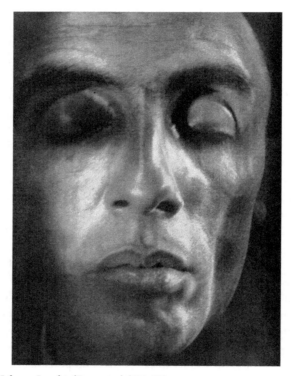

Figure 7.12 Helmar Lerski, 'Reporter' (*KA* 50)

Uschatz, on the rooftop of his studio in Tel Aviv. These images, assembled in the photobook *Verwandlungen durch Licht* (Transformations through Light), were never published during his lifetime. For a detailed account of the project, see Ebner, *Metamorphosen*.

[65] Several photobooks of death masks were published in the 1920s. They include Ernst Benkard, *Das ewige Antlitz: Eine Sammlung von Totenmasken* (Berlin: Frankfurter Verlags-Anstalt, 1926); Richard Langer, *Totenmasken* (Leipzig: Thieme, 1927); and Emil Schaeffer, ed., *Das letzte Gesicht* (Zurich: Orell Füssli, 1929). Alfred Döblin discusses death masks in his preface to August Sander's photobook, *Face of Our Time*. Alfred Döblin, 'Von Gesichtern, Bildern und ihrer Wahrheit', in *Kleine Schriften*, vol. 3, ed. Anthony W. Riley (Zurich: Walther, 1999), pp. 203–13.

Crucially, none of the subjects look straight at the camera; in the few photos where the model seems to look towards us, they in fact look *through* rather than *at* the viewer. Here, it is useful to place Lerski's photobook within a wider art historical context, for his images both echo and defy previous approaches to portraiture.

As Michael Fried has explored, contemplation became a major subject in French painting in the eighteenth century, when artists such as Jean-Baptiste Greuze and Jean-Baptiste-Siméon Chardin showed people in states of deep absorption. Subjects range from everyday domestic scenes—Chardin's *Le Château de cartes* (The House of Cards, 1737) and Greuze's *Un écolier qui étudie sa leçon* (A Pupil Studying his Lesson, 1757)—via strong emotions—Greuze's *Une Jeune fille qui pleure son oiseau mort* (Young Girl Crying for her Dead Bird, 1765)—to attending to the word of God.[66] The effect of these paintings is two-fold. By depicting people who are unaware of their surroundings, the painting effectively negates the presence, indeed the existence, of the observer. In a second step, however, the subjects' oblivion facilitates the opposite effect. In their state of immersion, they are unaware of potential observers, which in turn legitimizes our presence within the world of the painting. Not only does their contemplation enable us to study the painting at length, but their immersion becomes a source of fascination in its own right, a state of mind which, according to Fried, is mimetically emulated by the viewer: 'because his presence was neutralized in that way, the beholder was held and moved by Greuze's paintings as by the work of no other artist of the time'.[67] The deep immersion of the depicted person(s) is the actual subject of the painting, its enigma and source of fascination. By immersing ourselves in the painting, we partake in this mental state.

The similarities between these eighteenth-century paintings and Lerski's photographs are readily apparent; just as important, however, are their differences, which are material as well as cultural and psychological. Even if a painting is based on a real-life scene, it remains an invention, a product of the artist's creative imagination. The (analogue) photograph, in contrast, is indexically tied to its referent, to the physical reality which has left its imprint on the film. Lerski's sitters were once actually present in front of the camera, and this presence becomes tangible in and through the close-up perspective. Eighteenth-century paintings maintain a certain distance even when they depict an intimate scene;

[66] An example of the latter is Greuze's *La lecture de la Bible* (Reading the Bible, 1755). Fried locates the roots of this theme in the previous century: 'on examination it turns out that subjects involving absorptive states and activities are present in abundance in earlier painting, and that in the work of some of the greatest seventeenth-century masters in particular—Caravaggio, Domenichino [...], Vermeer, and, supremely, Rembrandt come at once to mind—those states and activities are rendered with an intensity and a persuasiveness never subsequently surpassed'. Michael Fried, *Absorption and Theatricality: Painting and Beholder in the Age of Diderot* (Berkeley, CA: University of California Press, 1980), p. 43.

[67] Fried, *Absorption and Theatricality*, p. 69.

Lerski's photography, in contrast, destroys this illusion of the 'fourth wall' and with it the voyeuristic pleasure of looking at people who are physically present but mentally absent, unaware of our gaze. His intimate portraits are the result of an equally intimate, almost intrusive recording situation. Lerski used no zoom, and all the photos in his book are contact copies. The camera's extreme closeness to the sitter is thus at odds with their apparent oblivion of the photographer's (and viewer's) presence.

The eighteenth century, as outlined in Chapter 1, knew contemplation to be unstable and vulnerable to disruption, but the subject's fundamental *capacity* to enter into such a state, given the right conditions and (self-)education, was taken as read. In the twentieth century, in contrast, contemplation was regarded very much as the exception, as an elusive state associated with a different place or time. The models' absorption, which links Lerski's portraits to these eighteenth-century paintings, thus also underlines the differences between them. The contemplation depicted by painters such as Greuze and Chardin always has a particular focus—an object, an activity, a memory, or God. In Lerski's portraits, no such object is visible or made otherwise apparent (for instance, via a caption). His photos depict an 'empty' kind of immersion with no ostensible cause or focus—an immersion which is arguably the result of the photographic process itself.

In technical terms, then, Lerski's portraits are not modelled on eighteenth-century painting; rather, they echo early photography, and specifically the portraits of Hill and Adamson, which are assembled in Schwarz's photobook published in the same year as *Everyday Heads*. The absorbed, dreamy, or vacant expression of Lerski's subjects and their physical posture recall Hill and Adamson's portraits. Some of the photographs printed in Schwarz's photobook, such as the 'Lesender Herr' (Reading Gentleman) and 'Master Hope Finlay',[68] show the model immersed in a book; the majority of sitters, however—including for instance John Ruskin and a 'Young Woman'[69]—do not focus on anything in particular but simply gaze downwards or into the distance (Figure 7.13).

Just like in *Everyday Heads*, every image in Schwarz's photobook has a double page to itself, and sometimes a mini-sequence hints at a sustained state of immersion, as in the case of 'Mrs Rigby', who appears in three successive plates. While the first of these is a full-body portrait, the second moves closer, showing us a half-portrait of the sitter's profile, while in the third she is turned towards the viewer, but does not actually look at the camera.[70]

Several of the technical aspects described by Schwarz also apply to Lerski's work. Schwarz's argument that Hill and Adamson did not drag people 'into a harsh light that destroys all mystery', but stuck with more 'primitive technical means' even at a time when technological advances allowed the photographer to

[68] Schwarz, *David Octavius Hill*, pp. 73; 40. [69] Schwarz, *David Octavius Hill*, pp. 59; 66.
[70] Schwarz, *David Octavius Hill*, pp. 15–17.

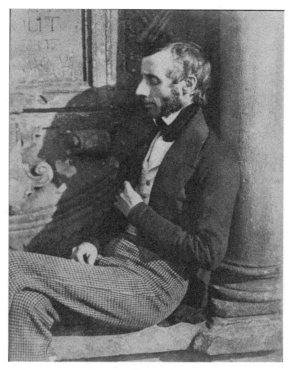

Figure 7.13 David Octavius Hill and Robert Adamson, 'Captain Wilkie (or Captain Sinclair). Has been called "John Ruskin"' (1843–7)

'conquer darkness and record phenomena as if in a mirror',[71] resonates with Lerski's play with light and shade. His faces emerge from the surrounding darkness, sharply lit and defined at the centre, but blurred around the edges. Most importantly, Lerski also relied on what Schwarz calls 'the blazing sunlight', 'das pralle Sonnenlicht', to create these effects. His studio was south- rather than north-facing, and he directed the sunlight with the help of screens and mirrors to create the desired effects. This was an extremely laborious process, and so each recording session took around two hours. In addition, Lerski used large glass plates requiring an exposure time of up to fifteen seconds.[72] By picturing each sitter in a series of photographs, he gives his portraits a sense of temporal expansion, showing contemplation as it unfolds across—and between—several images. In this way, the photo-groups capture something of the models' experience of sitting still for extended periods.

[71] Schwarz, *David Octavius Hill*, p. 40.
[72] *KA* viii. See the account by Reni Mertens and Walter Marti, based on conversations with Lerski: 'Lerskis Technik der Porträtaufnahme', in *der mensch—mein bruder: Lichtbilder von Helmar Lerski*, ed. Anneliese Lerski (Dresden: Verlag der Kunst, 1958), pp. 120–1.

Lerski thus emulates Hill and Adamson's work in both technique and expression. Indeed, there is an artistic genealogy which connects his portraits to the Scottish photographers. During his time in the United States, when he had only just started experimenting with photography, Lerski met the German photographer Rudolph Dührkoop, a leading figure of pictorialism. Dührkoop had first attracted attention in the early 1900s with portraits of his daughter Minya and her friends, which showed them in self-absorbed poses, apparently unaware of the camera[73] (Figure 7.14).

These images proved highly controversial, with critics calling them provocative and almost offensive. The contrast to the self-consciously posed studio portraits of the age is striking indeed—as are the resonances with Hill and Adamson's work, which Dührkoop encountered at the 1899 photography exhibition at the Hamburger Kunsthalle; their style of photography greatly influenced Dührkoop's own contemplative portraits.[74]

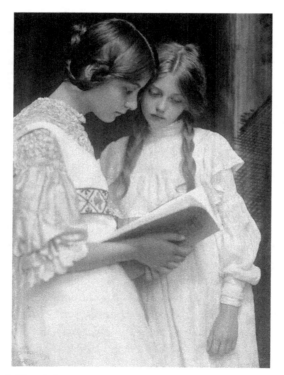

Figure 7.14 Rudolf Dührkoop, 'Gertrude and Ursula Falke' (1906)

[73] See Michel Frizot, *A New History of Photography* (Cologne: Köhnemann, 1998), p. 498.
[74] The curator of the exhibition was the art historian Alfred Lichtwark, who emphasized the independence of Hill and Adamson's portraits from the paintings of their time: 'Männer und Frauen sitzen wie mit sich selbst beschäftigt oder in ein Buch vertieft, als hätte sie niemand beobachtet' ('Men

In his memoirs, Lerski credits Dührkoop and his daughter Minya—who later became a prominent photographer in her own right—with encouraging him to pursue his own unorthodox method.[75] A direct line thus leads from Hill and Adamson via Dührkoop to Lerski, and yet their respective portraits are also very different from each other. Schwarz writes that Hill's camera 'keeps a discreet distance',[76] and Dührkoop similarly liked to portray his models from mid-distance, so as not to disturb their state of reflection. Lerski, in contrast, shows no such restraint. His camera invades the sitters' space, and its physical closeness jars with their apparent oblivious absorption. The sense of inwardness which links his portraits to their painted and photographic predecessors also highlights the differences between these respective traditions. The contemplation captured by Lerski emerges from a different context and has very different aesthetic, psychological, and moral implications.

Drugged and Exhausted?

Following the publication of Schwarz's photobook, Hill and Adamson's portraits were frequently held up as emblems of an authenticity and contemplative stillness that, it was felt, were lost in the modern age. However, while Weimar photographers and critics agreed on the importance of their work, they differed in their assessment as to how it could be emulated. Lendvai-Dircksen, as already mentioned, was a prominent voice in the chorus praising Hill and Adamson; she cast her own rural portraits as an attempt to resurrect the authenticity of these earliest photographs. In justifying her own approach she turned against other contemporary photographers who pursued a different path. Prior to 1933, this critique was phrased in general terms and broadly aimed at the 'empty' experiments of New Objectivity. After 1933, it became more targeted, directed specifically against the work of Helmar Lerski.

The first of these attacks can be found in a keynote address Lendvai-Dircksen delivered soon after the *Machtergreifung*, in May 1933, at the Gesellschaft deutscher Lichtbildner (Society of German Photographers [literally: Creators with Light]), of which she had been a member since 1924.[77] The Society's first

and women are sitting turned in on themselves or immersed in a book, as if no one were watching them'). Cited in Enno Kaufhold, 'Wir trauten', pp. 36–7.

[75] Helmar Lerski, 'Helmar Lerski über sich selbst', in *der mensch—mein bruder*, ed. Lerski, pp. 14–19 (p. 16).

[76] Schwarz, *David Octavius Hill*, p. 40.

[77] Founded in 1919, this elitist organization saw itself as the protector of photographic traditions, particularly during the Conservative Revolution of 1929-32, which in Weimar Germany turned against initiatives such as the labour movement, social democracy, and the Treaty of Versailles, and which saw Jewish people as the embodiment of these corrosive tendencies. See Sarah Jost, 'Unter Volksgenossen: Agrarromantik und Großstadtfeindschaft', in *Menschenbild und Volksgesicht: Positionen zur Porträtfotografie im Nationalsozialismus*, ed. Falk Blask and Thomas Friedrich, special issue of

order of business was the 'purification' of German portrait photography; Lendvai-Dircksen's keynote 'stressed the importance of photography and physiognomic theory in the new regime'.[78] She advances this argument through a vitriolic attack on Lerski's *Everyday Heads*.

Before doing so, however, she first professes her admiration for Lerski's 'phenomenal skill' and admits that she feels deeply divided about his portraits: 'the achievement is there, the semblance of truth is there, but it is not truth itself, and in any case the path leading towards it is an extremely dangerous one which almost belongs into the field of experimental psychology'.[79] Here, Lendvai-Dircksen draws a revealing analogy. Though the manipulation of the subject in psychological and medical experiments is more radical and sustained, both settings require the individual to sit still for extended periods of time, and both are sites of physical and mental conditioning.

There is, however, a crucial difference between the contexts. In psychological experiments physical immobility is meant to facilitate mental focus; in Lerski's studio, the envisaged effect is not attention but a vacant state. This, at least, is Lendvai-Dircksen's take on his approach. In his studio, she claims, Lerski used

> Kunstmittel [...] die mit Suggestion gleichlaufen [...]. Er nahm sich Arbeitslose, also die des regelnden Anstoßes durch Arbeit Beraubten, also die Zeitlosen, der Zeit Ledigen. Er ließ sie stundenlang warten, ermüdete sie, benebelte sie mit dem leichten Narkotikum einer Zigarette, einer Tasse starken Kaffees und dramatisierte nun eine Psyche in diese Gesichter herauf [sic], von der im Alltäglichen keine Spur war. Es könnte aber auch sein, daß Lersky [sic] sein eigenes Temperament in die Leere dieser Gesichter hineinsuggeriert, die nun zum buntschillernden Spiegel fast bühnenhafter Beredtsamkeit wurden.[80]

> [artificial means [...] which amount to suggestion [...]. He took unemployed people, those deprived of the regulating incentive of work, the time-less, those lacking [a sense of] time. He made them wait for hours, tired them out, clouded their minds with the light narcotics of a cigarette, a cup of strong coffee, and then dramatized into these faces an inner life [a psyche], which bore no traces of everyday life. It is also possible, however, that Lersky [sic] projected his own

Berliner Blätter: Ethnographische und ethnologische Beiträge, 36 (2005), 105–20 (p. 112); and Stefan Breuer, *Anatomie der konservativen Revolution* (Darmstadt: Wissenschaftliche Buchgesellschaft, 1993), pp. 49–50.

[78] Leesa Rittelmann, 'Facing Off: Photography, Physiognomy, and National Identity in the Modern German Photobook', *Radical History Review*, 106 (2010), 137–61 (pp. 137–8).

[79] '[D]ie Leistung ist da, der Wiederschein der Wahrheit ist da, aber es ist nicht Wahrheit selbst, jedenfalls ist der Weg ein äußerst gefährlicher und gehört fast in das Gebiet der Experimentalpsychologie'. Erna Lendvai-Dircksen, 'Über deutsche Porträtphotographie', *Das Atelier des Photographen*, 40:6 (1933), 72–4; 40:7 (1933), 84–6 (p. 84). Cited in Rittelmann, 'Constructed Identities', pp. 261–2.

[80] Lendvai-Dircksen, 'Über deutsche Porträtphotographie', p. 84. Cited in Rittelmann, 'Constructed Identities', pp. 261–2.

temperament into the emptiness of these faces, which now became the iridescent mirror of an almost theatrical eloquence.]

Art, or artistic means, are here equated with artificiality. Unlike in Hill and Adamson's case, Lerski's drawn-out sessions are not born out of genuine technological necessity (the time-consuming measures required to direct the sunlight; his use of glass plates with a long exposure time), but are simply designed to tire out the subject, an effect exacerbated by the use of 'mild narcotics', of caffeine and nicotine. All of these details serve to drive home one point: for Lendvai-Dircksen Lerski's expressive and yet strangely inward faces do not reflect a 'natural' repose, but are the product of physiological and psychological manipulation. Yet in contrast to the psychological laboratory, the individual here is not even expected to perform a particular task, but is meant to be completely passive.

Lendvai-Dircksen's diatribe is no doubt motivated by ideology, including racist prejudice, and by her own, conservative vision of portrait photography and its rightful, 'authentic' subjects. Yet her attack also speaks of a troubling, but disavowed, sense of affinity with Lerski's style and method, of a shared sense of artistic purpose. Her own inaugural photobook, *Face of the German People*, appeared only one year after Lerski's award-winning *Everyday Heads*; in her preface, she describes her aims and ambition in revealing terms:

> Es ist versucht worden, [...] das deutsche Volksgesicht in einer Bilderfolge zu Anschauung zur bringen [sic], in der bis auf wenige Ausnahmen die Darstellung des Antlitzes das Thema allein bestreitet. Es ist vermieden worden, den Menschen in einem Bewegungs- und Tätigkeitsaugenblick abzubilden, weil das von der Hauptsache abgelenkt hätte.[81]
>
> [It has been attempted [...] to make the face of the German people visible by means of a series of images, in which, with a few exceptions, the human countenance is the sole subject. The sitters are not depicted in a moment of movement or activity, for this would have distracted from the main issue.]

With its emphasis on image sequences, on the depiction of the face rather than the whole body, and on the passivity and restfulness of the models, this description could just as well apply to *Everyday Heads*. Lerski and Lendvai-Dircksen are situated at opposite ends of the political spectrum, and while their respective photobooks reflect their politics, they also share important similarities—most importantly, a quest for authenticity and immediacy, for sitters who are unselfconscious and can project a sense of presence akin to that of Hill and Adamson's subjects. *Everyday Heads* is thus the negative, the inverse Doppelgänger, of *The*

[81] Lendvai-Dircksen, *Das deutsche Volksgesicht*, p. 12.

Face of the German People, as both photobooks share a contemplative aesthetic, a quest to project a sense of stillness and inwardness (see Figure 7.5).

Three years later, in an essay on photographic method, Lendvai-Dircksen repeats her attack on Lerski, this time adding to it a photo-historical dimension. Describing the restlessness of modern city-dwellers, which makes them unable to sit still for any period of time, she concludes:

> Die nächstliegende Forderung wäre es dann, lange zu belichten, um dem Menschen Zeit zu sich selbst zu geben. Das kann kein Fotograf, es sei denn, er griffe zu Kunstmitteln, zu psychologischen Experimenten, wie sie z. B. Lerski angestellt hat, als er seine Modelle durch stundenlanges Warten ermüdete, mit Kaffee und Zigaretten narkotisierte und schließlich zum willenlosen Stoff machte, dem er seine Form einprägte. Eine Leistung, aber alles andere als lebendige Wirklichkeit, als Wahrheit.[82]

> [The obvious requirement might be to expand the exposure time, in order to give the sitter time to come to herself. No photographer can do this, except by resorting to artificial means and psychological experiments of the kind carried out by Lerski, for instance, who tired out his models by making them wait for hours, drugging them with coffee and cigarettes, and finally turning them into mindless matter onto which he could imprint his mark. An achievement, perhaps, but the opposite of living reality or truth.]

One way of producing 'authentic' portraits in the modern age, Lendvai-Dircksen concedes, would be to emulate the early photographers, returning to the long exposure times of old, which gave sitters time to come to stillness. Time, however, has moved on; so has photographic technology, and so have the people depicted. In the present day, she argues, stillness can paradoxically be achieved only with the help of artificial stimulants and other forms of psychological manipulation.

Lendvai-Dircksen's accounts of Lerski's photography sessions could be ascribed to spite and dismissed as slander, were it not for the fact that they resonate closely with the description given by Glaser. He too stresses the fundamental passivity of Lerski's sitters:

> Denn der Mensch spielt nicht mit in diesem Drama des Lichtes. Er wird nicht aufgefordert, sich so oder so zu stellen oder seine Züge zu verändern. Er sitzt ruhig, und dadurch daß er lange sitzen muß, weil die Prozedur schwierig ist und auch die Zeit der Belichtung nicht kurz sein darf, entspannen sich seine Züge, gewinnen jenen neutralen Charakter, den der Fotograf braucht, da er ihnen selbst den Ausdruck geben will, den er in sie hineinsieht. (*KA* vii)

[82] Lendvai-Dircksen, in *Meister der Kamera erzählen*, p. 37.

[For the subject does not perform in this drama of light. He is not asked to stand in such and such a way or to change his expression. He is sitting quietly, and because he has to sit for a long time, for the procedure is difficult and the exposure time must not be short, his features relax and take on that neutral character needed by the photographer to give them the expression he sees in(to) them.]

Glaser stresses the theatrical quality of these images, calling Lerski's photography a 'drama of light', but he notes that his subjects are not actors—indeed, that they are strictly forbidden from enacting different emotional states. Lerski's method requires the models to be entirely passive, and where Lendvai-Dircksen describes these faces as empty, mere mirrors of the photographer's vision, Glaser speaks of their relaxed and neutral expression. More importantly, he confirms Lendvai-Dircksen's core claim; Lerski's drawn-out recording sessions are not solely owed to technical factors, but have a psychological rationale—to make the models relax, lose their self-consciousness. And where Lendvai-Dircksen accuses Lerski of turning his models into 'mindless matter', Glaser writes that for Lerski 'the model is nothing more than raw material, shaped by the creative will'.[83] The human being as clay, as shapeless, amorphous matter—this narrative, with its overtones of the Book of Genesis,[84] strips the individual of all agency, making him or her the product of the photographer as (divine) creator.

Indeed, going further than Lendvai-Dircksen, Glaser regards this passivity as neither artificially induced nor temporary, but as part of these sitters' very essence and identity. Lerski's models are 'people whom no one knows, who do not know themselves'; this oblivious state makes them 'the best conveyors of this new and unique form of art through light'.[85] For Glaser, the photographer's challenge is not to *make* his sitters lose their self-consciousness, for they have no self-awareness and are hence indifferent to what is happening to them: 'they know nothing of the roles they are playing, and they do not care whether theirs is a true likeness, for they do not know themselves'.[86]

With these astonishing remarks, Glaser gives two conflicting accounts of the recording process and its underlying psychology. Like Schwarz in his description of Hill and Adamson's method, he notes that sitters first have to be settled down so they can become restful and relaxed, and yet he also casts these sitters as blank

[83] '[...] ist das Modell nicht mehr als ein Rohstoff, den zu formen Aufgabe des gestaltenden Willens bedeutet' (*KA* vi–vii).

[84] 'Then the Lord God formed a man from the dust of the ground and breathed into his nostrils the breath of life, and the man became a living being' (Gen. 2:7).

[85] '[...] Menschen, die niemand kennt, Menschen, die sich selbst nicht kennen'; 'die besten Träger dieser neuen und besonderen Art der Lichtkunst' (*KA* ix).

[86] '[S]ie wissen nichts von den Rollen, die sie hier spielen, und es kümmert sie nicht, ob ihr Bildnis ähnlich wurde, da sie sich selbst nicht kennen' (*KA* ix).

slates, as mindless matter without an inner life, without self-knowledge, and hence without a claim to their own image.[87]

Glaser's words strike an uncomfortable note and undermine the book's self-proclaimed socially critical agenda. He declares that Lerski is not interested in his models as people, but only in their faces as material for his dramatic visions:

> Da ist ein Straßenkehrer, der in seinem ganzen Leben den Kopf nicht aufzuheben wagte. Die Kamera richtet ihn auf, und ein Diktator könnte ihn um sein herrisches Profil beneiden. Da ist eine Waschfrau, die weiß, daß ihre Züge hart und knochig sind. Das Licht verschönt sie, und das Objektiv läßt sie edel und rein erscheinen. Ein Bettler wird, wenn der Apparat ihn umwandert [. . .], zu einem Meisterschauspieler, der soviele Rollen darstellt, wie er Aufnahmen hergibt. Ein junger Arbeiter erscheint, wenn das Licht ihm aus der Tiefe flackernde Helligkeit in das Profil zeichnet, wie eine Gestalt aus einem revolutionären Drama. (*KA* viii–ix)
>
> [There is a street sweeper who in his entire life has never dared to raise his head. The camera lifts it up, and a dictator could envy him his imperious profile. There is a washerwoman who knows that her features are hard and bony. The light makes her beautiful, and the lens makes her appear noble and pure. A beggar, encircled by the camera [. . .], becomes a master actor, who plays a different role in every portrait. A young worker appears, when the light draws a flickering kind of brightness into his profile from below, like a figure from a revolutionary drama.]

Lerski's expressive portraits draw on and evoke a cultural iconography, an archive of roles and faces, such as the Madonna, the revolutionary, and the dictator. They challenge the period's obsession with physiognomy, with the social and political readability of the face, instead casting the self as infinitely transformable. And yet this discourse carries its own, uncomfortable overtones of conditioning, manipulation, and appropriation—aspects seized upon by Lendvai-Dircksen.

Indeed, Lerski's photographic project is situated somewhere between art and science—between a theatrical, expressive aesthetic and the tradition of a 'scientific' photography used for the disciplinary conditioning of the human subject. Duchenne's electrode portraits form part of this tradition; their depiction of a panorama of human expressions divorced from an inner, emotional impulse prefigures Lerski's portrait sequences. Though his images are arranged according to sitter rather than expression, the calibrated effects of similarity and contrast within and between groups lend his photobook a similarly experimental character, one which emphatically abstracts from the individual. Like Duchenne, then,

[87] The search for the authentic, unselfconscious subject, the authentic face, was a recurrent theme not just in photography but also in film. For an account of this debate, see Brückle, 'Schauspiel Authentizität'.

Lerski uses the photographic process to condition the subject, producing images in a carefully controlled experimental environment. That said, there is another way of looking at his recording sessions and the resulting portraits: one which undermines the intentions of the photographer and ascribes to the images, and their subjects, a different, subversive kind of agency.

Lerski's sitters are no ordinary city-dwellers. They are, as already mentioned, destitute, recruited from those at the bottom of German society at the height of the Great Depression. Lendvai-Dircksen calls them 'the time-less, those lacking [a sense of] time', but in fact for the majority of them life was not lived 'outside' time in the modern, accelerated sense, but at its very centre. For Lerski's sitters, life was a relentless struggle, a rat race to survive from day to day. Against this backdrop, the recording session appears in a different light. Lendvai-Dircksen accuses Lerski of exploiting and exacerbating his models' general exhaustion: 'He made them wait for hours, tired them out'. This description evokes the long, futile wait at the employment office and at other bureaucratic institutions. But there is a different way of reading this experience. For these sitters, the recording sessions were arguably not an extension of their daily travails, but a brief respite, an opportunity to come to stillness, to do and think (of) nothing. Something of this state comes through in the photos. Beneath the vivid expressions, which are so virtuosically captured by Lerski's camera, there remains an underlying void. This inner state in some ways resembles the contemplation which is so palpable in older portraits, but it is also different—empty, enigmatic, and uncomfortable.

Looking at Photographs

The resonances of Lerski's work extended beyond Weimar Germany. In a 1931 review, Ken Macpherson, editor of the British avant-garde journal *Close Up*, describes his experience of leafing through *Everyday Heads*:

> Turning the pages is to enter a world of dream speculation [...]. A kind of fenland, bleak, massive and mysterious. There is something that arrests in the so examinable detail of these heads, something almost telescopic, nearness that seems to be about to topple on you.[88]

Macpherson describes the vertiginous sensations triggered by Lerski's portraits, which seem to oscillate between distance and nearness. In his account, he goes one step further than Glaser. Lerski's close-ups dissolve the depicted faces until they

[88] Kenneth Macpherson, 'As Is', *Close Up*, 8 (September 1931), 220–5 (p. 224). As he adds, through the 'wilful drama of lighting and tonal quality' Lerski allows the faces 'to find, like water, their own level of expression'.

come to resemble landscapes, aerial photographs perhaps. Macpherson feels the images 'toppling' onto him, a kinetic effect which brings back long-forgotten memories:

> In the 'planetary'—the telescopic—quality I have mentioned lies perhaps a rather significant truth. That these faces, more than normally abstract, intimate and unconcerned, as far as scrutiny carries effect—are like the faces we studied as children, when faces were stranger, more to be wondered at, stared at, explored, than at any other time in life. Perhaps part of the secret of this intimacy—part of the mystery and power—is sealed in this fact. We have access to these personalities as only children have, and knowledge or experience trailing in wake, strikes odd echoes, so that there is a winging between present and past. The 'unremembered' is like an electric sky-sign which occasionally flashes across the conscious, leaving a sense of expectation, wonder and unrest.[89]

Macpherson uses the established argument that children's perception is more immediate, less habitual and conditioned, than adult experience. Lerski's portraits return the viewer to this early state, when faces were not yet immediately decodable but enigmatic, objects of wonder, to be studied and explored in detail. His closing reference to the dual sensations of 'wonder and unrest' indicates that such immersion in the individual image, unsettling and yet endlessly captivating, is at odds with the organizational logic of the series, of the resonances within and between image groups, which, as outlined above, instils the viewing experience with a fundamental restlessness. The photobook—an object to be treasured, to be perused slowly, in the quiet of one's home—facilitates immersion, and yet it also continues to unsettle the stillness linking viewer and image. In this regard, it encapsulates the precarious state of contemplation in modernity, which can only ever be temporary and fleeting, prone to giving way again to a more dispersed mode of experience.

Indeed, a similar sense of restlessness, of being stirred out of one's contemplative immersion, is described by Benjamin in relation to one of Hill and Adamson's pictures. Commenting on one of their most famous calotypes, the portrait of Mrs Elizabeth (Johnstone) Hall (1843–47), Benjamin is struck by the fact that

> in jenem Fischweib aus New Haven, das mit so lässiger, verführerischer Scham zu Boden blickt, etwas [bleibt], was im Zeugnis für die Kunst des Photographen Hill nicht aufgeht, etwas, was nicht zum Schweigen zu bringen ist, ungebärdig nach dem Namen derer verlangend, die da gelebt hat, die auch hier noch wirklich ist und niemals gänzlich in die 'Kunst' wird eingehen wollen. (*BGS* II.1, 370)

[89] Macpherson, 'As Is', p. 225.

[in Hill's Newhaven fishwife, her eyes cast down in such indolent, seductive modesty, there remains something that goes beyond testimony to the photographer's art, something that cannot be silenced, that fills you with an unruly desire to know what her name was, the woman who was alive there, who even now is still real and will never consent to be wholly absorbed in 'art'.

(*BSW* II.2, 510)]

In Schwarz's book, Elizabeth Johnstone Hall's portrait is captioned 'Fischweib aus Newhaven' (Newhaven Fishwife).[90] Like the readers of Lerski's photobook, Benjamin has to content himself with an impersonal label. But her anonymity does not reduce this sitter's individuality, does not shift the focus of attention away from her and towards the photographer and his artistry. What survives, decades or centuries later, is not *his* name but *her* downcast gaze and coyly seductive posture, which are all the more captivating in their understatement (Figure 7.15).

Figure 7.15 David Octavius Hill and Robert Adamson, 'Mrs Elizabeth (Johnstone) Hall [Newhaven 14]' (1843–7)

[90] Schwarz, *David Octavius Hill*, plate 26 [no page no.].

Benjamin then describes the psychological dynamics of his encounter with the image in some detail:

> Hat man sich lange genug in ein Bild vertieft, erkennt man, wie sehr auch hier die Gegensätze sich berühren: die exakteste Technik kann ihren Hervorbringungen einen magischen Wert geben, wie für uns ihn ein gemaltes Bild niemals besitzen kann. Aller Kunstfertigkeit des Photographen und aller Planmäßigkeit in der Haltung seines Modells zum Trotz fühlt der Beschauer unwiderstehlich den Zwang, in solchem Bild das winzige Fünkchen Zufall, Hier und Jetzt, zu suchen, mit dem die Wirklichkeit den Bildcharakter gleichsam durchgesengt hat.
>
> (BGS II.1, 371)
>
> [Immerse yourself in such a picture long enough and you will realize to what extent opposites touch, here too: the most precise technology can give its products a magical value, such as a painted picture can never again have for us. No matter how artful the photographer, no matter how carefully posed his subject, the beholder feels an irresistible compulsion to search such a picture for the tiny spark of contingency, of the here and now, with which reality has (so to speak) seared the character of the image. (BSW II.2, 510)]

Five decades later, Benjamin's viewing experience is echoed by Roland Barthes in *La Chambre claire* (Camera Lucida, 1980) and summed up by his famous notion of the *punctum*. In contrast to a photograph's *studium*, a term which denotes the 'objective' meaning of an image, its situatedness within a cultural and historical context, the *punctum* refers to a seemingly insignificant detail which 'punctuate[s]' both the coherence of the image and the detached stance of the viewer, collapsing her rational distance from the photo.[91] Barthes describes the *punctum* as a 'sting, speck, cut, little hole', which singes through the photograph's smooth surface,[92] akin to Benjamin's 'tiny spark of contingency'.

Between them, Barthes's two concepts map out the difference between the sustained, rational, controlled examination of a photograph (with *studium* of course denoting study, voluntary attention) and the sudden, involuntary sensation of being captivated, arrested, spellbound by a minor, seemingly random detail. An 'authentic' photographic encounter, Barthes implies, involves relinquishing attentional control; he locates a photograph's authenticity neither in the identity of its sitter nor in its manner of production, but in the act of viewing, the temporally delayed encounter with a trace, a remnant, of the past. Modernist commentators,

[91] Roland Barthes, *Camera Lucida: Reflections on Photography*, trans. Richard Howard (London: Vintage, 2000), p. 26. For a more detailed reading of Benjamin's response to Hill's and other portraits and their implication for his conception of the aura of the photographic image, see Carolin Duttlinger, 'Walter Benjamin: The Aura of Photography', *Poetics Today*, 29 (2008), 79–101.

[92] Barthes, *Camera Lucida*, p. 27.

in contrast, remain wedded to a notion of authenticity which resides in the sitter, although both Macpherson and Benjamin describe experiences of captivation, of being struck or overwhelmed by the encounter with a particular image.

In 'Little History of Photography', as we have seen, Benjamin casts contemplative stillness as historically contingent, that is, as the product of a particular set of social and technological circumstances. This argument is typical of his thought more generally. For Benjamin, human experience is historically specific and hence changeable, although he is also interested in its anthropological, trans-historical dimension. While the 'Photography' essay endorses contemplation as the signature of a particular age, it paves, as we will see in the next chapter, the way for Benjamin's subsequent critique of this stance in modern culture.

8
Presence of Mind
Walter Benjamin

In the 'Photography' essay Benjamin is captivated by particular images, which he ponders in great detail, but he subsequently turns to the cinema as the expression, and facilitator, of a more mobile and dispersed mode of experience. In his endorsement of distraction, *Zerstreuung*, Benjamin goes against the tide of his time, which sought to defend attention against multiple sources of fragmentation. And yet his embrace of *Zerstreuung* in his seminal essay 'Das Kunstwerk im Zeitalter seiner technischen Reproduzierbarkeit' (The Work of Art in the Age of its Technological Reproducibility, 1935–6) is only one moment in his extraordinarily complex engagement with human experience ranging from immersion to dispersal. Benjamin's thought on attention, which is often expressed as concise reflections about a specific cultural configuration, does not amount to a coherent theory but is itself dispersed across the different parts of his disparate oeuvre, and yet in its dispersed treatment attention also acts as a red thread, a hidden centre of gravity. His thought is not, as Ansgar Hillar rightly notes, driven by a quest for conceptual coherence,[1] and so the notion of attention does not have one stable meaning but is highly dependent on the context of the argument. Benjamin is interested in the different facets of attention, ranging from contemplation to alertness, which are explored in their relation to habit and boredom, reverie and distraction. Indeed, his model of attention is persistently dialectical; it can only be grasped in its fluidity, as part of a configuration of opposites.

For Benjamin attention is both a universal and a historically specific phenomenon. In casting distraction as a quintessentially modern state, he is influenced by Siegfried Kracauer's work of the 1920s, but he diverges from Kracauer's increasingly bleak assessment, particularly in *The Salaried Masses*, of the 'spiritual homelessness' that characterizes modern experience even in its supposedly communitarian dimension. Rather, he takes his cue from Kracauer's earlier emphasis on the emancipatory potential of film's superficiality and fragmentation, an argument which he extends, building on other discourses and practices. These include experimental psychology, which he encounters while still a student, and psychotechnics, but also the particular confluence of aesthetic experimentation

[1] Ansgar Hillar, 'Dialektisches Bild', in *Benjamins Begriffe*, ed. Michael Opitz and Erdmut Wizisla, vol. 1 (Frankfurt a.M.: Suhrkamp, 2000), pp. 186–229 (p. 189).

and pedagogy in Weimar culture—in Bertolt Brecht's epic theatre and in the curatorial work of his own sister Dora Benjamin.

Benjamin's work on (in-)attention cannot be fully reflected in the space available; rather, this chapter singles out some strands of this engagement and traces their diachronic development in particular fields of his work: his anthropological writings; his work on mass culture; his studies of literature; and his historical materialism. Benjamin's emphasis on a shock-like and discontinuous kind of attention is one strand of this engagement; another, equally important one is his persistent interest in (religious) contemplation as a state which combines stillness and dialogical awareness. The third connecting strand is *Geistesgegenwart*, presence of mind, which takes on a vital political and methodological importance particularly in his later writings.

Measuring Diversion

Benjamin first encountered psychological research into attention during his student years at Albert-Ludwig University Freiburg. In 1913, preparing for a talk at a student conference in Breslau, he read all the back issues of the *Zeitschrift für angewandte Psychologie* (Journal for Applied Psychology), one of the leading periodicals in the field.[2] One of its editors was William Stern, the eminent Hamburg psychologist who had coined the term 'psychotechnics'.[3] Stern was married to Benjamin's cousin Clara, née Joseephi;[4] in his letters Benjamin repeatedly mentions this family connection, even though Stern was the figurehead of a more conservative group of student organizations, whose pedagogical agenda Benjamin attacked in his Breslau paper.[5]

Benjamin mined Stern's journal for its pronouncements on pedagogy, but in doing so he would have of course also come across articles on psychology. The 1908 issue, for instance, contains a long piece by Jonas Cohn and Werner Gent, both based at the Freiburg Institute for Psychology. Entitled 'Aussage und Aufmerksamkeit' (Statement and Attention), it describes a series of experiments designed to measure the impact of diversions, *Ablenkungen*, on participants' attention and recall. In their introduction, the authors note that most people can quickly get used to distractions which require no active response, such as the ticking of a metronome or

[2] In addition, Benjamin also read back issues of the *Zeitschrift für pädagogische Psychologie* (Journal for Pedagogical Psychology) and the *Zeitschrift für Philosophie und Pädagogik* (Journal for Philosophy and Pedagogy). See Walter Benjamin, *Gesammelte Briefe*, vol. 1: *1910–1918*, ed. Christoph Gödde (Frankfurt a.M.: Suhrkamp, 1995), pp. 115; 121.
[3] See Chapter 4, pp. 128–9.
[4] Emil Benjamin, Walter's father, was the brother of Clara Joseephi's mother Friederike.
[5] In a letter to Carla Seligson, he describes Stern as the head of that wing of the student movement that was opposed to the branch associated with Benjamin's former mentor, Gustav Wyneken. Letter of 4 August 1913; Benjamin, *Gesammelte Briefe*, I, p. 160.

someone reading out a text. In fact, 'frequently we witness the seemingly paradoxical effect whereby a task is better performed with distraction [...] than without. Here, the diverting stimulus apparently seems to be an incentive for the attention to become more focused'.[6] But what about diversions that require a more active response? To answer this question, subjects are asked to memorize two fairy-tale illustrations. In one instance, they are allowed to give the images their full attention, while in the other they have to do some simple mathematical calculations at the same time. Their recall of the pictures is then assessed, first immediately afterwards and again eight days later. The collected data differentiates between the quantity of recalled details, error rate, and the extent to which recall is skewed by suggestive questions. The results are less clear-cut than expected. Fundamentally, even more complex distractions, which require an active mental response, do not affect all aspects of mental performance. While the mathematical calculations tend to reduce the quantity of the recalled details, they do not noticeably increase participants' error rate and overall suggestibility.[7] Indeed, while the majority of distracted participants remember fewer visual details, some subjects' recall is *more* detailed after their attention was distracted.[8]

To add an element of self-reflexion, participants were then asked to rate their own mental performance in relation to six questions: Do they work best in the morning or the evening? Are they good at mental arithmetic? Do they have a good memory for names and numbers? Are they good at learning texts by heart? Are they able to work on an interesting task for more than two hours? And finally, how affected are they by street noise, music, and similar distractions?[9] Underlining the common and sometimes pronounced discrepancy between participants' self-assessment and their actual performance, the authors conclude how hard it is accurately to assess one's own mental capacities. People might think of themselves as easily distractible (or the opposite), but their actual performance often bears little resemblance to this self-evaluation—a finding which also casts doubt on the value of programmes of cognitive self-optimization.

Cohn and Gent's study challenges the widely held view that, in an age of sensory overload, attention is a faculty in crisis. As their experiments show, competing stimuli can have a neutral or even a positive effect on cognitive performance. At the same time, the authors are keen to stress that their results

[6] '[H]äufig tritt der scheinbar paradoxe Erfolg ein, daß bei Ablenkung besser gearbeitet wird [...], als ohne Ablenkung. Hier dient augenscheinlich der ablenkende Reiz lediglich als Anreiz, die Aufmerksamkeit schärfer anzuspannen'. Jonas Cohn and Werner Gent, 'Aussage und Aufmerksamkeit', *Zeitschrift für angewandte Psychologie und psychologische Sammelforschung*, 1 (1908), 129–52; 233–65 (p. 130).

[7] The authors compare their findings to an experiment conducted by Stern, which comes to a different conclusion. Here, a brief disruption of a student seminar greatly increased the error rate in participants' recall when tested a week later. As they note, this outcome might be explained by the different forms of attention at work in each case. While Stern's students had not been told in advance that they needed to pay particular attention, Cohn and Gent's participants knew they were being asked to withstand distraction. 'Aussage', pp. 253–4.

[8] Cohn and Gent, 'Aussage', p. 140. [9] Cohn and Gent, 'Aussage', p. 247.

are provisional, that mental performance varies between individuals and is highly dependent on task and context. For all these caveats, they come to one overarching conclusion: attention and distraction are not mutually exclusive but shade into each other in nuanced, unpredictable, and sometimes productive ways.

Stern's journal introduced the young Benjamin to psychological research into attention. As a student of philosophy and philology, he would have been particularly struck by Cohn and Gent's repeated self-critical reflections on their own terminology, as when they note 'how much the psychology of attention is affected by the indeterminacy of its fundamental concepts'.[10] This critique applies particularly to the term *Ablenkung*, which as they note has no single, stable meaning but is merely an umbrella term for a range of psychological phenomena.[11]

We do not know how attentively Benjamin read this article, nor to what extent he committed its findings to memory. Overall, the young Benjamin was sceptical of psychology and its aspirations; in a piece entitled 'Psychologie' (1917/18), he categorically rejects the discipline's assumption that the individual can be understood without considering his/her moral destination ('unter Abstraktion von seiner moralischen Bestimmung'; *BGS* VI, 65). Morality, then, is one aspect which is neglected by psychology; another is the role of the body:

> Die angebliche Differenz, daß fremdes Seelenleben uns im Gegensatz zum eignen nur mittelbar durch Deutung fremder Leiblichkeit gegeben sei[,] besteht nicht. Fremdes wie eignes Seelenleben ist uns unmittelbar und zwar immer in einer bestimmten Verbindung oder mindestens auf einem bestimmten Grunde von Leiblichkeit gegeben. (*BGS* VI, 65)
>
> [The alleged difference between our own inner lives and those of others, which are said to be accessible to us only through the interpretation of the other's body, does not exist. Both our own inner lives and those of others are immediately available to us only in conjunction with, or at least on the basis of, concrete bodily existence.]

For the early Benjamin, the route to the mind—our own and others'—is via the body; mental processes should be explored not through experiments or introspection but through the observation of people's actions, their comportment, in particular situations. This argument is echoed in subsequent texts, including the piece 'Über das Grauen' (On Dread, c.1920–2), which compares forms of contemplation in a religious and a secular context.

[10] '[...] wie sehr die Psychologie der Aufmerksamkeit unter der Unbestimmtheit ihrer Grundbegriffe leidet'. Cohn and Gent, 'Aussage', p. 254.

[11] Cohn and Gent, 'Aussage', p. 247.

Facets of Contemplation: 'On Dread' and *Origin of the German Trauerspiel*

Echoing Cohn and Gent's study, 'On Dread' asks to what extent different types of contemplation are vulnerable to (external) disruptions. The perspective is less psychological than anthropological, as Benjamin tries to pinpoint some universal laws that determine the human experience of objects and people.

The text's key concept is immersion, *Versenkung*, which recalls Kafka's fragment 'Breathless, I arrived...' (1922), written at around the same time. Where Kafka hints at the prospect of an actual, physical burial, Benjamin uses the term more metaphorically when he defines *Versenkung* as a state 'of deep contemplation and concentration, such as deep thinking, immersion in music or in sleep'.[12] Indeed, for him the problem with such states is precisely that they only involve the mind and senses, rather than being rooted in the body. In such a state, the individual is 'immersed in something foreign and hence immersed only in part',[13] leading to a potentially dangerous form of absent-mindedness.[14] Immersion, then, *is* absent-mindedness, leaving the subject vulnerable to the shock or even dread (*Grauen*) produced by sudden interruption, even and particularly by familiar persons.[15]

But this danger only affects certain forms of immersion, namely its worldly or secular varieties. Religious contemplation works very differently:

> Es gibt Zustände der Versunkenheit, gerade in ihrer Tiefe, welche dennoch den Menschen nicht geistesabwesend, sondern höchst geistesgegenwärtig machen. [...] Die einzige Art von Geistesgegenwart, welche Bestand hat und nicht untergraben zu werden vermag, ist die in der heiligen Versunkenheit, etwa der des Gebetes. (*BGS* VI, 75)
>
> [There are instances of particularly deep immersion which nonetheless do not make the individual absent-minded but rather engender the highest presence of mind. [...] The only presence of mind which is lasting and cannot be undermined is that of holy immersion, as for instance in prayer.]

Echoing psychological research, Benjamin stresses that not all forms of immersion are alike, that mental states vary depending on their focus and context. While

[12] '[...] tiefer Kontemplation und Konzentration, wie tiefes Sinnen, Versunkenheit in Musik oder Schlaf' (*BGS* VI, 75).

[13] '[...] in Fremdes und daher nur unvollständig versunken' (*BGS* VI, 76).

[14] If a stimulus or idea absorbs all mental energy, the subject is left 'depotenziert unter Abwesenheit des Geistes' ('depotentiated, lacking in presence of mind'; *BGS* VI, 76).

[15] The archetypal, most powerful source of dread, Benjamin notes, is the sight of one's own mother, whose familiar appearance turns uncanny, in the Freudian sense, as the boundaries between self and world collapse (*BGS* VI, 75).

ordinary, secular, absorption results in absent-mindedness, *Geistesabwesenheit*, prayer and other forms of religious contemplation are dialogical states, directed at a divine other. In a chiasmic variation of the earlier formulation, the praying subject is said to be 'immersed in God and hence [...] completely immersed in herself'.[16] The encounter with God dissolves the boundaries of the self but simultaneously fosters an ongoing presence of mind, or *Geistesgegenwart*, which protects against external disruptions. In a state of secular and incomplete immersion, in contrast, the subject gets sucked into a whirlpool (*Strudel*) of absent-mindedness, which can leave her speechless, deprived of language as a means of expression and communication (*BGS* VI, 77).[17]

This fragment maps out some of the key coordinates of Benjamin's early thought on attention, whose resonances will ripple all the way through his work. The mind is not a self-contained entity, nor is it made up of stable, clearly delineated states. Rather, experience is underpinned by both the body and by language, and constitutes itself either in the encounter with the outside, material and sensory, world or, preferably, in dialogue with the (divine) other. The latter point is crucial; throughout his writings, Benjamin will critique states of solipsistic absorption and advocate forms of experience which are dialogical in character.

In 1923, shortly after writing 'On Dread', Benjamin started work on his professorial dissertation, or Habilitationsschrift, on German Baroque drama. *Ursprung des deutschen Trauerspiels* (Origin of the German Trauerspiel), completed in 1925 and published in 1928, returns to states of (religious) contemplation, and again distinguishes between a mobile and a static variety. Contemplation features both in the theoretical introduction and in the literary-historical main part, thus providing a bracket between subject matter and methodology.

The famously dense 'Erkenntniskritische Vorrede' (Epistemo-Critical Foreword) outlines a dialectical model of contemplation which is immersive yet discontinuous, pitting this mode against the systematizing impulses of philosophy, particularly idealism, which tries to capture the truth 'in a spider's web stretched between bodies of knowledge'.[18] To avoid this appropriating impulse, philosophy needs to mindful of itself as unfolding process. This process is potentially interminable, for thought is essentially repeated practice, or *Übung*:

[16] '[...] in Gott und damit auch [...] in sich selbst völlig versunken' (*BGS* VI, 76).

[17] Vivian Liska notes that the critique of secular contemplation in 'On Dread' is echoed in Benjamin's contemporaneous essay on Goethe's *Die Wahlverwandtschaften* (Elective Affinities, 1921–2). For Benjamin, the novel's protagonists succumb to a *vita contemplativa* in which they become fixated on the interpretation of signs and symbols but are incapable of decisive, salvaging action of the kind which Goethe depicts in the inserted novella on 'Die wunderlichen Nachbarskinder' (The Curious Neighbours). Vivian Liska, 'Walter Benjamins Dialektik der Aufmerksamkeit', *Arcadia*, 35 (2000), 285–94 (pp. 286–7).

[18] Walter Benjamin, *Origin of the German Trauerspiel*, trans. Howard Eiland (Cambridge, MA: Harvard University Press, 2019) p. 2; 'in einem zwischen Erkenntnissen gezogenen Spinnennetz' (*BGS* I.1, 207).

Diese Übung hat sich allen Epochen, denen die unumschreibliche Wesenheit des Wahren vor Augen stand, in einer Propädeutik aufgenötigt, die man mit dem scholastischen Terminus des Traktats darum ansprechen darf, weil er jenen wenn auch latenten Hinweis auf die Gegenstände der Theologie enthält, ohne welche der Wahrheit nicht gedacht werden kann. (*BGS* I.1, 208)

[In all epochs in which the uncircumscribable essentiality of the truth has come into view, this practice has imposed itself in the form of a propaedeutic that can be designated by the scholastic term 'tractatus', for this term contains a reference, however latent, to those objects of theology without which truth cannot be thought.[19]]

This tentative reference to the 'objects of theology' demarcates a certain distance from the religious realm, which is evoked to suggest an alternative conception of, and approach towards, truth. For Benjamin, truth cannot be captured by means of philosophical systems but can only be approximated through a mode of thinking modelled on the scholastic tradition. Medieval monastic practice involves reading and re-reading the same piece of scripture many times over as a means of self-exploration,[20] and this process also informs the genre of the medieval theological tractatus—texts made up of self-contained chapters with no overarching structure, in which the 'unbroken course of intention' (the 'unausgesetzen Lauf der Intention') of ordinary philosophy gives way to a looser, intermittent form of immersion:

Ausdauernd hebt das Denken stets von neuem an, umständlich geht es auf die Sache selbst zurück. Dies unablässige Atemholen ist die eigenste Daseinsform der Kontemplation. Denn indem sie den unterschiedlichen Sinnstufen bei der Betrachtung ein und desselben Gegenstandes folgt, empfängt sie den Antrieb ihres stets erneuten Einsetzens ebenso wie die Rechtfertigung ihrer intermittierenden Rhythmik. (*BGS* I.1, 208)

[In its persevering, thinking constantly begins anew; with its sense of the circumstantial, it goes back to the thing itself. This continual breathing in and out is the form of existence most proper to contemplation. For inasmuch as the latter pursues various levels of meaning in observing one and the same object, it receives the impetus of its constantly renewed beginning as well as the justification of its intermittent rhythm.[21]]

Echoing 'On Dread', Benjamin here defines contemplation not as a state of oblivious immersion but as an intermittent, rhythmically structured thought

[19] Benjamin, *Origin*, p. 2.
[20] Peter von Moos, 'Attentio est quaedam sollicitudo: Die religiöse, ethische und politische Dimension der Aufmerksamkeit im Mittelalter', in *Aufmerksamkeiten*, ed. Aleida Assmann and Jan Assmann (Munich: Fink, 2001), pp. 91–127 (p. 98).
[21] Benjamin, *Origin*, pp. 2–3.

process. The act of breathing encapsulates this idea and highlights the importance of the body—contemplation as sustained *Geistesgegenwart*.

As Benjamin continues, the resulting text must reflect this intermittent immersion in its argument and structure. It must be discontinuous, made up of small-scale thought fragments, 'Denkbruchstücke', for the truth can only emerge from 'the most precise immersion in the details of a matter'.[22] Structurally, this means

> mit jedem Satze von neuem einzuhalten und anzuheben. Die kontemplative Darstellung hat dem mehr als jede andere zu folgen. Für sie ist es kein Ziel mitzureißen und zu begeistern. Nur wo sie in Stationen der Betrachtung den Leser einzuhalten nötigt, ist sie ihrer sicher. Je größer ihr Gegenstand, desto abgesetzter diese Betrachtung. (*BGS* I.1, 209)
>
> [that with every sentence it stops and starts anew. The contemplative presentation, more than any other, has to adhere to this. Its goal cannot be to enthral or excite enthusiasm. Only where it obliges the reader to pause at stations of reflection is it sure of itself. The greater its object, the more interrupted this reflection.[23]]

The envisaged result of this kind of *Darstellung* is to induce the same hesitation in the reader, resulting in a state of 'fruitful skepticism' which Benjamin likens to 'the deep breath taken by thinking before it can lose itself at its leisure, and without ever feeling winded, in the smallest detail'.[24] This mode of reflection prevents premature conclusions and the hasty appropriation of material for the sake of pre-formed hypotheses, and allows a renewed, even deeper immersion in seemingly minor details. Where sustained absorption can result in 'dull astonishment',[25] the intermittent, scholastic mode of engagement leads the mind, 'through an ascetic schooling, so to speak', to the 'fortitude' which enables it 'to remain master of itself'.[26]

In the literary-historical main part of his study, Benjamin returns to contemplation, highlighting both its downsides and its important benefits. The emotional essence of the Baroque period, as expressed in the Trauerspiel, is melancholy. The melancholic turns away from the world and focuses his or her attention on a handful of objects with a 'persevering absorption' that 'takes the dead things up into its contemplation in order to save them. [...] The tenacity inscribed in the

[22] Benjamin, *Origin*, p. 3; 'genaueste Versenkung in die Einzelheiten eines Sachgehalts' (*BGS* I.1, 208).
[23] Benjamin, *Origin*, p. 4.
[24] Benjamin, *Origin*, p. 23; a 'fruchtbaren Skepsis' comparable to 'dem tiefen Atemholen des Gedankens [...], nach dem er ans Geringste sich mit Muße und ohne die Spur einer Beklemmung zu verlieren vermag' (*BGS* I.1, 225).
[25] Benjamin, *Origin*, p. 24; 'Gegenstände eines trüben Staunens' (*BGS* I.1, 225).
[26] Benjamin, *Origin*, p. 39; 'in einer gewissermaßen asketischen Schule [...] zu der Festigung [...], die ihm erlaubt, im Anblick jenes Panoramas [of the Baroque period] seiner selbst mächtig zu bleiben' (*BGS* I.1, 237).

intention of mourning is born of its fidelity to the world of things'.[27] So Baroque melancholy is both valuable and detrimental. It reflects a 'fidelity' to the world of objects which discerns their value, and invests them with an allegorical significance, thereby leaving them 'secured in eternity'.[28] And yet this sustained, eternalizing gaze also comes at a cost; not only does it drain the objects of all life, but it also enforces a similarly rigid mindset in the contemplative observer. Benjamin describes the contemplative trance ('kontemplativen Starrkrampf'), which marks melancholy as a 'pathological condition' and which can lead 'only too easily into the bottomless'—into a reflection wholly absorbed in itself and detached from the surrounding world.[29]

This analysis echoes eighteenth-century thinkers such as Kant, who likewise warn against the dangers of excessive immersion. In his search for a remedy Benjamin harks back to Blaise Pascal's *Pensées* (Thoughts, 1670), specifically to his model of *divertissement*, (constructive) diversion or *Zerstreuung*. For Pascal, the affairs of trade, courtly life, and warfare, as well as entertainment, games, and hunting, all serve one underlying purpose. By keeping people busy, they stop them from pondering their own mortality.[30] Echoing Pascal, the *Trauerspiel* book presents its own linguistic model of diversion, namely allegory, the key rhetorical figure of Baroque drama and 'the sole and potent divertissement that the melancholic permits himself'.[31] For the melancholy disposition, allegory is symptom and remedy in one, a trope which involves the subject in 'the intermittent rhythm of continual arrest, sudden reversal, and new consolidation'.[32]

The *Trauerspiel* book thus situates human experience, and its expression in both thought and literature, at the crossroads between contemplation and distraction, *Sammlung* and *Zerstreuung*. As Howard Caygill notes, the close affinity between the study's method and its historical subject matter is no coincidence but builds on Benjamin's earlier attempts, in the late 1910s, to go beyond the Kantian

[27] Benjamin, *Origin*, p. 162. 'Die Melancholie verrät die Welt um des Wissens willen. Aber ihre ausdauernde Versunkenheit nimmt die toten Dinge in ihre Kontemplation auf, um sie zu retten. […] Die Beharrlichkeit, die in der Intention der Trauer sich ausprägt, ist aus ihrer Treue zur Dingwelt geboren' (*BGS* I.1, 334). One of the iconic depictions of melancholy is Albrecht Dürer's engraving *Melencolia I* (1514), which is repeatedly referenced in Benjamin's *Trauerspiel* book. Its successor in Benjamin's work is the famous figure of the Angel of History, based on Paul Klee's water colour *Angelus Novus* (1920), whose rigid stare at the destruction wreaked by human history is described in 'Über den Begriff der Geschichte' (On the Concept of History, 1940).
[28] Benjamin, *Origin*, p. 196. 'Wird der Gegenstand unterm Blick der Melancholie allegorisch, läßt sie das Leben von ihm abfließen, bleibt er als toter, doch in Ewigkeit gesicherter zurück' (*BGS* I.1, 359).
[29] Benjamin, *Origin*, pp. 144–5; 'auch die Versenkung führt allzu leicht ins Bodenlose' (*BGS* I.1, 319–20).
[30] Blaise Pascal, *Pensées*, ed. Dominique Descotes (Paris: Garnier-Flammarion, 1976), pp. 86–90.
[31] Benjamin, *Origin*, p. 198; 'das einzige und gewaltige Divertissement, das da dem Melancholiker sich bietet' (*BGS* I.1, 361).
[32] Benjamin, *Origin*, p. 213; 'die intermittierende Rhythmik eines beständigen Einhaltens, stoßweisen Umschlagens und neuen Erstarrens' (*BGS* I.1, 373).

model of experience, which stipulates a strict separation between the subject and object of enquiry. For Benjamin,

> critique does not possess any incontestable criteria which are immune to change in the encounter with the object of critique. The objects of critique [...] cannot be grasped as if they were objects of knowledge to which the appropriate criteria are to be applied, because these criteria themselves change in the encounter with the work. Such sensitivity to the transformation of both the object and the criteria informing critique is described by Benjamin in terms of digression and re-inauguration.[33]

Both the dialectical interplay between immersion and diversion and the symbiotic relationship between subject matter and method continue to shape Benjamin's thought on attention. And just as, between them, 'On Dread' and *Origin of the German Trauerspiel* exemplify the anthropological and historical facets of his engagement, Benjamin maintains this dual perspective in his subsequent writings on human experience.

Tipping Points: 'Ibizan Sequence' and *One-Way Street*

In 'Ibizenkische Folge' (Ibizan Sequence), a group of texts which he wrote in April/May 1932 during the first of two stays on the island, Benjamin returns to matters of (in-)attention. The group includes a dream narrative, some travel writing, and brief reflections on themes such as politeness, persuasion, and success, which sit somewhere between modern *Ratgeberliteratur* and traditional wisdom literature. In addition, a mini sequence explores alternatives to voluntary attention. One of them, 'Vergiß das Beste nicht' (Do Not Forget the Best), describes an acquaintance who is tidiest and most conscientious when he is unhappy, but who then consciously decides to surrender control over his daily life by 'abolishing' his clock, only to discover that his friends continue to visit him 'when he least expected them but needed them most'.[34] Another piece, 'Übung' (Practice), argues that the purpose of learning a particular skill is not to bring both the body and the material world under the control of the rational mind, but rather to tire out the individual to the point where 'his body and each of his limbs can act

[33] Howard Caygill, *Walter Benjamin: The Colour of Experience* (London: Routledge, 2005), p. 58. This revision of the Kantian model also has implications for the remit of philosophical investigation, as Benjamin 'came to realise that extending the limits of experience meant that philosophising could move beyond classical philosophical problems and texts into the critical reflection upon literature, art, and culture in the broadest sense' (Caygill, *Walter Benjamin*, p. 23).

[34] *BSW* II.2, 591; 'wenn er am wenigsten an sie dachte und sie am nötigsten hatte' (*BGS* IV.1, 407).

in accordance with their own rationality',³⁵ concluding with the thought that we are most likely to find a lost object after we have stopped looking for it. Here, Benjamin echoes Freud's *Psychopathology of Everyday Life*, which casts voluntary attention as a hindrance in executing many daily tasks and emphasizes the importance of an intuitive, preconscious kind of knowledge.

The most extensive discussion of (in-)attention, however, can be found in the piece 'Gewohnheit und Aufmerksamkeit' (Habit and Attention). It recalls Cohn and Gent's 'Statement and Attention' in both title and subject matter, for the text explores how attention can arise out of apparent absent-mindedness. 'To note something and to accustom oneself to it, to take offense and to put up with a thing—these are the peaks and troughs of the waves on the sea of the soul. But this sea has moments of calm'.³⁶ The sea image reflects the ebb and flow of awareness, which is outlined in more detail in an argument whose twists and turns may well induce a mental kind of seasickness.

The first example focuses on pain. Contrary to what we might expect, the argument goes, extreme pain can make us more rather than less alert to outside impressions, enabling us to become aware of 'a murmuring, the flight of an insect'³⁷—sounds so quiet they normally escape even deliberate attention. As pain becomes prolonged, a habitual state, it frees up cognitive resources, allowing the attention to be redirected towards other, subtler impressions. Unlike in 'On Dread', this redirection of awareness does not come as a sudden shock, but rather as a gradual shifting of mental focus. As the text concludes, listening to such subtle sounds while absorbed in pain is 'not just the furthest development of attention, but also its end—the moment when it gives birth to habit'.³⁸

The second example looks at dreams:

> Auch die Gewohnheit hat ein Komplement, und dessen Schwelle übertreten wir im Schlaf. Denn was im Traume sich an uns vollzieht, ist ein neues und unerhörtes Merken, das sich im Schoße der Gewohnheit losringt. Erlebnisse des Alltags, abgedroschene Reden, der Bodensatz, der uns im Blick zurückblieb, das Pulsen des eigenen Blutes—dies vorher Unvermerkte macht—verstellt und überscharf—den Stoff zu Träumen. (*BGS* IV.1, 408)

> [Even habit has a complement, and we cross its threshold while sleeping. For what comes to us when we dream is a new and unprecedented attentiveness that struggles to emerge from the womb of habit. Everyday experiences, hackneyed

³⁵ *BSW* II.2, 591; 'der Körper und ein jedes seiner Glieder nach ihrer eigenen Vernunft handeln können' (*BGS* IV.1, 407).
³⁶ *BSW* II.2, 592; 'Aufmerken und Gewöhnung, Anstoß nehmen und Hinnehmen sind Wellenberg und Wellental im Meer der Seele. Dieses Meer aber hat seine Windstillen' (*BGS* IV.1, 408).
³⁷ *BSW* II.2, 592; 'einem Murmeln, dem Flug eines Insekts' (*BGS* IV.1, 408).
³⁸ *BSW* II.2, 592; 'nicht weniger das Ende als die äußerste Entfaltung der Aufmerksamkeit—der Augenblick, da sie aus ihrem eigenen Schoße die Gewohnheit hervorgehen läßt' (*BGS* IV.1, 408).

expressions, the vestiges that remain in a glance, the pulsating of one's own blood—all this, hitherto unnoticed and in a distorted and overly sharp form, makes up the stuff of dreams. (*BSW* II.2, 592)]

Here, the relationship between attention and habit is reversed. When we are dreaming, the normal experiences of waking life are invested with a new vividness. This applies to stimuli both outside and within the body. But then Benjamin adds a further dialectical twist to this argument: 'In dreams there is no astonishment and in pain there is no forgetting, because both bear their opposites within them, just as in a calm the peaks and troughs of the waves lie merged in one another'.[39] As they gain a new sense of vividness, the experiences re-encountered in dreams do not trigger shock or surprise; conversely, the pain which becomes the habitual backdrop of intensified attention is never actually forgotten. Both examples thus show that attention and habit mutually enforce each other: 'All attentiveness has to flow into habit, if it is not to blow human beings apart, and all habit must be disrupted by attentiveness if it is not to paralyze the human being'.[40] No one mental state can last forever; what is more, Benjamin here casts habitual inattention as the precondition for conscious awareness.

The short and disparate pieces of 'Ibizan Sequence' explore as well as embody a discontinuous mode of attention. In a letter to Gretel Adorno, Benjamin notes that the little group revives a mode of presentation ('Darstellungsform') he had already used in *Einbahnstraße* (One-Way Street).[41] This volume of short prose texts was published in 1928, the same year as *Origin of the German Trauerspiel*; though the two books are at first sight almost diametrically opposed, they share both structural and methodological similarities.[42]

[39] *BSW* II.2, 592. 'Im Traum kein Staunen und im Schmerze kein Vergessen, weil beide ihren Gegensatz schon in sich tragen, wie Wellenberg und Wellental bei Windstille ineinander gebettet liegen' (*BGS* IV.1, 408). As Liska points out, Benjamin often uses water imagery to describe one mental state giving rise to another. Liska, 'Benjamins Dialektik der Aufmerksamkeit', p. 292.

[40] *BSW* II.2, 592. 'Alle Aufmerksamkeit muß in Gewohnheit münden, wenn sie den Menschen nicht sprengen, alle Gewohnheit von Aufmerksamkeit verstört werden, wenn sie den Menschen nicht lähmen soll' (*BGS* IV.1, 408).

[41] *BGS* IV.2, 1002.

[42] Several studies have compared the *Denkbilder* (thought images) of *One-Way Street* to the Baroque model of emblematic writing, which combines image and text in an enigmatic manner. See Eberhard Schulz, 'Zum Wort "Denkbilder"', in *Wort und Zeit: Aufsätze und Vorträge zur Literaturgeschichte*, ed. Eberhard Schulz (Neumünster: Wachholtz, 1968), pp. 218–52 (p. 242); Heinz Schlaffer, 'Denkbilder: Eine kleine Prosaform zwischen Dichtung und Gesellschaftstheorie', in *Poesie und Politik: Zur Situation der Literatur in Deutschland*, ed. Wolfgang Kuttenkeuler (Stuttgart: Kohlhammer, 1973), pp. 137–54 (p. 152); and Karoline Kirst, 'Walter Benjamin's *Denkbild*: Emblematic Historiography of the Recent Past', *Monatshefte*, 86 (1994), 514–24. In contrast, Andreas Huyssen notes that, unlike the three-part emblem, the miniatures of *One-Way Street* consist of only two parts. 'The Urban Miniature and the Feuilleton in Kracauer and Benjamin', in *Culture in the Anteroom: The Legacies of Siegfried Kracauer*, ed. Gerd Gemünden and Johannes von Moltke (Ann Arbor, MI: University of Michigan Press, 2012), pp. 213–28 (pp. 219–20).

In 1925, when his professorial dissertation was rejected by Frankfurt University, Benjamin decided to embark on the career of a freelance critic and writer. This move also facilitated a thematic reorientation—away from literary history and philosophy towards contemporary high and especially popular culture. *One-Way Street* assembles pieces originally written for newspapers and magazines; it also reflects on the experience of writing within the modern attention economy, where traditional rules of genre, form, and style no longer apply. This shift is spelled out in the opening piece, 'Tankstelle' (Filling Station), a clarion call for a radically new kind of writing. To be effective, writers must abandon 'the pretentious, universal gesture of the book' and turn to more ephemeral media such as leaflets, brochures, magazine articles, and posters to disseminate their ideas.[43] Modern life can only be reflected in texts written in a 'prompt language'; writing must not be turned in on itself but become a form of intervention, facilitating what Benjamin describes as the 'strict alternation between action and writing'.[44] As he adds, 'only the more feeble and distracted take an inimitable pleasure in closure', whereas 'to great writers, finished works weigh lighter than those fragments on which they work throughout their lives'.[45] Benjamin here echoes the period's disdain for distraction as an inferior and degenerate state of mind, but in a twist he associates this state with a need for closure, for the finished work as a kind of crutch which can provide the lacking sense of stability. The 'great mind', in contrast, is able to appreciate the fragment, the unfinished project, as the truer reflection of intellectual labour.[46]

The above-cited texts discuss writing and attention in fairly general terms. A more concrete and practical take on this issue is offered in 'Die Technik des Schriftstellers in dreizehn Thesen' (The Writer's Technique in Thirteen Theses), which gestures towards the genre of self-help literature and its agenda of cognitive self-optimization.[47] Rule seven reads: 'Never stop writing because you have run

[43] Here, Benjamin echoes a prominent Weimar cultural argument, namely that the so-called 'kleine Form', or little form, of prose writing is the genre best suited to capture the speed and ephemerality of modern life. The Austrian writer and critic Alfred Polgar, who coined this phrase, argues that 'das Leben ist zu kurz für lange Literatur, zu flüchtig für verweilendes Schildern und Betrachten, zu psychopathisch für Psychologie, zu romanhaft für Romane' ('too short for long literature, too fleeting for lingering description and reflection, too psychopathic for psychology, too novelistic for novels'). Alfred Polgar, *Orchester von oben* (Berlin: Rowohlt, 1926), pp. 11–12. See also Eckhart Köhn, *Straßenrausch: Flaneure und kleine Form. Versuch zur Literaturgeschichte des Flaneurs bis 1933* (Berlin: Das Arsenal, 1989), p. 9 and *passim*.

[44] *BSW* I, 444; 'strengem Wechsel von Tun und Schreiben' (*WuN* 8, 7).

[45] *BSW* I, 446; 'nur der Schwächere, der Zerstreutere hat seine unvergleichliche Freude am Abschließen', whereas 'den Großen wiegen die vollendeten Werke leichter als jene Fragmente, an denen die Arbeit sich durch ihr Leben zieht' (*WuN* 8, 14).

[46] This piece reads like a commentary on the *Arcades Project*, Benjamin's vast, unfinished historical project on which he was working from 1927 onwards and which resembles the tract in its open, fragmentary structure.

[47] This eclecticism is mirrored in the original cover image, a photomontage by Russian-born artist Sasha Stone. A photograph of store fronts receding into the distance is juxtaposed with the image of a huge double-decker bus intruding from the left. The two halves are linked and yet divided by a diagonal line of street signs bearing the word 'Einbahnstraße'.

out of ideas. Literary honour requires that one break off only at an appointed moment (a mealtime, a meeting) or at the end of the work'.[48] This advice seems diametrically opposed to the method outlined in the *Trauerspiel* book, which involves 'stopping and starting anew with every sentence'.[49] And yet the writing strategies suggested in *One-Way Street* also assume that writing is a discontinuous process, one which requires certain tricks to sustain a sense of momentum: 'Fill the lacunae of inspiration by tidily copying out what is already written. Intuition will awaken in the process'.[50] *One-Way Street* speaks of the difficulty faced by the modern writer surrounded by distractions. In order to escape 'the mediocrity of daily life', she needs to protect herself against low-level disruption. 'A state of half-quiet, accompanied by insipid noises, is degrading',[51] although crucially, keeping distractions at bay does not have to entail complete seclusion:

> Dagegen vermag die Begleitung einer Étude oder von Stimmengewirr der Arbeit ebenso bedeutsam zu werden, wie die vernehmliche Stille der Nacht. Schärft diese das innere Ohr, so wird jene zum Prüfstein einer Diktion, deren Fülle selbst die exzentrischen Geräusche in sich begräbt. (*WuN* 8, 33)
>
> [Accompaniment by an étude or a cacophony of voices can become as significant for work as the perceptible silence of the night. If the latter sharpens the inner ear, the former acts as a touchstone for a diction ample enough to bury within itself even the most wayward sounds. (*BSW* I, 458)]

Benjamin's advice is obviously born out of practical experience, reflecting the shift from the academic working in the silence of a library to the freelance author whose workplaces are less well insulated against the distractions of outside life. The text's baseline tone, however, is not despondency but resilience. The surrounding noises do not disperse attention but are absorbed and contained by the resulting text, which 'buries' these sounds within the 'fullness' of its diction. This argument recalls Kafka's account of writing 'The Judgement'; more specifically, it echoes Cohn and Gent's study, which finds that some distractions can in fact enhance concentration.[52] Indeed, Benjamin's text even contains an oblique (possibly deliberate) echo of their article. Where Cohn and Gent's experiments involve a ticking metronome and someone reading out loud, Benjamin describes the playing of an

[48] *BSW* I, 458. 'Höre niemals mit Schreiben auf, weil dir nichts mehr einfällt. Es ist ein Gebot der literarischen Ehre, nur dann abzubrechen, wenn ein Termin (eine Mahlzeit, eine Verabredung) einzuhalten oder das Werk beendet ist' (*WuN* 8, 33).
[49] Benjamin, *Origin*, p. 4; 'mit jedem Satze von neuem einzuhalten und anzuheben' (*BGS* I.1, 209).
[50] *BSW* I, 458; 'das Aussetzen der Inspiration fülle aus mit der sauberen Abschrift des Geleisteten. Die Intuition wird darüber erwachen' (*WuN* 8, 33).
[51] *BSW* I, 458. 'Halbe Ruhe, von schalen Geräuschen begleitet, ist entwürdigend' (*WuN* 8, 33).
[52] Cohn and Gent, 'Aussage', p. 130.

étude and the sound of human voices—aural distractions also taken from the realms of music and language.[53]

The change in Benjamin's professional circumstances also produced a shift, or rather a widening, of his personal networks and collaborations which included some leading avant-garde artists and journals;[54] indeed, this new network also involved some people closer to home. A particularly fruitful (but largely overlooked) such instance of intellectual dialogue was with his younger sister Dora Benjamin (1901–46). Her curatorial work provided an important source of inspiration for Benjamin's own engagement with modern culture—a theme which would dominate his writings of the 1930s.[55]

Dora Benjamin: Engaging the Viewer

Although Walter Benjamin's relationship to his sister Dora 'remained difficult long into the 1930s', the second half of the 1920s was a time of closer contact between the siblings as they both lived at their parents' house in the Delbrückerstraße in Berlin.[56] A rare opportunity for professional collaboration arose in 1929, when Dora Benjamin organized a public health exhibition in Berlin together with the addiction specialist Dr Ernst Joël. After Joël's sudden death,[57] she continued the organization together with Joël's colleague, the neurologist Dr Fritz Fränkel.[58] The exhibition, entitled 'Gesunde Nerven' (Healthy Nerves), took place in October 1929 in the Gesundheitshaus (House for Health) in Berlin

[53] Benjamin's call for the modern writer to embrace the distractions of daily life is partly disingenuous; two anecdotes relating to his young son Stefan illustrate the restrictions imposed on the Benjamin household in the interest of the father's productivity. See Howard Eiland and Michael W. Jennings, *Walter Benjamin: A Critical Life* (Cambridge, MA: Harvard University Press, 2014), pp. 134; 244.

[54] As Michael W. Jennings argues, this shift was in part facilitated by Benjamin's acquaintance with avant-garde artists associated with the so-called 'G group'. 'Walter Benjamin and the European Avant-Garde', in *The Cambridge Companion to Walter Benjamin*, ed. David S. Ferris (Cambridge: Cambridge University Press, 2004), pp. 18–34 (pp. 21–3).

[55] In a series of 'family trees' Benjamin tried to capture and visualize these networks, which include friends, relatives, and more distant acquaintances. While his wife and son are included in the surviving version, his sister Dora is missing from it. See the reprint of the diagram in Frederic J. Schwartz, *Blind Spots: Critical Theory and the History of Art in Twentieth-Century Germany* (New Haven, CT: Yale University Press, 2005), p. 43.

[56] Eiland and Jennings, *Benjamin*, pp. 245–6. During this time, Benjamin's younger brother Georg, a medical doctor, who, like Dora, was engaged in public health work, particularly with working-class children, was also a frequent visitor to the family home.

[57] Joël's early death was probably caused by his copious drug experiments in conjunction with a preexisting heart defect. See Klaus Täubert, 'Unbekannt verzogen…': *Der Lebensweg des Suchtmediziners, Psychologen und KPD-Gründsmitgliedes Fritz Fränkel* (Berlin: Trafo, 2005), p. 46.

[58] In 1927 Walter Benjamin had participated in hashish experiments supervised by Joël and Fränkel. Eiland and Jennings, *Benjamin*, p. 296. See also Regula Schindler, 'Die Drogen-Protokolle Walter Benjamins', in *Psychosen: Eine Herausforderung für die Psychoanalyse. Strukturen—Klinik—Produktionen*, ed. Peter Widmer and Michael Schmid (Bielefeld: Transcript, 2007), pp. 205–20 (p. 207). Fränkel ran a counselling service for psychiatric patients and drug addicts in Berlin

Kreuzberg. It drew visitors' attention to the risks posed by alcohol and drug addiction, by adverse working conditions, and by the more general mental and physical strains of modern life.[59] In an article published in the *Berliner Wohlfahrtsblatt* (Berlin Welfare Magazine), Dora Benjamin spells out the overarching aim, namely 'to cast a spotlight on the entirety of human life and experience'.[60] In these uncertain times, when the daily 'struggle for existence caused by the increased speed of the big city'[61] was exacerbated by the economic crisis, she argues, the exhibition tried to drive home the message that 'caring for mental health is just as important as caring for the body'.[62]

Benjamin's text highlights that key elements of the neurasthenia debate—concerns about sensory overload and its impact on mental and physical health—were still very much alive in the Weimar Republic. At the same time, the exhibition also illustrates the new, creative ways in which public health experts were trying to tackle this challenge. In fact, her article is backed up by extensive academic and practical experience. Dora Benjamin's doctoral thesis, completed in 1924, explored 'Die soziale Lage der Berliner Konfektionsheimarbeiterinnen mit besonderer Berücksichtigung der Kinderaufzucht' (The Social Situation of Women Working from Home in the Berlin Clothing Industry, with Particular Consideration of the Issue of Child Rearing). As the thesis concludes, although *Heimarbeit*, working from home, enables mothers to look after their young children and in particular to continue breastfeeding, the lower pay, compared to factory work, meant that children were often enlisted to help, leading to child labour through the back door.[63] Women's working conditions remained a core concern of Benjamin's work, though she grew increasingly disillusioned about the

Kreuzberg. See Eva Schöck-Quinteros, 'Dora Benjamin: "... denn ich hoffe nach dem Krieg in Amerika arbeiten zu können". Stationen einer vertriebenen Wissenschaftlerin (1901–1946)', *Bonjour Geschichte*, 4 (2014), 1–26.

[59] See Detlev von Graeve, 'Ausstellung "Gesunde Nerven" Berlin 1929', http://detlev.von.graeve.org/?p=5547 [accessed 20 January 2022].

[60] '[...] die Totalität menschlichen Lebens und Erlebens schlaglichtartig zu beleuchten'. Dora Benjamin, 'Gesunde Nerven', *Berliner Wohlfahrtsblatt: Beilage zum Amtsblatt der Stadt Berlin*, 24 (24 November 1929), 196–7 (p. 196).

[61] '[...] Existenzkampf infolge des gesteigerten Tempos der Großstadt'; Benjamin, 'Gesunde Nerven', p. 196.

[62] '[...] die Sorge für die geistige Gesundheit ebenso wichtig ist wie die Fürsorge um den Körper'; Benjamin, 'Gesunde Nerven', p. 196.

[63] Schöck-Quinteros, 'Dora Benjamin', p. 9. In her article about the exhibition, Benjamin also describes other knock-on effects of *Heimarbeit*, such as women often being forced to work at night to make up for time lost during the day when they have to look after their children: 'Auch Hausfrauen-Zeit ist Geld!'. Benjamin, 'Gesunde Nerven', p. 197. In a subsequent article, she criticizes how women working from home are shouldering three burdens: paid employment, housework, and raising children. Dora Benjamin, 'Verbreitung und Auswirkung der Frauenerwerbsarbeit', in *Die Kultur der Frau: Eine Lebenssymphonie der Frau des XX. Jahrhunderts*, ed. Ada Schmidt-Beil (Berlin: Verlag für Kultur und Wissenschaft, 1931), pp. 155–63 (p. 156).

scope for influencing public policy in this area. In the late 1920s, she thus shifted her efforts towards public health education.[64]

The Healthy Nerves exhibition was a major initiative in terms of both its agenda and its presentation. Designed by the artist and art pedagogue Fritz Wiegmann, it featured a two-and-a-half-metre tall cube in the first room, which bore a photomontage frieze with the slogan 'Give working people money, light, air, and space!'[65] Another photomontage was dedicated to the relationship between human beings and machines. Opposite the entrance a diorama depicted 'the living quarters of the poor, the factory, and the entertainment spaces of the rich'; the caption warned: 'work, poverty, stimulation use up the strength of your nerves'.[66] This statement sums up the exhibition's core agenda: to draw attention to the mutually exacerbating damage which work *and* leisure, particularly mass entertainment, wreaked on people's well-being (Figure 8.1).

The exhibition's innovative layout and conception were intended to spark a two-way dialogue between the organizers and the audience. Dora Benjamin spells out the envisaged feedback mechanism: 'The exhibition organizers seek to make use of [the visitors'] criticism. A feedback box will collect their wishes and objections, which will be considered as far as possible when the exhibition is expanded'.[67]

She concludes with a summary of the exhibition's intended impact and reception:

> Es ist nicht der Zweck der Ausstellung, beruhigend auf die Besucher zu wirken; sie soll nicht besichtigt werden, wie eine Sammlung, die lediglich darstellen will, was ist. Es ist vielmehr ihr Zweck, die Kritik der Besucher anzuregen, Kritik nicht nur an dem Dargebotenen, sondern darüber hinaus an bestehenden wirtschaftlichen und sozialen Gegebenheiten.[68]

> [The exhibition's purpose is not to calm down the visitors; it must not be viewed like a collection that merely wants to show the status quo. Rather, its purpose is to provoke critique in its visitors—critique not only of what it presents but, beyond that, of the current economic and social situation.]

Here, Dora Benjamin echoes Fränkel's opening speech, in which he stressed 'that this exhibition does not want to feed idle curiosity, but should encourage active,

[64] Dora Benjamin's main focus, including during her exile years in France and Switzerland, remained the well-being of children and the problems they faced for personal and social reasons. Schöck-Quinteros, 'Dora Benjamin', p. 14.

[65] 'Gebt den Werktätigen Geld, Zeit, Licht, Luft, Raum!'

[66] '[D]as Wohnviertel der Armen, die Fabrik und das Amüsierviertel der Reichen'; 'Arbeit, Armut, Trubel verbrauchen Eure Nervenkräfte'. Benjamin, 'Gesunde Nerven', p. 196.

[67] 'Es liegt im Bestreben der Veranstalter der Ausstellung, diese Kritik [der Besucher] nutzbar zu machen. Ein Zettelkasten soll Wünsche und Beanstandungen der Besucher sammeln, die beim Ausbau der Ausstellung nach Möglichkeit berücksichtigt werden sollen'. Benjamin, 'Gesunde Nerven', p. 196.

[68] Dora Benjamin, 'Gesunde Nerven', p. 196.

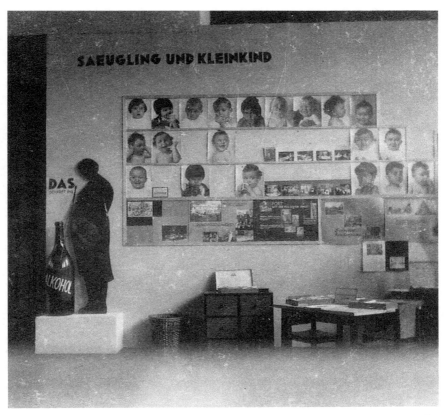

Figure 8.1 Display on the theme of Baby and Child; Healthy Nerves exhibition, Berlin 1929

responsible behaviour'.⁶⁹ The goal was to resist any form of passivity, particularly the contemplative, venerating stance adopted by visitors of museums and art galleries, but also the equally passive voyeurism engendered by sensationalist spectacles such as fairground curiosity cabinets.⁷⁰

In his exhibition review, Walter Benjamin picks up on and develops many of these ideas. His article, entitled 'Bekränzter Eingang' (Wreathed Entrance), which appeared on 10 January 1930 in *Die literarische Welt*, underlines the shared thinking between the siblings, for it emphatically repeats Dora

⁶⁹ '[...] daß die Ausstellung nicht der Schaulust dienen solle, sondern zu aktivem, verantwortungsbewußtem Handeln anregen müsse'. Harald Landry, 'Ausstellung für psychische Hygiene', *Vossische Zeitung*, 479/B 237 (10 October 1929), 3.
⁷⁰ On Weimar hygiene exhibitions more generally, see Michael Hau, *The Cult of Health and Beauty in Germany: A Social History 1890–1930* (Chicago, IL: University of Chicago Press, 2003), pp. 125–49; and Michael Cowan, 'From the Astonished Spectator to the Spectator in Movement: Exhibition Advertisements in 1920s Germany and Austria', *Canadian Journal of Film Studies*, 23:1 (2014), 2–29.

Benjamin's call for a different, more active and critical, mode of spectatorship. In his review, Benjamin is at pains to distinguish the exhibition from the traditional museum when he remarks that 'visitors should leave the exhibition wilier rather than more learned'.[71] At stake is a more practical and street-wise kind of knowledge than the *Bildung* imparted by the museum. Benjamin concurs with his sister when he stresses that one of the exhibition's principal aims is to alter reception habits, 'to stop everyone and at all cost from lapsing into a contemplative mindset, or into one of detached and base scrutiny'.[72] Though contemplative immersion and detached scrutiny are very different stances associated with different traditions and contexts, they must both be overcome, replaced by an alternative mode of engagement.

To this end, the exhibition is rooted in everyday life, trying to project a sense of authenticity. Benjamin singles out one display which warns against excessive alcohol consumption. Rather than showing, for instance, the bottles consumed over the course of three months, it features a more inconspicuous object: 'a filthy scrap of paper which has been folded many times: the wine merchant's quarterly bill'.[73] Real-life objects such as this have the power to spark a strong reaction— Benjamin describes 'the little shock that [...] leaps out [at us] from the things'.[74] In his review, he compares this strategy to Dada artworks, which likewise incorporate the debris of everyday life—'scraps of fabric, tram tickets, shards of glass, buttons, matches'—and thereby allow the chaos, the messiness of modern life to enter the aesthetic sphere.[75] In addition, the influence of Dadaism manifests itself in the way exhibits are juxtaposed with apparently incongruous commentaries,

[71] 'Nicht gelehrter sollen sie [die Besucher] die Ausstellung verlassen, sondern gewitzter' (*BGS* IV.1, 559). In his review of the 1896 'Gewerbe-Ausstellung' (trade exhibition) in Berlin, Georg Simmel observes the opposite effect, noting how that exhibition 'erzeugt eine Paralyse des Wahrnehmungsvermögens, eine wahre Hypnose, in der der einzelne Eindruck nur noch die obersten Schichten des Bewußtseins streift' ('creates a paralysis of perception, a veritable hypnosis, in which the individual impressions only brush across the upper layers of consciousness'). Georg Simmel, 'Die Berliner Gewerbe-Ausstellung', in *Soziologische Ästhetik*, ed. Klaus Lichtblau (Bodenheim: Philo, 1998), pp. 71–5 (p. 71). On Simmel's text, see Dorothy Rowe, 'Georg Simmel and the Berlin Trade Exhibition of 1896', *Urban History*, 22 (1995), 216–28. Hypnosis features prominently in cultural debates around 1900, when critics raised concerns about the manipulative effects of the new medium of film on impressionable audiences. See for instance Robert Gaupp, 'Der Kinematograph vom medizinischen und psychologischen Standpunkt', in Robert Gaupp and Konrad Lange, *Der Kinematograph als Volksunterhaltungsmittel* (Munich: Dürer-Bund, 1912), pp. 1–12. Reprinted in *Medientheorie 1888–1933: Texte und Kommentare*, ed. Albert Kümmel and Petra Löffler (Frankfurt a.M.: Suhrkamp, 2002), pp. 100–14. On this debate, see also Stefan Andriopoulos, *Besessene Körper: Hypnose, Körperschaften und die Erfindung des Kinos* (Munich: Fink, 2000).
[72] '[...] um jeden Preis und jedem die kontemplative Haltung, das unbeteiligte und schnöde Mustern zu verlegen' (*BGS* IV.1, 559).
[73] '[...] ein schmutziges Zettelchen mit den Spuren vielfacher Kniffe: die Vierteljahrsrechnung bei dem Weinhändler' (*BGS* IV.1, 560).
[74] '[...] der kleine Schock, der [...] aus den Dingen springt' (*BGS* IV.1, 561).
[75] '[...] Stoffreste, Straßenbahnbillets, Glasscherben, Knöpfe, Streichhölzer' (*BGS* IV.1, 560). Benjamin contrasts this approach with the one pursued by New Objectivity, a movement which he accuses, almost in passing, of undermining Dada's subversive agenda by trying to re-establish a sense of control within and through the resulting artworks.

a montage technique that creates 'clever traps, which lure and capture the attention'.[76] Ultimately, the 'little shocks' inflicted by the displays are meant to inspire a lasting change of attitude in the visitors: 'Those who have come to gawp should go home wanting to take part'.[77]

Though he does not spell out in what way exactly visitors are meant to 'take part', Benjamin's review marks an important juncture in his writings. It casts a spotlight on the Benjamin siblings' shared aesthetic and political agenda, which was crystallized around an active model of spectatorship. Echoing many of the points made in Dora Benjamin's newspaper article, Benjamin's exhibition review prefigures his writings of the 1930s and particularly his essay on 'The Work of Art in the Age of its Technological Reproducibility', where these ideas are expanded into a comprehensive theory of art, technology, and human experience.

The 'Work of Art' Essay: Against Contemplation

The 'Work of Art' essay, probably Benjamin's most famous and influential text, exists in no fewer than five versions, written between 1935 and 1936.[78] Indeed, even after he had completed the final version, Benjamin continued to jot down further ideas, obviously regarding the project as open-ended.[79] This considerable investment of time and effort reflects both the importance he placed on this, his most 'programmatic' contribution to aesthetic theory[80] and the resistance sparked by his argument among some of his friends and colleagues.

Only an abridged French translation—by Pierre Klossowski, but with Benjamin's extensive input—appeared during the author's lifetime, in Max Horkheimer's *Zeitschrift für Sozialforschung* (Journal for Social Research); Benjamin's efforts to publish the essay in the Moscow-based exile journals *Internationale Literatur* or *Das Wort* (The Word), the latter co-edited by Brecht, never came to fruition. To ensure the publication of the French version, Benjamin had to agree to swingeing cuts, including of the important afterword, designed to tone down what Horkheimer regarded as its overly political argument. The subsequent fifth version aimed at *Das Wort* contains new material partially intended to underline the affinities with Brecht's epic theatre. Just as notable as these changes, however, are the continuities. The core argument is already in place in the first version and associated notes, and remains surprisingly stable, even

[76] '[...] kluge Fallen, die die Aufmerksamkeit locken und festhalten' (*BGS* IV.1, 561).
[77] 'Wer als Gaffer gekommen ist, soll nachhause gehen als einer, der mitmachte' (*BGS* IV.1, 559).
[78] The new German critical edition of Benjamin's *Werke und Nachlass* thus extends and supersedes the previous count of three versions as set out in the *Gesammelte Schriften*.
[79] See editor Burkhardt Lindner's helpful summary in *WuN* 16, 319–75.
[80] In a letter to Werner Kraft of 27 December 1935, Benjamin calls the essay 'eine programmatische Arbeit zur Kunsttheorie' (*WuN* 16, 324; 'a programmatic work on the theory of art').

down to specific formulations, across its different iterations. This sense of continuity also links the project to the rest of Benjamin's writings; the essay picks up on ideas developed in earlier texts but takes them in new directions.

In some sense, the essay echoes texts such as 'On Dread' and 'Habit and Attention', where attention is explored in archetypical situations, but in the 'Work of Art' essay, this anthropological perspective is complemented by a historical narrative, which highlights the intertwined developments of (media) technology and experience. 'The way in which human perception is organized—the medium in which it occurs—is conditioned not only by nature but by history', Benjamin writes, adding that just as *the entire mode of existence of human collectives changes over long historical periods, so too does their mode of perception*.[81] The 'natural' and the 'historical', collective and personal experience—these opposites are shown to be closely linked, mutually inflecting each other.

In essence, the essay explores how people experience art, their everyday surroundings, and each other at different stages in human history. The term *Aufmerksamkeit* only features a handful of times and mostly in a negative light. More prominent are the extreme poles of the attentional spectrum: contemplation at one end, distraction, shock, and vigilance at the other. Echoing his exhibition review, Benjamin expands his attack on contemplation as a mode of aesthetic experience. This mindset, he argues, is rooted in cult and religious ritual; the earliest artworks were religious icons and statues, which acted as 'objects for magical contemplation (contemplation of an ancestral figure strengthens the occult powers of the beholder)'.[82] Contemplation thus creates a quasi-magical synergy between object and observer, causing the latter to merge with, or collapse into, the former. And yet on a social level, this experience is typically a solitary one, as when 'certain statues of gods are accessible only to the priest in the cell'.[83]

Benjamin concedes that under certain conditions, religious devotion could serve an emancipatory purpose. In the fifth version, he mentions the medieval *devotio moderna* movement, in which solitary prayer enabled worshippers to communicate directly with God, thereby bypassing the mediating authority of the church.[84] But as he stresses, in subsequent centuries contemplation loses this emancipatory, subversive impulse. What remains is an empty shell—a mindset no

[81] *BSW* IV, 255. 'Die Art und Weise, in der die menschliche Wahrnehmung sich organisiert—das Medium, in dem sie erfolgt—ist nicht nur natürlich sondern auch geschichtlich bedingt'; '*verändert sich mit der gesamten Daseinsweise der menschlichen Kollektiva auch die Art und Weise ihrer Sinneswahrnehmung*' (*WuN* 16, 214).

[82] *BSW* III, 107; 'Gegenstände einer magischen Kontemplation (die Betrachtung der Ahnenfigur stärkt die Zauberkraft des Betrachtenden)' (*WuN* 16, 107).

[83] *BSW* III, 106; 'gewisse Götterstatuen nur dem Priester in der cella zugänglich [sind]' (*WuN* 16, 106).

[84] *WuN* 16, 243. See Elias H. Füllenbach and Linda Maria Koldau, 'Devotio Moderna', in *Encyclopedia of the Bible and its Reception*, vol. 6: *Dabbesheth—Dreams and Dream Interpretation*, ed. Hans-Josef Klauck et al. (Berlin: de Gruyter, 2012), c. 716-19.

PRESENCE OF MIND: WALTER BENJAMIN 287

longer dialogically aimed at the divine other but focused on the inanimate artwork as its secular substitute. Even when such artworks are displayed in public spaces, in galleries and museums, the experience of the immersed viewer is solitary, inward-looking; as Benjamin pointedly puts it, in the nineteenth century aesthetic experience becomes 'a breeding ground for asocial behavior'.[85]

So here, Benjamin returns to the critique of secular immersion as set out in 'On Dread', where immersion in 'something foreign' is said to leave the individual 'depotentiated, lacking in presence of mind' (*BGS* VI, 76). In the 'Work of Art' essay, the antidote to this risk is not religion (prayer) but technology, the envisaged aim not the encounter with the divine but the formation of a collective consciousness. New media such as photography, radio, and film do not simply *re*produce original artworks but redefine the very notion of aesthetic experience as tied to a particular time and space—and with it *'the whole social function of art [...]. Instead of being founded on ritual, it is based on a different practice: politics'*.[86] This sweeping claim is then fleshed out in a series of case studies, which trace this shift from ritual to politics in relation to different media and their social and historical context.

Benjamin's first example is photography, which had already been the focus of his 1931 'Little History of Photography'; its argument is here repeated in condensed form. Photography sits at the threshold between tradition and modernity. In the earliest photographic portraits, the human face still has an aura comparable to that surrounding the original work of art. Eugène Atget's turn-of-the-century photographs of a Paris devoid of people, in contrast, are not auratic but unsettling; Benjamin likens them to crime-scene photographs. They are 'Beweisstücke im historischen Prozess' (proofs in the historical process or trial), revealing hidden power structures and investing familiar locations with an uncanny dimension. As he elaborates, this uncanniness lends them a 'hidden political significance. They demand a specific kind of reception. Free-floating contemplation is no longer appropriate to them. They unsettle the viewer; he feels challenged to find a particular way to approach them'.[87]

Passages such as this illustrate Benjamin's powerful rhetoric, but also the occasional slippages and gaps in his narrative. The above passage leaves it open

[85] *BSW* IV, 267; 'eine Schule asozialen Verhaltens' (*WuN* 16, 243). The famous notion of aura, which Benjamin defines as the 'einmalige Erscheinung einer Ferne, so nah sie sein mag' (*WuN* 16, 215; 'unique apparition of a distance, however near it may be'; *BSW* IV, 255) serves as a shorthand for this contemplative experience, although aura is no stable concept but appears in different guises and contexts in Benjamin's work. See Carolin Duttlinger, 'Walter Benjamin: The Aura of Photography', *Poetics Today*, 29 (2008), 79–101.

[86] *BSW* IV, 257; '*die gesamte soziale Funktion der Kunst [...]. An die Stelle ihrer Fundierung aufs Ritual tritt ihre Fundierung auf eine andere Praxis: nämlich ihre Fundierung auf Politik*' (*WuN* 16, 219).

[87] *BSW* IV, 258; 'verborgene politische Bedeutung [...]. Sie fordern schon eine Rezeption in bestimmtem Sinne. Ihnen ist die freischwebende Kontemplation nicht sehr angemessen. Sie beunruhigen den Betrachter; er fühlt: zu ihnen muss er sich einen bestimmten Weg suchen' (*WuN* 16, 223).

where precisely the political character of Atget's photographs originates, hinting that this is tied up with their disruption of a state of free-floating contemplation. Here as throughout the essay, the analysis oscillates between the levels of content, form or medium, and reception. Photography is the first in a succession of examples all linked by their incompatibility with, and resistance to, a contemplative mode of reception. While contemplation is firmly associated with the traditional artwork, its alternatives are more disparate; in trying to pinpoint possible counter models Benjamin touches on different modes of sensory perception (visual versus haptic), different states of mind (habit, distraction, shock), and different subjects of aesthetic experience (the individual versus the collective). His examples include avant-garde art as well as technical media, contemporary as well as historical examples. These paradigms are explored in short, self-contained chapters, which add up to a loosely structured argument that evolves not in a linear fashion but through more associative connections.

One such paradigm is Dadaism, an art movement already featured in Benjamin's exhibition review, where he highlights the ability of Dada collage to shock viewers out of their passive state. In the 'Work of Art' essay, he returns to this argument: 'from an alluring visual composition or an enchanting fabric of sound, the Dadaists turned the artwork into a missile. It jolted the viewer'.[88] The artwork as missile destroys the distance between work and recipient, an effect that can be observed across the spectrum of modern art: 'before a painting by Arp or a poem by August Stramm, it is impossible to take time for concentration and evaluation, as one can before a painting by Derain or a poem by Rilke'.[89]

Avant-garde art and literature are thus part of a cognitive revolution, whereby sustained contemplation, whether in the aesthetic sphere or in everyday life, is replaced by an experience which is shock-like, fragmented, and discontinuous, but

[88] BSW III, 119; 'aus einem lockenden Augenschein oder einem überredenden Klanggebilde wurde das Kunstwerk bei den Dadaisten zu einem Geschoß. Es stieß dem Betrachter zu' (WuN 16, 86). Benjamin assigns Dada art a 'taktische Qualität' (WuN 16, 135; BSW III, 119), a formulation which is, as Tobias Wilke has argued, derived from Alois Riegl's Spätrömische Kunst-Industrie (Late Roman Art Industry, 1901). Riegl uses the term 'taktisch' not in the military sense but to denote a mode of representation, which renders the tactile dimension of things through optical means. Riegl's text is mentioned in Benjamin's notes for the essay; indeed, it is from Riegl that Benjamin derives one of his core methodological assumptions: that an analysis of artworks allows us to draw conclusions about the underlying organization of perception and experience in a given period. Tobias Wilke, Medien der Unmittelbarkeit: Dingkonzepte und Wahrnehmungstechniken 1918–1939 (Munich: Fink, 2010), pp. 204–8; see also Tobias Wilke, 'Tacti(ca)lity Reclaimed: Benjamin's Medium, the Avant-Garde, and the Politics of the Senses', Grey Room, 39 (2010), 39–56 (pp. 47–9).

[89] BSW IV, 267; 'es ist unmöglich, vor einem Bild von Arp oder einem Gedicht August Stramms sich wie vor einem Bild Derains oder einem Gedicht von Rilke Zeit zur Sammlung und Stellungnahme zu lassen' (WuN 16, 243). This characterization of avant-garde art resembles Viktor Shklovsky's concept of ostranenie, defamiliarization, developed in his 1917 essay 'Art as Device'. Literature and art, he argues, can challenge the habitual modes of perception and rekindle a more immediate awareness of the world through defamiliarizing modes of representation. Viktor Shklovsky, 'Art as Device', in Viktor Shklovsky: A Reader, ed. and trans. Alexandra Berlina (London: Bloomsbury, 2017), pp. 73–96 (p. 80). Unlike Shklovsky, however, Benjamin does not regard habitual perception as the enemy; for him, habit, Gewöhnung, is part of a whole arsenal of anti-contemplative modes of experience.

which thereby, in Benjamin's theory at least, allows the viewer to stay engaged with a wider part of her surroundings. Film is the chief vehicle for this new, multifocal kind of experience. In his exhibition review, Benjamin curtly dismisses film as a medium whose aesthetic and political potential has been stunted by an 'amusement industry, which has developed its technological possibilities only to paralyze them'.[90] These reservations are set aside in the 'Work of Art' essay, where film's popular appeal, its ability to reach a wide audience, is central to its revolutionary potential. And yet, across its different versions Benjamin's essay frames this potential in very different ways, drawing on a range of other media and everyday practices in his attempt to pinpoint the role of film in reshaping attention in modern life. In a series of loosely linked reflections, he touches on cinematic style and technology and their effects on body and mind. This discussion is underpinned by several discourses and paradigms; one of the most prominent is psychotechnics, the discipline co-founded by his cousin's husband, William Stern.

Cinematic Experience

The 'Wreathed Entrance' review briefly references the 'testing devices' used in the field of career counselling (*BGS* IV.1, 559), and psychotechnics also features in Benjamin's 1930 radio broadcast 'Karussell der Berufe' (Carousel of Professions). Here, he cites the famous psychotechnical slogan 'the right man in the right place' when he describes the growing pressure faced by working people at a time when competition for jobs is at an all-time high (*WuN* 9.1, 488). Unlike Kracauer, he does not criticize psychotechnics but takes its use in the modern economy as a given. In the 'Work of Art' essay, in contrast, these practices are cast in a more ambivalent light. Brigid Doherty notes that in Benjamin's essay, psychotechnics acts 'as a technological and historical paradigm for the production and the reception of the cinema'; a closer look at its treatment, however, uncovers some revealing shifts and tensions.[91]

For Benjamin, the medium of film brings to light the widespread uses of psychotechnics across society and its insidious ability to shape human behaviour. This influence is both embodied in and reflected by the experience of the actor. Acting for the camera, Benjamin argues, is completely different from acting onstage; the film actor cannot adjust her performance in response to a live audience,

[90] An 'Amüsierindustrie, die die technischen Möglichkeiten nur entwickelt, um sie dann lahm zu setzen' (*BGS* IV.1, 561).

[91] Brigid Doherty, 'Test and Gestus in Benjamin and Brecht', *Modern Language Notes*, 115 (2000), 442–81 (p. 477). See also Mladen Gladic, 'Erziehung, zweckfrei: Zur Medialität der Pädagogik bei Walter Benjamin', in *Walter Benjamins anthropologisches Denken*, ed. Carolin Duttlinger, Ben Morgan, and Anthony Phelan (Freiburg i.Br.: Rombach, 2012), pp. 215–42 (pp. 221–4).

while the cinemagoers, in turn, get to see her performance not in its original form but as a montage of footage recorded by different cameras, in different takes and locations. Here, Benjamin draws an analogy with psychotechnical testing regimes used in everyday life. In the recording studio, 'the performance of the actor is subjected to a series of optical tests';[92] the same can be observed across modern society, where

> der Arbeitsprozess, besonders seit er durch das laufende Band normiert wurde, täglich unzählige Prüfungen am mechanisierten Test hervor[ruft]. Diese Prüfungen erfolgen unter der Hand: wer sie nicht besteht, wird aus dem Arbeitsprozess ausgeschaltet. Sie erfolgen aber auch eingeständlich: in den Instituten für Berufseignungsprüfungen. (*WuN* 16, 115)
>
> [the work process, especially since it has been standardized by the assembly line, daily generates countless mechanized tests. These tests are performed unawares [or underhand], and those who fail are excluded from the work process. But they are also conducted openly, in agencies for testing professional aptitude.
>
> (*BSW* III, 111)]

Testing happens openly and consensually at assessment centres, but it continues 'underhand' at the workplace. Modern work is a vast laboratory of physical and mental conditioning, and although psychotechnics is a prominent part of the German economy, Benjamin warns that its reach and implications are not sufficiently understood, for this assessment process cannot be exposed 'to the degree one would desire'.[93] Here, film can make a significant intervention. It makes '*test performances capable of being exhibited, by turning that ability itself into a test*'.[94]

What does Benjamin mean with this chiastic statement? As he stresses, performing for the camera is 'a test performance of the highest order', in which the director 'occupies exactly the same position as the examiner in an aptitude test'.[95] But acting for the camera is not simply another instance of psychotechnical testing; rather, it turns this practice into an aesthetic spectacle. The finished film displays this testing process, and the experience of the individual subjected to it, to a group of people who have had similar experiences in their own lives. Benjamin declares that, given the ubiquity of testing in modern life,

[92] *BSW* IV, 259; 'wird die Leistung des Darstellers einer Reihe von optischen Tests unterworfen' (*WuN* 16, 226).
[93] *BSW* III, 111; 'im wünschenswerten Mass ausstellbar' (*WuN* 16, 115).
[94] *BSW* III, 111; '[macht] *die Testleistung ausstellbar indem er aus der Ausstellbarkeit der Leistung selbst einen Test macht*' (*WuN* 16, 115–16).
[95] *BSW* IV, 259; 'steht genau an der Stelle, an der bei der Eignungsprüfung der Versuchsleiter steht' (*WuN* 16, 226).

das Interesse an dieser Leistung [of the actor] ist riesengross. Denn eine Apparatur ist es, vor der die überwiegende Mehrzahl der Städtebewohner in Kontoren und in Fabriken während der Dauer des Arbeitstages ihrer Menschlichkeit sich entäussern muss. Abends füllen dieselben Massen die Kinos, um zu erleben, wie der Filmdarsteller für sie Revanche nimmt, indem *seine* Menschlichkeit (oder was ihnen so erscheint) nicht nur der Apparatur gegenüber sich behauptet, sondern sie dem eignen Triumph dienstbar macht.

(*WuN* 16, 116)

[Interest in this performance is widespread. For the majority of city-dwellers, throughout the workday in offices and factories, have to relinquish their humanity in the face of an apparatus. In the evening these same masses fill the cinemas, to witness the film actor taking revenge on their behalf not only by asserting *his* humanity (or what appears to them as such) against the apparatus, but by placing that apparatus in the service of his triumph. (*BSW* III, 111)]

Even though the audience's viewpoint is identical to that of the camera, on an emotional level they empathize with the actor as the modern test subject par excellence. Unlike the majority of the workforce—the millions working 'in offices and factories'—however, the actor is not oblivious to this regime but knowingly subjects him- or herself to it. Although Benjamin cites from Luigi Pirandello's 1915 novel *Quaderni di Serafino Gubbio operatore* (The Notebooks of Serafino Gubbio, Cinematograph Operator), in which acting for camera is described as a profoundly alienating experience,[96] he stresses that this performance also harbours an emancipatory and subversive potential. Acting for the camera means 'preserv[ing] one's humanity in the face of the apparatus'[97]—and hence modelling a resistant kind of behaviour which viewers can emulate in their everyday lives.

This, at least, is Benjamin's argument; it is a bold and questionable claim. Its dialectical turn echoes Kracauer's 'Cult of Distraction' essay, where the superficial and fragmentated character of cinematic images is said to harbour the potential to spark revolt against the status quo. Benjamin invests film with a similarly subversive power, but his argument hinges not merely on film's overall stylistic and technological features but on human agency. In comparing filming to psychotechnical testing, he does not fully spell out *how* and *why* the actor emerges from

[96] Extracts of Pirandello's novel are contained in Léon Pierre-Quint's essay 'Signification du cinéma' (Meaning of the Cinema), which Benjamin read in preparation for his own essay. The film actor, Pirandello writes, is exiled from both the stage and his own body, which has been robbed of 'seiner Realität, seines Lebens, seiner Stimme und der Geräusche, die er verursacht, indem er sich rührt' ('his reality, his life, his voice, the noises he makes when moving about') and has been turned into 'ein stummes Bild [...], das einen Augenblick auf der Leinwand zittert und sodann in der Stille verschwindet' ('a mute image that flickers for a moment on the screen, then vanishes into silence'; *WuN* 16, 117; *BSW* III, 112).

[97] *BSW* III, 111; 'heisst, im Angesicht der Apparatur seine Menschlichkeit beibehalten' (*WuN* 16, 116).

this experience victorious, nor how he (or she) can take revenge 'by asserting *his* humanity (or what appears to them as such) against the apparatus'. For all his emphasis on the collective agency of the cinema audience as a quasi-revolutionary subject, Benjamin here falls back on the more traditional model of the individual hero. Revealingly, though, this argument is tempered by the phrase in brackets, which suggests that the actor's rebellion may not be real but only an illusion, a skilled performance. Crucially, the above-cited section is missing from the final version of the essay, where the focus on individual action is replaced by the agency of the collective and, more importantly, the apparatus. To understand this move, it is first necessary to reconstruct some other aspects of Benjamin's argument, particularly its endorsement of habit and distraction as the two interconnected antidotes of contemplation.

In order to pinpoint the cognitive effects of film, Benjamin draws analogies to a number of other artforms and media, most prominently architecture. Throughout history, he argues, buildings have been 'received in a dual manner: by use and by perception'.[98] With the exception of some architectural landmarks, which produce a state of 'gespanntes Aufmerken' (attentive observation) particularly in the tourist, the buildings that surround us are principally experienced via the sense of touch, through the embodied experience of dwelling in them. People's engagement with architecture, in other words, 'comes about not so much by way of attention as by way of habit', in a mode of 'casual noticing'.[99] As in his 1932 text 'Habit and Attention', *Gewohnheit* plays a key role in this argument, but the 'Work of Art' essay explores this notion not via individual experiences such as pain or dreaming, but in relation to architecture as the backdrop of communal existence: 'throughout history, architecture marked the prototype of an artwork which is received in [a state of] distraction and by the collective'.[100] This distracted and collective mode of experience makes architecture a precursor of film, which is likewise the subject of a 'simultaneous collective reception' transcending class, gender, and political orientation.[101]

In the cinema, Benjamin argues, the '*greatly increased mass of participants*' produces a completely '*different kind of participation*',[102] whereby individual viewers adjust their response to those around them. Cinemagoers, in other words, are not solipsistically immersed in the spectacle on the screen but remain aware of their fellow viewers—a model of split attention reminiscent of Cohn and

[98] *BSW* III, 120; 'auf doppelte Art rezipiert: durch Gebrauch und durch Wahrnehmung' (*WuN* 16, 137).

[99] *BSW* III, 120; 'erfolgt nicht sowohl auf dem Wege der Aufmerksamkeit als auf dem der Gewohnheit' (*WuN* 16, 137). For the resonances of Benjamin's model of habitual, tactile reception and casual attention in current theories of perception, see Martin Doll, 'Architektur und Zerstreuung: "Gebrauch", "Gewohnheit" und "beiläufiges Bemerken"', *Figurationen*, 2 (2015), 25–44.

[100] 'Die Architektur bot von jeher den Prototyp eines Kunstwerks, dessen Rezeption in der Zerstreuung und durch das Kollektivum erfolgt' (*WuN* 16, 137).

[101] *BSW* III, 116; *WuN* 16, 237. [102] *BSW* III, 119; *WuN* 16, 136.

Gent's 1908 experiments. To capture this mindset, Benjamin introduces another crucial term into his argument: *Zerstreuung* (distraction). In the essay's penultimate section, distraction takes centre stage as that state which condenses the revolutionary nature of cinematic experience.

Distraction can be traced back all the way to the essay's earliest stages. The notes which precede the first version include a list of bullet points headed 'Theorie der Zerstreuung' (Theory of Distraction). Inverting the consensus of his time, when sustained attention was held to be if not the cognitive norm then at least the ideal, Benjamin makes distraction the focal point of his theory of art and experience. As he writes in the notes, 'The values of distraction must be deduced from film, those of catharsis from tragedy', adding that 'both distraction and catharsis must be described as physiological phenomena'.[103] Catharsis, according to Aristotle the product and aim of tragedy, is thus superseded by distraction as its modern-day equivalent, just as the cinema succeeds the (Greek) theatre as a space where spectacle shapes collective experience. For all their differences, the two settings have more in common with each other than with the experience of the traditional artwork in either church or museum. Both catharsis and distraction are bodily experiences, Benjamin argues, thereby continuing the close association between body and mind in his earlier, anthropological texts.

In Benjamin's argument, *Zerstreuung* is a multi-faceted and slippery concept, one which echoes and yet subverts the term's overwhelmingly negative connotations as the corrosive adversary of attention. Benjamin is well aware of this argument and utilizes it for his purpose. To this end, he cites the French writer Georges Duhamel, for whom film is 'a spectacle which requires no concentration and presupposes no intelligence', offering 'a distraction for uneducated, wretched, worn-out creatures'.[104] His words, Benjamin comments, reflect a persistent, transhistorical prejudice, namely that the masses 'seek distraction' while art 'demands contemplation from the viewer'.[105]

Duhamel's palpable dislike of cinema provides Benjamin with a productive impulse, a 'place from which to investigate film'.[106] So what is the exact nature of this experience? Duhamel complains that when viewing a film, he cannot think what he wants to think: 'The moving images have taken the place of my

[103] 'Die Werte der Zerstreuung sind am Film zu entwickeln wie die Werte der Katharsis an der Tragödie'; 'Zerstreuung wie Katharsis sind als physiologische Phänomene zu umschreiben' (*WuN* 16, 50).

[104] *BSW* IV, 267; 'ein Schauspiel, das keinerlei Konzentration verlangt, kein Denkvermögen voraussetzt'; 'eine Zerstreuung für ungebildete, elende, abgearbeitete Kreaturen' (*WuN* 16, 245). Benjamin is here citing Duhamel's prose narrative *Scènes de la vie future* (Scenes of Future Life, 1930), which describes a cinema visit in the US as an uncanny, quasi-hypnotic experience. See *WuN* 16, 470–1.

[105] '[...] dass die Massen Zerstreuung suchen, die Kunst aber vom Betrachter Sammlung verlangt' (*WuN* 16, 245). That this argument is by no means limited to conservative circles is underlined by leftwing studies such as Kracauer's *Salaried Masses* and Emilie Altenloh's *Zur Soziologie des Kinos* (On the Sociology of the Cinema, 1914).

[106] '[...] Standort für die Untersuchung des Films' (*WuN* 16, 245).

thoughts'.¹⁰⁷ Benjamin seizes on his remark, noting that film prevents free association through the constant 'change of locations and settings, which intrude on the observer in a shock-like manner'.¹⁰⁸ He adds,

> Gewöhnen kann sich auch der Zerstreute. Mehr: gewisse Aufgaben in der Zerstreuung bewältigen zu können, erweist erst, dass sie zu lösen einem zur Gewohnheit geworden sind [sic]. Durch die Zerstreuung wie die Kunst sie zu bieten hat, wird unter der Hand kontrollierbar, wie weit neue Aufgaben der Apperzeption lösbar geworden sind. Da im Uebrigen für den Einzelnen die Versuchung besteht, sich solchen Aufgaben zu entziehen, so wird die Kunst deren schwerste und wichtigste da angreifen, wo sie Massen mobilisieren kann. Sie tut es gegenwärtig im Film. *Die Rezeption in der Zerstreuung, die sich mit wachsendem Nachdruck auf allen Gebieten der Kunst bemerkbar gemacht hat und das Symptom von tiefgreifenden Veränderungen der Apperzeption ist, hat am Film ihr eigentliches Übungsinstrument.* In seiner Chockwirkung kommt der Film dieser Rezeptionsform entgegen. (*WuN* 16, 247)

> [Even the distracted person can form habits. What is more, the ability to master certain tasks in a state of distraction proves that their performance has become habitual. The sort of distraction that is provided by art represents a covert [or underhand] measure of the extent to which it has become possible to perform new tasks of apperception. Since, moreover, individuals are tempted to evade such tasks, art will tackle the most difficult and most important tasks wherever it is able to mobilize the masses. It does so currently in film. *Reception in distraction—the sort of reception which is increasingly noticeable in all areas of art and is a symptom of profound changes in apperception—finds in film its true training ground.* Film, by virtue of its shock effects, is predisposed to this form of reception. (*BSW* IV, 268–9)]

This paragraph, one of the essay's most frequently cited, appears in all five versions; its argument is complex, involving several interrelated mental states associated with different media and different subjects of (aesthetic) experience.¹⁰⁹ One key term is 'shock', here associated with film, but another, contrasting one is 'distraction', which shades into *Gewohnheit* and *Gewöhnung*. While *Gewohnheit* designates the state of having grown used to an experience, an action, or a physical feature of one's environment, such as a building, *Gewöhnung* refers to the *process*

¹⁰⁷ '[I]ch kann schon nicht mehr denken, was ich denken will. Die beweglichen Bilder haben sich an den Platz meiner Gedanken gesetzt' (*WuN* 16, 244).
¹⁰⁸ The 'Wechsel der Schauplätze und Einstellungen, welche stossweise auf den Betrachter eindringen' (*WuN* 16, 243).
¹⁰⁹ See *WuN* 16, 33; 89; 138; 196; 247. In the first version, it features around the middle of the essay, in the second closer to the end, while in versions three to five it appears right at the end of the last section, just prior to the conclusion.

of habituation, which precedes this state. Unlike architecture, film is not (or not yet) part of the backdrop of everyday life; rather, it is a tool which teaches the audience to get used to the accelerated and fragmented nature of modern life.

This argument can be traced back to the essay's earliest version, and yet in his notes Benjamin associates distraction not with film but with aural media: 'the works exhibited by the radio, which, just like those exhibited by film, do not have an original in the strict sense of the word'.[110] He elaborates,

> Sehr sinnfällig ist das in der Musik der Fall, in der eine wesentliche [sic] Element neuesten Entwicklung [sic], der *Jazz*, seinen wichtigsten Agenten in der Tanzmusik hatte. Weniger sinnfällig, aber nicht weniger weittragend kommt diese Tendenz im Film zur Geltung, der durch die Chokwirkung seiner Bilderfolge ein taktisches Element in die Optik selbst trägt. (*WuN* 16, 33–4)
>
> [This is strikingly evident in music, where one of the decisive recent developments, namely *jazz*, has its most important agent in dance music. A less obvious but equally far-reaching manifestation of this tendency can be discerned in film, where the shock effects of the image sequence add a tactile [or tactical] element to its optical dimension.]

Film is here mentioned almost as an afterthought, for the key example is jazz, dance music. The above passage builds on texts such as *One-Way Street* and 'Habit and Attention', which describe how a continuous sound recedes into the background and thereby facilitates renewed, suddenly heightened awareness. In subsequent versions of the 'Work of Art' essay, however, the reference to music is deleted, and film reigns supreme as the catalyst of this new, non-attentional mindset.[111]

Coming back to the previous, longer quotation, film for Benjamin offers a putative answer to one of the core questions facing modern society, namely 'to what extent the new challenges of apperception can be solved'.[112] The term 'apperception', prominent in the writings of Wundt and his associates, features a few times in Benjamin's argument, though he actually misuses it (whether accidentally or deliberately). His 'solution' to the 'new challenges' is what he calls reception in a state of distraction, in other words, a form of engagement which does *not* involve voluntary attention—and which therefore does not qualify as apperception in the Wundtian (and Leibnizian) sense. So what are these new tasks and challenges, and in what capacity does film act as a cognitive training tool? The essay speaks in

[110] '[...] die durch den Rundfunk ausgestellten Kunstwerke, denen nicht anders als denen des Films—im strengen Sinn kein Original mehr entspricht' (*WuN* 16, 33).

[111] In the second version Benjamin sashays straight from architecture to the 'taktische Dominante', the tactile or tactical component of the visual field, which is exemplified by film and the shock effect of its image sequences (*WuN* 16, 89).

[112] '[...] wie weit neue Aufgaben der Apperzeption lösbar geworden sind' (*WuN* 16, 247).

vague but dramatic terms about the 'increased threat to life' faced by people today, arguing that people need to expose themselves to calibrated shock effects, as they are provided by film, to achieve a gradual 'adaptation to the dangers threatening it'.[113]

So how does this work in practice? When Benjamin speaks of the 'shock effect' of film, he does not, as is often claimed, refer principally to the experimental montage technique used by Eisenstein and the Surrealists, but rather to more mainstream features, such as fast cuts and changing camera angles, which require far-reaching mental adjustment on the part of the viewer.[114] The essay describes how the actor's performance is cut up into a series of short takes, which are then reassembled into a sequence; thus a fright reaction is actually a montage of unconnected shots.[115]

With his reference to the cognitive 'tasks' facing the cinema audience, Benjamin is once again using the vocabulary of psychotechnics, whose aim was to test people's suitability for particular roles and enhance existing skills through targeted training. Indeed, this link between cinematic and psychotechnical training is highlighted by the phrase 'unter der Hand' (underhand), which is also used to describe the covert rollout of psychotechnical assessment methods across the economy.[116] So here, the tables are turned. While elsewhere in the essay Benjamin argues that film reflects and thereby exposes such covert processes, offering audiences a figure of identification and resistance in the form of the actor, the medium is also part of this apparatus, a cognitive training device aimed at the viewer, which extends the project of mental optimization from the workplace into people's spare time.[117]

These two lines of argument, then, are at odds with each other, for they cast the role of the cinema in contrasting terms: as a means of revealing and resisting psychotechnical conditioning on the one hand; as a quasi-psychotechnical training device serving the 'task' of cognitive optimization on the other. In fact, Benjamin concedes that this training process will meet with resistance; almost in passing, he mentions the 'temptation to [...] evade such tasks'.[118] However, this temptation is only said to affect the individual, threatening a regression to the solipsistic mindset of contemplation. As Benjamin argues, such regressive tendencies can be overcome in

[113] BSW IV, 281; 'gesteigerten Lebensgefahr, der die Heutigen ins Auge zu sehen haben'; 'Bedürfnis, sich Chockwirkungen auszusetzen' (WuN 16, 244).

[114] See Lindner in WuN 16, 677–8. That Benjamin is thinking of mainstream cinema becomes clear not only in his references to Walt Disney and Charlie Chaplin, but also in his comments on the star cult of Hollywood cinema and the more general predominance of commercial considerations in (mainstream) film production. With very few exceptions, he notes, mainstream western film is not explicitly subversive, does not provide a 'revolutionary criticism of social conditions'; rather, its subversive potential is more general, rooted in its 'revolutionäre Kritik der überkommenen Vorstellungen von Kunst' (WuN 16, 231; 'revolutionary criticism of traditional concepts of art'; BSW IV, 261–2).

[115] WuN 16, 119; BSW III, 113. [116] See WuN 16, 115; BSW III, 111.

[117] Here, Benjamin concurs to some extent with Kracauer's argument in The Salaried Masses, while anticipating Horkheimer and Adorno's 'Culture Industry' chapter in their Dialectic of Enlightenment.

[118] The 'Versuchung [...], sich solchen Aufgaben zu entziehen' (WuN 16, 247).

and by the collective; the task of art, and specifically of film, is to 'mobilize' the masses as the principal subject of cognitive reorientation.

To erase the tension between these two arguments, Benjamin deletes the section which describes the underhand nature of psychotechnical testing in the wider economy and the actor as a figure of resistance from the fifth version of the essay, while adding two new sentences to the end of the above-cited paragraph at the end of section XV:

> Der Film drängt den Kultwert nicht nur dadurch zurück, dass er das Publikum in eine begutachtende Haltung bringt, sondern auch dadurch, dass die begutachtende Haltung im Kino Aufmerksamkeit nicht einschliesst. Das Publikum ist ein Examinator, doch ein zerstreuter. (*WuN* 16, 247)
>
> [Film [...] makes cult value recede into the background, not only because it encourages an evaluating attitude in the audience but also because, at the movies, the evaluating attitude requires no attention. The audience is an examiner, but a distracted one. (*BSW* IV, 269)]

The audience is here restored some agency, appearing as one (unified) examiner adopting an 'evaluating attitude'. Once again, Benjamin is keen to distance this mindset from any association with conventional, voluntary attention. The audience's probing, examining stance is said to be compatible with distraction, arising out of this baseline mental state. As previously mentioned, Benjamin hoped to publish the fifth version of his essay in the exile journal *Das Wort*, co-edited by Brecht. This addition to the end of section XV can be read as an attempt to highlight the affinities between his model of spectatorship and Brecht's agenda, providing what Burkhardt Lindner calls 'a memorable formula connecting Brecht's theory of epic theatre and Benjamin's film theory' (*WuN* 16, 357).[119]

To be more precise, Benjamin here echoes his own characterization of Brecht's dramatic technique, which he explores in a number of texts written in the 1930s. In 'Der Autor als Produzent' (The Author as Producer, 1934), he argues that Brecht's plays induce wonder ('Staunen') and surprise and thereby prevent a passive, contemplative response in the viewers (*BGS* II.2, 698), an argument which echoes his 1931 essay 'Was ist das epische Theater?' (What is Epic Theatre?), where Brecht's audience is said to be no 'mass of hypnotized experimental subjects', but 'a gathering of interested individuals'.[120] Quasi-hypnotic

[119] In addition, Benjamin also inserts two new footnotes referencing Brecht. See *WuN* 16, 221–2; 226.

[120] '[...] eine Versammlung von Interessenten' (*BGS* II.2, 520). Brecht himself concurs with some of these points, as when, in the 'Kleines Organon für das Theater' (Short Organon for the Theatre, 1949), he compares the viewers of traditional theatre to 'lauter Schlafenden, aber solchen, die unruhig träumen, weil sie, wie das Volk von den Albträumern sagt, auf dem Rücken liegen. Sie haben freilich ihre Augen offen, aber sie schauen nicht, sie stieren, wie sie auch nicht hören, sondern lauschen'. Bertolt Brecht, 'Kleines Organon für das Theater', in *Werke: Große kommentierte Berliner und*

absorption is replaced by 'relaxed interest', for Brecht's audience does not follow the onstage action 'tensed up, in a state of suspense' (*BGS* II.2, 535; 532).¹²¹ Rather, his plays produce 'a relaxed audience which is following the plot in a laid-back manner'¹²²—an idea which harks back to Benjamin's exhibition review of 1929, where he stresses the importance of maintaining 'a cool head' even in the face of the unexpected (*BGS* IV.1, 560).

In the final version of the 'Work of Art' essay, the audience's experience is thus purged of all empathy and identification with the actor, as distraction becomes synonymous with rational critical detachment. With this argument, Benjamin diverges from contemporary psychological theories; as Frederic J. Schwartz comments, his endorsement of distraction would have aroused 'the scepticism of anyone with even minimal psychotechnical training'.¹²³ Indeed, a 'lack of focused concentration and the reliance on habits are precisely what psychotechnicians were called in to prevent', for countless studies had shown the disastrous consequences of distraction.¹²⁴

Put alongside these empirical studies, Benjamin's model of reception in a state of distraction looks rather naïve, based on an ideological opposition to voluntary forms of attention rather than on hard empirical evidence. And yet this cognitive model is not wholly detached from psychological research; in fact, his argument echoes the findings of studies such as Cohn and Gent's, which had revealed that in particular circumstances, performing two mental tasks alongside each other is not only possible but can even improve performance and acuity. Indeed, although Benjamin does not mention this, film was often used for psychotechnical training purposes—in the assessment of tram and train drivers and to educate the general public. One interesting example of the latter use are the so-called 'rebus films', short films featuring visual puzzles, which were shown as part of a regular screening and which promised to train viewers' speedy mental response and their 'ability to divide attention between simultaneous perceptions'.¹²⁵

Frankfurter Ausgabe, vol. 23, ed. Werner Hecht et al. (Frankfurt a.M.: Suhrkamp, 1993), pp. 65–97 (pp. 75–6); 'people who are just sleeping, yet have restless dreams because, as the people say of those who have nightmares, they are lying on their backs. True, their eyes are open, yet they do not see, but stare, just as they do not listen, but eavesdrop'. Bertolt Brecht, 'Short Organon for the Theatre', in *Brecht on Theatre*, ed. Marc Silberman, Steve Giles, and Tom Kuhn (London and New York, NY: Bloomsbury, 2019), pp. 271–99 (pp. 279–80).

¹²¹ These latter comments are taken from a second essay also entitled 'What is Epic Theatre?', published in 1939, which is, however, completely separate from the first, unpublished essay of 1931.

¹²² '[...] ein entspanntes, der Handlung gelockert folgendes Publikum' (*BGS* II.2, 532).

¹²³ Schwartz, *Blind Spots*, p. 80.

¹²⁴ Schwartz, *Blind Spots*, p. 81. As Schwartz elaborates, 70–80 per cent of applicants for the role of tram driver failed the first assessment stage, which tested faculties such as fright-reaction and speed of response.

¹²⁵ Michael Cowan, 'Moving Picture Puzzles: Training Urban Perception in the Weimar "Rebus Films"', *Screen*, 51 (2010), 197–218 (p. 218). As Cowan comments, the aims and techniques of rebus films were similar to those of avant-garde movements, 'from futurism to dadaist collage, which places simultaneous perception and divided attention at the centre of urban aesthetics' (p. 213).

As this discussion has shown, a lot of weight is placed on *Zerstreuung* as the vanishing point of Benjamin's essay and as a term which brings together and absorbs previously discussed modes of experience. Distraction buckles under the weight put on it, for despite Benjamin's efforts to illuminate it from different angles, it seems too vague a term to carry these combined social, psychological, and political aspirations. Across its different versions, the 'Work of Art' essay draws on a wide range of historical paradigms to explain shifts in human experience; this includes changes in social viewing practices (from individualized contemplation to mass reception), in the materiality of the artwork, and in the aesthetic programmes underpinning different periods (from the autonomous aesthetic propagated in the eighteenth and nineteenth centuries to the avant-garde and its attempt to embrace everyday life). These different paradigms are sometimes juxtaposed with each other in associative ways, and the essay oscillates between historical analysis and more speculative claims about the present and future of human experience. Schwartz concludes that its argument 'does not correspond to any moment that really existed or could exist', but instead represents a 'palimpsest of revolutionary possibilities from different moments in history. Some were clearly in place; some might perhaps have emerged; but others had already passed'.[126]

However, to judge the essay solely by standards of historical (or psychological) accuracy is to miss its point. Benjamin's aim was neither to reconstruct the past 'as it actually had been',[127] nor to develop cognitive theories of scientific validity. Rather, his case studies are acts of intervention—responses to a specific historical moment: the rise of fascism with its catastrophic implications for art, society, and human experience. The essay's key narrative—about the shift from contemplation to non-contemplative modes of engagement—reflects Benjamin's notion of the 'Jetzt der Erkennbarkeit' ('now of recognizability'),[128] which is central to his historical method, particularly in the *Arcades Project*, which he references in letters relating to the 'Work of Art' essay.[129] Any understanding of the past is tied to the present moment, emerging out of an interplay between past and present.

[126] Schwartz, *Blind Spots*, p. 100.
[127] This phrase, 'wie es eigentlich gewesen', was used by nineteenth-century German historian Leopold von Ranke to set out the standard for historical research as the accurate reconstruction of the past. Leopold von Ranke, *Geschichten der romanischen und germanischen Völker von 1494 bis 1514*, 3rd edn (Leipzig: Duncker & Humblot, 1885 [1824]), p. vii.
[128] See *WuN* 19, 125; 129; and *BGS* V.1, 578.
[129] In his letter to Gretel Adorno of 9 October 1935, he declares that 'ich denjenigen Aspekt der Kunst des neunzehnten Jahrhunderts gefunden, der nur "jetzt" erkennbar ist, der es nie vorher war und der es nie später sein wird' ('that I have found that aspect of nineteenth-century art which is only recognizable "now", that is, never beforehand and never afterwards'). Gretel Adorno and Walter Benjamin, *Briefwechsel 1930–1940*, ed. Christoph Gödde and Henri Lonitz (Franfurt a.M.: Suhrkamp, 2005), p. 243.

As he boldly declares in the preface, the fundamental aim of the essay is to develop a set of aesthetic concepts that cannot be appropriated for fascist purposes (*WuN* 16, 97; *BSW* III, 102). Both artistic practices and aesthetic theory, then, have a practical purpose in trying to enact new, resistant ways of thinking and perceiving. The above-mentioned notes for a 'Theory of Distraction' phrase this idea in more general, trans-historical terms: 'The survival of artworks is to be depicted from the perspective of their fight for survival. Their true humanity consists in their unlimited adaptability'.[130] These sentences encapsulate the essay's core mission, its advocacy of new artforms producing new modes of experience. But this statement also crystallizes the profound differences between Benjamin's outlook and that of many fellow exile critics and writers of the 'inner emigration', that is, those who did not support Hitler's regime but nonetheless remained in Nazi Germany or Austria. As he warns three years later, to try and defend the cultural heritage against the barbarism of fascism, its utilization by totalitarian politics, is pointless if

> unter den drinnen Schweigenden oder denen, die draußen das Wort für sie führen dürfen, die Süffisanz der Erbberechtigten sich hervortäte [...]. Denn die geistigen Besitztümer sind derzeit um nichts besser gewährleistet als die materiellen. Und es ist Sache der Denker und Forscher, welche noch eine Freiheit der Forschung kennen, von der Vorstellung eines ein für alle Mal verfügbaren, ein für alle Mal inventarisierten Bestandes an Kulturgütern sich zu distanzieren.[131]
>
> [the arrogance of those who feel entitled to this cultural heritage becomes palpable among those who stayed on the inside or those on the outside who speak on their behalf. For in the current times, spiritual possessions are no more secure than material ones. And it is the responsibility of those thinkers and academics who are still free to do their research to distance themselves once and for all from the idea of a store of cultural goods which are permanently available, permanently inventoried.]

In the 1930s, mass culture was often seen as the enemy, as the sign and symptom of a new barbarism, which catastrophically culminated in the Third Reich. Benjamin counteracts this argument with a more combative and optimistic one,

[130] 'Das Fortleben der Kunstwerke ist unter dem Gesichtspunkt ihres Kampfs ums Dasein darzustellen. Ihre wirkliche Humanität besteht in ihrer unbegrenzten Anpassungsfähigkeit' (*WuN* 16, 50).
[131] *BGS* III, 525. The article in question, 'Ein deutsches Institut freier Forschung' (A German Institute for Free Research), published in 1938 in the *Zeitschrift für Sozialforschung*, is a survey of the Institute's research agenda. Though Benjamin praises the research conducted by its members, he also criticizes the lack of understanding for his own method, particularly his advocacy of mass culture and his emphasis on the material foundations of culture, which he had encountered from Horkheimer and Adorno.

embracing cultural and cognitive change as inevitable, indeed, as the only way forward in the current crisis. This, at least, is the position of the 'Work of Art' essay. To do justice to the complexity of Benjamin's thought on attention, however, this piece has to be read alongside his essays on literature—specifically on Charles Baudelaire, Nikolai Leskov, and Franz Kafka—which date from roughly the same period, and which complicate some of the 'Work of Art' essay's programmatic positions.

Literary Histories of Attention: Baudelaire, Leskov, Kafka

A kind of sequel to the 'Work of Art' essay, which expands on its argument about cognitive change is Benjamin's long essay 'Über einige Motive in Baudelaire' (On some Motifs in Baudelaire, 1939), an extract and 'miniature model' of his *Arcades Project*.[132] Where the 'Work of Art' essay takes the acceleration and fragmentation of modern life as a given and demands that people adapt to them with the help of training tools such as the cinema, the 'Baudelaire' essay adopts a much more critical stance. In many regards, its argument echoes the modernity-critical treatises of the early 1900s, for instance when Benjamin describes urban experience as 'a series of shocks and collisions', noting that these shocks even invade the home, via inventions such as the matchstick, the camera, and the telephone, where one abrupt hand gesture triggers 'a process of many steps'.[133] The most radical change, however, is caused by industrialization. Quoting Karl Marx, Benjamin writes that the factory worker is subjected to a 'dressage by the machine', whereby each manual task 'has no connection with the preceding gesture for the very reason that it repeats that gesture exactly'.[134] With this argument, Benjamin once again emphasizes the close connection between body and mind, and he uses it to draw links between seemingly unrelated aspects of nineteenth-century culture. The counterpart of the factory worker is the gambler, whose attention is likewise absorbed by endlessly repeated movements without any inner logic or coherence. Modern life, across all these settings, exposes the subject to a stream of disparate stimuli which cannot be synthesized. 'Shock', a term which in the 'Work of Art' essay plays a relatively minor role, here emerges as the key term of Benjamin's historical and literary analysis.

[132] *BGW* I.3, 1073; 1078. In the *Arcades Project*, the Baudelaire material is assembled in Convolute J, the largest of the convolutes. The Baudelaire complex also includes the essays 'Das Paris des Second Empire bei Baudelaire' (The Paris of the Second Empire in Baudelaire) and 'Notes sur les Tableaux parisien de Baudelaire' (Notes on Baudelaire's Tableaux Parisien). Benjamin's plans of publishing this material in book form never came to fruition. See Christine Schmider and Michael Werner, 'Das Baudelaire-Buch', in *Benjamin-Handbuch: Leben—Werk—Wirkung*, ed. Burkhardt Lindner (Stuttgart: Metzler, 2011), pp. 567–84 (pp. 567–70).

[133] *BSW* IV, 328; 'eine Folge von Chocks und Kollisionen'; 'eine vielgliedrige Ablaufsreihe' (*BGS* I.2, 630).

[134] *BSW* IV, 329–30; 'ist gerade dadurch mit dem vorhergehenden ohne Zusammenhang, daß er dessen strikte Wiederholung darstellt' (*BGS* I.2, 632–3).

While Benjamin's portrayal of modern society echoes treatises on neurasthenia, his proposed solution is modelled on Freud. Elaborating on the notion of shock, Benjamin cites Freud's *Beyond the Pleasure Principle* and its concept of *Reizschutz*—the protective shield that guards the mind against overly intense stimuli and whose breakdown can result in trauma. Elaborating on Freud, Benjamin argues that the best protection against such incidents is *Übung*, that is, repeated exposure to stimuli until fending them off has become second nature: 'The more readily consciousness registers these shocks, the less likely they are to have a traumatic effect'.[135]

For Freud, this parrying of stimuli by consciousness is an everyday occurrence which reflects the normal workings of the mind; the notion of shock implies a stimulus which exceeds and thereby destroys the mind's protective capacities.[136] For Benjamin, in contrast, shock is no longer a destructive exception but the default mode of modern experience. Baudelaire's poetry, he argues, reflects this permanent state of exception. His texts are exemplary of a type of writing 'for which exposure to shock has become the norm', and in which the encountered shocks, 'thus cushioned, are parried by consciousness'.[137] The verb *parieren* (to parry), which describes this protective mechanism, is derived from an image in Baudelaire's own texts, where artistic creation is described as a duel 'in which the artist, just before being beaten, screams in fright. [...] Thus, Baudelaire placed shock experience at the very center of his art'.[138] The act of writing is both an attempt to fend off these shocks and the result of a failure to do so, for it marks the moment when the poet is 'defeated' by too intense an impression.

Baudelaire's poems are thus written in times which are hostile to the production of poetry, and this climate also affects their reception in an age when 'the conditions for the reception of lyric poetry have become increasingly unfavorable'.[139] His texts, however, anticipate these obstacles; their envisaged readers, Benjamin notes, are not those select few who are still able to resist the pervasive cultural climate, but people

> die die Lektüre von Lyrik vor Schwierigkeiten stellt. [...] Mit ihrer Willenskraft und also auch wohl ihrem Konzentrationsvermögen ist es nicht weit her; sinnliche Genüsse werden von ihnen bevorzugt; sie sind mit dem spleen vertraut, der dem Interesse und der Aufnahmefähigkeit den Garaus macht. (*BGS* I.2, 607)

[135] *BSW* IV, 317. 'Je geläufiger ihre Registrierung dem Bewußtsein wird, desto weniger muß mit einer traumatischen Wirkung dieser Chocks gerechnet werden' (*BGS* I.2, 613).

[136] Schmider and Werner, 'Das Baudelaire-Buch', p. 578.

[137] *BSW* IV, 318; 'der das Chockerlebnis zur Norm geworden ist' (*BGS* I.2, 614).

[138] *BSW* IV, 319; 'in dem der Künstler, ehe er besiegt wird, vor Schrecken aufschreit. [...] Baudelaire hat also die Chockerfahrung ins Herzen seiner artistischen Arbeit hineingestellt' (*BGS* I.2, 615–16).

[139] *BSW* IV, 313; 'die Bedingungen für die Aufnahme lyrischer Dichtungen ungünstiger geworden sind' (*BGS* I.2, 608).

[to whom the reading of lyric poetry would present difficulties. [...] Willpower and the ability to concentrate are not their strong points. What they prefer is sensual pleasure; they are familiar with the 'spleen' which kills interest and receptiveness. (*BSW* IV, 313)]

This argument recalls Musil's remarks about a perpetually distracted reading public in the preface to his *Posthumous Papers of a Living Author* collection. However, where Musil tries to set his own writing and target readership apart from these adverse conditions, Benjamin casts the poet as equally affected by the prevailing climate. As he notes, Baudelaire dedicates his poetry collection *Les Fleurs du mal* (The Flowers of Evil, 1857) 'to those who are like him' (*BSW* IV, 313; *BGS* I.2, 607). His poetry not only coincides with a cultural crisis of attention but embodies this situation, written as it is by one who shares his reader's experience of mental fragmentation.

'On Some Motifs in Baudelaire' thus transplants the terms of Benjamin's cultural analysis into the literary domain. Baudelaire's poetry embodies the perceptual challenges of modern life which can only be mastered through perpetual alertness; however, it also harbours a contrasting, contemplative stance which allows an intermittent escape from the shocks of modern existence. As Benjamin argues in a reading inspired by Marcel Proust, while time in Baudelaire is fragmented but amorphous, particular days stand out from the stream of experiences. Thus separated, they are transformed into 'days of the completing time [...] days of recollection'.[140] Such moments of remembrance are encapsulated in Baudelaire's concept of *correspondances*, an infinite network of relations underpinning reality, which is, as Benjamin points out, 'the common property of mystics [...]. What Baudelaire means by *correspondances* can be described as an experience which seeks to establish itself in crisis-proof form. This is possible only within the realm of ritual'.[141]

It is no coincidence that this engagement with Baudelaire's *correspondances* as a framework of memory is in turn inspired by Proust's reading of *Les Fleurs du mal*. Both Proust's own notion of *mémoire involontaire* (involuntary memory) and Henri Bergson's model of *durée* (duration) feature prominently in Benjamin's 'Baudelaire' essay, yet ultimately these models of memory prove to be insufficient not only in the face of the challenges of modernity but also because their focus on the individual forecloses questions of collective experience.[142] In Baudelaire's

[140] *BSW* 4, 332–3; 'Tage der vollendeten Zeit, [...] Tage des Eingedenkens' (*BGS* I.2, 637).

[141] *BSW* 4, 333; 'Gemeingut der Mystiker [...]. Was Baudelaire mit den correspondances im Sinn hatte, kann als eine Erfahrung beschrieben werden, die sich als krisensicher zu etablieren sucht. Möglich ist sie nur im Bereich des Kultischen' (*BGS* I.2, 638).

[142] See *BGS* I.2, 608–9; 611/*BSW* 4, 314–16. Baudelaire's *correspondances*, in contrast, encapsulate such a collective dimension: 'Die correspondances sind die Data des Eingedenken. Sie sind keine historischen, sondern Data der Vorgeschichte. Was die festlichen Tage groß und bedeutsam macht, ist

poetry, in contrast, moments of remembrance take on a rather different function. Although they gesture towards a form of *Erfahrung* (experience) which is resilient against the shock and fragmentation of modern life, such moments remain isolated exceptions in Baudelaire's oeuvre and as such direct the poet's attention all the more firmly to the challenges of his own age: 'Only by appropriating these elements was Baudelaire able to fathom the full meaning of the breakdown which he, as a modern man, was witnessing'.[143]

The 'Work of Art' and 'Baudelaire' essays occupy contrasting but complementary positions within Benjamin's thought on modern experience. Where the 'Work of Art' essay focuses on the (trans)formation of collective perceptual habits, Baudelaire's poetry allows Benjamin to revisit this process from the perspective of the individual; and where the 'Work of Art' essay identifies the technical media as vehicles of cognitive adaptation, in 'Baudelaire' this role is assigned to poetry as a medium which reflects a personal struggle, namely the experience of being overwhelmed, defeated by the shocks of modern life. By reading Baudelaire through Freud's theory of traumatic shock, Benjamin acknowledges that certain experiences resist and exceed the process of cognitive (psychotechnical) habituation.

Freud's writings make another, covert, appearance in Benjamin's essay 'Der Erzähler: Betrachtungen zum Werk Nikolai Lesskows' (The Storyteller: Observations on the Works of Nikolai Leskov, 1936).[144] Where the 'Baudelaire' essay looks at the nineteenth century as the cradle of modernity, 'The Storyteller' turns to an earlier, pre-industrial age from which it tries to reconstruct a literary tradition whose social and cognitive foundations have since been eroded. Although the essay shares some features with the 'Work of Art' project, most notably a focus on collective experience, it depicts modernity in an unequivocally negative light, thereby anticipating the 'Baudelaire' essay.

The stories of Russian writer Nikolai Leskov (1831–95) provide the springboard for some far-reaching reflections about listening, attention, and memory. Though Leskov's texts are available in book form, Benjamin presents him as one of the last representatives of an oral narrative tradition. Indeed, his main interest is not in the stories themselves but in their mode of transmission. Storytelling involves active listening, for the recounted tales are designed to be re-told by others: 'The cardinal point for the willing listener is to assure himself of the possibility of reproducing

die Begegnung mit einem früheren Leben' (*BGS* I.2, 639; '*Correspondances* are the data of recollection—not historical data, but data of prehistory. What makes festive days great and significant is the encounter with an earlier life'; *BSW* 4, 333–4).

[143] *BSW* 4, 333. 'Nur indem er sich diese Elemente [of the *correspondances*] zu eigen macht, konnte Baudelaire voll ermessen, was der Zusammenbruch eigentlich bedeutete, dessen er, als ein Moderner, Zeuge war' (*BGS* I.2, 638).

[144] Having completed the third version of the 'Work of Art' essay in November 1935, Benjamin worked on 'The Storyteller' between March and July 1936, as a respite from research for his *Arcades Project* (*BGS* II.3, 1276). During this time, he was also engaged in a fractious correspondence with Horkheimer and his secretary, Hans Klaus Brill, about the French translation of his 'Work of Art' essay. See *WuN* 16, 332–42.

the story. Memory is the epic faculty par excellence'.[145] Deliberate attention is counterproductive for this purpose, for 'no one will remember worse than he who listens to a story with the intention of passing it on'.[146]

The mindset required for successful listening, then, is not voluntary attention but a deep state of relaxation. It is this state which is eroded in modern society. As Benjamin notes, the ability to remember stories

> verliert sich, weil nicht mehr gewebt und gesponnen wird, während man ihnen lauscht. Je selbstvergessener der Lauschende, desto tiefer prägt sich ihm das Gehörte ein. Wo ihn der Rhythmus der Arbeit ergriffen hat, da lauscht er den Geschichten auf solche Weise, daß ihm die Gabe, sie zu erzählen, von selber zufällt. So also ist das Netz beschaffen, in das die Gabe zu erzählen gebettet ist. So löst es sich heutzutage an allen Enden, nachdem es vor Jahrhunderten im Umkreis der ältesten Handwerksformen geknüpft worden ist. (*BGS* II.2, 447)
>
> [is lost when the stories are no longer retained. It is lost because there is no more weaving and spinning to go on while they are being listened to. The more self-forgetful [or oblivious] the listener is, the more deeply what he listens to is impressed upon his memory. When the rhythm of work has seized him, he listens to the tales in such a way that the gift of retelling them comes to him all by itself. This, then, is the nature of the web in which the gift of storytelling is cradled. This is how today it is unraveling on every side after being woven thousands of years ago in the ambience of the oldest forms of craftsmanship.
>
> (*BSW* III, 149)]

Traditional, craft-based activities such as spinning and weaving provide the ideal backdrop for listening since they require no conscious attention and hence free up mental capacity for the recounted story. The kind of receptivity required for storytelling is not produced by novelty and shock, nor by the 'dressage' of the production line, but results from a dialectical coalition with its opposites, boredom and *Gewohnheit*, fostering a sustainable receptivity which resembles Freud's evenly suspended attention.

We cannot be sure whether Benjamin was familiar with the 1912 text in which Freud develops his model of evenly suspended attention; he did, however, read

[145] *BSW* III, 153. 'Der Angelpunkt für den unbefangenen Zuhörer ist, der Möglichkeit der Wiedergabe sich zu versichern. Das Gedächtnis ist das epische Vermögen vor allen anderen' (*BGS* II.2, 453).

[146] '[K]einer [wird] schlechter behalten als wer schon mit der Absicht, sie weiterzugeben, eine Geschichte anhört' (*BGS* II.3, 1287). Despite his emphasis on the receptive disposition of the listeners, however, Benjamin notes that the storyteller also has an active responsibility when it comes to attracting and sustaining his or her listeners' attention; to this end, the storyteller's task was less to increase the stories' didactic content than to refine 'die Listen, mit denen die Aufmerksamkeit der Lauschenden gebannt wird' (*BGS* II.2, 457; 'the tricks with which the attention of the listener is captured'; *BSW* III, 157).

with great interest another one of Freud's later articles, 'Zum Problem der Telepathie' (On the Problem of Telepathy), which builds on this earlier conception of open, non-targeted listening.[147] Freud's springboard is a seemingly supernatural phenomenon, namely the predictions of a fortune-teller. Several of Freud's patients had consulted such mediums; Freud was not interested in the content of the predictions but in the psychological dynamics underpinning these sessions:

> Ich habe eine ganze Reihe von solchen Prophezeiungen gesammelt und von allen den Eindruck gewonnen, daß der Wahrsager nur die Gedanken der ihn befragenden Person und ganz besonders ihre geheimen Wünsche zum Ausdruck gebracht hatte, daß man also berechtigt war, solche Prophezeiungen zu analysieren, als wären es subjektive Produktionen, Phantasien oder Träume der Betreffenden.[148]
>
> [I have collected a whole number of such prophecies and from all of them I gained the impression that the fortune-teller had merely brought to expression the thoughts, and more especially the secret wishes, of those [who] were questioning her, and that we were therefore justified in analysing these prophecies as though they were subjective products, phantasies or dreams of the people concerned. (FSE XXII, 42–3)]

The fortune-teller is an alter ego of the psychoanalyst in that her predictions effectively channel, give voice to, her client's unconscious wishes. Her receptiveness is not the result of voluntary attention but of rituals such as palm reading, the laying of cards, and astronomical calculations. The routine nature of these acts, their repetitive and familiar character, frees up attention: 'The fortune-teller's astrological activities would in that case have performed the function of diverting her own psychical forces and occupying them in a harmless way, so that she could become receptive and permeable to the effects upon her of the client's thoughts'.[149]

In a letter to Gretel Karplus, Benjamin enthusiastically thanks her for Freud's essay, singling out the parallels between the essay and his own theory of language as it is developed in the essay 'Über das mimetische Vermögen' (On the Mimetic Faculty, 1933).[150] But Freud's argument also resonates with the 'Storyteller' essay and its model of listening. The fortune-teller's ritualistic actions are akin to

[147] Sigmund Freud, 'Zum Problem der Telepathie', *Almanach der Psychoanalyse*, 9 (1934), 9–34. This article, in turn, is the reprint of a section of his lecture on 'Traum und Okkultismus' (Dream and Occultism) in the *Neue Folge der Vorlesungen zur Einführung in die Psychoanalyse* (New Introductory Lectures on Psycho-Analysis). See *FGW* XV, 32–61.

[148] *FGW* XV, 45.

[149] *FSE* 18, 184. 'Der astrologischen Arbeit [des Mediums] fiele dabei die Rolle einer Tätigkeit zu, welche [seine] eigenen Kräfte ablenkt, in harmloser Weise beschäftigt, so dass [es] aufnahmefähig und durchlässig für die auf [es] wirkenden Gedanken des Anderen [...] werden kann' (*FGW* 17, 35). This formulation appears in Freud's 1921 lecture 'Psychoanalyse und Telepathie' (Psychoanalysis and Telepathy); the underlying idea is the same as in the *New Introductory Lectures*.

[150] I am indebted to Christina Striewski for drawing my attention to Benjamin's reception of Freud's essay. See Christina Striewski, 'Aufmerksamkeit und Zerstreuung im Anschluß an Walter Benjamin'

weaving and spinning; both are deeply engrained habits which facilitate a state of receptiveness for others' stories and unconscious wishes.

Freud comments on the phenomenon of telepathy without paying much attention to its historical and cultural context; Benjamin, in contrast, is highly attuned to this issue when he describes storytelling as an outdated tradition. The constructive boredom which accompanies craft-based labour is under threat, and 'with this, the gift for listening is lost and the community of listeners disappears'.[151] Industrial labour, which has replaced it, is monotonous but also pressurized, fast, and potentially dangerous, and therefore offers no scope for a meandering kind of attention. This shift, Benjamin argues, is reflected in literature and culture. As manual workers disappear into the factories, the storyteller is replaced by the solitary figure of the novelist, who has 'secluded himself. The birthplace of the novel is the individual in his isolation'.[152] The novel's mode of production is in turn mirrored by its reception: 'A man listening to a story is in the company of the storyteller [...]. The reader of a novel, however, is isolated, more so than any other reader'.[153]

Here, as in the depiction of a traditional, rural community, Benjamin's essay bears a striking resemblance to modernity-critical treatises. The sense of fragmentation which pervades modern work and life in turn gives rise to a short-lived news and entertainment culture; the final stage in Benjamin's social history of literature, following storytelling and the rise of the novel, is the popular press—newspapers and illustrated magazines, which tickle the palates of their readers with sensationalist stories that privilege 'newness, brevity, clarity, and, above all, lack of connection between the individual news items' (*BSW* IV, 316; *BGS* I.2, 610). This tendency also permeates popular literary genres such as romance and the detective story, which demand to be read speedily and do not require sustained attention.[154] As before, there is a mutually reinforcing link between medium and mindset. Despite the speed and reach of modern news reporting, these stories

(master thesis, Free University Berlin, 2003), pp. 79–80. Miriam Hansen discusses the impact of Freud's essay on Benjamin's concept of mimesis: 'Benjamin, Cinema and Experience: "The Blue Flower in the Land of Technology"', *New German Critique*, 40 (1987), 179–224 (p. 195). On Benjamin's response, see also *BGS* II.3, 952–3. In this edition, however, the title of Freud's article is erroneously given as 'Psychoanalyse und Telepathie' (Psychoanalysis and Telepathy), which is in fact the title of an unrelated essay of 1921 (see *FGW* XVII, 25–44).

[151] *BSW* III, 149; 'damit verliert sich die Gabe des Lauschenden, und es verschwindet die Gemeinschaft der Lauschenden' (*BGS* II.2, 446).

[152] *BSW* III, 146; *BGS* II.2, 443. This critique in turn explains why Benjamin in *One-Way Street* places such emphasis on the chatter of voices which accompanies the writer's work and connects his endeavours to the wider community.

[153] *BSW* III, 156; *BGS* II.2, 456. With this critique of the novel's isolating character, Benjamin echoes Georg Lukács's *Theorie des Romans* (Theory of the Novel, 1916). See Alexander Honold, 'Erzählen', in *Benjamins Begriffe*, ed. Michael Opitz and Erdmut Wizisla, vol. 1 (Frankfurt a.M.: Suhrkamp, 2000), pp. 363–98 (pp. 370–3).

[154] As J. J. Long argues, this drive for easily consumable literature is challenged by experimental modernist texts, which require non-linear reading practices; their 'inefficiency' resists 'the logic of the

narrow rather than widen the horizon of their readers; where the storyteller took her listeners on journeys to remote times and places, the appeal of modern news items resides in their 'prompt verifiability', their rootedness in the familiar world of the reader (*BSW* III, 147; *BGS* II.2, 444).

Modernity-critical texts often cite news reporting as an example of the sensationalism of modern culture. In 'The Storyteller', Benjamin concurs with this diagnosis, arguing that in the current age the gradual 'replacement of the older relation by information, and of information by sensation' both reflects and causes the atrophy of collectively accumulated experience (*Erfahrung*).[155] This process comes to a head in the First World War.

> Mit dem Weltkrieg begann ein Vorgang offenkundig zu werden, der seither nicht zum Stillstand gekommen ist. Hatte man nicht bei Kriegsende bemerkt, daß die Leute verstummt aus dem Felde kamen? nicht reicher—ärmer an mitteilbarer Erfahrung. (*BGS* II.2, 439)
>
> [Beginning with the World War, a process became apparent which continues to this day. Wasn't it noticeable at the end of the war that men who returned from the battlefield had grown silent—not richer but poorer in communicable experience? (*BSW* III, 143-4)]

Concurring with Freud and Krafft-Ebing, Benjamin casts the war as a social and experiential caesura, a moment which can no longer be integrated into collective memory. The roots of this problem, however, date back further, concerning not only the nature of human experience, but the conditions of its narrative communication. The most recent chapter in this history of experiential change and decline is fascism and with it the threat of another world war, which frames and overshadows the 'Work of Art' essay. In a letter to Adorno, Benjamin remarks that the argument in the 'Storyteller' essay displays 'some parallels to the "decline of the aura" in the fact [...] that the art of storytelling is nearing its end'.[156] Like the traditional artwork, storytelling is an anachronistic phenomenon; but whereas the 'Work of Art' essay embraces the decline of aura and the associated contemplative mindset, 'The Storyteller' casts this loss in melancholy terms.

One of Benjamin's best-known reflections on attention, finally, can be found in his 1934 essay 'Franz Kafka: Zur zehnten Wiederkehr seines Todestages' (Franz Kafka: On the Tenth Anniversary of his Death). While he takes Leskov's stories to

market, in which the rapid consumption of books both stimulates and is stimulated by the constant flow of new products'. J. J. Long, *W. G. Sebald: Image, Archive, Modernity* (Edinburgh: Edinburgh University Press, 2007), p. 141.

[155] *BSW* IV, 316; 'die Ablösung der älteren Relation durch die Information, der Information durch die Sensation' (*BGS* I.2, 611).

[156] '[...] einige Parallelen zu dem "Verfall der Aura" in dem Umstande [...], daß es mit der Kunst des Erzählens zuende geht' (*BGS* II.3, 1277).

be rooted in an agrarian age and Baudelaire's poetry to reflect the poet's encounter with the modern, industrialized world, his essay on Kafka is less explicitly concerned with the relationship between text and socio-cultural context. Written a year before his 'Work of Art' essay, Benjamin here puts forward a theological rather than a political reading of attention:

> Wenn Kafka nicht gebetet hat—was wir nicht wissen—so war ihm doch aufs höchste eigen, was Malebranche 'das natürliche Gebet der Seele' nennt—die Aufmerksamkeit. Und in sie hat er, wie die Heiligen in ihre Gebete, alle Kreatur eingeschlossen. (BGS II.2, 432)
>
> [Even if Kafka did not pray—and this we do not know—he still possessed in the highest degree what Malebranche called 'the natural prayer of the soul': attentiveness. And in this attentiveness he included all creatures, as saints include them in their prayers. (BSW II, 812)]

The French theologian Nicolas Malebranche (1638–1715), like other writers from this period, describes attention as the essence of religious devotion, as that faculty which enables us to hear the word of God.[157] With his argument, Benjamin harks back to one of his earliest forays into attention, namely his fragment 'On Dread', where prayer is said to immunize the subject against disruption, since the dialogue with God facilitates an ongoing awareness of the world. In the 'Kafka' essay, Benjamin returns to this argument, though here, prayer appears as one possible manifestation of a more general state of mind: awareness of the other, of 'all creatures'. So how exactly does Kafka's quasi-devotional attention manifest itself in his texts? The above passage appears at the end of the essay's third section, where it concludes Benjamin's musings on the German folksong about the little hunchback or 'Bucklicht Männlein':

> Wenn ich an mein Bänklein knie,
> Will ein bißlein beten;
> Steht ein bucklicht Männlein da,
> Fängt als an zu reden.
> Liebes Kindlein, ach ich bitt,
> Bet' für's bucklicht Männlein mit! (BGS II.2, 432)
>
> [When I kneel upon my stool
> And I want to pray,

[157] 'L'attention de l'esprit [...] est la prière naturelle que l'on fait au véritable Maître de tous les hommes, pour en recevoir quelque instruction' ('The attention of the spirit [...] is the natural prayer which one directs at the true master of human beings in order to receive from Him some instruction'). Nicolas Malebranche, Œuvres, ed. Geneviève Rodis-Lewis, vol. 1 (Paris: Gallimard, 1979), p. 770.

> A hunchbacked man is in the room
> And he starts to say:
> My dear child, I beg of you,
> Pray for the little hunchback too. (*BSW* II, 812)]

Prayer is here cast, once again, as a state of mindfulness towards the creaturely (in ourselves and others). The little hunchback is an uncanny kind of Doppelgänger who shadows the song's poetic voice in different situations, culminating in this, the final stanza. Prayer is the most intimate of the moments that are invaded by the figure; its plea to be included in it recalls Jakob and Wilhelm Grimm's fairy tale 'Der Bärenhäuter' (Bearskin, 1840), whose protagonist, cast out from human society, is not allowed to wash, to cut his hair and nails, or to pray for seven years, and hence asks those he meets to say a prayer on his behalf. The hunchback is a similar figure: it embodies the creaturely, monstrous other of human existence, but at the same time, and for that reason, human indifference and oblivion. As Benjamin notes, this dual structure of repression and uncanny return underpins all of Kafka's non-human characters: 'Odradek is the form which things assume in oblivion. They are distorted'.[158] According to Benjamin, this cycle of repression and disfiguration (reflecting, to speak with Adorno, the hidden violence of Enlightened rationality) can only be broken with divine interference. The hunchback 'is at home in distorted life; he will disappear with the coming of the Messiah, who (a great rabbi once said) will not wish to change the world by force but will merely make a slight adjustment in it'.[159] The moral imperative of an all-encompassing attention is matched by God's salvaging attention, which does not radically change the world but merely reverses the disfigurations caused by human oblivion.

In 1920 Kafka writes in his notebook: 'Schreiben als Form des Gebetes' ('Writing as a form of prayer').[160] Benjamin would not have known this passage, and yet his argument strikingly echoes Kafka's elliptical remark. A few pages later, Kafka records his piece 'If you keep running forward...', which describes the coming of the Messiah and the danger of missing his arrival if we are too wrapped up in our own daily concerns. A cross-reading of Kafka's notebook and Benjamin's essay emphasizes their shared thinking, where attention acts as the hinge between the creaturely and the divine and thereby takes on an ethical charge.

[158] *BSW* II, 811. 'Odradek ist die Form, die die Dinge in der Vergessenheit annehmen. Sie sind entstellt' (*BGS* II.2, 431).

[159] *BSW* II, 811. 'Dies Männlein ist der Insasse des entstellten Lebens, es wird verschwinden, wenn der Messias kommt, von dem ein großer Rabbi gesagt hat, daß er nicht mit Gewalt die Welt verändern wolle, sondern sie nur um ein Geringes zurechtstellen werde' (*BGS* II.2, 432).

[160] Franz Kafka, *Nachgelassene Schriften und Fragmente II*, ed. Jost Schillemeit, Franz Kafka: Schriften, Tagebücher, Briefe: Kritische Ausgabe (Frankfurt a.M.: Fischer, 1992), p. 254.

Rescue in the Face of Danger: 'The Handkerchief'

'In *The Arcades Project*, contemplation must be put on trial. But it should defend itself brilliantly and justify itself'.[161] In the 'Work of Art' essay, contemplation is indeed 'put on trial' and pronounced guilty of fostering an inward-looking, solipsistic mindset unsuitable for the challenges of the modern world. And yet, as underlined by the 'Kafka' essay, contemplation never disappears from Benjamin's critical vocabulary but continues to shape his later, historical-materialist work as part of a coalition of opposites.

The *Passagenarbeit* (Arcades Project, 1927–40), Benjamin's vast, unfinished study of nineteenth-century France, explores and embodies different modes of (in-)attention. Methodologically, it echoes the 'Foreword' of Benjamin's *Trauerspiel* study, which emphasizes the need for an intense yet intermittent kind of thinking as a way of going back 'to the thing itself'.[162] The *Arcades Project* is the radical realization of this technique. Despite its mammoth scale, it is the antithesis of the traditional academic monograph, as its thirty-six thematic sections range from material phenomena such as architecture, fashion, and commodity culture to more abstract reflections on method and on the mindset of the period. Benjamin's own comments are interspersed with lengthy quotations from historical, literary, and philosophical sources; to read the *Arcades Project* cover to cover makes for a peculiarly distracted reading experience, although with growing immersion various patterns begin to emerge. This interplay between focus and dispersal is integral to the *Arcades Project*'s mode of historical enquiry and envisaged effect on the reader.[163]

In his final completed text, 'Über den Begriff der Geschichte' (On the Concept of History, 1940), Benjamin elaborates on his method of historical enquiry, and on the historian's particular mindset, in eighteen short 'theses', a format reminiscent of the scholastic tractatus. Rejecting the notion that history amounts to a coherent, teleological narrative, he stresses that the past can never be reconstructed as it really was; rather, any engagement with the past is bound up with, and shaped by, the observer's current perspective.

To engage with the past in this way, the materialist historian needs to take a number of steps and employ a combination of approaches. The first is to dissociate herself from a vision of the present as an inevitable and unchangeable state of affairs. Benjamin likens this mindset to the discipline and seclusion of religious

[161] Walter Benjamin, *The Arcades Project*, trans. Howard Eiland and Kevin McLaughlin (Cambridge, MA: Harvard University Press, 2002), p. 866. 'In der Passagenarbeit muß der Kontemplation der Prozeß gemacht werden. Sie soll sich aber glänzend verteidigen und behaupten' (*BGS* V.2, 1036).

[162] Benjamin, *Origin*, pp. 2–3; *BGS* I.1, 208.

[163] For more details, see Sabine Müller, 'Von der "Kunst ohne Anführungszeichen zu zitieren": Benjamins anthropologischer Materialismus zwischen Methode und Utopie', in *Walter Benjamins anthropologisches Denken*, ed. Carolin Duttlinger, Ben Morgan, and Anthony Phelan (Freiburg i.Br.: Rombach, 2012), pp. 261–80.

life: 'The themes which monastic discipline assigned to friars for meditation were designed to turn them away from the world and its affairs. The thoughts we are developing here have a similar aim'.[164] As in 'On Dread', religious contemplation facilitates enhanced alertness: 'The true image of the past flits by. The past can be seized only as an image that flashes up at the moment of its recognizability, and is never seen again'.[165] To grasp the past in its transient, fleeting appearance requires a decisive response, what Benjamin describes as a 'tiger's leap', a *Tigersprung*, 'in the open air of history'.[166] Such a leap requires utmost *Geistesgegenwart*, presence of mind. This stance is central to the method of the materialist historian, who 'cannot look on history as anything other than a constellation of dangers which he is always, as he follows its development in his thought, on the point [or on the verge] of averting'.[167]

While in the 'Work of Art' and 'Baudelaire' essays, danger is used in a general sense, as a shorthand for the physical and mental pressures of modern life, this term takes on a more specific urgency in the *Arcades Project* against the backdrop of fascism and impending war. Fascist rule corrupts not only the present but also the past, as it rewrites history to match its warped ideology. In response, the materialist historian must arrest an image of the past 'which unexpectedly appears to the historical subject in a moment of danger';[168] elsewhere, Benjamin defines presence of mind as 'that which saves [*das Rettende*]; presence of mind in the capturing of fleeting images; presence of mind and [their] arrest'.[169]

The unusual verbal noun 'das Rettende' recalls the famous opening stanza of Friedrich Hölderlin's *Patmos* hymn:

Nah ist
Und schwer zu fassen der Gott.
Wo aber Gefahr ist, wächst
das Rettende auch.[170]

[164] *BSW* IV, 393. 'Die Gegenstände, die die Klosterregel den Brüdern zur Meditation anwies, hatten die Aufgabe, sie der Welt und ihrem Treiben abhold zu machen. Der Gedankengang, den wir hier verfolgen, ist aus einer ähnlichen Bestimmung hervorgegangen' (*BGS* I.2, 698).

[165] *BSW* IV, 390. 'Das wahre Bild der Vergangenheit *huscht* vorbei. Nur als Bild, das auf Nimmerwiedersehen im Augenblick seiner Erkennbarkeit eben aufblitzt, ist die Vergangenheit festzuhalten' (*BGS* I.2, 695; *WuN* 19, 129).

[166] *BSW* IV, 395; 'unter dem freien Himmel der Geschichte' (*WuN* 19, 40).

[167] Benjamin, *Arcades Project*, pp. 469–70; 'daß der Dialektiker die Geschichte nicht anders denn als eine Gefahrenkonstellation betrachten kann, die er, denkend ihrer Entwicklung folgend, abzuwenden jederzeit auf dem Sprunge ist' (*BGS* V.1, 586–7).

[168] *BSW* IV, 391; 'wie es sich im Augenblick der Gefahr dem historischen Subjekt unversehens einstellt' (*BGS* I.2, 695; *WuN* 19, 129).

[169] 'Geistesgegenwart als das Rettende; Geistesgegenwart im Erfassen der flüchtigen Bilder; Geistesgegenwart und Stillstellung' (*WuN* 19, 133).

[170] Friedrich Hölderlin, *Sämtliche Werke und Briefe*, ed. Michael Knaupp, vol. 1 (Munich: Hanser, 1992), p. 447. Benjamin engaged with two of Hölderlin's poems—'Dichtermut' and 'Blödigkeit'—in his 1914 essay on the poet, and he used an excerpt from his *Patmos* hymn as the epigraph of a cycle of sonnets dedicated to the memory of his friend Fritz Heinle, who had committed suicide. See Martin Jay,

[Near is
And difficult to grasp, the God.
But where danger threatens
That which saves from it also grows.[171]]

Rettung (rescue) appears in the *Trauerspiel* book to describe the rescuing effects of melancholy contemplation; it remains a key term in Benjamin's conception of criticism, *Kritik*, whose express purpose is to 'rescue' those authors, texts, or artefacts which are threatened by either oblivion or misappropriation.[172] In the 1930s, *Rettung* is then invested with a more existential, ethical, and political dimension, as it becomes associated with historical enquiry as a form of rescuing intervention. If this idea sounds fairly abstract, it is memorably illustrated in narrative form in the novella 'Das Taschentuch' (The Handkerchief), written in Ibiza in the spring or summer 1932 and published in the *Frankfurter Zeitung* in November that year.[173]

The novella's dramatic events are recounted by a young naval officer serving on an ocean liner that is returning to Germany from America. During the journey his attention is captured by a beautiful but melancholy young woman, who keeps herself apart from the other passengers. When she drops her handkerchief and he gallantly restores it to her, the narrator 'heard her say "Thank you" in a tone that suggested I'd just saved her life'.[174] A few days later, the officer observes how she throws some papers overboard. Shortly afterwards the ship is due to arrive at Bremerhaven. Preoccupied with the landing manoeuvre, the officer only notices the woman again when she jumps into the sea:

Jeder Rettungsversuch war aussichtslos. Hätte man die Maschine selbst augenblicklich abstoppen können—der Schiffsrumpf war vom Quai nicht mehr als drei Meter entfernt und seine Bewegung war unaufhaltsam. Wer dazwischen geriet, war verloren. (*BGS* IV.2, 744)

'Benjamin, Remembrance and the First World War', in *Walter Benjamin: Critical Evaluations in Cultural Theory*, ed. Peter Osborne, vol. 2: *Modernity* (London: Routledge, 2005), pp. 230–49 (p. 231).

[171] Friedrich Hölderlin, *Poems and Fragments*, trans. Michael Hamburger (London: Routledge, 1966), p. 463.

[172] See Heinrich Kaulen's detailed analysis of this concept in Benjamin's work and in the history of thought and literature more generally. 'Rettung', in *Benjamins Begriffe*, ed. Michael Opitz and Erdmut Wizisla, vol. 2 (Frankfurt a.M.: Suhrkamp, 2000), pp. 619–64 (pp. 625–6).

[173] The novella was thus written at around the same time as *Ibizan Sequence*. On his ten-day freighter journey from Hamburg to Barcelona, which in April preceded his move to Ibiza, Benjamin befriended the captain and crew members and recorded the stories he was told by them; he continued this practice of collecting local stories while on the island. 'The Handkerchief' is likely the product of this experience. See Eiland and Jennings, *Benjamin*, pp. 369–70.

[174] *BSW* II.2, 660; 'habe ich sie "Danke" sagen hören mit einem Ausdruck, als hätte ich ihr das Leben gerettet' (*BGS* IV.2, 744).

[Every effort to rescue her seemed futile. If only the engine could have stopped the boat dead—the stern was not more than three meters from the quay and it was unstoppable. Anyone who came between the ship and the quay was lost.
(*BSW* II.2, 660–1)]

Technology here appears as a destructive force which radically limits the scope for human intervention. And yet,

Es fand sich einer, der den ungeheuerlichen Versuch unternahm. Man sah ihn, jeden Muskel angespannt, die Augenbrauen in eins gezogen, als wenn er zielen wollte, von der Reling springen und während [...] der Dampfer seiner ganzen Länge nach steuerbords beilegte, kam an Backbord [...] der Retter, in seinem Arm das Mädchen, in die Höhe. Er hatte in der Tat gezielt und sie—genau, nach seiner ganzen Schwere, auf die andere stürzend, sie mit sich in die Tiefe reißend, unterm Kiel des Schiffes wieder in die Höhe tauchend—an die Oberfläche getragen. (*BGS* IV.2, 744)

[There was someone who was willing to make the superhuman effort. You could see him straining every muscle, his eyebrows drawn together as if he were taking aim; then he leaped over the rail. And while—to the horror of the onlookers—the whole length of the steamer moved to starboard and came to rest against the quay, the rescuer suddenly surfaced with the woman in his arms on the port side, which was so abandoned that at first no one noticed him. He had in fact taken aim with his entire weight and borne her down with him under the water and beneath the keel before coming back to the surface. (*BSW* II.2, 661)]

The story echoes Johann Wolfgang von Goethe's novella about 'Die wunderlichen Nachbarskinder' (The Curious Neighbours), part of his novel *Die Wahlverwandtschaften* (Elective Affinities, 1809). In the novella, a young woman jumps off a ship to commit suicide but is rescued by her childhood friend and estranged sweetheart, who jumps after her. Thus far, Benjamin's rescue narrative closely resembles Goethe's, but there are also important differences. Goethe's protagonist jumps into a river rather than the ocean, the vessel is not an ocean liner but a 'large, handsome, well-equipped ship', and the water is described as a 'friendly element'.[175] In the end the young couple get married.[176]

[175] '[...] ein großes, schönes, wohlausgeschmücktes Schiff'. Johann Wolfgang von Goethe, *Sämtliche Werke, Briefe, Tagebücher und Gespräche*, vol. I.8: *Die Leiden des jungen Werthers, Die Wahlverwandtschaften, Kleine Prosa, Epen*, ed. Waltraud Wiethölter (Frankfurt a.M.: Deutscher Klassiker Verlag, 1994), p. 475.

[176] For a more detailed comparison of Benjamin's and Goethe's novellas, see Carolin Duttlinger, 'Rescue Narratives: Goethe's *Die Wahlverwandtschaften* and Benjamin's "Das Taschentuch"', *Publications of the English Goethe Society*, 89 (2020), 94–110.

Despite these differences, however, Goethe's novella provides some clues concerning the conception behind Benjamin's story. At the end of his essay on 'Goethes Wahlverwandtschaften' (Goethe's Elective Affinities, 1924–5), Benjamin singles out the importance of the novella for the rest of the novel. Its final sentence reads: 'Only for the sake of the hopeless ones have we been given hope'.[177] This conclusion echoes the opening of Hölderlin's *Patmos* hymn; in both *Patmos* and 'The Curious Neighbours', danger and rescue, hopelessness and hope, are intrinsically linked and indeed proportionate to each other. In Benjamin's novella this proportionate relationship is exploded. Here, rescue becomes an impossible challenge—and yet someone undertakes it nonetheless. What enables this impossible undertaking is *Geistesgegenwart*—an instinctive response which overrides all rational consideration of risk, all reasonable objection: presence of mind as 'that which saves'.

This idea is echoed in an undated note, probably written around 1931 or 1932,[178] where Benjamin observes that presence of mind involves the willingness to surrender control, 'letting oneself go in the moment of danger'.[179] In the face of lethal danger, *Geistesgegenwart* needs to be spontaneous, irrational, even reckless, arising from an underlying 'universal readiness for action' which Benjamin in a 1929 review describes as the aim of Marxist pedagogy (*BSW* II.1, 274; *BGS* III, 208). This readiness is required of the materialist historian; it is dramatically staged and illustrated in 'The Handkerchief'. As Benjamin writes in the *Arcades Project*, the rescue of what lies in the past 'can operate solely for the sake of what, in the next moment, is already irretrievably lost'.[180]

Benjamin's exile and eventual suicide on his flight through the Pyrenees lend these reflections on *Geistesgegenwart* a particular poignancy. His notion of modern life as a 'constellation of dangers' was no abstract theoretical idea, but rooted in an experience of deep uncertainty. And yet *Geistesgegenwart* should not solely be attributed to the later, the exiled Benjamin, for it is a state of mind which can be traced back to his early religious and anthropological writings. While Benjamin encountered psychological theories of (in-)attention as a student and later built on this engagement in his writings on psychotechnics and film, his exploration of human experience cannot be reduced to experimental or technological paradigms. The early religious model of contemplation remains valid and indeed vital all the way through his intellectual career, despite his emphatic endorsement of (a certain kind of) distraction; more broadly speaking, attention remains a touchstone for Benjamin because it encapsulates one of his most enduring concerns: the notion that human experience is neither timeless nor universal, but profoundly historical as well as intersubjective, rooted in encounters with the divine, creaturely, or

[177] *BSW* I, 356. 'Nur um der Hoffnungslosen willen ist uns die Hoffnung gegeben' (*BGS* I.1, 201).
[178] On the difficulty of dating this remark, see *BGS* IV.2, 767–8.
[179] '[...] im Augenblick der Gefahr sich gehen lassen' (*BGS* VI, 207).
[180] Benjamin, *Arcades Project*, p. 473. 'Die Rettung [des Geschehenen] [...] läßt immer nur an dem, im nächsten Augenblick schon unrettbar verlornen [sich] vollziehen' (*BGS* V.2, 592).

human other. In Benjamin's thought, attention and distraction are thus not opposites but closely connected; while they emerge from a particular historical configuration, they also harbour, for that very reason, a more active and strategic dimension, as a form of action and intervention.

The previous two chapters have expanded the focus of this study from texts to images—to the role of visual media and technologies in shaping people's mental and physical experience. Chapters 9 and 10 take us into yet another sensory realm: that of listening and specifically of music, another focus of modernist debates around attention. Changes in listening practices both in the concert hall and in society at large were seen as symptomatic of wider cognitive and social shifts; as in the realm of visual culture, the response to this situation was not unified but revealed profound differences in what contemporaries perceived as the value and purpose of attention in modern culture.

9
Musical Listening between Immersion and Detachment

In the discussion so far, the relationship between sound and attention has been an intermittent but recurring theme. In Kafka's texts, aural stimuli are often experienced as unsettling and invasive, whether in his personal writings, which chart his pathological noise sensitivity, or in his prose fiction, where disembodied sounds point to a hostile adversary, and where music is often experienced as alien and incomprehensible. In Musil's 'The Blackbird', which describes three instances of intensified aural experience, the narrator is unable to distinguish between the ordinary and the sublime—the songs of a blackbird and of a nightingale—while birdsong in turn has a similarly epiphanic effect to the sound of a lethal weapon. Benjamin is interested in attentional threshold states particularly in relation to everyday sounds—the buzzing of an insect or a piano étude being played next door—which move in and out of awareness. Like Musil and Kafka, he does not draw an absolute distinction between music and noise but treats them as points on a cognitive continuum, as stimuli with comparable effects when it comes to the dynamics of attention.

In these modernist texts, music appears as part of the wider soundscape of modern life; it elicits particular attentional patterns and responses, but is not necessarily treated as a separate field with its own aesthetic and cognitive laws. In psychology, in contrast, sound perception was a major field of enquiry; it was explored in sensory threshold experiments and in studies which analysed the impact of sound on attention compared to other types of stimuli. A milestone study was Hermann von Helmholtz's *Die Lehre von den Tonempfindungen* (On the Sensations of Tone, 1863), which analyses both the physics of sound and the physiology of sound perception and introduces the distinction between consonance and dissonance. Although Helmholtz proclaimed his focus to be purely empirical and scientific, his study 'drifts into the realm of aesthetics and the evolutionary history of musical systems', and he uses his findings to argue for the superiority of nineteenth-century music over that of earlier periods.[1]

The psychological exploration of aural experience, however, sits alongside a much longer tradition, in which music is not treated as one stimulus among many

[1] Leon Botstein, 'Time and Memory: Concert Life, Science, and Music in Brahms's Vienna', in *Brahms and his World*, ed. Walter Frisch (Princeton, NJ: Princeton University Press, 1990), pp. 3–22 (p. 9).

but is attributed a particular, indeed a unique, place in the field of human experience. This debate is conducted in the field of aesthetics, although psychological concerns, and particularly the workings of attention, play a central part in it. Musical attention is vital not only from a subjective point of view but on an objective level—as a mindset which both reflects and determines the status of musical works vis-à-vis other artforms. The close, interdependent relationship between music and (a particular mode of) attention first emerges in the late eighteenth century; it remains a touchstone for musical theory and practice well into the twentieth century.

Immersive Listening

In his *Anthropology from a Pragmatic Point of View*, Kant discusses attention in an everyday context, as an embodied experience which can, if sustained for too long, pose risks for the subject's mental health.[2] In his *Kritik der Urteilskraft* (Critique of the Power of Judgement, 1790), in contrast, attention appears in a more general capacity, as a principle of human experience. As Kant argues, the attention with which we encounter the beautiful, particularly works of art, is fundamentally different from a practical or indeed a theoretical, for instance a scholarly, kind of attention. Attention, in other words, enables Kant to define aesthetic judgement as distinct and autonomous, by separating it from moral and cognitive reasoning. The pleasure we derive from the beautiful depends neither on the body—on our subjective tastes and preferences—nor on rational arguments or explanations: 'One can say that among all these three kinds of satisfaction only that of the taste for the beautiful is a disinterested and *free* satisfaction; for no interest, neither that of the senses nor that of reason, extorts approval'.[3] The attention with which we encounter a work of art is 'disinterested', that is, independent of the actual existence of the object or its specific properties. As he adds, 'Hence the judgment of taste is merely contemplative, i.e., a judgment that, indifferent with regard to the existence of an object, merely connects its constitution together with the feeling of pleasure and displeasure'.[4] For Kant, then,

[2] See Chapter 1, pp. 23–26.

[3] Immanuel Kant, *Critique of the Power of Judgement*, ed. Paul Guyer, trans. Paul Guyer and Eric Matthews, The Cambridge Edition of the Works of Immanuel Kant (Cambridge: Cambridge University Press, 2000), p. 95. 'Man kann sagen: daß unter allen diesen drei Arten des Wohlgefallens das des Geschmacks am Schönen einzig und allein ein uninteressirtes und *freies* Wohlgefallen sein; denn kein Interesse, weder das der Sinne, noch das der Vernunft, zwingt den Beifall ab'. Immanuel Kant, *Kritik der praktischen Vernunft; Kritik der Urteilskraft*, Kants Werke: Akademie-Textausgabe, vol. 5 (Berlin and New York: de Gruyter, 1968), p. 210.

[4] Kant, *Critique of the Power of Judgement*, p. 95. 'Dagegen ist das Geschmacksurteil bloß *contemplativ*, d. i. ein Urtheil, welches indifferent in Ansehung des Daseins eines Gegenstandes, nur seine Beschaffenheit mit dem Gefühl der Lust und Unlust zusammenhält'. Kant, *Kritik der Urteilskraft*, p. 209.

aesthetic judgement is 'purposive' but without a specific purpose. 'Beauty is the form of the purposiveness of an object, insofar as it is perceived in it without representation of an end';[5] as Lydia Goehr glosses, 'if an object looks as if it were designed for a moral, practical, or scientific end, and the viewer takes account of that end, then the viewer is not contemplating the object aesthetically'.[6]

Many of Kant's contemporaries echoed his argument, among them the writer Karl Philipp Moritz, one of the leading figures of *Erfahrungsseelenkunde*, or experiential psychology. As he comments, objects of utility, such a clock or a knife, only afford pleasure in conjunction with their intended purpose;

> von diesem Zweck abgeschnitten, lassen sie mich völlig gleichgültig. [...] Bei dem Schönen ist es umgekehrt. Dieses hat seinen Zweck nicht außer sich, und ist nicht wegen der Vollkommenheit von etwas anderm, sondern wegen seiner eignen innern Vollkommenheit da. Man betrachtet es nicht, in so fern man es brauchen kann, sondern man braucht es nur, in so fern man es betrachten kann.[7]
>
> [divorced from that function, they are a matter of total indifference [...]. The opposite is the case with the beautiful. This has no extrinsic purpose. It is not there to fulfil anything else, but it exists on account of its own perfection. We do not contemplate it to discover what use we may make of it; we use it only to the extent that we can contemplate it.[8]]

This definition of aesthetic pleasure as disinterested, rooted in a contemplative rather than a practical or theoretical mode of attention, had vast implications for the period, but nowhere more so than in music. While music prior to the late eighteenth century had been regarded as subsidiary to other artforms and purposes (such as theatre, recitation, or dancing), its value defined by extra-musical criteria, around 1800 instrumental music in particular emancipated itself from such extra-musical purposes and laid claim to aesthetic autonomy. In the Romantic aesthetic, music was redefined as an 'absolute' art.[9] For German authors such as Johann Gottfried Herder, Wilhelm Heinrich Wackenroder, and Ludwig Tieck, music did not merely *point* to the transcendent but actually embodied it,

[5] Kant, *Critique of the Power of Judgement*, p. 120. 'Schönheit ist Form der Zweckmäßigkeit eines Gegenstandes, sofern sie ohne Vorstellung eines Zwecks an ihm wahrgenommen wird'. Kant, *Kritik der Urteilskraft*, p. 236.

[6] Lydia Goehr, *The Imaginary Museum of Musical Works: An Essay in the Philosophy of Music* (Oxford: Oxford University Press, 1992), p. 168.

[7] Karl Philipp Moritz, 'Versuch einer Vereinigung aller schönen Künste und Wissenschaften unter dem Begriff des in sich selbst Vollendeten', in *Schriften zur Ästhetik und Poetik*, ed. Hans Joachim Schrimpf (Tübingen: Niemeyer, 1962), pp. 3–9 (p. 4).

[8] Letter to Moses Mendelssohn, reprinted in *Music and Aesthetics in the Eighteenth and Early-Nineteenth Centuries*, ed. Peter le Huray and James Day (Cambridge: Cambridge University Press, 1981), p. 187.

[9] See Goehr's lucid analysis in *The Imaginary Museum*, pp. 148–75. See also Carl Dahlhaus, *Die Idee der absoluten Musik* (Kassel: Bärenreiter and Munich: Deutscher Taschenbuch Verlag, 1978), pp. 62–3.

opening up new realms of spiritual experience. Aesthetic contemplation was essential in this process, for the metaphysical realm could only be accessed in the right frame of mind, requiring what Herder termed *Andacht* or religious awe. As he writes in his essay 'Cäcilia' (1793): 'For religious awe, it seems to me, is the highest summation of music—holy, heavenly harmony, devotion, and joy'.[10] Describing this state of immersion, the theologian and philosopher Friedrich Schleiermacher coined the term *Kunstreligion*, art (as) religion.[11]

In reality, however, not all listeners complied with these lofty ideals. Contemplative listening, having been stipulated either in general, philosophical, or else in highly subjective terms, required specific measures and social changes to become a widely accepted cultural practice. While Romantic writers described aesthetic immersion as a spontaneous, effortless experience, in reality sustained attentive listening did not come naturally to most people but demanded considerable self-discipline. Goehr rightly stresses the class angle of this cognitive stance; aesthetic contemplation involved 'the setting-aside of one's everyday concerns. It was a form of meditation that persons of higher cultivation or taste could successfully engage in'.[12] As we will see, issues such as class, gender, and education continued to beset debates about musical listening all the way into the twentieth century.

To embed contemplative listening as a cultural practice, then, required concrete changes on the levels of musical composition, performance, and reception. Purpose-built concert halls put the musical performance centre stage, and the programme length was shortened to accommodate listeners' attention span. Above all, silent listening had to be established as the norm, though the applause at the end gave listeners an outlet for their pent-up emotions.[13] But the onus

[10] '[D]enn Andacht, dünkt mich, ist die höchste Summe der Musik, heilige, himmlische Harmonie, Ergebung und Freude'. Johann Gottfried Herder, 'Cäcilia', in *Zerstreute Blätter*, vol. 5 (Gotha: Ettinger, 1793), pp. 287–320 (p. 295). Cited in Dahlhaus, *Die Idee*, p. 81. Herder's notion of *Andacht* does not refer solely to the kind of worship which takes place in church, where music had traditionally played an accompanying role. On the contrary, music's promotion from a subsidiary to an absolute art was dependent on a process of secularization, a turning away from organized religion, which started in the Enlightenment and in the course of which 'many modes of behaviour traditionally associated with church worship were being adopted by the institution of fine art'. This development also underpinned the establishment of museums as secular 'temples' dedicated to the appreciation of fine art. Goehr, *The Imaginary Museum*, pp. 154; 157.

[11] Schleiermacher distinguished between three forms of contemplation as pathways towards the transcendent: self-reflection, the contemplation of a particular feature of the world, and the contemplative immersion in a work of art. See Dahlhaus, *Die Idee*, p. 91. For a survey of the evolution of this notion from the late eighteenth century to the present, see Albert Meier, Alessandro Costazza, and Gérard Laudin, eds., *Kunstreligion: Ein ästhetisches Konzept der Moderne in seiner historischen Entfaltung*, 3 vols (Berlin: de Gruyter, 2011–14).

[12] Goehr, *The Imaginary Museum*, p. 169.

[13] As Peter Gay puts it, 'good nineteenth-century listeners controlled their appreciation until the designated moment for emotional explosion had arrived': *The Naked Heart: Bourgeois Experience. Victoria to Freud* (New York, NY: Norton, 1996), p. 21.

was not just on the audience but also on the composer. Treatises on musical composition explored how pieces should be structured in order to hold listeners' attention; in European music of the late eighteenth century and beyond, the aim of sustaining listeners' engagement provided 'a potential aesthetic rationale for all the changes and modifications that occur during the overall temporal course of musical compositions'.[14]

In a letter to Tieck, Wackenroder admits that he enjoys music in two different ways. He is capable of complete immersion, of the 'most attentive observation of the musical notes and their progressions', in which his mind is shielded from 'distracting thoughts and extraneous sensory impressions'.[15] As he admits, however, this deep yet active immersion cannot be sustained for more than an hour, for it 'requires a certain effort'; a less effortful listening mode, in contrast, allows the listener's thoughts and imagination to be 'virtually swept away on the waves of song'.[16] Musical experience, Wackenroder's letter suggests, is far from uniform within an audience, nor indeed within the individual listener, who may shift from fully attentive listening into a state of reverie, of free-flowing associations and intense emotions.[17]

The central place of contemplative listening in European culture is reflected in numerous nineteenth-century paintings, which portray this experience, importing 'a religious aura into their depictions of secular concerts private and public'.[18] Some paintings show the performer together with his or her audience, their interaction surveyed by a bust of the composer, but the Belgian artist Fernand Khnopff dispenses with the performer altogether. His 1883 painting *En écoutant du Schumann* (Listening to Schumann) shows a young woman, her face shielded

[14] Matthew Riley, *Musical Listening in the German Enlightenment: Attention, Wonder, and Astonishment* (Burlington, VT: Ashgate, 2004), p. 9.

[15] The 'aufmerksamste Beobachtung der Töne u[nd] ihrer Fortschreitung', in which his mind is shielded 'von jedem störenden Gedanken und von allen fremdartigen sinnlichen Eindrücken'. Wilhelm Heinrich Wackenroder, *Sämtliche Werke und Briefe: Historisch-kritische Ausgabe*, vol. 2, ed. Silvio Vietta and Richard Littlejohns (Heidelberg: Deutscher Klassiker Verlag, 1991), p. 29.

[16] '[...] gleichsam auf den Wellen des Gesangs entführt'. Wackenroder, *Werke und Briefe*, vol. 2, p. 29. On Wackenroder's conception of musical listening in its historical context, see Janina Klassen, 'In und auf dem Strom von Empfindungen: Wilhelm Heinrich Wackenroders immersive Hörerfahrung und der Hörwandel um 1800', in *Musik im Zusammenhang: Festschrift Peter Revers zum 65. Geburtstag*, ed. Klaus Aringer, Christian Utz, and Thomas Wozonig (Vienna: Hollitzer, 2019), pp. 805–12.

[17] The wide variety of actual listening practices is described most vividly in contemporary concert reviews by music critics such as Friedrich Rochlitz, whose satirical sketches of different listener types appeared in 1799 in the *Allgemeine musikalische Zeitung* (General Musical Newspaper). See Christiane Tewinkel, '"Everybody in the Concert Hall should be Devoted Entirely to the Music": On the Actuality of Not Listening to Music in Symphonic Concerts', in *The Oxford Handbook of Music Listening in the 19th and 20th Centuries*, ed. Christian Thorau and Hansjakob Ziemer (Oxford: Oxford University Press, 2019), pp. 477–502 (p. 483). See also Daniel Fuhrimann, *'Herzohren für die Tonkunst': Opern- und Konzertpublikum in der deutschen Literatur des langen 19. Jahrhunderts* (Freiburg i.Br.: Rombach, 2005).

[18] Gay, *The Naked Heart*, p. 31.

Figure 9.1 Fernand Khnopff, 'En écoutant du Schumann' (Listening to Schumann, 1883)

by her hand. Listening is here elevated to an art, a spectacle and object of fascination, in its own right (Figure 9.1).

But what is really going on in the minds of these contemplative listeners? At first glance, these listening scenes resemble eighteenth-century paintings of states of immersion by artists such as Chardin and Greuze.[19] When it comes to musical listening, however, the actual focus of the experience remains invisible and hence elusive. Are these listeners really paying attention to the musical work, or are they swept away, like Wackenroder, on the wave of their emotions and imagination?

This ambiguity at the heart of musical listening troubled various commentators, chiefly among them the Austrian music critic Eduard Hanslick (1825–1904). A defender of 'absolute', instrumental, music over so-called 'programme music'—embodied by Richard Wagner's *Leitmotivtechnik* and Franz Liszt's symphonic poems—he rebutted any attempts to dilute the autonomy of musical works by anchoring them in extra-musical concerns:

[19] See Chapter 7, pp. 251–2.

Die notwendigste Forderung einer ästhetischen Aufnahme der Musik ist aber, daß man ein Tonstück um *seiner selbst willen höre*, welches es nun immer sei und mit welcher Auffassung immer. Sobald die Musik nur als Mittel angewandt wird, eine gewisse Stimmung in uns zu fördern, akzessorisch, dekorativ, da hört sie auf, als reine Kunst zu wirken.[20]

[The most indispensable requirement if we are to hear music aesthetically is, however, that we hear the piece for its own sake, whichever it be and with whatever comprehension we hear it. The instant music is put to use merely as a means to produce a certain mood in us or as an accessory or an ornament, it ceases to be effective as pure art.[21]]

Thus Hanslick argues in his hugely influential professorial dissertation, *Vom Musikalisch-Schönen* (On the Musically Beautiful, 1854),[22] in which he advocates a particular 'aesthetic' mode of listening over the alternative, 'emotional', variety. On the face of it, both involve immersion in the musical experience; as Hanslick stresses, however, only the former listening mode meets Kant's original definition of aesthetic pleasure, of the contemplative, disinterested immersion in the beautiful.

For Hanslick, emotional listeners, or *Gefühlsmusiker*, are people who respond to a musical work in a state of 'passive receptivity'; their experience is 'a constant twilight state of sensation and reverie, a drooping and yearning in resounding emptiness'.[23] Indeed, they only take in the overall mood of a piece rather than its finer details; when confronted with several pieces, they will extrapolate only the common elements. Emotional listeners do not respond to music with an intellectual, critical mindset but are motivated solely by sensory pleasure:

Halbwach in ihren Fauteuil geschmiegt, lassen jene Enthusiasten von den Schwingungen der Töne sich tragen und schaukeln, statt sie scharfen Blickes zu betrachten. [. . .] Sie bilden das 'dankbarste' Publikum und dasjenige, welches geeignet ist, die Würde der Musik am sichersten zu diskreditieren. Das ästhetische Merkmal des *geistigen* Genusses geht ihrem Hören ab; eine feine Zigarre, ein pikanter Leckerbissen, ein laues Bad leistet ihnen unbewußt, was eine Symphonie [sic].[24]

[20] Eduard Hanslick, *Vom Musikalisch-Schönen: Aufsätze, Musikkritiken* (Leipzig: Reclam, 1982), pp. 122–3.

[21] Eduard Hanslick, *On the Musically Beautiful*, trans. Geoffrey Payzant (Indianapolis, IN: Hackett, 1986), p. 66.

[22] In Hanslick's lifetime, the work saw a total of ten editions, in which Hanslick revised and updated his text to reflect current debate.

[23] Hanslick, *On the Musically Beautiful*, p. 58; 'ein stetes Dämmern, Fühlen, Schwärmen, ein Hangen und Bangen in klingendem Nichts'. *Vom Musikalisch-Schönen*, p. 113.

[24] Hanslick, *Vom Musikalisch-Schönen*, p. 114.

[Slouched dozing in their chairs, these enthusiasts allow themselves to brood and sway in response to the vibrations of tones, instead of contemplating tones attentively. [...] These people make up the most 'appreciative' audience and the one most likely to bring music into disrepute. The aesthetical criterion of intellectual pleasure is lost to them; for all they would know, a fine cigar or a piquant delicacy or a warm bath produces the same effect as a symphony.[25]]

The body reflects as well as produces the underlying state of mind. The enthusiasts' reclining posture is anathema to attentive listening; this listener type does not value music for its beauty but instrumentalizes it, treating it as one of a whole range of sensory pleasures. Consequently, this experience cannot be classed as aesthetic, for it does not meet Kant's criterion of disinterested attention, of pleasure which is independent of any extra-aesthetic purpose or considerations. Indeed, its closest equivalent is not culinary consumption but intoxication: 'Incidentally, for people who want the kind of effortless suppression of awareness they get from music, there is a wonderful recent discovery which far surpasses that art. We refer to ether and chloroform'.[26]

In his argument, Hanslick goes further than Kant. He rejects emotional, culinary listening not only as aesthetically inadequate but as positively dangerous—to the integrity of the musical work and to the health and sanity of the listeners, indeed, of the entire nation. '[T]he raw emotion of savages and the gushing of the music enthusiast',[27] he declares, belong to the same category; indeed, only 'Nordländer', people from northern countries, are able to listen in a rational manner, while southern nations, such as the Italians, are prevented from reaching such mental heights due to their 'mental indolence'.[28] Finally, women are incapable of musical composition, which is an inherently rational pursuit, due to their overly emotional disposition.[29]

Racist, nationalist, and misogynist stereotypes thus prop up Hanslick's model of aesthetic listening. Unlike the Romantics, he does not focus on the spiritual dimension of immersive listening, but foregrounds its rational component, which requires the listener's active and sustained engagement with the musical work as it unfolds over time:

[25] Hanslick, *On the Musically Beautiful*, p. 59.
[26] Hanslick, *On the Musically Beautiful*, p. 59. 'Die neue Zeit hat übrigens eine herrliche Entdeckung gebracht, welche für Hörer, die ohne alle Geistesbetätigung nur den Gefühlsniederschlag der Musik suchen, diese Kunst weit überbietet. Wir meinen den Schwefeläther, das Chloroform'. Hanslick, *Vom Musikalisch-Schönen*, p. 114.
[27] Hanslick, *On the Musically Beautiful*, p. 63; 'der rohe Affekt des Wilden und der schwärmende des Musikenthusiasten'. Hanslick, *Vom Musikalisch-Schönen*, p. 119.
[28] Hanslick, *On the Musically Beautiful*, p. 64; *Vom Musikalisch-Schönen*, pp. 120–1.
[29] See Hanslick, *Vom Musikalisch-Schönen*, pp. 123–4; *On the Musically Beautiful*, p. 67.

Nicht eine angeblich geschilderte Leidenschaft reißt uns in Mitleidenschaft. Ruhig freudigen Geistes, in affektlosem, doch innig-hingebendem Genießen sehen wir das Kunstwerk an uns vorüberziehen [...]. Dieses Sich-Erfreuen mit wachem Geiste ist die würdigste, heilvollste und nicht die leichteste Art, Musik zu hören.[30]

[There is not a feigned emotion lacerating us with compassion. Joyfully, in unemotional yet heartfelt pleasure, we behold the artwork passing before us [...]. Thus to take pleasure in one's own mental alertness is the worthiest, the wholesomest, and not the easiest manner of listening to music.[31]]

The listener must remain 'awake', that is to say, calm and rationally detached, in order to appreciate the work in all its complexity. Only with active alertness is the listener capable

den Absichten des Komponisten fortwährend zu folgen und voran zu eilen, sich in seinen Vermutungen hier bestätigt, dort angenehm getäuscht zu finden. Es versteht sich, daß dieses intellektuelle Hinüber- und Herüberströmen, dieses fortwährende Geben und Empfangen, unbewußt und blitzvoll vor sich geht. Nur solche Musik wird vollen künstlerischen Genuß bieten, welche dies geistige Nachfolgen, welches ganz eigentlich ein *Nachdenken der Phantasie* genannt werden könnte, hervorruft und lohnt. Ohne geistige Tätigkeit gibt es überhaupt keinen ästhetischen Genuß.[32]

[in continuously following and anticipating the composer's designs, here to be confirmed in his expectations, there to be agreeably led astray. It goes without saying that this mental streaming this way and that, this continual give and take, occurs unconsciously and at the speed of lightning. Only such music as brings about and rewards this mental pursuing, which could quite properly be called a musing [...] of the imagination, will provide fully artistic satisfaction. Without mental activity, there can be no aesthetical pleasure whatever.[33]]

In contrast to the enthusiast slumped in the armchair, aesthetic listening is mobile and reciprocal, involving a 'streaming this way and that', a 'continual give and take' between work and recipient. Hanslick here anticipates Théodule-Armand Ribot's claim that, in order to be sustained over longer periods of time, attention cannot be static but requires constant change and movement. And he does not define aesthetic listening as a purely cerebral stance, but highlights the pleasure it affords,

[30] Hanslick, *Vom Musikalisch-Schönen*, pp. 119–20.
[31] Hanslick, *On the Musically Beautiful*, p. 64.
[32] Hanslick, *Vom Musikalisch-Schönen*, pp. 120–1.
[33] Hanslick, *On the Musically Beautiful*, p. 64.

as well as its imaginative and pre-rational, 'unconscious', component.[34] That said, the listener must never completely surrender control, for true pleasure can only arise out of intellectual effort. Given that music is a temporal art, it requires 'an unflagging attendance [...] in keenest vigilance'.[35] In the case of complex compositions, this amounts to a form of intellectual labour, or 'geistige Arbeit'. The effort involved will differ from listener to listener, depending on their prior knowledge and disposition, but some degree of active engagement is indispensable: 'To become drunk requires only weakness, but true aesthetical *listening* is an *art*'.[36]

Hanslick's treatise was hugely influential in the author's lifetime and beyond. Its argument was developed by music theorists such Hugo Riemann, whose *Über das musikalische Hören* (On Musical Listening, 1874) propagated 'active listening' and characterized musical experience as a logical, rational activity of the human mind, and Heinrich Schenker, who shared Hanslick's view of the compositional process and the ensuing importance he ascribed to it for the understanding of music.[37] This emphasis on the structural qualities of musical works was also reflected in the emerging genre of programme notes guiding audiences in their listening experience.

In practice, however, this structural listening model coexisted with other forms of musical experience, key among them Wagner's Bayreuth Festspielhaus, where music was part of a multi-sensory immersive spectacle. The darkened room and the innovation of the orchestra pit, which hid musicians from view, focused the audience's attention on the stage and pushed the intensity of the musical experience to new levels. Holding his audience's attention spellbound, Wagner's musical theatre was accused of emotionally manipulating listeners to the point of depriving them of their 'clear sense of separate selfhood'.[38]

In this regard, Wagner's musical theatre was no isolated phenomenon. The second half of the nineteenth century saw a plethora of new musical styles, formats, and practices that challenged Hanslick's model of aesthetic listening. Musical performance was no longer the preserve of the opera house and concert

[34] Hanslick defends himself against the accusation of ignoring emotions in the preface of the ninth, 1891 edition of his work, a point echoed by Nicholas Cook, who notes that Hanslick 'did not say that music does not, cannot, or should not convey feelings, moods, or emotions', though he did insist 'that the objective properties of music, rather than people's subjective responses to it, constitute the proper concern of musical aesthetics'. Nicholas Cook, *The Schenker Project: Culture, Race, and Music Theory in Fin-de-Siècle Vienna* (Oxford: Oxford University Press, 2007), p. 50.

[35] Hanslick, *On the Musically Beautiful*, p. 64; 'ein in schärfster Wachsamkeit unermüdliches Begleiten'. *Vom Musikalisch-Schönen*, p. 121.

[36] Hanslick, *On the Musically Beautiful*, p. 65. 'Zum Berauschtwerden braucht's nur der Schwäche, aber wirklich ästhetisches *Hören* ist eine *Kunst*'. *Vom Musikalisch-Schönen*, p. 121.

[37] Cook, *The Schenker Project*, p. 49.

[38] Gay, *The Naked Heart*, pp. 34–5. On Wagner's strategies of audience engagement, see also Lutz P. Koepnick, *Framing Attention: Windows on Modern German Culture* (Baltimore, MD: Johns Hopkins University Press, 2007), pp. 62–94.

hall but migrated into public spaces where it formed the backdrop of social interaction, while the invention of the gramophone and, a few decades later, the radio, severed the spatial link between listener and performer. As music became more firmly embedded in everyday life, this diversification of listening practices was greeted with great anxiety, sparking talk of a fully-fledged crisis of musical listening and with it calls for practical reform.

Modernist Debates: Listening in Crisis

This new ubiquity of music was condemned by many contemporaries as a nuisance and a public health risk, for it exacerbated the steady increase of noise levels in modern society. William James singles out the 'din' of modern life as a key cause of distraction, while historian Karl Lamprecht dismisses sounds such as 'the whistling of the locomotive, the ringing of the tram' as deeply 'un-aesthetic' in character.[39] Anti-noise campaigns tried to stem this tide on both sides of the Atlantic; the leading German campaigner Theodor Lessing condemns the 'allgemeine Musikwut' (universal craze for music), which eradicates the silence needed for concentration.[40] Neurologist Wilhelm Erb concurs. 'Our ear', he complains, 'is excited and overstimulated by intrusive and noisy music, administered in large doses'; this leads to a vicious circle, whereby audiences clamour for 'strongly seasoned pleasures' to titillate their worn-out nerves, and contemporary composers oblige, having themselves grown incapable of composing more calming, classically balanced works.[41]

These mental health arguments are echoed by musical experts alarmed by the erosion of contemplative listening even in the traditional concert setting. In his 1907 study *Die Musik im täglichen Leben* (Music in Daily Life), the musicologist Wilibald Nagel describes concertgoers as chronically over-stimulated. Having grown accustomed to 'the accumulation of effects, mass impacts, strong stimuli', they are unable to appreciate subtle musical nuances or to sustain their attention

[39] PP 456; Karl Lamprecht, *Deutsche Geschichte, Ergänzungsbände: Zur jüngsten deutschen Vergangenheit*, vol. 1: *Tonkunst—Bildende Kunst—Dichtung—Weltanschauung* (Berlin: Gaertner, 1902), p. 184.

[40] Theodor Lessing, *Der Lärm: Eine Kampfschrift gegen die Geräusche unseres Lebens* (Wiesbaden: Bergmann, 1908), p. 69. On Lessing, see Baron Lawrence, 'Noise and Degeneration: Theodor Lessing's Crusade for Quiet', *Journal of Contemporary History*, 17 (1982), 165–78; and Matthias Lentz, '"Ruhe ist die erste Bürgerpflicht": Lärm, Großstadt und Nervosität im Spiegel von Theodor Lessings "Antilärmverein"', *Medizin, Gesellschaft und Geschichte*, 13 (1995), 81–105. For the broader context, see Karin Bijsterveld, *Mechanical Sound: Technology, Culture, and Public Problems of Noise in the Twentieth Century* (Cambridge, MA: MIT Press, 2008).

[41] 'Unser Ohr wird von einer in großen Dosen verabreichten, aufdringlichen und lärmenden Musik erregt und überreizt'. Wilhelm Erb, *Ueber die wachsende Nervosität unserer Zeit* (Heidelberg: Hörning, 1893), pp. 23–4.

throughout a symphony, to follow the gradual unfolding of a musical work.[42] In 1913, the composer and musicologist Edgar Istel argues that for most of his contemporaries opera houses and concert halls are 'veritable torture chambers', for the prevailing listening conventions no longer match their emotional or social needs.[43] The concert hall, held up in the nineteenth century as a space for deep, collective attention and hence as 'an ideal place with the power to represent and influence society', no longer fulfilled this unifying purpose.[44]

In the 1920s, this shift elicited a flurry of initiatives intended to revive or reform musical culture. New music societies tried to adapt the format of the symphony concert in an effort to bring classical music to non-bourgeois, working-class, audiences. Initiatives included concerts without a conductor, concerts without applause, and concerts for workers staged at mass venues such as Frankfurt Festhalle. At the performances of Paul Hindemith's Gemeinschaft für Musik (Community for Music) project, the programme and names of the performers were only announced at the start of the performance, only unknown works were performed, and no music critics were allowed to attend. Other initiatives abandoned the concert format altogether in favour of more casual, interactive musical experiences.

But what about those traditional institutions whose very survival was threatened by these developments? As an example of the problems facing German orchestras in the interwar period, Hansjakob Ziemer explores the fate of the Museums-Gesellschaft, Frankfurt's leading symphony orchestra. Having announced grand plans to build a vast new concert hall in 1908, by 1933 the orchestra was nearly bankrupt as audience numbers had dwindled and the orchestra was forced, for the first time in its history, to advertise its subscriptions.[45] An indication of the social and cognitive shifts which contributed to the decline of the symphony concert was the fact that even its long-standing audience failed to comply with the expected behavioural standards. Concert reviews of the interwar years describe chaotic scenes of audience members arriving late, chatting during the performance, and leaving noisily before the final piece, on one occasion causing the chief conductor, Hermann Scherchen, to walk out on a performance before the end.

In an effort to stem this tide of aberrant behaviour, the organizers turned to methods borrowed from experimental psychology. The 1924 programme notes explain the new system put in place to alert concertgoers to the start of the performance:

[42] Wilibald Nagel, *Die Musik im täglichen Leben* (Langensalza: Beyer, 1907), p. 9. Cited in Hansjakob Ziemer, 'The Crisis of Listening in Interwar Germany', in *The Oxford Handbook of Music Listening*, ed. Thorau and Ziemer, pp. 97–121 (p. 100).

[43] Edgar Istel, 'Die moderne Folterkammer: Auch ein Beitrag zur "Konzertreform"', *Neue Zeitschrift für Musik*, 80:40 (1913), 549.

[44] Ziemer, 'Crisis of Listening', p. 101. [45] See Ziemer, 'Crisis of Listening', p. 102.

8 min vor 7 Uhr [...]: ein Glockenzeichen, gelbes Lichtsignal; 4 Minuten vor 7 [...]: zwei Glockenzeichen, grünes Lichtsignal, Punkt 7 [...]: drei Glockenzeichen, rotes Lichtsignal, worauf sämtliche Eingänge geschlossen werden. [...] Die geehrten Konzertbesucher werden dringend ersucht, durch rechtzeitiges Erscheinen den Vorstand in seinen Bestrebungen um pünktlichen Anfang zu unterstützen.[46]

[Eight minutes to seven [...]: the bell rings once, accompanied by an amber light; four minutes to seven [...]: the bell rings twice, accompanied by a green light; seven on the dot [...]: the bell rings three times, accompanied by a red light, upon which all doors are shut. [...] The orchestra board urgently asks our esteemed audience to support the punctual start of the performance by arriving in good time.]

As these instructions show, listeners could not be expected to adopt the right mindset without some time and preparation. The concert hall could no longer be taken as an automatic bulwark against everyday distractions, making it necessary to import methods of mental conditioning as they were used across Weimar society. Indeed, the light signals employed to alert concertgoers to the start of the performance bear a striking resemblance to the first German traffic lights, which were installed that same year in Berlin's Potsdamer Platz.[47]

The Museums-Gesellschaft's audience alert system was a hybrid and a compromise, using contemporary psychotechnical strategies of behavioural conditioning to restore the listening ideal of the previous century. The ongoing relevance of this contemplative model was also underlined by Arnold Schönberg's Verein für musikalische Privataufführungen (Society for Private Musical Performances) in Vienna. Founded in 1918, its concerts took place in reverent silence, excluded music critics, and permitted neither applause nor any other, positive or negative, response. By immersing listeners in a programme of atonal music undiluted by tonal pieces, Schönberg hoped to establish new listening habits which would eventually make new music as familiar as the eighteenth- and nineteenth-century canon.

Other commentators, however, objected to the period's continued adherence to the listening modes and conventions of the previous century, warning that they were no longer suited for either contemporary music or society. The musicologist Kurt Westphal warns in 1928 that for most audience members, contemplative

[46] Programme Collection, Museums-Gesellschaft, University Library, Goethe University Frankfurt am Main. Cited in Ziemer, 'Crisis of Listening', p. 122, n. 57.

[47] In a little piece which comments on this innovation, Siegfried Kracauer singles out the amber light, whose purpose is to compel pedestrians and drivers to pay attention, freeing them from all reflection and personal initiative—in marked contrast to Paris, where amber lights did not exist and where the responsibility for alertness rested with the individual. Siegfried Kracauer, 'Kleine Signale', in *Schriften*, vol. 5.2: *Aufsätze 1927–1931*, ed. Inka Mülder-Bach (Frankfurt a.M.: Suhrkamp, 1990), pp. 234–6 (pp. 235–6).

listening elicited not a rational but an irrational, emotional response: 'We are not in control of the nineteenth century, but the nineteenth century largely controls us'.[48] For Hindemith, in turn, listeners' attitude towards new music was akin to that of people who judge current developments in the automobile industry with reference to 'the time of the stage coach'.[49] To root out such outdated listening modes, Westphal calls for the institution of a new listening culture, 'das neue Hören'. Like New Vision, its counterpart in the field of photography, this concept belongs to the wider context of New Objectivity; it aims for a more immediate mode of musical experience. This new kind of listening was meant to be neither emotional and identificatory nor purely rational, focused on musical forms and structures. Rather, listeners should approach a work in a state of detached openness, taking in the unfolding piece as an immediate sound experience. The music critic Paul Bekker coins the term 'physiological music' to describe contemporary works which resist 'psychological', identificatory, listening strategies. Calling on listeners to experience 'naked' sounds rather than musical structures, he writes: 'Listen and feel and trust in your immediate experience rather than in your understanding, which has been corrupted or at least limited by education and experience'.[50] The composer Walther Hirschberg wants listeners to be 'passionately dispassionate',[51] and Westphal envisages a 'mechanization' of the concert format, in which listeners listen without any inner participation and do not identify with the performing artist or the conductor.[52]

Heinrich Besseler: Embodied Listening

For many contemporaries, new, particularly atonal, music marked a break with nineteenth-century conceptions of *Kunstreligion* and contemplative listening. Others, in turn, looked not to the present but to the more distant past, namely to the medieval and early modern periods, in their search for alternative models of musical experience. This period was the focus of the musicologist Heinrich Besseler (1900–69) in his ground-breaking 1926 study 'Grundfragen des musikalischen Hörens' (Fundamental Issues of Musical Listening).

[48] 'Wir beherrschen das 19. Jahrhundert noch nicht; es beherrscht zum großen Teil uns'. Kurt Westphal, 'Das neue Hören', *Melos*, 7 (1928), 352–4 (p. 354).
[49] Paul Hindemith, 'Über Musikkritik', *Melos*, 8 (1929), 106–9 (p. 107).
[50] 'Hört und fühlt und vertraut dem, was ihr dadurch erfahrt, mehr als eurem Verstehen, das durch Erziehung und Gewohnheit verdorben oder doch einseitig abgegrenzt worden ist'. Paul Bekker, 'Physiologische Musik', *Frankfurter Zeitung*, 2 December 1922.
[51] Walther Hirschberg, 'Objektive Musik', *Vossische Zeitung*, 20 August 1927.
[52] Westphal, 'Das neue Hören', p. 354. On this general process of 'de-subjectifying' the concert experience, see Hansjakob Ziemer, *Die Moderne hören: Das Konzert als urbanes Forum 1890–1940* (Frankfurt a.M.: Campus, 2008), pp. 290–5.

Besseler was one of the most brilliant musicologists of his generation,[53] but his 1926 article is no conventional academic study but rather an attempt to extrapolate a bold new listening model from practices of the past. Like many of his contemporaries, he is alive to the crisis that has engulfed the bourgeois musical institutions. In his opening section he singles out Hanslick and Riemann as the representatives of a musical aesthetic which has lost its legitimacy in the current cultural climate.[54] In addressing this challenge, however, a psychological approach, which tries to isolate specific perceptual patterns, will be worthless. For Besseler, changes in listening habits need to be understood within their social context, as musical experience both reflects and enforces 'certain social formations'.[55]

What Besseler most dislikes about the concert format is its strict divide between listeners and performers. In Beethoven's time, he notes, the concert audience offered an idealized form of community, a microcosm of humanity, but this social ideal has gradually evaporated, leaving only an 'atomized and incoherent mass' ('atomisierte, zusammenhanglose Masse'), who passively let the music wash over them and whose main expectation is a technically polished performance rather than a meaningful (let alone a spiritual) experience.[56] The new technical media of gramophone and radio do not mark a radical caesura but merely enforce a pre-existing problem, namely the vast, artificial gulf between performers and listeners. Around 1800, he concedes, this division of labour facilitated the emancipation of musical works from their extra-musical use and context; by the twentieth century, however, this separation has ceased to be constructive. It reduces listeners either to passive consumers or to detached 'experts' with little or no practical expertise.

In his description of modern musical culture, Besseler thus concurs with many of his contemporaries. Where he diverges from them is in his proposed solutions, his evaluation of the place of music in modern society, and indeed in his overall assessment of modern culture.

His reference point throughout the essay is everyday life in all its diversity— 'work that has to be done every day, the pressure of certain duties, hoped-for or unwelcome news, misunderstandings in our dealings with others, distraction or calm contemplation after the business of the day, anxiety, financial concerns,

[53] Besseler's doctoral dissertation, published in 1923, focused on the German suite of the seventeenth century and his Habilitationsschrift on motets from Petrus de Cruce to Philipp of Vitry, but his international reputation was cemented by his 1931 magnum opus, *Die Musik des Mittelalters und der Renaissance* (The Music of the Middle Ages and the Renaissance).

[54] Heinrich Besseler, 'Grundfragen des musikalischen Hörens', *Jahrbuch der Musikbibliothek Peters*, 32 (1925), 35–52 (pp. 35–6); Heinrich Besseler, 'Fundamental Issues of Musical Listening (1925)', trans. Matthew Pritchard with Irene Auerbach, *Twentieth-Century Music*, 8 (2012), 49–70 (p. 49). Rob C. Wegman characterizes Besseler's method as an 'inductive aesthetics', that is, the attempt to infer from the analysis of a composition 'the mode of listening that it seems to call for, or that seems proper to it': '"Das musikalische Hören" in the Middle Ages and Renaissance: Perspectives from Pre-War Germany', *Musical Quarterly*, 82 (1998), 434–54 (p. 441).

[55] Besseler, 'Fundamental Issues', p. 50; Besseler, 'Grundfragen', p. 36.

[56] Besseler, 'Fundamental Issues', p. 51; Besseler, 'Grundfragen', p. 36.

recreation, sport, shared moments of joy, etc.'.[57] What makes this list remarkable is that negative aspects, such as time pressure, unwelcome news and misunderstandings, and financial worries, are listed alongside positive experiences, indeed, are often yoked together into an oppositional pair. Thus, 'Zerstreuung', distraction, is mentioned alongside 'ruhige Sammlung' (calm contemplation), undermining the black-and-white approach to the two states taken by many contemporary commentators. Besseler does not want to escape from the mêlée of modern life into the sheltered space of pure contemplation, which is the space of Kunstmusik (art music) and its disinterested enjoyment. His goal is a way of life where music is not separated from work and social interaction but an integral part of them. 'The essential thing is always that music does not enter into the context of everyday life as something extraneous, but that it is supported by its rhythm, continuing in an alternation of tension and release, work and relaxation'.[58] This kind of musical experience can offer an antidote to 'the destructive artificiality of metropolitan capitalist existence'.[59]

So what does Besseler have in mind with this rather allusive description? Reflecting his own research, his reference point is the musical culture of the medieval and early modern times, which he casts as a model for modern practice. In these societies, the emphasis was not (yet) on the passive, aural reception of music, but on its enactive, physical dimension, on musical experience rooted in everyday activities such as work and leisure, praying and dancing:

> An der Haltung eines Tänzers oder auch nur eines unmittelbar beteiligten Zuschauers fällt sogleich auf, daß die Musik für ihn keineswegs im Mittelpunkt steht. Er hört nur mit halbem Ohr hin [...]. Und ähnlich wie hier zwischen Musik und Hörern eine uns gewohnte Distanz zu fehlen scheint, so verschmelzen auch die sonst fest umrissenen Einzelpersonen zu einer Art von rhythmisch-vitalem Kollektivdasein, durch das die Musik als verbindendes Fluidum hindurchströmt. Es liegt auf der Hand, daß ein bloßer Beobachter nicht den angemessenen Zugang zu dieser Musik hat, insofern er eben nicht 'mitmacht'. Von Zuhören in konzerthaftem Sinne ist hier keine Rede. Man könnte das Leitenlassen der eigenen musikalisch-tänzerischen Aktivität allenfalls als *Mithören* bezeichnen.[60]

[57] Besseler, 'Fundamental Issues', p. 59; 'täglich zu erledigende Arbeit, Druck bestimmter Verpflichtungen, erwünschte oder unwillkommene Neuigkeiten, Mißverständnisse im Verkehr mit anderen, Zerstreuung oder ruhige Sammlung nach dem Betrieb des Tages, Unruhe, Geldsorgen, Erholung, Sport, gemeinsame Freuden usw. usw.'. Besseler, 'Grundfragen', p. 45.

[58] Besseler, 'Fundamental Issues', p. 60. 'Wesentlich ist dabei [...], daß die Musik nicht als etwas Fremdes in den Zusammenhang des Alltags hineintritt, sondern von seinem Rhythmus getragen wird, der im Wechsel von Spannung und Lösung, Arbeit und Erholung fortschwingt'. Besseler, 'Grundfragen', p. 45.

[59] Besseler, 'Fundamental Issues', p. 60; 'die zerreißende Unnatur des großstädtisch-kapitalistischen Daseins'. Besseler, 'Grundfragen', p. 45.

[60] Besseler, 'Grundfragen', p. 38.

[What immediately strikes one about the posture of a dancer or even of a closely involved spectator is that for him the music is not the main focus. The dancer is only half listening to it. [...] And nearly in the same way as here the distance we expect between music and listener appears to be absent, so the otherwise distinct and discrete individuals blend into a kind of rhythmically vital collective being, whose lifeblood is the music. It is quite obvious that a mere observer does not have the appropriate access to this music, inasmuch as he does not 'join in'. There is no question of 'listening' in the way one would at a concert. This 'letting oneself be guided' in one's own active response to the music through dance could be designated, at most, as a kind of overhearing.[61]]

Rebutting Hanslick's Kantian model of disinterested contemplation, Besseler here unfolds his own, anti-contemplative framework. Its central modus is *Mithören*, listening as an accompaniment to other activities, situated not in the centre of awareness but somewhere towards its margins.

A second, even more radical example of this mode of musical experience is provided by the *Arbeitslied*, or work song, which embodies the Gebrauchsmusik model of collective music-making in its purest form.[62] In his discussion of this tradition, Besseler cites the economist Karl Bücher's 1896 study *Arbeit und Rhythmus* (Work and Rhythm), which explores the importance of music, and specifically singing, as a backdrop to collective manual labour. As Bücher argues, the central element in work songs is not the melody or sound ('Klang'), but their rhythm, which facilitates, as well as reflects, synchronized bodily movement.[63] In work songs, then, no division exists between performer and listener, nor between the individual and the group; music accompanies a 'mutual adjustment to common activity'.[64] In this context, Besseler reiterates an earlier point. Someone listening to labour songs 'from the outside' will only gain a superficial and derivative, at worst a completely distorted insight, shaped by 'a quite alien scholarly or atmospheric-literary attitude'; as he stresses, this type of music can only be truly understood by actively *'joining in'*.[65]

[61] Besseler, 'Fundamental Issues', p. 53.
[62] Besseler, 'Fundamental Issues', p. 54; Besseler, 'Grundfragen', p. 39. Gebrauchsmusik can be roughly translated as 'music designed to be used'.
[63] Karl Bücher, *Arbeit und Rhythmus*, 2nd rev. edn (Leipzig: Teubner, 1899 [1896]), p. 44. Bücher's study is cross-cultural as he analyses the role of labour songs in African, South-East Asian, and Eastern European culture. An appendix assembles labour songs from around the world—principally 'Bootgesänge' or rowing songs, but also songs to accompany planing, hammering, forging—and the loading of goods onto a camel (pp. 384–405).
[64] Besseler, 'Fundamental Issues', p. 54; 'gegenseitige Anpassung bei gemeinsamer Tätigkeit'. Besseler, 'Grundfragen', p. 40.
[65] Besseler, 'Fundamental Issues', p. 55; 'eine ganz fremde wissenschaftliche oder stimmungshaft-literarische Einstellung'; 'das leiblich-tätige (Mit-)*Vollziehen*'. Besseler, 'Grundfragen', p. 40. Another aspect which characterizes Gebrauchsmusik is its trans-historical continuity. Unlike Kunstmusik, orally passed-down music such as work songs, political songs, and national anthems change very little

These examples lead Besseler to his core question: 'what is the position of music-making in the context of any given human existence [*Dasein*] and its everyday manifestations?'[66] Here, his theory of musical experience has two interrelated sides. The vision of a society permeated by collective musical practices, such dancing, working, and worship, in turn reflects 'the essence of music [...] as a *way of being human*'[67]—human existence as profoundly shaped by musical features such as rhythm, melody, and sound.[68]

Here and throughout his essay, Besseler's use of the term Dasein reflects the influence of his Freiburg teacher Martin Heidegger, with whom he had studied in the early 1920s and whom he credits in a footnote.[69] Rebutting Edmund Husserl's phenomenological reduction, Heidegger argues in *Sein und Zeit* (Being and Time, 1927) that human beings understand the world by immersing themselves in it, by interacting with it in a practical manner. In his commentary on *Being and Time*, Hubert Dreyfus describes this engagement as 'everyday skillful coping'—a stance which involves 'awareness but no self-awareness'.[70] As Heidegger argues, we encounter the objects of the world not as a set of abstract qualities (shape, size, weight, colour), but as equipment (*Zeug*) defined by a specific purpose. To illustrate this point, Heidegger uses examples from manual labour. The nature of a hammer is disclosed in the act of hammering; to use it we do not need to reflect on its abstract, general properties:

[J]e weniger das Hammerding nur begafft wird, je zugreifender es gebraucht wird, um so ursprünglicher wird das Verhältnis zu ihm, um so unverhüllter begegnet es als das, was es ist, als Zeug. Das Hämmern selbst entdeckt die

over time. Liturgical music also falls into this category, particularly Gregorian chant and Protestant chorales, which facilitate a collective devotional experience. From these musical discussions Besseler then branches out into other fields such as psychology, pedagogy, ethnography, and literary history, as for instance when he discusses the role of music in 'primitive' societies and the residues of this mindset in the child, in myth and fairy tale. See Besseler, 'Grundfragen', pp. 41–4; Besseler, 'Fundamental Issues', pp. 56–8.

[66] Besseler, 'Fundamental Issues', p. 59. 'Wie steht das Musizieren im Zusammenhang des jeweiligen Daseins und seiner Alltäglichkeit?'. Besseler, 'Grundfragen', p. 45.

[67] Besseler, 'Fundamental Issues', p. 62; 'das Musikalische [...] als eine *Weise menschlichen Daseins*'. Besseler, 'Grundfragen', p. 47.

[68] On the role of rhythm in modernism, see Julian Murphet, Helen Groth, and Penelope Hone, eds., *Sounding Modernism: Rhythm and Sonic Mediation in Modern Literature and Film* (Edinburgh: Edinburgh University Press, 2017).

[69] See Besseler, 'Fundamental Issues', p. 59; Besseler, 'Grundfragen', p. 45. Alongside Heidegger, the other formative influence on Besseler in Freiburg was Wilibald Gurlitt, head of the new musicological institute. Besseler's move from a theoretical, formalist musicology in the Riemann tradition to a more socially contextualized approach reflects Gurlitt's own research focus, which is encapsulated in lecture courses such as 'Basic Principles of Comparative Musicology as an Introduction to the Music of Non-European Cultures' and 'Music and Society (Principal Historical-Sociological Forms of Music-Making)'. See Matthew Pritchard, 'Who Killed the Concert? Heinrich Besseler and the Interwar Politics of Gebrauchsmusik', *Twentieth-Century Music*, 8 (2011), 29–48 (p. 31).

[70] Hubert L. Dreyfus, *Being-in-the-World: A Commentary on Heidegger's 'Being and Time', Division I* (Cambridge, MA: MIT Press, 1991), p. 67.

spezifische 'Handlichkeit' des Hammers. Die Seinsart von Zeug, in der es sich von ihm selbst her offenbart, nennen wir die Zuhandenheit.[71]

[The less we just stare at the hammer-thing, and the more we seize hold of it and use it, the more primordial does our relationship to it become, and the more unveiledly is it encountered as that which it is—as equipment. The hammering itself uncovers the specific 'manipulability' of the hammer. The kind of Being which equipment possesses—in which it manifests itself in its own right—we call 'readiness-to-hand'.[72]]

The contrast between using a hammer and merely 'staring' at it in a detached fashion resembles Besseler's opposition between the dancers immersed in music and the derivative experience of the detached passive observer. Challenging philosophical and aesthetic conventions, both Heidegger and Besseler privilege the state of enactive absorption, which accompanies habitual everyday activities, over voluntary, dedicated, and sustained contemplation.[73]

In his analysis of modern culture, Besseler echoes many of his contemporaries, as for instance when he links the decline of the classical concert to the dwindling cultural influence of the middle classes, or when he emphasizes the growing prominence of the 'geistige Arbeiter' (intellectual labourer), who feel disconnected from this tradition and whose musical needs are better met by the jazz band than by the symphony orchestra.[74] Besseler, however, does not focus his attention on them but on the group of predominantly young listeners, 'the youth movement, having broken away from the previous social order', who have consciously turned their back on the symphony concert and have found a new musical home in their revival of the German folk song tradition.[75] They are at the vanguard of the Gebrauchsmusik movement, where music-making and listening are enmeshed in everyday life. Besseler regards Gebrauchsmusik as the antidote to Kunstmusik with its ossified separation between performers and listeners. Gebrauchsmusik seeks to overcome this divide. It designates a musical movement not centred on the concert format, where the technical perfection of the performance is of minor importance.[76] Its audience is no passive, amorphous mass but 'a true community

[71] Martin Heidegger, *Sein und Zeit*, 11th edn (Tübingen: Niemeyer, 1967), p. 69.
[72] Martin Heidegger, *Being and Time*, trans. John Macquarrie and Edward Robinson (New York, NY: Harper & Row, 1962), p. 98.
[73] On the wider repercussions of Heidegger's thought for a phenomenology of listening, see David Espinet, *Phänomenologie des Hörens: Eine Untersuchung im Ausgang von Martin Heidegger* (Tübingen: Mohr Siebeck, 2009).
[74] Besseler, 'Fundamental Issues', p. 52; Besseler, 'Grundfragen', p. 37.
[75] Besseler, 'Fundamental Issues', p. 52; 'die aus dem früheren Gesellschaftsgefüge abgesprengte Jugendbewegung'. Besseler, 'Grundfragen', p. 37.
[76] For details on the movement and its leading figures, which include Paul Hindemith, Kurt Weill, and Hanns Eisler, see Stephen Hinton, *The Idea of Gebrauchsmusik: A Study of Musical Aesthetics in the Weimar Republic (1919–1933) with Particular Reference to the Works of Paul Hindemith* (New York, NY: Garland, 1989).

of like-minded individuals', who follow the music with an 'active, expectant attitude'.[77] In stressing the importance of an active reception, Besseler in fact echoes elements of Hanslick's *On the Musically Beautiful*, whose principal objection to emotional, 'culinary', modes of reception is the passivity of the listener.

Although its author later retracted his more radical ideas,[78] Besseler's 1925 essay marks an important intervention in Weimar debates about music and attention. It challenges the long-standing ideal of contemplative listening and instead tries to think about musical experience in historical terms and as a socially embedded practice. In this regard, his listening model combines several elements: the search for non-contemplative modes of reception rooted in everyday, embodied activity; the attempt to break down the barrier between listener and performer; and the intersubjective, active and interactive, nature of this experience.[79] These ideas bear a striking resemblance to Walter Benjamin's thoughts on attention, specifically his own suggested alternatives to aesthetic contemplation.

Just as Besseler turns his back on the concert hall and instead focuses on informal and enactive forms of communal musical experience, Benjamin favours the cinema and its distracted audience over the secular temples of the art gallery and the museum. Indeed, as we have seen in the previous chapter, in the earliest notes for his 'Work of Art' essay, Benjamin's casts music as the site where new cognitive habits are formed. Echoing Besseler's comments about dancers taking in the accompanying music with 'half an ear', he writes that non-contemplative reception 'is strikingly evident in music, where one of the most important recent

[77] Besseler, 'Fundamental Issues', 52; 'echte Gemeinschaft gleichgestimmter Einzelner'. Besseler, 'Grundfragen', p. 38.

[78] In his 1959 essay 'Das musikalische Hören der Neuzeit' (Musical Listening in the Modern Era), Besseler brackets off the wider social context of musical experience and instead assumes a 'direct, one-to-one relationship between musical object and listening subject'. Wegman, 'Das musikalische Hören', p. 445. Indeed, in the post-war years he returns to Riemann's notion of 'synthetic' listening, whereby the elements of musical work are 'mentally assembled into an architectural structure', thus going back on the 'radical promise' of his earlier argument. Pritchard, 'Who Killed the Concert?', pp. 33–4. Much more problematic is Besseler's active role in National Socialism, when he joined first the SA and later the NSDAP and publicly endorsed the new regime and its musical culture. While Lütteken reads his Weimar work as containing the seeds of his later ideology, Pritchard rejects this argument as a skewed backward projection. Laurenz Lütteken, 'Das Musikwerk im Spannungsfeld von "Ausdruck" und "Erleben": Heinrich Besselers musikhistoriographischer Ansatz', in *Musikwissenschaft—eine verspätete Disziplin? Die akademische Musikforschung zwischen Fortschrittsglauben und Modernitätsverweigerung*, ed. Anselm Gerhard (Stuttgart: Metzler, 2000), pp. 213–32 (p. 228); and Pritchard, 'Who Killed the Concert?', p. 37.

[79] To further the case of Gebrauchsmusik, Besseler also draws on the role of music in religious contexts, arguing that hymns and Gregorian chants channel the congregation's faith and strengthen collective worship while criticizing the introduction of Kunstmusik (here, he presumably refers to Masses and other works performed by a choir) into the liturgy as a distraction from religious matters. In this, he echoes an argument dating back to St Augustine, who worries about the power of music to absorb the congregation, about its centripetal pull away from the religious 'message'. See Besseler, 'Grundfragen', p. 42; 'Fundamental Issues', p. 57.

developments, namely *jazz*, has its most important agent in dance music'.[80] For Benjamin, as for Besseler, dancing is both symptom and vehicle of cognitive change.

The text in which the parallels between Besseler and Benjamin are most apparent, however, is Benjamin's 1934 'Storyteller' essay. It contrasts the novel—the bourgeois, individualist genre par excellence—with oral storytelling, a tradition bound up with collective manual labour. Both Besseler and Benjamin advocate modes of aesthetic experience which are collective, rooted in routine physical activity, and therefore at odds with the Kantian model of disinterested contemplation. In doing so, both turn to examples from pre-modern communities as they search for equivalents and resonances of such practices in modern society. Anticipating Benjamin's argument, Besseler singles out the communal practice of storytelling and its 'repetitions of rhythm and intonation', which create a sense of monotony that actually furthers the process of recollection.[81]

Rob C. Wegman has queried the historical accuracy of Besseler's historical narrative, calling it an 'idealized, almost fairy-tale' portrayal of a rural German musical tradition unspoilt by modernization;[82] a similar charge can be levelled against Benjamin's 'Storyteller' essay. This critique, however, misses the point. What matters is not the historical accuracy of these and similar narratives, but their status as the products and symptoms of modernity—narratives which oscillates between the desire for contemplative solitude and the search for alternative, authentic modes of experience facilitating a renewed sense of collectivity.[83]

Besseler's and Benjamin's respective models of non-contemplative reception are emphatically rejected by Benjamin's friend and colleague Theodor W. Adorno. Adorno concurred with his contemporaries in diagnosing the decline of sustained musical listening. As we will see in Chapter 10, however, for him the answer was not to abandon disinterested contemplation altogether, but rather to defend it as a vehicle of critique and resistance.

[80] 'Sehr sinnfällig ist das in der Musik der Fall, in der eine wesentliche [sic] Element neuesten Entwicklung [sic], der *Jazz*, seinen wichtigsten Agenten in der Tanzmusik hatte' (*WuN* 16, 34). See Chapter 8, p. 295.

[81] 'Gute Erzähler wenden an solchen Stellen einen leiernden, halb musikalisch-rezitierenden Vortrag an, der wohl jedem, der ihn als Kind hörte, unvergeßlich bleibt'. Besseler, 'Grundfragen', p. 44 ('Good narrators will apply to such passages a half droning, half musical reciting delivery that is likely to remain unforgettable for anyone who has heard it as a child'. Besseler, 'Fundamental Issues', p. 58).

[82] Wegman, 'Das musikalische Hören', p. 439.

[83] An emphatic defence of the community-forging power of nineteenth-century Kunstmusik, in contrast, is mounted by Paul Bekker. In his 1911 Beethoven biography, he casts Beethoven's symphonies as speeches to the nation and to humanity as a whole, and he later adds that this music is able to forge 'Gefühlsgemeinschaften', communities of feeling. Pritchard, 'Who Killed the Concert?', pp. 43–4. As Margaret Motley argues, this notion was common among German and Austrian critics at the time. Margaret Motley, '*Volksconcerte* in Vienna and Late Nineteenth-Century Ideology of the Symphony', *Journal of the American Musicological Society*, 50 (1997), 421–53.

10
Spellbound
Theodor W. Adorno on Music and Style

Music is the lynchpin of Theodor W. Adorno's (1903–69) life and work. His musical writings take up eight of the twenty volumes of his *Gesammelte Schriften* (Collected Writings); they range from monographs on individual composers— Wagner, Mahler, Berg—to studies of more specific works, of musical schools and movements. Atonal, 'new' music is a particular focus of his work. However, in his musical writings Adorno also pursues a more general, philosophical and sociological, approach to music, its role in history and in modern society. For Adorno, as Tia DeNora writes, music was 'a manifestation of the social, and the social, likewise, a manifestation of music', as his texts explore 'music's role in relation to consciousness, to the psycho-cultural foundations of social life'.[1] Within this field, he was particularly interested in issues of reception, in how people in different periods, cultures, and social contexts experience music. Rather than simply describing different listening modes, he is vocal about what he regards as the appropriate way to encounter 'autonomous' works and, conversely, about what he regards as the threats to this listening model.

At first glance, Adorno's musical writings are strikingly consistent.[2] Their method and conceptual framework are in place by the early 1930s and remain fairly constant across the caesuras of fascism and exile all the way to his post-war return to West Germany. But this continuity masks some important shifts, notably with regard to the question of musical listening, which are motivated in part by his experience in American exile and which manifest themselves theoretically as well as on a more practical level, in the way the later Adorno engages with his audience.

Adorno's thought is relentlessly dialectical, which makes it hard to extract short and pithy statements from the twists and turns of his argument (even though some of his more aphoristic pronouncements have been cited in this fashion).

[1] Tia DeNora, *After Adorno: Rethinking Music Sociology* (Cambridge: Cambridge University Press, 2003), p. 151.

[2] Max Paddison speaks of the 'striking' unity of his thought and the 'evident connections between even the most occasional of the early pieces and the large-scale philosophical writings of his last years', though he also emphasizes its development over time as shaped by various intellectual, political, and biographical caesuras. Max Paddison, *Adorno's Aesthetics of Music* (Cambridge: Cambridge University Press, 1993), p. 21.

As he is keen to stress, however, his notoriously dense and complex style is no elitist quirk but integral to his way of thinking. This chapter, then, falls into two sections. Its first half explores Adorno's writings on musical listening and attention across the different stations of his intellectual life; the second half looks at how his (dialectical) concept of musical listening is reflected in his own method and style, and in his post-war personal reflections on these issues. As I will argue, Adorno's texts, whether on music or on one of his many other subjects, follow his own precept of 'mit den Ohren [...] denken', 'thinking with one's ears' (*AGS* 10.1, 11). Ranging from densely argued monographs to short essays and aphoristic pieces, they enact his own thought on musical listening which, contrary to its austere reputation, is alive to the diversity of human experience and advocates both sustained immersion and a more spontaneous, playful mode of engagement.

Adorno versus Benjamin

A good entry point into Adorno's writings is his debate with Walter Benjamin, one of his main conversation partners in the 1930s. The two fiercely disagreed about certain issues, most notably about attention and aesthetic experience, and yet Benjamin's thought exerted a lasting influence on Adorno far beyond his premature death in 1940. Their respective positions are crystallized in their exchange about Benjamin's 'Work of Art' essay.[3] Adorno's long letter of 18 March 1936, together with subsequent, shorter comments, represents the only substantial response to the essay in Benjamin's lifetime. Although he acknowledges some points of convergence, his assessment is largely critical, hinging on Benjamin's critique of contemplation and concomitant advocacy of habitual and distracted modes of reception.

Kant's *Critique of the Power of Judgement* and its model of disinterested aesthetic contemplation provide the implicit backdrop to Benjamin's historical argument.[4] As he argues, contemplation ties the traditional artwork back to its ritualistic origins, which survive in the bourgeois institutions of the museum and the concert hall, lending these experiences a reactionary and solipsistic dimension. For Benjamin, then, disinterested contemplation is the enemy; in the fight against this adversary he enlists several allies, ranging from habit, shock, and tactile experience to distraction. Avant-garde art, especially Dadaism, goes some way

[3] Adorno read the essay in its third and, subsequently, in its published French (fourth) version.
[4] In his second semester at the Albert-Ludwig University in Freiburg, Benjamin took a seminar on Kant's *Critique of Judgement*. See Howard Eiland and Michael W. Jennings, *Walter Benjamin: A Critical Life* (Cambridge, MA: Harvard University Press, 2014), p. 55. On his Kant reception, see also Peter Fenves, '"Über das Programm der kommenden Philosophie"', in *Benjamin-Handbuch: Leben—Werk—Wirkung*, ed. Burkhardt Lindner (Stuttgart: Metzler, 2011), pp. 134–50 (pp. 136–7). Adorno first studied Kant's writings together with his older friend and mentor Siegfried Kracauer in the 1920s. See Stefan Müller-Doohm, *Adorno: Eine Biographie* (Frankfurt a.M: Suhrkamp, 2003), p. 71.

towards challenging this mindset, but for Benjamin the true agent of perceptual change is mass culture: *'The technological reproducibility of the artwork changes the relation of the masses to art. The extremely backward attitude toward a Picasso painting changes into a highly progressive reaction to a Chaplin film'.*[5]

Such remarks must have acted like a red rag to Adorno. Commenting on the central, penultimate section of the essay, he declares himself unconvinced by Benjamin's theory of distraction 'despite its shock-like appeal'; he elaborates: 'You underestimate the technical component of autonomous artworks and overestimate that of their non-autonomous counterparts; that, broadly speaking, might be my main objection'.[6] In a letter to Horkheimer, he makes the same point rather more bluntly, accusing Benjamin of ignoring 'the progressive intention of "autonomous" art, involving a good form of rationality, the technical command over the material'; in doing so, he 'pours out the baby with the bathwater and then worships the empty tub'.[7] The baby in this analogy is the artwork, the bathwater the associated bourgeois aesthetic ideology, while the (empty) bathtub stands for what remains after the aggressive clear-out of cultural tradition: modern mass culture, where the contemplative encounter with the artwork is replaced by a habitually distracted mode of reception.

In his letter Adorno accuses Benjamin of being insufficiently dialectical both in his critique of the traditional artwork and his endorsement of mass culture; as a result, he argues, Benjamin risks mythologizing certain phenomena and social agents. One example is the cinema audience, which Benjamin casts as a revolutionary force forged by this new, distracted experience. For Adorno, this argument is based on a naïve Marxist belief in the 'autonomy of the proletariat in the historical process'.[8] Against Benjamin's charge that the traditional (bourgeois) artwork remains tied to its ritualistic origins, he asserts a different narrative—art's

[5] *BSW* III, 116. 'Die technische Reproduzierbarkeit des Kunstwerks verändert das Verhältnis der Masse zur Kunst. Aus dem rückständigsten, z. B. einem Picasso gegenüber, schlägt es in das fortschrittlichste, z. B. angesichts eines Chaplin, um' (*WuN* 16, 128).

[6] '[D]ie Theorie der Zerstreuung will mich, trotz ihrer chokhaften Verführung, nicht überzeugen [...]. Sie unterschätzen die Technizität der autonomen Kunst und überschätzen die der abhängigen; das wäre vielleicht in runden Worten mein Haupteinwand'. Letter by Adorno to Benjamin, 18 March 1936; Theodor W. Adorno, *Briefe und Briefwechsel*, vol 1: Theodor W. Adorno/Walter Benjamin, *Briefwechsel 1928-1940*, ed. Henri Lonitz (Frankfurt a.M.: Suhrkamp, 1994), pp. 172-3; Theodor W. Adorno and Walter Benjamin, *The Complete Correspondence 1928-1940*, ed. Henri Lonitz, trans. Nicholas Walker (Cambridge, MA: Harvard University Press, 1999), p. 130.

[7] He ignores 'die fortschrittlichen, auf gute Rationalität und technische Bemächtigung abzielenden Intentionen der "autonomen" Kunst' and 'schüttet erst das Kind mit dem Bade aus und betet dann die leere Wanne an'. Letter by Adorno to Horkheimer, 21 March 1936. Max Horkheimer, *Gesammelte Schriften*, vol. 15: *Briefwechsel 1913-1936*, ed. Gunzelin Schmidt-Noerr and Alfred Schmidt (Frankfurt a.M.: Fischer, 1995), pp. 498-9.

[8] The 'Selbstmächtigkeit des Proletariats im geschichtlichen Vorgang' (*WuN* 16, 588). As Douglas Brent McBride glosses, in Adorno's eyes Benjamin 'dispenses with the myth of the bourgeois individual only to fall victim to the spell of its Romantic inverse: the myth of the People as a collective subject, invested by Nature with the moral authority and cognitive insight to critique culture'. Douglas Brent McBride, 'Romantic Phantasms: Benjamin and Adorno on the Subject of Critique', *Monatshefte*, 90 (1998), 465-87 (p. 467).

emancipation from feudalistic structures and religious rituals; against Benjamin's emphasis on technology as the driver of cognitive and political change, he stresses the immanent laws of aesthetic production, of the work as a space where the age-old conflict between individual and society is played out in a mediated yet recognizable fashion, making it a site of personal expression, aesthetic innovation, and social critique.[9]

Benjamin and Adorno's exchange about the 'Work of Art' essay is often used to highlight their contrasting attitudes towards modernity and mass culture. Benjamin almost inevitably comes off better in such comparisons, as his open-minded embrace of the technical media is contrasted favourably with Adorno's 'myopic mandarinism' and blindness to the 'utopian and progressive dimensions of mass media such as film'.[10] But such arguments are based on a skewed premise. Even though Adorno defends autonomous art against Benjamin's charge of solipsistic anachronism, he does not suggest simply preserving cultural traditions as an end in itself. While he is critical of the 'culture industry' and the associated modes of reception, he describes modern popular and 'high' culture as two sides of the same coin, both of them subject to the same commodification of art and experience. This double-bind is nowhere more evident than in the field of music.

Modern Listening I: Genres and Settings

In the summer semester 1932, Adorno taught a critical reading seminar on Hanslick's *On the Musically Beautiful* at Goethe University Frankfurt together with the musicologist Moritz Bauer.[11] Resonances of Hanslick's argument, his advocacy of active, aesthetic listening and rejection of passive, emotional and 'culinary', listening habits, can be found across his musical writings. In the Frankfurt cultural scene, Adorno encountered a variety of listening practices across different settings; his experience is reflected in concert reviews and in more general essays about musical culture.[12]

[9] Recognizing that Adorno's reference point was different from his own focus on visual art and culture, Benjamin tries to tone down the contrast between their positions. He suggests that the 'verschiedene Verteilung der Licht- und Schattenpartien in unseren respektiven Versuchen' might not solely be owed to 'theoretische Divergenzen', adding, 'es ist ja nicht gesagt, dass akustische und optische Apperzeption einer revolutionären Umwälzung gleich zugänglich sind' (*WuN* 16, 642; the 'different distribution of light and shade in our respective writings'; 'it is not certain that acoustic and optical apperception is equally susceptible to revolutionary change'). Benjamin here raises an important point. As psychological experiments had revealed, visual and aural attention do follow different laws, both in general, cognitive terms and with regard to their susceptibility to aesthetic, societal, and technological change.

[10] Thomas Y. Levin and Michael von der Linn, 'Elements of a Radio Theory: Adorno and the Princeton Radio Research Project', *The Music Quarterly*, 78 (1994), 316–24 (p. 316).

[11] Müller-Doohm, *Adorno*, p. 944.

[12] After returning from Vienna, where he had studied piano and composition, Adorno established himself as a prominent concert critic. His reviews, which mostly appeared in the bi-monthly journal *Die Musik*, offer detailed sketches of the Frankfurt music scene. While he admired the conductor Hermann Scherchen, a leading advocate of new music, he was scathing about the conservatism of

His 1930 essay 'Bewußtsein des Konzerthörers' (Consciousness of the Concert Listener) echoes contemporary debates which cast the symphony concert as a dying tradition. Unlike some of fellow critics, Adorno seeks neither to reform nor to revive this format. As he argues, even in its nineteenth-century heyday the concert was no haven of authentic musical experience, but only provisionally insulated against the surrounding capitalist reification by notions of aesthetic autonomy and contemplative reception. This already fragile autonomy was shattered after the First World War, when the concert's bourgeois customer base lost its wealth and cultural capital. Those who survived this crisis, he notes, were pushed into a 'polemical stance' towards popular culture. Together with the new financial elite, they continue to cling to the symphony concert as a reflection of their own social and cultural superiority (*AGS* 5, 815).

Adorno's argument displays some remarkable similarities to Heinrich Besseler's 'Fundamental Issues of Musical Listening'. Both stress the link between music and society, casting the crisis of the symphony concert as the product of social factors such as the decline of the middle classes as the traditional torch-bearers of high culture. Both, indeed, are scathing about modern concert audiences. Besseler describes an amorphous, atomized mass made up of mostly passive listeners and a small cohort of expert critics who are solely interested in the technical matters of musical performance.[13] Adorno comes to a similar verdict when, in an echo of Hanslick, he classes most listeners as 'narcotics' who use music to escape into a better world (*AGS* 5, 816). As we will see, expanded versions of this listener typology feature across his musical writings.[14]

So what about the idea of recruiting new social groups to the concert experience, which was the aim of many Weimar initiatives? Adorno does not hold out much hope for this approach. The younger generation, in particular,

> kommt [...] als Konzerthörerschaft im hergebrachten Sinne kaum mehr in Betracht. [...] das Kunstwerk als Gebilde zu begreifen, fehlt es ihr an Muße und Freiheit; der Zwang des Lebens, in dem sie existieren, fordert andere Stimulantien. So entspannen sie sich bei einer leichten Musik, die ihnen vom Reklameapparat des gleichen Trustkapitalismus samt Radio, Grammophon und Tonfilm eingehämmert wird, dem sie zu entfliehen meinen in eine Kunst, die mit

Frankfurt audiences, noting that 'wenig ist vom Frankfurter Konzertleben zu berichten, wenig Gutes zumal' ('there is little to report about the Frankfurt concert scene—little that is good, at any rate'; *AGS* 19, 32).

[13] Heinrich Besseler, 'Grundfragen des musikalischen Hörens', *Jahrbuch der Musikbibliothek Peters*, 32 (1925), 35–52 (p. 36); Heinrich Besseler, 'Fundamental Issues of Musical Listening (1925)', trans. Matthew Pritchard with Irene Auerbach, *Twentieth-Century Music*, 8 (2012), 49–70 (p. 51).

[14] On the similarities between Adorno's and Besseler's typologies, see Sigrid Abel-Struth, 'Ansätze einer Didaktik des Musikhörens', in *Musikhören*, ed. Bernhard Dopheide et al. (Darmstadt: Wissenschaftliche Buchgesellschaft, 1975), pp. 319–45 (p. 323).

Textwort und Rhythmus sie auch für die karge Freizeit den Ideologien der herrschenden Mächte unterwirft. (*AGS* 5, 816)

[barely qualify as concertgoers in the traditional sense. [...] they lack the leisure and freedom to understand the work as an entity; the pressure of the life they lead demands other types of stimuli. Hence they relax to the sounds of a light music which is being hammered into their minds by the advertising machinery of the same capitalist system, embodied by radio, gramophone, and sound film, from which they try to flee into an art which subjects them, through lyrics and rhythm, to the ideologies of the ruling powers even in their meagre spare time.]

Caught up in the daily fight for survival, or *Daseinskampf*, these young (white-collar) workers do not go to symphony concerts but to bars and venues of mass entertainment, 'too tired for the labour of active listening'.[15] What is sold to them as relaxing and fun, Adorno warns, is informed by the same capitalist principles and cognitive patterns as their working lives.

Here, Adorno echoes Siegfried Kracauer's *Salaried Masses*, published in the same year, which draws the same analogy between working life and mass culture. Alongside mass entertainment, Kracauer singles out mass sport and union activism for particular critique; their veneer of collectivism conceals an underlying lack of solidarity, a sense of spiritual homelessness. Adorno identifies similar tendencies in the youth and Gebrauchsmusik movements, which Besseler regards as the modern heirs of earlier, collective musical traditions. For Adorno, these initiatives are based on a flawed premise, for they mistake the collective mode of experience for higher meaning, when in fact it only masks participants' utterly meaningless, atomized existence (*AGS* 5, 815).

Unlike Kracauer, Adorno does not base his argument on empirical data, and yet his diagnosis is reaffirmed by (and perhaps even based on) an article published in the journal *Melos*, which was dedicated to contemporary musical culture. Its 1930 issue featured an interview with a woman called Therese Lütticke, whom the editorial characterizes as an 'average listener'. In rather poetic terms, she declares that she loves to spend her spare time either playing or watching sport: 'At the ice hockey matches of the Canadians, in the sold-out Sportpalast, at the boxing championships—that's where I feel the breath of my time, which I love and which, above all, I want to live, with all its brutality and its wonderful power and vivaciousness'.[16] Asked about her relationship to music, Lütticke admits that she and some of her friends often feel a strong urge to listen to music but are

[15] '[...] zu müde, noch die Arbeit des aktiven Hörens zu leisten' (*AGS* 5, 817).

[16] 'Im Eishockey der Kanadier, im gefüllten Sportpalast, bei Titelkämpfen der Boxer, beim Fußball da spüre ich den Atem meiner Zeit, die ich suche und die ich liebe und die ich, vor allem, leben will, mit all ihrer Brutalität und all ihrer wunderbaren Kraft und Lebendigkeit'. Therese Lütticke, 'Musik unserer Zeit?', *Melos*, 9:1 (1930), 13–15 (p. 14). Cited in Hansjakob Ziemer, 'Konzerthörer unter Beobachtung:

puzzled, even alienated, by classical music and the format of the concert or recital: 'a beautiful voice, a dexterous pianist's hand, they do not speak to me'.[17]

Unlike many of his contemporaries, Adorno diagnoses the population's growing alienation from classical music without suggesting concrete steps to address the situation. For him, the solution lies neither in Gebrauchsmusik nor in tweaking the traditional concert format. That said, he is not ready to give up on the symphony concert altogether. Its decline reflects wider social developments, but in this way it can serve as a repository for 'things [...] which have no place, no resonance, anywhere else in the current social order'.[18] Specifically, the concert is currently the only public space where new, radical atonal music can be performed with any scope to make a mark. As a refuge for new music, concerts can become the 'Zellen eines radikalen Bewußtseins' ('cells of a radical consciousness') at a time when both established cultural institutions and mass cultural initiatives prop up the status quo (*AGS* 5, 818). As he concludes with a dialectical flourish, only as a dying, obsolete tradition can the concert accommodate a new radical consciousness. In this regard, the symphony concert is timelier than new, informal musical formats, which conceal their own commodity character beneath a veneer of spontaneity.

In subsequent essays, Adorno turns his attention to these new musical formats, which thrive as the traditional concert declines in popularity. More informal modes of live performance already sprang up in the heydays of the symphony concert, that is, in the second half of the nineteenth century, when a network of coffeehouses, beer gardens, and recreation parks emerged in many European cities. In Berlin and elsewhere, small coffeehouse ensembles faced stiff competition from military bands, which were allowed to accept civilian engagements and dominated the live music market, performing marches as well as 'light' classical music.[19]

This musical culture is the subject of Adorno's 1934 essay 'Musik im Hintergrund' (Music in the Background). Its title alludes to a key issue in psychological research, namely the process whereby a stimulus moves from the 'background' of sensory perception to the 'foreground' of conscious awareness. The music played in coffeehouses and similar venues usually remains below this apperceptional threshold, even though customers are willing to pay more for their

Skizze für eine Geschichte journalistischer Hörertypologien zwischen 1870-1940', in *Wissensgeschichte des Hörens in der Moderne*, ed. Hör-Wissen im Wandel (Berlin: de Gruyter, 2017), pp. 183-207 (p. 196-7).

[17] '[E]ine schöne Stimme, eine Handfertigkeit auf dem Klavier sagen mir gar nichts'. Lütticke, 'Musik unserer Zeit?', p. 14.

[18] '[...] Dinge [...], für die anderswo, in der gegenwärtigen Ordnung der Dinge, weder Raum noch Resonanz ist' (*AGS* 5, 817).

[19] Daniel Morat, 'Music in the Air—Listening in the Street: Popular Music and Urban Listening Habits in Berlin ca. 1900', in *The Oxford Handbook of Music Listening in the 19th and 20th Centuries*, ed. Christian Thorau and Hansjakob Ziemer (Oxford: Oxford University Press, 2019), pp. 335-54 (p. 338).

vermouth or hot chocolate to enjoy its soothing or stimulating effect. Echoing his description of rushed and exhausted white-collar workers in 'Consciousness of the Concert Listener', Adorno depicts a motley audience made up of 'the tired ones with their stimulating drink, the busy ones at their negotiations, even the newspaper readers' and, rarely, a flirting couple.[20] These, then, are the people—both young and old—who shun the concert in favour of this more casual setting; the musical arrangements are based on opera and other popular classics, but the listening conventions are completely different. 'Art connoisseurs who go "Shhh!"—here they are implacably exposed as comical';[21] Adorno elaborates: 'The first characteristic of background music is that you don't have to listen to it'.[22]

But this does not mean the performed music has no effect. First of all, it is noticeable in its absence, when it suddenly stops, an effect which Adorno compares to a stingy waiter turning off the lights to save electricity. In addition, even inattentive listening can trigger a preconscious kind of response. The performed melodies are like ghosts haunting the place; 'they are quoted from the unconscious memory of the listeners, not introduced to them'.[23] In Benjamin's texts, alertness can unexpectedly arise out of absent-mindedness, and at the end of his essay Adorno describes a similar experience: 'Anyone who, moved, is startled out of his conversation or thoughts after all, and who looks in that direction, is transformed into Georg Heym's suburban dwarf: "he looks up to the great green bell of heaven, where silent meteors cross far away"'.[24] Citing the final lines of Heym's Expressionist poem 'Die Vorstadt' (The Suburb, 1911), he uses the image of the *silent* meteors to describe a moment of aural awakening. Even as an insipid potpourri, music retains the power occasionally to startle and disrupt, to catapult listeners out of their state of indifference as they perhaps catch a glimpse of their own, bleak situation.

Adorno's exploration of modern listening habits takes on a much more polemical edge when it comes to popular music, including *Schlager* (hit songs) and jazz. His remarks on the latter subject, first laid out in detail in his 1936 essay 'Über Jazz' (On Jazz), have sparked ongoing outrage and have been rightly

[20] Theodor W. Adorno, 'Music in the Background', in Theodor W. Adorno, *Essays on Music*, ed. Richard Leppert, trans. Susan H. Gillespie (Berkeley, CA: University of California Press, 2002), pp. 506–10 (p. 507); 'die Müden beim anspornenden Getränk, die Geschäftigen bei der Verhandlung, auch die Zeitungsleser' (*AGS* 18, 820).

[21] Adorno, 'Music in the Background', p. 507. 'Kunstverständige, die pst rufen—hier enthüllen sie unerbittlich sich als komisch' (*AGS* 18, 820).

[22] Adorno, 'Music in the Background', p. 507. 'Vorab bezeichnet es die Hintergrund-Musik, daß man nicht zuzuhören braucht. Keine Stille legt sich als Isolierschicht darum; sie sickert ins Gesumm der Gespräche' (*AGS* 18, 820).

[23] Adorno, 'Music in the Background', p. 509; 'sie werden zitiert aus der unbewußten Erinnerung der Hörer, nicht ihnen vorgestellt' (*AGS* 18, 822).

[24] Adorno, 'Music in the Background', p. 509. 'Wer, betroffen, doch aus Gespräch oder Gedanken aufschreckt und hinblickt, verwandelt sich in Georg Heyms Vorstadt-Zwergen: "er schaut hinauf zur grünen Himmelsglocke, wo lautlos ziehn die Meteore weit"' (*AGS* 18, 823).

described as tendentious and biased.[25] The focus of his 1936 essay is on the technical characteristics of jazz; in its sequel, 'Über den Fetischcharakter in der Musik und die Regression des Hörens' (On the Fetish-Character in Music and the Regression of Listening, 1938), Adorno turns his attention to the associated listening practices. Published in the *Zeitschrift für Sozialforschung* (Journal for Social Research), the piece was a direct response to Benjamin's 'Work of Art' essay; in fact, Adorno references Benjamin's model of the 'apperception of the cinema in a condition of distraction'[26] as a phenomenon which can also be observed in popular music, though he does not make it clear that Benjamin in fact endorses this mode of reception.

Central to Adorno's critique is his distinction between 'autonomous' and 'commercial' music, two concepts which are neatly summed up in his 1941 essay 'On Popular Music'.[27] In an autonomous work such as Ludwig van Beethoven's 'Appassionata' piano sonata, 'every detail derives its musical sense from the concrete totality of the piece which, in turn, consists of the living relationship of the details and never of a mere reinforcement of the musical scheme'; as a consequence, 'by omitting the exposition and development and starting with the repetition, all is lost' (*CM* 414). Commercial music, in contrast, lacks this structural coherence; it is made up of interchangeable building blocks (intro, stanzas, chorus, instrumental), which do not interact with each other and do not evolve significantly over the course of a piece.

This fragmented structure has a profound effect on listeners' experience, as Adorno outlines in the 'Fetish-Character' essay. Not only do these pieces not require sustained attention, but they actively discourage such a mindset: 'the standardized products, hopelessly like one another except for conspicuous bits such as hit lines, do not permit concentrated listening without becoming unbearable to the listeners'.[28] Adorno labels the resulting listening habits fetishistic and regressive. The experience never deepens or evolves, and with repeated listening

[25] Diedrich Diederichsen, a theorist of pop music, acknowledges the accuracy of Adorno's formal analysis, but criticizes his conclusions as limited and skewed. Diedrich Diederichsen, 'Zeichenangemessenheit: Adorno gegen Jazz und Pop. "Der farbige Duke Ellington, ein ausgebildeter Musiker"', in *Adorno: Die Möglichkeit des Unmöglichen/The Possibility of the Impossible*, ed. Nicolaus Schafhausen et al. (Frankfurt a.M.: Lukas & Sternberg, 2003), pp. 33–46. For an overview of Adorno's jazz theory and its critical reception, see Georg Mohr, 'Jazz als Interferenz', in *Adorno-Handbuch: Leben-Werk-Wirkung*, ed. Richard Klein, 2nd edn (Stuttgart: Metzler, 2019), pp. 194–201.

[26] Theodor W. Adorno, 'On the Fetish-Character in Music and the Regression of Listening', in Adorno, *Essays on Music*, ed. Leppert, trans. Gillespie, pp. 288–317 (p. 305); 'Apperzeption des Films im Zustand der Zerstreuung' (*AGS* 14, 37).

[27] The essay was originally written in English, with the assistance of George Simpson.

[28] Adorno, 'On the Fetish-Character in Music', p. 305; 'die genormten, mit Ausnahme schlagzeilenhaft auffälliger Partikel einander hoffnungslos ähnlichen Produkte [gestatten] konzentriertes Hören nicht [...], ohne den Hörern unerträglich zu werden' (*AGS* 14, 37).

popular music in fact makes less rather than more sense until eventually the piece disintegrates into an array of component parts.[29]

Here, as so often in his musical essays, the description of musical structures is an implicit analysis of social relations—in this instance, the irrelevance and expendability of the individual within the capitalist machinery. In society, as in popular music, 'every detail is substitutable; it serves its function only as a cog in the machine' (*CM* 414). Commercial music stabilizes the status quo by transferring cognitive patterns acquired at the workplace into aesthetic experience and the realm of social relations:

> Die perzeptive Verhaltensweise, durch die das Vergessen und das jähe Wiedererkennen der Massenmusik vorbereitet wird, ist die Dekonzentration. [...] Der übliche kommerzielle Jazz etwa kann seine Funktion bloß ausüben, wenn er nicht im Modus der Attentionalität aufgefaßt wird, sondern während des Gesprächs und vor allem als Begleitung zum Tanz. (*AGS* 14, 37)
>
> [Deconcentration is the perceptual activity which prepares the way for the forgetting and sudden recognition of mass music. [...] The usual commercial jazz can only carry out its function because it is not attended to except during conversation and, above all, as an accompaniment to dancing.[30]]

Adorno here uses Wilhelm Wundt's famous spotlight metaphor when he adds that 'realisiert wird nur, worauf gerade der Scheinwerferkegel fällt' ('only those parts which are caught up in the momentary spotlight of attention enter into the realm of awareness'). Psychology had shown attention to be inherently mobile and unstable, but Adorno does not accept this conclusion when it comes to the experience of music. For him, there is nothing natural, let alone progressive, about inattentive listening habits, nor does he regard such listening modes as sociable. Rather, commercial music leads to the gradual 'reduction of people to silence, the dying out of speech as expression, the inability to communicate at all'.[31] If we are incapable of listening to music, we are also incapable of listening to each other. Popular music, then, forces people into a behavioural and cognitive conformity, depriving them of the freedom to think and choose for themselves, but also, and just as importantly, of pleasure and spontaneity:

[29] Here, Adorno refers back to the musical potpourris performed in dance cafés, which reflect this fetishizing tendency, which is also readily apparent in serious music, for instance in the trend towards increasingly perfect (in the technical sense) performances, where music sounds as polished as on a record. This 'bewahrende Fixierung des Werks' ('protective fixation of the work'), he argues, causes its destruction, for the unity of a classical work (such as Beethoven) can only be realized by means of spontaneity (*AGS* 14, 32; Adorno, 'On the Fetish-Character in Music', p. 301).

[30] Adorno, 'On the Fetish-Character in Music', p. 305.

[31] Adorno, 'On the Fetish-Character in Music', p. 289; 'Verstummen der Menschen, dem Absterben der Sprache als Ausdruck, die Unfähigkeit, sich überhaupt mitzuteilen' (*AGS* 14, 15).

> Die Lust des Augenblicks und der bunten Oberfläche wird zum Vorwand, den Hörer vom Denken des Ganzen zu entbinden, dessen Anspruch im echten Hören enthalten ist, und der Hörer wird auf der Linie seines geringsten Widerstandes in den akzeptierenden Käufer verwandelt. (AGS 14, 18)
>
> [The delight in the moment and the colourful facade becomes an excuse for absolving the listener from the thought of the whole, whose claim is comprised in proper listening. The listener is converted, along his line of least resistance, into the acquiescent purchaser.[32]]

Adorno does not only aim his critique at popular music, for he discerns these tendencies in all parts of (musical) culture, where 'fetishized mass music threatens the fetishized cultural goods'.[33] Crucially, this situation characterizes both capitalist and fascist societies. The purpose of totalitarian radio is 'entertainment and diversion'[34] as well as the alleged preservation of the so-called cultural heritage.

With such remarks, Adorno distances himself from right-wing commentators, who, in drawing a sharp distinction between 'high' and 'popular' music, cast the latter as symptomatic of cultural decline, of the 'invasion' of German and European musical culture by foreign, particularly African-American influences. In fact, he argues, the argument that music is a corrupting influence which appeals to the senses and undermines a rational mindset can be traced back all the way to the ancient Greeks;[35] as he adds, in the 1930s similar warnings about a 'decline of musical taste'[36] are often a vehicle for an elitist, even eugenicist, agenda which regards the listening habits of 'the masses' as degenerate.

Modern Listening II: Typologies

In the texts discussed so far, Adorno categorizes musical experience along the lines of musical genre, period, and occasion, but he also draws on sociological and psychological criteria which feed into his definition of different listening types. In doing so, Adorno once again reveals his debt to Hanslick's distinction between aesthetic and emotional listeners, which he refigures as one between 'adequate' and 'regressive' listening modes. These two categories are then further broken down; their most detailed elaboration can be found in his *Einleitung in die*

[32] Adorno, 'On the Fetish-Character in Music', p. 291.
[33] Adorno, 'On the Fetish-Character in Music', p. 313; 'die fetischisierte Massenmusik bedroht die fetischisierten Kulturgüter' (AGS 14, 48).
[34] Adorno, 'On the Fetish-Character in Music', p. 292; 'Unterhaltung und Zerstreuung' (AGS 14, 19).
[35] The argument that music undermines a more decisive, heroic stance is particularly used by Plato (AGS 14, 16).
[36] Adorno, 'On the Fetish-Character in Music', p. 288; 'Verfall des musikalischen Geschmacks' (AGS 14, 14–16).

Musiksoziologie (Introductory Lectures on the Sociology of Music, 1961–2), although shorter versions also appear in other texts written in the Weimar Republic and in exile.[37]

The lecture subdivides listeners into eight groups, ranging from the expert—Adorno's ideal listener and authorial alter ego—to the 'musically indifferent' type. The former is 'the fully conscious listener whom nothing escapes and who is able, in every moment, to reflect on what he is hearing',[38] embodying an ideal of complete, rational immersion and unwavering self-awareness. With only one other exception, that of the 'good listener', all other listener types are deficient in one way or another. The *Bildungskonsument*, or 'educated listener', for instance, listens to a lot of music and is 'well informed', but his or her musical experience is 'atomistic', and 'on the whole his relationship to music has a fetishistic quality'.[39] The portrayal of the emotional listener is lifted directly from Hanslick; for such people, music serves a cathartic purpose, often moving them to tears; their state of mind is not alert, but resembles 'the nebulous daydream, snoozing'.[40] The largest group is made up of those who treat music as entertainment, as 'comforting distraction'. For them, music is

> nicht Sinnzusammenhang sondern Reizquelle. [...] Die Struktur dieser Art des Hörens ähnelt der des Rauchens. Sie wird eher durchs Unbehagen beim Abschalten des Radioapparats definiert als durch den sei's auch noch so bescheidenen Lustgewinn, solange er läuft. (*AGS* 14, 192–3)
>
> [not a meaningful whole but simply a source of stimuli. [...] Their listening patterns resemble the experience of smoking. It is defined more by the discomfort when the radio is turned off than by any sense of pleasure, however modest, which is felt while the music is playing.]

This analogy between listening and smoking echoes Bertolt Brecht's description of the critically detached spectator, who smokes while watching a play, a model which resonates in Benjamin's 'Work of Art' essay.[41] Elaborating on this form of a split attention, Adorno concedes that background music can sometimes enhance productivity and concentration: 'This compromise is most strikingly embodied

[37] They include the above-mentioned 'Consciousness of the Concert Listener' (1930), 'Zur gesellschaftlichen Lage der Musik' (On the Social Situation of Music, 1932), 'On the Fetish-Character in Music and the Regression of Listening' (1938), 'On Popular Music', *Philosophie der neuen Musik* (Philosophy of New Music, 1949), and 'Anweisungen zum Hören neuer Musik' (Guidelines for Listening to New Music, 1953).

[38] '[...] der voll bewußte Hörer, dem tendentiell nichts entgeht und der zugleich in jedem Augenblick über das Gehörte Rechenschaft sich ablegt' (*AGS* 14, 182).

[39] '[S]ein Verhältnis zur Musik hat insgesamt etwas Fetischistisches' (*AGS* 14, 184).

[40] '[...] dem vagen Tagtraum, dem Dösen' (*AGS* 14, 187).

[41] Bertolt Brecht, 'Anmerkungen zur Oper "Aufstieg und Fall der Stadt Mahagonny" [1930]', in *Werke: Große kommentierte Berliner und Frankfurter Ausgabe*, vol. 24: *Schriften* 4, ed. Werner Hecht et al. (Frankfurt a.M.: Suhrkamp, 1991), pp. 74–86 (p. 81).

by the person who plays his radio while working'.[42] Describing such listening strategies and endorsing them, however, are two different things. In 'On the Fetish-Character', inattentive listening is cast as the inadvertent response to a set of external factors, but in his lecture Adorno describes listeners who actively resist, and resent, having to pay attention, who are 'determinedly passive and strongly resist the effort which artworks demand of them'.[43]

Adorno's text makes for uncomfortable reading and shows him as prescriptive, prejudiced, and elitist. At his worst he even echoes Hanslick's misogynistic and nationalist rhetoric. Where Hanslick argues that women are unfit to be composers and Italians incapable of aesthetic listening, Adorno declares the 'emotional type' to be most common 'among people of Slavic origin; also among young girls and among frustrated people' (*CM* 456). These latter remarks are contained in the draft of his essay 'On Popular Music'; mercifully, they did not make it into the published version, though this fact offers little comfort to the reader, as the occasional wittiness of his portraits is marred by a sense of unsympathetic detachment, even spite, and intellectual snobbery.

This, however, is not the whole story. Adorno emphasizes that this list of abstract types has to be tested against the empirical reality and modified accordingly (*AGS* 14, 179–80). And he concludes his 1961 lecture with a caveat:

> Der herrschende Zustand, den die kritische Typologie visiert, ist nicht die Schuld derer, die so und nicht anders hören, und nicht einmal erst die des Systems der Kulturindustrie, das ihren geistigen Zustand befestigt, um ihn besser ausschlachten zu können, sondern gründet in gesellschaftlichen Tiefenschichten wie der Trennung geistiger und körperlicher Arbeit; der hoher und niedriger Kunst; [...] schließlich darin, daß ein richtiges Bewußtein in einer falschen Welt nicht möglich ist und daß auch die gesellschaftlichen Reaktionsweisen auf Musik im Bann des falschen Bewußtseins stehen. (*AGS* 14, 197)

> [The current situation, which is the focus of this critical typology, is not the fault of those who listen in a particular way nor indeed of the system of the culture industry, which stabilizes their mental state so as better to exploit it; its roots lie in the deepest foundations of [modern] society, such as the separation of mental and physical labour; of high and popular art; [...] and finally in the fact that the right consciousness [or awareness] is impossible in a false world and that social responses to music are under the spell of this false consciousness.]

[42] 'Der Kompromißcharakter könnte nicht drastischer sich zeigen als im Verhalten dessen, der gleichzeitig das Radio tönen läßt und arbeitet' (*AGS* 14, 194).

[43] They are 'entschlossen passiv und wehren sich heftig gegen die Anstrengung, die Kunstwerke ihnen zumuten' (*AGS* 14, 195).

The blame for inadequate, fragmented, and inattentive listening lies neither with the individual, nor even with the culture industry and its profit-maximizing mentality, for this is the product of the underlying societal and economic structures. For Benjamin, the cognitive changes brought about by the technical media could potentially pave the way for social and political revolution. Though Adorno does not believe in the revolutionary power of mass culture per se, his lectures describe a similar moment of critical resistance. In mass culture, listeners do not consciously unite in rebellion against the status quo. Rather,

> Ihre Bewegung ist Reflexbewegung, das von Freud diagnostizierte Unbehagen in der Kultur, gegen diese gewandt. Darin steckt ebenso das Potential eines Besseren, wie in fast jeglichem der Typen auch, sei's noch so erniedrigt, Sehnsucht und Möglichkeit eines menschenwürdigen Verhaltens zur Musik, zur Kunst schlechthin überdauert. (*AGS* 14, 197)
> [Their reaction is motivated by reflex, by Freud's discontent in civilization, turned against the latter. This response harbours the potential of something better, just as in almost every listener type, however debased, there survives the longing for, and the possibility of, a more human, dignified behaviour towards music, to art more generally.]

Such dialectical turns—here, from absolute reification to subversion and resistance—are central to Adorno's argument; they prevent his critique of modern culture from becoming hopeless and defeatist. Another, equally important element which opens up his thought towards new considerations is his encounter with empirical listener research in his American exile. Though he disagreed with both the methods and the purpose of this research, it nonetheless confronted him with the needs and experiences of real, non-expert listeners and in turn forced him to approach the challenge of musical listening from a more sympathetic, nuanced, and indeed creative perspective.

Radio Music

Having spent four unhappy years in Oxford, Adorno emigrated to the United States in February 1938 to take up a position at the Princeton Radio Research Project. Funded by the Rockefeller Foundation, it was headed by the Austrian-Jewish sociologist Paul Felix Lazarsfeld, a pioneer of audience-measuring techniques still used today.[44] The project was charged with assessing listeners' responses to different broadcasts using empirical methods Lazarsfeld had

[44] David Jenemann, *Adorno in America* (Minneapolis, MN: University of Minnesota Press, 2007), p. 8.

developed in Vienna in the early 1930s and which he further refined while in the United States. Having been subdivided according to gender, age, and class, listeners were asked to press a green button if they liked the content of a programme and a red one if they disliked it; no button indicated a neutral response. This method enabled listeners to rate their experience in real time, avoiding the distortions caused by retrospective assessment; the simplicity of the method allowed listeners to follow a programme with minimal disruption. Based on the results, Lazarsfeld and his co-researchers then played back those specific segments and asked participants to comment on their experience in more detail.

The method was initially applied to spoken content; Adorno was hired to extend this approach to musical broadcasts. Apart from the audience-measuring techniques described above, his remit also included the evaluation of listener-mail, and interviews with radio staff and musicians.[45] Adorno must have seemed an excellent appointment for this role, for he had both musical and sociological expertise and was also interested in the new technical media. In 1929, when he became co-editor of the music journal *Anbruch* (Departure), he had instituted a new column on 'mechanical music'; in the editorial, he stresses that modes of 'mechanische Darstellung', mechanical (re)presentation, profoundly affect musical experience, adding that 'the availability of means corresponds to an availability of consciousness'.[46]

Adorno's assessment of American radio and its musical broadcasts, however, was by no means positive. In 'On the Fetish-Character', he cites an American expert on radio advertising, according to whom 'people have learnt to withhold their attention from what they are hearing even while listening',[47] and his listener typology contains the habitual radio listener, for whom music is merely a 'background phenomenon', a way of 'occupying his spare time' (*CM* 458). Fundamentally, he argues, the radio inserts music into a false dichotomy of original and copy by suggesting that the broadcast is the reproduction of an original—the live performance. This assumption, however, is fundamentally wrong, for music has no original but exists only in the process of performance (*CM* 37). As he concludes, the immediacy of the live broadcast—in the first decade nearly all music was broadcast live—was an illusion concealing an underlying process of distorting mediation. Adorno draws attention to the so-called 'hear-stripe', or *Hörstreifen*, a term denoting the (white) background noise that accompanied broadcasts, lending music on the radio a mediated or 'image quality' which made even autonomous music resemble the products of the culture industry (*CM* 38).

[45] See Levin and von der Linn, 'Elements of a Radio Theory', p. 321.
[46] '[...] die Bereitschaft der Mittel einer Bereitschaft des Bewußtseins entspricht' (*AGS* 19, 607).
[47] '[...] die Menschen gelernt hätten, selbst während des Hörens dem Gehörten die Aufmerksamkeit zu versagen' (*AGS* 14, 15).

Adorno's critical stance immediately put him at odds with the colleagues and funders of the Radio Research Project, which was driven by an almost evangelical belief in the radio as a force for good—but also a major capitalist enterprise. In the United States, as in Europe, the radio was still a relatively new technology, but it had rapidly gained in popularity over the past two decades. In 1922 only about a thousand American households owned a radio receiver; by 1939, this had increased to twenty-seven million (*CM* 13). The radio was regarded as a civilizing and democratizing medium of unprecedented reach; music played a central role in this mission. The vast majority of broadcast music belonged to the European eighteenth- and nineteenth-century repertoire. Contrary to Adorno's listener typology, these broadcasts were not treated as background entertainment but as a tool of education and self-improvement. Rural radio stations interspersed farming news with short classical pieces; these broadcasts were aimed particularly at 'the farmer's wife', a frequently evoked archetypal figure, who got on with her household chores while listening to the same music as mink-clad ladies in Carnegie Hall (*CM* 18).

One of the most prominent musical broadcasts of the time, however, was aimed not at adults but at school children. This was the 'NBC Music Appreciation Hour', an educational flagship programme which aired during school hours. Its presenter was the German-born composer and conductor Walter Damrosch, a prominent figure in American musical life.[48] Running from 1928 until 1942 and broadcast for the entire school year, it was a compulsory part of the curriculum and reached a total of seven million pupils at over seventy thousand schools across the United States. The programme was accompanied by a teacher's guide and student worksheets as well as regular scheduled multiple-choice tests to assess how much of Damrosch's teaching pupils had absorbed.[49]

The NBC programme echoed similar initiatives in Weimar Germany, including in Adorno's home city. In 1926, the Hoch'sches Konservatorium, Frankfurt's renowned music school, opened a 'Conservatorium für Musikhörende' (Conservatory for Music Listeners). Its aim was to explain symphonic music to blue- and white-collar workers. As the promotional booklet sets out, 'following a carefully conceived plan which aims to make music relatable, lovers of music get to expand and deepen their capacity for musical listening'.[50] A similar mission drives Damrosch's programme. By analysing different musical forms and by

[48] On Damrosch and the 'Music Appreciation Hour', see George Martin, *The Damrosch Dynasty: America's First Family of Music* (Boston, MA: Houghton Mifflin, 1983), esp. ch. 30.

[49] See *CM* 20.

[50] 'Nach einem wohldurchdachten, stets auf Anschaulichkeit basierenden Plane soll den Musikliebhabern die Fähigkeit des musikalischen Hörens erweitert und vertieft werden'. Capsule 66, Programme Collection, 'Werbeprospekt für ein Conservatorium für Musikhörende, Museums-Gesellschaft', UB Frankfurt a.M. Cited in Hansjakob Ziemer, 'The Crisis of Listening in Interwar Germany', in *The Oxford Handbook of Music Listening*, ed. Thorau and Ziemer, pp. 97–121 (p. 109).

comparing the works of 'outstanding' composers, the series wants to promote 'an enjoyment of good music through an understanding of it'.[51]

Adorno's 'Analytical Study of the NBC Music Appreciation Hour' is the longest piece he wrote for the Princeton Radio Research Project[52] and one of the most vitriolic texts in his entire oeuvre. It provides a forensic analysis of the programme, its content, aims, and method, which he casts as limited and inaccurate, and driven by authoritarian tendencies. As he notes, much of the programme is taken up with biographical anecdotes about the lives of composers and generalizing value judgements about individuals, genres, and periods, many of them misleading. Even worse, however, is the approach to the musical works themselves. Damrosch does not aim for a holistic understanding, for a sense of a work's overarching structure and development. He teaches listeners how to recognize the themes of a symphony or concerto but ignores the rest of the work (*CM* 256-8).[53] While purporting to awaken and train listeners' sensitivity to music, in practice the NBC programme pursues a more limited, instrumentalizing approach—thus encouraging the very atomistic and fetishistic listening habits which Adorno castigates in contemporary culture.

This tendency dovetails with what Adorno identifies as Damrosch's authoritarian, infantilizing approach. As he notes, the purported aim of making classical music 'fun' for young listeners is just a smokescreen: 'while children are supposed to get the fun they want, they are actually being subjected to authority. Drill plays a larger role in the *Hour* than its humanitarian phrases would have one believe' (*CM* 296). The assessments which accompanied the programme were multiple-choice tests, 'a typical example of the transplanting of an administrative procedure to a field of human spontaneity to which it is essentially unsuited', for these tests forced children to repeat 'pat value judgements and to adapt themselves to given norms instead of judging autonomously' (*CM* 312-13).

Both the teacher's guide and the student worksheets contained photographs of the presenter, variously shown with his orchestra or seated at the piano; listeners could order an autographed copy. The photos printed inside the worksheets were captioned, 'Your conductor, Walter Damrosch'—casting, as Adorno remarks, the conductor as '"your" leader, the man whose authority you must follow and in

[51] *Radio Guide*, 18 March 1939, p. 38.

[52] They also include the lecture 'A Social Critique of Radio Music', presented to the researchers and funders of the Radio Research Project in 1939, and the essays 'On Popular Music', 'Radio Physiognomics', and 'The Radio Symphony: An Experiment in Theory'.

[53] In 'Radio Physiognomics', Adorno argues that the radio accentuates this listening mode, for it 'lessens the sensual charm, richness and colorfulness of each sound' (*CM* 178). In an implicit reference to Hanslick's theory, chapter nine is entitled 'Atomistic Listening: Culinary Qualities of Music'. Here, Adorno remarks that the atomized, fragmented mode of listening encouraged by the radio is also 'valid for much broader spheres of our musical life, at least for light popular music and, we believe, for the apperception of serious music as well', adding that this listening mode can be 'traced back to a period in the history of music when the possibility of mechanical reproduction in the modern sense was not even thought of' (*CM* 183).

whom you must believe' (*CM* 302).⁵⁴ In the field of musical listening, as in Weimar self-help guides citing the example of 'great' men, cognitive training and (self-)optimization follow an authoritarian principle.

Even more worryingly for Adorno, the methods of Damrosch's programme were in turn replicated in the listener research which he witnessed at the Princeton Radio Research Project. In the multiple-choice tests, the 'essence' of a work was meant to be summed up in a handful of glib phrases,⁵⁵ while Lazarsfeld's participants were asked to choose between the even more basic alternatives of 'like' and 'don't like' by pressing the aforementioned green or red button. The broadcast content and the associated assessment methods thus mirrored each other, mutually reinforcing a reductive approach to human experience where even musical listening was subject to methods used in focus groups and advertising psychology.

As Adorno stresses with hindsight, musical experience resists being assessed in either quantitative or qualitative terms. Quantitative methods, such as measuring listeners' heart rate, are a crude means, while qualitative approaches, which involve people describing their experience, are equally problematic: 'Musical introspection is extremely uncertain. Specifically verbalizing their musical experience is almost impossible for most people'.⁵⁶

For all his reservations, however, Adorno's participation in the Radio Research Project confronted him with the practical dimension of musical education, with the challenge of how to practically engage listeners who are not intimately familiar with musical tradition. While in the United States, Adorno engaged with this challenge by devising his own version of an educational musical broadcast aimed at high school and college students (*CM* 327). Five episodes, which he presented himself, were aired on WNYC radio station between late April and 11 June 1940.

As the programme announcer concedes at the start of the first episode, 'our listeners have had their fill of music appreciation broadcasts':

⁵⁴ Adorno adds that this personality cult is at odds with Damrosch's actual input into the series, for he wrote neither the Teacher's Guide nor the student worksheets. The personality cult around Damrosch, which also underpins the programme's biographical narratives of 'great' composers, applies the capitalist 'idea of business competition, that the best man is the one who beats his competitors, economically or occupationally', to music (*CM* 304).

⁵⁵ For sample questions, see *CM* 313–15.

⁵⁶ 'Musikalische Introspektion ist überaus ungewiß. Vollends die Verbalisierung des musikalisch Erlebten stößt bei den meisten Menschen auf unüberwindliche Hindernisse' (*AGS* 14, 181). Adorno here repeats his previously expressed suspicion, voiced for instance in a letter to Benjamin, of 'Tests und ähnlichen Zivilisationsgottheiten' ('tests and similar deities of [modern] civilization'; Adorno/Horkheimer, *Briefwechsel*, I, p. 132), which impose a spurious sense of objectivity onto human experience and relations. Recent studies of musical experience, however, continue to rely on a combination of quantitative and qualitative (verbalizing) methods. See for instance Alf Gabrielsson, *Strong Experiences with Music: Music is Much More than Just Music* (Oxford: Oxford University Press, 2011); and Ruth Herbert, *Everyday Music Listening: Absorption, Dissociation and Trancing* (New York, NY: Routledge, 2011).

Here at the station [...] we think there is too much talk on the air these days about musical mountain peaks and starving yet immortal masters, with too little assistance in understanding the music itself. [...] Dr. Adorno believes the mere enjoyment of music is not enough. To him it is more than entertainment; it goes beyond it. The fullest experience comes only from a true understanding of the structure and not from blurred, half-hearted listening, or quasi-analysis. This, of course, demands a certain amount of effort from the listener. (*CM* 346)

The printed version, 'Was eine Music Appreciation Hour sein sollte' (What a Music Appreciation Hour Should Be Like), comprises scripts of the actual broadcasts, in both English and German versions, together with a methodological introduction, which outlines the aim and method of the series. Setting himself apart from Damrosch's programme, Adorno stresses the need to move beyond a culinary or fragmented mode of listening, but also beyond the format of *Würdigung*, the passive appreciation of great works and composers without critical analysis.[57] Biographical anecdotes have no place in his broadcasts, whose focus is firmly on the music itself as an unfolding process.

When following a piece, listeners must be encouraged 'virtually to compose the piece in the course of listening'[58]—an idea reminiscent of Hugo Riemann's active listening as the reconstruction of the process of composition.[59] For Adorno, this involves 'grasping the subject in question by means of immediate, spontaneous reception'[60]—a skill which cannot be taught in the abstract but can only be practised in the 'concrete' encounter with a piece. In order to enjoy music, listeners must get away from the trite and commodified notion of 'fun' as propagated by commercial entertainment. By fostering 'the ability to differentiate and serious critical independence', listeners will be able to develop a complex understanding of music, which alone can bring lifelong pleasure and satisfaction.[61]

This clearly is a tall order, especially in a programme aimed at young listeners, and yet Adorno defends his aim and the means by which he wants to achieve it, emphasizing that his series will not be 'teacherly and boring in a German way',[62]

[57] *CM* 322–3. Adorno reiterates many of its points in the radio broadcast 'Die gewürdigte Musik' (Appreciated Music), contained in the 1963 volume *Der getreue Korrepetitor* (The Faithful Repetiteur), where he looks back at his Princeton experience, framing it through Benjamin's critique of *Würdigung* in his *Origin of the German Trauerspiel* (*AGS* 15, 163).

[58] '[...] das Stück virtuell selber im Hören zu komponieren'; another, related aim is 'immer richtiger, bewußter und differenzierter zu hören' (*CM* 322).

[59] See Carl Dahlhaus, *Die Idee der absoluten Musik* (Kassel: Bärenreiter and Munich: Deutscher Taschenbuch Verlag, 1978), p. 86.

[60] '[...] in unmittelbarer, spontaner Auffassung der Musik das betreffende Subjekt als einen Sinnzusammenhang zu erfassen' (*CM* 321).

[61] '[...] wirkliche Unterscheidungsfähigkeit und ernsthafte kritische Selbständigkeit' (*CM* 323).

[62] '[D]as bedeutet aber nicht, daß man deutsch lehrhaft und langweilig sein soll. Im Gegenteil' (*CM* 323).

but nor will it be superficial and formulaic like Damrosch's programme. His broadcasts want to foster a living relationship to music which capitalizes on listeners' prior experience:

> Da es um das lebendige Verständnis der Musik geht, so kommt es darauf an, nicht Bildungsstoff zu übermitteln, sondern bei der lebendigen musikalischen Erfahrung anzuknüpfen, die man bei der Hörerschaft voraussetzen kann: bei der musikalischen Sprache, die sie selber sprechen. Diese Sprache ist dann so zu verfeinern, daß sie zu neuen musikalischen Spracherfahrungen führt. (*CM* 325)
>
> [Since the aim is a living understanding of music, the priority is not to pass on facts but to start with the living musical experience we can presuppose among our listeners—with the musical language which they speak themselves. This language should then be refined in such a way that it leads to new musical experiences.]

Although the radio is a one-way medium, he envisages a two-way conversation with his listeners, whereby the presenter responds to written questions; indeed, the programme could also include occasional live discussions with listeners—'but only about the subject-matter rather than the method'. Time and again, his notes stress the non-hierarchical, egalitarian ethos of the series and the need to avoid any 'avuncular traits, personality cult, authoritarian elements'.[63]

To achieve this goal Adorno proves himself to be both creative and pragmatic. He wants to start with music his listeners already know, including opera and even jazz, as a route into a more complex repertoire (*CM* 325).[64] One tricky question is the speed with which to proceed. Too slow, and the broadcast might become 'didactic, boring and trying'; too fast, and listeners will find it difficult to follow. The question of speed is in turn related to that of register. While Adorno does not want to avoid all technical terms, 'it will be attempted to make [the broadcasts] as simple, colloquial and understandable as possible' (*CM* 328). The principal aim is to unfold the complexity of a musical piece, for

> Je strenger Musik konstruiert ist, um so 'schwerer' ist sie zu hören, d. h. um so mehr muß sie der Hörer mitkomponieren, anstatt sich ihr bloß passiv zu überlassen. Das Postulat des spontanen Hörens. Erläutern durch den Vergleich von leichter und schwerer Prosa. (*CM* 334)
>
> [The more rigorously structured a piece, the 'harder' it is to listen to it, that is to say, the more actively does the listener have to participate in its composition

[63] '[. . .] aber nur über die Sache, nicht über die Methode' to avoid 'onkelhafte Züge, personality cult, autoritäre Elemente' (*CM* 327).
[64] The aim would be to guide listeners away from the 'supremacy' of jazz and towards an understanding of 'real' music (*CM* 326–7).

rather than succumbing to it passively. Explain this via the comparison of light and difficult prose.]

So what does this mean in practice? In his fifth and final broadcast, Adorno uses the analogy of reading an illustrated magazine to explain his approach to his audience:

> When you take a magazine and your eyes are caught by some story you may approach it in different ways. You may read it from the beginning to the end understanding the plot. Or you may begin it, guessing, after some paragraphs, how the rest will be, and put it aside. Or you may simply look at the characters, identify honest, brave Bill, glamorous Diana and shrewd, selfish Mr. Sloan, and then be happy when you find them again in the illustrations. (*CM* 289–90)

He elaborates:

> Something similar takes place when you are listening to music. You may follow attentively the whole context of the piece from the beginning to the end. Or you may guess, after a couple of bars, how the whole thing is going to be. [...] Or you may just realize the characters, that is to say your main themes and may be happy when you recognize them as soon as they reappear. (*CM* 390)

However, this analogy between reading (and looking at pictures) and listening also has its limits:

> It is easier to listen in a vague and absent-minded way than to read in the same manner. [...] As far as my experience goes most people when listening to music are absorbed only by the tunes, or maybe by the rhythm, but are very little concerned about what happens to these tunes. Speaking with some exaggeration, one may say that most listeners to music do not behave so very differently from the child who looks only at the pictures. Or putting it in another way: their musical experience has not changed very much since their own childhood. (*CM* 390)

This passage is remarkable for several reasons. First, Adorno is realistic about people's listening habits, acknowledging that what he elsewhere condemns as 'atomistic' listening is a common and perhaps natural response especially to complex works. At first sight, he concedes, there seems nothing wrong with this kind of listening as long as it affords us pleasure; and yet, 'by listening this way [...] we do not get the utmost out of our music' (*CM* 390).[65] Echoing his theoretical reflections,

[65] Echoing eighteenth- and nineteenth-century discourses about musical autonomy, Adorno rejects the notion that (most) classical music can be linked to an extra-musical programme. What matters is the internal 'plot' of a work, 'namely what happens to a theme and how the development determines the course of the whole' (*CM* 391–2).

Adorno is at pains to reassure his audience that they require no prior knowledge: 'when listening to music we should not theorize about it [...]. What we should do, however, in order to understand music, is to follow spontaneously with our ears, not with our brains, all the interrelationships it contains' (*CM* 394). By pointing out musical structures in the unfolding piece, Adorno wants to train his listeners' sustained active attention by modelling this very process live on air:

> If we once realize consciously relationships of the kind I tried to point out, we'll get used to devoting our attention to the factors of musical interconnection. We'll grasp more and more relations immediately without verbally accounting for them and without even thinking of them. In order to achieve this, however, we must once have the experience that such relations really exist at all and this can be shown by putting them into words. (*CM* 394)

So verbal commentary is a first step, an important aid, in the journey towards active listening; once the listener has learnt to recognize musical structures, she will be able to develop her own relationship to music.[66] The ultimate aim of the broadcasts is not to impart specific knowledge but to enact a listening experience based on active, supple yet sustained attention. As the analogy with reading shows, this is a skill which can be transferred to other areas of life: musical listening as a training ground for independent critical thinking.

Unfortunately, the above reflections on the analogies between looking, reading, and listening were never aired on American radio. The broadcast five episodes took listeners on a journey which started with Schubert's unfinished B minor Symphony and also included atonal chamber music by Anton Webern and Alban Berg. Another modern piece scheduled for the fifth episode was the oboe sonata by German-born composer Stefan Wolpe. The pianist on the programme, Trude Rittmann, recounts how, due to a technical glitch, the piece was cut off prematurely; following a personal intervention by the mayor of New York City, the series was terminated with immediate effect.[67] And yet the experiment of devising his own strategies for listener engagement resonated with Adorno far beyond his American exile. After his return

[66] In Schubert's C major Symphony, for instance, 'identity of the theme of the trombones and of the introduction is so plain that every attentive listener without any analytical knowledge should realize it at once' (*CM* 395).

[67] Rittmann, a noted pianist and composer, was performing the sonata with oboist Josef Marx; their performance was cut off half-way through due to a miscommunication between her and Marx about the repeats. As she remembers, 'Adorno was called out while we were playing, and returned looking very pale and disturbed, and afterwards he told us Mayor LaGuardia had called to say he didn't want any more of that music on his station. He was very outspoken about it'. Cited in Andy Lanset, 'Frankfurt School Theorist on WNYC in 1940'; https://www.wnyc.org/story/161557-frankfurt-school-theorist/ [accessed 20 January 2022]. As Jennifer Doctor has demonstrated in her insightful study, there was a much greater appetite to introduce radio listeners to atonal music, particularly of the Second Vienna School, in the United Kingdom, and specifically within the BBC. Jennifer Doctor, *The BBC and Ultra-Modern Music, 1922–1936: Shaping a Nation's Tastes* (Cambridge: Cambridge University Press, 1999).

to West Germany in 1953, he became one of the most prominent voices on German radio, presenting programmes on music as well as literature, thought, and culture. In the second half of this chapter, I turn to Adorno's post-war reflections on method and style, where attention, particularly in its more contemplative variety, plays a central but ambivalent role. First, however, I will explore how his reflections on new music and new listening modes underpin his entire theory of modernist art, which is inflected by Benjamin's thought in unexpected ways.

Shock and Spontaneity

In his 1952 radio broadcast 'Anweisungen zum Hören neuer Musik' (Guidelines for Listening to New Music),[68] Adorno picks up where he had left off in New York. The programme gives a running commentary on atonal works, accompanied by frequent musical examples, explaining their structure as they unfold.[69] As in his US broadcast, Adorno wants to exemplify and teach a 'structural' kind of listening, whereby the individual elements of a piece become comprehensible as part of one 'Sinnzusammenhang' or meaningful whole (AGS 15, 184). Immersion in the moment has to be combined with a wider, more detached perspective, an awareness of the work's general structure. This involves a difficult balancing act: 'to listen does not mean to analyse; any analysis which is separated off from listening is alien to music; but conversely, without the work and effort of analysis proper listening is impossible'.[70] This tension affects all encounters with (autonomous) music; genuine, sustained listening is impossible without active, analytical engagement, but is not limited to it. In trying to square this circle, Adorno further refines his psychological analysis of the musical experience.

Only an active kind of alertness, he argues, allows listeners to trace both the vertical and the horizontal dimensions of a classical work, for instance its counterpoint.[71] New music demands even greater mental agility—'a sensory-mental speed of reacting which is unknown in relation to older music'—because it no longer follows conventional structures and harmonic patterns.[72] But summoning this degree of

[68] The programme aired on 24 March 1952 on NWDR radio station. See Monika Boll, *Nachtprogramm: Intellektuelle Gründungsdebatten in der frühen Bundesrepublik* (Münster: LIT, 2004), p. 184.

[69] Adorno had hoped that the printed version could be accompanied by a phonographic record featuring the discussed musical passages, but this proved impossible for copyright reasons (AGS 15, 160).

[70] '[...] hören heißt nicht analysieren, die vom Hören abgespaltene Analyse wäre musikfremd; aber ohne Arbeit und Anstrengung der Analyse wird umgekehrt nicht richtig gehört' (AGS 15, 222).

[71] As he adds, this challenging task 'hat die kulinarischen Hörer in der Generation unserer Väter an Bach abgestoßen' ('has put the culinary listeners of our fathers' generation off Bach's music'; AGS 15, 205).

[72] '[...] eine sinnlich-geistige Raschheit des Reagierens, wie sie der älteren unbekannt war' (AGS 15, 210).

attention is an increasing struggle in an age when the consumerist habits engrained by the culture industry have caused a virtual 'paralysis' of listeners' concentration (*AGS* 15, 189). New music requires listeners to throw away the crutches of tonality, of familiar forms and structures, and 'surrender' to the unfolding musical event (*AGS* 15, 202–3). Such surrender, however, must not manifest itself as devotional inwardness but as a state 'of heightened attention and concentration'.[73] Indeed, a listener who lets herself drift ('sich treiben läßt') in new music is lost; the only way to do justice to these works is 'to be vigilant like a guard dog'.[74]

At this point in the argument, Adorno mentions Jean Cocteau's polemic against the contemplative listener, who sits absorbed, head in hand, like the woman in Fernand Khnopff's *En écoutant du Schumann*.[75] The alternative, however, cannot be the 'derisive disinterest' affected by the smoker in the music hall but the listener sitting with her head craned forward so as not to miss anything, 'bright, ready to leap forward [*auf dem Sprung*], as it were, and to sink her teeth into what she hears'.[76] Finally, and in another snub of the Romantic notion of *Kunstreligion*, he casts this posture as diametrically opposed to the inwardness of 'the dreamily enthralled bourgeois listener' ('des entrückt träumenden Bürgers'), for the alertness required by new music has nothing in common with 'disinterested pleasure or contemplative detachment. [...] New music destroys this distance and invades the listeners' physical space [rückt den Hörern auf den Leib], who cannot respond in any other way than by getting physically close to this music in turn'.[77]

Time and again, Adorno expresses his envisaged model of listening not in purely cerebral terms, but with images of the body that cross the line between the metaphorical and the literal, as in the latter notion of *auf den Leib rücken*. Other such images are the canine comparisons and the characterization of the alert listener being ready to leap forward, *auf dem Sprung*. This formulation bears the unmistakable traces of Benjamin's 'tiger's leap' into the past, and the underlying model of a pre-rational alertness rooted in the body and expressed in sudden, decisive action, as illustrated in his novella 'The Handkerchief'.

In their correspondence of the 1930s, as we have seen, Adorno is fiercely critical of Benjamin's advocacy of distraction and in turn defends the autonomous artwork and its contemplative reception. After Benjamin's death, however, he

[73] '[...] der erhöhten Aufmerksamkeit, der Konzentration' (*AGS* 15, 203).
[74] '[...] auf[zu]passen wie ein Wachhund' (*AGS* 15, 203).
[75] See Chapter 9, p. 322. Adorno might here be referring to the scene where Orpheus is entranced by the radio in Cocteau's 1950 film *Orphée*.
[76] Not 'die Haltung schnöder Desinteressiertheit, die des Rauchers in der Music Hall' but 'eine mit nach vorn gestrecktem Kopf, eine, die nichts versäumen will, hell, auf dem Sprung gleichsam und bereit, mit aller Energie ins Vernommene sich zu verbeißen' (*AGS* 15, 203–4).
[77] '[...] des traditionellen interesselosen Wohlgefallens, der kontemplativen Distanz. [...] Die Distanz zieht sie [neue Musik] ein, rückt den Hörern auf den Leib, und dem können jene nicht anders antworten, als indem sie ihrerseits der Musik auf den Leib rücken' (*AGS* 15, 204).

moves much closer to his friend's position. A passage from his 'Aufzeichnungen zu Kafka' (Notes on Kafka) essay of 1954 illustrates this U-turn:

> Durch die Gewalt, mit der Kafka Deutung gebietet, zieht er die ästhetische Distanz ein. Er mutet dem angeblich interesselosen Betrachter von einst verzweifelte Anstrengung zu, springt ihn an und suggeriert ihm, daß weit mehr als sein geistiges Gleichgewicht davon abhänge, ob er richtig versteht, Leben oder Tod. (*AGS* 10.1, 256)
>
> [Through the power with which Kafka commands interpretation, he collapses aesthetic distance. He demands a desperate effort of the allegedly 'disinterested' observer of an earlier time, overwhelms him, suggesting that far more than his intellectual equilibrium depends on whether he truly understands; life and death are at stake.[78]]

The 'allegedly "disinterested" observer of an earlier time' is a clear allusion, once again, to Kant's *Critique of the Power of Judgement*. For Adorno, this mindset is no longer tenable in modern times, in the age of universal reification, where all human relations, all products of human endeavour and creativity, have become reified, subsumed into the capitalist logic of exchange value. Kafka's texts thus institute a radically different mindset:

> Unter den Voraussetzungen Kafkas ist nicht die geringfügigste, daß das kontemplative Verhältnis von Text und Leser von Grund auf gestört ist. Seine Texte sind darauf angelegt, daß nicht zwischen ihnen und ihrem Opfer ein konstanter Abstand bleibt, sondern daß sie seine Affekte derart aufrühren, daß er fürchten muß, das Erzählte käme auf ihn los wie Lokomotiven aufs Publikum in der jüngsten dreidimensionalen Filmtechnik. Solche aggressive physische Nähe unterbindet die Gewohnheit des Lesers, mit Figuren des Romans sich zu identifizieren. Um jenes Prinzips willen kann der Surrealismus mit Recht ihn für sich in Anspruch nehmen. (*AGS* 10.1, 256)
>
> [Among Kafka's presuppositions, not the least is that the contemplative relation between text and reader is shaken to its very roots. His texts are designed not to sustain a constant distance between themselves and their victim but rather to agitate his feelings to a point where he fears that the narrative will shoot towards him like a locomotive in a three-dimensional film. Such aggressive physical proximity undermines the reader's habit of identifying himself with the figures in the novel. It is by reason of this principle that surrealism can rightfully claim him.[79]]

[78] Theodor W. Adorno, 'Notes on Kafka', in Theodor W. Adorno, *Prisms*, trans. Samuel and Shierry Weber (Cambridge, MA: MIT Press, 1981), pp. 243–71 (p. 246).

[79] Adorno, 'Notes on Kafka', p. 246.

Adorno's reference to film's 'aggressive physical proximity' is a clear echo of Benjamin's theory of the 'tactile', shock-like character of cinematic images, which, like Dada or Surrealist art, radically reshape human experience. That said, Adorno's main focus is not on the film audience as a collective subject but on the individual. The notion of shock, which Benjamin applies to experiences ranging from Baudelaire's poetry to film and the modern city, is recast by Adorno as the essence of modern(ist) aesthetics.

In his unfinished *Ästhetische Theorie* (Aesthetic Theory, 1970), Adorno continues this exploration. Kant's aesthetic contemplation features in a prominent but ambivalent capacity. On the one hand, Adorno endorses (aesthetic) contemplation as a resistant, subversive stance in the age of ceaseless and mindless activity:

> Noch das kontemplative Verhalten zu den Kunstwerken, den Aktionsobjekten abgezwungen, fühlt sich als Kündigung unmittelbarer Praxis und insofern ein selbst Praktisches, als Widerstand gegen das Mitspielen. [...] Kunst ist nicht nur der Statthalter einer besseren Praxis als der bis heute herrschenden, sondern ebenso Kritik von Praxis als der Herrschaft brutaler Selbsterhaltung inmitten des Bestehenden und um seinetwillen.　(*AGS* 7, 25–6)
>
> [Even the contemplative attitude to artworks, wrested from objects of action, is felt as the announcement of an immediate practice and—to this extent itself practical—as a refusal to play along. [...] Art is not only the plenipotentiary of a better practice than that which has to date predominated, but is equally the critique of practice as the rule of brutal self-preservation at the heart of the status quo and in its service.[80]]

In the encounter with modernist texts and artworks, however, the Kantian model of disinterested pleasure is no longer sufficient or applicable. Adorno refers to Kafka's writings to drive home this point:

> Sicherlich erweckt Kafka nicht das Begehrungsvermögen. Aber die Realangst, die auf Prosastücke wie die Verwandlung oder die Strafkolonie antwortet, der Schock des Zurückzuckens, Ekel, der die Physis schüttelt, hat als Abwehr mehr mit dem Begehren zu tun als mit der alten Interesselosigkeit, die er und was auf ihn folgt kassiert. [...] Autonom ist künstlerische Erfahrung einzig, wo sie den genießenden Geschmack abwirft. Die Bahn zu ihr führt durch Interesselosigkeit hindurch [...]. Aber sie kommt in der Interesselosigkeit nicht zur Ruhe.
>
> (*AGS* 7, 26)

[80] Theodor W. Adorno, *Aesthetic Theory*, ed. Gretel Adorno and Rolf Tiedemann, new trans. Robert Hullot-Kentor (London: Continuum, 1997), p. 12.

> [Certainly Kafka does not awaken the power of desire. Yet the real fear triggered by prose works like *Metamorphosis* or *The Penal Colony*, that shock of revulsion and disgust that shakes the physis, has, as defense, more to do with desire than with the old disinterestedness canceled by Kafka and what followed him. [...] Only once it is done with tasteful savoring does artistic experience become autonomous. The route to aesthetic autonomy proceeds by way of disinterestedness [...]. Yet art does not come to rest in disinterestedness.[81]]

Though the Kantian model of disinterested pleasure can be evoked to protect modern artworks against (political) appropriation and commodification,[82] in cognitive, experiential terms it falls short of the visceral, shock-like intensity which is produced by difficult or dissonant works. Modernist literature, art, and music rebel against their 'neutralization as an object of contemplation',[83] and while this resistance is typical of modernism, Adorno in fact concludes that the 'feeling of being overwhelmed'[84] is the quintessence of *all* aesthetic experience.

This argument is prefigured, from a more personal angle, in a little anecdote which Adorno recounts at the beginning of his study of the NBC Music Appreciation Hour. 'A person who is in a real living relation with music', he declares, won't have acquired this relationship through a carefully designed educational programme. For in fact,

> the deciding childhood experiences of music are much more like a shock. More prototypical as stimulus is the experience of the child who lies awake in his bed while a string quartet plays in an adjoining room and who is suddenly so overwhelmed by the excitement of the music that he forgets to sleep and listens breathlessly. (*CM* 252)

In its earliest, most unmediated form, the encounter with music does not involve rational distance, the 'labour' of sustained listening, nor indeed a vigilant mindset that tracks every moment of a piece. Listening here is described as spontaneous, effortless, and joyful, as the young listener is left spellbound, breathless by the encounter with music.[85]

[81] Adorno, *Aesthetic Theory*, p. 12.
[82] As he reaffirms, 'die Funktion der Kunst in der gänzlich funktionalen Welt ist ihre Funktionslosigkeit; purer Aberglaube, sie vermöchte direkt einzugreifen oder zum Eingriff zu veranlassen' (*AGS* 7, 475; 'the function of art in the totally functional world is functionless; it is pure superstition to believe that art could intervene directly or lead to intervention'; Adorno, *Aesthetic Theory*, p. 316).
[83] Adorno, *Aesthetic Theory*, p. 157; 'gegen ihre Neutralisierung zu einem Kontemplativen' (*AGS* 7, 235).
[84] Adorno, *Aesthetic Theory*, p. 79; 'Gefühl des Überfallen-Werdens im Angesicht jedes bedeutenden Werks' (*AGS* 7, 123).
[85] Though phrased in the third person, this scene has obvious personal resonances; its autobiographical character is confirmed in a conversation with Hellmut Becker, where Adorno remarks:

Critical readers might object that the unquestionable sense of social privilege which underpins this anecdote—a bourgeois apartment in which chamber music is being performed—make it ill-suited as a primal scene of aesthetic experience. And yet the importance of this episode for Adorno's thought cannot be overstated. This short scene encapsulates everything he tries to defend in his dual critique of fascism and the culture industry.

Alertness, shock, and spontaneity are the leitmotifs of Adorno's theory of musical experience. The feeling of being spellbound, entirely caught up in the moment, is both its starting point and its final goal, that spark which gives rise to more sustained, structural engagement but which must never be entirely lost in the process. The child for Adorno is a universal figure, the ideal listener, who encounters music as it should be encountered, without prejudice, training, or bias. And yet in its autobiographical character, this anecdote also forms part of another strand of Adorno's writings: his personal, self-reflexive essays on method and style, in which issues of shock, joy, and spontaneity also play a prominent role.[86]

Words from Abroad

At first sight, playfulness and spontaneity are not epithets we associate with Adorno's writings. Edward Said describes Adorno as 'exceptionally difficult to read', his prose as 'slow, unjournalistic, unpackageable',[87] while Fredric Jameson declares that

> in the language of Adorno [...] density is itself a conduct of intransigence: the bristling mass of abstractions and cross-references is precisely intended to be read in situation, against the cheap facility of what surrounds it, as a warning to the reader of the price he has to pay for genuine thinking.[88]

'musikalische Erfahrungen in der frühen Kindheit macht man, wenn man im Schlafzimmer liegt, schlafen soll und und mit weitaufgesperrten Ohren unerlaubt hört, wie im Musikzimmer eine Beethoven-Sonate für Klavier und Violine gespielt wird' ('in early childhood, we make musical experiences by lying wide awake in our bedroom when we should be asleep, listening to a Beethoven sonata for violin and piano that is being performed in the music room'). In contrast, he doubts whether music can reach the same 'depth of experience' if it is imparted to the child 'in a pre-regulated process'. Theodor W. Adorno, *Erziehung zur Mündigkeit: Vorträge und Gespräche mit Hellmut Becker, 1959–1969*, ed. Gerd Kadelbach (Frankfurt a.M.: Suhrkamp, 1970), pp. 117–18.

[86] In this regard, the episode also underlines a point made by Max Paddison, who stresses that in Adorno's writings, music is not simply 'subsumed under abstract philosophical categories', but that 'musical problems [...] provided, in a certain sense, the material sources of his philosophical approach'. Paddison, *Adorno's Aesthetics*, p. 23.

[87] Edward Said, *On Late Style: Music and Literature Against the Grain* (New York, NY: Vintage, 2006), pp. 14–15.

[88] Fredric Jameson, *Marxism and Form* (Princeton, NJ: Princeton University Press, 1971), p. xiii.

More specifically, scholars have drawn analogies between works of new music and Adorno's own texts, whose density requires 'a particular kind of attention which is best compared to the attention required to listen analytically to a piece of music'.[89]

In fact, Adorno himself draws a similar analogy. In 'Guidelines for Listening to New Music', he stresses that atonal works need to be listened to time and again, first for their overall structure, then for their finer details, 'just as densely woven literary or theoretical texts want to be read several times'.[90] He adds:

> Das ist der wahre Rechtsgrund des Postulats äußerster Konzentration beim Hören: weil virtuell alles gleich wichtig, gleich nahe zum Mittelpunkt ist, weil nichts für die Konstitution des musikalischen Sinns äußerlich und zufällig bleibt, muß auch alles ins Feld der Aufmerksamkeit gerissen werden, wofern nicht der musikalische Sinn versäumt werden soll. (*AGS* 15, 242–3)
> [This is the true foundation of the postulate of utmost concentration when listening [to music]: since virtually everything is equally important, equally close to the centre, and nothing marginal and accidental in the constitution of musical meaning, everything has to be drawn into the field of attention lest the meaning of the musical work should be missed altogether.]

These remarks are equally applicable to Adorno's own writings. His texts are not skimmable or easily digestible; they do not fit into the age of the meme and the tweetable soundbite. Indeed, even in the 1950s and 1960s, long before the invention of digital and social media, contemporaries reacted to his style with hostility and incomprehension. After his return to West Germany, Adorno quickly established himself as one of the country's leading public intellectuals. This position was greatly aided by the radio. In total, nearly 300 of his broadcasts from the 1950s and 1960s have survived, together with 300 public lectures given in the same period. In these two decades, Adorno could be heard somewhere in Germany almost every week.[91]

Adorno was well aware of the requirements associated with these more popular formats. In his post-war radio work, he built on the conversational style of his WNYC series. He did not read out pre-written scripts; rather, his notes were designed for verbal presentation and subsequently revised for publication. Adorno spoke freely and fluently but used particular phrases as verbal building blocks that gave him time to formulate his ideas and establish a rapport with the listener. As Michael Schwarz concludes, his aim was to sound spontaneous and informal; he

[89] Christoph Demmerling, 'Schwerpunkt: Adorno in der Diskussion', *Deutsche Zeitschrift für Philosophie*, 65 (2017), 31–3 (pp. 31–2).

[90] '[…] ähnlich wie dicht gewobene literarische oder theoretische Texte mehrmals gelesen werden wollen' (*AGS* 15, 213).

[91] Michael Schwarz, '"Er redet leicht, schreibt schwer": Theodor W. Adorno am Mikrophon', *Zeithistorische Forschungen/Studies in Contemporary History*, 8 (2011), 286–94 (p. 287).

did not write texts specifically for the radio, the so-called 'radio essay' format popular at the time. Rather, his spoken versions were 'trial runs' of the printed texts, occasions where he tried out the effectiveness of his argument as well as the sound and rhythm of his prose, a method which shows that he was mindful of its musical as well as its dramatic dimension.[92]

These efforts, however, did not always yield the desired effect. Listener letters complained of an 'inflation' and 'deluge' of Adorno broadcasts, bringing at least one radio station, the Norddeutsche Rundfunk, to the conclusion that it needed to avoid 'broadcasting too many Adorno talks, which do, after all, make very great demands on listeners'.[93] One broadcast which elicited a particularly negative response was a programme on Marcel Proust's *À la recherche du temps perdu* (In Search of Lost Time, 1913–27), aired by the Hessische Rundfunk, in which Adorno gave brief introductions to readings by the actor Marianne Hoppe. A reviewer for the *Katholische Funkkorrespondenz* (Catholic Radio Communications) describes the target audience as a 'congregation of undoubtedly "attentive" and "discerning" listeners',[94] but concludes that only a select few would have been able to sustain their concentration for the duration of the ninety-minute programme. For the reviewer, the blame lies entirely with Adorno, whose dialectical method can yield 'sudden flashes of insight' ('blitzhaft erhellende Einsichten'), but whose style, which reflects a truly heroic intellectual effort ('ungeheure Denkanstrengung'), is only tolerable in written form. Only those intimately familiar with this dense kind of language will be able to follow his argument as it unfolds. Adorno, the reviewer concludes, 'is messing with language'; his texts are written in 'bestes deutsches Gelehrtenchinesisch', academic German verging on Chinese.[95]

This oxymoron sums up a common reaction to Adorno's style, namely listeners' and readers' sense of alienation from their own native language. In a letter written to the Hessische Rundfunk about the Proust programme, one listener accuses him of being incapable of speaking a 'natural, easily comprehensible *German*', backing up this claim with reference to another letter, printed in the *Stuttgarter Zeitung*, whose author complains that when reading or listening to certain intellectuals 'it seems as if we do not encounter our own native German but some foreign language which is completely incomprehensible, and in the first moment one feels terribly stupid and ignorant'.[96]

[92] Schwarz, 'Er redet', p. 290.

[93] '[. . .] eine allzu grosse Massierung von Adorno-Vorträgen, die ja sehr grosse Ansprüche an die Hörer stellen'. Thus Adorno's own gloss of the situation in a letter to Samuel Bächli of 7 October 1965; cited in Schwarz, 'Er redet', p. 292.

[94] A 'Gemeinde der zweifellos "aufmerksamen" und "anspruchsvollen" Hörer'.

[95] The closest English equivalent is the phrase 'it's all Greek to me'. Anon., 'Bestes deutsches Gelehrtenchinesisch: Eine Sendung zum Abschluss der deutschen Proust-Ausgabe', *Katholische Funkkorrespondenz*, 18 (30 April 1958). Typescript, Theodor W. Adorno Archiv, Akademie der Künste Berlin.

[96] '[. . .] ein natürliches, klar verständliches *Deutsch*'; 'kommt es einem vor, als vernähmen wir nicht unsere deutsche Sprache, sondern irgend eine fremdländische, die wir absolut nicht verstehen, und im

In all of these responses, the contrast between comprehensible and incomprehensible, easy and difficult prose, is recast along national(ist) lines; complex style is dismissed as foreign and un-German. For Adorno, having recently returned to West Germany from exile, this parochializing argument must have struck a deeply uncomfortable chord. Indeed, the above-cited responses to the Proust broadcast are likely to have directly inspired his essay 'Wörter aus der Fremde' (Words from Abroad, 1959), in which he confronts these nationalist assumptions head on.

The title alludes to the German term *Fremdwörter*—words of non-Germanic etymology whose meaning might not be immediately obvious to a German native speaker. Though a technical linguistic term, it is also culturally loaded, and comes with uncomfortable overtones and associations. As Adorno argues, the visceral response to the 'excessive' use of *Fremdwörter* is often a covert criticism of the content of the argument: 'Ultimately, what is going on is largely a defense against ideas, which are imputed to the words; the blame is misdirected'.[97] But this hostility also has a cultural dimension. Adorno identifies the roots of his own penchant for such words in his school time. As he recalls, he and his friends used such terms to show up some of the teachers 'to whom we were entrusted for our education during World War I'.[98] Their hostility towards *Fremdwörter* betrayed their narrow-minded parochialism; in contrast, 'foreign words constituted little cells of resistance to the nationalism of World War I'.[99]

As Adorno then elaborates, adopting a comparative perspective, the fact that German, unlike French and English, has the concept of *Fremdwörter* in the first place reflects its internal breaks and fissures, 'jenes Brüchige und Ungehobelte', which is a challenge for the writer but also an opportunity, 'because the language is not completely trapped within the net of socialization and communication. It can be used for expression because it does not guarantee expression in advance'.[100] *Fremdwörter* are essential for Adorno's non-totalizing way of thinking and writing because they introduce caesuras, moments of obscurity and resistance, which stall

ersten Moment kommt man sich furchtbar dumm und unwissend vor'. Letter by R.M., 7 April 1958; Adorno Archiv, Akademie der Künste Berlin. The fact that the letter is dated the same day as the actual programme, which was broadcast at 9 p.m., gives a sense of the urgency the listener felt in wanting to express 'meinen unter dem unmittelbaren Eindruck der Sendung stehenden Unwillen' ('my disdain, being still under the immediate impression left by the programme'). I am grateful to Michael Schwarz of the Adorno Archiv for sharing this and other letters relating to Adorno's radio broadcasts with me.

[97] Theodor W. Adorno, 'Words from Abroad', in Theodor W. Adorno, *Notes to Literature*, ed. Rolf Tiedemann, trans. Shierry Weber Nicholson (New York, NY: Columbia University Press, 1991), p. 188. 'Schließlich geht es vielfach um die Abwehr der Gedanken, die den Wörtern zugeschoben werden: der Sack wird geschlagen, wo der Esel gemeint ist' (*AGS* 11, 216).

[98] Adorno, 'Words', p. 189; 'denen wir zu unserer Erziehung während des Ersten Krieges überantwortet waren' (*AGS* 11, 217).

[99] Adorno, 'Words', p. 189; 'die Fremdwörter bildeten winzige Zellen des Widerstands gegen den Nationalismus im Ersten Krieg' (*AGS* 11, 218).

[100] Adorno, 'Words', p. 191; 'weil die Sprache nicht gänzlich vom Netz der Vergesellschaftung und Kommunikation eingefangen ist. Sie taugt zum Ausdruck, weil sie ihn nicht vorweg garantiert' (*AGS* 11, 220).

the smooth flow of the reading process. The resulting text forces the reader to work hard, to be actively involved in the production of meaning. In its resistance against easy consumption, such critical writing emulates the equally resistant nature of modern literature, art, and music, their inherent negativity, which alone can gesture towards truth in a post-enlightened world. In language, 'the discrepancy between the foreign word and the language can be made to serve the expression of truth'.[101]

Here, as so often in his critique of modern modes of reception, Adorno lays himself open to the charge of elitism. Surely the use of Latinate, Greek, and other non-Germanic words has a class dimension, for they confound not only the lazy, absent-minded reader but anyone who lacks the knowledge—the education and social privilege—needed to understand them. But Adorno is as wary of the notion of linguistic accessibility, of communication across class boundaries, as he is of the culture industry and its mantra of effortless consumption. If words are seen as little more than tools, the means to an end, then they can be exploited for political propaganda, advertising, and other forms of indoctrination. In the current age, language does not need to become *more* but *less* accessible, for it is in desperate need of defamiliarization: 'in any case shock may now be the only way to reach human beings through language'.[102] Essentially, if people cannot understand certain words this does not mean that critical language should adapt to match their level; precisely in being incomprehensible to many, such writing points to the inequalities of a society where only a few have access to a more traditional, humanist education. That said, he concedes that the use and effect of *Fremdwörter* has its limitations in modern society, where their meaning has become inaccessible to most. In this climate, such words are little more than 'dead husks', which counteract the fundamental, communicative purpose of language: 'What language is in itself is not independent of what it is for others'.[103]

'Words from Abroad' is Adorno's response to the narrow-minded and parochial climate of Konrad Adenauer's Germany, and yet in its core tenet, his essay reiterates the argument of 'Music in the Background', written nearly three decades earlier. The decline of musical listening and of the underlying faculty of sustained attention is a phenomenon which interlinks Weimar and West Germany across the caesura of fascism, and yet this caesura also indelibly shapes Adorno's postwar outlook, for it lends his critique of distraction and other, related mindsets an added urgency. In 'Words from Abroad', he speaks of the rage which is sparked when someone dares to swim against the current of 'the prevailing babble', 'das

[101] Adorno, 'Words', p. 191; 'die Diskrepanz zwischen Fremdwort und Sprache kann in den Dienst des Ausdrucks der Wahrheit treten' (*AGS* 11, 220).

[102] Adorno, 'Words', p. 194; 'ohnehin ist der Schock vielleicht die einzige Möglichkeit, durch Sprache heute die Menschen zu erreichen' (*AGS* 11, 224).

[103] Adorno, 'Words', p. 200. 'Noch das Ansichsein der Sprache ist nicht unabhängig von ihrem Füranderessein' (*AGS* 11, 232).

übliche Sprachgeplätscher',[104] and therefore forces readers or listeners to exert themselves. This irrational response is indeed discernible beneath the polite veneer of the above-cited documents, which use stylistic critique as an outlet for nationalist (and potentially anti-Semitic) sentiments. In his radio work and lectures in particular, Adorno tries to accommodate his listeners and adjust his style; in keeping with his critique of inadequate and superficial musical listening, however, he refuses to cross a certain line, unrepentantly stressing the enduring importance of difficult ideas, difficult music, and difficult literature in post-war society.

Allotria

Most of the writers featured in this book struggle with concentration at some point in their lives, turning to techniques of (self-)optimization to enhance productivity and keep distractions at bay. Adorno is a notable exception; his vast and wide-ranging oeuvre reflects his seemingly tireless attention, his ability to immerse himself in ever-new subjects and pursue several projects at once. Indeed, as he declares in his late essay 'Freizeit' (Free Time, 1969), such is his commitment to his studies that he has no need for hobbies:

> Musik machen, Musik hören, konzentriert lesen ist ein integrales Moment meines Daseins, das Wort hobby wäre Hohn darauf. Umgekehrt ist meine Arbeit, die philosophische und soziologische Produktion und das Lehren an der Universität, mir bislang so glückvoll gewesen, daß ich sie nicht in jenen Gegensatz zur Freizeit zu bringen vermöchte, den die gängige messerscharfe Einteilung von den Menschen verlangt. (*AGS* 10.2, 646)
>
> [Making music, listening to music, reading with all my attention, these activities are part and parcel of my life; to call them hobbies would make a mockery of them. On the other hand I have been fortunate enough that my job, the production of philosophical and sociological works and university teaching, cannot be defined in terms of that strict opposition to free time, which is demanded by the current razor-sharp division of the two.[105]]

Adorno lays open his personal situation partially to justify his critique of mass culture; but there is also a sense of guilt and regret as he concedes that he is speaking 'as a privileged person', that his own ability to follow his passions is owed to a combination of 'Zufälligkeit und Schuld', 'chance and guilt [or debt]', the

[104] Adorno, 'Words', p. 188; *AGS* 11, 216.
[105] Theodor W. Adorno, 'Free Time', in Theodor W. Adorno, *The Culture Industry: Selected Essays on Mass Culture*, ed. J. M. Bernstein (London: Routledge, 2001), pp. 187–97 (p. 189).

latter referring to the economic and social privilege enjoyed by his family.[106] As he concedes, his own ability to turn his passion into his profession is neither earned nor deserved, but imposes an ongoing sense of moral obligation.

The result is a life lived allegedly without the need for distraction. Adorno's writings embody this sense of never being 'off duty', of encountering new phenomena with alertness and curiosity. In his personal essays, he repeatedly highlights a sense of playfulness and spontaneous fascination, echoing the episode which features the listening child.

Indeed, the child is a recurring reference point in these later, more self-reflexive writings. As Adorno stresses time and again, children's attention is not the result of disciplinary (self-)conditioning but rapt and unpredictable. In early childhood, experience is not yet determined by acquired or imposed patterns, and while commentators across the ages have characterized children's attention as unstable, in need of discipline and focus, Adorno emphatically sides with the child:

> Auf dem Schulzeugnis des Kindes gab es früher Noten für Aufmerksamkeit. Dem entsprach die subjektiv vielleicht sogar wohlmeinende Sorge der Älteren, die Kinder möchten in der Freizeit nicht zu sehr sich anstrengen: nicht zuviel lesen, abends nicht zu lange das Licht brennen lassen. Insgesamt wittern Eltern dahinter eine Ungebärdigkeit des Geistes, oder aber eine Insistenz auf dem Vergnügen, die mit der rationellen Einteilung der Existenz sich nicht verträgt. (AGS 10.2, 648)

> [In earlier times children were allotted marks for attentiveness in their school reports. This had its corollary in the subjective, perhaps even well-meaning worries of adults that the children should not overstrain themselves in their free time; not read too much and not stay awake too late in the evening. Secretly parents sensed a certain unruliness of mind which was incompatible with the efficient division of human life.[107]]

Adults try to curb the 'unruliness' of children's attention and channel it into 'sensible' pursuits such as schoolwork, thereby laying the grounds for the toxic division between work and leisure, which underpins capitalist society:

> Auf der einen Seite soll man bei der Arbeit konzentriert sein, nicht sich zerstreuen, keine Allotria treiben; darauf beruhte einst die Lohnarbeit, und ihre Gebote haben sich verinnerlicht. Andererseits soll die Freizeit, vermutlich damit man danach umso besser arbeiten kann, in nichts an die Arbeit erinnern. Das ist der Grund des Schwachsinns vieler Freizeitbeschäftigungen. Unter der Hand wird freilich die Kontrebande von Verhaltensweisen aus der Arbeit, welche die Menschen nicht losläßt, doch eingeschmuggelt. (AGS 10.2, 647–8)

[106] Adorno, 'Free Time', p. 189; AGS 10.2, 646. [107] Adorno, 'Free Time', p. 190.

[On the one hand one should pay attention at work and not be distracted or lark about; wage labour is predicated on this assumption and its laws have been internalized. On the other hand free time must not resemble work in any way whatsoever, in order, presumably, that one can work all the more effectively afterwards. Hence the inanity of many leisure activities. And yet, in secret as it were, the contraband of modes of behaviour proper to the domain of work, which will not let people out of its power, is being smuggled into the realm of free time.[108]]

Here, Adorno uses a term which plays a central role in his thought on attention: Allotria, from the Greek ἀλλότρια, meaning strange or foreign things, which the German *Duden* dictionary defines as 'mit Lärm, Tumult o. Ä. ausgeführter Unfug; dummes Zeug, Dummheiten, Albernheiten'[109]—in English, tomfoolery or monkey business, albeit of a harmless kind, which is not directed against others.

This term also features in 'Der Essay als Form' (The Essay as Form), a text written in 1954–8, which remained unpublished in Adorno's lifetime. In 'Words from Abroad', Adorno defends difficult and complex writing, but in 'The Essay as Form' he pursues a rather different argument when he endorses a playful mode of thinking unrestricted by rigid discipline in both the academic and the cognitive sense of the word:

Der Essay läßt sich sein Ressort nicht vorschreiben. Anstatt wissenschaftlich etwas zu leisten oder künstlerisch etwas zu schaffen, spiegelt noch seine Anstrengung die Muße des Kindlichen wider, der ohne Skrupel sich entflammt an dem, was andere schon getan haben. [...] Glück und Spiel sind ihm wesentlich. Er fängt nicht mit Adam und Eva an sondern mit dem, worüber er reden will; er sagt, was ihm daran aufgeht, bricht ab, wo er selber am Ende sich fühlt und nicht dort, wo kein Rest mehr bliebe. So rangiert er unter den Allotria. (*AGS* 11, 10)

[The essay, however, does not let its domain be prescribed for it. Instead of accomplishing something academically or creating something artistically, its efforts reflect the leisure of a childlike person who has no qualms about taking his inspiration from what others have done before him. [...] Happiness and play are essential to it. It starts not with Adam and Eve but with what it wants to talk about; it says what occurs to it in that context and stops when it feels finished rather than when there is nothing to say. Hence it is classified a trivial endeavor.[110]]

[108] Adorno, 'Free Time', pp. 189–90.
[109] https://www.duden.de/rechtschreibung/Allotria [accessed 20 January 2022]. The word does not feature in the Grimms' *Deutsches Wörterbuch*.
[110] Theodor W. Adorno, 'The Essay as Form', in Adorno, *Notes to Literature*, ed. Tiedemann, trans. Weber Nicholson, pp. 29–47 (p. 30).

Referring to children's spontaneous, fluid, and potentially anarchical attention, Adorno casts the essay as the product of childlike enthusiasm and its author as childlike (*der Kindliche*). Its focus is nomadic, unrestricted by plans, research strategies, or output targets, and instead guided by the unpredictability of attention, which may draw it to small and seemingly irrelevant details. Another important benefit is the freedom to stop before a topic has been exhausted, thus preserving a sense of spontaneity.[111]

In this way, the essay resists the capitalist system, in which every object and person, every activity and mental impulse, is attributed a fixed value. This ideology underpins programmes of cognitive (self-)optimization aimed at cultivating the skill of sustained attention; the essay, in contrast, embodies an anti-systematic, anarchical mode of thinking.

From this socio-political argument, Adorno's critique of disciplinary attention then evolves to encompass philosophical and ethical considerations. In its anti-systematic character, the essay does not subsume the particular under the general, the detail under the overarching system. Rather, it 'allows for the consciousness of nonidentity, without expressing it directly; it is radical in its non-radicalism, by not reducing phenomena to general principles, and hence in its focus on the particular, in its fragmentary character'.[112]

This emphasis on the other, the particular, is at the heart of Adorno's late thought, which manifests itself as a critique of Hegelian dialectics, whereby difference is eliminated in the process of synthesis and sublation (*Aufhebung*). His alternative model is based on a mode of thinking which engages with the particular, the other, in its own right, facilitated by a particular, open form of attention. This philosophical method is outlined in the book-length study *Negative Dialektik* (and its counterpart, *Aesthetic Theory*), but it is in his essays that Adorno puts this model into practice. Here, the critic is able to enter into 'smallness—the eternal smallness of the most profound work of the intellect in face of life—and even emphasizes it with ironic modesty'.[113] In doing so, the essay

[111] The essay is central to the thought of both Adorno and Benjamin. While Benjamin does not formulate a theory of the essay as such, his comments on the tract, on the importance of repetition and *Übung*, practice, in the 'Epistemo-Critical Foreword' of the *Trauerspiel* book anticipate Adorno's argument. At stake in both cases is a form of thinking that is non-systematic, does not aim to exhaust its subject, but whose form is shaped by the subject at hand. Echoing Benjamin, Adorno writes that 'der Gegenstand des Essays [...], die Artefakte, versagen sich der Elementaranalyse und sind einzig aus ihrer spezifischen Idee zu konstruieren' (*AGS* 11, 22; 'Artifacts, however, which are the subject matter of the essay, do not yield to an analysis of elements and can be constructed only from their specific idea'. Adorno, 'The Essay as Form', pp. 38–9).

[112] Adorno, 'The Essay as Form', p. 35; 'trägt dem Bewußtsein der Nichtidentität Rechnung, ohne es auch nur auszusprechen; radikal im Nichtradikalismus, in der Enthaltung von aller Reduktion auf ein Prinzip, im Akzentuieren des Partiellen gegenüber der Totale, im Stückhaften' (*AGS* 11, 17).

[113] Adorno, 'The Essay as Form', p. 35; 'die ewige Kleinheit der tiefsten Gedankenarbeit dem Leben gegenüber und mit ironischer Bescheidenheit unterstreicht er sie noch' (*AGS* 11, 17). Here, Adorno is quoting Georg Lukács's 'Über Wesen und Form des Essays' (On the Essay's Essence and Form), part of his 1911 essay collection *Die Seele und die Form* (The Soul and the Form).

writer rebels 'against the doctrine, deeply rooted since Plato, that what is transient and ephemeral is unworthy of philosophy'.[114]

The result and expression of this approach is a thinking in constellations, whose concepts 'do not form a continuum of operations' and whose individual elements 'are interwoven as in a carpet. The fruitfulness of the thoughts depends on the density of the texture'.[115] This non-linear mode of writing requires an equivalent reading strategy, a mobile attention able to pick up on allusions and cross-connections in an argument which is intermittent and provisional. The essay

> muß sich so fügen, als ob er immer und stets abbrechen könnte. Er denkt in Brüchen, so wie die Realität brüchig ist, und findet seine Einheit durch die Brüche hindurch, nicht indem er sie glättet. [...] Diskontinuität ist dem Essay wesentlich, seine Sache stets ein stillgestellter Konflikt. (AGS 11, 25)
>
> [has to be constructed as though it could always break off at any point. It thinks in fragments, just as reality is fragmentary, and finds its unity in and through the breaks and not by glossing them over. [...] Discontinuity is essential to the essay; its subject matter is always a conflict brought to a standstill.[116]]

Like modernist literature and music, the essay lacks closure and coherence, therefore requiring a supple mindset in both recipient and producer. As in 'Words from Abroad' and 'Free Time', Adorno describes the joy that flows from such a mode of writing and thinking—a joy often rooted in single words, in the hunt for an obscure, almost forgotten expression, which instils ordinary language with the exoticism of far-flung associations. While the pervading emotion underlying the culture industry is boredom (AGS 10.2, 649), the essay is a playing field for 'curiosity, the pleasure principle of thought', its subject 'the new in its newness, not as something that can be translated back into the old existing forms'.[117]

Beyond Contemplation?

Here and elsewhere in Adorno's writings, the resonances of Benjamin's anti-systematic way of thinking are readily apparent. Another important interlocutor was his close friend and colleague Max Horkheimer, with whom Adorno wrote

[114] Adorno, 'The Essay as Form', p. 35; 'gegen die seit Platon eingewurzelte Doktrin, das Wechselnde, Ephemere sei der Philosophie unwürdig' (AGS 11, 18).

[115] Adorno, 'The Essay as Form', p. 38; 'bilden [...] kein Kontinuum der Operationen, der Gedanke schreitet nicht einsinnig fort, sondern die Momente verflechten sich teppichhaft. Von der Dichte dieser Verflechtung hängt die Fruchtbarkeit von Gedanken ab' (AGS 11, 21).

[116] Adorno, 'The Essay as Form', p. 41.

[117] Adorno, 'The Essay as Form', p. 45; 'Neugier, das Lustprinzip des Gedankens. [...] Gegenstand des Essays [...] ist das Neue als Neues, nicht ins Alte der bestehenden Formen Zurückübersetzbares' (AGS 11, 30).

Dialektik der Aufklärung (Dialectic of Enlightenment, 1944). In his 1937 essay 'Traditionelle und kritische Theorie' (Traditional and Critical Theory), Horkheimer attacks those academics and thinkers who withdraw from society into the sphere of 'pure' reflection:

> Eine Wissenschaft, die in eingebildeter Selbständigkeit die Gestaltung der Praxis, der sie dient und angehört, als ihr Jenseits betrachtet und sich bei der Trennung von Denken und Handeln bescheidet, hat auf Humanität schon verzichtet.[118]
> [A kind of research which, in an imagined state of autonomy, regards the shaping of [social] practice, which it is meant to serve and of which it is a part, as beyond its remit and which is content with the separation of thought and action, has already forsaken its humanity.]

Horkheimer defines the chief purpose of thought, (critical) theory, as 'social change, the bringing about of justice among people'.[119] He concludes: 'philosophy which is content to rest in itself, in some kind of truth, has nothing in common with critical theory'.[120]

Horkheimer thus defines critical theory as active engagement, setting it apart from a contemplative, inward-looking, and self-contained mode of reflection. In his 1951 essay 'Kulturkritik und Gesellschaft' (Cultural Critique and Society), in which he famously declares the writing of poetry after Auschwitz 'barbaric', Adorno concurs with this view, remarking that 'critical intelligence cannot be equal to this challenge [of complete objectification] as long as it confines itself to self-satisfied contemplation'.[121] Like Horkheimer, Adorno casts critique and contemplation as incompatible, particularly in the age of 'complete objectification', a phrase which encapsulates fascism as well as capitalism. As we have seen, this historically situated critique of contemplation also underpins his aesthetic theory, as when he argues that the 'shock effect' of Kafka's novels foreshadows life after Auschwitz, where 'the contemplative attitude has become a mockery because the permanent threat of catastrophe no longer permits any human being to be an uninvolved spectator; nor does it permit the aesthetic imitation of that stance'.[122]

[118] Max Horkheimer, 'Traditionelle und kritische Theorie', in *Gesammelte Schriften*, vol 4: *Schriften 1936–1941*, ed. Alfred Schmidt (Frankfurt a.M.: Fischer, 1988), pp. 162–216 (p. 199).

[119] '[...] gesellschaftliche Veränderung, die Herstellung eines gerechten Zustandes unter den Menschen'. Horkheimer, 'Traditionelle und kritische Theorie', p. 199.

[120] 'Philosophie, die bei sich selbst, bei irgendeiner Wahrheit, Ruhe zu finden meint, hat mit kritischer Theorie nichts zu tun'. Horkheimer, 'Traditionelle und kritische Theorie', p. 209.

[121] Theodor W. Adorno, 'Cultural Criticism and Society', in Adorno, *Prisms*, trans. Weber and Weber, pp. 17–34 (p. 34); 'der absoluten Verdinglichung ist der kritische Geist nicht gewachsen, solange er bei sich bleibt in selbstgenügsamer Kontemplation' (*AGS* 10.1, 30).

[122] Adorno, 'Cultural Criticism and Society', p. 57; 'die kontemplative Haltung zum blutigen Hohn ward, weil die permanente Drohung der Katastrophe keinem Menschen mehr das unbeteiligte Zuschauen und nicht einmal dessen ästhetisches Nachbild mehr erlaubte' (*AGS* 11, 46).

On closer inspection, however, a more complex picture emerges, one which is informed by the simultaneous critique *and* defence of contemplative thought—indeed, of the contemplative life. This ambiguity is encapsulated by *Minima Moralia* (1951), Adorno's second major exile work alongside his *Dialectic of Enlightenment*. With its short essays and aphorisms, whose headings reference concrete phenomena from everyday life, *Minima Moralia* diverges almost provocatively from the systematic rigour of the traditional philosophical study.[123] This structure recalls Benjamin's call, in *Origin of the German Trauerspiel*, for an intermittent, discontinuous mode of thinking punctuated by acts of 'constantly renewed beginning', where insights arise out of 'the most precise immersion in the details of a matter'.[124]

The subtitle of *Minima Moralia*, *Reflexionen aus dem beschädigten Leben* (Reflections from Damaged Life), alludes to this model of immersion, for it places the thinker in the middle of damaged life. And yet in the preface Adorno partially retracts this claim, admitting that this book was written 'under conditions enforcing contemplation. The violence that expelled me thereby denied me full knowledge of it'.[125] To write about fascism from the perspective of exile, at a physical and mental remove from its terrors, puts the writer at a severe disadvantage, for contemplative detachment prevents detailed immersion. As Martin Seel rightly notes, by attributing his contemplative detachment to *external* circumstances, Adorno fails to take personal responsibility for the 'dubious privilege' of solitary contemplation.[126]

As if to defend his own writing position, Adorno then mounts a dialectical defence of contemplation, which he characterizes as 'a residue of fetishist worship' but also as 'a stage in overcoming' this mythical worldview.[127] To underline this latter claim, he cites the Scottish Enlightenment philosopher David Hume, who defended contemplation against his more 'worldly' ('weltfreundlichen') compatriots by arguing that 'accuracy is, in every case, advantageous to beauty, and just

[123] Or, as Adorno puts it, 'Das Ganze ist das Unwahre' (*AGS* 4, 55); 'The whole is the false'. Theodor W. Adorno, *Minima Moralia: Reflections from Damaged Life*, trans. E. F. N. Jephcott (London: Verso, 1974), p. 50.

[124] Walter Benjamin, *Origin of the German Trauerspiel*, trans. Howard Eiland (Cambridge, MA: Harvard University Press, 2019), p. 3; 'genaueste Versenkung in die Einzelheiten eines Sachgehalts' (*BGS* I.1, 208). In his preface, Adorno references 'das Lose und Unverbindliche' ('the loose and noncommittal nature') of his chosen form, while characterizing the underlying mindset as one of asceticism, 'Askese' (*AGS* 4, 17). This is a direct echo of Benjamin's 'Foreword', in which he argues that 'a mode of observation [...] capable of renouncing the prospect of totality' constitutes an 'ascetic schooling' that lends the mind the necessary rigour to master its subject-matter. *BGS* I.1, 237; Benjamin, *Origin*, p. 39.

[125] Adorno, *Minima Moralia*, p. 18; 'unter Bedingungen der Kontemplation. Die Gewalt, die mich vertrieben hatte, verwehrte mir zugleich ihre volle Erkenntnis' (*AGS* 4, 16).

[126] Martin Seel, *Adornos Philosophie der Kontemplation* (Frankfurt a.M.: Suhrkamp, 2004), pp. 10–11.

[127] Adorno, *Minima Moralia*, p. 224; 'ein Restbestand fetischistischer Anbetung und zugleich eine Stufe von deren Überwindung' (*AGS* 4, 256).

reasoning to delicate sentiment'.[128] Modern capitalism and its underlying 'Geist der Praxis' or 'spirit of practicability', Adorno warns, 'serve in a profit economy to stunt human qualities, and the further they spread the more they sever everything tender'.[129] This use of the term *Praxis* is a long way removed from Horkheimer's definition of critical theory as the unity of thought and action, whose task is the 'shaping of [social] practice'. For Adorno, practice is the emblem of the mind- and thoughtless activism of capitalism, with its output targets and mantra of efficiency, which have even invaded the academic sphere, where 'bustle endangers concentration with a thousand claims'.[130]

In *Minima Moralia*, Adorno does not aspire to develop a 'Lehre vom richtigen Leben' (teaching of the good life);[131] true to his famous dictum that 'there is no right living inside the false',[132] he portrays modern existence in almost exclusively negative terms, as alienated and disfigured.[133] And yet in the piece 'Sur l'eau' (On the Water), he offers a brief glimpse of how he imagines the alternative, the liberated life. It is a surprisingly simple, almost childlike vision: 'Rien faire comme une bête, lying on water and looking peacefully at the sky, "being, nothing else, without any further definition and fulfilment", might take the place of process, act, satisfaction'.[134] Liberation is principally defined as a physical state of weightlessness. The skyward gaze hardly qualifies as contemplative in the conventional sense of the word, recalling the empty expression of Helmar Lerski's sitters or the office clerk gazing out of his window, who so impresses Karl Rossmann in Kafka's *The Man who Disappeared*. Both of these are provisional states, offering only momentary respite from the rat race of modern life; Adorno's skyward gaze is meant to designate a permanent state of liberation, but in its unstable foundations, his vision has a similarly transient feel to it.

[128] Adorno, *Minima Moralia*, p. 40. 'Genauigkeit kommt immer Schönheit zugute, und richtiges Denken dem zarten Gefühl' (*AGS* 4, 44). See David Hume, *An Enquiry Concerning Human Understanding*, ed. Peter Millican (Oxford: Oxford University Press, 2007), p. 6.

[129] Adorno, *Minima Moralia*, p. 41; 'lassen in der Profitwirtschaft das Menschliche verkümmern, und je mehr sie sich ausbreiten, umso mehr schneiden sie alles Zarte ab' (*AGS* 4, 44–5).

[130] Adorno, *Minima Moralia*, p. 29; 'tausend Anforderungen der Betriebsamkeit die Konzentration gefährden' (*AGS* 4, 30).

[131] *AGS* 4, 7; Adorno, *Minima Moralia*, p. 15.

[132] 'Es gibt kein richtiges Leben im falschen' (*AGS* 4, 43). Jephcott's translation, 'Wrong life cannot be lived rightly' lends Adorno's sentence an overly moral dimension, which is absent from the German opposition 'richtig/falsch', which is more aptly translated as 'right/false' or 'correct/incorrect'. See Adorno, *Minima Moralia*, p. 39.

[133] Rahel Jaeggi, '"Kein Einzelner vermag etwas dagegen": Adornos *Minima Moralia* als Kritik von Lebensformen', in *Dialektik der Freiheit: Frankfurter Adorno-Konferenz 2003*, ed. Axel Honneth (Frankfurt a.M.: Suhrkamp, 2005), pp. 115–41 (p. 133).

[134] Adorno, *Minima Moralia*, p. 157. 'Rien faire comme une bête, auf dem Wasser liegen und friedlich in den Himmel schauen, "sein, sonst nichts, ohne alle weitere Bestimmung und Erfüllung", könnte an Stelle von Prozeß, Tun, Erfüllen treten' (*AGS* 4, 179). This unreferenced quotation is taken from Georg Wilhelm Friedrich Hegel's *Wissenschaft der Logik*, part I: *Die objektive Logik*, vol. 1: *Die Lehre vom Sein*, ed. Hans-Jürgen Gawoll, 2nd edn (Hamburg: Meiner, 2008), p. 58. Adorno explicitly references Hegel later on in *Minima Moralia*, in the 'Thesen gegen den Okkultismus' (Theses against Occultism; *AGS* 4, 279).

Elsewhere in the book, he defines this liberated state in interpersonal, relational terms, or rather, as an 'awareness of the possibility of relations without purpose, a solace still glimpsed by those embroiled in purposes'.[135] Here, we encounter Adorno's dialectical reasoning in its purest form. In modernity, a life of contemplation is not only exceedingly rare, but the sign of undeserved privilege based on the inheritance of actual as well as cultural capital. And yet, even in its blatant unfairness this contemplative life, which Adorno in 'Free Time' describes as his own, can foreshadow the utopia of a liberated humanity, where personal relations are no longer defined by their use value. True freedom of thought, he writes in 1967, is possible only when thinking is liberated 'from the curse of work and coming to rest in its object'.[136] In this specific context, Adorno's remark is directed against the hierarchical structures of modern academia; but it also speaks of a more fundamental suspicion of, even disdain for, the ordinary, practical pursuits of life—a prejudice which also pervades his musical writings, most prominently his listener typologies.[137] Unlike Benjamin and Besseler, Adorno remains suspicious of the active and interactive, communal, life. Having apologized for his own contemplative writing conditions in exile, he continues to defend the *vita contemplativa* if not as a personal entitlement then as a utopian ideal and resistant practice.

This position gains a polemical edge in his clash with his own students during the student protests of the late 1960s. German student activists were greatly influenced by Adorno and other Frankfurt School thinkers in their rebellion against authoritarian structures at universities, in politics and society. Adorno expressed his sympathy for the student Benno Ohnesorg, who in 1967 was shot by a police officer during a demonstration against the Iranian Shah, but refused to actively endorse the overall student cause, a stance which led to a series of well-documented confrontations between him and his students.[138] In a 1969 radio broadcast, 'Resignation', he defends his stance and responds to accusations of quietism and passivity, to the 'reproach of resignation' levelled against the older members of the Frankfurt School:[139]

> Weder hätten wir Aktionsprogramme gegeben noch gar Aktionen solcher, die durch die kritische Theorie angeregt sich fühlen, unterstützt [...]. Distanz von der Praxis ist allen anrüchig. Beargwöhnt wird, wer nicht fest zupackt, nicht die Hände sich schmutzig machen möchte, als wäre nicht die Abneigung dagegen legitim und erst durchs Privileg entstellt. [...] Man soll mitmachen.

[135] Adorno, *Minima Moralia*, p. 41; 'das Bewußtsein von der Möglichkeit zweckfreier Beziehungen, das noch die Zweckverhafteten tröstlich streift; Erbteil alter Privilegien, das den privilegienlosen Stand verspricht' (*AGS* 4, 45).
[136] '[...] vom Fluch der Arbeit und in seinem Objekt zur Ruhe kommt' (*AGS* 10.2, 607).
[137] Seel, *Philosophie der Kontemplation*, p. 15.
[138] See Müller-Doohm, *Adorno*, pp. 679–706; 722–6.
[139] The programme aired on 9 February 1969 on the Sender Freies Berlin.

Wer nur denkt, sich selbst herausnimmt, sei schwach, feige, virtuell ein Verräter. (*AGS* 10.2, 794–5)

[We neither designed programmes for action nor did we support the actions of those who felt themselves inspired by critical theory. [...] Distance from practice is disreputable in the eyes of everyone. Anyone who does not take immediate action and who is not willing to get his hands dirty is the subject of suspicion; it is felt that his antipathy toward such action was not legitimate, and further that his view has even been distorted by the privileges he enjoys. [...] One should take part. Whoever restricts himself to thinking but does not get involved is weak, cowardly and virtually a traitor.[140]]

Adorno takes these reactions to be symptomatic of a more general 'repressive intolerance toward thought'.[141] 'Aktionismus', pseudo-activity, he warns, is at best a substitute for true contentment and quickly risks becoming an end in itself. He concludes, 'only thinking could provide an escape, and then only the kind of thinking whose results are not prescribed'.[142] Thought, then, must not be co-opted for political or societal purposes; only in its autonomous, self-sufficient form can it become a 'force of resistance' and a 'figuration of practice'.[143] Adorno thus contrasts two models of practice: practice as pseudo-activism, which masks underlying disempowerment, as opposed to the practice of thought, which is neither neutral nor passive but involves resisting current developments. By defining thought in this way, Adorno harks back to Horkheimer's definition of critical theory as a 'Gestaltung der Praxis'. The term contemplation does not feature in his argument.

Adorno pursues a similar line of argument in his 1967 lecture 'Anmerkungen zum philosophischen Denken' (Notes on Philosophical Thinking). Once again, he avoids contemplation in favour of a different term, in this case concentration:

Das aktive Moment des denkenden Verhaltens ist Konzentration. Sie sträubt sich gegen die Ablenkung von der Sache. [...] Denkfeindlich ist die Gier, der abgelenkte Blick zum Fenster hinaus, der möchte, daß nichts ihm entgehe; theologische Überlieferungen wie die des Talmuds haben davor gewarnt. (*AGS* 10.2, 602)

[The active element of thinking behaviour [*Verhalten*] is concentration. It resists being distracted from its subject. [...] Greed, in contrast, and the distracted gaze out of the window, which does not want to miss anything, are anathema to thought; theological traditions such as the Talmud have warned against it.]

[140] Theodor W. Adorno, 'Resignation', in Adorno, *The Culture Industry*, ed. Bernstein, pp. 198–203 (pp. 198–9).

[141] Adorno, 'Resignation', p. 200; 'repressive Intoleranz gegen den Gedanken' (*AGS* 10.2, 795).

[142] Adorno, 'Resignation', p. 200; 'einen Ausweg könnte einzig Denken finden, und zwar eines, dem nicht vorgeschrieben wird, was herauskommen soll' (*AGS* 10.2, 796).

[143] Adorno, 'Resignation', p. 202; 'ein Verhalten, eine Gestalt von Praxis' (*AGS* 10.2, 798).

Unlike in Kafka's *The Man who Disappeared*, the gaze out of the window does not embody a moment of liberation; rather it is driven by the fear of missing out—on sights, events, and other sensations—sown by the modern attention economy. Concentration, on the other hand, anchors the mind and offers a defence against this mindlessly wandering gaze. By describing it as 'active', a form of *Verhalten*, Adorno echoes psychological distinctions between voluntary and involuntary attention; his explicit reference point, however, is not psychology but religion, specifically Talmudic debates about *kavvanah*, a term which means 'intention' or 'sincere direction of the heart'. The Talmud stipulates that prayer requires an active orientation of the heart and mind rather than the mechanical execution of rituals; if the worshipper is distracted by worldly concerns, it is preferable to postpone praying until a later point.[144] Twentieth-century Jewish thinkers continued to emphasize the central role of contemplation, but situate it in a disparate reality. The Jewish philosopher Gershom Scholem describes *kavvanah* as 'Ariadne's thread, with whose help a person's mythical intention is feeling its dangerous way towards its destination. Since all worlds and all domains are in constant flux, are constantly evolving, a new *kavvanah* exists for every moment'.[145]

Adorno seems to have something similar in mind when he defines patience as the 'virtue of thought' or 'Tugend des Denkens'; this involves neither 'busy milling about' nor 'stolid fixation' but 'gazing at the object in a sustained and non-violent way'.[146] Just like Scholem, he stresses that this virtue of persistent concentration must not result in complete withdrawal from the (modern) world. The ideal of pure thinking quickly becomes a parody of itself, embodied in the figure of the self-absorbed sage; 'wisdom today appears as a historically irrevocable, quasi-agrarian mode of thinking'.[147] Adorno's self-absorbed sage is the figurehead of those idylls of a bygone contemplative age, which so abundantly feature in modernity-critical writings. He compares this ideal to pseudo-primitivist sculptures, which hope to capture an 'old authenticity [...] which never actually existed and which nowadays neatly complements late-industrial society'.[148] Not only is this age and its holistic mindset a mere fiction, but by reiterating the idea that past and present are essentially, unbridgeably divided, such arguments stabilize the modern, fragmented status quo.

[144] H. Blumenthal, 'Kavvanah', in *Encyclopaedia Judaica*, ed. Michael Berenbaum and Fred Skolnik, 2nd edn, vol. 12 (Detroit: Macmillan Reference USA, 2007), pp. 39–40.
[145] '[...] einen Ariadnefaden, mit dessen Hilfe sich die mythische Intention des Menschen auf gefährlichem Wege zu ihrem Ziel hintastet. Weil eben alle Welten und Bereiche in ständigem Fluß und in beständiger Entwicklung sind, gibt es eine neue *Kawwana* für jeden Augenblick'. Gershom Scholem, *Die jüdische Mystik in ihren Hauptströmungen* (Zurich: Rhein, 1957), p. 304.
[146] '[...] weder emsiges sich Tummeln noch stures sich Verbohren, sondern der lange und gewaltlose Blick auf den Gegenstand' (*AGS* 10.2, 602).
[147] 'Weisheit heute fingiert eine geschichtlich unwiederbringliche, agrarische Gestalt des Geistes' (*AGS* 10.2, 602).
[148] '[...] das alte Wahre [...], das nie gewesen ist und heutzutage die spätindustrielle Welt nur allzu treu ergänzt' (*AGS* 10.2, 603).

Conclusion

At the end of this chapter, it is worth returning to Adorno's own maxim of 'mit den Ohren [...] denken', thinking with one's ears (*AGS* 10.1, 11). The following passage from his 'Schönberg' essay of 1953 sums up the essence, as well as the irreducible tensions, of his thought on attention. Schönberg's music

> erheischt [...] von Anbeginn aktiven und konzentrierten Mitvollzug; schärfste Aufmerksamkeit für die Vielheit des Simultanen; Verzicht auf die üblichen Krücken eines Hörens, das immer schon weiß, was kommt; angespannte Wahrnehmung des Einmaligen, Spezifischen [...]. Sie verlangt, daß der Hörer ihre innere Bewegung spontan mitkomponiert, und mutet ihm anstelle bloßer Kontemplation gleichsam Praxis zu. (*AGS* 10.1, 152–3)
>
> [demands from the very beginning active and concentrated participation, the most acute attention to simultaneous multiplicity, the renunciation of the customary crutches of a listening which always knows what to expect, the intense perception of the unique and specific [...]. It requires the listener to spontaneously compose its inner movement and demands of him not mere contemplation but practice.[149]]

Instead of pure contemplation, Adorno advocates practice, once again echoing Horkheimer's definition of Critical Theory as active social engagement. Another familiar term is spontaneity, which prominently features in his essays on method and style. And yet in calling for an active and perpetually alert mode of listening, his thought also remains indebted to older models of aesthetic experience, which he tries to adapt for his own age.

Adorno's work thus reflects one of the irresolvable questions which beset the debate about attention in modern society: whether to protect this mindset against fragmentation, or whether to refigure or indeed discard it in response to current cultural and cognitive challenges. For Adorno, as for all the writers and artists discussed in this book, this question has an intensely personal as well as a political dimension. Twentieth-century debates about attention are never solely about the present, but are deeply inflected by a historical awareness of human experience as rooted in a particular time and place. Attention is more than a theoretical issue—it is a matter of practice, embodied and enacted within these works.

Adorno's key reference point remains music; new music in particular is for him 'at one with his philosophical task, namely, to challenge what we take in experience

[149] Theodor W. Adorno, 'Arnold Schoenberg, 1874–1951', in Adorno, *Prisms*, trans. Weber and Weber (Cambridge, MA: MIT Press, 1981), pp. 147–72 (pp. 149–50).

to be most self-evident'.[150] As he continues to defend active, attentive, rationally engaged listening, his own texts, whose complex structure and dense network of images evoke musical compositions, make similar demands on the reader's mental capacities. Just as important, however, is the child's breathless encounter with music, which acts as a primal scene of aesthetic experience. Thus, the density of his writings is counterbalanced by a sense of playfulness, by a dislike of closed philosophical systems and the self-justifying rhetoric of academia. Adorno's prominence on West German radio was motivated in part by the desire to reach out to his listeners and communicate some of this joyful experience.

This gesture was often rebutted and misunderstood, and the rhetoric of his critics reflected the conservative climate of the early Federal Republic. But even today Adorno's writings at times provoke a similar response. Of all the figures discussed in this study so far, he is closest to us historically, but in his critique of popular music and culture he may seem furthest removed. And yet, in his unflinching willingness to challenge cultural orthodoxies his critique is more relevant than ever. His writings, which span five decades, show that the challenges associated with attention and distraction transcend the caesuras of war, fascism, and exile, but also that they change in line with the specific context, preventing twentieth-century debates from being seamlessly absorbed into the current context.

[150] Lydia Goehr, 'Dissonant Works and the Listening Public', in *The Cambridge Companion to Adorno*, ed. Tom Huhn (Cambridge: Cambridge University Press, 2004), pp. 222–47 (p. 223).

11
Celan, Sebald, Hoppe

Networks of Attention

Attention is central to human happiness, to a life which is not passive but autonomous, aware of itself and the world, and open towards others. This core assumption remains strikingly stable across the periods I have explored, and continues to shape present debates.[1] Recent behavioural and neuroscientific studies have underlined the far-reaching effects of distraction on our mental performance and decision-making capacity.[2] While even minor and momentary diversions can constitute an immediate safety hazard, sustained competing demands on our attention can have long-term effects as they affect rational decision-making, thereby eroding life chances and cementing inequality.[3] These findings have led to calls to designate attention a collective resource equivalent to clean water and air,[4] and for concrete measures to protect the 'attentional bandwidth' of people in both emerging economies and Western societies.[5]

As we have seen, many of these sentiments are shared by earlier commentators. Around 1900, the workings of attention were foremost among the issues explored by experimental psychologists, and their findings in turn fed into ambitious state-sponsored initiatives. Compared to the present, Weimar Germany was far more interventionist in making the population's attention one of its priorities, and the aims of psychotechnics were in turn internalized by individuals and enforced through practices of self-fashioning. But this period also highlights the

[1] For a summary see Matthew Crawford, *The World Beyond Your Head: How to Flourish in a World of Distraction* (London: Penguin, 2015), pp. 16–17; 31–44. This process of behavioural conditioning already starts in childhood, as Crawford shows at the example of the TV programme *Mickey Mouse Clubhouse*, which embodies the 'dissociative or abstract quality of children's television in general these days'. *The World*, p. 77.

[2] Sendhil Mullainathan and Eldar Shafir treat distraction as one of various forms of scarcity, arguing that any shortage, whether of money, food, time, or silence, affects behaviour, often leading to irrational choices and skewed priorities. As they put it, 'scarcity captures the mind'. One common response is 'tunnelling', whereby we only focus on the immediate challenge thrown up by a lack of resources, which can lead to illogical decisions as it 'distorts the trade-offs we make'. Sendhil Mullainathan and Eldar Shafir, *Scarcity: The True Cost of Not Having Enough* (London: Penguin, 2013), pp. 5; 41.

[3] A study from the 1970s, for instance, looked at a US-American school located next to a railway line. The reading ability of those pupils whose classroom faced the tracks was a full school year behind that of their peers on the quieter side of the building. Once the city installed sound insulation, this erased the difference. See A. L. Bronzaft and D. P. McCarthy, 'The Effect of Elevated Train Noise on Reading Ability', *Environment and Behaviour*, 4 (1975), 517–28; and A. L. Bronzaft, 'The Effect of a Noise Abatement Program on Reading Ability', *Journal of Environmental Psychology*, 1 (1981), 215–22.

[4] Crawford, *The World*, pp. 8–14. [5] Mullainathan and Shafir, *Scarcity*, pp. 167–226.

considerable and often unaddressed downsides of such interventions. In prioritizing attention as a key mental resource, the period imposed uniform, purpose-driven forms of engagement, which left little space for divergent practices and risked discriminating, as Kracauer powerfully shows, against those who fell short of the norm. While nowadays the competing demands on our attention may be seen as *insufficiently* important, too low on the list of political and public health priorities, in the early twentieth century the consensus regarding the importance of attention had profound effects across German society, in domains such as labour, leisure, education, and consumption. Just as striking as these interventions is their underlying justification, the arguments advanced to pinpoint the causes behind attention's (perceived) decline. This search for the causes was interdisciplinary in character, but the proposed answers reveal an overwhelming consensus across fields such as medicine, sociology, and history, all of which cast the decline of attention as a direct or indirect consequence of modern life. This view drove concrete initiatives, but it also fed into a less tangible anti-modern sentiment, which was often expressed as nostalgia for a contemplative, traditional way of life. In the early twentieth century, this argument became increasingly politicized and was at the centre of the Nazis' vision of an authentic Germany. Like so many of the arguments about attention, however, it also cut across the political spectrum, as is evident for instance in Benjamin's and Lendvai-Dircksen's shared admiration for David Octavius Hill and Robert Adamson's contemplative portraits as an antidote to modernity.

My aim in this book, then, has been to show the tangible as well as intangible effects of this engagement with (in-)attention across modern society. To tease out these effects, I have adopted both a macro- and a micro-perspective. Chapters which map out broader social and cultural practices—such as psychology, medicine, photography, or musical culture—have been interspersed with chapters on individual thinkers, such as Freud, Kracauer, Benjamin, and Adorno, who reflect on these developments from within their own disciplines. These chapters demonstrate that the engagement with attention and distraction rarely yields one coherent position, nor a teleological development, but manifests itself as a force field of contrasting models whose contradictions cannot simply be resolved.

One aspect these four thinkers (and others discussed in this book) have in common is the fact that in thinking about (in-)attention they often draw on examples from the arts: from literature, film, photography, or music. But the arts are of course themselves a distinctive space of intervention, where human experience is both reflected and reflected on in often subversive and experimental ways. To this end, a particular emphasis of this book has been on attention in these different media, and on how individual writers and artists engage with these matters.

In his *Aesthetic Theory* Adorno calls art (in all its manifestations) a *Verhaltensweise*, a form of behaviour or comportment. As he argues, artworks

are part of society, and hence inflected by social practices, but they are also separate from them; Adorno speaks of their 'refusal to play along'.[6] This dialectic of connectedness and disconnection is central for the artwork's agency, its interventionist power; but this interplay does not translate into one particular mode of engagement or response. Adorno, as we have seen, advocates (modernist) works, in music and beyond, that resist easy consumption and demand an active, sustained kind of attention.[7] For him, such works nurture skills that are also vital in other domains and which he encourages, and demands, in his own writings. But this model of sustained attention risks shading into the prescriptive, and recalls the disciplinary practices outlined in Chapter 4. Artworks, after all, are more than a cognitive training tool, a kind of corrective to a culture of inattention. Rather, they reflect the full and constantly changing spectrum of human experience in an immersive way. Adorno speaks of the 'immanent processual quality of the work'[8] and the associated ebb and flow of attention. Kafka's poetics of digression, where minor instances of absent-mindedness have major consequences and where the protagonists' unstable focus is shared by the reader, is one of many examples where artworks complicate dominant social arguments about the relative value of specific mental states, instead driving home the fact that human experience is multi-faceted and fluid, and that this fluidity is not a problem to be fixed.

Literature and other artworks thus mark concrete, practical interventions into the wider debate about attention and distraction; and in this way, they also act as a springboard for dialogue and reflection. What the critics featured in this book have in common is that they think about (in-)attention not merely in sociological, psychological, or historical terms, but in and through artistic practice. Music and visual art produce and reflect modes of engagement in particular contexts. Literature does the same, but in addition it provides a rich archive of tropes and narratives on which thinkers draw when trying to reflect on human experience in a contextually embedded and dialectical manner. Benjamin's elaboration on Kafka's stance towards prayer and attention is one such example, where the engagement with a literary text helps to crystallize a theoretical argument. Indeed, this practice of thinking about attention in and through works of art has a second effect, one which has also become apparent in this study. While I have delved deep into the work of individuals, I have also stressed their ongoing

[6] Theodor W. Adorno, *Aesthetic Theory*, ed. Gretel Adorno and Rolf Tiedemann, new trans. Robert Hullot-Kentor (London: Continuum, 1997), p. 28. 'Noch das kontemplative Verhalten zu den Kunstwerken [...] fühlt sich als Kündigung unmittelbarer Praxis und insofern ein selbst Praktisches, als Widerstand gegen das Mitspielen' (*AGS* 7, 26).

[7] Adorno's argument is echoed by the British philosopher R. G. Collingwood. In *The Principles of Art* (1938), he argues that to produce or engage with a difficult piece of art facilitates a more general state of attentiveness, which helps to overcome what he calls 'corrupt consciousness', that is, a state of passive cultural drift.

[8] Adorno, *Aesthetic Theory*, p. 188; the 'immanente Prozeßcharakter des Gebildes' (*AGS* 7, 262).

dialogue. The engagement with attention and distraction unfolds through intellectual networks both synchronic and diachronic, as artists and thinkers engage with their predecessors and contemporaries. The result is a dense web of resonances and cross-references, which interlink even those at opposite ends of the aesthetic or political spectrum.

In the final part of this chapter, I will show how this network extends well beyond modernism into post-war and contemporary literature. To do so, I turn to three writers who engage with this much longer debate in both explicit and implicit ways. Paul Celan, W. G. Sebald, and Felicitas Hoppe belong to different generations, and their engagement with attention reflects very different life stories and cultural contexts, but all three are concerned with the nexus between memory and attention, with how particular states of mind facilitate an encounter with the past. This question underpins their literary practice, and it is also at the centre of their more theoretical texts, where Celan, Sebald, and Hoppe draw on a literary and philosophical tradition in order to formulate their own poetics of (in-)attention.

Paul Celan: Dates of Attention

Paul Celan (1920–70) is one of the most important poets of the twentieth century. Born into a German-speaking Jewish family in Cernăuți in Romanian Bukovina, he survived the Holocaust in a labour camp; his parents were killed in an internment camp. Celan's famously hermetic poetry echoes Adorno's argument about the importance of difficult writing which resists easy consumption.[9] In his famous Büchner Prize speech, 'Der Meridian' (The Meridian, 1961), Celan offers some programmatic insights into his poetics, which are woven around quotations by Georg Büchner and other literary predecessors.

For Celan, contemporary poetry shows 'a marked tendency towards falling silent',[10] but in this way it is also paradoxically dialogical:

[9] Celan's poem 'Todesfuge' (Death Fugue, 1948) had initially sparked Adorno's infamous remark, in his 1951 essay 'Cultural Critique and Society', that to write poetry after Auschwitz was 'barbaric' (AGS 10.1, 30). He later nuanced and then retracted this claim; in *Aesthetic Theory*, he praises Celan's poetry, noting that his texts 'wollen das äußerste Entsetzen durch Verschweigen sagen' (AGS 7, 477; 'want to speak of the most extreme horror through silence'; *Aesthetic Theory*, p. 317).

[10] Paul Celan, *Der Meridian: Endfassung—Entwürfe—Materialien*, ed. Bernhard Böschenstein and Heino Schmull with assistance from Michael Schwarzkopf and Christiane Wittkop, Paul Celan, Werke: Tübinger Ausgabe, ed. Jürgen Wertheimer (Frankfurt a.M.: Suhrkamp, 1999), p. 8. Celan, *The Meridian: Final Versions—Drafts—Materials*, ed. Bernhard Böschenstein and Heino Schmull with assistance from Michael Schwarzkopf and Christiane Wittkop, trans. and preface Pierre Joris (Stanford, CA: Stanford University Press, 2011), p. 8. Since both editions are identically paginated, I will give henceforth only give one single reference.

Das Gedicht will zu einem Andern, es braucht dieses Andere, es braucht ein Gegenüber. Es sucht es auf, es spricht sich ihm zu.
Jedes Ding, jeder Mensch ist dem Gedicht, das auf das Andere zu hält, eine Gestalt dieses Anderen.
Die Aufmerksamkeit, die das Gedicht allem ihm Begegnenden zu widmen versucht, sein schärferer Sinn für das Detail, für Umriß, für Struktur, für Farbe, aber auch für die 'Zuckungen' und die 'Andeutungen', das alles ist, glaube ich, keine Errungenschaft des mit den täglich perfekteren Apparaten wetteifernden (oder mit eifernden) Auges, ist vielmehr eine aller unserer Daten eingedenk bleibende Konzentration.

[The poem wants to head toward some other, it needs this other, it needs an opposite. It seeks it out, it bespeaks itself to it.
Every thing, every human is, for the poem heading toward this other, a figure of this.
The attention the poem tries to pay [or dedicate] to everything it encounters, its sharper sense of detail, outline, structure, color, but also of the 'tremors' and 'hints', all this is not, I believe, the achievement of an eye competing with (or emulating) ever more precise instruments, but is rather a concentration that remains mindful of all our dates.[11]]

By making the poem, rather than the poet, the subject of his argument, Celan lends it an independent kind of agency. This agency revolves around attention. The poem embodies a particular kind of attention; the associated verb *widmen* means to pay or, better, to dedicate attention. This attention has a wide remit and is particularly concerned with details of nuance, shade, and colour. Citing a famous passage from Büchner's novella *Lenz* (1836) in which the writer-protagonist sets out his anti-classicist conception of art, Celan suggests that the poem's focus is on the creaturely and the unconscious—the twitching of the body and the hidden meanings contained within human expression. The remit of this engagement, which recalls Freud's *Psychopathology of Everyday Life*, is very different from that of scientific instruments, the embodiments of a rational, quantifying approach to the world.

The poem's openness towards both things and people recalls Benjamin's conception of prayer as a dialogical encounter with God and the creaturely world. This model, which is first outlined in 'On Dread', is, as we have seen, reiterated in Benjamin's 'Kafka' essay. And indeed, in his 'Meridian' speech, Celan cites that essay's salient passage: '"Attention"—permit me to quote here a phrase by Malebranche, via Walter Benjamin's essay on Kafka—"Attention is the natural

[11] Celan, *Meridian*, p. 9.

prayer of the soul"'.[12] Though he does not include Benjamin's next sentence—'And in this attentiveness he [Kafka] included all creatures, as saints include them in their prayers'[13]—Celan echoes Benjamin's notion that the remit of attention should go beyond the human and must entail a fundamental openness towards the (radically) other.

The Benjamin quotation in Celan's speech signals a multi-layered approach to attention, whereby voices from different periods—Benjamin reading Kafka with the seventeenth-century Catholic theologian Malebranche—are juxtaposed to pinpoint certain constellations of ideas. Celan's main interlocutor, however, remains Büchner, as he weaves his argument around passages from Büchner's works. A prominent such reference point is the opening of his novella *Lenz*, 'Den 20. ging Lenz durchs Gebirg' ('On the 20th Lenz went through the mountains').[14] It leads Celan to a reflection on the role of dates in poetry:

> Vielleicht darf man sagen, daß jedem Gedicht sein '20. Jänner' eingeschrieben bleibt? Vielleicht ist das Neue an den Gedichten, die heute geschrieben werden, gerade dies: daß hier am deutlichsten versucht wird, solcher Daten eingedenk zu bleiben?
> Aber schreiben wir uns nicht alle von solchen Daten her? Und welchen Daten schreiben wir uns zu?
>
> [Perhaps one can say that every poem has its own '20th of January' inscribed in it? Perhaps what's new in the poems written today is exactly this: theirs is the clearest attempt to remain mindful of such dates?
> But don't we all write ourselves from such dates? And toward what dates do we write ourselves?[15]]

Celan supplies the month which is omitted in Büchner's opening sentence, using the Austrian-German *Jänner* rather than the standard German *Januar*. This term signals a subtle but pronounced distance from another date that underpins Celan's speech: 20 January 1942 was the date of the Wannsee Conference, when the so-called Final Solution, the deportation and murder of the European Jewish population, was officially adopted by the Nazi leadership. Celan does not spell out this connection but leaves it for his audience to discern, thus demanding of them an

[12] '"Aufmerksamkeit"—erlauben Sie mir hier, nach dem Kafka-Essay Walter Benjamins, ein Wort von Malebranche zu zitieren—"Aufmerksamkeit ist das natürliche Gebet der Seele"'. Celan, *Meridian*, p. 9.

[13] *BSW* II, 812. 'Und in sie hat er, wie die Heiligen in ihre Gebete, alle Kreatur eingeschlossen' (*BGS* II.2, 432).

[14] Georg Büchner, *Sämtliche Werke, Briefe und Dokumente in zwei Bänden*, ed. Henri Poschmann and Hannelore Poschmann, vol. 1: *Dichtungen* (Frankfurt a.M.: Suhrkamp, 1992), p. 223.

[15] Celan, *Meridian*, p. 8.

active and mobile kind of attention that is able to make lateral connections and read between the lines.

Celan's 'Meridian' speech thus interlinks attention and memory. In the first of the two above-cited passages, he casts the poem's attention as an openness towards the other, but this openness rests on an underlying concentration directed at past dates and their connections to the present. Celan's verb *eingedenk bleiben*, to remain mindful, echoes Benjamin's second 'Baudelaire' essay, where he argues that particular days are separated, lifted out of the amorphous flow of time to become 'bedeutende Tage [...], Tage des Eingedenkens' ('significant days, days of remembrance').[16] In Celan's speech, this idea is refigured in the wake of the Holocaust, whose remembrance likewise involves dates that are lifted out of the continuum of time as they are inscribed into the poem. This mode of remembrance is not mono-focal but seeks to interconnect different dates or, to use Celan's own titular image, different points on a meridian.[17]

Indeed, this strategy of associative connections also informs Celan's engagement with other writers, his virtual dialogue with other, specifically Jewish, voices. For with the exception of Büchner, Celan cites all his other sources not directly but mediated through the works of Jewish writers and critics.[18] One of the most prominent examples is Malebranche as cited by Benjamin; in an earlier version of his speech, Celan writes: 'Attention is, here I quote a word by Malebranche— I quote it following Walter Benjamin's Kafka essay first published in the *Jüdische Rundschau*—attention, that is the natural prayer [or piety] of the soul'.[19] This parenthetical remark may seem innocuous, but it takes on a loaded quality given the circumstances in which Celan delivered his speech. In 1960 he was unjustly and very publicly accused by Claire Goll of having plagiarized the poetry of her late husband, the poet Ivan Goll; the reporting of the dispute in the German newspapers had distinctly hostile overtones, chiming with a climate of residual anti-Semitism in West Germany as diagnosed by intellectuals such as Adorno and Horkheimer.[20] Read against this backdrop, Celan's citation of other Jewish voices

[16] BSW 4, 332–3; BGS I.2, 637.

[17] See Celan, *Meridian*, p. 12. On Celan's first use of this term, in the image of a 'meridian of pain' connecting him to his friend, the poet Nelly Sachs, see *Meridian*, p. xiv.

[18] These mediated references also include a quotation attributed to the French writer Louis-Sébastien Mercier, which appears in Soviet Germanist M. N. Rosanow's monograph on Jakob Michael Reinhold Lenz, Pascal as cited by the Russian philosopher Lev Shestov, and Baudelaire cited by Hugo von Hofmannsthal. See Celan, *Meridian*, pp. 226; 232. Hofmannsthal's great-grandfather was Jewish, though his grandfather converted to Catholicism.

[19] 'Aufmerksamkeit, das ist, ich zitiere hier ein Wort von Malebranche—ich zitiere es nach dem ursprünglich in der *Jüdischen Rundschau* erschienenen Kafka-Aufsatz von Walter Benjamin—, Aufmerksamkeit, das ist die natürliche Frömmigkeit der Seele'. Celan, *Meridian*, p. 63; see also p. 69.

[20] On the Goll affair, see Barbara Wiedemann (ed.), *Paul Celan—Die Goll-Affäre: Dokumente zu einer 'Infamie'* (Frankfurt a.M.: Suhrkamp, 2000). In his 1960 speech 'Über deutsche Juden' (On German Jews), Max Horkheimer argued that many Germans harboured a deep-seated resentment towards Jewish people sparked by the official narrative of German guilt.

can be read as a 'conscious provocation',[21] and yet this method of interweaving his argument with other voices also harks back to his definition of attention as a dialogical kind of openness, a form of encounter which he casts as the essence of the modern poem.

In fact, Celan's speech also reflects this emphasis on attention on an implicit, rhetorical level. He begins with the conventional address 'Meine Damen und Herren!' (Ladies and gentlemen!), and this phrase is then repeated a further fifteen times over the course his speech. Its repetition marks an almost anxious attempt to sustain his listeners' attention, and yet the way the way the phrase is often inserted mid-sentence, interrupting the flow of the argument, turns it into a distraction. This rhetorical quirk is rooted in a particular cultural tradition. In his 1912 diary, Kafka describes attending a talk on Jewish folklore music by the writer Nathan Birnbaum. Rather than commenting on its content, Kafka observes the 'eastern Jewish habit of inserting "my esteemed ladies and gentlemen" or simply "my esteemed" at every pause in the talk', adding that Birnbaum repeats this phrase 'to the point of being ridiculous'.[22] Kafka, who grew up in an assimilated family, responded to eastern European Judaism with a mixture of fascination and detachment; Celan is rooted in this tradition and highlights these roots through his rhetoric of attention. On one level, his speech enacts its own core thesis, namely that attention is the basis for dialogue and encounter. Read against the backdrop of the Goll affair, Celan's repeated appeal for attention is driven less by an antagonistic sentiment than by a 'call for political vigilance'.[23] That said, the excessive and disruptive use of this phrase also speaks of a profound anxiety as to whether this gesture will be understood and reciprocated.

The anxiety which underlies the speech becomes more apparent in Celan's notes, where he delves deeper into Kafka's writings, going beyond Benjamin's reading. Two passages reflect his own response. Elaborating on Benjamin's 'Kafka' essay, he remarks: '"Writing as a form of prayer," we read—deeply moved—in Kafka. This, however, does not mean that praying comes first, writing does: one cannot do it with folded hands'.[24] Where Benjamin echoes Kafka's equivalence of praying and writing, Celan prioritizes one over the other. The act of writing

[21] Alexandra Richter, 'Die politische Dimension der Aufmerksamkeit im *Meridian*', *Deutsche Vierteljahrsschrift für Literaturwissenschaft und Geistesgeschichte*, 77 (2003), 659-76 (p. 662).

[22] Franz Kafka, *Diaries, 1910-1923*, ed. Max Brod, trans. Joseph Kresh and Martin Greenberg with the cooperation of Hannah Arendt (New York: Schocken, 1988), p. 173. The 'ostjüdische Gewohnheit, wo die Rede stockt, "meine verehrten Damen und Herren" oder nur "meine Verehrten" einzufügen. Wiederholt sich am Anfang der Rede Birnbaums zum Lächerlichwerden'. Kafka, *Tagebücher*, ed. Hans-Gerd Koch, Michael Müller, and Malcolm Pasley, Franz Kafka: Schriften, Tagebücher, Briefe: Kritische Ausgabe (Frankfurt a.M.: Fischer, 1990), p. 360.

[23] Richter, 'Politische Dimension', p. 664.

[24] '"Schreiben als Form des Gebets" lesen wir—ergriffen—bei Kafka. Auch das bedeutet zunächst nicht Beten, sondern Schreiben: man kann es nicht mit gefalteten Händen tun'. Celan, *Meridian*, pp. 72; 157.

'comes first', takes precedence as a physical, embodied form of engagement. But Celan's own reception of Kafka goes beyond this single sentence. Also contained in Kafka's 1920 convolute is the story (fragment) 'Immersed in the Night...', from which Celan extrapolates the final two sentences: '"Someone has to be there," writes Kafka, "someone has to keep watch"', and then adds his own comment: 'The poem—an endless vigil'.[25] Revealingly, Celan cites the fragment's last two sentences in reverse order,[26] thereby putting the emphasis not on the guard's physical presence but on the inner state of vigilance. Celan would no doubt have recognized Kafka's text as a take on the Exodus narrative, that is, as a story which foregrounds the need for vigilance in the face of persecution. By casting the poem as an 'endless vigil', he thus adds an important, more ambivalent facet to the speech's reflections on attention as the basis of memory and encounter.

Sebald: Diversion and Melancholy

As Celan's 'Meridian' speech shows, the modernist engagement with attention remains an important reference point across the caesura of the Holocaust. Celan highlights the specifically Jewish roots of this discourse, which he reads as the response to a prevailing sense of crisis. While the vigil suggests a sustained state of alertness, his model of memory is built on a more open and associative awareness, which draws connections between different times and places.

A similarly associative practice of recollection is at work in the writings of W. G. Sebald (1945–2001). Born in Bavaria at the very end of the war, Sebald belongs to the so-called second generation of writers who did not witness National Socialism but wrestled with its legacy on a collective as well as a personal level. His protagonists show little concern for the modern world (recent European history, including the German reunification, is barely mentioned in his texts) and instead embark on long and meandering memory quests which lack a clear destination. These journeys are propelled by two contrasting but connected impulses: on the one hand the protagonists' absent-mindedness, which easily leads them astray; on the other hand their propensity for deep immersion in specific objects, images, and other minutiae.

Like Celan, Sebald frames these different mental states through allusions to literary predecessors. One of his most important interlocutors is Kafka.

[25] '"Einer muß dasein," schreibt Kafka, "einer muß wachen."—Das Gedicht—eine endlose Vigilie'. Celan, *Meridian*, p. 91.
[26] 'Einer muß wachen, heißt es. Einer muß dasein' ('Someone has to keep watch, they say. Someone has to be there'; *NS II*, 260–1).

References to Kafka's life and texts appear throughout his writings; one of the most prominent such intertexts is Kafka's 'Hunter Gracchus'. In the third part of his prose text *Schwindel. Gefühle.* (Vertigo, 1990), Sebald retraces Kafka's 1913 trip to Vienna and northern Italy, which inspired his 'Gracchus' story, but the hunter and his ghostly vessel also appear in other parts of the narrative. Gracchus embodies an existential homelessness, reflected in the motif of the endless journey, which is rooted in a fluid and unstable attention. Drawing an analogy between Sebald's plots and narrative structure, J. J. Long speaks of Sebald's 'ambulatory' storylines and his 'poetics of digression'.[27] His narrators are often led astray, either because they are lost in thought or because they are too easily side-tracked, captivated by what they encounter. In this regard, Sebald's narrators are the heirs of both Gracchus (who plunges to his death while pursuing a mountain-goat) and his helmsman, who is absorbed, and hence led off course, by the sight of the hunter's beautiful homeland.

This unstable kind of attention is disorienting but also productive. Sebald's texts are full of unexpected diversions involving flashbacks, dream sequences, and sudden leaps into another storyline. His most meandering text is *Die Ringe des Saturn* (The Rings of Saturn, 1995), where a walk along the Suffolk coast gives rise to a succession of excursi which take the reader into other times and places. A recurring thread is colonialism—the atrocities committed by the Belgian colonial rule in Congo, for instance, or the English and French invasion of China. But the narrative also touches on more recent history and, in a controversial chapter, segues from the plight of the herring species at the hands of humans to the Holocaust.[28]

Sebald's textual strategy chimes with what the US historian Michael Rothberg calls 'multidirectional memory'. Debates about collective memory, he argues, are often implicitly competitive, in that the engagement with one period of violence and oppression is seen to detract from other, equally urgent such instances. Rothberg gives the example of the Holocaust Memorial Museum in Washington, DC, which has been criticized by activists campaigning for a greater focus on the history of colonialism and slavery and its present-day legacy. Underlying this argument, though Rothberg does not put it in these terms, is the familiar notion that attention is limited in its scope or 'bandwidth'. In

[27] J. J. Long, *W. G. Sebald: Image, Archive, Modernity* (Edinburgh: Edinburgh University Press, 2007), pp. 130; 137 and *passim*. Long describes this narrative approach, which requires repeated rereading, as 'uneconomic', running contrary to the modern drive for fast, effortless consumption (p. 140).

[28] This transition occurs in chapter three, where an extended account of creaturely suffering is immediately followed by a passage about the liberation of the Bergen-Belsen concentration camp in 1945. A double-page photograph, which remains uncommented upon in the text, shows hundreds of corpses of prisoners in a forest near the camp. W. G. Sebald, *Die Ringe des Saturn: Eine englische Wallfahrt* (Frankfurt a.M.: Fischer, 1997), p. 78–9; W. G. Sebald, *The Rings of Saturn*, trans. Michael Hulse (London: Harvill, 1998), pp. 60–1.

response, Rothberg advocates a different, multidirectional model of memory, which is capable of connecting different histories of suffering.[29] As he stresses, the engagement with the Holocaust intersects with other instances of oppression and violence, such as colonialism.[30]

In Sebald's texts, such intersections make for effective and poignant reading, but they do require a great deal of alertness on the part of the reader. Some transitions between narrative strands are jarring and abrupt while others are barely noticeable. In chapter eight of *The Rings of Saturn*, for instance, the narrative switches mid-paragraph into a dream sequence, which at first appears to take place in the English country house of Boulge, the current station of the narrator's journey, but then turns out to be set in an unnamed Irish country estate, which the narrator claims to have visited some years ago. This disorienting segue is immediately preceded by an allusion to Kafka's 'Hunter Gracchus'. Lying in his bed in the Woodbridge inn, the narrator feels 'as if I were in a cabin aboard a ship on the high seas, as if the whole building were rising on the swell of a wave, shuddering a little on the crest, and then, with a sigh, subsiding into the depths'.[31] This passage takes us back to *Vertigo*, whose narrator also feels afloat, as if on a ship with Gracchus and his helmsman.[32] The recurrence of the ship imagery in *The Rings of Saturn* implies that Sebald's protagonists are no more in charge of their physical and mental journey than Kafka's characters. Sebald emulates Kafka's poetics of digression in texts which repeatedly shift between different times and places. The effect of this technique can be vertiginous, but it enables Sebald's narratives to range widely across history, connecting apparently unrelated incidents, particularly of violence and suffering. But there is a flipside to this mental and narrative agility. Time and again, deep, melancholy contemplation stalls the movement of the narrative, in a pattern which reflects a constitutive tension at the heart of Sebald's texts.

All of Sebald's protagonists are prone to the saturnine state, which is referenced in the title *The Rings of Saturn*. In his treatment of melancholy, Sebald's interlocutor is not Kafka but Benjamin, whose *Origin of the German Trauerspiel* is one of Sebald's most important intertexts. His 1963 edition of Benjamin's text

[29] Michael Rothberg, *Multidirectional Memory: Remembering the Holocaust in the Age of Decolonization* (Stanford, CA: Stanford University Press, 2009), p. 11.
[30] Rothberg, *Memory*, p. 6.
[31] Sebald, *The Rings*, p. 208; 'als läge ich in einer Kajüte auf einem Schiff, als befänden wir uns auf hoher See, als höbe das ganze Haus sich auf den Kamm einer Welle, als zitterte es dort ein wenig und senkte sich dann mit einem Seufzer in die Tiefe hinab'. *Die Ringe*, p. 247. The narrator adds, 'Eingeschlafen bin ich erst im Morgengrauen mit dem Schrei einer Amsel im Ohr' ('I only fell asleep at the break of dawn with the call of a blackbird in my ear'), a possible allusion to Musil's 'The Blackbird', in which the song of a blackbird also triggers an altered state of awareness.
[32] W. G. Sebald, *Schwindel. Gefühle* (Frankfurt a.M.: Fischer, 1994), p. 204; W. G. Sebald, *Vertigo*, trans. Michael Hulse (London: Vintage, 2002), p. 179.

contains underlinings in no fewer than nine different colours[33]—a veritable palimpsest of annotations, which testifies to his intermittent and yet sustained engagement with this text over the course of several decades.

In a passage underlined by Sebald, Benjamin notes 'the penchant of the melancholic for distant journeys',[34] a remark borne out by Sebald's narrators, who are often propelled by an amorphous sense of dread. In the foreword to his collection of essays on Austrian literature, Sebald mounts an emphatic defence of the melancholy state:

> Melancholie, das Überdenken des sich vollziehenden Unglücks, hat aber mit Todessucht nichts gemein. Sie ist eine Form des Widerstandes. [...] Wenn sie, starren Blicks, noch einmal nachrechnet, wie es nur so hat kommen können, dann zeigt es sich, daß die Motorik der Trostlosigkeit und diejenige der Erkenntnis identische Exekutiven sind. Die Beschreibung des Unglücks schließt in sich die Möglichkeit zu seiner Überwindung ein.[35]
>
> [Melancholy, reflecting on the unfolding misfortune, has nothing in common with a longing for death. It is a form of resistance. [...] When with a rigid gaze it calculates how things could have come to such a pass, the motor activity of despondence and of knowledge are identical. The description of misfortune includes within itself the possibility of its overcoming.]

Melancholy is active and productive, involving *Überdenken* (reflection), *Beschreibung* (description), and *Überwindung* (overcoming). Pondering the (desolate) state of the world requires a willingness to immerse oneself in discarded objects, to confront forgotten instances of human and creaturely suffering. This close engagement is a 'form of resistance' as well as the first step in overcoming it. Sebald's reference to the 'Motorik', the motor activity, of melancholy echoes Benjamin's 'intermittent rhythm of continual arrest, sudden reversal, and new consolidation'[36] as the underlying pattern of the Baroque *Trauerspiel*.

Benjamin highlights the productive effects of melancholy, its 'faithfulness' to a world of objects which it 'rescues' from oblivion, but he also warns against its excessive, pathological dimension, its ossifying effect on both subject *and* object.

[33] According his former colleague Richard Sheppard, Sebald's 'increasingly dark view of the present, his growing, self-confessed disposition to melancholy' were almost certainly reinforced by his reading of Benjamin's *Trauerspiel* study: 'Dexter—Sinister: Some Observations on Decrypting the Morse Code in the Work of W. G. Sebald', *Journal of European Studies*, 35 (2005), 419–63 (p. 425).

[34] Walter Benjamin, *Origin of the German Trauerspiel*, trans. Howard Eiland (Cambridge, MA: Harvard University Press, 2019), p. 152; the 'Neigung des Melancholischen zu weiten Reisen' (*BGS* I.1, 326).

[35] W. G. Sebald, *Die Beschreibung des Unglücks: Zur österreichischen Literatur von Stifter bis Handke* (Frankfurt a.M.: Fischer, 1994), p. 12.

[36] Benjamin, *Origin*, p. 213; the 'intermittierende Rhythmik eines beständigen Einhaltens, stoßweisen Umschlagens und neuen Erstarrens' (*BGS* I.1, 373).

Sebald's preface does not acknowledge this danger; his prose narratives, however, testify to it implicitly and at times perhaps inadvertently.

A key scene in his last novel, *Austerlitz* (2001), is set in the Czech garrison town of Terezín, the site of the former ghetto where the protagonist's mother was imprisoned by the Nazis. Austerlitz has come to Terezín on his quest to retrace his mother's journey, but the town appears closed off and deserted, reflecting his struggle to gain emotional access to the past. But then his attention is suddenly captivated by the window of a second-hand shop. The displayed objects include an

> elfenbeinfarbene[...] Porzellankomposition, die einen reitenden Helden darstellte, der sich auf seinem soeben auf der Hinterhand sich erhebenden Roß nach rückwärts wendete, um mit der linken Hand ein unschuldiges, von der letzten Hoffnung verlassenes weibliches Wesen zu sich emporzuziehen und aus einem dem Beschauer nicht offenbarten, aber ohne Zweifel grauenvollen Unglück zu retten.[37]

> [ivory-colour porcelain group of a hero on horseback turning to look back, as his steed rears up on its hindquarters, in order to raise up with his outstretched left arm an innocent girl already bereft of her last hope, and to save her from a cruel fate not revealed to the observer.[38]]

A female figure is rescued by a proverbial knight in shining armour; this moment of *Rettung* is immortalized in this figurine, but also revealed in its profound ambiguity. This passage is an oblique echo of Benjamin's 'Handkerchief' novella, another text which is annotated in Sebald's edition.[39] In Benjamin's novella, the idea of an impossible and yet successful rescue mission is dramatically brought to life; in *Austerlitz* rescue is not narrated but presented as a clichéd, meaningless pose. What sets the two scenes apart is also the mindset associated with them. Benjamin's hero embodies utmost *Geistesgegenwart* in the moment of extreme danger, as the body performs a feat deemed impossible by the mind. No such impulse is discerned by or indeed in Austerlitz as he ponders the figurine:

> So zeitlos wie dieser verewigte, immer gerade jetzt sich ereignende Augenblick der Errettung waren sie alle, die in dem Bazar von Terzín gestrandeten Zierstücke, Gerätschaften und Andenken, die aufgrund unerforschlicher Zusammenhänge ihre ehemaligen Besitzer überlebt und den Prozeß der Zerstörung überdauert

[37] W. G. Sebald, *Austerlitz* (Munich: Hanser, 2001), pp. 280–1.
[38] W. G. Sebald, *Austerlitz*, trans. Anthea Bell, intro. James Wood (London: Penguin, 2018), p. 276.
[39] For details of Sebald's annotations, see Carolin Duttlinger, 'Walter Benjamin', in *Sebald-Handbuch: Leben—Werk—Wirkung*, ed. Claudia Öhlschläger and Michael Niehaus (Stuttgart: Metzler, 2017), pp. 285–9.

hatten, so daß ich nun zwischen ihnen schwach und kaum kenntlich mein eigenes Schattenbild erkennen konnte.⁴⁰

[They were all as timeless as that moment of rescue, perpetuated but for ever just occurring, the ornaments, utensils and mementoes stranded in the Terezín bazaar, objects that for reasons one could never know had outlived their former owners and survived the process of destruction, so that I could now see my own faint shadow image barely perceptible among them.⁴¹]

The displayed objects are 'Zierstücke', ornaments, rather than objects of use; like baroque allegorical objects, they have become detached from daily life and drained of meaning. Austerlitz leans his head against the glass, adopting the classic pose of melancholy contemplation. Like a seventeenth-century melancholic, he ponders the objects in question, reading them as the remnants and emblems of destruction. Indeed, this melancholy perspective is not limited to the protagonist but pervades the entire narrative. The above passage hints that the displayed objects used to belong to the victims of Nazi genocide, having survived this 'process of destruction' only to end up in this shop window. The narrative gives no further evidence to support this claim, which seems far-fetched given the sensitivities around the commemoration of the Holocaust, which would surely prevent the possessions of its victims being put up for sale. Within the narrative, however, this passage is symptomatic of a more general tendency to see all parts of reality through a gaze tinted with melancholy. Indeed, the above passage even spells out this process of projection, as Austerlitz's sees his own reflection, or 'Schattenbild', overlaid with the objects on display. While their melancholy disposition attunes Sebald's protagonists to instances of suffering, there is also a narcissistic side to this, which causes them to see suffering and destruction wherever they turn. Attention can create multidirectional links between different times and spaces, but there is also a tendency for this movement to stall, for the melancholy gaze to grow rigid, and for the text to give way to silence.

Sebald's texts underline what is already apparent in Celan, namely how postwar writers turn to earlier, modernist and early modern, discourses about attention in their own attempts to reflect on mindfulness and remembrance. My third and final writer is also concerned with this nexus between attention and memory, though she does not explicitly engage with either Kafka or Benjamin. On closer inspection, however, Felicitas Hoppe (b. 1960) continues these preceding discussions both in her theoretical writings, where matters of attention take centre stage, and in her narratives, which enact the different facets of this state.

⁴⁰ Sebald, *Austerlitz*, p. 281. ⁴¹ Sebald, *Austerlitz*, trans. Bell, pp. 276–7.

Hoppe: Leaping and Swimming

When Hoppe was awarded the Büchner Prize in 2012, she was suddenly catapulted into the limelight, having previously been a rather niche author, whose complex and allusive prose texts were seen as extravagant, anachronistic, and even hermetic.[42] Hoppe's hermeticism is quite different from Celan's; her prose writings are playful and multi-layered, with a notable penchant for meta-fictional and self-reflexive narration. Her 2012 'dream biography' *Hoppe* is a virtuosic example. It simultaneously caters for and subverts the fascination with the author as a public figure, with narratives of personal formation, by blurring the boundaries between fact and fiction.[43] The text starts with an extract from Hoppe's Wikipedia page but then proceeds to obscure the empirical author behind multiple layers of invention. Like the author, the fictional 'Hoppe' hails from the north German town of Hamelin, but she then migrates, both physically and in a literary sense, from this shared starting point into more exotic territory. In the course of the novel, she lives in Canada, Australia, and the United States, pursues careers as a hockey player and conductor, and has love affairs with both real-life and fictional people. *Hoppe* makes great demands on the reader's acuity as biographical facts are 'overtaken by fiction at every turn of the plot, and each fiction intersects with or gives rise to multiple others'.[44] Authorial identity is fractured into multiple personae, which include the novel's creator, its protagonist, and the text's narrator or editor, who interjects the narrative with parenthetical comments initialled 'fh'.

This playfully self-reflexive approach extends to Hoppe's theoretical writings. Her essays and lectures provide an ongoing meta-poetic commentary on her own work; in this discourse, the unpredictable workings of attention play a central role, in relation to creative writing and particularly its engagement with the past. Hoppe has repeatedly distanced herself from the current boom in historical fiction, a genre which she accuses of catering for readers' escapist desire. Such desire is based on a false premise: novels cannot offer 'authentic' access to the past, for they are rooted in the present and hence reshape the past according to their own agenda; therefore, 'to be transported into another time is wholly impossible'.[45]

[42] Michaela Holdenried, 'Introduction', in *Felicitas Hoppe: Das Werk*, ed. Michaela Holdenried (Berlin: Schmidt, 2015), pp. 7–10 (p. 7).

[43] Described in the back blurb as the author's 'dream biography', 'in der Hoppe von einer anderen Hoppe erzählt' ('in which Hoppe tells [the story] of another Hoppe'), the text's subtitle labels it a novel. Felicitas Hoppe, *Hoppe: Roman* (Frankfurt a.M.: Fischer, 2012).

[44] Myrto Aspioti, 'Uncertain Identities in German-Language Novels since 2010' (doctoral dissertation, University of Oxford, 2019), p. 170.

[45] '[S]ich in eine andere Zeit zu versetzen, ist aber ganz unmöglich'. Felicitas Hoppe, 'Über Geistesgegenwart', in *Felicitas Hoppe im Kontext der deutschsprachigen Gegenwartsliteratur*, ed. Stefan Neuhaus and Martin Hellström (Innsbruck: Studienverlag, 2008), pp. 11–24 (p. 21). Or, as

This impossibility is at the heart of *Johanna* (2006), Hoppe's subversive take on the historical novel. The novel's unnamed first-person narrator is a doctoral student in history who is working on a dissertation about Joan of Arc but struggles to maintain an emotional distance from her subject. She is deeply affected by Joan's (in German, Johanna's) capture, trial, and execution, unable to distance herself from her story: 'Johanna is burning, and I am asleep'.[46] This juxtaposition underlines both the stark contrast between past and present and their interconnection. The narrator's dissertation is mocked by her supervisor as overly emotional, more akin to a novel than to a piece of historical research.[47] He declares that such research must involve 'persistently seeking out the old sources in order to find out what really happened',[48] an echo of the Rankian dictum of reconstructing the past 'as it had really been'. The novel casts this project as futile, a futility which dates back all the way to Johanna's death:

> Wir sitzen seit sechshundert Jahren am Feuer [...]. Lieder werden gesungen, Stöckchen unter die Asche geschoben, auf der Suche nach Resten, nach Hinweisen, Funden, nach irgendwas, das wir anfassen können und das die ganze Geschichte erklärt. Wie traurig und sentimental uns das macht, die einfache Tatsache, dass wir nichts finden, weder Zacken noch Fetzen, auch kein schlagendes Herz.[49]
>
> [For six hundred years we have been sitting round the fire [...]. Songs have been sung, sticks poked into the ashes in search of remains, of clues, discoveries, of anything we are able to touch and which can explain the whole story. How sad and sentimental this makes us, the simple fact that we find nothing—no scraps or rags, nor a beating heart.]

The burnt remains of Joan's body were thrown into the Seine, but according to legend, her heart remained intact. For those seeking to understand her story, the narrator suggests, sifting through the ashes, the dead remains of the past, will not yield any usable clues, least of all Johanna's heart, a synecdoche for the living person. And yet this heart is within the grasp of those who have the courage to reach for it:

> Das fehlende Herz macht uns sehr zu schaffen, es hätte so gut in die Sammlung gepasst, wir hatten es schon so deutlich vor Augen, an manchen Tagen zum

Hoppe puts it in *Johanna*: 'Eine Flucht ist in Wahrheit völlig unmöglich' ('An escape [from the present] is in truth completely impossible'). Felicitas Hoppe, *Johanna: Roman* (Frankfurt a.M.: Fischer, 2006), p. 145.

[46] 'Johanna brennt und ich schlafe'. Hoppe, *Johanna*, p. 34. [47] Hoppe, *Johanna*, p. 123.
[48] '[...] beharrlich die alten Quellen aufsuchen, um zu wissen, was damals wirklich geschah'. Hoppe, *Johanna*, p. 73.
[49] Hoppe, *Johanna*, p. 56.

Greifen nah, als müssten wir nur die Hand ausstrecken und selber beherzt ins Wasser fassen. Denn das menschliche Herz schwimmt meistens weit oben. Um das zu wissen, muss man kein Taucher sein.[50]

[The missing heart troubles us greatly, it would have fitted so well into the collection; we had already envisaged it clearly, and on some days it seemed tangibly close, as if we only had to stretch out our hand and reach confidently [*beherzt*] into the water. For the human heart tends to float close to the top. To know this, one does not have to be a diver.]

Recovering Johanna's heart from the water requires a decisive leap into the treacherous element—precisely the kind of leap described in 'The Handkerchief'. Benjamin's novella casts rescue as an impossible feat which nonetheless has to be attempted. In *Johanna*, the professor's postdoctoral assistant Peitsche (Whip) encourages the narrator to take this literal and metaphorical plunge:

Sind Sie schon in der Seine gewesen [...]. Können Sie überhaupt schwimmen? Sie sehen nicht aus, als ob Sie gern schwimmen [...]. Beim Schwimmen kommt man auf andere Gedanken, das heißt, die Gedanken verschwinden einfach, weil man mit Schwimmen beschäftigt ist. Mit Atmen, wenn Sie so wollen. Sie sehen nicht aus, als ob Sie das wollen. Vielleicht später, im Sommer, es ist ja erst Mai, keiner springt gern ins kalte Wasser. Übrigens, konnte Johanna schwimmen?[51]

[Have you been in the Seine [...]. Can you even swim? You don't look like you like swimming [...]. While swimming one is able to think of different things, or rather, one's thoughts simply disappear for one is busy swimming. Or breathing, if you like. You don't look like that's what you want to do. Maybe later, in the summer, it's only May after all, no one likes jumping into cold water. By the way, could Johanna swim?]

The leap into the water requires courage, overcoming one's inhibitions, but once in the water, the swimmer is immersed both physically and mentally, as a different kind of movement facilitates a different way of thinking.

Peitsche concludes his advice to the narrator with a rather abrupt question: 'By the way, could Johanna swim?'. His remark is later echoed by the narrator: 'By the way, could Johanna swim? Johanna certainly couldn't swim. [...] She's off to join the soldiers, we're off to the swimming pool; she's off to war, we're off into the summer break. She's off to battle, we're off to enjoy ourselves'.[52] Here, Hoppe

[50] Hoppe, *Johanna*, p. 56. [51] Hoppe, *Johanna*, p. 26.
[52] 'Übrigens, konnte Johanna schwimmen? Johanna konnte sicher nicht schwimmen. [...] Sie zu den Soldaten, wir ab ins Schwimmbad, sie in den Krieg und wir in den Sommer. Sie in die Schlacht und wir ins Vergnügen'. Hoppe, *Johanna*, p. 51.

uses her trademark technique of juxtaposing the past and the present, but in this instance the apparent contrast conceals a deeper affinity. Swimming, like the engagement with history, is risky and dangerous, requiring a leap into the unknown. The narrator muses: 'Water is only beautiful from afar, as the distant view from a balcony, and only as long as one doesn't have jump in. Just like war'.[53]

This analogy between swimming and warfare is not unique to Hoppe's novel; in fact, it can be traced back to one of the most famous manuals of military strategy— Prussian general Carl von Clausewitz's influential treatise *Vom Kriege* (On War, 1832-4).[54] Svenja Frank has convincingly read *Johanna* in the light of Clausewitz's text, which uses swimming to explain the difference between a military strategy and its practical implementation. Swimming strokes can be practised on dry land, but nothing can prepare the swimmer for the experience of doing them in the water. By analogy, Clausewitz argues, warfare is 'movement under adverse conditions'.[55] Indeed, he later returns to the water metaphor in a passage which discusses the mindset required in combat. This time, the water is negotiated not by the swimmer but by the captain of a ship. War is like

> ein unbefahrenes Meer voll Klippen, die der Geist des Feldherrn ahnen kann, die aber sein Auge nicht gesehen hat, und die er nun in dunkler Nacht umschiffen soll. Erhebt sich noch ein widriger Wind, d.h. erklärt sich noch irgendein großer Zufall gegen ihn, so ist die höchste Kunst, Geistesgegenwart und Anstrengung da nötig, wo dem Entfernten alles von selbst zu gehen scheint.[56]
>
> [an uncharted sea full of cliffs, which the mind of the general can fathom, but which his eye has not seen, and which he now has to circumnavigate in the dark of night. If he then also faces a headwind, that is to say, some great adverse coincidence, then his greatest ingenuity, presence of mind, and exertion are needed where, to the distant observer, everything seems to be going smoothly.]

Johanna echoes Clausewitz's treatise both in its analogy between water and warfare and its emphasis on presence of mind as essential in the face of danger. For the narrator, Johanna's fearlessness and spontaneity make her a figure of

[53] 'Wasser ist nur von weitem schön, als ferne Aussicht von einem Balkon, nur solange man nicht hineinspringen muss. Genau wie der Krieg'. Hoppe, *Johanna*, p. 168.

[54] Frank calls the imagery of swimming and warfare in *Johanna* an 'unmarked reference' to Clausewitz's book. Svenja Frank, 'Ikonisches Erzählen als Einheit von Realität und Imagination: Zum Verhältnis von ästhetischer Reflexion und narrativer Realisation im Werk von Felicitas Hoppe', in *Ehrliche Erfindungen: Felicitas Hoppe als Erzählerin zwischen Tradition und Transmoderne*, ed. Svenja Frank and Julia Ilgner (Bielefeld: Transcript, 2016), pp. 207-36 (p. 218).

[55] '[...] eine Bewegung im erschwerenden Mittel'. Carl von Clausewitz, *Vom Kriege: Hinterlassenes Werk des Generals von Clausewitz*, ed. Werner Hahlweg, 18th edn (Bonn: Dümmler, 1973), p. 263.

[56] Clausewitz, *Vom Kriege*, p. 263.

admiration,⁵⁷ and Hoppe echoes this sentiment, revealing in an article that Johanna's vigilance and skills as a military strategist were what first motivated her to write the novel.⁵⁸

Hoppe returns to matters of attention and distraction in two public lectures where she reflects on her own approach to creative writing. In the first one, entitled 'Über Geistesgegenwart' (On Presence of Mind, 2008), she tackles a common problem, namely writer's block, on which countless self-help guides have been written and which is often associated with our frantic modern world. As she retorts, however,

> Schreibblockaden sind reine Erfindung. Nicht dass es keine Blockaden gäbe, nur sind diese von anderer Art. Die Behauptung der Schreibblockade dient einzig dem Zweck, uns darüber hinweg zu täuschen, dass wir in Wahrheit noch gar nicht wissen, worauf wir mit all den Schätzen, die wir gesammelt haben, eigentlich hinauswollen.⁵⁹
>
> [writer's block is a pure invention. That's not to say that blockades don't exist, but they're of a different kind. In claiming to suffer from writer's block, we merely want to ignore the fact that in truth we do not yet know where we want to go with all the treasures we have collected.]

For Hoppe, writer's block is a form of procrastination. In fact, it is a sham problem, one which stems not from a lack of concentration but, on the contrary, from an unhealthy detachment from everyday life. Overcoming this state of inertia does not require psychotechnics or autosuggestion but a much simpler practical solution:

> Erst wenn der Druck unerträglich wird, weil das Umzugsunternehmen bereits vor der Tür steht, tun wir, was jede gute Hausfrau täglich tut und aus dem Handgelenk beherrscht: Wir beginnen, Ordnung zu machen, das Wichtige vom Unwichtigen zu trennen, zu unterscheiden, was zu bewahren, was zu verwerfen ist, was in den Papierkorb gehört und was auf den Schreibtisch. Die Hausfrau ordnet, wählt aus und sortiert und ist damit Meisterin über den Zufall.⁶⁰
>
> [Only when the pressure becomes unbearable, because the removal company is already outside the door, then we do what every good housewife does every day

⁵⁷ Her supervisor, in contrast, warns: 'Was lehrt uns Johanna? [...] Überstürzung ist ungesund und gefährlich. Sehr richtig. Stattdessen Ausdauer und Hartnäckigkeit' ('What do we learn from Johanna? [...] Impulsiveness is unhealthy and dangerous. Quite right. What's needed is endurance and persistence'). Hoppe, *Johanna*, p. 32.

⁵⁸ Felicitas Hoppe, 'Auge in Auge: Über den Umgang mit historischen Stoffen', *Neue Rundschau*, 1 (2007), 56–69 (p. 67).

⁵⁹ Hoppe, 'Geistesgegenwart', p. 19. ⁶⁰ Hoppe, 'Geistesgegenwart', p. 20.

and without thinking [in a completely routine fashion]: we start to tidy up, to separate the important from the unimportant stuff, to distinguish between what to keep and what to throw away, between what belongs in the bin and what on the desk. The housewife arranges, selects, and sorts, and in this way she's mistress over chance.]

The housewife who gets on with her daily work is the antidote to the male scholar immersed in his study. Indeed, she is the successor of the nameless woman in Kafka's late fragment 'Breathless, I arrived...', who dismisses the narrator's quest for immersion as a 'whim', as evidence of people's 'enslavement' to unattainable ideals.

Ten years later, Hoppe returns to this theme in a lecture about creative writing and inspiration. Inspiration, she says, requires three cardinal virtues: patience (*Geduld*), endurance (*Ausdauer*), and presence of mind (*Geistesgegenwart*). Patience enables the writer to wait, 'which has become a rare virtue at a time when all of us—authors, editors, agents, and readers—are subject to the diktat of accelerated production'.[61] Endurance in turn is vital for completing a project. Fostering it requires

> Training und Übung, ohne die kein Ziel zu erreichen ist. Mit der Geduld in eins gebracht, kann man sie auch als Beharrungsvermögen bezeichnen. Keine Idee, und sei sie noch so schön, ist ohne Training und Übung in das zu verwandeln, was wir am Ende einen bündigen Text nennen.[62]
>
> [training and practice, without which no goal can be reached. If combined with patience, it can also be described as persistence. No idea, no matter how beautiful, can be transformed into what, in the end, we call a coherent text without training and practice.]

Here, Hoppe echoes her earlier lecture by emphasizing the pragmatic attitude that is required when writing. To illustrate her third virtue, presence of mind, she gives another example taken not from writing but from sport. Presence of mind means living in the present, ready for that moment when

[61] '[...] warten zu können, eine selten gewordene Tugend in einer Zeit, in der wir alle, Schreibende, Verleger, Agenten und Leserinnen, der Diktatur beschleunigter Produktion unterworfen sind'. The latter, she adds, is a self-destructive trend in a society 'die an ihrer eigenen Produktion längst zu ersticken droht' ('which is being suffocated by its own production'). Felicitas Hoppe, 'Schreiben 1: Mythos Inspiration', in *Schreiben: Dortmunder Poetikvorlesungen von Felicitas Hoppe; Schreibszenen und Schrift—literatur- und sprachwissenschaftliche Perspektiven*, ed. Ludger Hoffmann and Martin Stingelin (Munich: Fink, 2018), pp. 11–24 (p. 15).

[62] Hoppe, 'Schreiben', p. 15.

das Tor wirklich fällt. Der von Hoppe immer wieder zitierte Satz 'Wer zögert, verliert!' meint also nicht Übereilung und überstürztes Handeln, sondern schlicht die Fähigkeit, den passenden Moment zu erkennen, in dem Gelingen tatsächlich möglich ist. Die Griechen nannten das Kairos.[63]

[the goal is actually scored. Hence Hoppe's oft-cited sentence 'If you hesitate you lose!' does not mean a mad rush and premature action but simply the ability to spot that opportune moment when it is actually possible to succeed. The Greeks called it kairos.]

Elaborating on the concept of kairos, Hoppe calls presence of mind a gift ('eine Gabe'), and in her 'On Presence of Mind' lecture, she cites the Brockhaus definition of *Geistesgegenwart* which refers to the definition of *Geist* as (holy) spirit.[64] Expanding on this definition, she concludes that presence of mind combines two elements, 'Besonnenheit und rasche Entschlusskraft' ('thoughtfulness and quick decisiveness'). She adds that thoughtfulness is not identical with contemplation, 'but the result of gathering one's mind, that is, of using our senses, of lucid perception and concentration'. To illustrate this state, Hoppe sketches out a particular situation, namely 'a night spent on a very high mountain, without which decisions cannot be made'.[65] Here, we find yet another echo of Kafka's 1920 fragment 'Immersed in the Night...', which plays such a pivotal role in Celan's reflections on the poetics (and politics) of vigilance. To be sure, Hoppe's lecture is not underpinned by the same sense of political urgency as Celan's speech, but her comments hark back to the same long religious and literary tradition which emphasizes the importance of alertness in times of crisis.

In their explorations of attention since the 1960s, Celan, Sebald, and Hoppe all echo historical precursors. Celan and Sebald refer to Kafka and Benjamin, both separately and in conjunction; Hoppe does not explicitly reference these authors, and yet she uses very similar images and narratives to set out her own, multifaceted notion of attention as sustained yet mobile, patiently waiting to take the plunge.

As this concluding chapter has shown, the engagement with (in-)attention remains an open-ended project, one which responds to shifting social conditions while also being part of a longer tradition marked by conflict and debate, but also by fruitful and at times surprising networks and synergies. Texts about attention and distraction use recurring narratives and images, which are adapted over time to resonate with current concerns, but which also reveal enduring fault lines concerning its aesthetic and political implications. Irrespective of where individual

[63] Hoppe, 'Schreiben', p. 15. [64] Hoppe, 'Geistesgegenwart', p. 13.
[65] 'Besonnenheit ist nicht Besinnlichkeit, sondern die Folge von Besinnung, Gebrauch der Sinne also, wache Wahrnehmung und Konzentration, eine Nacht auf einem sehr hohen Berg, ohne die Entschlüsse nicht gefasst werden können'. Hoppe, 'Geistesgegenwart', p. 12.

authors or artists stand on this question, they all grapple with the same underlying challenge: with the unpredictability of world *and* mind, which makes attention and distraction such enduring human concerns. To explore them requires an openness towards the unexpected as opposed to withdrawal from the messiness of life. As this study has argued, the fluid relationship between attention and distraction is no flaw to be fixed but an opportunity—a form of freedom.

Bibliography

Primary Texts

Anon., 'Bestes deutsches Gelehrtenchinesisch: Eine Sendung zum Abschluss der deutschen Proust-Ausgabe', *Katholische Funkkorrespondenz*, 18 (30 April 1958). Typescript, Theodor W. Adorno Archiv, Akademie der Künste Berlin

Anon., 'Können Sie schnell denken? Sind Sie ein guter Beobachter? Neue Intelligenzproben', *Uhu*, 2:11 (1926), 108

Adorno, Gretel, and Walter Benjamin, *Briefwechsel 1930–1940*, ed. Christoph Gödde and Henri Lonitz (Frankfurt a.M.: Suhrkamp, 2005)

Adorno, Theodor W., *Erziehung zur Mündigkeit: Vorträge und Gespräche mit Hellmut Becker, 1959–1969*, ed. Gerd Kadelbach (Frankfurt a.M.: Suhrkamp, 1970)

Adorno, Theodor W., *Minima Moralia: Reflections from Damaged Life*, trans. E. F. N. Jephcott (London: Verso, 1974)

Adorno, Theodor W., 'Arnold Schoenberg, 1874–1951', in Theodor W. Adorno, *Prisms*, trans. Samuel and Shierry Weber (Cambridge, MA: MIT Press, 1981), pp. 147–72

Adorno, Theodor W., 'Cultural Criticism and Society', in Theodor W. Adorno, *Prisms*, trans. Samuel and Shierry Weber (Cambridge, MA: MIT Press, 1981), pp. 17–34

Adorno, Theodor W., 'Notes on Kafka', in Theodor W. Adorno, *Prisms*, trans. Samuel and Shierry Weber (Cambridge, MA: MIT Press, 1981), pp. 243–71

Adorno, Theodor W., 'The Essay as Form', in Theodor W. Adorno, *Notes to Literature*, ed. Rolf Tiedemann, trans. Shierry Weber Nicholson (New York, NY: Columbia University Press, 1991), pp. 29–47

Adorno, Theodor W., 'Words from Abroad', in Theodor W. Adorno, *Notes to Literature*, ed. Rolf Tiedemann, trans. Shierry Weber Nicholson (New York, NY: Columbia University Press, 1991)

Adorno, Theodor W., *Briefe und Briefwechsel*, vol. 1: Theodor W. Adorno/Walter Benjamin, *Briefwechsel 1928–1940*, ed. Henri Lonitz (Frankfurt a.M.: Suhrkamp, 1994)

Adorno, Theodor W., *Aesthetic Theory*, ed. Gretel Adorno and Rolf Tiedemann, new trans. Robert Hullot-Kentor (London: Continuum, 1997)

Adorno, Theodor W., *Gesammelte Schriften*, ed. Rolf Tiedemann, paperback edn, 20 vols (Frankfurt a.M.: Suhrkamp, 1997)

Adorno, Theodor W., 'Free Time', in Theodor W. Adorno, *The Culture Industry: Selected Essays on Mass Culture*, ed. J. M. Bernstein (London: Routledge, 2001), pp. 187–97

Adorno, Theodor W., 'Resignation', in Theodor W. Adorno, *The Culture Industry: Selected Essays on Mass Culture*, ed. J. M. Bernstein (London: Routledge 2001), pp. 198–203

Adorno, Theodor W., 'Music in the Background', in Theodor W. Adorno, *Essays on Music*, ed. Richard Leppert, trans. Susan H. Gillespie (Berkeley, CA: University of California Press, 2002), pp. 506–10

Adorno, Theodor W., 'On the Fetish-Character in Music and the Regression of Listening', in Theodor W. Adorno, *Essays on Music*, ed. Richard Leppert, trans. Susan H. Gillespie (Berkeley, CA: University of California Press, 2002), pp. 288–317

Adorno, Theodor W., *Current of Music: Elements of a Radio Theory*, ed. Robert Hullot-Kentor (Frankfurt a.M.: Suhrkamp, 2006)
Adorno, Theodor W., and Walter Benjamin, *The Complete Correspondence 1928–1940*, ed. Henri Lonitz, trans. Nicholas Walker (Cambridge, MA: Harvard University Press, 1999)
Allgemeines Deutsches Kommersbuch, 55th edn (Lahr: Schauenburg, 1896)
Altenloh, Emilie, *Zur Soziologie des Kinos: Die Kino-Unternehmung und die sozialen Schichten ihrer Besucher*, Schriften zur Soziologie der Kultur, 3 (Jena: Diederichs, 1914)
Balázs, Béla, *Der Geist des Films*, intro. Hartmut Bitomsky (Frankfurt a.M.: Makol-Verlag, 1972)
Balázs, Béla, *Der sichtbare Mensch oder die Kultur des Films*, in Béla Bálazs, *Schriften zum Film*, vol. 1, ed. Helmut H. Diedrichs, Wolfgang Gersch, and Magda Nagy (Munich: Hanser, 1982), pp. 43–143
Balázs, Béla, 'Nicht der Maler, der Gemalte ist schuldig', in *Wechselwirkungen: Ungarische Avantgarde in der Weimarer Republik*, ed. Hubertus Gassner (Marburg: Jonas, 1986), pp. 535–6
Baudouin, Charles, *Suggestion and Autosuggestion: A Psychological and Pedagogical Study*, trans. Eden and Cedar Paul (New York, NY: Dodd, Mead and Company, 1922)
Baudouin, Charles, *Suggestion und Autosuggestion*, trans. Paul Amann (Dresden: Sibyllen-Verlag, 1923)
Baudouin, Charles, *The Power within Us*, trans. Eden and Cedar Paul (London: Allen & Unwin, 1923)
Baudouin, Charles, *Die Macht in uns: Entwicklung einer Lebenskunst im Sinne der neuen Psychologie*, trans. Paul Amann (Dresden: Sibyllen-Verlag, 1924)
Beard, George M., *American Nervousness: Its Causes and Consequences* (New York, NY: Putnam's Sons, 1881)
Bechterew, Wladimir, 'Ueber die Bedeutung der Aufmerksamkeit für die Lokalisation und Entwicklung halluzinatorischer Bilder', *Centralblatt für Nervenheilkunde und Psychiatrie*, 28 (1905), 329–37
Bekker, Paul, 'Physiologische Musik', *Frankfurter Zeitung*, 2 December 1922
Benjamin, Dora, 'Gesunde Nerven', *Berliner Wohlfahrtsblatt: Beilage zum Amtsblatt der Stadt Berlin*, 24 (24 November 1929), 196–7
Benjamin, Dora, 'Verbreitung und Auswirkung der Frauenerwerbsarbeit', in *Die Kultur der Frau: Eine Lebenssymphonie der Frau des XX. Jahrhunderts*, ed. Ada Schmidt-Beil (Berlin: Verlag für Kultur und Wissenschaft, 1931), pp. 155–63
Benjamin, Walter, *Gesammelte Schriften*, ed. Rolf Tiedemann and Hermann Schweppenhäuser, paperback edn, 7 vols (Frankfurt a.M.: Suhrkamp, 1991)
Benjamin, Walter, *Gesammelte Briefe*, ed. Christoph Gödde and Henri Lonitz, 6 vols (Frankfurt a.M.: Suhrkamp, 1995–2000)
Benjamin, Walter, *Selected Writings*, ed. Michael W. Jennings, 4 vols (Cambridge, MA: Belknap Press, 1996–2003)
Benjamin, Walter, *The Arcades Project*, trans. Howard Eiland and Kevin McLaughlin (Cambridge, MA: Harvard University Press, 2002)
Benjamin, Walter, *Werke und Nachlass: Kritische Gesamtausgabe*, ed. Christoph Gödde and Henri Lonitz in collaboration with the Walter Benjamin Archive, 21 vols (Frankfurt a.M.: Suhrkamp, 2008–)
Benjamin, Walter, *Origin of the German Trauerspiel*, trans. Howard Eiland (Cambridge, MA: Harvard University Press, 2019)
Benkard, Ernst, *Das ewige Antlitz: Eine Sammlung von Totenmasken* (Berlin: Frankfurter Verlags-Anstalt, 1926)

Benoist-Hanappier, Louis, *En marge de Nietzsche: Tactique de la volonté* (Paris: Figurière, 1912)

Bergk, Johann Adam, *Die Kunst, Bücher zu lesen, nebst Bemerkungen über Schriften und Schriftsteller* (Jena: Hempel, 1799)

Bergmann, Wilhelm, *Selbstbefreiung aus nervösen Leiden* (Freiburg i.Br.: Herder, 1922)

Bertels, Arved, *Versuch über die Ablenkung der Aufmerksamkeit* (Dorpat: Kaakmann, 1889)

Besseler, Heinrich, 'Grundfragen des musikalischen Hörens', *Jahrbuch der Musikbibliothek Peters*, 32 (1925), 35–52

Besseler, Heinrich, 'Fundamental Issues of Musical Listening (1925)', trans. Matthew Pritchard with Irene Auerbach, *Twentieth-Century Music*, 8 (2012), 49–70

Boisserée, Sulpiz, *Briefwechsel, Tagebücher*, vol. 2: *Briefwechsel mit Goethe*, ed. Mathilde Boisserée (Stuttgart: Cotta, 1862)

Brecht, Bertolt, 'Anmerkungen zur Oper "Aufstieg und Fall der Stadt Mahagonny" [1930]', in *Werke: Große kommentierte Berliner und Frankfurter Ausgabe*, vol. 24: *Schriften 4*, ed. Werner Hecht et al. (Frankfurt a.M.: Suhrkamp, 1991), pp. 74–86

Brecht, Bertolt, 'Kleines Organon für das Theater', in *Werke: Große kommentierte Berliner und Frankfurter Ausgabe*, vol. 23: *Schriften 3*, ed. Werner Hecht et al. (Frankfurt a.M.: Suhrkamp, 1993), pp. 65–97

Brecht, Bertolt, 'Short Organon for the Theatre', in *Brecht on Theatre*, ed. Marc Silberman, Steve Giles, and Tom Kuhn (London and New York, NY: Bloomsbury, 2019), pp. 271–99

Brockes, Barthold Heinrich, *Irdisches Vergnügen in Gott* (Hamburg: Herold 1737; repr. Bern: Lang, 1970)

Bücher, Karl, *Arbeit und Rhythmus*, 2nd rev. edn (Leipzig: Teubner, 1899 [1896])

Büchner, Georg, *Sämtliche Werke, Briefe und Dokumente in zwei Bänden*, ed. Henri Poschmann and Hannelore Poschmann (Frankfurt a.M.: Suhrkamp, 1992)

Campe, Joachim Heinrich, *Über die früheste Bildung junger Kinderseelen*, ed. with an essay by Brigitte H. E. Niestroj (Frankfurt a.M.: Ullstein, 1985)

Cattell, James McKeen, 'Psychometrische Untersuchungen: Erste Abtheilung', *Philosophische Studien*, 3 (1886), 305–35

Celan, Paul, *Der Meridian: Endfassung—Entwürfe—Materialien*, ed. Bernhard Böschenstein and Heino Schmull with assistance from Michael Schwarzkopf and Christiane Wittkop, Paul Celan, Werke: Tübinger Ausgabe, ed. Jürgen Wertheimer (Frankfurt a.M.: Suhrkamp, 1999)

Celan, Paul, *The Meridian: Final Versions—Drafts—Materials*, ed. Bernhard Böschenstein and Heino Schmull with assistance from Michael Schwarzkopf and Christiane Wittkop, trans. and preface Pierre Joris (Stanford, CA: Stanford University Press, 2011)

Clausewitz, Carl von, *Vom Kriege: Hinterlassenes Werk des Generals von Clausewitz*, ed. Werner Hahlweg, 18th edn (Bonn: Dümmler, 1973)

Clauss, Ludwig Ferdinand, 'Das menschliche Antlitz', in *Das deutsche Lichtbild* (Berlin: Robert & Bruno Schultz, 1931), [no page numbers]

Cohn, Jonas, and Werner Gent, 'Aussage und Aufmerksamkeit', *Zeitschrift für angewandte Psychologie und psychologische Sammelforschung*, 1 (1908), 129–52; 233–65

Darwin, Erasmus, *Zoonomia, or, the Laws of Organic Life*, vol. 1 (London: Johnson, 1794)

Demmerling, Christoph, 'Schwerpunkt: Adorno in der Diskussion', *Deutsche Zeitschrift für Philosophie*, 65 (2017), 31–3

Diderot, Denis, 'Distraction (Morale)', in *Encyclopédie, ou dictionnaire raisonné des sciences, des arts et des métiers, par une societé de gens de lettres*, ed. Denis Diderot and Jean le Rond d'Alembert, vol. 4 (Paris: le Breton et al., 1751–80), vol. 4, p. 1061

Döblin, Alfred, 'Von Gesichtern, Bildern und ihrer Wahrheit', in *Kleine Schriften*, vol. 3, ed. Anthony W. Riley (Zurich: Walther, 1999), pp. 203–13

Duchenne (de Boulogne), G.-B., *Mécanisme de la physionomie humaine, ou analyse électrophysiologique de l'expression des passions applicable à la pratique des arts plastiques*, 2 vols (Paris: Renouard, 1862)

Ebbinghaus, Hermann, *Grundzüge der Psychologie*, vol. 1 (Leipzig: Veit, 1902)

Eisenstein, Sergej, 'Zum Prinzip des Helden im Panzerkreuzer Potemkin', in *Schriften*, vol. 2: *Panzerkreuzer Potemkin*, ed. Hans-Joachim Schlegel (Munich: Hanser, 1973), pp. 126–7

Erb, Wilhelm, *Ueber die wachsende Nervosität unserer Zeit* (Heidelberg: Hörning, 1893)

Fechner, Gustav Theodor, *Elemente der Psychophysik*, vol. 2 (Leipzig: Breitkopf & Härtel, 1860, repr. Amsterdam: Bonset, 1964)

Fechner, Gustav Theodor, 'Über einige Verhältnisse des binokularen Sehens', in *Abhandlungen der mathematisch-physischen Classe der königlich sächsischen Gesellschaft der Wissenschaften*, vol. 5 (Leipzig: Hirzel, 1861), pp. 337–565

Fechner, Gustav Theodor, *Einige Ideen zur Schöpfungs- und Entwicklungsgeschichte der Organismen* (Leipzig: Breitkopf und Härtel, 1873)

Freud, Sigmund, *Über Coca* (Vienna: Perles, 1885)

Freud, Sigmund, 'Zum Problem der Telepathie', *Almanach der Psychoanalyse*, 9 (1934), 9–34

Freud, Sigmund, *The Standard Edition of the Complete Psychological Works of Sigmund Freud*, trans. and ed. James Strachey, 24 vols (London: Hogarth Press, 1973)

Freud, Sigmund, 'Über Coca', trans. Steven A. Edminster, *Journal of Substance Abuse Treatment*, 1 (1984), 206–17

Freud, Sigmund, *Gesammelte Werke*, ed. Anna Freud et al., paperback edn, 18 vols (Frankfurt a.M.: Fischer, 1999)

Freud, Sigmund, and Lou Andreas-Salomé, *Briefwechsel*, ed. Ernst Pfeiffer (Frankfurt a.M.: Fischer, 1966)

Gaupp, Robert, 'Der Kinematograph vom medizinischen und psychologischen Standpunkt', in Robert Gaupp and Konrad Lange, *Der Kinematograph als Volksunterhaltungsmittel* (Munich: Dürer-Bund, 1912), pp. 1–12

Gaupp, Robert, 'Der Kinematograph vom medizinischen und psychologischen Standpunkt', in *Medientheorie 1888–1933: Texte und Kommentare*, ed. Albert Kümmel and Petra Löffler (Frankfurt a.M.: Suhrkamp, 2002), pp. 100–14

Gerling, Reinhard, *Die Kunst der Konzentration: Ein Kursus in Unterrichtsbriefen für Geistesarbeiter, Studierende, Beamte, Kaufleute, für Zerstreute, Nervöse, Gedächtnisschwache* (Prien: Anthropos, no date [1920])

Goethe, Johann Wolfgang von, *Sämtliche Werke, Briefe, Tagebücher und Gespräche*, vol. I.8: *Die Leiden des jungen Werthers, Die Wahlverwandtschaften, Kleine Prosa, Epen*, ed. Waltraud Wiethölter (Frankfurt a.M.: Dt. Klassiker-Verlag, 1994)

Grimm, Jacob, and Wilhelm Grimm, *Deutsches Wörterbuch* (Leipzig: Hirzel, 1854–1961); digitized version: *Wörterbuchnetz des Trier Center for Digital Humanities*, Version 01/21, https://www.woerterbuchnetz.de/DWB [accessed 20 January 2022]

Hanausek, Gustav, *Unfallversicherung und Beweislast nach österreichischem Rechte: Zugleich ein Beitrag zur allgemeinen Rechtslehre* (Vienna: Manz, 1916)

Hanslick, Eduard, *Vom Musikalisch-Schönen: Aufsätze, Musikkritiken* (Leipzig: Reclam, 1982)

Hanslick, Eduard, *On the Musically Beautiful*, trans. Geoffrey Payzant (Indianapolis, IN: Hackett, 1986)

Hegel, Georg Wilhelm Friedrich, *Wissenschaft der Logik*, part I: *Die objektive Logik*, vol. 1: *Die Lehre vom Sein*, ed. Hans-Jürgen Gawoll, 2nd edn (Hamburg: Meiner, 2008)
Heidegger, Martin, *Being and Time*, trans. John Macquarrie and Edward Robinson (New York, NY: Harper & Row, 1962)
Heidegger, Martin, *Sein und Zeit*, 11th edn (Tübingen: Niemeyer, 1967)
Hellpach, Willy, *Nervosität und Kultur* (Berlin: Räde, 1902)
Helmholtz, Hermann von, *Handbuch der physiologischen Optik* (Leipzig: Voss, 1867)
Helmholtz, Hermann von, 'Über das Verhältnis der Naturwissenschaften zur Gesamtheit der Wissenschaft', in *Vorträge und Reden*, vol. 1, 5th edn (Brunswick: Vieweg, 1903), pp. 117–45
Herder, Johann Gottfried, 'Cäcilia', in *Zerstreute Blätter*, vol. 5 (Gotha: Ettinger, 1793), pp. 287–320
Hindemith, Paul, 'Über Musikkritik', *Melos*, 8 (1929), 106–9
Hirschberg, Walther, 'Objektive Musik', *Vossische Zeitung*, 20 August 1927
Hölderlin, Friedrich, *Poems and Fragments*, trans. Michael Hamburger (London: Routledge, 1966)
Hölderlin, Friedrich, *Sämtliche Werke und Briefe*, ed. Michael Knaupp (Munich: Hanser, 1992)
Hoppe, Felicitas, *Johanna: Roman* (Frankfurt a.M.: Fischer, 2006)
Hoppe, Felicitas, 'Auge in Auge: Über den Umgang mit historischen Stoffen', *Neue Rundschau*, 1 (2007), 56–69
Hoppe, Felicitas, 'Über Geistesgegenwart', in *Felicitas Hoppe im Kontext der deutschsprachigen Gegenwartsliteratur*, ed. Stefan Neuhaus and Martin Hellström (Innsbruck: Studienverlag, 2008), pp. 11–24
Hoppe, Felicitas, *Hoppe: Roman* (Frankfurt a.M.: Fischer, 2012)
Hoppe, Felicitas, 'Schreiben 1: Mythos Inspiration', in *Schreiben: Dortmunder Poetikvorlesungen von Felicitas Hoppe; Schreibszenen und Schrift—literatur- und sprachwissenschaftliche Perspektiven*, ed. Ludger Hoffmann and Martin Stingelin (Munich: Fink, 2018), pp. 11–24
Horkheimer, Max, 'The End of Reason', in *The Essential Frankfurt School Reader*, ed. Andrew Arato and Eike Gebhardt (New York, NY: Continuum, 1982), pp. 26–48
Horkheimer, Max, 'Vernunft und Selbsterhaltung', in *Gesammelte Schriften*, vol. 5, ed. Alfred Schmidt and Gunzelin Schmid Noerr (Frankfurt a.M.: Fischer, 1987), pp. 320–50
Horkheimer, Max, 'Traditionelle und kritische Theorie', in *Gesammelte Schriften*, vol. 4: *Schriften 1936–1941*, ed. Alfred Schmidt (Frankfurt a.M.: Fischer, 1988), pp. 162–216
Horkheimer, Max, *Gesammelte Schriften*, vol. 15: *Briefwechsel 1913–1936*, ed. Gunzelin Schmidt-Noerr and Alfred Schmidt (Frankfurt a.M.: Fischer, 1995)
Hume, David, *An Enquiry Concerning Human Understanding*, ed. Peter Millican (Oxford: Oxford University Press, 2007)
Husserl, Edmund, *Ideen zu einer reinen Phänomenologie und phänomenologischen Philosophie*, vol. 1, ed. W. Biemel, Husserliana, 3 (The Hague: Nijhoff, 1950)
Husserl, Edmund, *Logical Investigations*, trans. J. N. Findlay (New York, NY: Humanities Press, 1970)
Husserl, Edmund, *Logische Untersuchungen*, vol. 2.1: *Untersuchungen zur Phänomenologie und Theorie der Erkenntnis*, ed. Ursula Panzer, Husserliana, 14.1 (The Hague: Nijhoff, 1984)
Istel, Edgar, 'Die moderne Folterkammer: Auch ein Beitrag zur "Konzertreform"', *Neue Zeitschrift für Musik*, 80:40 (1913), 549
James, William, *The Principles of Psychology*, vol. 1 (New York, NY: Dover, 1950)

Jameson, Fredric, *Marxism and Form* (Princeton, NJ: Princeton University Press, 1971)
Janet, Pierre, *Der Geisteszustand der Hysterischen (Die psychischen Stigmata)* (Leipzig: Deuticke, 1894)
Jevons, William Stanley, 'The Power of Numerical Discrimination', *Nature*, 9 (1871), 281–3
Kafka, Franz, *Das Schloß*, ed. Malcolm Pasley, Franz Kafka: Schriften, Tagebücher, Briefe: Kritische Ausgabe (Frankfurt a.M.: Fischer, 1982)
Kafka, Franz, *Der Verschollene*, ed. Jost Schillemeit, Franz Kafka: Schriften, Tagebücher, Briefe: Kritische Ausgabe (Frankfurt a.M.: Fischer, 1983)
Kafka, Franz, *Diaries, 1910–1923*, ed. Max Brod, trans. Joseph Kresh and Martin Greenberg with the cooperation of Hannah Arendt (New York, NY: Schocken, 1988)
Kafka, Franz, *Der Proceß*, ed. Malcolm Pasley, Franz Kafka: Schriften, Tagebücher, Briefe: Kritische Ausgabe (Frankfurt a.M.: Fischer, 1990)
Kafka, Franz, *Letters to Milena*, trans. Philip Boehm (New York, NY: Schocken, 1990)
Kafka, Franz, *Tagebücher*, ed. Hans-Gerd Koch, Michael Müller, and Malcolm Pasley, Franz Kafka: Schriften, Tagebücher, Briefe: Kritische Ausgabe (Frankfurt a.M.: Fischer, 1990)
Kafka, Franz, *Nachgelassene Schriften und Fragmente II*, ed. Jost Schillemeit, Franz Kafka: Schriften, Tagebücher, Briefe: Kritische Ausgabe (Frankfurt a.M.: Fischer, 1992)
Kafka, Franz, *Nachgelassene Schriften und Fragmente I*, ed. Malcolm Pasley, Franz Kafka: Schriften, Tagebücher, Briefe: Kritische Ausgabe (Frankfurt a.M.: Fischer, 1993)
Kafka, Franz, *Drucke zu Lebzeiten*, ed. Wolf Kittler, Hans-Gerd Koch, and Gerhard Neumann, Franz Kafka: Schriften, Tagebücher, Briefe: Kritische Ausgabe (Frankfurt a.M.: Fischer, 1996)
Kafka, Franz, *Briefe 1900–1912*, ed. Hans-Gerd Koch, Franz Kafka: Schriften, Tagebücher, Briefe: Kritische Ausgabe (Frankfurt a.M.: Fischer, 1999)
Kafka, Franz, *Briefe an Milena*, ed. Jürgen Born and Michael Müller, ext. and rev. edn (Frankfurt a.M.: Fischer, 1999)
Kafka, Franz, *Briefe 1913–März 1914*, ed. Hans-Gerd Koch, Franz Kafka: Schriften, Tagebücher, Briefe: Kritische Ausgabe (Frankfurt a.M.: Fischer, 2001)
Kafka, Franz, *Amtliche Schriften*, ed. Klaus Hermsdorf and Benno Wagner, Franz Kafka: Schriften, Tagebücher, Briefe: Kritische Ausgabe (Frankfurt a.M.: Fischer, 2004)
Kafka, Franz, *Briefe April 1914–1917*, ed. Hans-Gerd Koch, Franz Kafka: Schriften, Tagebücher, Briefe: Kritische Ausgabe (Frankfurt a.M.: Fischer, 2005)
Kafka, Franz, *The Castle*, trans. Anthea Bell, with an introduction and notes by Ritchie Robertson (Oxford: Oxford University Press, 2009)
Kafka, Franz, *The Office Writings*, ed. Stanley Corngold, Jack Greenberg, and Benno Wagner, trans. Eric Patton with Ruth Hein (Princeton, NJ and Oxford: Princeton University Press, 2009)
Kafka, Franz, *The Trial*, trans. Mike Mitchell, with an introduction and notes by Ritchie Robertson (Oxford: Oxford University Press, 2009)
Kafka, Franz, *A Hunger Artist and Other Stories*, trans. Joyce Crick, with an introduction and notes by Ritchie Robertson (Oxford: Oxford University Press, 2012)
Kafka, Franz, *The Man who Disappeared (America)*, trans. with an introduction and notes by Ritchie Robertson (Oxford: Oxford University Press, 2012)
Kafka, Franz, *Letters to Felice*, trans. James Stern and Elisabeth Duckworth (New York, NY: Schocken, 2016)
Kant, Immanuel, *Kants gesammelte Schriften*, ed. the Königlich-Preußische Akademie der Wissenschaften, vol. 10 (Berlin: Reimer, 1900)

Kant, Immanuel, *Kritik der praktischen Vernunft; Kritik der Urteilskraft*, Kants Werke: Akademie-Textausgabe, vol. 5 (Berlin and New York, NY: de Gruyter, 1968)

Kant, Immanuel, *Anthropologie in pragmatischer Hinsicht*, ed. and intro. Wolfgang Becker (Stuttgart: Reclam, 1983)

Kant, Immanuel, *Critique of the Power of Judgement*, ed. Paul Guyer, trans. Paul Guyer and Eric Matthews, The Cambridge Edition of the Works of Immanuel Kant (Cambridge: Cambridge University Press, 2000)

Kant, Immanuel, *Anthropology from a Pragmatic Point of View*, trans. and ed. Robert B. Louden, Cambridge Texts in the History of Philosophy (Cambridge: Cambridge University Press, 2006)

Kolodnaja, A., 'Beiträge zur Berufsanalyse des Lokomotivführerberufs', *Industrielle Psychotechnik*, 5 (1928), 278

König, Theodor, *Reklame-Psychologie: Ihr gegenwärtiger Stand—ihre praktische Bedeutung* (Munich and Berlin: Oldenbourg, 1924)

Kracauer, Siegfried, 'Kult der Zerstreuung: Über die Berliner Lichtspielhäuser', in *Das Ornament der Masse: Essays* (Frankfurt a.M.: Suhrkamp, 1977), pp. 311–17

Kracauer, Siegfried, 'Die Photographie', in *Schriften*, vol. 5.2: *Aufsätze 1927–1931*, ed. Inka Mülder-Bach (Frankfurt a.M.: Suhrkamp, 1990), pp. 83–98

Kracauer, Siegfried, 'Kleine Signale', in *Schriften*, vol. 5.2: *Aufsätze 1927–1931*, ed. Inka Mülder-Bach (Frankfurt a.M.: Suhrkamp, 1990), pp. 234–6

Kracauer, Siegfried, 'Cult of Distraction: On Berlin's Picture Palaces', in *The Mass Ornament: Weimar Essays*, trans., ed., and intro. Thomas Y. Levin (Cambridge, MA: Harvard University Press, 1995), pp. 323–8

Kracauer, Siegfried, *Soziologie als Wissenschaft, Der Detektiv-Roman, Die Angestellten*, ed. Inka Mülder-Bach with Mirjam Wenzel, Siegried Kracauer, Werke, vol. 1 (Frankfurt a. M.: Suhrkamp, 2006)

Krafft-Ebing, Richard von, *Über gesunde und kranke Nerven* (Tübingen: Laupp, 1885)

Krafft-Ebing, Richard von, *Nervosität und neurasthenische Zustände* (Vienna: Hölder, 1895)

Lamprecht, Karl, 'Was ist Kulturgeschichte? Beitrag zu einer empirischen Historik', *Deutsche Zeitschrift für Geschichtswissenschaft*, Neue Folge, 1 (1896/97), 75–150

Lamprecht, Karl, *Deutsche Geschichte, Ergänzungsband 1: Zur jüngsten deutschen Vergangenheit*, vol. 1: *Tonkunst—Bildende Kunst—Dichtung—Weltanschauung* (Berlin: Gaertner, 1902)

Landry, Harald, 'Ausstellung für psychische Hygiene', *Vossische Zeitung*, 479/B 237 (10 October 1929), 3

Lange, Nicolai, 'Beiträge zur Theorie der sinnlichen Aufmerksamkeit und der activen Apperception', *Philosophische Studien*, 4 (1888), 390–422

Langer, Richard, *Totenmasken* (Leipzig: Thieme, 1927)

Leibniz, Gottfried Wilhelm, *New Essays on Human Understanding*, ed. Peter Remnant and Jonathan Bennett, abridged edn (Cambridge: Cambridge University Press, 1981)

Leibniz, Gottfried Wilhelm, 'Nouveaux essais sur l'entendement humain', in *Sämtliche Schriften und Briefe, VI: Philosophische Schriften*, vol. 6: *Nouveaux Essais*, ed. Leibniz-Forschungsstelle der Universität Münster (Berlin: Akademie, 1990)

Leibniz, Gottfried Wilhelm, *New Essays on Human Understanding*, ed. Peter Remnant and Jonathan Bennett (Cambridge: Cambridge University Press, 1996)

Lendvai-Dircksen, Erna, *Das deutsche Volksgesicht* (Berlin: Kulturelle Verlagsgesellschaft, 1932)

Lendvai-Dircksen, Erna, 'Über deutsche Porträtphotographie', *Das Atelier des Photographen*, 40:6 (1933), 72–4; 40:7 (1933), 84–6

Lendvai-Dircksen, Erna, [untitled], in *Meister der Kamera erzählen: Wie sie wurden und wie sie arbeiten*, ed. Wilhelm Schöppe (Halle: Wilhelm Knapp, no date [1935]), pp. 35–41

Lendvai-Dircksen, Erna, 'Psychologie des Sehens', in *Theorie der Photographie*, vol. 2: *1912–1945*, ed. Wolfgang Kemp (Munich: Schirmer/Mosel, 1979), pp. 158–62

Lerski, Helmar, 'Helmar Lerski über sich selbst', in *der mensch—mein bruder: Lichtbilder von Helmar Lerski*, ed. Anneliese Lerski (Dresden: Verlag der Kunst, 1958), pp. 14–19

Lessing, Theodor, *Der Lärm: Eine Kampfschrift gegen die Geräusche unseres Lebens* (Wiesbaden: Bergmann, 1908)

Lindner, Gustav Adolf, and F. Lukas, *Lehrbuch der empirischen Psychologie: Für den Gebrauch an höheren Lehranstalten*, 4th edn (Vienna: Carl Gerolds Sohn, 1912)

Lütticke, Therese, 'Musik unserer Zeit?', *Melos*, 9:1 (1930), 13–15

Mach, Ernst, *Die Analyse der Empfindungen und das Verhältnis des Psychischen zum Physischen*, 4th edn (Jena: Fischer, 1904)

Macpherson, Kenneth, 'As Is', *Close Up*, 8 (September 1931), 220–5

Malebranche, Nicolas, *Œuvres*, ed. Geneviève Rodis-Lewis, vol. 1 (Paris: Gallimard, 1979)

Meier, Georg Friedrich, *Philosophische Sittenlehre: Anderer Theil* (Halle: Hemmerde, 1754)

Meier, Georg Friedrich, *Philosophische Sittenlehre: Dritter Theil* (Halle: Hemmerde 1756)

Möbius, Paul Julius, *Ueber den physiologischen Schwachsinn des Weibes* (Halle/Saale: Marhold, 1900)

Moholy-Nagy, László, *Malerei, Photographie, Film*, Bauhausbücher, 8 (Munich: Langen, 1925)

Moholy-Nagy, László, *Von Material zu Architektur*, Bauhausbücher, 14 (Munich: Langen, 1929)

Montaigne, Michel de, 'Von der Ablenkung', in *Essais*, vol. 3, trans. Hans Stilett (Frankfurt a.M.: Eichborn, 1998), pp. 413–17

Montaigne, Michel de, 'On Diversion', in *The Complete Essays*, trans. and ed. Michael Andrew Screech (London: Penguin, 2003), pp. 935–46

Moritz, Karl Philipp, 'Vorschlag zu einem Magazin einer Erfahrungs-Seelenkunde', *Deutsches Museum*, 1 (1782), 485–503

Moritz, Karl Philipp, 'Versuch einer Vereinigung aller schönen Künste und Wissenschaften unter dem Begriff des in sich selbst Vollendeten', in *Schriften zur Ästhetik und Poetik*, ed. Hans Joachim Schrimpf (Tübingen: Niemeyer, 1962), pp. 3–9

Moritz, Karl Philipp, 'Vorschlag zu einem Magazin einer Erfahrungs-Seelenkunde', in *Werke in zwei Bänden*, ed. Heide Hollmer and Albert Meier, vol. 1: *Dichtungen und Schriften zur Erfahrungsseelenkunde* (Frankfurt a.M.: Deutscher Klassiker Verlag, 1999), pp. 793–809

Müh, Philipp, *Coué in der Westentasche! Durch Konzentration (Kraftdenken) und dynamische Autosuggestion zum Lebens-Erfolg* (Pfullingen: Baum, no date [c.1927])

Münsterberg, Hugo, *Psychologie und Wirtschaftsleben: Ein Beitrag zur angewandten Experimental-Psychologie* (Leipzig: Barth, 1912)

Münsterberg, Hugo, *Grundzüge der Psychotechnik* (Leipzig: Barth, 1914)

Münsterberg, Hugo, *The Photoplay: A Psychological Study* (New York, NY: Appleton, 1916)

Münsterberg, Hugo, *Das Lichtspiel: Eine psychologische Studie [1916] und andere Schriften zum Kino*, ed. and trans. Jörg Schweinitz (Vienna: Synema, 1996)

Musil, Martha, *Briefwechsel mit Armin Kesser und Philippe Jaccottet*, ed. Marie Roth, 2 vols (Bern: Lang, 1997)

Musil, Robert, *Tagebücher*, ed. Adolf Frisé (Reinbek bei Hamburg: Rowohlt, 1976)
Musil, Robert, *Der Mann ohne Eigenschaften*, ed. Adolf Frisé, rev. edn, 2 vols (Reinbek bei Hamburg: Rowohlt, 1978)
Musil, Robert, 'Psychotechnik und ihre Anwendungsmöglichkeiten im Bundesheere', in Robert Musil, *Beitrag zur Beurteilung der Lehren Machs und Studien zur Technik und Psychotechnik* (Reinbek bei Hamburg: Rowohlt, 1980), pp. 177–200
Musil, Robert, *Briefe 1901–1942: Kommentar, Register*, ed. Adolf Frisé (Reinbek bei Hamburg: Rowohlt, 1981)
Musil, Robert, *Gesammelte Werke*, ed. Adolf Frisé, 2nd, improved paperback edn, 9 vols (Reinbek bei Hamburg: Rowohlt, 1981)
Musil, Robert, *Posthumous Papers of a Living Author*, trans. Peter Wortsman (Hygiene, CO: Eridanos, 1987)
Musil, Robert, *Der literarische Nachlaß*, CD-ROM, ed. Friedrich Aspetsberger, Karl Eibl, and Adolf Frisé (Reinbek bei Hamburg: Rowohlt, 1992)
Musil, Robert, *The Man Without Qualities*, trans. Sophie Wilkins and Burton Pike, 2 vols (New York, NY: Knopf, 1995)
Musil, Robert, 'Toward a New Aesthetic: Observations on a Dramaturgy of Film', in *Robert Musil: Precision and Soul*, ed. and trans. Burton Pike and David S. Luft (Chicago, IL: University of Chicago Press, 1995), pp. 193–207
Musil, Robert, *Diaries 1899–1941*, selected, trans., and annotated by Philip Payne, ed. Mark Mirsky (New York, NY: Basic Books, 1999)
Nagel, Wilibald, *Die Musik im täglichen Leben* (Langensalza: Beyer, 1907)
Neuburger, Albert, 'Das Taylor-System: Das vielumstrittene Verfahren zur Erhöhung und Prüfung der Arbeitsleistung', *Berliner Illustrirte Zeitung*, 28:21 (25 May 1919), 182–4
Nordau, Max, *Entartung*, 3rd edn (Berlin: Duncker, 1896)
Orlik, Emil, *Kleine Aufsätze* (Berlin: Propyläen, 1924)
Otto, Franz, *Männer eigener Kraft: Lebensbilder verdienstvoller, durch Thatkraft und Selbsthülfe emporgekommener Männer* (Leipzig: Spamer, 1875)
Pascal, Blaise, *Pensées*, ed. Dominique Descotes (Paris: Garnier-Flammarion, 1976)
Picard, Max, *Das Menschengesicht* (Munich: Delphin, 1929)
Piorkowski, Curt, *Die psychologische Methodologie der wirtschaftlichen Berufseignung*, 2nd ext. edn (Leipzig: Barth, 1919)
Polgar, Alfred, *Orchester von oben* (Berlin: Rowohlt, 1926)
Ranke, Leopold von, *Geschichten der romanischen und germanischen Völker von 1494 bis 1514*, 3rd edn (Leipzig: Duncker & Humblot, 1885 [1824])
Reil, Johann Christian, *Rhapsodien über die Anwendung der psychischen Curmethode auf Geisteszerrüttungen* (Halle: Curtsche Buchhandlung, 1803; repr. Amsterdam: Bonset, 1968)
Ribot, Théodule-Armand, *The Psychology of Attention*, 5th rev. edn [no translator] (Chicago, IL: Open Court Publishing Company, 1903)
Sanctis, Sante de, *Die Mimik des Denkens*, trans. Joh[annes] Bresler (Halle: Marhold, 1906)
Schaeffer, Emil, ed., *Das letzte Gesicht* (Zurich: Orell Füssli, 1929)
Schmidt, K. O., *Wie konzentriere ich mich? Eine praktische Anleitung zur Ausbildung der Denkkraft und zur Ausübung des Kraftdenkens* (Pfullingen: Baum, no date [c.1927])
Schwarz, Heinrich, *David Octavius Hill: Der Meister der Photographie* (Frankfurt a.M.: Insel, 1931)
Sebald, W. G., 'The Undiscover'd Country: The Death Motif in Kafka's *Castle*', *Journal of European Studies*, 2 (1972), 22–34

Sebald, W. G., *Die Beschreibung des Unglücks: Zur österreichischen Literatur von Stifter bis Handke* (Frankfurt a.M.: Fischer, 1994)
Sebald, W. G., *Schwindel. Gefühle.* (Frankfurt a.M.: Fischer, 1994)
Sebald, W. G., *Die Ringe des Saturn: Eine englische Wallfahrt* (Frankfurt a.M.: Fischer, 1997)
Sebald, W. G., *The Rings of Saturn*, trans. Michael Hulse (London: Harvill, 1998)
Sebald, W. G., *Austerlitz* (Munich: Hanser, 2001)
Sebald, W. G., *Vertigo*, trans. Michael Hulse (London: Vintage, 2002)
Sebald, W. G., *Austerlitz*, trans. Anthea Bell, intro. James Wood (London: Penguin, 2018)
Simmel, Georg, 'The Berlin Trade Exhibition', trans. Sam Whimster, *Theory, Culture & Society*, 8 (1991), 119–23
Simmel, Georg, 'Die Großstädte und das Geistesleben', in *Gesamtausgabe*, ed. Otthein Rammstedt (Frankfurt a.M.: Suhrkamp, 1989-2015), vol. VII.1: *Aufsätze und Abhandlungen 1901–1908*, ed. Rüdiger Kramme, Angela Rammstedt, and Otthein Rammstedt (1995), pp. 116–31
Simmel, Georg, *Philosophie des Geldes* (Frankfurt a.M.: Suhrkamp, 1996)
Simmel, Georg, 'Die Berliner Gewerbe-Ausstellung', in *Soziologische Ästhetik*, ed. Klaus Lichtblau (Bodenheim: Philo, 1998), pp. 71–5
Simmel, Georg, 'The Metropolis and Mental Life', in *The Blackwell City Reader*, 2nd edn, ed. Gary Bridge and Sophie Watson (Chichester: Wiley-Blackwell, 2010), pp. 103–10
Simmel, Georg, *The Philosophy of Money*, trans. Tom Bottomore and David Frisby (London: Routledge, 2011)
Sommer, Robert, 'Zur Messung der motorischen Begleiterscheinungen psychischer Zustände', *Beiträge zur psychiatrischen Klinik*, 1 (1902), 143–64
Stern, William, 'Angewandte Psychologie', *Beiträge zur Psychologie der Aussage: Mit besonderer Berücksichtigung der Rechtspflege, Pädagogik, Psychiatrie und Geschichtsforschung*, 1 (1903), 4–45
Stern, William, 'Hugo Münsterberg: Ein Gedenkwort', *Zeitschrift für pädagogische Psychologie und Jugendkunde*, 18 (1917), 54–7
Stern, William, *Die differentielle Psychologie in ihren methodischen Grundlagen*, 3rd edn (Leipzig: Barth, 1921 [1911])
Swift, Edgar James, 'Disturbances of the Attention during Simple Mental Processes', *American Journal of Psychology*, 5 (1892), 1–19
Tissot, Samuel, *A Treatise on the Diseases Incident to Literary and Sedentary Persons*, trans. by a Physician (Edinburgh: Donaldson, 1772)
Tissot, Samuel, *De la santé des gens de lettres* (Lausanne: François Grasset, 1795)
Tramm, Karl August, *Psychotechnik und Taylor-System* (Berlin: Springer, 1921)
Tuczek, Franz, 'Zur Lehre von der Hysterie der Kinder', *Berliner klinische Wochenschrift*, 23 (1886), 511–15; 534–7
Wackenroder, Wilhelm Heinrich, *Sämtliche Werke und Briefe: Historisch-kritische Ausgabe*, vol. 2, ed. Silvio Vietta and Richard Littlejohns (Heidelberg: Deutscher Klassiker Verlag, 1991)
Walser, Robert, *Der Räuber* (Frankfurt a.M.: Suhrkamp, 1986)
Westphal, Kurt, 'Das neue Hören', *Melos*, 7 (1928), 352–4
Wolff, Christian, *Vernünfftige Gedancken von Gott, der Welt und der Seele des Menschen, auch allen Dingen überhaupt*, in *Gesammelte Werke*, founded by Jean École and Hans Werner Arndt, ed. Robert Theis, Werner Schneiders, and Jean-Paul Paccioni, 3 parts; part I: *Deutsche Schriften*, vol. 2 (Hildesheim: Olms, 1983)
Wundt, Wilhelm, *Grundzüge der physiologischen Psychologie* (Leipzig: Engelmann, 1874)

Wundt, Wilhelm, *Grundzüge der physiologischen Psychologie*, 4th edn, vol. 2 (Leipzig: Engelmann 1893)
Wundt, Wilhelm, *Grundriss der Psychologie* (Leipzig: Engelmann, 1896)
Wundt, Wilhelm, *Logik: Eine Untersuchung der Prinzipien der Erkenntnis und der Methoden wissenschaftlicher Forschung*, vol. 3: *Logik der Geisteswissenschaften*, 4th rev. edn (Stuttgart: Enke, 1921)
Wundt, Wilhelm, *Völkerpsychologie: Eine Untersuchung der Entwicklungsgesetze von Sprache, Mythos und Sitte*, vol. 1: *Die Sprache*, 4th edn (Stuttgart: Kröner, 1921)
Zimmermann, E., *Liste 33: Über Psychotechnik* (Leipzig and Berlin, 1923)

Secondary Texts

Abel-Struth, Sigrid, 'Ansätze einer Didaktik des Musikhörens', in *Musikhören*, ed. Bernhard Dopheide et al. (Darmstadt: Wissenschaftliche Buchgesellschaft, 1975), pp. 319–45
Alford, Lucy, *Forms of Poetic Attention* (New York, NY: Columbia University Press, 2020)
Alt, Peter-André, *Franz Kafka: Der ewige Sohn* (Munich: Beck, 2005)
Alt, Peter-André, *Sigmund Freud: Der Arzt der Moderne* (Munich: Beck, 2016)
Anderson, Mark M., *Kafka's Clothes: Ornament and Aestheticism in the Habsburg 'Fin-de-Siècle'* (Oxford: Clarendon Press, 1992)
Andriopoulos, Stefan, *Besessene Körper: Hypnose, Körperschaften und die Erfindung des Kinos* (Munich: Fink, 2000)
Arntzen, Helmut, *Musil-Kommentar sämtlicher zu Lebzeiten erschienener Schriften außer dem Roman 'Der Mann ohne Eigenschaften'* (Munich: Winkler, 1980)
Arntzen, Helmut, *Musil-Kommentar zu dem Roman 'Der Mann ohne Eigenschaften'* (Munich: Winkler, 1982)
Aspioti, Myrto, 'Uncertain Identities in German-Language Novels since 2010' (doctoral dissertation, University of Oxford, 2019)
Baier, Karl, 'Der Magnetismus der Versenkung: Mesmeristisches Denken in Meditationsbewegungen des 19. und 20. Jahrhunderts', in *Aufklärung und Esoterik: Wege in die Moderne*, ed. Monika Neugebauer-Wölk with Holger Zaunstöck (Berlin: de Gruyter, 2013), pp. 407–40
Baisch, Martin, 'Medien der Faszination im höfischen Roman', in *Wie gebannt: Ästhetische Verfahren der affektiven Bindung von Aufmerksamkeit*, ed. Martin Baisch, Andreas Degen, and Jana Lüdtke (Freiburg i.Br.: Rombach, 2013), pp. 213–34
Band, Henri, *Mittelschichten und Massenkultur: Siegfried Kracauers publizistische Auseinandersetzung mit der populärem Kultur und der Kultur der Mittelschichten in der Weimarer Republik* (Berlin: Lukas, 1999)
Barthes, Roland, *Camera Lucida: Reflections on Photography*, trans. Richard Howard (London: Vintage, 2000)
Bauer, Julian, 'Aufmerksamkeit, Zerstreuung, Erschöpfung: Skizzen zur Körpergeschichte bei Mach, Meinong, Musil und Malinowski', in *Geteile Gegenwarten: Kulturelle Praktiken von Aufmerksamkeit*, ed. Stephanie Kleiner, Miliam Lay Brander, and Leon Wansleben (Munich: Fink, 2016), pp. 59–90
Bauer, R., and Gerald Ullrich, 'Psychotechnik: Wissenschaft und/oder Ideologie. Dargestellt an der Zeitschrift für *Industrielle Psychotechnik*', *Psychologie und Gesellschaftskritik*, 9 (1985), 106–27
Baumbach, Sybille, *Literature and Fascination* (Basingstoke: Palgrave Macmillan, 2015)

Becker, Wolfgang, 'Einleitung', in *Immanuel Kant: Anthropologie in pragmatischer Hinsicht*, ed. and intro. by Wolfgang Becker (Stuttgart: Reclam, 1983), pp. 9–26

Bell, Matthew, *The German Tradition of Psychology in German Literature and Thought, 1700–1840* (Cambridge: Cambridge University Press 2005)

Bennett, Alice, *Contemporary Fictions of Attention: Reading and Distraction in the Twenty-First Century* (London: Bloomsbury, 2018)

Berz, Peter, 'Der Fliegerpfeil: Ein Kriegsexperiment Musils an den Grenzen des Hörraums', in *Armaturen der Sinne: Literarische und technische Medien 1870 bis 1920*, ed. Jochen Hörisch and Michael Wetzel (Munich: Fink 1990), pp. 265–88

Bijsterveld, Karin, *Mechanical Sound: Technology, Culture, and Public Problems of Noise in the Twentieth Century* (Cambridge, MA: MIT Press, 2008)

Blatter, Jeremy Todd, 'The Psychotechnics of Everyday Life: Hugo Münsterberg and the Politics of Applied Psychology, 1887–1917' (doctoral dissertation, Harvard University, Cambridge, MA, 2014), https://core.ac.uk/download/pdf/28948930.pdf [accessed 20 January 2022]

Bleumer, Hartmut, ed., *Immersion im Mittelalter* (Stuttgart: Metzler, 2012)

Blumenthal, H., 'Kavvanah', in *Encyclopaedia Judaica*, ed. Michael Berenbaum and Fred Skolnik, 2nd edn, vol. 12 (Detroit, MI: Macmillan Reference USA, 2007), pp. 39–40

Boll, Monika, *Nachtprogramm: Intellektuelle Gründungsdebatten in der frühen Bundesrepublik* (Münster: LIT, 2004)

Bonacchi, Silvia, *Die Gestalt der Dichtung: Der Einfluß der Gestalttheorie auf das Werk Robert Musils* (Bern: Lang, 1998)

Botstein, Leon, 'Time and Memory: Concert Life, Science, and Music in Brahms's Vienna', in *Brahms and his World*, ed. Walter Frisch (Princeton, NJ: Princeton University Press, 1990), pp. 3–22

Breuer, Stefan, *Anatomie der konservativen Revolution* (Darmstadt: Wissenschaftliche Buchgesellschaft, 1993)

Brinckmann, Christine N., and Evelyn Echle, eds., *Hugo Münsterberg*, Montage, AV (Marburg: Schüren, 2018)

Bronzaft, A. L., 'The Effect of a Noise Abatement Program on Reading Ability', *Journal of Environmental Psychology*, 1 (1981), 215–22

Bronzaft, A. L., and D. P. McCarthy, 'The Effect of Elevated Train Noise on Reading Ability', *Environment and Behaviour*, 4 (1975), 517–28

Brown, Elspeth, *The Corporate Eye: Photography and the Rationalization of American Commercial Culture, 1884–1929* (Baltimore, MD: Johns Hopkins University Press, 2005)

Brückle, Wolfgang, 'Kein Porträt mehr? Physiognomik in der deutschen Bildnisphotographie um 1930', in *Gesichter der Weimarer Republik: Eine physiognomische Kulturgeschichte*, ed. Claudia Schmölders and Sander Gilman (Cologne: DuMont, 2000), pp. 131–55

Brückle, Wolfgang, 'Schauspiel Authentizität: Die Vermittlung "wahrer" Leidenschaften durch Fotografie und Film der späten Stummfilmzeit', in *Fotografische Leidenschaften*, ed. Katharina Sykora, Ludger Derenthal, and Esther Ruelfs (Marburg: Jonas, 2006), pp. 144–65

Calamari, Elena, 'Hugo Münsterberg nell'opera di Musil', *Annali: Studi Tedeschi*, 23 (1980), 287–314

Caygill, Howard, *Walter Benjamin: The Colour of Experience* (London: Routledge, 2005)

Celis Bueno, Claudio, *The Attention Economy: Labour, Time and Power in Cognitive Capitalism* (London: Rowman and Littlefield, 2017)

Chickering, Roger, *Karl Lamprecht: A German Academic Life (1856–1915)* (Atlantic Highlands, NJ: Humanities Press, 1993)
Cook, Nicholas, *The Schenker Project: Culture, Race, and Music Theory in Fin-de-Siècle Vienna* (Oxford: Oxford University Press, 2007)
Corino, Karl, *Robert Musil: Eine Biographie* (Reinbek bei Hamburg: Rowohlt, 2003)
Cowan, Michael, *Cult of the Will: Nervousness and German Modern Culture* (University Park, PA: Pennsylvania State University Press, 2008)
Cowan, Michael, 'Moving Picture Puzzles: Training Urban Perception in the Weimar "Rebus Films"', *Screen*, 51 (2010), 197–218
Cowan, Michael, 'From the Astonished Spectator to the Spectator in Movement: Exhibition Advertisements in 1920s Germany and Austria', *Canadian Journal of Film Studies*, 23:1 (2014), 2–29
Crary, Jonathan, *Suspensions of Perception: Attention, Spectacle, and Modern Culture* (Cambridge, MA: MIT Press, 1999)
Crawford, Matthew, *The World Beyond Your Head: How to Flourish in a World of Distraction* (London: Penguin, 2015)
Csikszentmihalyi, Mihaly. *Flow: The Psychology of Happiness. The Classic Work on How to Achieve Happiness* (London: Rider, 2002)
Dahlhaus, Carl, *Die Idee der absoluten Musik* (Kassel: Bärenreiter and Munich: Deutscher Taschenbuch Verlag, 1978)
Daniels, Simon J., and Christopher F. Chabris, 'Gorillas in our Midst: Sustained Inattentional Blindness for Dynamic Events', *Perception*, 28 (1999), 1059–74
Danziger, Kurt, *Constructing the Subject: Historical Origins of Psychological Research* (Cambridge: Cambridge University Press, 1990)
Daston, Lorraine, 'Curiosity in Early Modern Science', *Word and Image*, 11 (1995), 391–404
Daston, Lorraine, and Peter Galison, *Objectivity* (New York, NY: Zone Books, 2007)
Davenport, Thomas H. and John C. Beck, *The Attention Economy: Understanding the New Currency of Business* (Boston, MA: Harvard Business School Press, 2001)
DeGranpre, Richard, *Ritalin Nation* (New York, NY: Norton, 1999)
DeNora, Tia, *After Adorno: Rethinking Music Sociology* (Cambridge: Cambridge University Press, 2003)
Dewitz, Bodo von, 'Zur Geschichte des Buches "David Octavius Hill—Der Meister der Photographie" von Heinrich Schwarz (1931)', in *David Octavius Hill & Robert Adamson: Von den Anfängen der künstlerischen Photographie im 19. Jahrhundert*, ed. Bodo von Dewitz and Karin Schuller-Procopovici (Cologne: Museum Ludwig/Agfa Photo-Historama, 2000), pp. 45–52
Diamant, Dora, 'Mein Leben mit Franz Kafka', in *'Als Kafka mir entgegenkam…': Erinnerungen an Franz Kafka*, ed. Hans-Gerd Koch (Frankfurt a.M.: Fischer, 2000), pp. 174–85
Diederichsen, Diedrich, 'Zeichenangemessenheit: Adorno gegen Jazz und Pop. "Der farbige Duke Ellington, ein ausgebildeter Musiker"', in *Adorno: Die Möglichkeit des Unmöglichen/The Possibility of the Impossible*, ed. Nicolaus Schafhausen et al. (Frankfurt a.M.: Lukas & Sternberg, 2003), pp. 33–46
Doctor, Jennifer, *The BBC and Ultra-Modern Music, 1922–1936: Shaping a Nation's Tastes* (Cambridge: Cambridge University Press, 1999)
Doherty, Brigid, 'Test and Gestus in Benjamin and Brecht', *Modern Language Notes*, 115 (2000), 442–81

Doll, Martin, 'Architektur und Zerstreuung: "Gebrauch", "Gewohnheit" und "beiläufiges Bemerken"', *Figurationen*, 2 (2015), 25–44

Dowden, Stephen, *Sympathy for the Abyss: A Study in the Novel of German Modernism: Kafka, Broch, Musil, and Thomas Mann* (Tübingen: Niemeyer, 1986)

Dreyfus, Hubert L., *Being-in-the-World: A Commentary on Heidegger's 'Being and Time', Division I* (Cambridge, MA: MIT Press, 1991)

Duttlinger, Carolin, *Kafka and Photography* (Oxford: Oxford University Press, 2007)

Duttlinger, Carolin, 'Walter Benjamin: The Aura of Photography', *Poetics Today*, 29 (2008), 79–101

Duttlinger, Carolin, 'Kafkas Poetik der Aufmerksamkeit von *Betrachtung* bis "*Der Bau*"', in *Kafka und die kleine Prosa der Moderne/Kafka and Short Modernist Prose*, ed. Manfred Engel and Ritchie Robertson (Würzburg: Königshausen & Neumann, 2010), pp. 79–97

Duttlinger, Carolin, 'Schlaflosigkeit: Kafkas *Schloss* zwischen Müdigkeit und Wachen', in *'Schloss'-Topographien: Lektüren zu Kafkas Romanfragment*, ed. Malte Kleinwort and Joseph Vogl (Bielefeld: Transcript, 2013), pp. 219–43

Duttlinger, Carolin, 'From Photography to Film and Back Again: Helmar Lerski's Dramaturgy of the Human Face', *Monatshefte*, 109 (2017), 229–42

Duttlinger, Carolin, 'Modernist Writing and Visual Culture', in *The Cambridge Companion to the Literature of Berlin*, ed. Andrew Webber (Cambridge: Cambridge University Press, 2017), pp. 89–110

Duttlinger, Carolin, 'Walter Benjamin', in *Sebald-Handbuch: Leben—Werk—Wirkung*, ed. Claudia Öhlschläger and Michael Niehaus (Stuttgart: Metzler, 2017), pp. 285–9

Duttlinger, Carolin, 'Rescue Narratives: Goethe's *Die Wahlverwandtschaften* and Benjamin's "Das Taschentuch"', *Publications of the English Goethe Society*, 89 (2020), 94–110

Ebner, Florian, *Metamorphosen des Gesichts: Die 'Verwandlungen durch Licht' von Helmar Lerski* (Göttingen: Steidl, 2002)

Ehrenspeck-Kolasa, Yvonne, 'Das Thema Aufmerksamkeit in der Pädagogik des 18. Jahrhunderts: Joachim Heinrich Campes Reflexionen zur Beobachtung und Bildung "junger Kinderseelen"', in *Aufmerksamkeit: Geschichte—Theorie—Empirie*, ed. Sabine Reh, Kathrin Berdelmann, and Jörg Dinkelaker (Hamburg: Springer, 2015), pp. 21–34

Eiland, Howard, 'Reception in Distraction', *Boundary 2*, 30 (2003), 51–66

Eiland, Howard, and Michael W. Jennings, *Walter Benjamin: A Critical Life* (Cambridge, MA: Harvard University Press, 2014)

Eming, Jutta, 'Faszination und Trauer: Zum Potential ästhetischer Emotionen im mittelalterlichen Roman', in *Wie gebannt: Ästhetische Verfahren der affektiven Bindung von Aufmerksamkeit*, ed. Martin Baisch, Andreas Degen, and Jana Lüdtke (Freiburg i.Br.: Rombach, 2013), pp. 235–64

Espinet, David, *Phänomenologie des Hörens: Eine Untersuchung im Ausgang von Martin Heidegger* (Tübingen: Mohr Siebeck, 2009)

Ewald, François, *Der Vorsorgestaat*, trans. Wolfram Bayer and Hermann Kocyba (Frankfurt a.M.: Suhrkamp, 1993)

Fahrenberg, Jochen, *Wilhelm Wundts Kulturpsychologie (Völkerpsychologie): Eine Psychologische Entwicklungstheorie des Geistes* (Trier: Leibniz-Zentrum für Psychologische Information und Dokumentation, 2016)

Farias, Miguel, and Catherine Wikholm, *The Buddha Pill: Can Meditation Change You?*, rev. edn (London: Watkins, 2019)

Fawcett, Jonathan M., Evan Risko, and Alan Kingstone, eds., *The Handbook of Attention* (Cambridge, MA: MIT Press, 2015)

Fenves, Peter, '"Über das Programm der kommenden Philosophie"', in *Benjamin-Handbuch: Leben—Werk—Wirkung*, ed. Burkhardt Lindner (Stuttgart: Metzler, 2011), pp. 134–50
Fleig, Anne, *Körperkultur und Moderne: Robert Musils Ästhetik des Sports* (Berlin: de Gruyter, 2008)
Franck, Georg, *Ökonomie der Aufmerksamkeit* (Munich: Hanser, 1998)
Frank, Svenja, 'Ikonisches Erzählen als Einheit von Realität und Imagination: Zum Verhältnis von ästhetischer Reflexion und narrativer Realisation im Werk von Felicitas Hoppe', in *Ehrliche Erfindungen: Felicitas Hoppe als Erzählerin zwischen Tradition und Transmoderne*, ed. Svenja Frank and Julia Ilgner (Bielefeld: Transcript, 2016), pp. 207–36
Frank, Svenja, and Julia Ilgner, 'Felicitas Hoppe als Erzählerin zwischen Tradition und Transmoderne: Eine Einführung', in *Ehrliche Erfindungen: Felicitas Hoppe als Erzählerin zwischen Tradition und Transmoderne*, ed. Svenja Frank and Julia Ilgner (Bielefeld: Transcript, 2016), pp. 15–41
Fried, Michael, *Absorption and Theatricality: Painting and Beholder in the Age of Diderot* (Berkeley, CA: University of California Press, 1980)
Frizot, Michel, *A New History of Photography* (Cologne: Köhnemann, 1998)
Fuhrimann, Daniel, '*Herzohren für die Tonkunst*': Opern- und Konzertpublikum in der deutschen Literatur des langen 19. Jahrhunderts (Freiburg i.Br.: Rombach, 2005)
Füllenbach, Elias H., and Linda Maria Koldau, 'Devotio Moderna', in *Encyclopedia of the Bible and its Reception*, vol. 6: *Dabbesheth—Dreams and Dream Interpretation*, ed. Hans-Josef Klauck et al. (Berlin: de Gruyter, 2012), c. 716–19
Gabrielsson, Alf, *Strong Experiences with Music: Music is Much More than Just Music* (Oxford: Oxford University Press, 2011)
Gasser, Martin, 'A Master Piece: Heinrich Schwarz's Book on David Octavius Hill', *Image*, 36 (1993), 33–53
Gay, Peter, *The Naked Heart: Bourgeois Experience. Victoria to Freud* (New York, NY: Norton, 1996)
Geuter, Ulrich, *The Professionalization of Psychology in Nazi Germany*, trans. Richard J. Holmes (Cambridge: Cambridge University Press, 1992)
Gilman, Sander, *Freud, Race, and Gender* (Princeton, NJ: Princeton University Press, 1992)
Gladic, Mladen, 'Erziehung, zweckfrei: Zur Medialität der Pädagogik bei Walter Benjamin', in *Walter Benjamins anthropologisches Denken*, ed. Carolin Duttlinger, Ben Morgan, and Anthony Phelan (Freiburg i.Br.: Rombach, 2012), pp. 215–42
Goehr, Lydia, *The Imaginary Museum of Musical Works: An Essay in the Philosophy of Music* (Oxford: Oxford University Press, 1992)
Goehr, Lydia, 'Dissonant Works and the Listening Public', in *The Cambridge Companion to Adorno*, ed. Tom Huhn (Cambridge: Cambridge University Press, 2004), pp. 222–47
Graeve, Detlev von, 'Ausstellung "Gesunde Nerven" Berlin 1929', http://detlev.von.graeve.org/?p=5547 [accessed 20 January 2022]
Greve, Jochen, 'Editorische Notiz', in Robert Walser, *Der Räuber* (Frankfurt a.M.: Suhrkamp, 1986), pp. 195–9
Gubrich-Simitis, Ilse, *Zurück zu Freuds Texten: Stumme Dokumente sprechen machen* (Frankfurt a.M.: Fischer, 1993)
Gundlach, Horst U. K., 'Moede, Walther', *Neue Deutsche Biographie*, 17 (1994), 611
Gundlach, Horst U. K., 'Germany', in *The Oxford Handbook of the History of Psychology: Global Perspectives*, ed. David B. Baker (Oxford: Oxford University Press, 2012), pp. 255–88

Haas, Norbert, Rainer Nägele, and Hans-Jörg Rheinberger, eds., *Liechtensteiner Exkurse III: Aufmerksamkeit* (Eggingen: Edition Isele, 1998)

Hagner, Michael, 'Towards a History of Attention in Culture and Science', *Modern Language Notes*, 118 (2003), 670–8

Hake, Thomas, 'Nachlass zu Lebzeiten (1936)', in *Robert-Musil-Handbuch*, ed. Birgit Nübel and Norbert Christian Wolf (Berlin: de Gruyter, 2016), pp. 320–40

Hamilton, Peter, and Roger Hargreaves, *The Beautiful and the Damned: The Creation of Identity in Nineteenth Century Photography* (Aldershot: Lund Humphries, 2001)

Hansen, Miriam, 'Benjamin, Cinema and Experience: "The Blue Flower in the Land of Technology"', *New German Critique*, 40 (1987), 179–224

Hau, Michael, *The Cult of Health and Beauty in Germany: A Social History 1890–1930* (Chicago, IL: University of Chicago Press, 2003), pp. 125–49

Hemecker, Wilhelm W., *Vor Freud: Philosophiegeschichtliche Voraussetzungen der Psychoanalyse* (Munich: Philosophia, 1991)

Henning, Hans, 'Die Untersuchung der Aufmerksamkeit', in *Handbuch der biologischen Arbeitsmethoden, Abteilung VI: Methoden der experimentellen Psychologie*, Teil B, vol. 5 (Berlin: Urban & Schwarzenberg, 1925), pp. 593–802

Herbert, Ruth, *Everyday Music Listening: Absorption, Dissociation and Trancing* (New York, NY: Routledge, 2011)

Hillar, Ansgar, 'Dialektisches Bild', in *Benjamins Begriffe*, ed. Michael Opitz and Erdmut Wizisla, vol. 1 (Frankfurt a.M.: Suhrkamp, 2000), pp. 186–229

Hinton, Stephen, *The Idea of Gebrauchsmusik: A Study of Musical Aesthetics in the Weimar Republic (1919–1933) with Particular Reference to the Works of Paul Hindemith* (New York, NY: Garland, 1989)

Hoffmann, Christoph, *'Der Dichter am Apparat': Medientechnik, Experimentalpsychologie und Texte Robert Musils, 1899–1942* (Munich: Fink, 1997)

Hoffmann, Christoph, 'Technische Aufsätze', in *Robert-Musil-Handbuch*, ed. Birgit Nübel and Norbert Christian Wolf (Berlin: de Gruyter, 2016), pp. 429–34

Holdenried, Michaela, 'Introduction', in *Felicitas Hoppe: Das Werk*, ed. Michaela Holdenried (Berlin: Schmidt, 2015), pp. 7–10

Honold, Alexander, 'Erzählen', in *Benjamins Begriffe*, ed. Michael Opitz and Erdmut Wizisla, vol. 1 (Frankfurt a.M.: Suhrkamp, 2000), pp. 363–98

Huyssen, Andreas, 'The Urban Miniature and the Feuilleton in Kracauer and Benjamin', in *Culture in the Anteroom: The Legacies of Siegfried Kracauer*, ed. Gerd Gemünden and Johannes von Moltke (Ann Arbor, MI: University of Michigan Press, 2012), pp. 213–28

Huyssen, Andreas, *Miniature Metropolis: Literature in the Age of Photography and Film* (Cambridge, MA: Harvard University Press, 2015)

Jäger, Hans-Wolf, 'Lehrdichtung', in *Deutsche Aufklärung bis zur Französischen Revolution 1680–1789*, ed. Rolf Grimminger, Hansers Sozialgeschichte der deutschen Literatur vom 16. Jahrhundert bis zur Gegegenwart, 3 (Munich: Hanser, 1980), pp. 500–44

Jaeger, Roland, 'Bleibende Dokumente des Neuen Sehens: Der Verlag Hermann Reckendorf, Berlin', in *Autopsie: Deutschsprachige Fotobücher 1918 bis 1945*, ed. Manfred Heiting and Roland Jaeger, vol. 1 (Göttingen: Steidl, 2012), pp. 248–67

Jaeggi, Rahel, '"Kein Einzelner vermag etwas dagegen": Adornos *Minima Moralia* als Kritik von Lebensformen', in *Dialektik der Freiheit: Frankfurter Adorno-Konferenz 2003*, ed. Axel Honneth (Frankfurt a.M.: Suhrkamp, 2005)

Jay, Martin, *Cultural Semantics: Keywords of Our Time* (Amherst, MA: University of Massachusetts Press, 1998)

Jay, Martin, 'Benjamin, Remembrance and the First World War', in *Walter Benjamin: Critical Evaluations in Cultural Theory*, ed. Peter Osborne, vol. 2: *Modernity* (London: Routledge, 2005), pp. 230–49

Jenemann, David, *Adorno in America* (Minneapolis, MN: University of Minnesota Press, 2007)

Jennings, Michael W., 'Walter Benjamin and the European Avant-Garde', in *The Cambridge Companion to Walter Benjamin*, ed. David S. Ferris (Cambridge: Cambridge University Press, 2004), pp. 18–34

Johnston, William M., *The Austrian Mind: An Intellectual and Social History, 1848–1938* (Berkeley, CA: University of California Press, 1972)

Jordan, Christa, *Zwischen Zerstreuung und Berauschung. Die Angestellten in der Erzählprosa am Ende der Weimarer Republik* (Frankfurt a.M.: Lang, 1988)

Jost, Sarah, 'Unter Volksgenossen: Agrarromantik und Großstadtfeindschaft', in *Menschenbild und Volksgesicht: Positionen zur Porträtfotografie im Nationalsozialismus*, ed. Falk Blask and Thomas Friedrich, special issue of *Berliner Blätter: Ethnographische und ethnologische Beiträge*, 36 (2005), 105–20

Kahneman, Daniel, *Thinking, Fast and Slow* (London: Penguin, 2011)

Kastner, Sabine, and Anna C. Nobre, eds., *The Oxford Handbook of Attention* (Oxford: Oxford University Press, 2014)

Kaufhold, Enno, '"Wir trauten anfangs unseren Augen nicht": David Octavius Hill: Legitimation der photographischen Unschärfe', in *David Octavius Hill & Robert Adamson: Von den Anfängen der künstlerischen Photographie im 19. Jahrhundert*, ed. Bodo von Dewitz and Karin Schuller-Procopovici (Cologne: Museum Ludwig/Agfa Photo-Historama, 2000), pp. 33–44

Kaulen, Heinrich, 'Rettung', in *Benjamins Begriffe*, ed. Michael Opitz and Erdmut Wizisla, vol. 2 (Frankfurt a.M.: Suhrkamp, 2000), pp. 619–64

Kim, Alan, 'Wilhelm Maximilian Wundt', in *The Stanford Encyclopedia of Philosophy* (Fall 2016 edn), ed. Edward N. Zalta, https://plato.stanford.edu/archives/fall2016/entries/wilhelm-wundt [accessed 20 January 2022]

Kimmich, Dorothee, 'Kleine Dinge in Großwahrnehmung: Bemerkungen zu Aufmerksamkeit und Dingwahrnehmung bei Robert Musil und Robert Walser', *Jahrbuch der deutschen Schillergesellschaft*, 44 (2000), 177–94

Kirst, Karoline, 'Walter Benjamin's *Denkbild*: Emblematic Historiography of the Recent Past', *Monatshefte*, 86 (1994), 514–24

Kittler, Friedrich A., *Aufschreibesysteme 1800/1900* (Munich: Fink, 1985)

Kittler, Wolf, 'Schreibmaschinen, Sprechmaschinen: Effekte technischer Medien im Werk Franz Kafkas', in *Franz Kafka: Schriftverkehr*, ed. Wolf Kittler and Gerhard Neumann (Freiburg i.Br.: Rombach, 1990), pp. 75–163

Klassen, Janina, 'In und auf dem Strom von Empfindungen: Wilhelm Heinrich Wackenroders immersive Hörerfahrung und der Hörwandel um 1800', in *Musik im Zusammenhang: Festschrift Peter Revers zum 65. Geburtstag*, ed. Klaus Aringer, Christian Utz, and Thomas Wozonig (Vienna: Hollitzer, 2019), pp. 805–12

Kleiner, Stephanie, and Robert Suter, 'Konzepte von Glück und Erfolg in der Ratgeberliteratur (1900–1940): Eine Einleitung', in *Guter Rat: Glück und Erfolg in der Ratgeberliteratur 1900–1940*, ed. Stephanie Kleiner and Robert Suter (Berlin: Neofelis, 2015), pp. 9–40

Kleinschmidt, Erich, 'Die Aufmerksamkeit der Begriffe: Zum figuralen Schwellendiskurs der (Ap)perzeption', in *Wie gebannt: Ästhetische Verfahren der affektiven Bindung von Aufmerksamkeit*, ed. Martin Baisch, Andreas Degen, and Jana Lüdtke (Freiburg i.Br.: Rombach, 2013), pp. 21–69

Koepnick, Lutz P., *Framing Attention: Windows on Modern German Culture* (Baltimore, MD: Johns Hopkins University Press, 2007)

Köhn, Eckhart, *Straßenrausch: Flaneure und kleine Form. Versuch zur Literaturgeschichte des Flaneurs bis 1933* (Berlin: Das Arsenal, 1989)

Koukkou, Martha, Marianne Leutziger-Bohleber, and Wolfgang Mertens, eds, *Erinnerung von Wirklichkeiten: Psychoanalyse und Neurowissenschaften im Dialog* (Stuttgart: Verlag der Internationalen Psychoanalyse, 1998)

Kriebel, Sabine T., *Revolutionary Beauty: The Radical Photomontages of John Heartfield* (Berkeley, CA: University of California Press, 2014)

Kümmel, Albert, *Das MoE-Programm: Eine Studie über geistige Organisation* (Munich: Fink, 2001)

Kusch, Martin, *Psychologism: A Case Study in the Sociology of Philosophical Knowledge* (London: Routledge, 1995)

Lachmann, Tobias, 'Ästhetik und Politik der Zerstreuung: Ausgangspunkte', in *Ästhetik und Politik der Zerstreuung*, ed. Tobias Lachmann (Paderborn: Brill/Fink, 2021), pp. 1–24

Lanham, Richard, *The Economics of Attention: Style and Substance in the Age of Information* (Chicago, IL: University of Chicago Press, 2006)

Lanset, Andy, 'Frankfurt School Theorist on WNYC in 1940', 28 October 2011, https://www.wnyc.org/story/161557-frankfurt-school-theorist/ [accessed 20 January 2022]

Lawrence, Baron, 'Noise and Degeneration: Theodor Lessing's Crusade for Quiet', *Journal of Contemporary History*, 17 (1982), 165–78

Lay Brander, Miriam, 'Mit List und Tücke: Praktiken der Aufmerksamkeit im frühneuzeitlichen Schelmenroman am Beispiel des *Lazarillo de Tormes*', in *Geteilte Gegenwarten: Kulturelle Praktiken von Aufmerksamkeit*, ed. Stephanie Kleiner, Miriam Lay Brander, and Leon Wansleben (Munich: Fink, 2016), pp. 243–63

le Huray, Peter, and James Day, eds., *Music and Aesthetics in the Eighteenth and Early-Nineteenth Centuries* (Cambridge: Cambridge University Press, 1981)

Lentz, Matthias, '"Ruhe ist die erste Bürgerpflicht": Lärm, Großstadt und Nervosität im Spiegel von Theodor Lessings "Antilärmverein"', *Medizin, Gesellschaft und Geschichte*, 13 (1995), 81–105

Lethen, Helmut, *Cool Conduct: The Culture of Distance in Weimar Germany*, trans. Don Reneau (Berkeley, CA: University of California Press, 2002)

Levin, Thomas Y., and Michael von der Linn, 'Elements of a Radio Theory: Adorno and the Princeton Radio Research Project', *The Music Quarterly*, 78 (1994), 316–24

Lindstrom, Richard, '"They All Believe They are Undiscovered Mary Pickfords": Workers, Photography, and Scientific Management', *Technology and Culture*, 41 (2000), 725–51

Liska, Vivian, 'Walter Benjamins Dialektik der Aufmerksamkeit', *Arcadia*, 35 (2000), 285–94

Löffler, Petra, 'Schwindel, Hysterie, Zerstreuung: Zur Archäologie massenmedialer Wirkungen', in *Trancemedien und neue Medien um 1900: Ein anderer Blick auf die Moderne*, ed. Marcus Hahn and Erhard Schüttpelz (Bielefeld: Transcript, 2009), pp. 375–401

Löffler, Petra, *Verteilte Aufmerksamkeit: Eine Mediengeschichte der Zerstreuung* (Zurich: Diaphanes, 2014)

Long, J. J., *W. G. Sebald: Image, Archive, Modernity* (Edinburgh: Edinburgh University Press, 2007)

Löwy, Michael, *Georg Lukács: From Romanticism to Bolshevism*, trans. Patrick Camiller (London: NLB, 1979)

Lüders, Sven, 'The "Fluctuations of Attention": Between Physiology, Experimental Psychology and Psycho-Technical Application', in *Psychology's Territories: Historical and Contemporary Perspectives from Different Disciplines*, ed. Mitchell G. Ash and Thomas Sturm (Mahwah, NJ: Erlbaum, 2007), pp. 31–50

Lütteken, Laurenz, 'Das Musikwerk im Spannungsfeld von "Ausdruck" und "Erleben": Heinrich Besselers musikhistoriographischer Ansatz', in *Musikwissenschaft—eine verspätete Disziplin? Die akademische Musikforschung zwischen Fortschrittsglauben und Modernitätsverweigerung*, ed. Anselm Gerhard (Stuttgart: Metzler, 2000), pp. 213–32

Lutz, Tom, *American Nervousness, 1903: An Anecdotal History* (Ithaca, NY: Cornell University Press, 1991)

McBride, Douglas Brent, 'Romantic Phantasms: Benjamin and Adorno on the Subject of Critique', *Monatshefte*, 90 (1998), 465–87

Magilow, Daniel H., *The Photography of Crisis: The Photo Essays of Weimar Germany* (University Park, PA: Pennsylvania State University Press, 2012)

Martin, George, *The Damrosch Dynasty: America's First Family of Music* (Boston, MA: Houghton Mifflin, 1983)

Meier, Albert, Alessandro Costazza, and Gérard Laudin, eds., *Kunstreligion: Ein ästhetisches Konzept der Moderne in seiner historischen Entfaltung*, 3 vols (Berlin: de Gruyter, 2011–14)

Menninghaus, Winfried, 'Kant über "Unsinn", "Lachen" und "Laune"', *Deutsche Vierteljahrsschrift für Literaturwissenschaft und Geistesgeschichte*, 68 (1994), 263–86

Mertens, Reni, and Walter Marti, 'Lerskis Technik der Porträtaufnahme', in *der mensch— mein bruder: Lichtbilder von Helmar Lerski*, ed. Anneliese Lerski (Dresden: Verlag der Kunst, 1958), pp. 120–1

Mohr, Georg, 'Jazz als Interferenz', in *Adorno-Handbuch: Leben-Werk-Wirkung*, ed. Richard Klein, 2nd edn (Stuttgart: Metzler, 2019), pp. 194–201

Moos, Peter von, 'Attentio est quaedam sollicitudo: Die religiöse, ethische und politische Dimension der Aufmerksamkeit im Mittelalter', in *Aufmerksamkeiten*, ed. Aleida Assmann and Jan Assmann (Munich: Fink, 2001), pp. 91–127

Morat, Daniel, 'Music in the Air—Listening in the Street: Popular Music and Urban Listening Habits in Berlin ca. 1900', in *The Oxford Handbook of Music Listening in the 19th and 20th Centuries*, ed. Christian Thorau and Hansjakob Ziemer (Oxford: Oxford University Press, 2019), pp. 335–54

Motley, Margaret, '*Volksconcerte* in Vienna and Late Nineteenth-Century Ideology of the Symphony', *Journal of the American Musicological Society*, 50 (1997), 421–53

Mullainathan, Sendhil, and Eldar Shafir, *Scarcity: The True Cost of Not Having Enough* (London: Penguin, 2014)

Müller, Sabine, 'Von der "Kunst ohne Anführungszeichen zu zitieren": Benjamins anthropologischer Materialismus zwischen Methode und Utopie', in *Walter Benjamins anthropologisches Denken*, ed. Carolin Duttlinger, Ben Morgan, and Anthony Phelan (Freiburg i.Br.: Rombach, 2012), pp. 261–80

Müller-Doohm, Stefan, *Adorno: Eine Biographie* (Frankfurt a.M: Suhrkamp, 2003)

Murphet, Julian, Helen Groth, and Penelope Hone, eds., *Sounding Modernism: Rhythm and Sonic Mediation in Modern Literature and Film* (Edinburgh: Edinburgh University Press, 2017)

Nelson-Field, Karen, *The Attention Economy: Simple Truths for Marketers* (Basingstoke: Palgrave Macmillan, 2020)

Neumann, Gerhard, 'Der verschleppte Prozeß: Literarisches Schreiben zwischen Schreibstrom und Werkidol', *Poetica*, 14 (1982), 92–111

Neumann, Gerhard, 'Nachrichten vom "Pontus": Das Problem der Kunst im Werk Franz Kafkas', in *Franz Kafka: Schriftverkehr*, ed. Wolf Kittler and Gerhard Neumann (Freiburg i.Br.: Rombach, 1990), pp. 164–98

Nolte, Karen, *Gelebte Hysterie: Erfahrung, Eigensinn und psychiatrische Diskurse im Anstaltsalltag um 1900* (Frankfurt a.M.: Campus, 2003)

North, Paul, *The Problem of Distraction* (Stanford, CA: Stanford University Press, 2012)

Paddison, Max, *Adorno's Aesthetics of Music* (Cambridge: Cambridge University Press, 1993)

Parr, Martin, and Gerry Badger, *The Photobook: A History*, vol. 1 (London: Phaidon, 2004)

Peters, Dorothea, 'Fotografie, Buch und grafisches Gewerbe: Zur Entwicklung der Druckverfahren von Fotobüchern', in *Autopsie: Deutschsprachige Fotobücher 1918 bis 1945*, ed. Manfred Heiting and Roland Jaeger, vol. 1 (Göttingen: Steidl, 2012), pp. 12–23

Peukert, Detlev J. K., *Die Weimarer Republik: Krisenjahre der klassischen Moderne* (Frankfurt a.M: Suhrkamp, 1995)

Pfohlmann, Oliver, 'Robert Musil', in *1914–1918 online: International Encyclopedia of the First World War*, https://encyclopedia.1914-1918-online.net/article/musil_robert [accessed 20 January 2022]

Phillips, Natalie M., 'Literary Neuroscience and History of Mind: An Interdisciplinary fMRI Study of Attention and Jane Austen', in *The Oxford Handbook of Cognitive Literary Studies*, ed. Lisa Zunshine (Oxford: Oxford University Press, 2015), pp. 55–81

Phillips, Natalie M., *Distraction: Problems of Attention in Eighteenth-Century Literature* (Baltimore, MD: Johns Hopkins University Press, 2016)

Price, Brian, 'Frank and Lillian Gilbreth and the Motion Study Controversy, 1907–1930', in *A Mental Revolution: Scientific Management since Taylor*, ed. Daniel Nelson (Columbus, OH: Ohio State University Press, 1992), pp. 58–73

Pritchard, Matthew, 'Who Killed the Concert? Heinrich Besseler and the Interwar Politics of Gebrauchsmusik', *Twentieth-Century Music*, 8 (2011), 29–48

Purser, Ronald, *McMindfulness: How Mindfulness Became the New Capitalist Spirituality* (London: Repeater, 2019)

Rabinbach, Anson, *The Human Motor: Energy, Fatigue and the Origins of Modernity* (Berkeley, CA: University of California Press, 1992)

Radkau, Joachim, *Das Zeitalter der Nervosität: Deutschland zwischen Bismarck und Hitler* (Munich: Propyläen, 2000)

Rauchensteiner, Manfried, 'Österreich-Ungarn', in *Enzyklopädie Erster Weltkrieg*, ed. Gerhard Hirschfeld et al., updated and ext. edn (Paderborn: Schöningh, 2009), pp. 64–86

Reichling, Philipp E., *Rezeption als Meditation: Vergleichende Untersuchungen zur Betrachtung in Mystik und klassischer Moderne* (Oberhausen: Athena, 2004)

Richie, Alexandra, *Faust's Metropolis: A History of Berlin* (London: HarperCollins, 1999)

Richter, Alexandra, 'Die politische Dimension der Aufmerksamkeit im *Meridian*', *Deutsche Vierteljahrsschrift für Literaturwissenschaft und Geistesgeschichte*, 77 (2003), 659–76

Riedel, Wolfgang, 'Anthropologie und Literatur in der deutschen Spätaufklärung: Skizze einer Forschungslandschaft', *Internationales Archiv für Sozialgeschichte der deutschen Literatur*, 6 (1994), 93–157

Riley, Matthew, *Musical Listening in the German Enlightenment: Attention, Wonder, and Astonishment* (Burlington, VT: Ashgate, 2004)

Rittelmann, Leesa, 'Facing Off: Photography, Physiognomy, and National Identity in the Modern German Photobook', *Radical History Review*, 106 (2010), 137–61

Robertson, Richie, *Kafka: Judaism, Literature, and Politics* (Oxford: Oxford University Press, 1987)

Robertson, Richie, 'Reading the Clues: Franz Kafka, *Der Proceß*', in *The German Novel in the Twentieth Century*, ed. David Midgley (Edinburgh: Edinburgh University Press, 1993), pp. 59–79

Ross, Corey, 'Visions of Prosperity: The Americanization of Advertising in Interwar Germany', in *Selling Modernity: Advertising in Twentieth-Century Germany*, ed. Pamela E. Swett, S. Jonathan Wiesen, and Jonathan R. Zatlin (Durham, NC: Duke University Press, 2007), pp. 52–77

Rothberg, Michael, *Multidirectional Memory: Remembering the Holocaust in the Age of Decolonization* (Stanford, CA: Stanford University Press, 2009)

Rowe, Dorothy, 'Georg Simmel and the Berlin Trade Exhibition of 1896', *Urban History*, 22 (1995), 216–28

Ryan, Judith, *The Vanishing Subject: Early Psychology and Literary Modernism* (Chicago, IL: University of Chicago Press, 1991)

Said, Edward, *On Late Style: Music and Literature Against the Grain* (New York, NY: Vintage, 2006)

Sand, Rosemarie, 'J. F. Herbart (1776–1841)', in *The Freud Encyclopedia: Theory, Therapy, and Culture*, ed. Edward Erwin (New York, NY: Routledge, 2002), pp. 376–8

Schaffner, Brigitte, 'Kairos', in *Der neue Pauly: Enzyklopädie der Antike*, ed. Hubert Cancik and Helmuth Schneider, series Altertum, vol. 6 (Stuttgart: Metzler, 1999), pp. 138–9

Schindler, Regula, 'Die Drogen-Protokolle Walter Benjamins', in *Psychosen: Eine Herausforderung für die Psychoanalyse. Strukturen—Klinik—Produktionen*, ed. Peter Widmer and Michael Schmid (Bielefeld: Transcript, 2007), pp. 205–20

Schings, Hans-Jürgen, ed., *Der ganze Mensch: Anthropologie und Literatur im 18. Jahrhundert* (Stuttgart: Metzler, 1994)

Schlaffer, Heinz, 'Denkbilder: Eine kleine Prosaform zwischen Dichtung und Gesellschaftstheorie', in *Poesie und Politik: Zur Situation der Literatur in Deutschland*, ed. Wolfgang Kuttenkeuler (Stuttgart: Kohlhammer, 1973), pp. 137–54

Schmider, Christine, and Michael Werner, 'Das Baudelaire-Buch', in *Benjamin-Handbuch: Leben—Werk—Wirkung*, ed. Burkhardt Lindner (Stuttgart: Metzler, 2011), pp. 567–84

Schmidgen, Henning, 'Zur Genealogie der Reaktionsversuche in der experimentellen Psychologie', in *Instrument—Experiment: Historische Studien*, ed. Christoph Meinel (Berlin: Verlag für Geschichte der Naturwissenschaften und der Technik, 2000), pp. 168–79

Schmidt, Jochen, *Die Geschichte des Genie-Gedankens in der deutschen Literatur, Philosophie und Politik 1750–1945*, 3rd, improved edn (Heidelberg: Winter, 2004)

Schmölders, Claudia, 'Das Gesicht von "Blut und Boden": Erna Lendvai-Dircksens Kunstgeographie', in *Körper im Nationalsozialismus: Bilder und Praxen*, ed. Paula Diehl (Munich: Fink, 2006), pp. 51–78

Schnyder, Mireille, 'Überlegungen zu einer Poetik des Staunens im Mittelalter', in *Wie gebannt: Ästhetische Verfahren der affektiven Bindung von Aufmerksamkeit*, ed. Martin Baisch, Andreas Degen, and Jana Lüdtke (Freiburg i.Br.: Rombach, 2013), pp. 95–114

Schöck-Quinteros, Eva, 'Dora Benjamin: ". . . denn ich hoffe nach dem Krieg in Amerika arbeiten zu können". Stationen einer vertriebenen Wissenschaftlerin (1901–1946)', *Bonjour Geschichte*, 4 (2014), 1–26

Scholem, Gershom, *Die jüdische Mystik in ihren Hauptströmungen* (Zurich: Rhein, 1957)

Schöttker, Detlev, 'Fragment und Traktat: Walter Benjamin und die aphoristische Tradition', *Weimarer Beiträge*, 43 (1997), 503–19

Schrage, Dominik, *Psychotechnik und Radiophonie: Subjektkonstruktionen in artifiziellen Wirklichkeiten 1918–1932* (Munich: Fink, 2001)

Schrott, Heinz, and Rainer Tölle, *Geschichte der Psychiatrie: Krankheitslehren, Irrwege, Behandlungsformen* (Munich: Beck, 2006)

Schulz, Eberhard, 'Zum Wort "Denkbilder"', in *Wort und Zeit: Aufsätze und Vorträge zur Literaturgeschichte*, ed. Eberhard Schulz (Neumünster: Wachholtz, 1968), pp. 218-52

Schwartz, Frederic J., *Blind Spots: Critical Theory and the History of Art in Twentieth-Century Germany* (New Haven, CT: Yale University Press, 2005)

Schwarz, Michael, '"Er redet leicht, schreibt schwer": Theodor W. Adorno am Mikrophon', *Zeithistorische Forschungen/Studies in Contemporary History*, 8 (2011), 286-94

Schweinitz, Jörg, 'Psychotechnik, idealistische Ästhetik und der Film als mental strukturierter Wahrnehmungsraum: Die Filmtheorie von Hugo Münsterberg', in Hugo Münsterberg, *Das Lichtspiel: Eine psychologische Studie [1916] und andere Schriften zum Kino*, ed. and trans. Jörg Schweinitz (Vienna: Synema, 1996), pp. 9-26

Seel, Martin, *Adornos Philosophie der Kontemplation* (Frankfurt a.M.: Suhrkamp, 2004)

Sheppard, Richard, 'Dexter – Sinister: Some Observations on Decrypting the Mors Code in the Work of W. G. Sebald', *Journal of European Studies*, 35 (2005), 419-63

Shklovsky, Viktor, 'Art as Device', in *Viktor Shklovsky: A Reader*, ed. and trans. Alexandra Berlina (London: Bloomsbury, 2017), pp. 73-96

Sirotkina, Irina and Roger Smith, 'Russian Federation', in *The Oxford Handbook of the History of Psychology: Global Perspectives*, ed. David B. Baker (Oxford: Oxford University Press, 2012), pp. 412-41

Spiegelberg, Herbert, *The Phenomenological Movement: A Historical Introduction*, 2nd edn, vol. 1 (The Hague: Nijhoff, 1965)

Sprung, Helga, with Lothar Sprung, *Carl Stumpf: Eine Biografie. Von der Philosophie zur experimentellen Psychologie* (Munich: Profil, 2006)

Stetler, Pepper, *Stop Reading! Look! Modern Vision and the Weimar Photographic Book* (Ann Arbor, MI: University of Michigan Press, 2015)

Stiegler, Bernd, *Der montierte Mensch* (Munich: Fink, 2016)

Striewski, Christina, 'Aufmerksamkeit und Zerstreuung im Anschluß an Walter Benjamin' (master thesis, Free University Berlin, 2003)

Täubert, Klaus, *'Unbekannt verzogen...': Der Lebensweg des Suchtmediziners, Psychologen und KPD-Gründsmitgliedes Fritz Fränkel* (Berlin: Trafo, 2005)

Tewinkel, Christiane, '"Everybody in the Concert Hall should be Devoted Entirely to the Music": On the Actuality of Not Listening to Music in Symphonic Concerts', in *The Oxford Handbook of Music Listening in the 19th and 20th Centuries*, ed. Christian Thorau and Hansjakob Ziemer (Oxford: Oxford University Press, 2019), pp. 477-502

Thums, Barbara, *Aufmerksamkeit: Wahrnehmung und Selbstbegründung von Brockes bis Nietzsche* (Munich: Fink, 2008)

Treisman, A. M., 'Features and Objects', *Quarterly Journal of Experimental Psychology*, 40 (1988), 201-37

Troscianko, Emily T., *Kafka's Cognitive Realism* (New York, NY: Routledge, 2014)

Troscianko, Emily T., 'Reading Kafka', in *Franz Kafka in Context*, ed. Carolin Duttlinger (Cambridge: Cambridge University Press, 2017), pp. 283-92

Vatan, Florence, 'Gestalttheorie', in *Robert-Musil-Handbuch*, ed. Birgit Nübel and Norbert Christian Wolf (Berlin: de Gruyter, 2016), pp. 531-7

Vogl, Joseph, *On Tarrying*, trans. Helmut Müller-Sievers (Calcutta: Seagull Books, 2011)

Wagner, Benno, *Der Unversicherbare: Kafkas Protokolle* (Habilitationssschrift, University of Siegen, 1998)

Wagner-Engelhaaf, Martina, 'Anderer Zustand', in *Robert-Musil-Handbuch*, ed. Birgit Nübel and Norbert Christian Wolf (Berlin: de Gruyter, 2016), pp. 710–12

Wagner-Engelhaaf, Martina, 'Mystik', in *Robert-Musil-Handbuch*, ed. Birgit Nübel and Norbert Christian Wolf (Berlin: de Gruyter, 2016), pp. 705–10

Wajcman, Judy, *Pressed for Time: The Acceleration of Life in Digital Capitalism* (Chicago, IL: University of Chicago Press, 2014)

Waldenfels, Bernhard, *Phänomenologie der Aufmerksamkeit* (Frankfurt a.M.: Suhrkamp, 2004)

Ward, Janet, *Weimar Surfaces: Urban Visual Culture in 1920s Germany* (Berkeley, CA: University of California Press, 2001)

Wegener, Mai, *Neuronen und Neurosen: Der psychische Apparat bei Freud und Lacan. Ein historisch-theoretischer Versuch zu Freuds Entwurf von 1895* (Munich: Fink, 2004)

Wegman, Rob C., '"Das musikalische Hören" in the Middle Ages and Renaissance: Perspectives from Pre-War Germany', *Musical Quarterly*, 82 (1998), 434–54

Weidmann, Heiner, 'Geistesgegenwart: Das Spiel in Walter Benjamins *Passagenarbeit*', *Modern Language Notes*, 107 (1992), 521–47

Weigel, Sigrid, and Gerhard Schabert, eds, *A Neuro-Psychoanalytical Dialogue for Bridging Freud and the Neurosciences* (Cham: Springer, 2016)

Weingart, Peter, *Doppel-Leben: Ludwig Ferdinand Clauss. Zwischen Rassenforschung und Widerstand* (Frankfurt a.M.: Campus, 1995)

Werner, Nadine, *Archäologie des Erinnerns: Sigmund Freud in Walter Benjamins 'Berliner Kindheit'* (Göttingen: Wallstein, 2015)

Wiedemann, Barbara, ed., *Paul Celan—Die Goll-Affäre: Dokumente zu einer 'Infamie'* (Frankfurt a.M.: Suhrkamp, 2000)

Wiese, Wanja, and Thomas Metzinger, 'Vanilla PP for Philosophers: A Primer on Predictive Processing', in *Philosophy and Predictive Processing*, ed. Thomas Metzinger and Wanja Wiese (Frankfurt a.M.: MIND Group, 2017), pp. 1–18

Wilke, Tobias, *Medien der Unmittelbarkeit: Dingkonzepte und Wahrnehmungstechniken 1918–1939* (Munich: Fink, 2010)

Wilke, Tobias, 'Tacti(ca)lity Reclaimed: Benjamin's Medium, the Avant-Garde, and the Politics of the Senses', *Grey Room*, 39 (2010), 39–56

Williams, Mark, and Danny Penman, *Mindfulness: A Practical Guide to Finding Peace in a Frantic World* (London: Piatkus, 2011)

Wohlfahrt, Irving, 'Et cetera? Der Historiker als Lumpensammler', in *Passagen: Walter Benjamins Urgeschichte des neunzehnten Jahrhunderts*, ed. Norbert Bolz and Bernd Witte (Munich: Fink, 1984), pp. 70–95

Wolf, Norbert Christian, '*Der Mann ohne Eigenschaften* (1930/1932/posthum)', in *Robert-Musil-Handbuch*, ed. Birgit Nübel and Norbert Christian Wolf (Berlin: de Gruyter, 2016), pp. 224–319

Wulf, Ada, 'Das Problem der Aufmerksamkeit in der modernen Pädagogik', *Schweizerische Pädagogische Zeitschrift*, 27 (1917), 169–217

Ziemer, Hansjakob, *Die Moderne hören: Das Konzert als urbanes Forum 1890–1940* (Frankfurt a.M.: Campus, 2008)

Ziemer, Hansjakob, 'Konzerthörer unter Beobachtung: Skizze für eine Geschichte journalistischer Hörertypologien zwischen 1870–1940', in *Wissensgeschichte des Hörens in der Moderne*, ed. Hör-Wissen im Wandel (Berlin: de Gruyter, 2017), pp. 183–207

Ziemer, Hansjakob, 'The Crisis of Listening in Interwar Germany', in *The Oxford Handbook of Music Listening in the 19th and 20th Centuries*, ed. Christian Thorau and Hansjakob Ziemer (Oxford: Oxford University Press, 2019), pp. 97–121

Ziolkowsky, Theodore, 'Law', in *Franz Kafka in Context*, ed. Carolin Duttlinger (Cambridge: Cambridge University Press, 2018), pp. 183–90

Zunshine, Lisa, ed., *The Oxford Handbook of Cognitive Literary Studies* (Oxford: Oxford University Press, 2015)

Index

Note: Figures are indicated by an italic "*f*", respectively, following the page number.

Ablenkung, *see* diversion
acceleration 2, 23, 35n.76, 48–53, 56, 63n.81, 93, 168, 170n.41, 176, 195–6, 207–8, 261, 294–5, 301
Adamson, Robert 10–11, 229–31, 233, 237, 252–5, 257–60, 262, *see also* David Octavius Hill
Adler, Alfred 177–8
Adorno, Gretel 277
Adorno, Theodor W. 23–4, 296n.117, 300n.131, 308, 310, 337–82, 384–6, 389–90
'Analytical Study of the NBC Music Appreciation Hour' 354–5
'Anmerkungen zum philosophischen Denken' (Notes on Philosophical Thinking) 379–80
'Arnold Schönberg' 381
Ästhetische Theorie (Aesthetic Theory) 363–4, 373–4, 384–5, 386n.9
'Aufzeichnungen zu Kafka' (Notes on Kafka) 361–2
'Bewußtsein des Konzerthörers' (Consciousness of the Concert Listener) 342–5, 349n.37
'Der Essay als Form' (The Essay as Form) 372–4
and Max Horkheimer, *Dialektik der Aufklärung* (Dialectic of Enlightenment) 296n.117, 374–6
Einleitung in die Musiksoziologie (Introductory Lectures on the Sociology of Music) 348–51
'Freizeit' (Free Time) 370–2, 374, 378
'Guidelines for Listening to New Music' 360–1, 366
Minima Moralia 376–8
'Musik im Hintergrund' (Music in the Background) 344–5
Negative Dialektik 373–4
'On Popular Music' 346, 350
'Resignation' 378–9
'Sur l'eau' (On the Water) 377
'Über den Fetischcharakter in der Musik und die Regression des Hörens' (On the Fetish Character in Music and the Regression of Listening) 345–50, 352
'Über Jazz' (On Jazz) 345–6
'Was eine Music Appreciation Hour sein sollte' (What a Music Appreciation Hour Should Be Like) 356
'Wörter aus der Fremde' (Words from Abroad) 368–70, 374
advertising 130–1, 135, 140–5, 149, 162–3, 215, 342–3, 352, 355, 369
psychology 141–5
anderer Zustand, *see* other state
anthropology 23, 218, 265, 267, 270, 275, 286, 293, 315–16
apperception 15–16, 24, 29, 40–1, 43–4, 77–9, 89–92, 142–3, 294–6, 341n.9, 344–6, 354n.53, *see also* perception
architecture 292, 294–5, 311
Aristotle 5n.14, 293
art (as) religion, see *Kunstreligion*
Atget, Eugène 287
aura 264n.91, 287, 308, 321–2
Austrian Ministry for Military Affairs 10, 159
autosuggestion 177–8, 181–2, 185, 204, 213–15, 401

Balázs, Béla 198–200, 239
Der sichtbare Mensch (The Visible Man) 198
Barthes, Roland
La Chambre claire (Camera Lucida) 264–5
Baudelaire, Charles 300–4
Les Fleurs du mal (The Flowers of Evil) 303–4
Baudouin, Charles 10, 177–84, 200
La Force en nous (The Power within Us) 179
Suggestion et Autosuggestion (Suggestion and Autosuggestion) 181–2
Bauer, Felice 111–14, 116–17, 125–6
Beard, George M. 54, 59
American Nervousness 54

Beethoven, Ludwig van 331, 337n.83, 346, 347n.29, 364n.85
Benjamin, Dora 266-7, 280-5
 'Die soziale Lage der Berliner Konfektionsheimarbeiterinnen mit besonderer Berücksichtigung der Kinderaufzucht' (The Social Situation of Women Working from Home in the Berlin Clothing Industry, with Particular Consideration of the Issue of Child Rearing) 281-2
Benjamin, Walter 19, 23-4, 106, 147-8, 155, 218, 231-4, 236, 239, 262-316, 336-7, 339-41, 345-6, 349-51, 361-2, 374-5, 378, 383-90, 393-6, 403-4
 'Das Kunstwerk im Zeitalter seiner technischen Reproduzierbarkeit' (The Work of Art in the Age of its Technological Reproducibility) 11, 147-8, 266, 285-9, 292, 295, 298-301, 304, 308-9, 311-12, 336-7, 339-41, 345-6, 349-50
 'Das Taschentuch' (The Handkerchief) 313-15, 395, 399
 'Der Erzähler' (The Storyteller) 19, 106, 304-8, 337
 Einbahnstraße (One-Way Street) 277-80, 295, 307
 'Franz Kafka: Zur zehnten Wiederkehr seines Todestages' (Franz Kafka: On the Tenth Anniversary of his Death) 308-10, 387-8
 'Gewohnheit und Aufmerksamkeit' (Habit and Attention) 276, 292, 295
 'Ibizenkische Folge' (Ibizan Sequence) 275-7, 313n.173
 'Karussell der Berufe' (Carousel of Professions) 289
 'Kleine Geschichte der Photographie' (Little History of Photography) 228-9, 231-3, 236, 265-6, 287
 Passagenarbeit (Arcades Project) 278n.46, 299, 301, 304n.144, 311-12
 'Psychologie' 269
 'Über das Grauen' (On Dread) 269-73, 275-6, 286-7, 309, 311-12, 387-8
 'Über das mimetische Vermögen' (On the Mimetic Faculty) 306-7
 'Über den Begriff der Geschichte' (On the Concept of History) 311
 'Über einige Motive in Baudelaire' (On some Motifs in Baudelaire) 301-4, 312
 Ursprung des deutschen Trauerspiels (Origin of the German Trauerspiel) 271-5, 277, 311, 313, 356n.57, 373n.111, 376, 393-4
Berdrow, Wilhelm 51-2

Berg, Alban 338, 359-60
Bergk, Johann Adam 26-7
Bergson, Henri 303-4
Bergmann, Wilhelm 58-9, 219
 Selbstbefreiung aus nervösen Leiden (Liberating Oneself from Nervous Illness) 58-9
Bergson, Henri 303-4
Bertels, Arved
 Versuch über die Ablenkung der Aufmerksamkeit (Attempt on the Distraction of Attention) 37
Bertillon, Alphonse 139
Besseler, Heinrich 23, 330-7, 378
Binswanger, Otto
 Die Pathologie und Therapie der Neurasthenia (The Pathology and Therapy of Neurasthenia) 64
Bloch, Ernst 155
Bonnet, Charles 21
Bossert, Helmuth Theodor
 Aus der Frühzeit der Photographie, 1840-70 (The Early Days of Photography, 1840-70) 227
Brecht, Bertolt 147-8, 218n.44, 266-7, 285-6, 297-8, 349-50
 'Kleines Organon für das Theater' (Short Organon for the Theatre) 297n.120
Brentano, Franz 43, 64-5, 77-8, 88n.12, 205n.2
Brockes, Barthold Heinrich 21, 68-9
 Irdisches Vergnügen in Gott (Earthly Pleasure in God) 21-3
Brown, John
 Elementa Mediciniae (Elements of Medicine) 16
Brücke, Ernst 77-8
Bücher, Karl
 Arbeit und Rhythmus (Work and Rhythm) 333
Büchner, Georg 386-90
 Lenz 387-90
Buffon, Georges-Louis Leclerc, Comte de 33, 221

Campe, Joachim Heinrich
 'Über die früheste Bildung junger Kinderseelen' (On the Earliest Education of Young Children's Souls) 16-17
Cattell, James McKeen 38, 128
Caygill, Howard 274-5
Celan, Paul 23-4, 386-92, 396-7, 403-4
 'Der Meridian' (The Meridian) 386-90, 396-7, 403
Chaplin, Charlie 296n.114, 339-40

Charcot, Jean-Martin 61n.72, 66–7, 77–8, 81n.142
Chardin, Jean-Baptiste-Siméon 251–2, 322
Chesterfield, Philip Dormer Stanhope, 4th Earl of 33
chronoscope 34–8, 133, 221
cinema, *see* film
city 25, 49–50, 60, 64–5, 83, 141–2, 165–7, 171, 182, 196, 226–7, 237–9, 241, 258, 261, 280–1, 291, 363
Clausewitz, Carl von
 Vom Kriege (On War) 400–1
Clauss, Ludwig Ferdinand
 'Das menschliche Antlitz' (The Human Countenance) 239–40
Cocteau, Jean 361
Cohn, Jonas, and Werner Gent
 'Aussage und Aufmerksamkeit' (Statement and Attention) 267–70, 276, 279–80, 292–3, 298
cognitive bias 74, 87, 207n.9
Coué, Emile 178, 215
Cowan, Michael 49n.19, 206n.4, 211n.27, 283n.70, 298n.125
Crary, Jonathan 6–7, 35n.76, 44n.119, 107n.50
culture industry 296n.117, 341, 351–2, 360–1, 365, 369, 374

Dadaism 144, 284–5, 339–40, 363
dance 199–200, 295, 319–20, 332–7, 347n.29
d'Annunzio, Gabriele 202–3
Damrosch, Walter 353–7
Darwin, Charles
 The Expression of the Emotions in Man and Animals 221–4
Darwin, Erasmus 28n.64
Daston, Lorraine, and Peter Galison 35–6, 43
Das Wort (The Word, journal) 285–6, 297
DeNora, Tia 338
Diamant, Dora 114
Diderot, Denis 26
dietetics 25–6
diversion (*Ablenkung*) vi, 3–4, 19, 23–8, 26n.56, 67, 97–8, 109, 121, 145–7, 174–5, 267–70, 274–5, 306, 391–7
Doherty, Brigid 289
Doyle, Arthur Conan 85–6
Dreyfus, Hubert 334
Duchenne de Boulogne, Guillaume-Benjamin-Amand
 Mécanisme de la physionomie humaine (The Mechanism of Human Facial Expression) 221–4, 260–1
Duhamel, Georges 293–4

Dührkoop, Rudolph 254–5, 254*f*
Duisberg, Carl 155

Ebbinghaus, Hermann 30, 38
Eckhart, Meister 173
Eder, Josef Maria
 Geschichte der Photographie (History of Photography) 228–9
education 16–17, 32n.71, 47, 104–5, 129–30, 133–4, 141–2, 160–1, 163, 179, 207–8, 212, 225–9, 233–4, 251–2, 267–8, 281–2, 298, 315, 320, 353, 355, 369, 383–4
Ehrenfels, Christian von
 Sexualethik (Sexual Ethics) 64–5
Eiland, Howard 50n.24, 280n.53, 339n.4
Eisenstein, Sergei 239, 296
Eisler, Hanns 335n.76
Enlightenment 3, 6–8, 13–28, 31–6, 44–5, 59–60, 76–7, 154–5, 174–5, 210, 212, 221, 251–2, 274, 299, 317–22, 376–7
epic theatre 266–7, 285–6, 297, 298n.121, *see also* Bertolt Brecht
epiphany 6–7, 10, 184–6, 188–9, 248, 317
Erb, Wilhelm
 'Ueber die wachsende Nervosität unserer Zeit' (On the Growing Nervousness of our Time) 54–8, 63–4, 100–2, 207n.11, 327
Erfahrungsseelenkunde, *see* experiential psychology
ergograph 134*f*, 134
Esquirol, Jean-Étienne Dominique 27
evenly suspended attention 73–7, 84, 305–6, *see also* Sigmund Freud
experiential psychology 28–9, 319

fascism, *see* National Socialism
Fallada, Hans
 Kleiner Mann, was nun? (Little Man—What Now?) 247–8
Fechner, Gustav Theodor 29–31, 40–1, 77–80
 Einige Ideen zur Schöpfungs- und Entwicklungsgeschichte der Organismen (Some Reflections on the Creation and Developmental History of the Organisms 80
 Elemente der Psychophysik (Elements of Psychophysics) 30
fatigue 26, 32, 36–7, 44–5, 47–8, 54–7, 69–70, 77, 127, 144–5, 151–2, 161, 172–3, 207–8
film ix, 11, 13, 136, 143–8, 151–2, 154, 196–202, 222–4, 227, 239, 241, 247–8, 266–7, 284n.71, 287–98, 315–16, 336–7, 339–43, 345–6, 362–3, 384

First World War 9, 81, 84, 129n.10, 157–8, 242, 308, 342, 368
fixation 8, 24–5, 134, 153, 170–1, 183, 212, 234, 271n.17, 380
Fließ, Wilhelm 77–8
flow 110
Foucault, Michel 219
Frank, Svenja 400
Frankfurter Zeitung (newspaper) 145–7, 155, 313
Fränkel, Fritz 280–3
Freud, Sigmund 8–9, 21, 58–60, 63–84, 87–8, 109–10, 124, 170, 177–8, 195–6, 207, 240, 275–6, 302, 305–8, 351, 384, 387
 'Beobachtungen einer hochgradigen Hemianästhesie bei einem hysterischen Manne' (Observations about a Severe Case of Hemi-Anaesthesia in a Hysterical Man) 66
 'Die "kulturelle" Sexualmoral und die moderne Nervosität' (The 'Cultural' Sexual Morality and Modern Nervousness) 64
 Die Traumdeutung (The Interpretation of Dreams) 68
 Entwurf einer Psychologie (Project for a Scientific Psychology) 77–8
 Jenseits des Lustprinzips (Beyond the Pleasure Principle) 79–84, 124, 302
 Psychopathologie des Alltagslebens (Psychopathology of Everyday Life) 9, 68, 74–5, 84, 100, 275–6, 387
 'Ratschläge für den Arzt bei der psychoanalytischen Behandlung' (Recommendations to Physicians Practising Psycho-Analysis) 73, 87–8
 'Tatbestandsdiagnostik und Psychoanalyse' (Psycho-Analysis and the Establishment of the Facts in Legal Proceedings) 72–3
 Totem und Tabu (Totem and Taboo) 65–6
 Vorlesungen zur Einführung in die Psychoanalyse (Introductory Lectures on Psychoanalysis) 68
 'Zum Problem der Telepathie' (On the Problem of Telepathy) 305–7
Fried, Michael 251

Garfield, James Abram 212
Gebrauchsmusik (music for use) 333, 335–6, 336n.79, 343–4
Geistesgegenwart, see presence of mind
gender 26–7, 51, 59–64, 111, 137, 141–2, 144, 208n.15, 218, 221, 242–3, 247, 292–3, 320, 352
Gent, Werner, *see* Cohn, Jonas

Gerling, Reinhard 206–13
 Die Gymnastik des Willens (Will Gymnastics) 206
 Die Kunst der Konzentration (The Art of Concentration) 206–15, 217–19
Giese, Fritz 130–1
Gilbreth, Frank and Lillian 136
Glaser, Curt 241, 247–9, 258–60
Goehr, Lydia 318–20
Goethe, Johann Wolfgang von
 Die Wahlverwandtschaften (Elective Affinities) 314
Goll, Claire 389–90
Goll, Ivan 389–90
Gracián, Baltasar
 The Art of Worldly Wisdom 218
Gräff, Werner
 Es kommt der neue Photograph! (Here Comes the New Photographer!) 227
Greuze, Jean-Baptiste 251–2, 322
Grimm, Jakob and Wilhelm 68–9, 310
 'Der Bärenhäuter' (Bearskin) 310
Guttmann, Heinrich
 Aus der Frühzeit der Photographie, 1840–70 (The Early Days of Photography) 228–9

habit 12, 21, 24–5, 32–4, 39, 49–50, 62, 66, 90–1, 93, 105, 142–5, 170–1, 174–5, 180, 184, 188, 195–6, 199–200, 207–8, 225–6, 227n.16, 231, 262, 266, 276–7, 283–4, 288n.89, 291–2, 294–5, 298, 304, 306–7, 329, 331, 335–7, 339–41, 345–8, 352, 354, 358–62, 390
Hagner, Michael 16
Hall, Elizabeth (Johnstone) 262
Hanausek, Gustav 94
Hanslick, Eduard 11–12, 322–7, 331, 333, 336, 341, 348–50
 Vom Musikalisch-Schönen (On the Musically Beautiful) 11–12, 322–7, 336, 341
'Healthy Nerves' (Gesunde Nerven) exhibition 280–2, 282–3f
Heartfield, John 144
Hegel, Georg Wilhelm Friedrich 373–4, 377n.134
Heidegger, Martin 5n.14, 13
 Sein und Zeit (Being and Time) 334–5
Hellpach, Willy 57, 62–3, 100, 234–5
 Nervosität und Kultur (Nervousness and Culture) 62–3, 234–5
Helmholtz, Hermann von 1–2, 6–8, 32–7, 40, 317
 Die Lehre von den Tonempfindungen (On the Sensations of Tone) 317
Helvétius, Claude-Adrien 33

Henning, Hans 222–5
Herbart, Johann Friedrich 9, 31, 88–91, 93
Herder, Johann Gottfried 319–20
Herz, Marcus 28n.64
Heyde, Ludwig 151–2
Heym, Georg 344–5
Hill, David Octavius, and Robert
 Adamson 10–11, 229–33, 236–8, 252–5,
 253f, 257–60, 262, 263f, 383–4
Hillar, Ansgar 266
Hindemith, Paul 328–30, 335n.76
Hipp, Matthäus 34–5
Hirsch, Adolph 34–5
Hirschberg, Walther 329–30
Hitler, Adolf 300
Hoffmann, Ludger 168–9
Hölderlin, Friedrich 312–14
Holocaust 375, 386, 388–9, 391–3, 396
Hoppe, Felicitas 23–4, 386, 396–404
 Hoppe 397
 Johanna 398–401
 'Über Geistesgegenwart' (On Presence of
 Mind) 401–3
Hoppe, Marianne 367
Horkheimer, Max 13, 102, 285–6, 296n.117,
 374–7, 379, 381, 389–90
 and Theodor W. Adorno, *Dialektik der
 Aufklärung* (Dialectic of
 Enlightenment) 374–5
 'Kulturkritik und Gesellschaft' (Cultural
 Critique and Society) 375
 'Traditionelle und kritische Theorie'
 (Traditional and Critical Theory) 374–5
Huch, Ricarda 233
Hume, David 31, 376–7
Husserl, Edmund 43–5, 205n.2, 334
 Logische Untersuchungen (Logical
 Investigations) 43–4
Huyssen, Andreas 194, 277n.42
hygiene literature 17, 28, 77, 210
hysteria 47–8, 54–5, 60–7, 72, 76n.128, 81n.142,
 83n.151

inattentional blindness 87
Istel, Edgar 327–8
Itten, Johannes 130–1

James, William 1, 3–4, 6–7, 9, 31–4, 43, 128,
 179, 327
 The Principles of Psychology 1, 31, 43, 128
Jameson, Fredric 365
Janet, Pierre
 L'automatisme psychologique (The
 Psychological Automatism) 66–7

jazz 295, 335–7, 345–7, 357
Jennings, Michael W. 50n.24, 280, 339n.4
Jesenká, Milena 117n.73, 122–3
Joël, Ernst 280–1
Joseephi, Clara 267
Jüdische Rundschau (Jewish Review,
 journal) 389–90
Jung, Carl Gustav 178

Kafka, Franz 6–7, 9–10, 39, 84–127, 151, 183,
 219–20, 270, 317, 361–4, 377, 380, 384–8,
 390–2, 396, 403–4
 'Atemlos kam ich an' (Breathless,
 I arrived...) 123–6, 270, 279–80, 402
 Betrachtung (Meditation) 104n.44
 'Blumfeld ein älterer Junggeselle' (Blumfeld, an
 Elderly Bachelor) 113–14
 Das Schloss (The Castle) 98, 118–21, 123,
 125–6
 'Das Urteil' (The Judgement) 109–12, 279–80
 'Der Bau' (The Burrow) 39, 114–20, 124, 126,
 300–1, 308–10
 'Der Jäger Gracchus' (The Hunter
 Gracchus) 95–8, 391–3
 'Der Nachbar' (The Neighbour) 117–18
 Der Process (The Trial) 9, 86–93
 'Der Schlag ans Hoftor' (The Knock at the
 Courtyard Gate) 98–100
 Der Verschollene (The Man who
 Disappeared) 100–8, 151, 377, 380
 Die Verwandlung (The
 Metamorphosis) 363–4
 'Eine kleine Frau' (A Little Woman) 118, 125–6
 'Großer Lärm' (Great Noise) 108–9, 111–13, 124
 'In der Strafkolonie' (In the Penal
 Colony) 363–4
 'Josefine, die Sängerin oder Das Volk der
 Mäuse' (Josefine, the Singer or The Mouse
 People) 125–6
 letters to Felice Bauer 111–14, 116–17, 125–6
 'Unfallverhütungsmaßregel bei
 Holzhobelmaschinen' (Measures for
 Preventing Accidents from Wood-Planing
 Machines) 94–5f
 'Versunken in die Nacht...' (Immersed in the
 night...) 121–3, 403
kairos 118–19, 121, 403
Kant, Immanuel 3–4, 23–6, 33, 274–5, 318–19,
 324, 333, 337, 362–4
 Anthropologie in pragmatischer Hinsicht
 (Anthropology from a Pragmatic Point of
 View) 23–6, 318–19
 Kritik der Urteilskraft (Critique of the Power of
 Judgement) 318–19, 339–40, 362–4

Karplus, Gretel 306–7
Kaulen, Heinrich 313n.172
Khnopff, Fernand 321–2, 322f, 361
Killian, Hans
 Facies Dolorosa (Faces of Suffering) 234n.34
Klossowski, Pierre 285–6
Koffka, Kurt 205n.2
Köhler, Wolfgang 205n.2
Kollwitz, Käthe 233–4
König, Theodor
 Reklame-Psychologie: Ihr gegenwärtiger Stand—ihre praktische Bedeutung (Advertising Psychology: Its Current State—its Practical Significance) 141–5, 149
Kracauer, Siegfried 9, 13–14, 103, 145–56, 160–1, 239, 242, 266–7, 384
 Die Angestellten (The Salaried Masses) 9, 145, 242, 266–7, 291–2
 'Kult der Zerstreuung' (Cult of Distraction) 146n.55, 291–2
Kraepelin, Emil 62
Krafft-Ebing, Richard von 59–61, 208n.14, 308
 Nervosität und neurasthenische Zustände (Nervousness and Neurasthenic States) 64
Külpe, Oswald 41–2
Kunstmusik (art music) 331–2, 333n.65, 335–6, 337n.83
Kunstreligion (art religion) 319–20, 330, 361

Laehr, Max 60
Lamarck, Jean-Baptiste de 56
Lamprecht, Karl 48–51, 53, 57, 63, 100, 235–6, 327
 'Was ist Kulturgeschichte?' (What is Cultural History?) 49
Lang, Fritz 241
Lange, Nicolai 36–7
Lazarsfeld, Paul Felix 351–2, 355
Leibniz, Gottfried Wilhelm 15–16, 17n.9, 21n.34, 24, 26, 29, 40–1, 43–4, 77–9, 295–6
Lendvai-Dircksen, Erna 10–11, 233–9, 238f, 241, 249, 255–61, 383–4
 Das deutsche Volksgesicht (The Face of the German People) 233, 237, 257
 'Psychologie des Sehens' (Psychology of Vision) 235
Leni, Paul 241
Lerski, Helmar 11, 241–65, 377
 Köpfe des Alltags (Everyday Heads) 241–65, 243f, 244f, 245f, 246f, 250f
Leskov, Nikolai 300–1, 304–5, 308–9
Lessing, Theodor 327
Lethen, Helmut 83–4, 218
Lindner, Burkhardt 285n.79, 297

Lindner, Gustav Adolf 88–91, 93, 183, 297
 Lehrbuch der empirischen Psychologie (Handbook of Empirical Psychology) 88–91
Liszt, Franz 322
Die literarische Welt (The Literary World, journal) 174, 283–4
Locke, John 116
Löffler, Petra 35n.78, 37nn.86,87
Lombroso, Cesare 47
Long, J. J. 307n.154, 391–2
Lotze, Hermann 31, 205n.2
Lukács, Georg 307n.153, 373n.113
Lukács, Hugo 177–8, 184
 Psychologie des Lehrlings (Psychology of the Apprentice) 177–8

Mach, Ernst 31, 158
Macpherson, Ken 261–2
madness 25–8, 63, 235
Mahler, Gustav 338
Malebranche, Nicolas 309, 387–90
Marbe, Karl 36–7
Marx, Karl 301
mass culture 6–7, 12, 147–8, 267, 300–1, 300n.131, 339–41, 343–4, 351
Maudsley, Henry 47
meditation 10, 213–20, 228n.87, 311–12, 320
Meier, Georg Friedrich
 Philosophische Sittenlehre (Philosophical Treatise on Morality) 17–20, 28, 33, 211
melancholy 245, 250, 273–4, 308, 313, 393–6
memory 3, 12, 19, 21, 24, 30–1, 36–7, 46, 50, 52, 68–9, 73–4, 76–82, 88–9, 105–8, 135, 138f, 141–3, 163–4, 183, 207n.9, 209–10, 212, 216–17, 228n.92, 252, 261–2, 267–9, 303–5, 308, 344–5, 386, 389–93, 396
Mergenthaler, Ottmar 52
mindfulness 5n.13, 208n.15, 219–20, 310, 396
Mitchell, Weir 58–9
Möbius, Paul Julius
 'Ueber den physiologischen Schwachsinn des Weibes' (On the Physiological Idiocy of Woman) 60–1
Moede, Walther 130–1
Moholy-Nagy, László 130–1, 146n.55, 245n.138
Morel, Bénédict 47–8
Moritz, Karl Philipp 28, 319–20
Müh, Philipp
 Coué in der Westentasche! (Coué for the Waistcoat Pocket!) 215–19
Müller, Georg Elias 36–7

Münsterberg, Hugo 9, 36–7, 41–2, 127–30, 159–60, 162–3, 196–8
 Grundzüge der Psychotechnik (Principles of Psychotechnics) 128–30, 162–3
 The Photoplay 196–7
 Psychologie und Wirtschaftsleben (Psychology and Economic Life) 128
Murnau, F. W.
 Der letzte Mann (The Last Man) 247–8
music 11–13, 56–7, 189, 208–9, 268, 270, 317–66, 368–70, 378, 381–2, 384–5, 390
 attentive listening to 322, 324–6, 337–9
 background 344–5, 349–50
 classical 209, 328, 343–4, 358n.65
 composition 320–1, 324
 as distraction 56–7, 268, 279–80, 295, 327, 337
 immersion in 270, 321, 323, 326
 performance 208, 320–1, 370
 pleasure in 319–20, 323, 325, 356
 popular 12, 345–8, 350, 354n.53
 theory 317–20, 326, 342
Musil, Robert 6–7, 10, 156–203, 303, 317
 'Als Papa Tennis lernte' (When Daddy Learnt to Play Tennis) 172–3
 'Ansätze zu neuer Ästhetik' (Towards a New Aesthetic) 184
 Der Mann ohne Eigenschaften (The Man without Qualities) 10, 157–8, 163–8, 182–3, 193–4, 201
 'Die Amsel' (The Blackbird) 184–9
 Die Schwärmer (The Enthusiasts) 178, 210n.19
 Drei Frauen (Three Women) 163
 Nachlaß zu Lebzeiten (Posthumous Papers of a Living Author) 182–93, 303
 'Physiologie des dichterischen Schaffens' (Physiology of Literary Production) 166
 'Psychotechnik und ihre Anwendungsmöglichkeit im Bundesheere' (Psychotechnics and its Applicability in the Austrian Army) 159, 168–9, 173, 176
 Vereinigungen (Unions) 183–4

Nagel, Wilibald
 Die Musik im täglichen Leben (Music in Daily Life) 327–8
National Socialism 128n.6, 146n.54, 233n.32, 234–5, 239, 240n.54, 300, 308, 312, 336n.78, 348, 365, 375–6, 383–4, 388–9, 395–6
NBC Music Appreciation Hour 12, 353–4, 364
Neue Sachlichkeit, *see* New Objectivity
Neues Sehen, *see* New Vision

neurasthenia and nervous illness 27, 36–7, 47–8, 50–65, 67, 69–70, 76, 83n.151, 101–2, 208, 212, 215, 234–5, 237–8, 327, *see also* 'Healthy Nerves' exhibition
neurosis 47–8, 55–6, 58–9, 64–6, 75–6, 80–1, 83, 177–8
New Objectivity 235–6, 241, 284n.75, 329–30
New Vision 235–6, 329–30
noise 33–4, 37–8, 53–4, 56–7, 108–14, 116–17, 150, 167, 189, 218, 268, 278–80, 291n.96, 317, 327–8, 352
Nordau, Max 47–8, 55–6, 61
 Entartung (Degeneration) 47
North, Paul 5n.14, 116n.68

observation (scientific) 21, 35–6, 74, 76
Ohnesorg, Benno 378
opera 326–8, 344–5, 357
Orlik, Emil 231
other state (*anderer Zustand*) 173–4, 182, 199–200, 228n.87, 232n.102, *see also* Robert Musil
Otto, Franz
 Männer eigener Kraft (Men of Great Strength) 212

Paddison, Max 338n.2, 365n.86
paranoia 65–6, 85, 113–18, 123
parapraxis 9, 68–72, 173, *see also* Sigmund Freud
Pascal, Blaise 274
Paulhan, Frédéric 32
pedagogy, *see* education
Penman, Danny, *see* Mark Williams
Pestalozzi, Johann Heinrich 16–17
photography ix, 10–11, 13, 35n.75, 87n.7, 136–8, 196–7, 220–66, 278n.47, 287–8, 329–30, 354–5, 384, 392n.28
 calotype 229–30, 262
 exposure time 230, 232, 236, 252–3, 257–9
 portrait photography 11, 227, 229–37, 239–64, 287, 350, 383–4
 snapshot 222–4, 227
physiognomy 10–11, 149, 222, 223f, 231, 233–4, 256, 260
Picard, Max 239
Picasso, Pablo 339–40
Pinel, Philippe 27
Piorkowski, Curt 159–61
 Die psychologische Methodologie der wirtschaftlichen Berufseignung (Psychological Methodology of Economic Aptitude Testing) 161

Pirandello, Luigi
　Quaderni di Serafino Gubbio operatore (The Notebooks of Serafino Gubbio, Cinematograph Operator) 291
Plato 348n.35, 373–4
Plessner, Helmuth 218
Poe, Edgar Allan 154–5
practice (*Übung*) 17–18, 24, 27–8, 33, 145, 170–3, 177–8, 180–2, 206, 209–10, 271–2, 275–6, 278–9, 302, 320–1, 356, 373n.111, 376–7, 379, 381, 383–4, 400, 402, *see also* training
prayer 208, 214, 219, 270–1, 286–7, 309–10, 332, 380, 385–91
predictive processing 89n.16
presence of mind 4, 87, 90–1, 103, 118n.74, 135–6, 160, 267, 270–1, 287, 312, 314–15, 400–3
Princeton Radio Research Project 12, 351–2, 354
Proust, Marcel 303–4, 367–8
　À la recherche du temps perdu (In Search of Lost Time) 367
psychiatry 2–3, 8–9, 27–8, 44–5, 47–8, 57, 59–60, 62, 64–5, 67, 71, 73–4, 76, 83–4, 86, 139, 222–4
psychic cure 27–8
psychology 28–45
　experiential psychology 28–9, 319
　experimental psychology vi, 11, 13, 31–42, 44–6, 74, 94, 117–18, 127–9, 136, 157–8, 164–5, 170, 198, 222, 256, 266–7, 328, 383–4
　in the German and Austrian school curriculum 9, 88–9
　laboratory 8, 28, 31, 34–9, 77–8, 131n.15, 133, 160
psychotechnics 9–11, 126–56, 160–6, 168–71, 173–4, 176–8, 196–8, 202–4, 217, 222, 225, 266–7, 288–90, 296–8, 304, 315–16, 329, 383–4, 401
psychotherapy 10, 174, 177–8, 184, 204

radio vi, 12, 235, 287, 289, 295, 326–7, 331, 342–3, 348–60, 366–7, 369–70, 378, 381–2
Radkau, Joachim 51–2, 54n.36
Rank, Otto 71
Ranke, Leopold von 49n.21, 299n.127, 398
Reifenberg, Benno 155
Reil, Johann Christian 3, 27–8, 33
　Rhapsodien über die Anwendung der psychischen Curmethode auf Geisteszerrüttungen (Rhapsodies on the Application of the Method of the Psychical Cure on Mental Disturbance) 27–8

Retzlaff, Erich
　Das Antlitz des Alters (The Countenance of Old Age) 234n.34, 247n.61
Ribot, Théodule-Armand 1, 6–9, 46–8, 55–6, 183–4, 222–4, 325–6
　La Psychologie de l'attention (The Psychology of Attention) 1, 46, 179, 183–4
Riedel, Hans 130–1
Riedler, Alois 51–2
Riegl, Alois
　Spätrömische Kunst-Industrie (Late Roman Art Industry) 288n.88
Riemann, Hugo 326, 331, 356
　Über das musikalische Hören (On Musical Listening) 326
Rilke, Rainer Maria 13–14, 288
　Die Aufzeichnungen des Malte Laurids Brigge (The Notebooks of Malte Laurids Brigge) 13–14
　Neue Gedichte (New Poems) 13–14
Rittmann, Trude 359–60
Robertson, Ritchie 85–6, 122n.77
Rothberg, Michael 392–3
Ryan, Judith 104n.43

Said, Edward 365
Sanctis, Sante de
　La mimica del pensiero (The Reflection of Thought in Facial Expression) 222–4
Sander, August 233–4, 241–2, 248–9
　Antlitz der Zeit (Face of our Time) 233
　Menschen des 20. Jahrhunderts (People of the Twentieth Century) 242
Schenker, Heinrich 326
Scherchen, Hermann 328, 341n.12
Schiller, Friedrich 71, 84
　Wallenstein 71
Schleiermacher, Friedrich 319–20
Schliemann, Heinrich 212
Schmidt, Karl Otto 213–15, 217–20
　Wie konzentriere ich mich? (How Do I Concentrate?) 213–15
Schmitt, Carl 218
scholar, attention of the 1n.3, 24–7, 59–60, 173, 318–19, 333, 366, 402
Scholem, Gershom 380
Schönberg, Arnold 329, 381
Schubert, Franz 359–60, 359n.66
Schwartz, Frederic J. 298–9
Schwarz, Heinrich
　David Octavius Hill: Der Meister der Photographie (The Master of Photography) 230–1, 237–8, 252–3, 255, 259–60, 263
Schwarz, Michael 366–7

scientific management 136
Sebald, W. G. 23-4, 386, 391-6, 403-4
　Austerlitz 395
　Die Ringe des Saturn (The Rings of Saturn) 392-4
　Schwindel. Gefühle. (Vertigo) 391-2
Seel, Martin 376
self-help literature 10, 13-14, 17, 58-9, 77, 174-5, 178, 204, 225, 228n.92, 278-9, 355, 401
self-care 8, 17, 28, 74, 77, 84, 219-20
self-observation 21, 25n.50, 28-31, 158
Shakespeare, William 71, 84
　The Merchant of Venice 71
Shklovsky, Viktor 195, 288n.89
Simmel, Georg 13-14, 49-51, 53, 83, 100, 235-6, 284n.71
　'Die Großstädte und das Geistesleben' (The Metropolis and Mental Life) 13-14, 49-50, 79-80
Simon, Heinrich 155
slip of the tongue, *see* parapraxis
Sommer, Robert 222-4
Spencer, Herbert 31
Stern, William (Wilhelm Louis) 9, 11, 128-9, 148-9, 267-9, 288-9
Stetler, Pepper 248
Stiegler, Bernd 226-7
Stifter, Adalbert 68-9
Stumpf, Carl 10, 31, 43-4, 158-9, 165
surrealism 157, 296, 362-3
Swift, Edgar James 38-9
symphony concert 11-12, 328, 335-6, 342-4

tachistoscope 35-6, 72, 133*f*, 133, 158, 221
talking cure 68, 72, 74, 76, 173, *see also* Sigmund Freud
Tieck, Ludwig 319-21
Tissot, Samuel-Auguste
　De la santé des gens de lettres (On the Diseases Incident to Literary and Sedentary Persons) 26
Titchener, Edward Bradford 37, 128
Tramm, Karl August 159-60
trauma 8-9, 67-8, 76n.128, 79-81, 83-4, 131-2, 302, 304
Tuczek, Franz 67

Übung, *see* practice
Uhu (magazine) 225, 234, 241

Umbo (Otto Umbehr) 227, 228*f*
Urbantschitsch, Victor 36-7

Viertel, Berthold 241

Wachsmuth, G. F. 61
Wackenroder, Wilhelm Heinrich 319-22
Wagner, Richard 322, 326-7, 338
Waitz, Theodor
　Lehrbuch der Psychologie als Naturwissenschaft 32n.71
Waldenfels, Bernhard 43-4
Walser, Robert 13-14
　Der Räuber (The Robber) 14
Weber, Eduard, and Ernst Heinrich 29
Webern, Anton 356
Wegener, Mei 77-8
Wegman, Rob C. 337
Weill, Kurt 335n.76
Wernicke, Carl 60
Wertheimer, Max 205n.2
Westphal, Kurt 329-30
white-collar workers 59-60, 62, 148, 153, 155n.87, 242, 344-5, 353-4
Whytt, Robert 27
Wiegmann, Fritz 282
Wigman, Mary 233
Williams, Mark and Danny Penman 219-20
Wolff, Christian 3, 17nn.9-10
　Vernünfftige Gedancken von Gott, der Welt und der Seele des Menschen, auch allen Dingen überhaupt (Sensible Thoughts about God, the World, the Soul of Man, and all Existing Things) 3
Wolpe, Stefan 359-60
Wundt, Wilhelm 31, 34-7, 39-45, 62, 66, 77-9, 128, 158, 295-6, 347
　Grundzüge der physiologischen Psychologie (Principles of Physiological Psychology) 40-1
　Völkerpsychologie 42

Yan-Tsen-Tsai 113

Ziemer, Hansjakob 328
Zimmermann, E. 132-40, 149, 166
Zeitschrift für Sozialforschung (Journal for Social Research) 285-6, 345-6